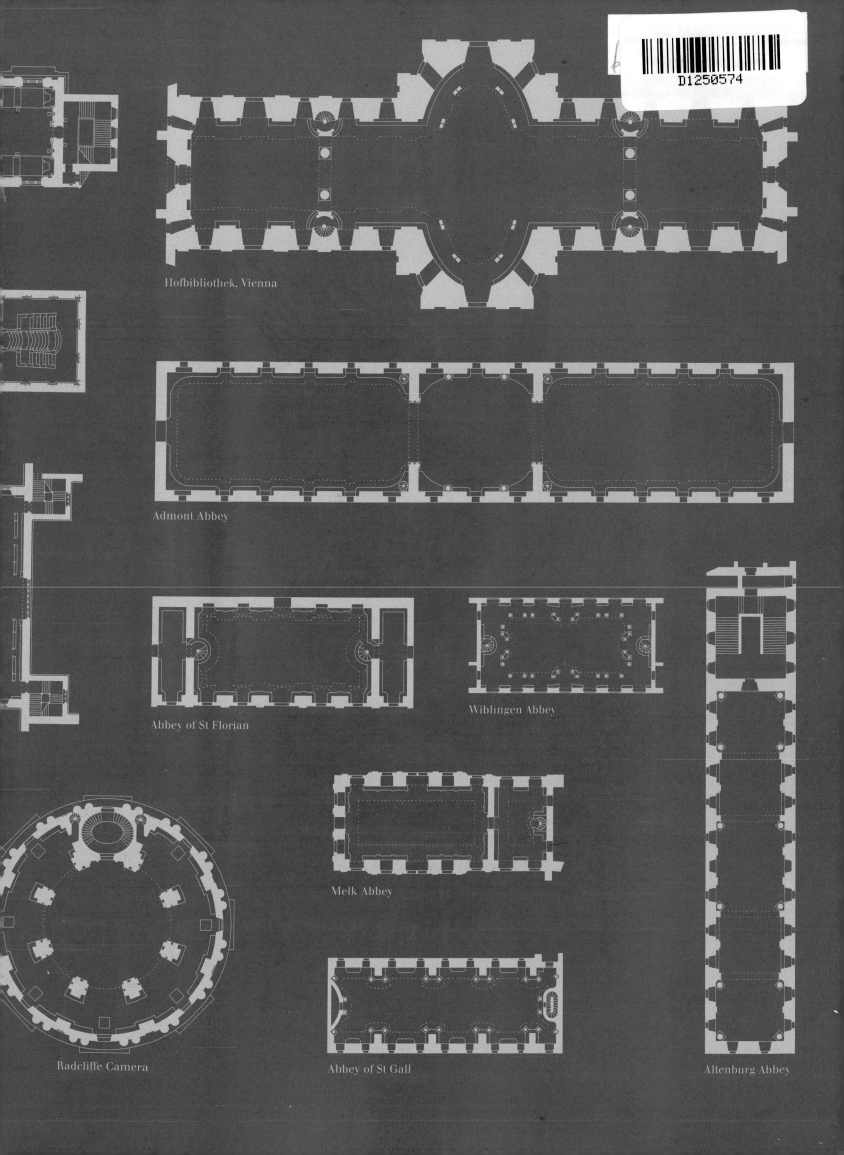

Hofbibliothek, Vienna

Admont Abbey

Abbey of St Florian

Wiblingen Abbey

Melk Abbey

Radcliffe Camera

Abbey of St Gall

Altenburg Abbey

The Library
A WORLD HISTORY

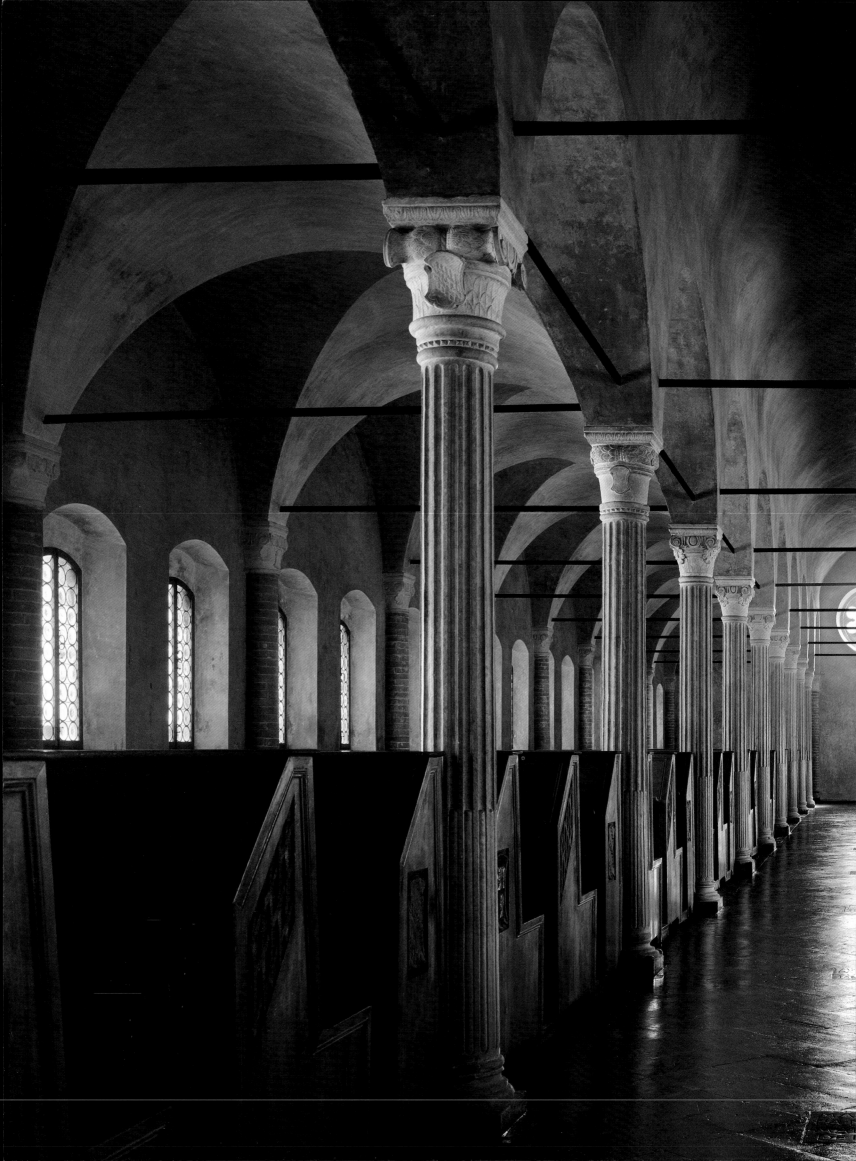

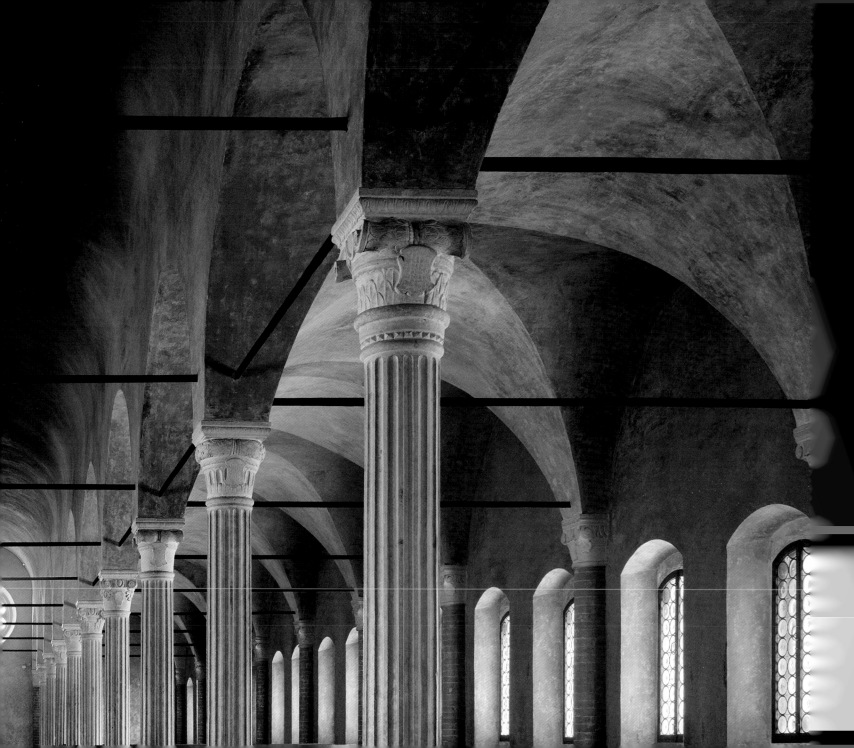

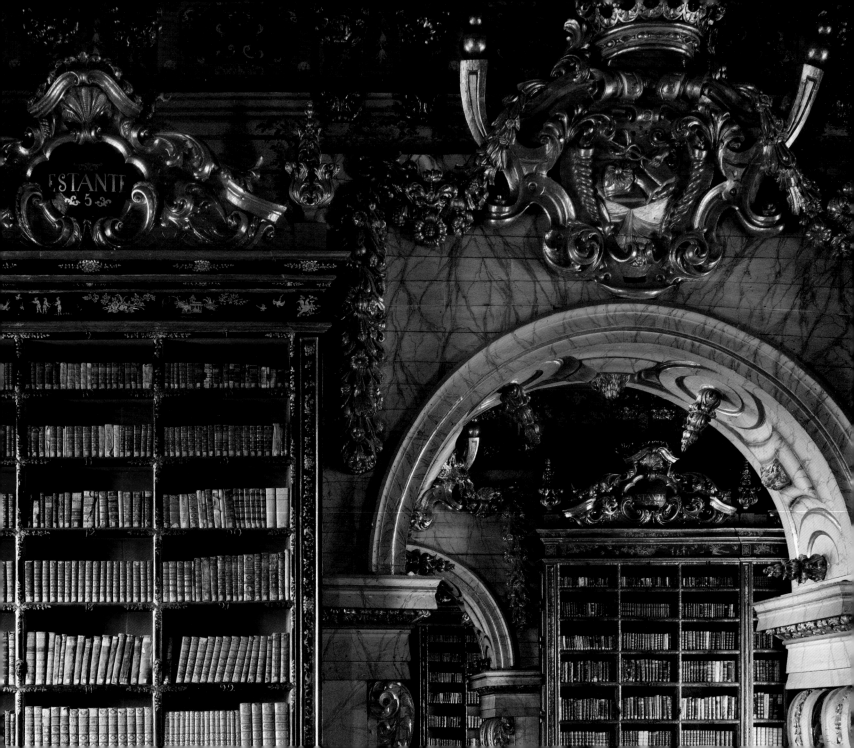

The Library

A WORLD HISTORY

James W. P. Campbell

Photographs by Will Pryce

THE UNIVERSITY OF CHICAGO PRESS

CHICAGO

The University of Chicago Press, Chicago 60637
Published by an arrangement with
Thames & Hudson Ltd., London

The Library: A World History
© Thames & Hudson Ltd., London
Text © 2013 by James W. P. Campbell
Photographs © 2013 by Will Pryce
All rights reserved. Published 2013.

Designed by Maggi Smith
Printed in China on acid-free paper

22 21 20 19 18 17 16 15 14 13 1 2 3 4 5

ISBN-13: 978-0-226-09281-2 (cloth)

Library of Congress Cataloging-in-Publication Data

Campbell, James W. P., author.
 The library : a world history / James W. P. Campbell ;
photography by Will Pryce.
 pages cm
 Includes bibliographical references and index.
 ISBN 978-0-226-09281-2 (cloth : alkaline paper) 1.
Libraries–History. I. Pryce, Will, illustrator. II. Title.
 Z721.C22 2013
 027.009–dc23

 2013019928

ACKNOWLEDGMENTS

The ambitious scale and scope of this book have
only been made possible by the involvement of a
great number of people over a period of many years.
We are grateful to the staff at Thames & Hudson for
all their expertise. Ian Sutton, who championed this
project at the beginning, sadly did not live to see the
result. We have missed his wit and scholarship.

We would like to thank the members of the production
team who have put so much of their time into the
book: Stephen Robinson for the digital processing of the
photographs, Niall Bird who produced the line drawings,
Maggi Smith for her patience and care in designing this
book and Michael Hall for his editorial skill.

This project involved a considerable degree of
international coordination and we were inevitably
reliant on help to aid negotiations. In this regard
we would like to thank Angela Caine, Marta Casares,
Rebekah Clements, Sophie Descat, Manuolo Guerci,
Dustin Hässler, Stefan Holzer, Bo-Yun Jung, Jin Woo
Jung, Miao Li, Werner Lorenz, Ana Martins, Roland
May, Yiting Pan, Daphne Thissens and Hongbin
Zheng. Our work in Japan was greatly assisted by
Martin Morris and Miyoko, to whom we are hugely
grateful. Thanks also to those friends who very kindly
provided accommodation and moral support: Deanna
Griffin, Simon Kuper, Tamsin Aspinall and Barnaby
Prendergast, Kathy Long and Glen Horton, Cecily
Hilsdale and Jonathan Sachs.

We would also like to thank the directors and staff
of all the libraries included in this book for giving
us their permission, help and advice: D. Abulafia,
M. Agosta, R. Aiello, M. Allen, M. do Amaral,
E. Andersson, N. Aubertin-Potter, A. Bambery,
A. Baumann, M. Beckett, S. Bohnet, O. Braides,
F. Buchmayr, J. van Burk, S. Cannady, A. Cappa,
I. Ceccopieri, Z. Cerkvenik, L. Comstock-Tirrell,
E. Desrochers, A. Diffley, T. Eggington, K. Ekholm,
P. Errani, P. Espinosa, E. Fighiera, S. Frigg, K. Fujii,
Y. Fujii, A. Gamerith, D. Giuliani, M. Le Goff,
P. A. Groiss, F. Gruss, P. Hansaghy, A. Heijn, M. Heikkilä,
S. Helfferich, K. Hildebrandt, S. Jones, W. Keller,
J. Lam, P. Leroy, M. Lubing, I. Maclean, R. Martz,
D. McKitterick, K. Molloy, G. Morgan, C. Nicholson,
R. Ovenden, J. Parez, V. Perry, C. Peters, A.-M. Pietilä-
Ventelä, J. Pollard, M. Prüller, J. Quinn, D. Ruhlmann,
Lord Salisbury, D. Scialanga, E. Sonnleitner,
S. Soulignac, K. Spears, K. Spence, M. Statham,
J. Taylor, K. Tollkühn, J. Tomaschek, P. Trowles,
M. Uemura, J. Walworth, I. Yglesias de Oliveira
and N. Zins.

This book is dedicated to the memory of our fathers,
who we think might have liked it, and to our sons,
who we hope in time may come to enjoy libraries
as much as we do.

Page 1: A lectern in the Biblioteca Malatestiana,
Cesena, Italy, 1452

Pages 2–3: The view from the ante-room into the
reading room of the Biblioteca Marciana, Venice, 1564

Pages 4–5: Bomb-damaged books in the chapter
library, Noyon Cathedral, France, 1506–7

Pages 6–7: The Biblioteca Malatestiana, Cesena,
Italy, 1452

Page 8 (title page): The Biblioteca Joanina, Coimbra,
Portugal, 1728

Opposite: The library of the Abbey of St Gall,
St Gallen, Switzerland, 1765

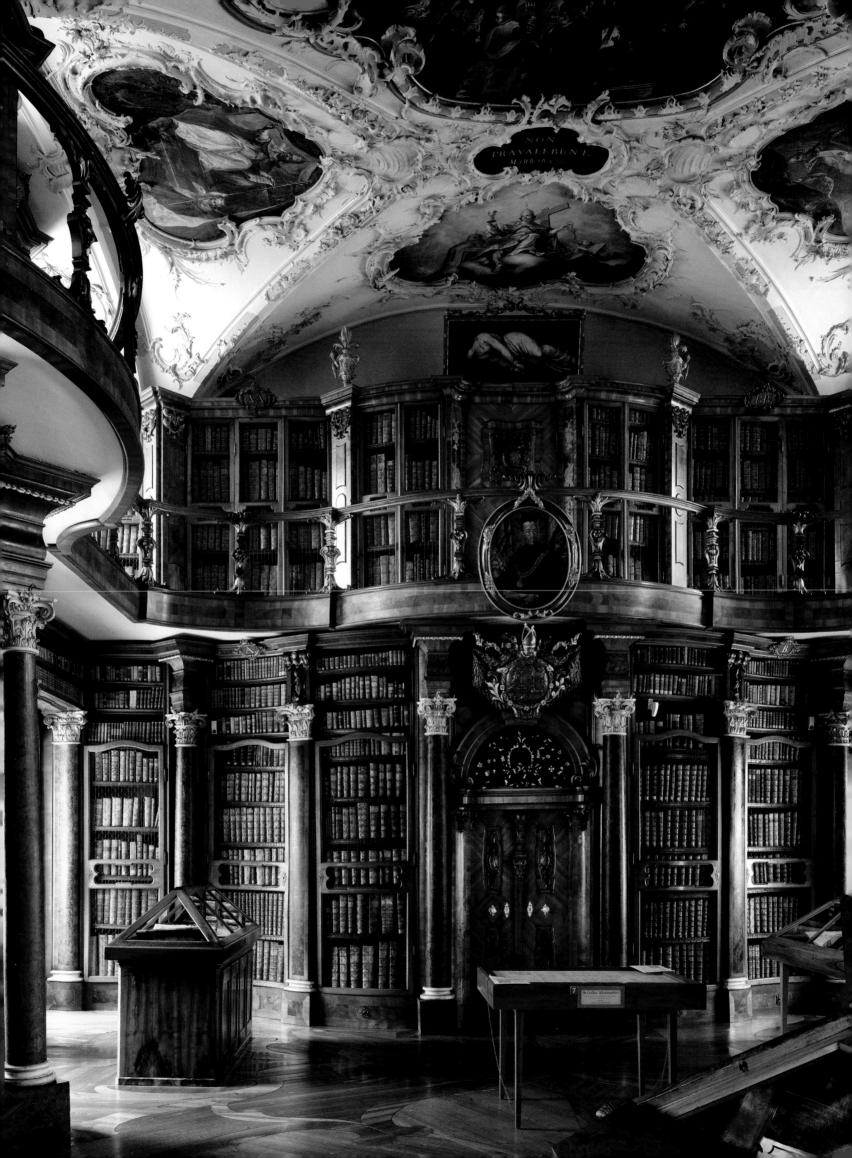

Contents

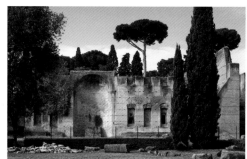

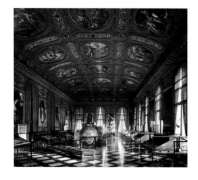
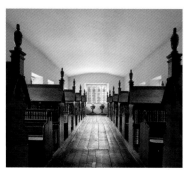

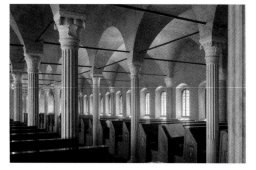

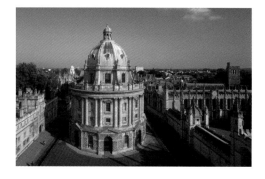
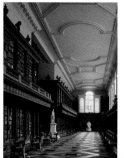

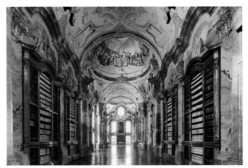

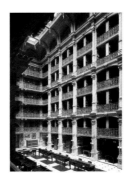
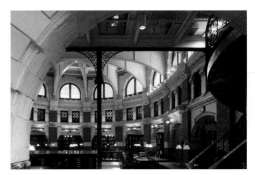
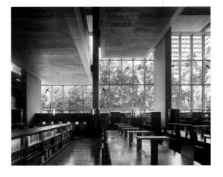

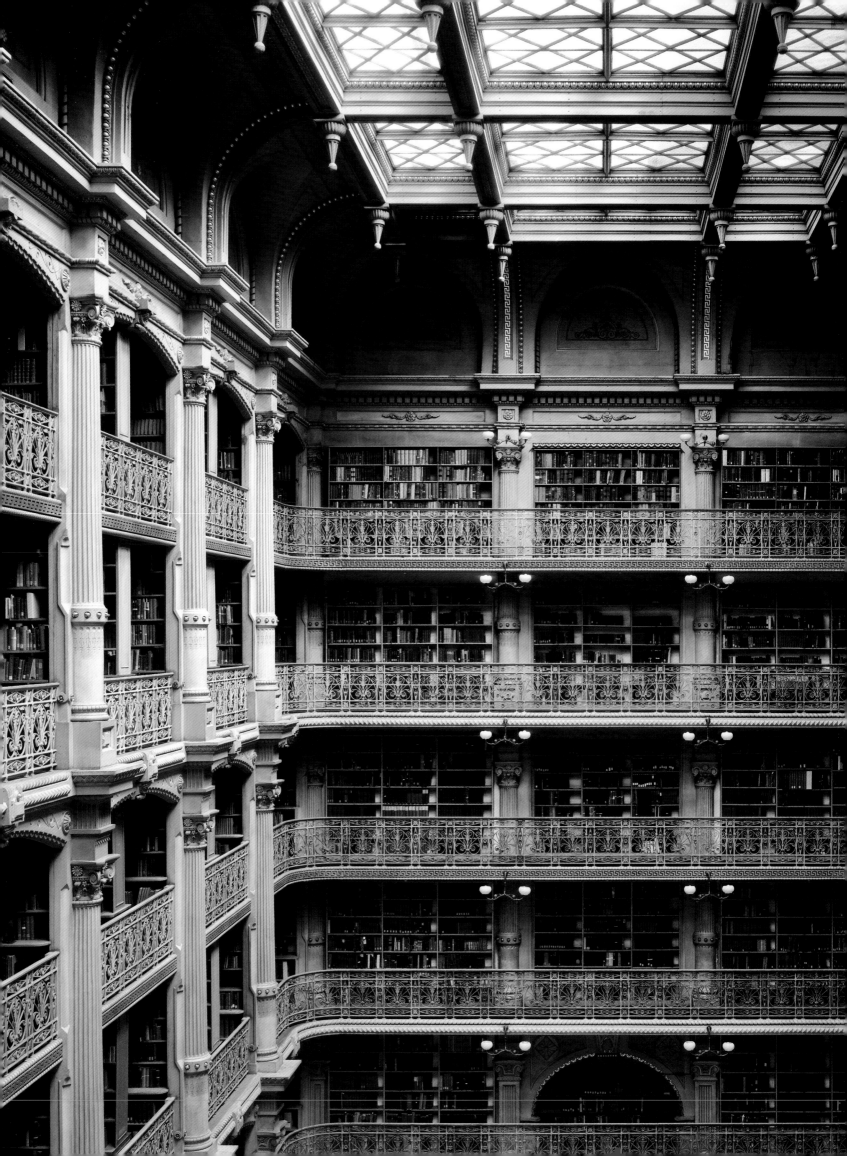

Preface

The idea for this book first occurred to me when, as an architecture student, I wrote a dissertation about the Radcliffe Camera in Oxford. Naturally, I started by looking for a book that surveyed the whole history of library architecture. Then the only significant works in English were J. W. Clark's *The Care of Books,* published in 1901, and the excellent, but relatively short, chapter on the subject by Nikolaus Pevsner in his *A History of Building Types* (1976). When, twenty years later, I still could not find such a book, it seemed permissible to write one myself.

The irony is that today we are told that the book, and hence the library, is under threat. So will this study serve merely as a memorial to a defunct building type? Perhaps, but not quite yet. Today more books are being printed each year than ever before. While public libraries are being closed in Europe, other parts of the world, such as China, are building them. The sales of physical books are increasing, not diminishing: 229 million books were sold in the United Kingdom alone in 2010, a huge increase on the 162 million sold in 2001. Perhaps the world will switch entirely to digital books in the future, but in the meantime an unprecedented volume of physical books must be stored. What is changing is the role of libraries, and as a result the architecture of libraries needs to change with it. It is tempting to assume that this need for change is new;

that until recently libraries have been relatively static in their form. The central argument of this book is that this has never been the case: the history of libraries has been a story of constant change and adaptation.

Any book on architectural history is entirely dependent upon its illustrations, so I was delighted that Will Pryce agreed to photograph the entire project from scratch. Together he and I have travelled to eighty-two libraries in twenty-one countries. I have spent countless happy hours researching the history of libraries in libraries and have been lucky enough to visit many not normally accessible to the public. There remains no substitute for experiencing a building first hand.

Any attempt to encompass thousands of years of history in a single volume naturally involves an act of selection. In the end, I have chosen libraries that I thought were particularly pertinent to the story and have arranged the book broadly chronologically, although I dip out to explore particular themes. In all cases I have been heavily reliant on the work of other scholars and existing scholarship. These sources are listed in the references and bibliographical essay at the end of this book. I hope that the result will provide an entertaining introduction not just for those interested in the history of libraries and the development of architecture, but also for all those who love books and the beautiful spaces designed to house them.

James W. P. Campbell

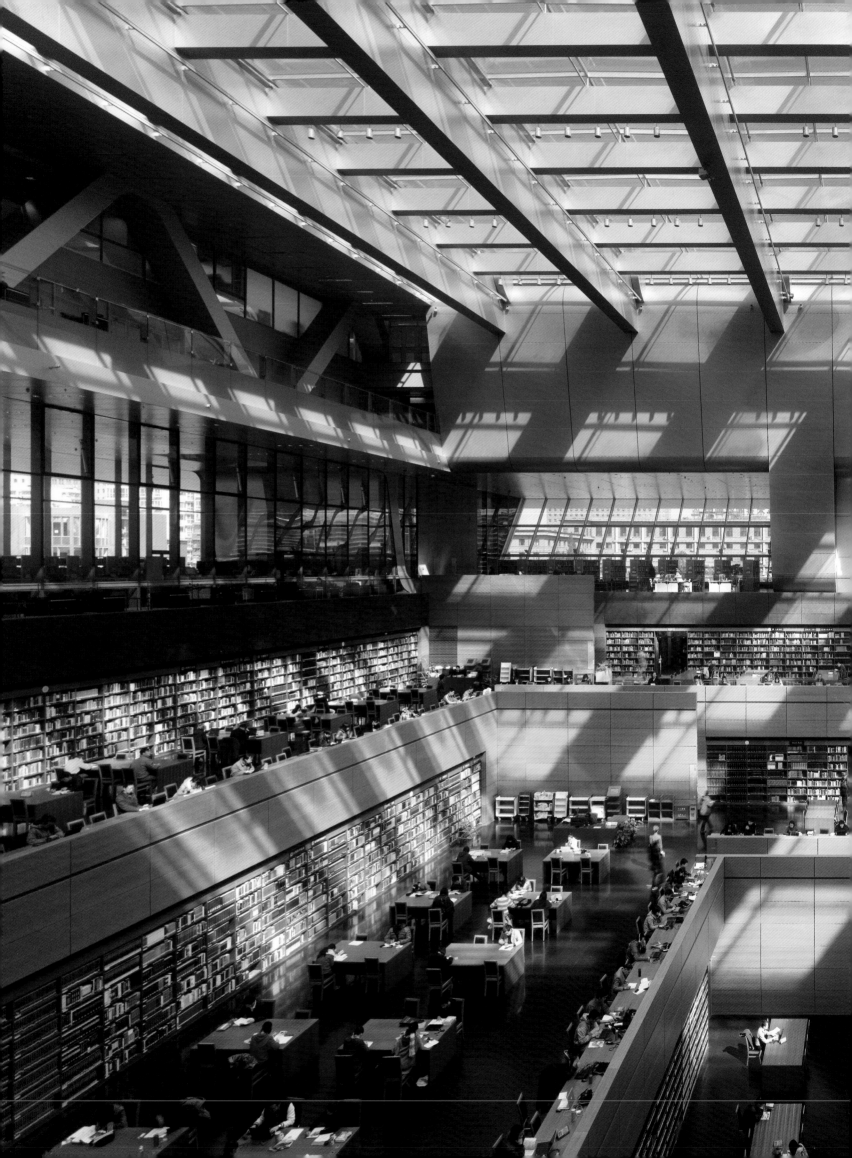

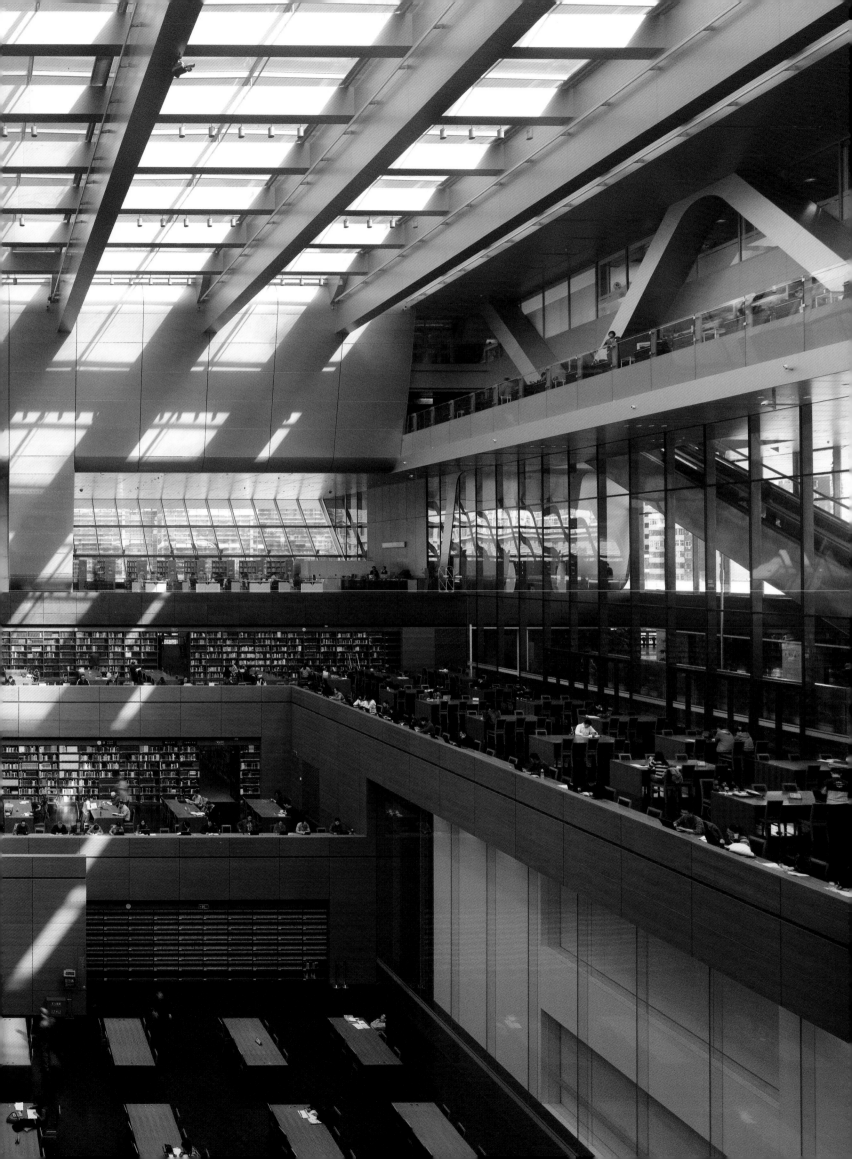

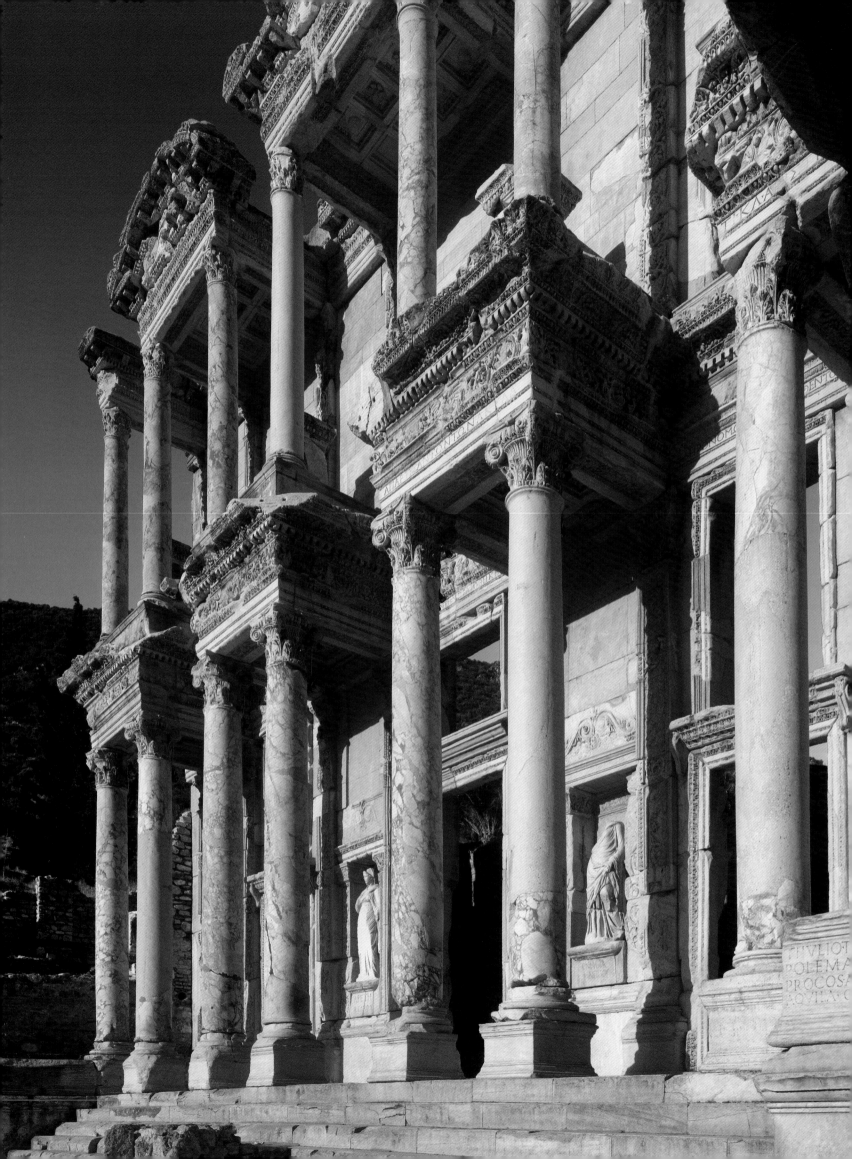

Introduction

Libraries can be much more than simply places to store books. Throughout the ages, the designs of the greatest library buildings have celebrated the act of reading and the importance of learning. They have became emblems of culture, whether it be for an individual, an institution, or even a whole nation. This book tells for the first time the complete story of the development of library buildings from the first libraries, in ancient Mesopotamia, through the lost libraries of the classical civilizations, the monastic libraries of the Middle Ages and the lavish libraries of the Rococo, to the monumental libraries of the modern world. It shows how the development of library buildings illustrates the changing relationship of mankind with the written word and that across the world libraries have always been not just dusty repositories for documents but active symbols of culture and civilization.

The word 'library' in English and most other European languages is ambiguous: it can refer either to a collection of books or to the space that houses them. This lack of distinction between the two is interesting, but it is far from universal. In Chinese, and many other languages, the words for collections of books and the spaces that contain them are not the same. In Chinese, a library space is called 'a building for books'. Indeed, the present work might be justifiably called a 'history of buildings for books'. Despite these linguistic differences, libraries across the world developed in strikingly similar ways.

Any historical survey must necessarily be selective. A recent government census suggested that there are 2,925 public libraries in China alone.[1] A majority do not have buildings of their own. Like most of the public libraries in the late-19th-century United States, they will be housed in parts of existing buildings that have been adapted for the purpose.[2] Such rooms are rarely architecturally interesting. A great many owners of libraries and institutions have taken only the slightest interest in the way that their collections are housed. However, in every period others have wished to display their books. They have taken pride in their shelving and have been eager to show their books off to the best advantage. They have wanted not only to own books, but also to create a beautiful library to put them in. The history of the library as a piece of architecture – the one that this book seeks to tell – is the history of those libraries: that is, libraries that are designed to be seen.

Survival and alteration

The problems of interpreting ruins are obvious, but even where libraries have survived, they rarely remain completely unchanged. Many have been subject to quite radical alterations over time. Few libraries demonstrate this better than the Long Room at Trinity College, Dublin. The arrangement of this impressive early-18th-century library, which combines a barrel vault with two storeys of alcoves, appears to be the first of its kind. However, it is not what it seems. The building, which was designed by Thomas Burgh (1670–1730), the Surveyor General of Ireland, and completed in 1732, was undoubtedly an important library when it was first built, but it looked very different from the room we admire today.[3] Its tripartite design consisted of two three-storey pavilions flanking a colonnade on the ground-floor level and the two-storey-high Long Room above. One of the pavilions contained the staircase leading to the library and offices for the librarian, and the other provided room for a philosophy school on the ground floor and a manuscripts room above. The ceiling of the Long Room was originally lower and flat and the upper galleries did not support bookcases. The distinctive barrel vault was only introduced by the architects Deane and Woodward in 1856, when the original library underwent a radical remodelling, which included raising the roof and filling in the ground floor.[4] Thus the library we see today is essentially a 19th-century creation. Here, as elsewhere, distinguishing later additions from the original is a considerable challenge. This brings us to another important issue in the history of libraries: who designs them?

Who designs libraries?

The intentions of the designers of libraries are often very difficult to determine. Libraries are never entirely

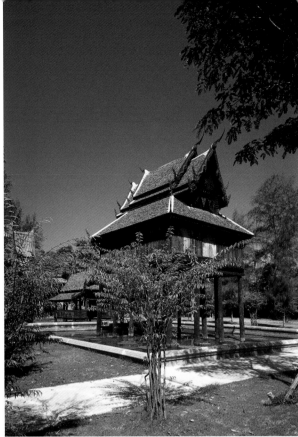

the work of individuals. Patrons are involved from
the outset. Thus the layout of the library of Merton
College, Oxford, seems to have been determined
by Henry Savile, a close friend of Thomas Bodley,
the founder of the Bodleian Library (see pp. 113–14).
Neither had any formal training in design. Patrons
were not always individuals. Libraries have from
the beginning been funded by corporate bodies,
governments or civic authorities. In such cases, the
committees involved may be happy to devolve the
decision-making to design teams or other groups
of individuals. An architect or patron may indeed
be a guiding figure, but often is just one voice among
many. Patrons, architects, cabinet-makers, painters,
sculptors, librarians, scholars – all may have a direct
influence on the final form. In some cases, architects
might design nothing more than the shell. In others,
they might exercise complete control, obsessively
orchestrating an extraordinarily elaborate, complete
work of art. In modern times, librarians are frequently
involved in the design of libraries, yet this has not
always been the case. In the past, a librarian was
often not appointed until the library was finished.
The changing power of the librarian in library
design is an important theme in this book.

Iconography and social meaning in libraries

Libraries are always built with a particular socio-
political intent. They indicate to the wider world the
scholarly ambitions of individuals or organizations
and, in the case of public libraries, they can also
be a charitable, civic gesture. In the simplest cases,
the mere existence of the library may represent the

complete extent of this message. Usually a more
explicit message is implied. Thus the Lenin State
Library in Moscow was built not just as an important
resource but also as a symbol of the intellectual
pretensions of the fledgling Communist state, in which
the readers were watched over by brooding statues of
their leaders. The most complex Rococo libraries, such
as those at Altenburg Abbey in Austria and Wiblingen
Abbey in Germany, had intricate iconographies,
integrating sculptural and pictorial decoration to
communicate to the reader a particular intellectual
attitude to knowledge and its place in civilized society
or a particular institution. The interpretation of such
messages is relatively simple and straightforward if
the patrons or designers have been kind enough to
leave behind a written statement of their intentions.
Unfortunately, this is rarely the case. In the absence
of any documentary evidence, it is necessary to study
those libraries for which written sources do exist and
then draw parallels with those where they do not. It
is important to guard against over-interpretation and
the imposition of over-elaborate or anachronistic
reasons for elements that may have been shaped
simply by practical considerations or the desire to
copy a well-worn formula or established device.

The form of books and their effect on library design

The history of libraries is in part the history of the
book. For the purposes of the present study, 'book'
refers to anything that can be written on and that is
intended to be kept for later reference. The current
form of the book is neither universal, nor particularly
old. Early books took the form of clay tablets, scrolls,
palm leaves, carved stones and rolls of silk, all of
which were stored in libraries of one sort or another.
The modern book – or codex, to use its proper name –
is a relatively recent invention.

The method of manufacture of books is important
as it affects their form and their cost, as does the
material from which they are made. The copying of
books by hand is a slow, laborious process. Printing
enabled books to be produced more quickly and sold
more cheaply. Printing in China, Korea and Japan
developed in a different way from that in the West.
In those countries, there were no printing presses

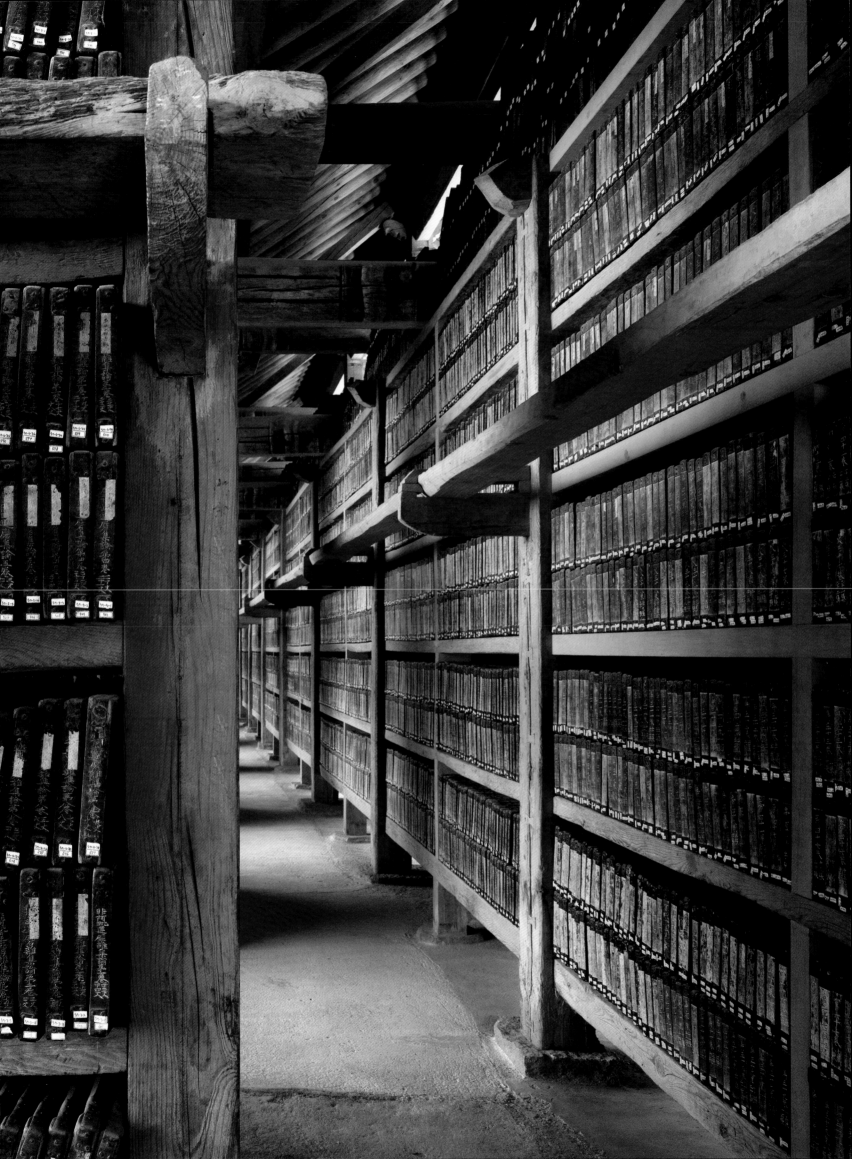

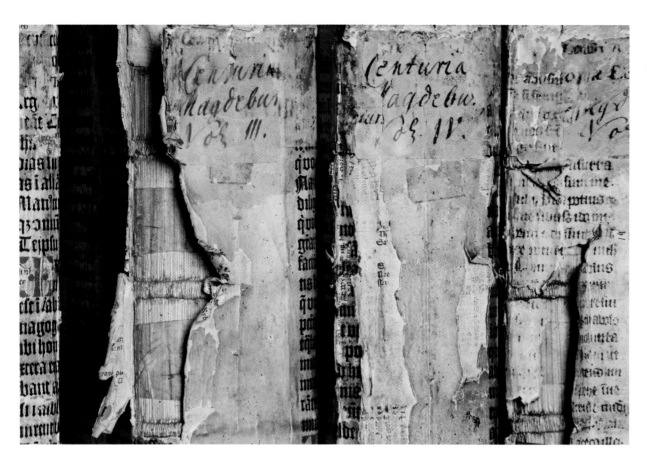

left
**18th-century books,
ABBEY OF ST FLORIAN
LIBRARY, Austria**

*Old manuscripts have been
reused as endpapers in the
bindings of these books, a
common practice.*

involved. Instead, woodblock plates were covered in
ink and the paper or cloth was placed over them and
rubbed down by hand or with a brush. This was made
possible by the use of very soft, very thin paper.
In texture it was akin to silk and indeed may have
been made to imitate it.

In Europe, the printed codex mimicked its
manuscript forebear. It was made from thick paper
or parchment, which, as it was opaque, could be
printed on both sides. Groups of pages were folded
into what are called quires. These quires were then
fixed together to form a single volume. The thick
paper needed to be pressed onto the printing block
using a mechanical press. This use of thick paper
with writing on both sides, bound using quires,
resulted in the type of book familiar to us today.

Scrolls (folded like concertinas, or rolled like
Greek and Roman scrolls) were used in China,
Korea and Japan from the Spring and Autumn period
(770–481 BC) to the Tang dynasty (AD 618–906), but
they were primarily reserved for documents written
by hand. As printing in China involved impressing
the pages onto separate, flat printing-block-sized
sheets, from the beginning it involved making a form
of codex rather than a scroll.[5] Typically a woodblock
was used to print two pages. The page was designed
for the two inked sides to be folded to face each other.
The transparency of the thin paper made printing on
the reverse difficult, so it was rarely done. The folded
sheets were then simply stacked. When the book
was complete, single-sheet covers of coarse paper
were placed on the top and bottom of the pile of
folded pages, which were then bound into a volume
by threading string through the whole stack (which
was not in individual quires as in the West). Separate
volumes making up a single work were put into a box
or wrapped in paper or in a cloth-bound board cover
to keep them together. The result, with its thin sheets
of paper, simple, exposed string bindings and covers
was, and still is, quite unlike a Western codex.[6]

Terms used for describing libraries
One element that sets libraries apart from most other
architectural spaces is the primary importance of
their furniture and fittings. It is possible to discuss
the architecture of a church or castle that has lost its
original furnishings, but very difficult to discuss a
library that has had its fittings removed. The physical
form of a book is important because it determines
its method of storage. This might be in a chest, in a
pigeon-hole, on a rack, in a cupboard or on a shelf.
The history of the library is partly the history of the
relationship between the changing format of the book
and its method of shelving. And just as shelving has
changed throughout the ages, so the book itself has
been adapted to make it easier to shelve.

Various terms are used for types of book storage.
Books may be kept in chests, in cupboards or on
shelves. The term 'book chest' is self-explanatory.
Freestanding book cupboards are often called by

the Latin term *armaria* or by the word 'press', from which we get the term 'pressmark', a notation on a book indicating where it should be placed in a library. Of course, all such cupboards contained shelves, but they were not visible. Glass-fronted bookcases did not appear until the 17th century. Early libraries have either cupboards or open shelves. Later ones often combine the two, placing cupboards under shelves.

Bookshelves in libraries are usually fittings, that is, they are built-in or permanently attached to the walls. Ways of describing the various shelving arrangements used in libraries throughout the ages are awkward and vary in different languages. This book follows other English writers on the history of library design by using the terms coined by J. W. Clark in *The Care of Books* (1901). Medieval libraries

generally placed books on reading desks, often with integral benches, in rows at right angles to the walls. Clark called this 'the lectern system'.[7] A beautiful example of this arrangement survives in Zutphen in the Netherlands (see pp. 88–9). As we shall see, the lectern system had important variants. After the invention of printing, lecterns could no longer cope with the increase in the number of books. One solution was to replace them with full-height bookcases, dividing the room into separate bays. Clark called this the 'stall system', although it should perhaps be more correctly termed the 'Oxford system', because that is the place where it was invented and where it was most common.[8] Although it has been much copied, as we shall see, it is not an ideal solution. It is a fascinating example of how a certain arrangement has become so associated with library design that it is still used despite its drawbacks.

The alternative to the lectern or stall systems was lining the walls of libraries with the built-in shelves, which Clark called the 'wall system'.[9] There is an intermediate stage, which Clark did not discuss, in which open bookcases are placed against the walls but not made integral with them, from which the true wall system developed. The most famous example of this type is the library of the Escorial in Spain. Wall-system libraries could be in rooms of one, two or even three storeys or tiers, the upper levels being accessed by galleries. In the late 17th century a new form of library arrangement appeared that combined the characteristics of the wall and stall systems with cases both against and at right angles to the walls. This book uses the term 'alcove' (see Chapter Four) to describe this arrangement, which is the normal description, although it is not one used by Clark.

As books became more numerous, other ways to store them had to be invented. Mass storage led to the development of the stack, a series of spaces specifically designed to maximize the number of books stored in the least possible volume. Bookstacks were at first fixed, but later examples were designed to move on rollers placed in the floor or suspended from the ceiling. Stack shelving greatly increased capacity, but was rarely a subject of architectural celebration, usually being confined to publicly inaccessible and windowless stack rooms, which were designed to

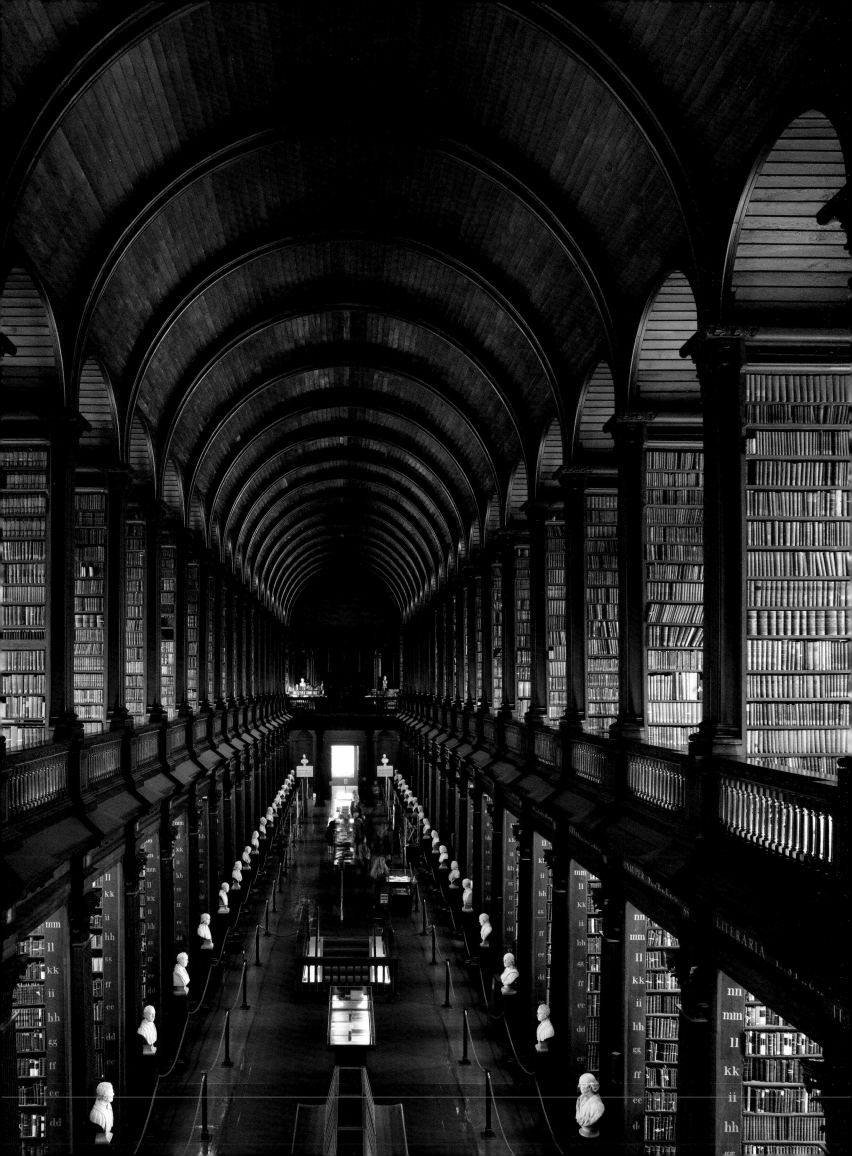

TRINITY COLLEGE LIBRARY, 1856
Dublin, Ireland

Designed by Thomas Burgh and completed in 1732, this is rightly considered one of the most famous libraries in the world, but all is not as it seems. An engraving (below) shows the library as originally built, with a flat ceiling and no books on the galleries. The library as it appears today (opposite and right) is not a reflection of 18th-century thinking but the result of a major reconstruction by the architects Deane and Woodward completed in 1856.

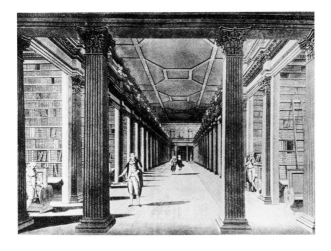

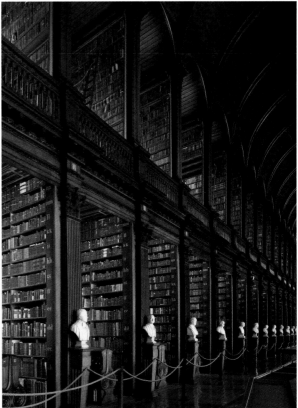

have the perfect conditions for book storage rather than to suit the needs of human beings.

Books have not always been placed on the shelves vertically. This is a comparatively recent innovation. It was developed because it enabled a large number of books to be stored in a relatively small space, but it is far from universal and really only suitable for books that are designed to be shelved in that way. In many cultures, books are simply stacked horizontally on top of each other on the shelf. This arrangement has its drawbacks: taking a book from the bottom of a pile involves moving those on top. The vertical spacing of shelves in a bookcase in which books are stacked in this way is relatively unimportant as long as the shelves are far enough apart to accommodate a few volumes. Shelves in such libraries are thus invariably fixed, and the regular spacing of the shelves is pleasing to the eye.

Once books were placed upright, the spacing of the shelves became important if the number of volumes that could be accommodated was to be maximized. The books had to be sorted by size and the shelves were arranged accordingly. Large books were typically placed on the lower shelves while smaller ones – which were easier to steal – were placed at the top, out of reach. Designers of libraries were reluctant to abandon fixed shelves and examples such as the library at Mafra Palace in Portugal and the Duchess Anna Amalia Library in Weimar, Germany, show that libraries were still using them in the late 18th century. But gradually it

became clear that it was more efficient if the shelves could be adjusted, so various systems were invented in the 18th century to allow this to be done. Initially these relied on timber notches or slots cut into the vertical supports, but in the late 19th century they were gradually replaced by proprietary systems using metal fixings. The shelves on which the books were placed were at first always timber. Metal shelving did not appear until the 19th century. Its strength and resistance to fire were obvious advantages. But there were always concerns about placing expensive leather bindings on hard metal surfaces. Owners of particularly valuable collections preferred timber shelves and often spend large sums lining them with leather or cloth coverings.

Stairs, ladders and stools

The design of the shelving also presents another problem: access to the shelves. Ideally, no library shelving system would place the books out of reach of those trying to retrieve them. If this dictum had been followed religiously then no library would have had shelves more than 2 m (6 ft 6 in.) above the floor. However, throughout the ages library designers have broken this rule continuously. The history of library design is partly an exploration of why they have chosen to do so, and partly a history of the ways that designers have then dealt with the problems that they have created.

In simple libraries, reaching high shelves might require nothing more than standing on a bench

below
MAFRA PALACE LIBRARY, 1771
Mafra, Portugal

Construction of the palace in Mafra was started in 1717, but the library was not completed until 1771. By then the original plans for a richly gilded interior had been abandoned. Since its opening the library has been home to a colony of tiny bats, which feed on the insects that might otherwise damage the books.

opposite
DUCHESS ANNA AMALIA LIBRARY, 1766
Weimar, Germany

The library is named after Duchess Anna Amalia of Saxe-Weimar-Eisenach, who expanded the ducal library and arranged for it to be moved into the present Rococo building. It is an oval room set within a rectangle. The left-over spaces form a passage around the oval, and open shelves provide glimpses between the two. Johann Wolfgang von Goethe was later appointed its librarian. On 4 September 2004 an electrical fault caused a fire that destroyed over 50,000 volumes and completely gutted the library. It has since been painstakingly reconstructed.

or a stool. For the Wren Library at Trinity College, Cambridge, for instance, Christopher Wren (1632–1723) designed stools that have specially splayed legs to make them more stable when they are being used in this way. Longer reaches require a ladder of some sort. Often these are fixed to the shelving in some way to reduce the likelihood of accidents. In the Biblioteca Joanina in Coimbra, Portugal, ladders slide out of ingeniously designed pockets in the uprights between the bookcases.

Very tall spaces will incorporate one or more galleries accessed by staircases. In some libraries the staircases are hidden within the walls; in others they are exposed and even celebrated. In Baroque and Rococo libraries they frequently give rise to elaborate methods of concealment, incorporating secret doors and moving panels. Readers may thus be able to see the books that they want but be completely unaware of how to reach them. At Wiblingen Abbey, for instance, the doors opening into the gallery are disguised as niches containing statues. The theatricality of this arrangement was typical of the Baroque and Rococo, which enjoyed architectural surprises and conceits.

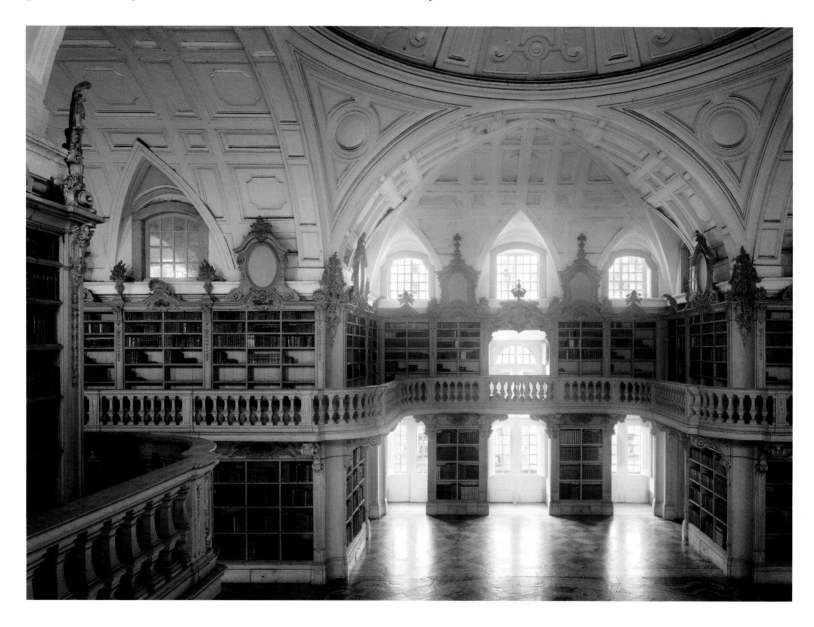

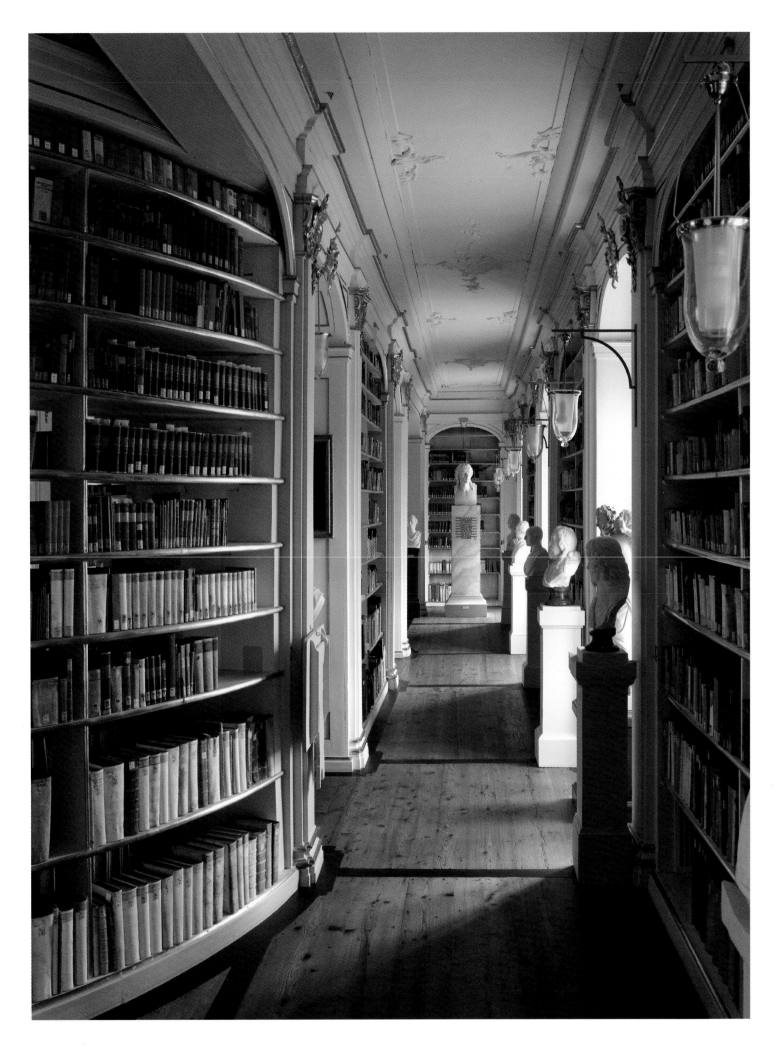

**ALTENBURG ABBEY
LIBRARY, 1742**
Altenburg, Austria

*This Rococo library was
designed by Josef Muggenast
to deliberately exaggerate the
importance of the collection.
Despite its enormous size, the
room contains relatively few
books.*

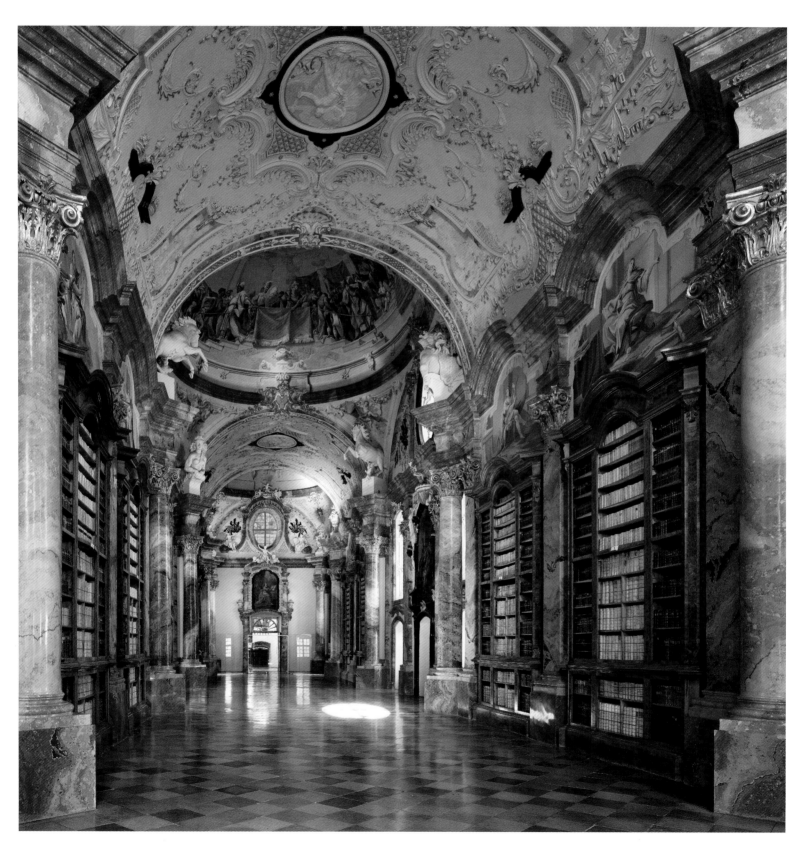

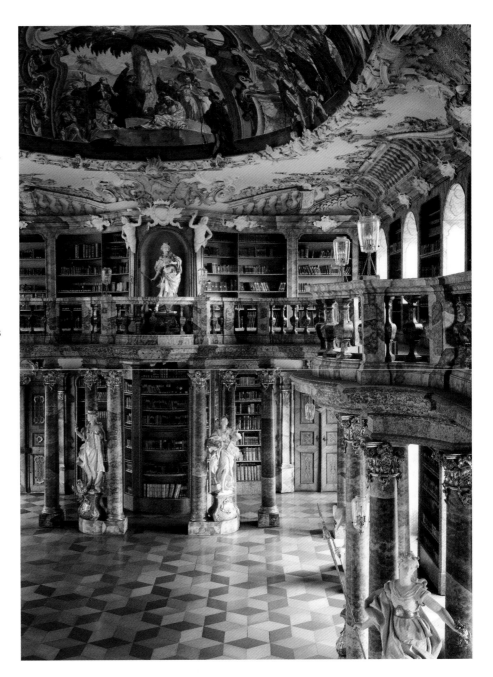

**WIBLINGEN ABBEY
LIBRARY, 1744**
Wiblingen, Germany

*Constructed between 1737 and
1740 and decorated in 1744, this
magnificent Rococo library
spans the complete width of
one wing of the monastery.*

The arrangement of the books

The arrangement of shelving is designed not only
to preserve the books, but also to make them
possible to find. Once volumes are placed on a
shelf, it is natural to sort them. From the beginning,
libraries have had written catalogues. Much has
been written on how libraries in the past were
designed to help guide the reader to particular subjects
using paintings or sculpture. In particular, André
Masson (1900–1986), a former French government
inspector of libraries and leading library historian,
traced the idea of a pictorial catalogue.[10] However, as
Masson himself was forced to admit, this relationship
was never straightforward. Even Rococo libraries,
such as those at Wiblingen Abbey and Altenburg
Abbey, had lettered and numbered shelves and relied
on written catalogues to find the books.

The first written catalogues were simple inventories
and finding lists and could be written effectively on clay
tablets or a few sheets of parchment. But as libraries
expanded so did the size of catalogues. Callimachus's
Pinakes, a catalogue of Greek writing compiled in the
3rd century BC, mostly from the library of Alexandria,
is said to have filled 120 scrolls.[11] The inventory of the
10th-century Islamic library in Cordoba, Spain, filled
forty-four twenty-page booklets.[12] In neither case do
we know where the catalogue was placed within the
library. As libraries became very large, the physical
form of the catalogue and its placement became a key
issue in library design, until physical catalogues were
swept away entirely by computers.

Protecting books from harm

Libraries have always been designed not only to
help readers find the volumes they want, but also to
preserve their collections from the great enemies of
books, namely dust, damp, mould, insects, vermin,
theft and fires. Of these, fire is by far the most
devastating. Deliberate and accidental fires have
over the centuries deprived us of many of the world's
greatest collections and the buildings that housed
them.[13] The Palatine library in ancient Rome was
destroyed in a fire in AD 80. Libraries today can still
be susceptible: in 2004 the beautiful Rococo Duchess
Anna Amalia Library in Weimar suffered an electrical
fire with devastating consequences.

Fear of fire has had an effect on library design
throughout the ages. Most libraries banned the use
of candles for lighting, which limited their hours of
operation and meant that large windows had to be
provided to give adequate light for reading. Libraries
were often built in brick or stone and given masonry
vaults in the hope of resisting the spread of fire from
other buildings. As heating in early buildings was

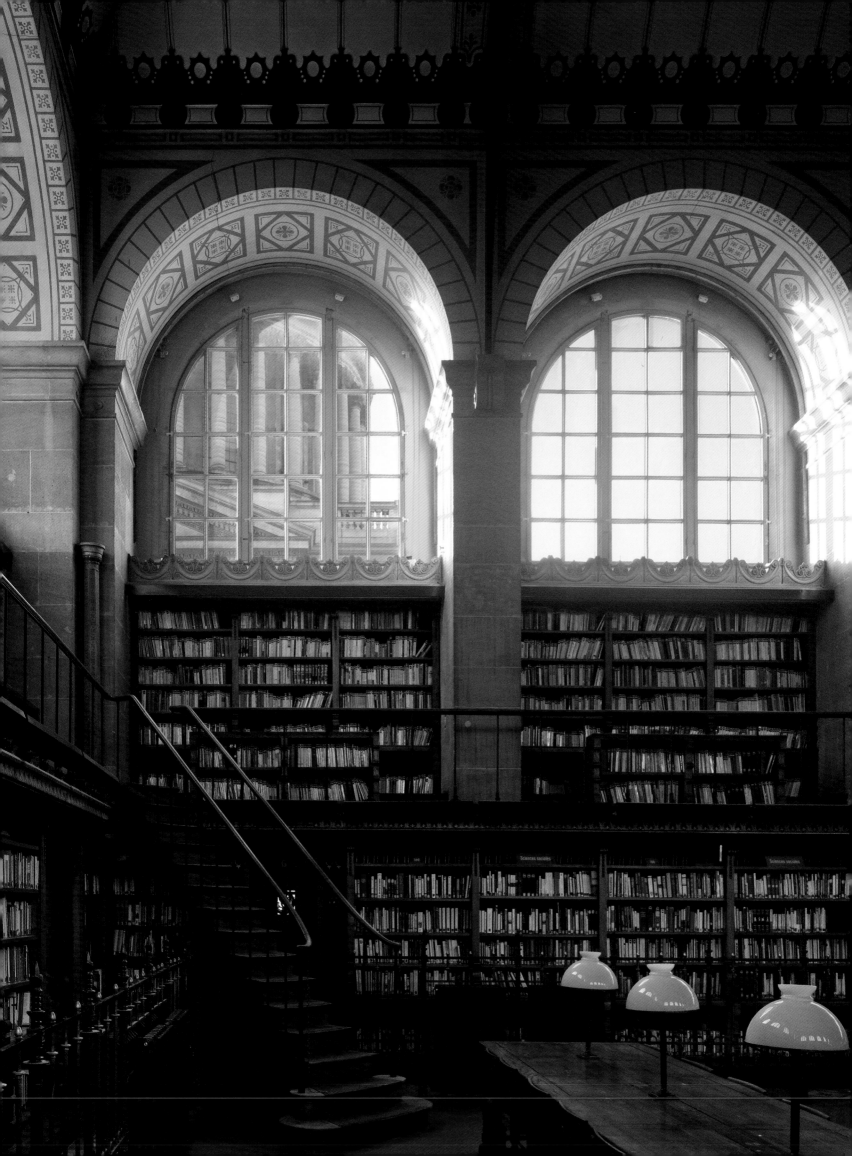

generally from open fires, many libraries were left
unheated. Later, elaborate systems for circulating
hot air were developed.

Vermin are more difficult to prevent by means
of design. Mice like nothing better than making
their nests out of paper. Many readers assume that
eating and drinking are banned in libraries to avoid
damaging the books. This is part of the reason, but
the main concern has always been to avoid
encouraging mice, rats and insects. Unfortunately,
the voids behind bookcases, designed to separate
the timber holding the books from the damp masonry
walls behind, make ideal spaces for mice to live in.

Insects can devastate collections. Although there
is no such thing as a 'book worm' that lives on nothing
else, a variety of insects will eat books because of the
similarity of paper to dry wood. Others are attracted
to the starch and glue in the bindings. Some of the
commonest pests are the larvae of the common
furniture beetle (*Anobium punctatum*) and silverfish
(the genus *Lepisma*). In tropical countries termites
are a major problem and both furniture beetles and
termites will eat the shelves as well as the books.[14]
Sealing books in cabinets does not necessarily
protect them. Temperature and humidity are factors
in the prevalence of insects and warm cupboards
may provide perfect breeding grounds. In modern
libraries air-conditioning and sealing the building
are the usual solutions. Historically, all sorts of
methods have been attempted to eliminate insects.

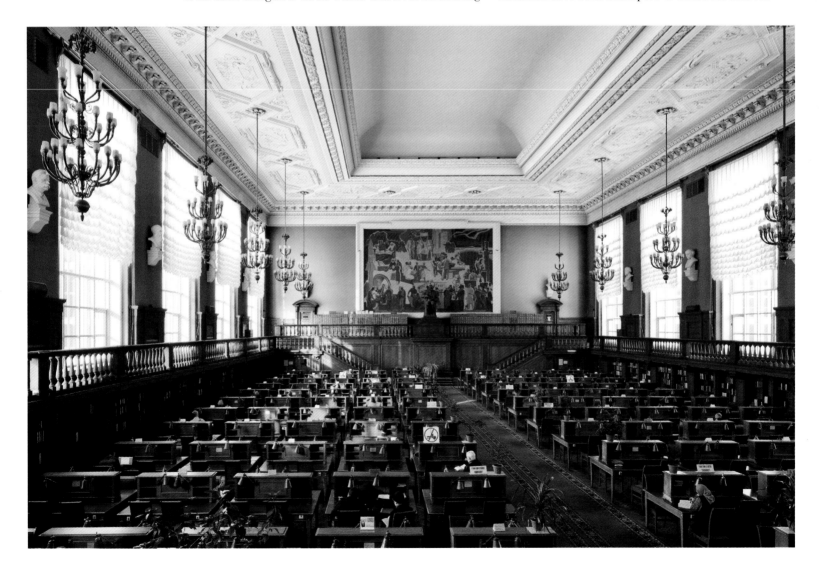

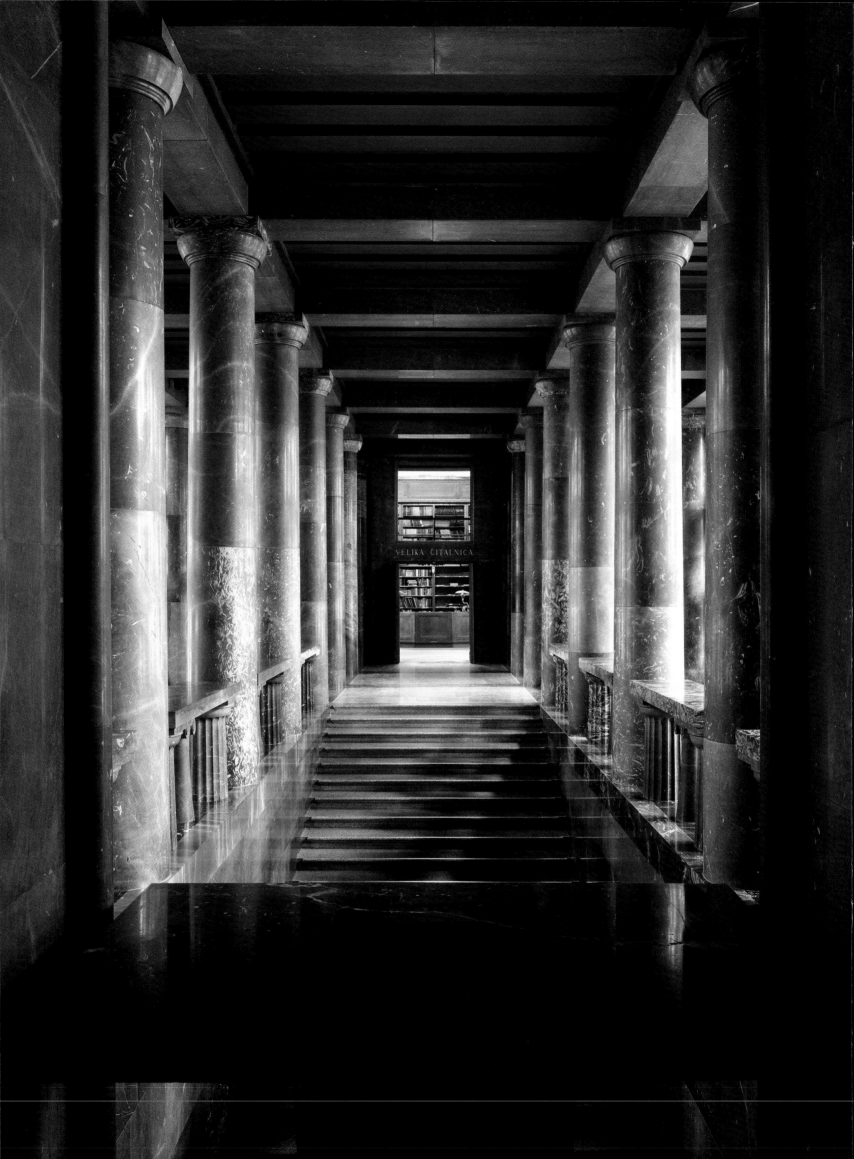

In the Tianyi Chamber in China in the 16th century bags of insect-repelling herbs were placed in the cupboards. The 18th-century libraries in Coimbra and Mafra used (and still use) colonies of bats. They roost behind the bookcases in winter and outside in summer, emerging at night to feed on the insects that live on the books. As the bats in question are tiny, barely 25 mm (1 in.) long, they can squeeze through gaps in the window frames and cause no damage to the books themselves. The only downside is that they leave droppings on the floor of the library that need to be cleared up every morning.

Damp, and the mould that results from it, has always been a big problem in libraries. In tropical climates mould destroyed libraries quicker than elsewhere, but only in desert climates could it be entirely avoided. Damp Alexandria was one of the worst places in Egypt to choose as the site for a great library. Shelves are designed to prevent damp from the walls transmitting to the books. In some libraries the backs of the cases are filled with desiccating or absorbent materials. In China, gypsum was placed beneath cases to try to reduce damp. In all cases, books are placed so the air can circulate freely and humidity levels can be carefully monitored.

Lastly, there is the problem of book theft. Book collections are often extremely valuable, and in all periods library designers have been keen to deter thieves. In older libraries physical measures were taken to stop visitors and readers from stealing the books, including fitting doors with stout locks and chaining books to the shelves. Newer ones employ sophisticated electronic surveillance systems to do the same. In many periods the prevention of theft has been a major factor in determining a library's form and location.

Building construction

Various factors have helped to favour certain forms of construction for library buildings over others. For instance, the fear of fire has always been a strong determinant in the choice of materials, resulting in brick and stone vaults in Rococo libraries and iron frames in 19th-century ones. Strength of materials and structural form also determine the limits of what can be achieved. Shelves of books are heavy, presenting a not inconsiderable structural problem in their own

right. When the library at Trinity College, Cambridge, was constructed in the late 17th century, the weight of books it contained was so great that Wren had to design a special timber truss to support the cases.[15] In the 19th century, the use of iron solved many of the structural problems. The iron structure of the Peabody Library in Baltimore, MD, in the United States, easily supported six storeys of books and allowed it to be built over the top of a concert hall.

Books are only part of the problem. The main spaces of libraries, the reading rooms, often present considerable structural challenges. Their width is limited by the ability to construct a roof or ceiling that can cover them. If that roof is to be fireproof

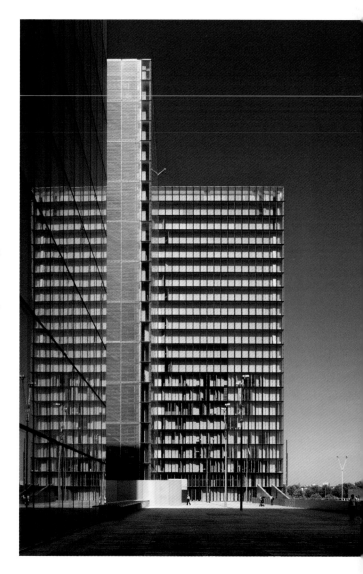

then there are additional problems to be addressed. Thus the brick vaults of many early libraries required rows of columns to support them. In the 16th century, when the architect Jacopo Sansovino (1486–1570) first tried to design a free-spanning vault for the Biblioteca Marciana in Venice without intermediate columns, it collapsed, delaying the works and causing considerable embarrassment.

Stacks pack very large numbers of books into small spaces and thus create very large loads, which in turn determine their position and construction.

The early examples tended to be on the ground floor as a result. The main reading room in the New York Public Library is placed above the stacks because the reverse arrangement would be very difficult to achieve structurally. Readers have to climb to the top of the building, however, a situation that could have been avoided had the reading room been on the ground floor. Similarly, the wish to have brick vaults over libraries in the Rococo period placed constraints on the size and shape of the spaces that could be created.

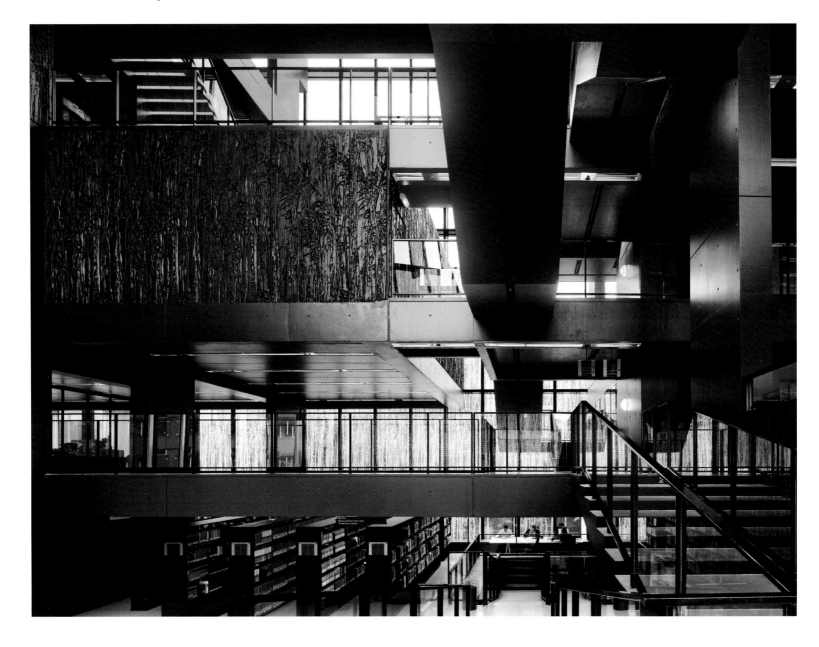

TAMA ART UNIVERSITY LIBRARY, 2007
Tokyo, Japan

The library, designed by Toyo Ito, consists of steel-plate arches embedded in concrete. The ground floor slopes, following the terrain. The building is typical of a spirit of experimentation in Japan that has produced some of the strangest and most imaginative library buildings over the past fifty years. The curving floor plate and arched windows challenge the rectilinear geometry of the bookcases, and thus our expectations of what a library should look like.

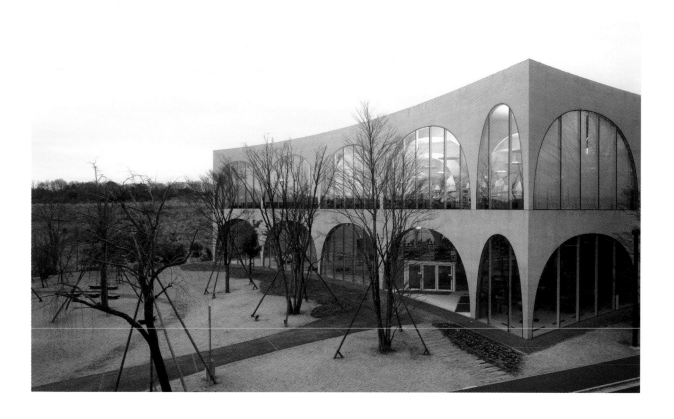

Tracing the changing form of the library

The factors discussed in this introduction – structure, heating, lighting, the form of the book, the iconography of the building, and the necessity of protecting books from harm – have affected the shape of libraries in all parts of the world in all historical periods to varying degrees. It is tempting to assume that this is a straightforward linear evolution, but, as this book seeks to show, this has never been the case. The library is a constantly changing idea. Forms have continually appeared and disappeared throughout history, yet at every point there are recurring themes.

Architects and librarians embarking on a new building project have often started by touring existing great libraries. The architect Gunnar Asplund (1885–1940), for instance, travelled to England, Germany and the United States before he prepared the designs for his Stockholm City Library. Similarly, Wiel Arets (1955–) has written about the lessons he learned from visiting Dominique Perrault's Bibliothèque Nationale in Paris and Hans Scharoun's Berlin Staatsbibliothek before he began designing the Utrecht University library. A knowledge of why things were built in a certain way is the first step in understanding how, or why, we might want to do it differently in the future.

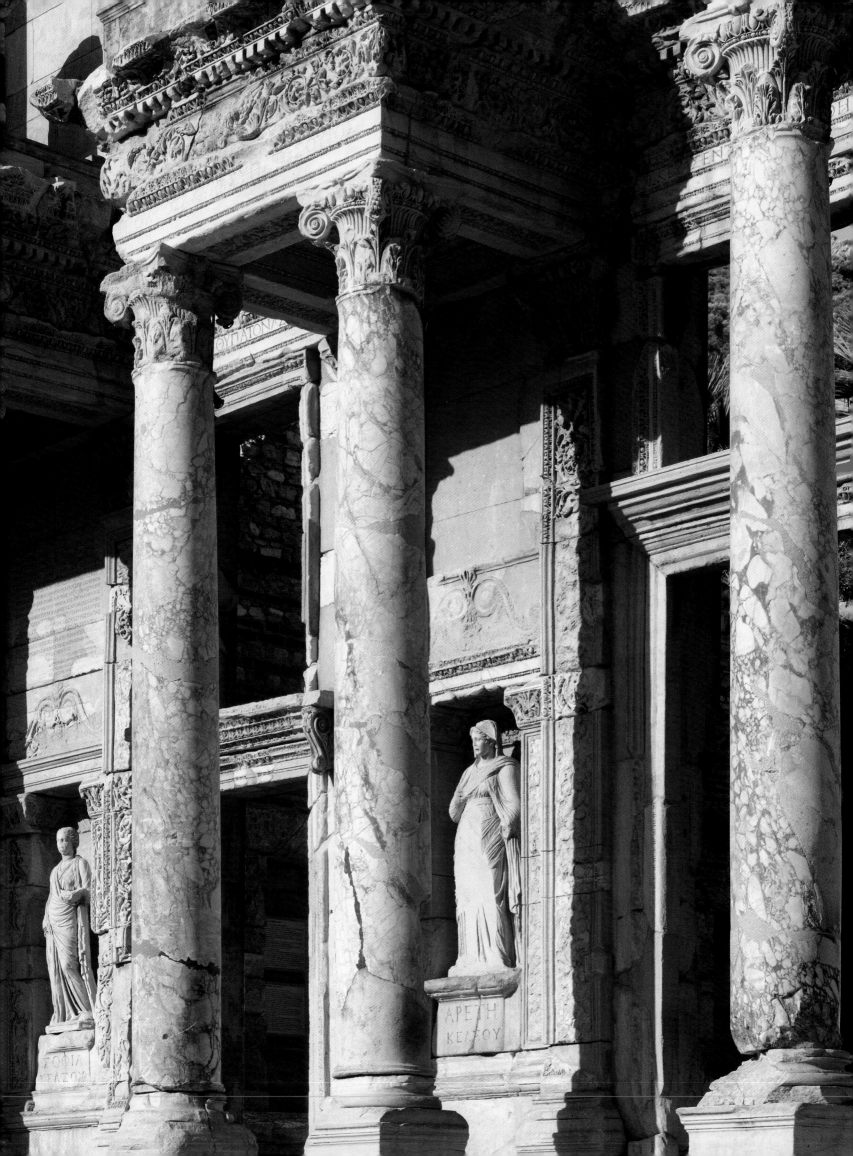

Lost Beginnings
Libraries in the Ancient World

Books are written by the living for the living, but as time passes a library inevitably becomes the repository of the thoughts and conversations of the dead talking to the dead. If the books themselves disintegrate, or are destroyed, those thoughts and memories, and our sense of the culture that held them, are lost to history. Thus we know a great deal about some cultures, but others that did not write, or that chose to write on perishable materials, are invisible to posterity. Our knowledge of ancient cultures is essentially a story of loss.

This chapter traces the story of libraries from the beginning of writing to the fall of the Roman Empire. This period, from around 3400 BC to AD 600, some 4,000 years, was instrumental in forming the institutions that characterize Western civilization. Most of the types of libraries that exist today have their roots in the ancient world: the idea of the encyclopaedic library (which aimed to collect all the books in the world); the academic library; the administrative archive; the private library; and the public library all began in the Middle East. The legends that grew up around these prototypes were highly influential on the form and organization of their later equivalents, and the myths that surround them continue to inspire architects today.

Mesopotamia

The first writing system was developed 5,500 years ago in Uruk in ancient Mesopotamia for keeping simple records of financial transactions. The exact date of its invention is uncertain but it is generally accepted that it appeared sometime between 3400 and 3000 BC.[1] Writing developed to answer a particular cultural need. The civilizations that grew up in ancient Mesopotamia coalesced around a mythical system in which it was understood that the gods had chosen the king and the priesthood to own all the land. Their subjects were allowed to farm it on their behalf in return for payments of food. Writing was invented to keep track of these payments, and the earliest surviving written documents were lists on clay tablets recording who had paid what, to whom and when. This information was kept to make sure that everyone had paid their dues, and from the very beginning such records needed to be stored for reference. The records were kept for generations in an orderly fashion until eventually, like all files, they became irrelevant and were discarded.

These archives are the very earliest form of library, although purists would claim that as they were used to store files, not books, they should not be termed libraries at all.[2] In most sites where clay tablets have been found in excavations, they are no longer in their original context. They are found in the remains of ancient rubbish dumps, or where the tablets have been reused as building materials, leaving no clue to their original location. Thankfully, this is not always

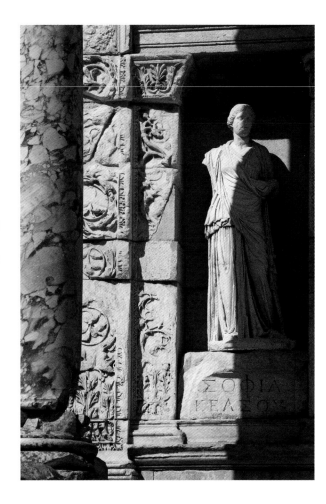

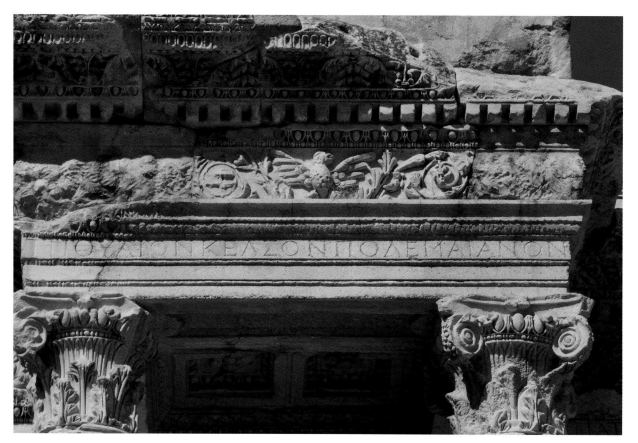

the case.[3] In 1975 archaeologists excavating the palace
of the ancient city of Ebla, in Syria, near modern-day
Aleppo, were lucky enough to uncover an archive room
containing small fragments and larger parts of 15,000
original tablets that had still been on their shelves
when invaders set fire to the palace in 2300–2250 BC.
The tablets were found scattered on the floor of the
room where they had fallen when the wooden shelves
supporting them collapsed. They were still more or
less in the order in which they had been placed on
the shelves some 4,000 years before.[4]

The library at Ebla

The library at Ebla is unlikely to have been the oldest
library in the world, but it is certainly the best-preserved
early example discovered so far and it provides
invaluable information about the physical appearance of
Mesopotamian libraries. What is immediately noticeable
is that it was a very modest room. Rectangular and
measuring just 3.5 x 4 m (approximately 11 ft 6 in. x
13 ft), it was little more than a storeroom, lined with
bookshelves on all sides. Other excavations have shown
similar rooms elsewhere in Mesopotamia and Ebla
appears to have been typical. One side and the upper
parts of its walls and ceiling were destroyed in the fire,
so we cannot be exactly certain of its size or shape but
it cannot have been a large room and probably had no
windows. Adjacent to this room was another, which
had benches around the sides. It contained a jar with
writing implements and is thus presumed to have been

a room where scribes worked. Thus at this very early
date we first see the common later arrangement of the
separation of spaces for storage and for reading and
writing.[5] The tablets found at Ebla are a mixture of
archival records and pieces of a more literary nature,
including bilingual texts, incantations and the written
version of a Sumerian myth. The non-archival texts
seem to have been stored on a top shelf in the north
wall. They were presumably a few reference works
used by the scribes working in the adjacent room.[6]

Shelving clay tablets

The Ebla library is particularly important for the
insights it gives into the shelving of books in this period.
The books in question were, of course, clay tablets. The
Ebla examples were quite large, measuring 210 x 210
mm (a little over 8 in. square) and 20–30 mm thick (a
little under to a little over 1 in.). Clay tablets were cheap
and easy to make. The size of tablet used throughout
the Middle East varied. The smallest were tiny (just 2
cm – 0.8 in. – square and a few millimetres thick) while
the largest could be 30–40 cm (12–15 in.) square and 4–8
cm (appx. 1½–3 in.) thick.[7] Most tablets are surprisingly
small and fitted easily in the palm of a hand. They
would be partly dried in the sun and then marked,
while still soft, using a wooden stylus with a flat end.
The simplest marks to make with such a device are
small wedges, which leads to the term 'cuneiform' (from
cuneus, Latin for 'wedge'). Once complete, they would be
laid out in the hot Mesopotamian sun to bake hard. In

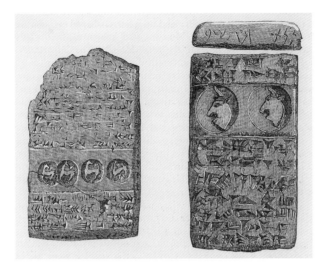

certain cases they might be fired in a kiln, creating
a more permanent record.[8] Many of the tablets that
have been recovered, including those from Ebla, have
been accidentally burned in fires, which is how they
came to be preserved. Indeed, Mesopotamian libraries
are the only ones in history for which fires, far from
being detrimental, were the principal cause of
their survival.

The tablets at Ebla were placed on wooden shelves
that extended down to the ground. They were not
arranged like modern books with the spine outwards, but
in rows like index cards, the marked front face towards
the reader, with other tablets behind. The shelves were
widely spaced (double the height of the tablet) so that the
reader could reach in and tip the tablets forward in order
to see the tops of the ones behind.[9] In other excavated
library buildings there were masonry benches around
the walls. Some had masonry pigeonholes into which
the tablets were slotted. Others featured clay boxes in
which the tablets were stored vertically and examined
like index cards. Similar boxes of wood, leather or woven
materials were used for transport. Many collections had
small clay dockets attached by string to the upper edge
of each tablet giving the tablet number, the coffer or
basket number and a note of what the tablet contained.[10]
Others, as at Ebla, had a colophon on the upper or outer
edge. The reader could thus read the dockets or scan the
edges of the tablets to find the one required. As tablets
could contain only a limited amount of text, longer pieces
of writing took up many tablets. Tablets were not the

only form of writing material: we know from library
catalogues that boards covered in wax were popular, but
none of these survive. A very large number of tablets
have now been recovered from a considerable number
of Mesopotamian sites. Clay tablets, correctly stored,
and kept away from damp, can last for many hundreds
of years and in the case of those that have been fired
(accidentally or deliberately), for tens of thousands.
Clay, however, is unwieldy compared to other writing
materials. The reason for its use was simple expediency:
it was the only material readily to hand in ancient
Mesopotamia.

The earliest cuneiform writing consisted only
of numbers and nouns, but it was not long before
the system was adapted to incorporate the ability to
translate any word into writing. As the writing system
was phonetic, it could be used to transcribe languages
other than ancient Sumerian. As a result, cuneiform
was a remarkably resilient form of writing and was
used to write Akkadian, Eblaite, Elamite, Hittite, Hattic,
Hurrian, Luwian and Urartian, ensuring its survival
for over 3,500 years, long after clay tablets had ceased
to be used.[11] The vast majority of clay tablets found
in archaeological excavations in the Middle East are
archival and consist of lists of items. From around 2500
BC other forms of writing begin to appear. Sometimes
these are textbooks for teaching writing, but in the
Sumerian city of Nippur lists of gods, professions,
hymns and writing exercises have been found,
suggesting that they belonged to a school of scribes or a
temple and formed some sort of early library.[12] The best-
known and most extensive library of the period was that
of the Assyrian king Ashurbanipal at Nineveh, dating
from 668–630 BC.

The library of Ashurbanipal

Tablets from Ashurbanipal's library were discovered
almost by accident by the amateur archaeologist and
adventurer Henry Layard (1817–1894) in 1849. Others
were subsequently excavated by his associate Hormuzd
Rassam (1826–1910) and many ended up in the British
Museum.[13] Ashurbanipal's library was remarkable
because it represents the first documented attempt
to collect all knowledge systematically, predating the
much better-known library of Alexandria (see pp. 44–7)
by three hundred years. Ashurbanipal went about the

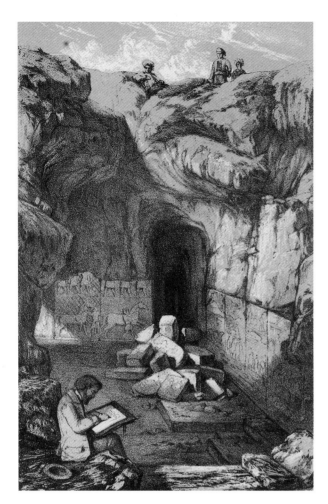

Ancient Egypt

The use of clay tablets in the Middle East ensured the survival of the texts inscribed on them. Those cultures that chose to write on more fragile materials have left fewer traces behind them for archaeologists to find. The Egyptians, for instance, had a writing system at least as early as 3000 BC and inscriptions survive. Unfortunately, however, their chosen medium for books and records was papyrus. Indeed, for over 3,000 years papyrus was the chosen writing material not just of ancient Egypt, but of the whole Mediterranean.[17] The Egyptians enjoyed a monopoly on its production. Their rulers later exported it to the Greeks and Romans, limiting supply to keep the price high.[18] As a writing material papyrus was not perfect. Its roughness affected the marks that could be made and its flexibility was limited: if the leaves were fixed at the edges to form books they tended to snap near the spine. Papyrus was thus used in flat sheets or rolled into scrolls. In normal conditions it gradually rotted away. The few scraps of ancient papyrus that have survived have done so only because they were preserved in unusual conditions.[19]

A vast majority of the writings we have from ancient Egypt were painted on or engraved into the walls of buildings. We know that libraries did exist. Inscriptions list positions such as Keeper of the King's Records, Keeper of the Sacred Books, and Learned Men of the Magic Library, suggesting libraries of some social importance.[20] The Temple of Horus at Edfu and the Ramesseum, the mortuary temple of Ramesses II at Thebes, are both known to have had important libraries, but the temple at Edfu belongs to the later Hellenistic period, when Egypt was under Greek rule, and the room itself amounts to little more than a large cupboard with niches in the walls. Iamblichus of Syria (*fl.* AD 270) describes how the library in the Ramesseum contained 20,000 scrolls, but if that was the case nothing now remains to indicate their location or disposition.[21] Thus for Egypt we have literary references and hints of the existence of libraries but no clear idea of their physical form. The situation is thankfully slightly better for ancient Greece and Rome.

Ancient Greece

The earliest known Greek writings are, like the ancient Mesopotamian ones, on clay tablets. Greek civilization

task with great energy, seeking out and acquiring other collections. Whether he did so by force or purchase is unclear. His library contained books on waxed boards, as well as tablets, but only the tablets survive. It has been estimated that it held 1,500 works, but each work would have occupied a number of tablets or boards.[14]

Layout and destruction

Despite the fact that Ashurbanipal's collection is one of the most important libraries to survive from antiquity we know little about its original location. Layard found the tablets in the ruins of a series of small storerooms near the main entrance to Ashurbanipal's palace.[15] After the king's death the library was broken up, so it is not clear whether these rooms were their original home or whether they had been thrown there after the palace was looted. From the numerous collections found so far, it is clear that the standard Mesopotamian arrangement was to have small compact storerooms in which tablets were kept; these were often locked by applying seals to the door.[16] The documents were retrieved from these rooms when required, to be read elsewhere. The books themselves were not displayed and the rooms were rather mundane as a result. The existence of libraries in ancient Mesopotamia is culturally significant, but the evidence so far suggests that they were architecturally uninteresting.

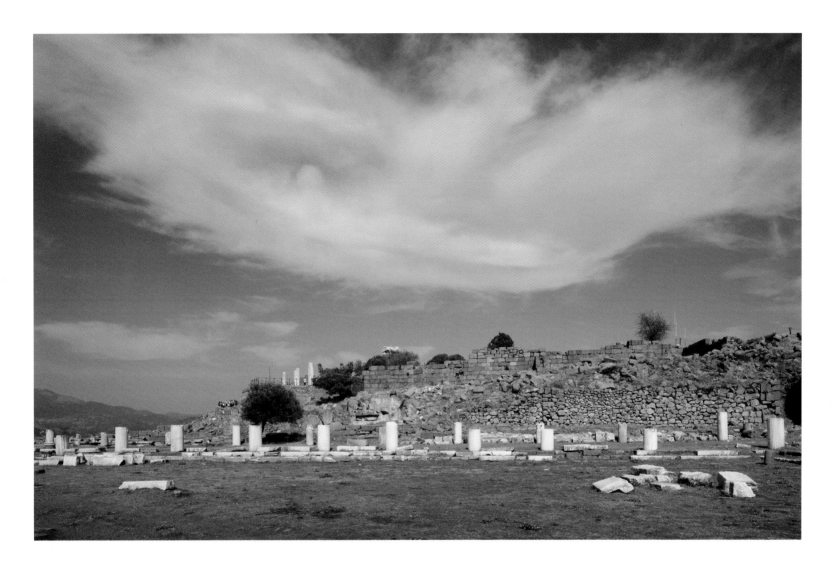

LIBRARY OF PERGAMUM,
c. 197–60 BC. Bergama, Turkey

*When it was completed, the
great library at Pergamum
was second in size only to the
library of Alexandria in the
Hellenistic world. The remains
of the bases of the columns that
are thought to have formed the
colonnade of a two-storey stoa
(a covered walkway) in front
of the library can be seen in
the foreground. The library is
believed to have been behind
the stoa's upper level, with
rooms opening onto it.*

first began to emerge in what is called the Mycenaean
age, between 1600 and 1200 BC. A series of wars brought
this early stage to a close and the art of writing then
seems to have been lost. When Greek culture emerged
from what historians normally term the Greek Dark
Ages around 750 BC they adopted the Phoenician
alphabet.[22] Cuneiform was complicated to learn,
requiring the mastery of hundreds of combinations of
marks. The Phoenician alphabet reduced the number
of combinations to a few dozen letters. This made
the process of learning much simpler and promoted
literacy. Schools began to appear and the number of
people who could read and write markedly increased.

The first Greek books appeared around 500 BC.
They were in the form of scrolls, made from papyrus
imported from Egypt. The earliest description of
papyrus manufacture is an unreliable account in
Pliny the Elder's *Historia naturalis* (*c.* AD 77).[23] More
accurate information has been gathered through
analysis of surviving material. The stalks of the papyrus
plant separate relatively easily into flat strips. These
were soaked in water, releasing a natural glue. The
strips were then simply overlaid on a flat surface and
hammered together in two layers, the lower layer at 90
degrees to the one above. Pressure was then applied and

they were allowed to dry. The result was a flat, uniform
writing surface that could easily be written on with pen
and ink.[24] The size of papyrus sheets determined the size
of the scrolls. They were generally 20–25 cm (8–10 in.)
wide and 19–33 cm (7½–13 in.) high and were typically
sold joined into rolls of about twenty sheets, so the
average scroll was a 19–33 cm roll which was 2–5 m long
(6 ft 6 in. to over 16 ft) if fully unwound.[25]

The first Greek books were probably scripts for
the author to read aloud in much the same way that
a lecturer or poet might read to an audience today.
Gradually a process of making copies for sale appeared,
so that by 400 BC there were booksellers in the major
cities, producing and selling manuscript copies of texts.
We know people collected books at this time because
Aristophanes (*c.* 446–386 BC) poked fun at Euripides
(*c.* 480–406 BC) for doing so and Aristotle (384–322 BC)
was renowned for owning a substantial library.[26] No
images or physical remains of private libraries from
ancient Greece have come down to us. The gymnasia
of ancient Greece had libraries, but no library ruins
have yet been positively identified.[27] The few remains
of Greek libraries are from the Hellenistic period. The
most significant of these are those of the Attalid library
at Pergamum, in modern-day Turkey.

LIBRARY OF PERGAMUM, *c.* 197–60 BC
Bergama, Turkey

This view of Pergamum from the sanctuary of Asclepius reveals its strategic position at the top of a steep hill. The library is known from written sources to have been in the precinct of the Temple of Athena (marked in red on the plan opposite), which stood on the top of the hill, behind the prominent watchtower visible at the right of this photograph. The exact position of the library is uncertain, but archaeologists currently place it on the left of this view, on the upper level of a two-storey stoa. Readers working in the stoa would have had a dramatic view of the surrounding landscape.

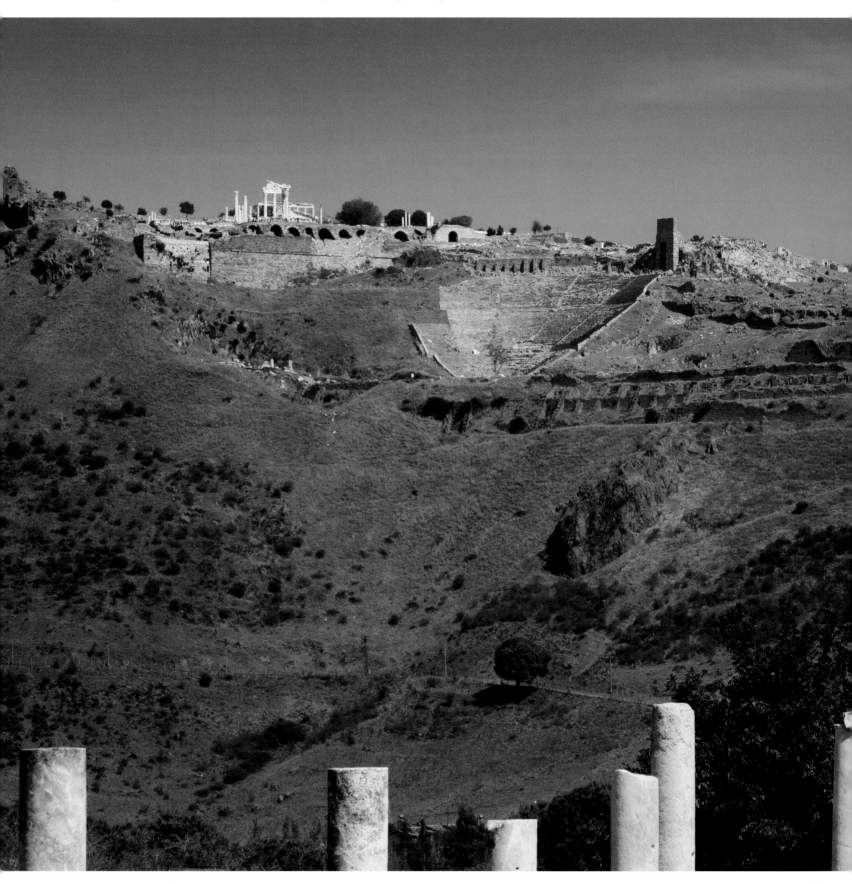

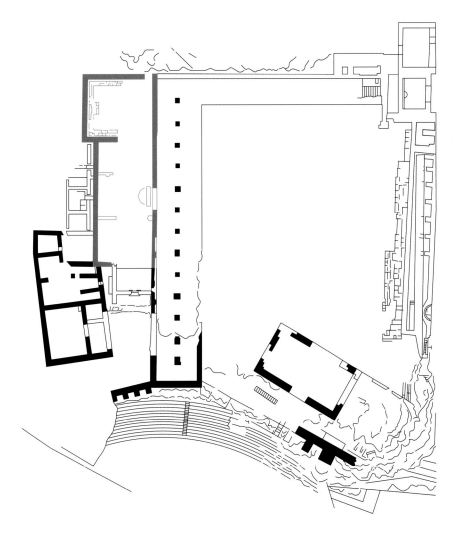

The library at Pergamum

The city of Pergamum owed its fortune to Philetaerus, a man of humble origins who had risen through the ranks to become an administrator to Lysimachus, one of Alexander the Great's generals. Lysimachus was put in charge of Thrace and from it managed to conquer much of Asia Minor.[28] Pergamum was a natural fortress and Lysimachus used it to store much of the treasure he had amassed, leaving Philetaerus in charge. It turned out to be a bad choice. Philetaerus betrayed Lysimachus, siding with one of his enemies, who invaded. Philetaerus became king and the founder of a dynasty, the Attalids, who ruled Pergamum for the next 150 years. His grandson Eumenes II (197–160 BC) founded the library. It quickly became one of the finest collections in the ancient world. As always, the size is disputed. Mark Antony is said to have given 200,000 scrolls from Pergamum to Cleopatra as a gift for the library at Alexandria but this number is probably wildly

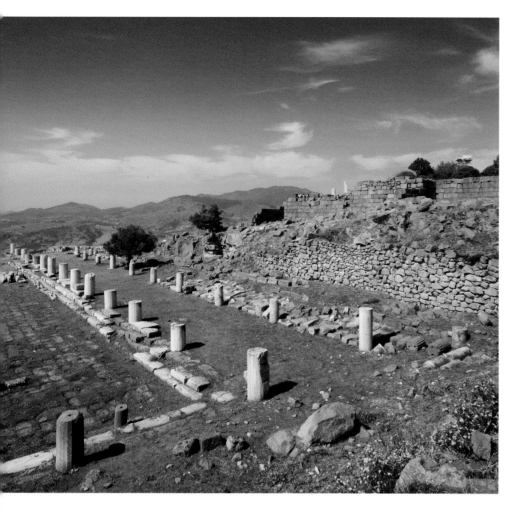

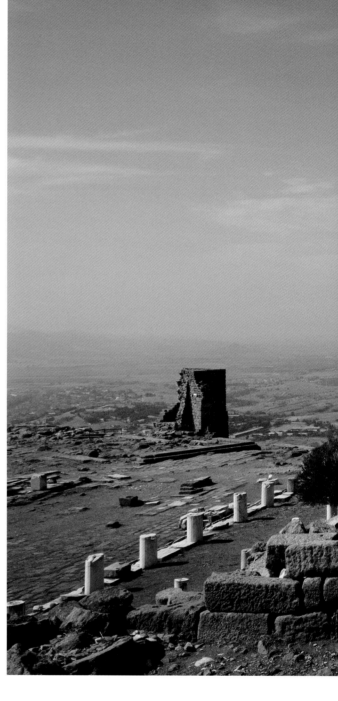

exaggerated.[29] In any event, Pergamum was admired for its size and importance as a collection, second only to Alexandria, and records show that it was attached to the sanctuary of the goddess Athena.

Excavations started in Pergamum in the second half of the 19th century.[30] They revealed a town that had been transformed architecturally under the Attalids into a magnificent city. A building was identified amongst the mass of ruins as the library. The structure in question consisted of four rooms. The first and largest had stone platforms about 90 cm (3 ft) high set 50 cm (about 1 ft 8 in.) clear of the walls around three sides. A series of unconvincing reconstructions has been made showing timber bookcases balanced on these platforms, tied back to the walls by iron cramps.[31] A more convincing suggestion was that the platforms were couches and the largest room was a banqueting chamber and reading room, but the truth is that we do not know.[32] The use of the other three rooms is unclear and they have simply been labelled 'bookstacks'. All these rooms appear to have opened onto the upper level of a large two-storey stoa, where the books were meant to have been read.

The scholarly disagreements over the platforms are a useful reminder that in truth we know very little about what the Pergamum library looked like or how it was used, or whether the rooms identified really were the library at all. The ruins of Pergamum contain only the vague trace of a library, rather than a surviving building. It represents the first of many classical library reconstructions that are the cause of continual debate among archaeologists and historians. The legendary library of Alexandria that is meant to have inspired that at Pergamum is even more problematic.

The library of Alexandria

The Greek world that flourished between 500 and 336 BC consisted of fragmented city-states. Some, such as Athens, exerted more power and influence than

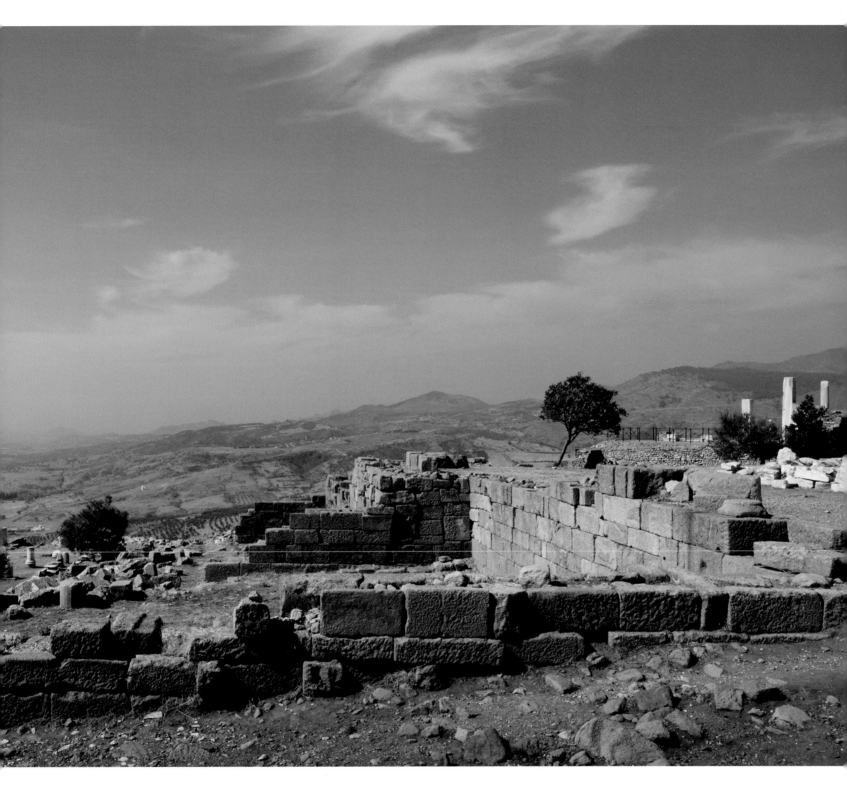

others. In 338 BC Philip II of Macedon led an army that
conquered the combined forces of Athens and Thebes
and established a Hellenic alliance. Philip had a son,
Alexander, and hired the famous philosopher Aristotle
to teach him. Alexander was just twenty in 336 BC when
his father was assassinated and he ascended the throne.
In a series of extraordinary campaigns over the next ten
years, Alexander established an empire that included
all of Greece, Persia and Mesopotamia, Syria, Lebanon
and Greece, and extended as far east as India. On his
death in Babylon in 323 BC at the age of thirty-two his
empire was divided into three parts. Egypt passed to the

general Ptolemy Soter. Alexandria, the city Alexander
had founded in 331 BC, became the capital of this new
state. This period, from 331 until the end of the first
century, is called the Hellenistic age.

The library of Alexandria was thus founded in an
Egyptian state that was ruled over by a Greek dynasty:
the Ptolemies. Ptolemy Soter (367–282 BC) became
Ptolemy I (r. 305–282 BC). He was followed by Ptolemy II
(282–246 BC), Ptolemy III (246–222 BC) and Ptolemy IV
(222–205 BC). All were Greek-speaking, cultured and
well-educated. It was thus hardly surprising that what
is widely regarded as the greatest library of antiquity

below
LIBRARY OF CELSUS, AD 155
Ephesus, Turkey

A statue of Sophia, denoting wisdom, adorns the library façade. This is one of four female statues, the others being Arete (diligence), Ennoia (understanding) and Episteme (erudition), each representing one of the virtues of Celsus. They are copies reconstructed in the 20th century from fragments found at the site. Traces of metal fastenings have led some scholars to argue that the statues were marble replacements for bronze originals.

opposite and overleaf
LIBRARY OF CELSUS,
AD 155. Ephesus, Turkey

The library was approached from the upper city down a long street. Its rear and sides were enclosed by other buildings and the hillside. The plan (opposite) shows how the building was arranged to be lit entirely from the front. The void behind the inner walls may have contained staircases giving access to the upper levels, but no remains of these were found. Many writers have pointed out that the separation of the walls would have reduced the risk of damp reaching the books. The library's façade (overleaf), its most dramatic feature, is not entirely original. When the library was discovered in 1903 its remains were piled in heaps where they had fallen after a series of earthquakes. Many stones had been removed, but the 750 blocks that remained provided sufficient clues for its reconstruction.

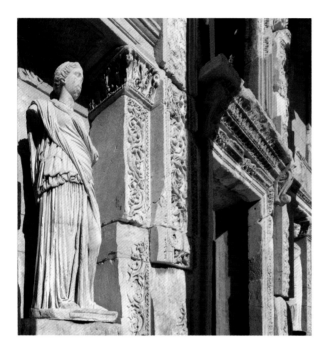

sprang up under their guidance. The library they formed aimed to collect every book in the Greek world.[35] At its heart was a House of Scholars, 'the Museion' [museum], a figurative temple of the Muses.[34] The scholars who used it included Euclid, Archimedes and Eratosthenes.[35] They were fed and housed and had the library continually at their disposal. The first Greek version of the Hebrew scriptures, the Septuagint, was said to have been compiled in the library of Alexandria.[36] In time a second library in the Temple of Serapis grew up and the two libraries existed side-by-side in the city.[37] The Ptolemies sent for books from all over the known world, paying for copies to be made or stealing them, and making every attempt to get 'authentic' texts (that is, texts with as few copying errors as possible).

Form and size

There is no doubt that the library of Alexandria really existed because it is mentioned in so many different accounts. But like so many ancient libraries we know tantalizingly little about it. We are not even sure exactly when it was formed: it may have been as early as 323 BC or as late as 246 BC.[38] We do not know how many books it had. Some sources say it had 40,000 works, others 200,000, some as many as 700,000.[39] One recent analysis suggests that a more likely figure was

10,000–15,000 scrolls.[40] We know virtually nothing about the location and spatial layout of the library. The very few descriptions we have suggest that the books may have been kept in a series of storerooms or corridors arranged around courtyards, where they were read.[41] It is possible that there are ruins of the library in the harbour of modern Alexandria, but it is most likely that the library is under the present city and thus is never likely to be excavated.

Destruction

Just as we know very little about its form, we know equally little about when the great library of Alexandria disappeared.[42] Some accounts maintain that it was burned in the fires accidentally started by Julius Caesar in 48 BC. Others note Mark Antony's gift to the library as evidence that it survived those fires and suggest that it was destroyed in the battles fought by the Emperor Aurelian in AD 270. Still others suggest that it was destroyed by Arab invaders in AD 641, when Emir Amr ibn al-As took the city. According to legend he is meant to have sent a letter to Caliph Omar asking what he should do with the library and received this reply:

> If the content of the books is in accordance with the book of Allah we may do without them, for in that case the book of Allah more than suffices. If, on the other hand, they contain matter not in accordance with the book of Allah, there can be no need to preserve them. Proceed, then, and destroy them.[43]

It is thus reported that Amr obediently ordered the library destroyed and the books are said to have been so numerous that they fuelled all the bathhouses of the city for many months.

This story, however, is probably nothing more than Christian propaganda. Papyrus does not last for eight centuries, particularly not in the humid atmosphere of Alexandria. Unless the library continually employed teams of scribes to copy out its books, they would have gradually fallen apart. This is the most likely reason for the demise of the great library of Alexandria. As the Roman Empire lost power and influence, the funds that supported the library would have dried up, leaving it vulnerable to neglect and decay. The most

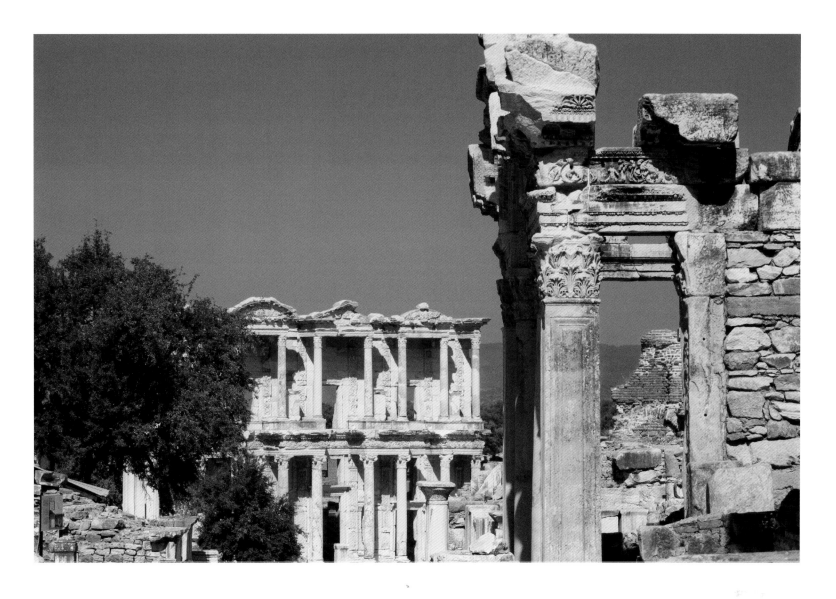

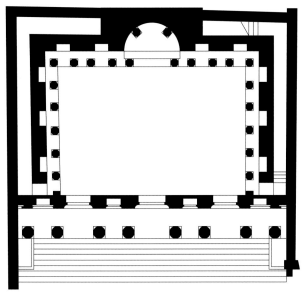

likely fate of the library of Alexandria was that what was left of it simply rotted away.[44] Despite the lack of physical remains, the library is still a potent symbol of the encyclopaedic endeavour, that very human urge to conquer knowledge by collecting all of it under one roof. It is a theme that, as we shall see, recurs again and

again throughout history and is as alive today as it was 2,300 years ago.

Roman libraries

The library of Alexandria was not a public library; it was a royal library. It aimed to collect copies of every work of Greek literature, but it did not aim to make them available to the public at large. Nor is it clear how accessible libraries such as Pergamum were to those who wished to use them. The Romans may have been the first to have entertained the notion of creating libraries for public usage, even if the idea of what constituted 'public' was probably still limited to some extent.[45]

The library of Celsus at Ephesus is the finest surviving example of a Roman library building. As it exhibits all the key features of Roman libraries, it is a good place to start an account of them. It is identified by a dedication:

For Tiberius Julius Celsus Polemaeanus,
consul, proconsul of Asia [governor of the
province], Tiberius Julius Aquila Polemaeanus,
consul, his son, set up the library of Celsus

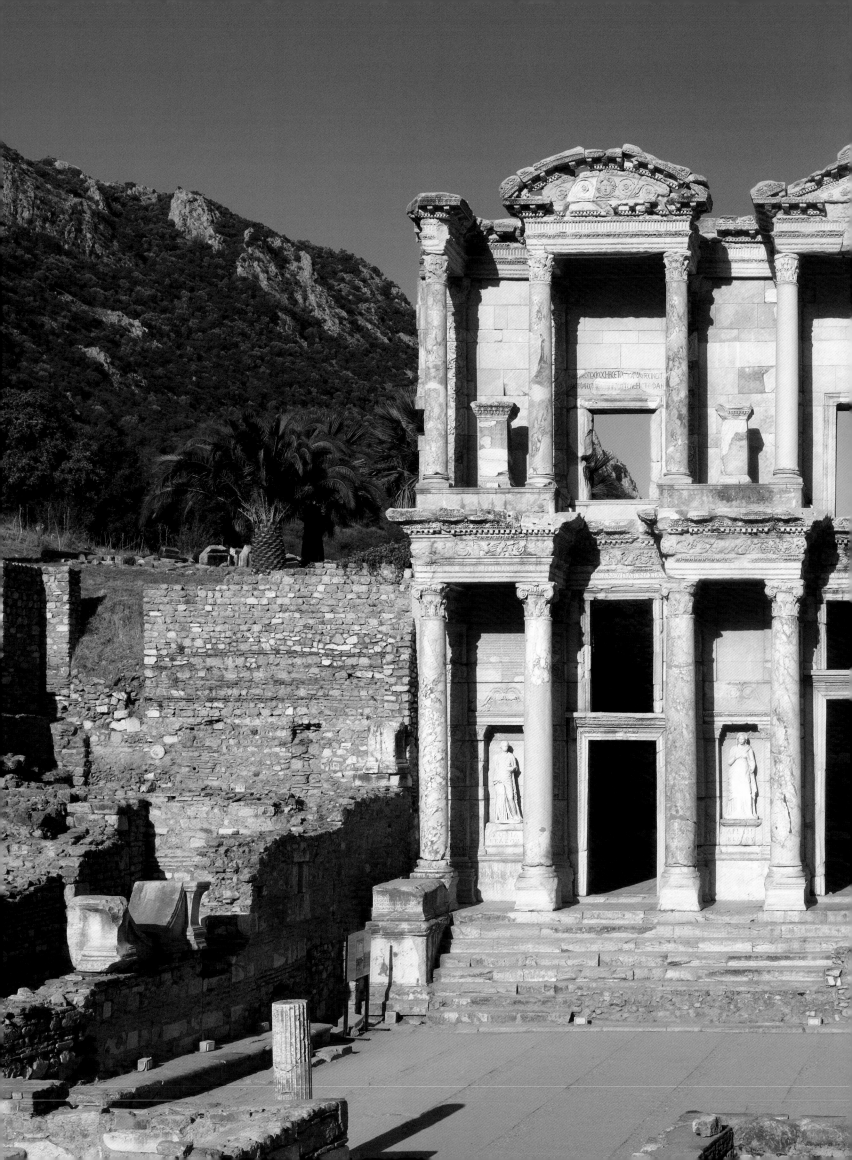

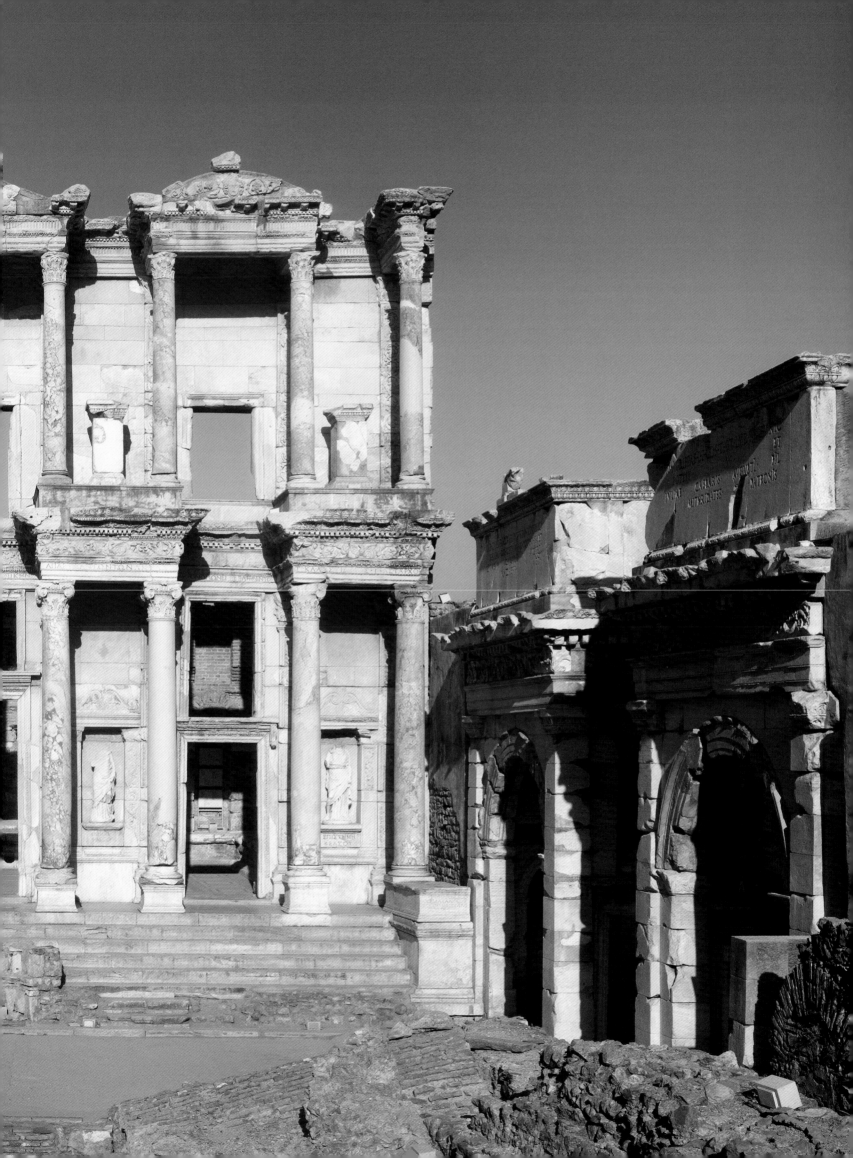

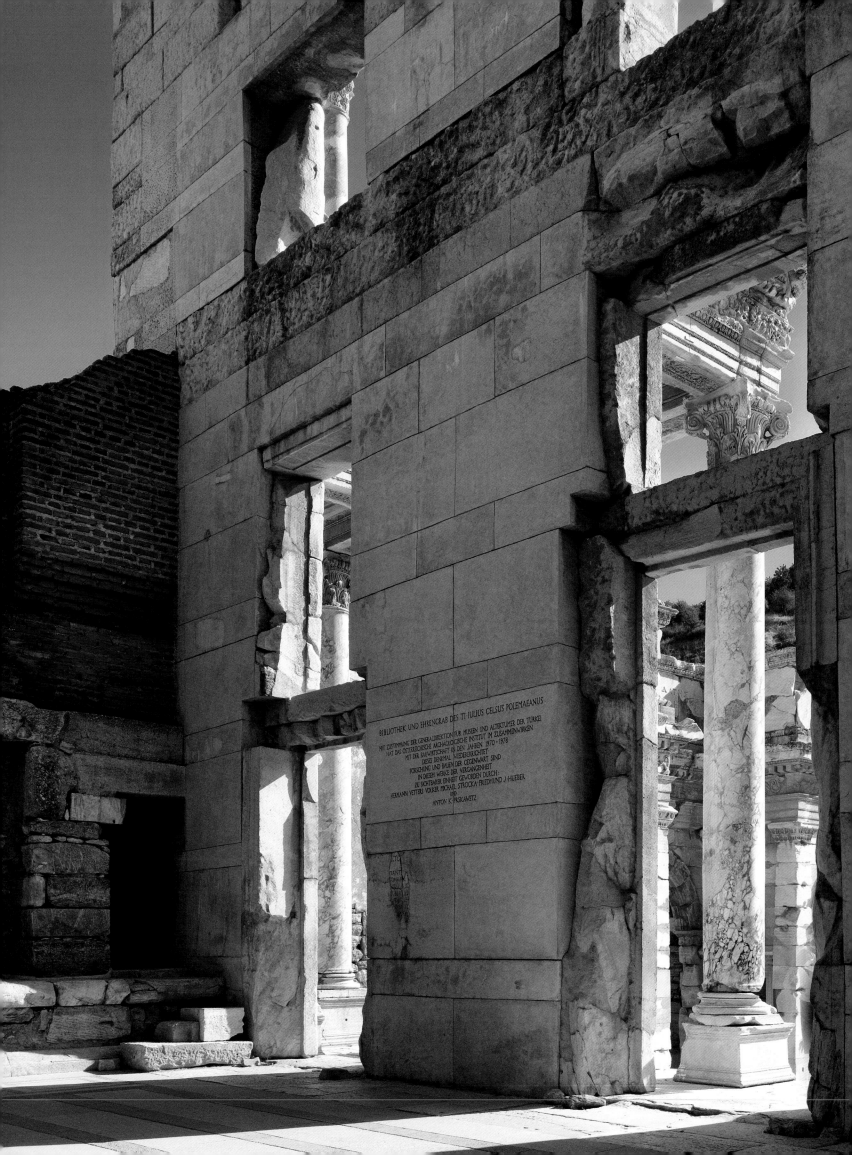

BIBLIOTHEK UND EHRENGRAB DES TI·IULIUS·CELSUS·POLEMAEANUS

MIT ZUSTIMMUNG DER GENERALDIREKTION FÜR MUSEEN UND ALTERTÜMER DER TÜRKEI
HAT DAS ÖSTERREICHISCHE ARCHÄOLOGISCHE INSTITUT IM ZUSAMMENWIRKEN
MIT DER BAUWIRTSCHAFT IN DEN JAHREN 1970–1978
DIESES DENKMAL WIEDERERRICHTET
FORSCHUNG UND BAUEN DER GEGENWART SIND
IN DIESEM WERKE DER VERGANGENHEIT
ZU SICHTBARER EINHEIT GEWORDEN DURCH:
HERMANN·VETTERS·VOLKER·MICHAEL·STROCKA·FRIEDMUND·J·HUEBER
UND
ANTON·K·PASKAWETZ

right and opposite
LIBRARY OF CELSUS,
AD 135. Ephesus, Turkey

The rear of the façade (opposite) is reinforced with new masonry. The 94 cm (37 in.) high plinth, which runs around three sides of the room and gave access to the lowest level of bookcases, is clearly visible on the left of the picture. The two stones that act as steps are not original. The large number of dowel holes suggest that low metal balustrades may have separated the public from the books, with only librarians being allowed on the plinth. The large apsidal niche in the rear wall (right) held a statue. The smaller ones contained the books. There were ten of these small niches on each level, each measuring 57–60 cm deep (appx. 22–23 in.) and 2.55 m (8 ft 4 in.) high. Their width deliberately varies between 1.15 and 1.2 m (3 ft 9 in. and 3 ft 11 in.), one of a number of optical corrections employed in the library's design to make it appear more uniform.

below
LIBRARY OF TIMGAD (TAMUGADI), 3rd century AD
Timgad, Algeria

When this library in Timgad, a town founded by Trajan in about AD 100, was excavated by French archaeologists in the first decades of the 20th century, it was identified as a library by an inscription naming the donor. The semi-circular apse is thought to have been covered by a half-dome, allowing it to be lit from an attic window in the front façade. The books were stored in the niches.

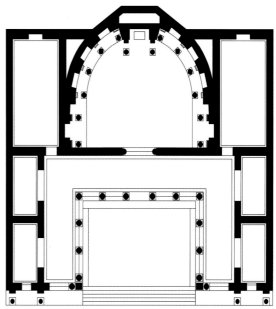

with his own money, along with its decoration, statuary and books. He left for its maintenance and for the purchase of books 25,000 *denarii* … The heirs of Aquila have completed it.[46]

The building was subject to a number of earthquakes over the centuries and the remains were little more than 2 m (6 ft 6 in.) high when excavations by Austrian archaeologists began in the 1890s, but the fragments of the original building remained where they had fallen, allowing later archaeologists to reconstruct the ruin we see today, and it gives a remarkably good idea of what the building must have looked like when it was completed in about AD 135.[47]

The form of Roman libraries
The library of Celsus consists of a large room measuring 16.7 x 10.9 m (appx. 55 x 35 ft). From the height of the reconstructed façade it appears to have been a single space, with two balconies and a high platform running around the walls. The walls are lined with niches. The large one in the centre of the rear wall is thought to have contained a statue. Celsus himself was buried in a tomb at the back, the library being both monument and sepulchre.[48]

It has become generally accepted that Roman public libraries came in pairs, one for Greek books and one for Latin ones, so archaeologists look for

overleaf
LIBRARY OF THE BATHS OF CARACALLA, AD 217
Rome, Italy

The whereabouts of the library in the Baths of Caracalla is uncertain. This view shows the most commonly accepted location, based on the presence of niches of the right size and a plinth like that found in other Roman libraries. The large central niche would have held a statue, with the bookcases ranged on two levels on either side, accessed by wooden galleries.

pairs of rooms when identifying libraries. The Greek language in Rome occupied the same place Latin would in Europe until the end of the 19th century: it was a language that all educated people were expected to be able to read. The idea that Greek and Roman collections were kept separate is based on a single quotation from Isidore of Seville (*c.* AD 560–636) and on inscriptions on gravestones for librarians that mention their role in 'the Greek library' or 'the Latin library' in various sites.[49] It is important to note that neither of the two public libraries identified by inscriptions (Timgad and Ephesus) has two halls, suggesting at the very least that the division into two libraries was not universal.

The other feature generally associated with Roman library buildings is the combination seen at Timgad and Ephesus of a raised stone platform and a series of niches in the walls behind. The raised stone platform is thought to have separated the public from the books, which would have been fetched by a librarian slave. It is believed that the books themselves were kept in timber cupboards with doors (the Latin term is *armaria*) set into the niches. They were, of course, not books in the modern sense, but rather papyrus scrolls. The Greeks and Romans divided all literary works into books of varying length. It is possible that they always meant these to be separate scrolls. Certainly a scroll can contain only a fraction of a modern book, so most works occupied more than one. The Roman building

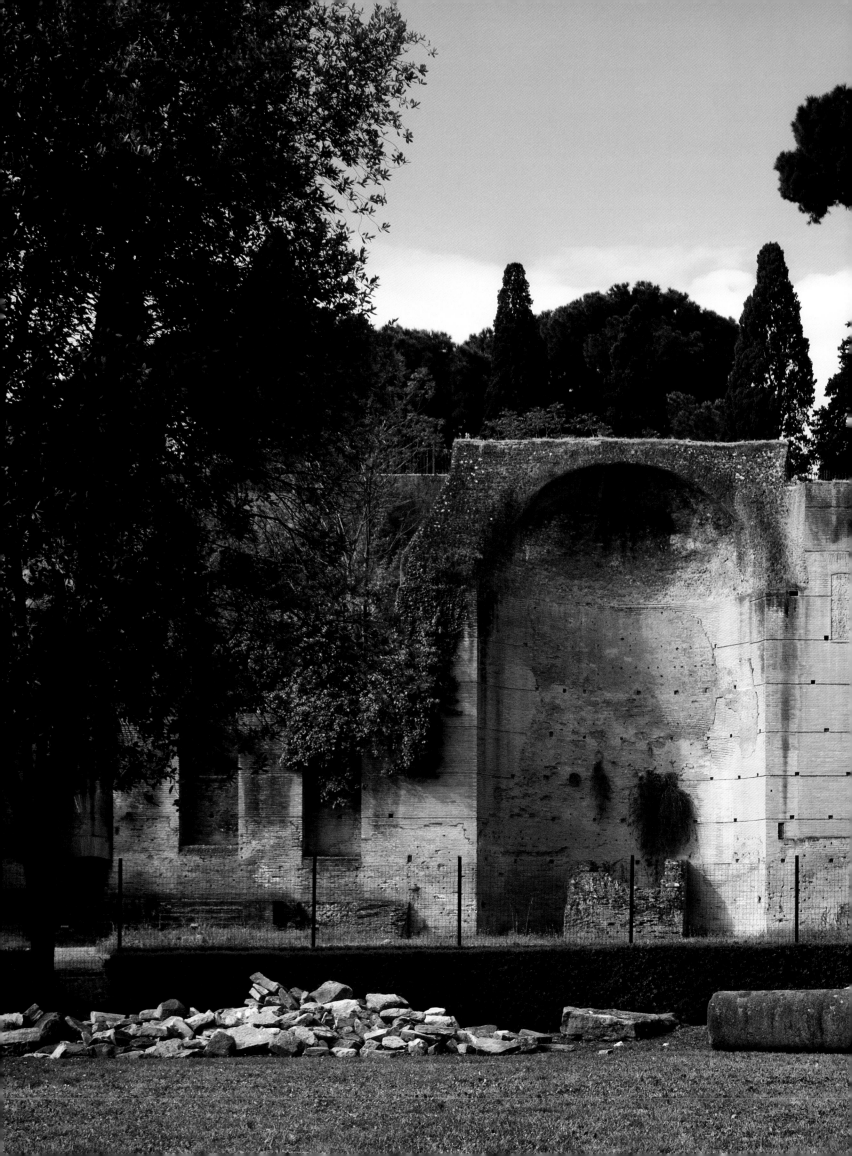

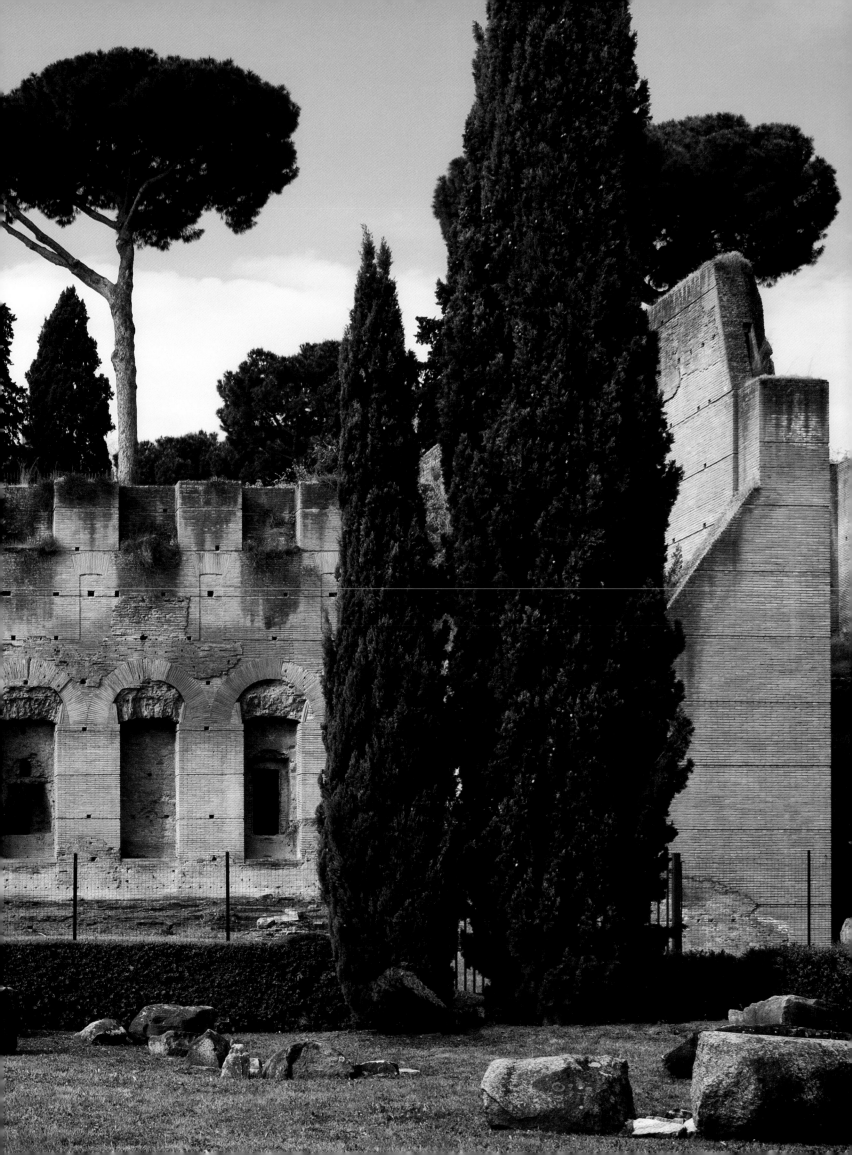

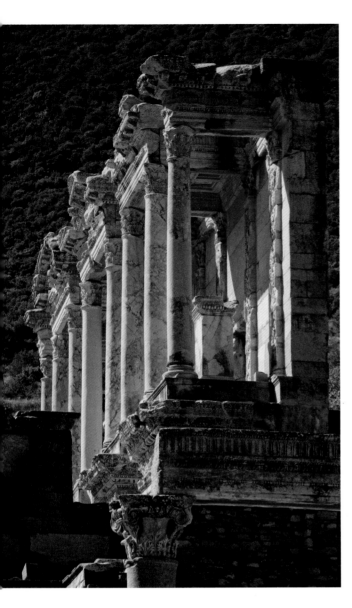

manual by Vitruvius, *The Ten Books on Architecture*, was almost certainly intended to be written on ten scrolls. Leather buckets were used to carry sets of scrolls around. Roman scrolls were cylinders 25–33 cm (10–13 in.) in length (slightly larger than the Greek ones before them).[50] Niches suitable for *armaria* thus had to be about 60 cm (2 ft) deep to allow for the timberwork to make the back of the *armaria* and leave space for the doors. Lining the niches with timber was necessary to protect the fragile scrolls from the damp walls. The doors would have provided security and kept out insects.

Texts attest to the use of niches for books and we have reliefs and mosaics showing freestanding *armaria* but no pictures of *armaria* in niches survive. It is thus not entirely clear what these book niches looked like. The existence of niches in both the library of Celsus and the library at Timgad has strengthened the belief that the presence of niches of the correct depth is an indication that a particular building is a library, especially when those niches are associated with a platform. Most other libraries have thus been identified

only by the presence of these features. In some cases the identification is highly questionable.

If the niches were used for books, then Roman libraries were incredibly inefficient. The arrangement of a small number of cupboards set in large, blank walls seems odd to modern eyes accustomed to walls entirely filled with books. Some modern writers have responded to this inefficiency by saying that there cannot have been enough space in these cupboards to take a large collection and additional spaces must have been provided elsewhere for book storage. It is more likely that the reverse was true: that Roman libraries were built primarily as impressive buildings and that storage was only a secondary consideration; in other words, they had excess capacity rather than too little. The viewer entering the library would have been impressed by the soaring space. The cupboards set in regular intervals around the wall were almost certainly closed. Thus the viewer had no way of knowing how many books the library actually contained. Indeed, if that is true, this design had the advantage that the cupboards could be entirely empty when the library was first constructed without detracting from the building's appearance. The presence or absence of books would make no difference to the impressiveness of the space as a library. As we shall see, closed cupboards were to be employed by later libraries that sought to impress the visitor without wishing to show how few books they had, or reveal the state of those that they owned.

If this is the case, then attempts to calculate the size of public libraries in Rome based on the capacity of the full cupboards are also misplaced. For instance, one such calculation estimates that Trajan's library could have accommodated 10,000 scrolls in one wing alone, and presumably another 10,000 in its matching counterpart.[51] Yet some scholars estimate that the entire corpus of Greek literature by known authors would fill just 31,150 scrolls, so it seems likely that such figures are exaggerated.[52] Trajan's library might have had the capacity to hold 20,000 scrolls, but it probably actually had only a fraction of that number. If its niches had been closed by doors nobody would have known.

Use of libraries
Latin authors talk about going to libraries to read, so there must have been provision for reading within the

right above
LIBRARY IN TRAJAN'S FORUM, AD 112–13
Rome, Italy

As this plan shows, the two libraries faced each other across a courtyard with Trajan's Column in the centre. Only the ruins of the chamber on the left remain. They are identified as a library by the presence of a plinth and the bottom of a series of niches.

right below
THE PALATINE LIBRARY, *c.* 28 BC
Rome, Italy

Rome's second public library was built by the Emperor Augustus on the Palatine Hill, next to the Temple of Apollo that he had erected there. Only fragments of the parts shown in red in this plan remain. The two chambers are thought to have been separate Greek and Latin libraries.

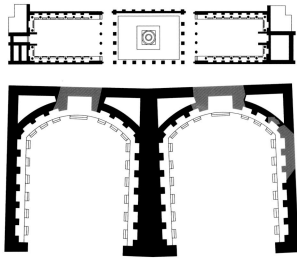

main space, probably on tables in the centre. However, they also talk about going to libraries to hear lectures, so this space had to fulfil both functions and the platform may have doubled as a seat for the audience.[53] If the library at Ephesus is taken as an example, most of the lighting seems to have come through windows in the front wall, but as none of the ruins identified as libraries has retained the upper parts of its walls or roofs we will never know for sure. Vitruvius suggests that libraries should face east to catch the morning sun, but the means by which Roman libraries were lit remains uncertain.[54]

Public libraries in Rome

The first public library in Rome that we know of was founded by Asinius Pollio in 39 BC. No remains have been identified, but it is mentioned in various writings. The earliest public library for which remains have been identified was built a few years later (28 BC) by the Emperor Augustus on the Palatine Hill, near the Temple of Apollo. It is sometimes called the library of the Temple of Apollo and sometimes simply the Palatine library. The identification is made on the basis of the survival of a set of niches that can be matched to a plan preserved in a fragment of the *Forma Urbis Romae*, an ancient map of Rome. This fragment shows two chambers side-by-side, presumably one for Greek and one for Latin. The front wall of each is open and the side walls are flat, while the back is curved into an apse with a niche for a large statue in the centre. All around the walls are more niches, 3.8 m high, 1.8 m wide and 60 cm deep (12 ft 6 in. x 5 ft 11 in. x 2 ft). In front of these is a platform raised a few feet above the main floor level.[55]

The library in Trajan's Forum

By the time of Augustus's death in AD 14, Rome had three libraries: Pollio's, the one on the Palatine, and a third in the Portico of Octavia (position unknown). Tiberius added one (or possibly two) on the Palatine Hill and

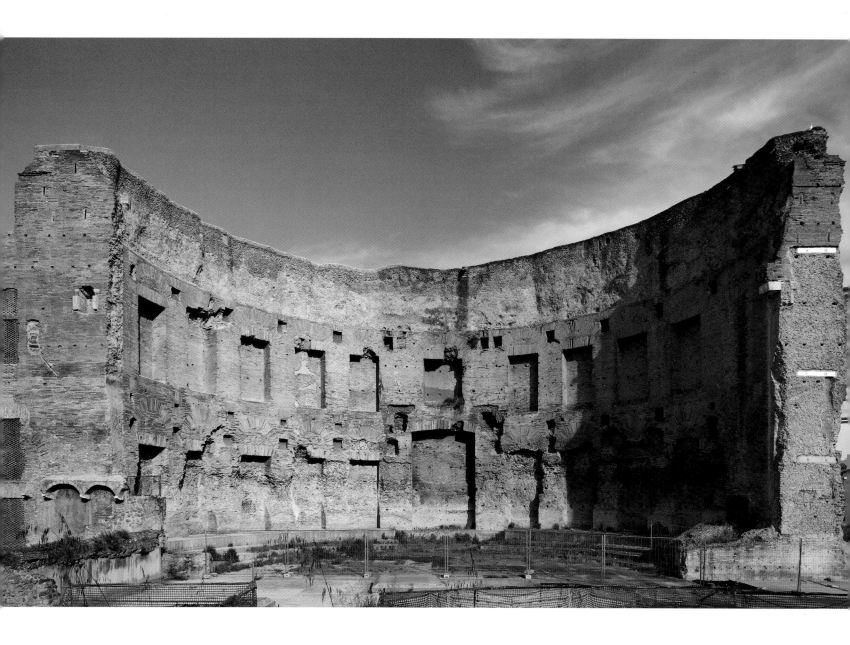

Vespasian added another in the Temple of Peace that he erected in AD 70 near the Forum. The only thing we know about Tiberius's was that it was large enough to accommodate a 15 m (appx. 50 ft) statue of Apollo. No substantial remains of any of these survive.

In AD 112 Trajan is known to have added a library to the massive new forum he had constructed. Based on the idea that such a library must have had two chambers and have been surrounded by niches, archaeologists have identified the remains of two rectangular buildings as the ancient library of Trajan. They face each other across a square with Trajan's Column in between. The ruins indicate a room 27.1 m long and 20 m wide (appx. 89 x 65 ft). A platform three steps high ran along each side giving access to seven niches, each 1.6 m high and 62.5 cm deep (5 ft 3 in. x 2 ft). Two further niches at the end flanked a much larger niche for a statue. The bases of columns on the edge of the platform suggest that there was a second floor above, accessed by a gallery. This is one of the most substantial survivals of its kind, although it cannot be

said with absolute certainty to be the library and many questions remain unanswered, not least how tall the building was and how it was lit.[56]

Libraries in Roman baths

Knowledge of the existence of libraries in Roman baths is based entirely on textual references. In the absence of any further evidence archaeologists have identified a number of ruins as possible bath libraries, based on the features noted above. The suggested rooms in the Baths of Trajan (completed in AD 109) are apsidal. The northern one remains substantially intact but unroofed. Its front side is thought to have had no wall, and was presumably closed by some sort of metal grille for security. Like the other Roman libraries discussed so far, this identification is based mainly on the presence of niches of the appropriate depth. The lowest shelves are reached by a platform a few steps above the library floor. The niches here are huge, however: 4.45 m high, 2.06 m wide and 73 cm deep (appx. 14 ft 8 in. x 7 ft x 2 ft 5 in.). Doors of the necessary size would have been

LIBRARY OF THE BATHS OF TRAJAN,
AD 104–9. Rome, Italy

This view shows the full extent of the remains. The front wall and roof of the building are missing. The large central niche was presumably for a statue, while the others are thought to have contained cupboards with shelves full of scrolls. There are 21 niches and they are huge, which would have made accessing the upper shelves difficult. The platform which runs around the bottom of the niches is stepped. Writers mention going to lectures in the libraries at the baths and one can easily imagine an audience sitting on these steps listening to a speaker in the centre of the space.

heavy and difficult to move, if they existed. Moreover, only the very lowest shelves would have been accessible without using a ladder. The space has tiers of these niches and archaeologists have presumed that this meant there must have been open timber galleries to access them. If this was the case, the librarians would have needed a very good head for heights to retrieve scrolls on the uppermost shelves of the top niches. They would be standing on a ladder on a gallery 10 m (33 ft.) or more above the floor. This, coupled with the fact that the supposed twin (forming a pair of Latin and Greek libraries), was some 300 m (appx. 325 yd) away across a central garden calls into question the identification.[57]

An even more impressive structure survives in the Baths of Caracalla, begun in AD 212 and completed *c.* AD 217. Here the so-called 'libraries' were 260 m (285 yd) – apart in the south-east and south-west corners of the site, again separated from the huge bath buildings by gardens. The one that survives is rectangular and measures 56.5 x 21.9 m (appx. 119 x 72 ft). It had galleries with a huge apsidal niche for a statue in the back wall. There are five niches in the side walls at each level and three niches at each level on either side of the central statue niche, making thirty-two niches in all. The problem here and in the Baths of Trajan is that both

bath complexes contain many other structures with niches and they cannot all have been libraries. We must thus treat these attributions with caution.[58]

From written sources we know that emperors continued to build public libraries and that at their height there were twenty-eight or twenty-nine in Rome alone. Vitruvius writes that every town of any size should have one. He also states that houses of the wealthy should have their own libraries. Of these, the best surviving example is in the Villa of the Papyri in Herculaneum.

The Villa of the Papyri

In the 18th century, workers tunnelling through the mud under Herculaneum (modern-day Ercolano) made an extraordinary discovery. They came across the remains of a complete Roman private library caught in the eruption of Vesuvius in AD 79 (the same eruption that destroyed Pompeii).[59] No scrolls survived in Pompeii but Herculaneum was luckier. Although it was subject to the same deadly pyroclastic flow, it was buried in mud, which preserved some wood and papyrus.

The charred remains of the scrolls were barely recognisable as such. The room that contained them had been relatively small: about 3 x 3 m (10 x 10 ft). A pile of scrolls in the middle of the room had obviously

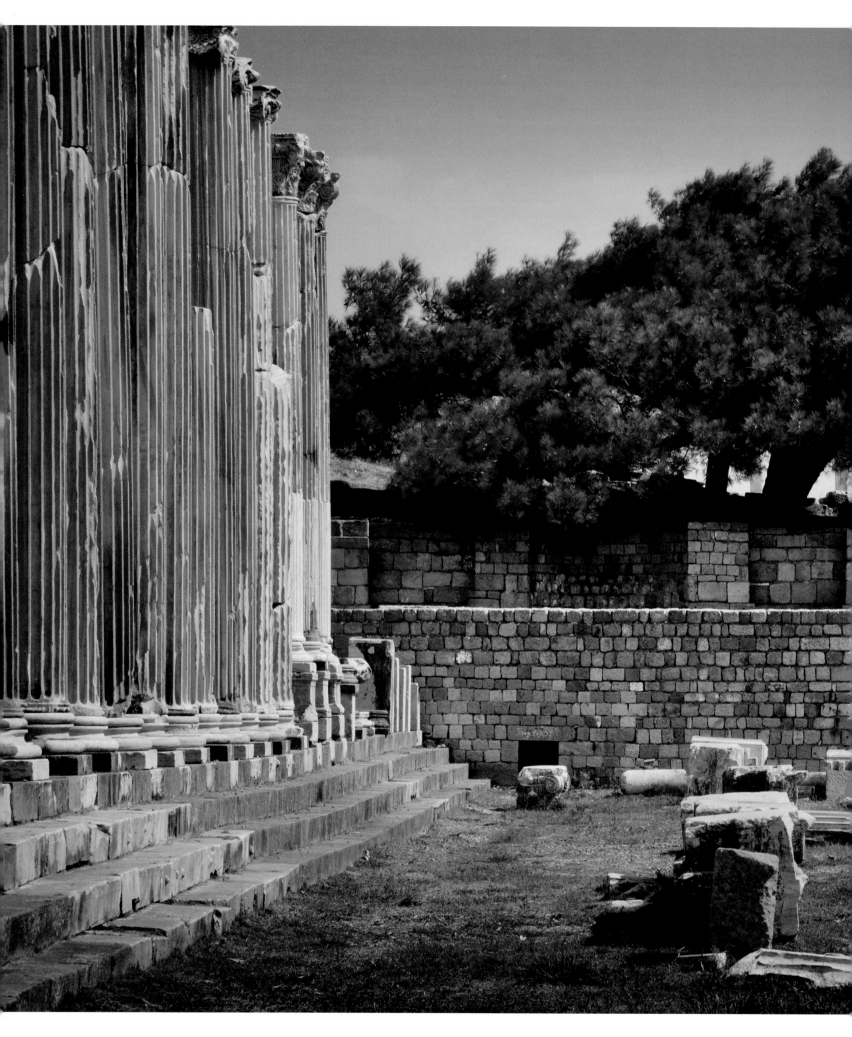

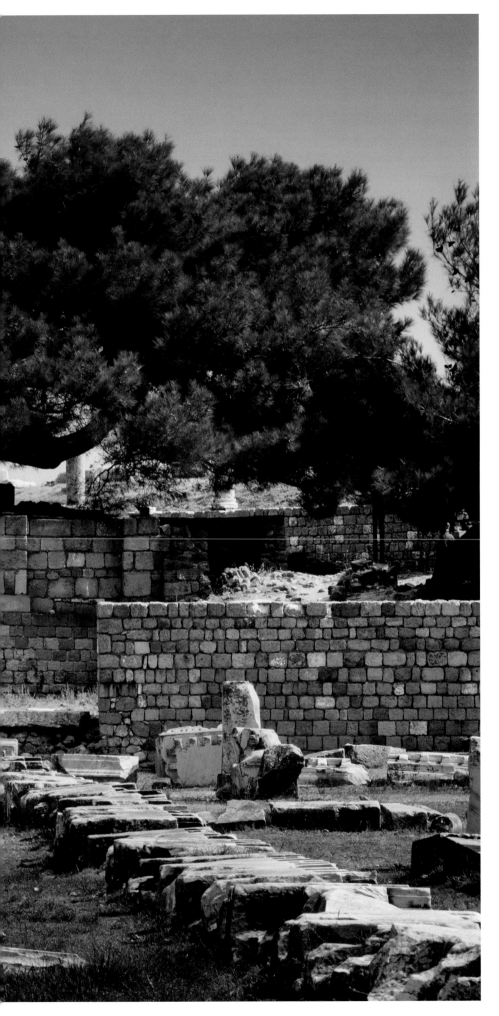

SANCTUARY OF ASCLEPIUS, *c.* AD 100
Bergama, Turkey

The sanctuary, founded in 2 BC, was a centre for healing. Asclepius was the god of medicine. The sanctuary at Pergamum achieved fame in the 2nd century AD as the birthplace of Claudius Galenus (better known as Galen), whose writings on medicine were still being consulted by students in the 19th century. The building identified as the library is at the end of the colonnade. The identification is based chiefly on the presence of niches in the rear and side walls, but there is no plinth.

been stacked on some sort of table, the walls were lined with shelves and a large freestanding bookcase stood on one side.[60] The library was what we might expect of a private collection – it was a small storeroom for books. It was never intended for reading. The owner used it to secure his collection, taking those rolls that he wanted to read out into the adjacent courtyard to consult them in the sunlight. This model – a cloistered garden and an adjacent book room – probably Greek in origin, was to be echoed in the Middle Ages in monasteries throughout western Europe. Larger collections may have been stored more dramatically, but the Herculaneum library was probably typical of private collections in Roman times.

Destruction of Roman libraries

The Roman writer Cassiodorus (*c.* AD 485–585) recorded how in AD 546 Totila, king of the Ostrogoths, sacked the city of Rome and destroyed 'all the libraries'. However, many scholars have speculated that by then financial support for Rome's libraries had long since disappeared and there was probably little left of the once great collections for Totila to destroy. Cassiodorus retired to his villa outside Rome with some of the books that he had managed to save from destruction and set up his famous monastery, named 'Vivarium' after the fish ponds it contained. There he set out to retrieve what had been lost and to create a new, complete library of Greek and Roman literature. He lived to the age of ninety-five, but his monastery barely outlasted him; it was destroyed in subsequent Lombard invasions. The last remaining Roman libraries were in the eastern empire, in Constantinople, and would be wiped out by the Ottomans 900 years later. Their architectural form remains unclear.[61]

The ancient Mesopotamians and the Greeks had left behind them the notion of the great and all-encompassing library. The Romans had added to this architectural splendour: their legacy was the idea that libraries should be significant buildings. Neither buildings nor books could survive the political turmoil of the end of the empire, but the concept of the beautiful library was not lost. Moreover, other cultures far from Rome and Greece were already developing their own very different ideas of what a library should be.

Cloisters, Codices and Chests
Libraries in the Middle Ages

This chapter looks at the period normally termed the 'Middle Ages', between the fall of the Roman Empire and the Renaissance; that is between AD 600 and approximately 1500. The story of the survival of classical manuscripts in medieval collections in the West is well known, but the architectural form of early medieval libraries is not widely understood, a situation not helped by their exaggerated and frequently erroneous depiction in films and literary fiction. This chapter explains the current scholarly understanding of the development of libraries in the Middles Ages in Europe, a period from which, despite general assumptions, remarkably little survives.

The largest libraries in this period were not in Christian Europe. They lay in the Arab world and in Southeast Asia. Islam spread across north Africa from the Middle East and reached as far as Spain. Paper allowed Islamic scholars to produce books in greater numbers and distribute them widely. The technology for paper production, however, was not invented in the Middle East but in China, where the use of paper was combined with printing to produce books very different from their European counterparts, centuries before these technologies were available in Europe. It is thus not in Europe that this chapter begins, but in the very oldest library to survive in Asia.

opposite
SUTRA HALL, MII-DERA TEMPLE, 15th century
Ōtsu, Japan

The books, which contain Buddhist sutras, are paper wrapped in linen. Each is placed in its own niche in a lead box to protect it from the elements.

right
THE *TRIPITAKA KOREANA*, 1251
Haeinsa Temple, South Korea

The timber printing blocks of the Tripitaka Koreana, *a complete set of the Buddhist scriptures, fill the shelves of one of the oldest intact libraries in the world.*

The *Tripitaka Koreana* and the invention of printing

The remote Buddhist monastery of Haeinsa sits high in the mountains of South Korea, a five-and-a-half-hour drive from Seoul and 45 km (28 mi.) from Daegu, the nearest city. Its location has enabled it to remain largely unaffected by the changing world outside, and to preserve intact the *Tripitaka Koreana*, one of the world's most extraordinary literary artefacts. The *Tripitaka Koreana*, also called the *Goryeo Daejanggyeong* (meaning 'The *Tripitaka* made by the Goryeo ruling dynasty'), was compiled in AD 1251 and is, in the words of UNESCO, 'the most important and most complete corpus of Buddhist doctrinal texts in the world'.[1] In fact, this is the second version. The first *Tripitaka Koreana*, which was commissioned in AD 1011 and took eighty-six years to complete, was destroyed by fire after the Mongol invasions of 1232. A second copy was commissioned soon after and it is this 'new' 1251 edition, engraved nearly eight hundred years ago, that is stored in the monastery today.[2]

As an artefact the *Tripitaka* is hugely important, but it is the buildings that house it that concern us here: they are some of the oldest intact library buildings in the world and are strikingly different from the library buildings discussed so far. Haeinsa Temple is arranged on a series of terraces cut out of the steep mountainside and is entered at the lowest level. The library courtyard is at the top of the site,

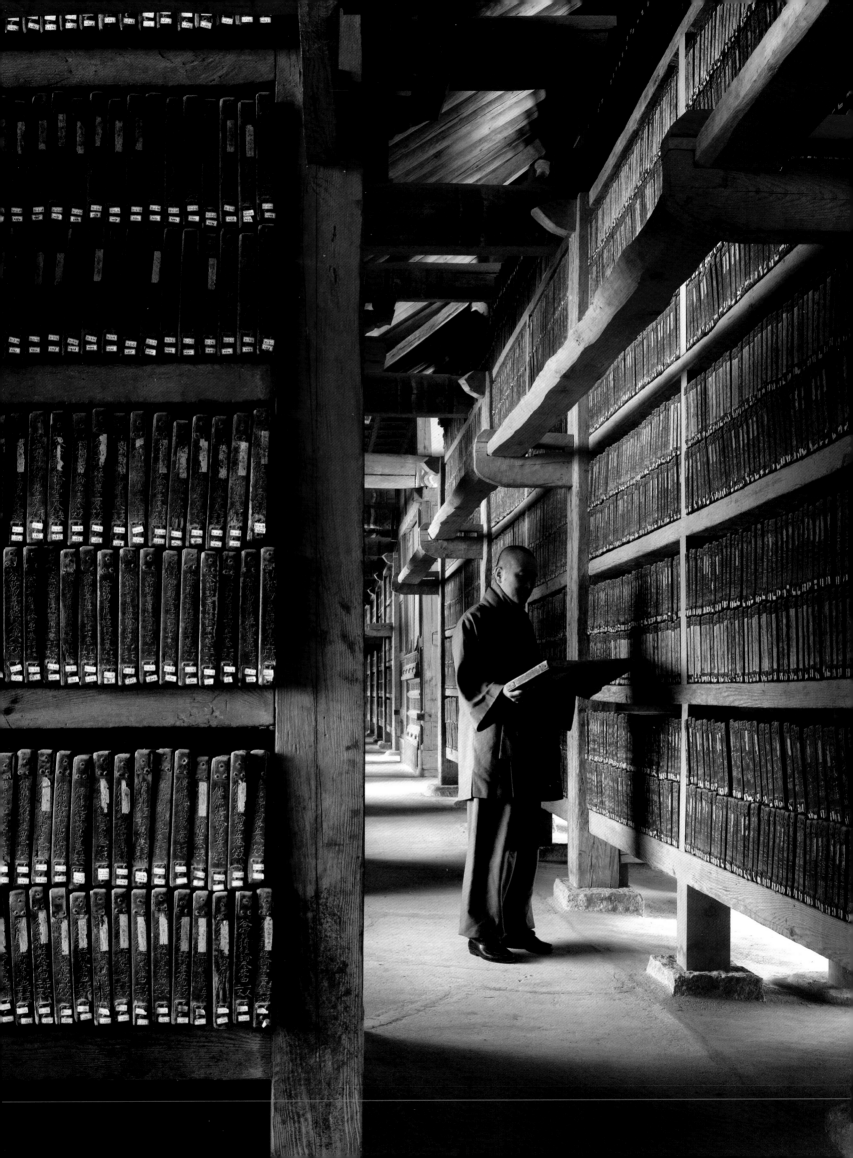

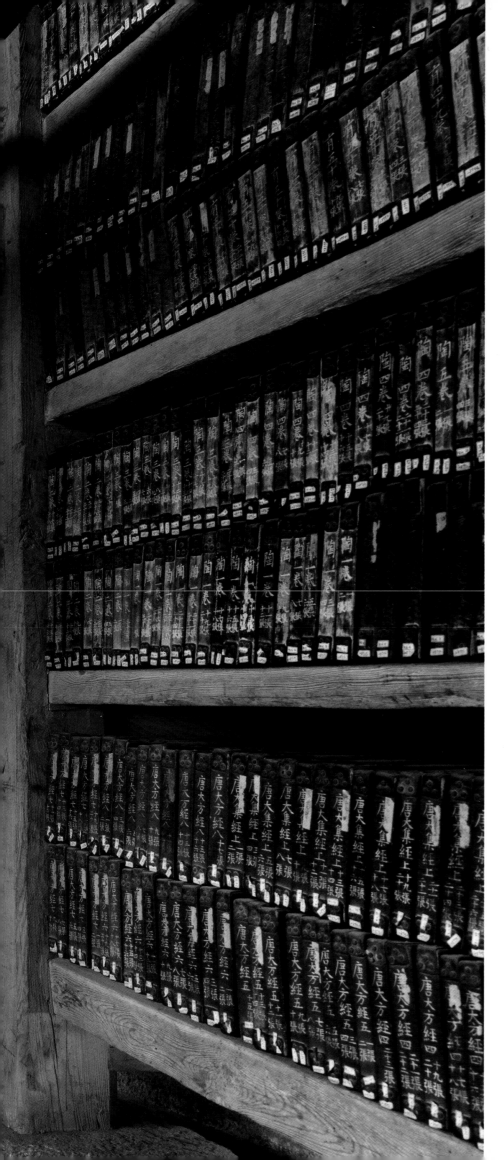

This view shows the inside of the longer of the two halls that house the Tripitaka Koreana. *The blocks are stored in open racks to allow the air to circulate freely around them. The timber structure is lifted off the floor on pad stones and the building is raised on a stone plinth surrounded by drainage channels.*

on the highest terrace. It consists of two long, plain wooden pavilions, the Janggyeong Panjeon, that form two sides of a small enclosed courtyard, the ends of which are completed by two further smaller buildings. The first of the longer buildings is divided in two by a corridor that forms a gateway from the staircase into the courtyard, leaving two chambers, one on each side of the entrance. The second building has a prayer hall set within it, but behind this hall is a corridor, so that it is possible walk internally between the chambers in this building from one end to the other. Both buildings are firmly locked and generally inaccessible.

The building in which the *Tripitaka Koreana* is housed is an unconventional library because of the form of the books within it. The objects stacked in neat rows are printing blocks: 81,258 of them. Each block is exactly 70 x 24 x 3 cm (appx. 28 x 9½ x 1¼ in.) and weighs 3.25 kg (just over 7 lb). They are made of wood, originally assumed to be birch from the island of Koje.[3] Tests have since shown that ten different species were used, however, and that each block is made from a timber board that was cut and then boiled in salt water before being left to dry slowly for three years. Once thoroughly seasoned, only the hardiest blocks were selected, and each one fitted with end panels and reinforced with metal. They were then painstakingly carved by hand. Every block is engraved on both sides so it can be used to print two sheets of paper. After the engraving was completed the blocks were coated in thick, grey, poisonous lacquer to protect them from insects.[4]

The survival of the wooden blocks for nearly 800 years can largely be attributed to the exceptionally clever design of the buildings that house them. The first point to note is that the blocks were not always in Haeinsa. They were carved in Namhae (in South Gyeongsang province) and were originally stored in the Taejanggyong P'andang, outside the western gate of the Ganghwa Fortress, before being moved in 1318 to the Sonwonsa Temple on Ganghwa Island and then finally to the present depositories in Haeinsa in 1398, to protect them from the frequent invasions of Korea during this period. Records show that the king personally oversaw the transportation of the blocks.[5]

The current buildings date from the move to Haeinsa in 1398 and although it is assumed that much

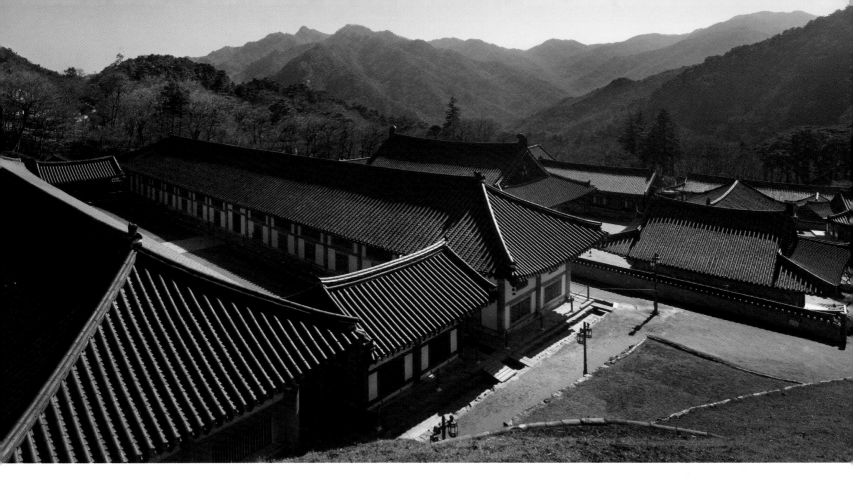

of the fabric is original, documents show that the buildings were repaired in 1481 and again in the 17th and the 20th centuries.[6] The structure consists of stout timber posts sitting on stone pads to protect them from damp. The floor itself is made from layers of charcoal, mud, sand, salt and limestone. The building is surrounded by a shallow trough that quickly carries the rain away when it falls off the projecting eaves of the tiled roof, protecting the walls from damp. The walls are plastered to provide protection from the elements, and have two levels of openings with timber louvres, which are carefully positioned to provide plenty of ventilation while protecting the contents from the driving rain and snow. In the winter the temperature outside drops to -20 degrees Celsius (-4 degrees Fahrenheit) while in the summer it can get as hot as 35 degrees Celsius (95 degrees Fahrenheit). There is no heating of any kind in these buildings, yet they have preserved their precious contents intact through countless seasons.

Inside, the shelves form the structural frame of the building. They are open so that air can freely circulate around all parts of each block and the blocks themselves are carefully stacked two-deep on their supports. Ventilation is key to the success of the building. The air moves freely throughout the space. In winter, the combination of the cold and the poisonous lacquer that coats the blocks kills any insects. In summer, the stack effect helps to drive the air through the blocks to counter any humidity, which the altitude and orientation help to lessen.

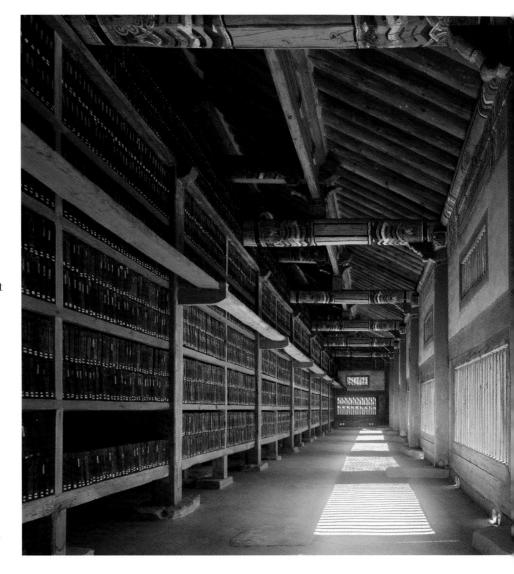

opposite above and below
THE *TRIPITAKA*
***KOREANA*, 1251**
Haeinsa Temple,
South Korea

*The Haeinsa monastery
(above) is set high in the
mountains. In the winter
the temperature drops to far
below freezing. In the summer
the mountain breezes help
reduce the effects of the stifling
heat. The* Tripitaka Koreana
*is stored in the two long
buildings in the foreground,
at the highest point in the
monastery. Two smaller
pavilions that complete the
courtyard contain lesser texts.
The view of half of the interior
of the shorter hall (below)
shows the planks supported
on brackets projecting from the
cases that provide a gangway
to enable the blocks on the
upper shelves to be retrieved.
The roof beams are decorated
with ripples, denoting water,
to ward off fire.*

In 1971 the authorities decided that the blocks should be moved to better, modern, climate-controlled buildings where they could be monitored. Concrete bunkers were constructed to house them in 1972 and some of the blocks were moved, but they quickly began to deteriorate so the plan was abandoned and the blocks were returned to the original buildings.

Of course, the printing blocks were never intended to be read directly. The relevant block had to be retrieved from these storerooms to be printed and the result read elsewhere. There was thus no need to accommodate a reader in these spaces, but it was necessary to be able to find individual blocks. When the blocks were recarved, a three-volume index was created as part of the collection. Today the blocks are also carefully numbered and catalogued. They were always stored in the order in which they were meant to be printed (each block carries its volume and page number on its surface). Today, as in the past, the whole set is printed, a few pages a day; the whole set of 6,802 volumes takes decades to complete. The *Tripitaka Koreana*, which is written in Chinese characters, is remarkable for its accuracy. No scribal errors have been found in its 81,258 blocks. Accessing the blocks is an interesting process. The three lowest shelves can be reached from ground level but the upper two can be reached only by balancing precariously along a plank of wood supported on brackets from the shelves. Ladders are kept to get up to these planks, which require both a head for heights and considerable dexterity to use.

The birth of printing

The existence of wooden printing blocks in Korea in AD 1011, 440 years before Gutenberg, is an immediate reminder of the sophistication of both technology and civilization in China, Japan and Korea compared to that of Europe in this period. The *Tripitaka Koreana* is just one example of these advances.[7] It is tempting to search for an inventor of printing but such a person probably never existed. The first woodblock prints on paper seem to have appeared around AD 700.[8] However, the critical thing to understand about printing on paper is that it was merely a transfer of an existing and long-established technology to a slightly different purpose.

Printing is as old as civilization. In ancient Mesopotamia roll seals were used in a form of printing or embossing to sign and inscribe clay tablets, and similar seals were used throughout ancient times to seal documents in wax and other soft, impressionable materials. It was a small step to put ink on larger-scale prints and print cloth. The origins of printing as we know it today lie in this imprinting of textiles. Woodblocks were first used to print textiles in China in the Han dynasty (206 BC–AD 220). From this it was only another small step to printing pages of a book on skins or paper. The earliest surviving example of a printed book is the *Diamond Sutra*, preserved in the British Library in London. This dates from AD 868. However, records suggest that books had been around for at least two hundred years by the time the *Diamond Sutra* was completed.[9]

The woodblock may seem unwieldy but it served the Chinese language very well. The 10,000 characters of Chinese made it difficult to use moveable type and as a result woodblock printing was used well into the 20th century until it was finally supplanted by modern printing techniques. However, it would be wrong to assume that moveable type was in any way a Western invention. The Chinese had experimented with ceramic moveable type in the middle of the 11th century and the Korean Choe Yun-ui is credited with inventing metal moveable type in 1234.[10] Printing had been invented and its possibilities exploited in Southeast Asia hundreds of years before it was in the West.

The library in Japan

China was not, as might have been expected, particularly secretive about its technology, which transferred quickly to its neighbours. Korea and Japan had paper and printing soon after their invention, as did states bordering China to the west. The Japanese book in this period (AD 600–1500) might be a scroll or a book bound in the Chinese manner. There were three basic types of libraries: imperial libraries, private libraries and temple collections. All seem to have had the same basic structure: the storage was always separate from the reading area.

The Japanese never read books in the room in which they were stored. The architecture of the Japanese library before the Meiji period

(AD 1868–1912) is the story of two building types: the
bunko (meaning 'storehouse of literature') and the
shoin (study room). This division was common to
all three types of library. The storehouse is a crucial
part of Japanese architecture. Its existence is the
key to understanding the Japanese interior, which
is characterized by a lack of the furniture and the
clutter of possessions common in Western houses.
It is not that the Japanese do not have possessions,
but that they are brought out one at a time, from the
storehouse (or cupboards in smaller dwellings), and
put back after use.[11]

The storehouses are always at the rear of the
complex. The early ones were wooden buildings. They
were raised off the ground on stilts to prevent damp,
with overhangs to prevent the entry of vermin. There
are no windows, both for security and because no
windows are required. This immediately distinguishes
them from other Japanese buildings. In the earliest
examples, they are typically constructed using logs laid
horizontally in such way that in summer small gaps
for ventilation open up as the timber dries and shrinks
across the grain. In winter, as the timber gets damper,
it expands and seals the building against the elements.
Heavy projecting roofs throw the rain clear, while stout
doors and heavy locks prevent unauthorized entry. The
buildings are typically set apart to reduce the risk of
fire from neighbouring buildings.[12]

The sutra store at Tōshōdai-ji in Nara is one of the
oldest surviving examples of this building type. Here
it is attached to a temple and used to store Buddhist
sutras and other precious objects. It was built in AD
800 and has remained intact and largely unchanged
since its construction.[13] Larger examples were built for
the imperial palaces. A feature of all these buildings
is that they are inaccessible. Only one person was
allowed to enter them, and they were fitted with locks
incorporating seals to reveal unauthorized access.
The very grandest were the imperial storehouses
and these contained the largest collections of books.

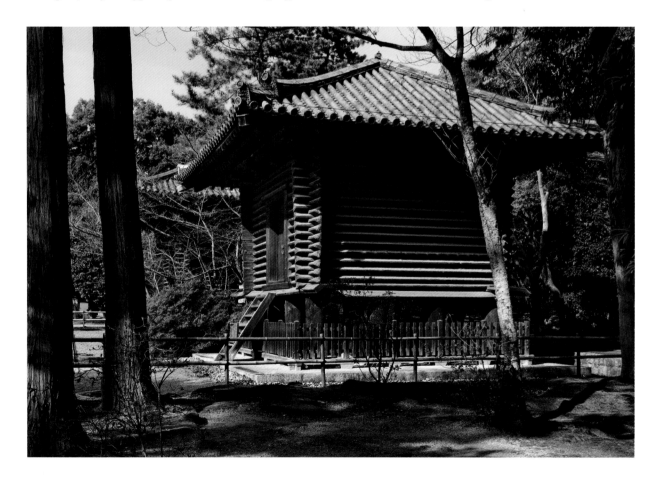

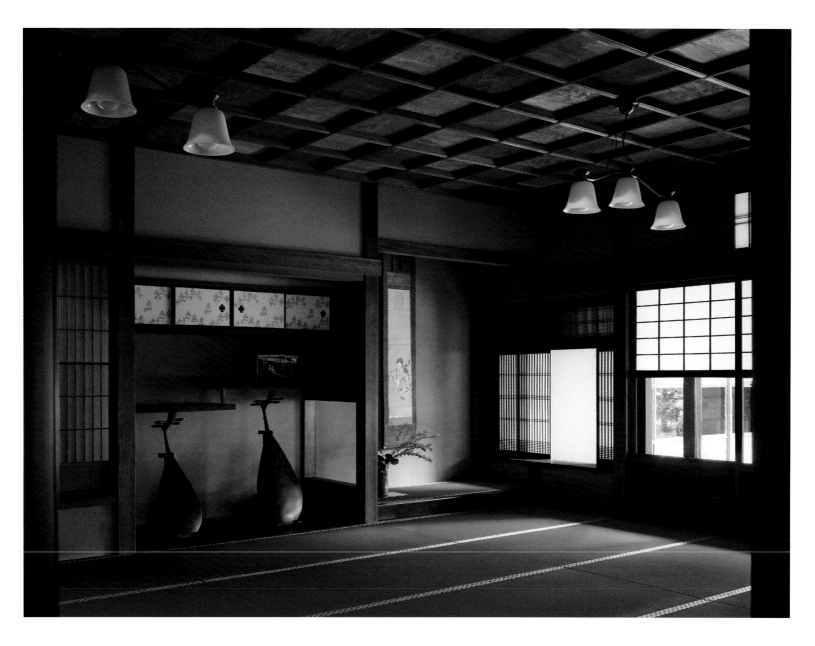

The *Bunko*, or storehouse, is complemented by the *Shoin*, the study room. This term is used to denote a type of formal reception room familiar in Japanese dwellings. The *Shoin* first appeared in temples and the houses of rich individuals. The rooms were floored with *tatami* mats, the dimensions of which determined the size of the rooms. The main space is surrounded by smaller rooms and corridors, which can be reconfigured using sliding doors (*fusuma*) or paper screens (*shōji*). The focus of the space is the study niche, which is designed to highlight the sophistication and learning of the owner. Its elements were fixed by tradition. The niche is the *tokonoma*. It developed in the Muromachi period and continues to be a key feature of traditional Japanese interiors. The niche is traditionally used to display a hanging scroll and a bowl of flowers or sculpture. On one side it is bordered by a post, the *tokobashira*, which can be ornate or rustic. Beside the niche and on the other side of the *tokobashira* is a second niche, which contains the staggered shelves (*oshi-ita*). The other

side of the *tokonoma* forms a desk alcove (*tsukeshoin*). The desk alcove is shown in scrolls from the 13th and 14th centuries AD. The desk itself is formed from the window sill of a bay window that projects into the wooden veranda that overlooks the garden. This was the ideal place to write, sheltered from the wind and the rain but with plenty of light from the window. The scholar sat cross-legged before the desk. Books and scrolls were placed readily at hand in the *tokonoma*. The materials for writing (pitcher, brush tray, water jar, knife, seal case and scrolls) were all neatly arranged according to custom on the desk, and in time became formal elements of display.[14] These features are beautifully illustrated by the desk and niche in the Reizei House in Kyoto.

The storehouse developed from a wooden structure to one that was increasingly fireproofed. The 17th-century examples, such as the one at the Reizei House, were completely covered in a thick layer of plaster. Even the door was covered in plaster. The doors were sealed with more plaster in the event of

left and far left
BUNKO, REIZEI HOUSE,
17th century (rebuilt 1789)
Kyoto, Japan

*A window (far left) and end
elevation (left) of the bunko,
or book store. The windows
are made of metal, for security,
and are covered by their own
roofs to protect them from
rain. The timber structure is
clad in a thick layer of white
plaster to protect it from fire.
The roof is also a double
structure, consisting of a
thick fireproof layer of plaster
protected from rain by a clay-
tile roof. The door is timber
and only the master of the
house is allowed access. A
second, plaster-covered door
swings shut over the first
in the event of a fire in the
neighbouring house to seal
the building and prevent
the spread of flames.*

a fire. Completely encased and lifted off the ground
to protect them from damp, these extraordinary
storehouses were designed to keep their precious
contents in perfect condition. To this day, only the
most senior member of the family has the privilege
of entering the storehouse of the Reizei House.

Sutra repositories

Buddhism entered China from India around AD 217 and
sutras appear to have circulated from this period. It
was common for monasteries to include some form of
library to store them. In Japan, temple collections
were significant and by the end of the Heian period
(AD 794–1185) a sutra repository had become an
indispensable part of Buddhist monastic complexes.[15]
There were two ways of storing sutras. The first was
in a simple store building like that which survives at
Tōshōdai-ji, dating from the 8th century AD. The
second was the revolving sutra case, a form that
originated in China and is particularly interesting
because it has no Western equivalent. Revolving sutra
libraries appear to have been invented in China during
the Northern and Southern dynasties (AD 420–589)
and remained popular until the 20th century.

According to an ancient Japanese source,
revolving sutra stores were invented by a celebrated
Chinese layman, Fu Hsi (AD 497–569), Fu Kiu in
Japanese. Fu is said to have thought that if any pious

person touched such a bookcase containing the whole
Tripitaka and made it revolve just once he would
gain the same merit as if he had read the complete
text. The same source records that it was customary
to place a statute of Fu Kiu flanked by his two sons in
front of the revolving sutra repository.[16] The revolving
cases first appear in Japan in the 11th century AD.

The system of revolving sutra stores is described
in detail in the *Yingzao Fashi*, the oldest surviving
Chinese building manual, printed in AD 1103. Its
eleventh chapter details the size of the elements, and
chapter thirty-two provides illustrations showing
their detailed decoration and construction. It sets out
standard dimensions of 20 *chi* (6.4 m or 21 ft) in height
and 16 *chi* (5.1 m or 16 ft 9 in) in diameter. The whole
structure is in the form of a building within a building,
complete with a roof and decorative bracket sets. The
structure is cantilevered from a huge axle post, the
bottom of which is rounded and covered in a metal
shoe to act as a pivot.[17]

A good example can be found in the temple
complex of Mii-dera in Japan. The library sits in a
modest freestanding building, among the trees at
the top of a steep, stepped path. The inside is almost
entirely filled by a huge octagonal structure mounted
on a pivot so that it can revolve. Sadly, the pivot is no
longer operational and the bottom of the structure
is encased in a platform to protect it, but originally

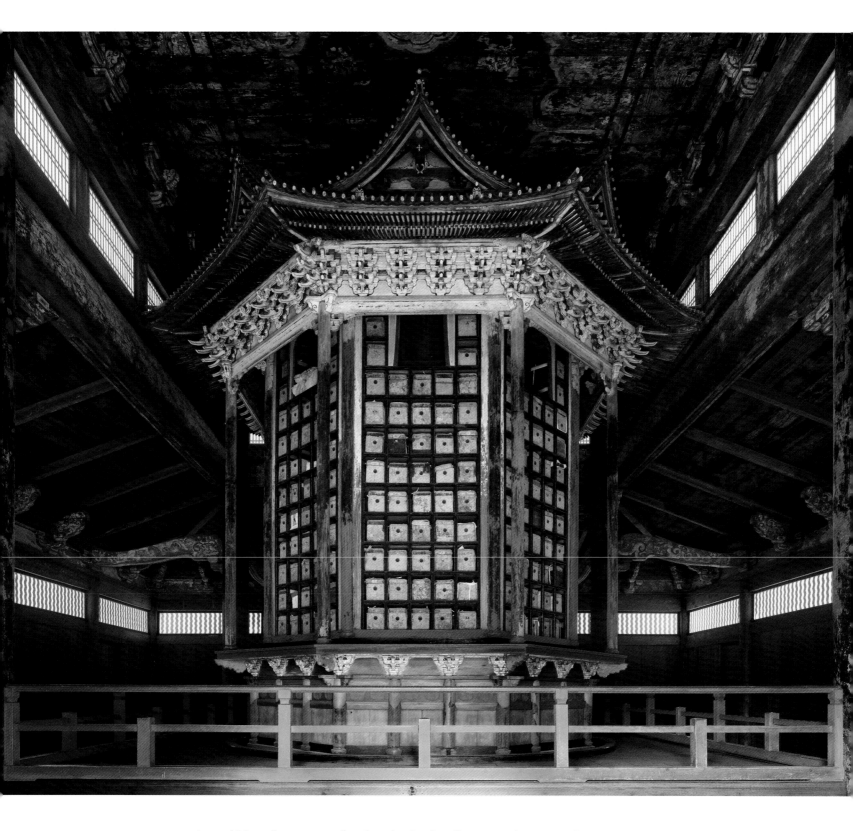

above
SUTRA HALL, MII-DERA TEMPLE, 15th century
Ōtsu, Japan

This octagonal sutra case was moved here in AD 1602. It is now fixed, but originally the faithful could turn the whole structure on its pivot. Each complete turn was thought to be equivalent to reading the whole Buddhist canon once. This type of revolving sutra case originated in China.

it would have been exposed and projecting handles would have enabled the visitor to push the whole structure so that it turned on the pivot. The upper part of the structure is divided into neat pigeonholes, each containing a lead box filled with a portion of the Buddhist sutra. The whole is one of the finest preserved revolving sutra cases in the world. They are a strange form of library. The rationale behind them was far from scholarly: the books inside them were not meant to be read. The sutras were preserved and venerated as sacred artefacts. Indeed, the form of

the case makes accessing the texts both difficult and dangerous. However, it would be wrong to assume that sutra cases represent the typical Southeast Asian form of library. As we have seen, Chinese, Japanese and Korean libraries came in many forms.

Size of collections in Southeast Asia

The use of printing and paper no doubt increased the size of libraries in Southeast Asia. In Japan in the Heian period (AD 794–1185), the powerful leader of the Fujiwara clan, Fujiwara no Michinaga (966–1028), had

left and opposite
**SUTRA HALL, MII-DERA
TEMPLE, 15th century.**
Ōtsu, Japan

*The pavilion sits in an idyllic
situation, close to, but set
apart from, the main hall.
It is approached from the
main part of the monastery
by crossing a bridge over
a pond and ascending a
staircase. The roof of the
sutra case (opposite) mimics
a building, complete with
miniature roof brackets.*

shelves built for his collection of 2,000 volumes, while
the celebrated scholar Ōe no Masafusa (1041–1111)
is said to have owned 10,000 volumes, housed in a
specially built storehouse, the Goke Bunko, which
burnt down in 1153. The 12th-century poet Fujiwara
no Sanesada is also said to have collected over 10,000
volumes, which were burnt in the great fire of Kyoto
of 1177.[18]

Chinese collections were usually measured in *juan*,
which in the Song period (AD 960–1279), when bound
codices were used, meant 'chapters', but in earlier
periods probably refers to scrolls.[19] At the start of the
Song dynasty the imperial library held 13,000 *juan*.
Fires and invasions destroyed successive collections,
which were then rebuilt.[20] At its peak, in 1177, the
imperial collection reached 72,567 *juan*. In the Ming
dynasty (AD 1368–1644), collections grew further, so that
in 1420 the imperial collection contained an estimated
20,000 titles and some 100,000 volumes. Sizeable private
collections often had 10,000 *juan*, with the largest
having as many as 40,000.[21] It is obviously difficult to
convert these figures to their modern book equivalents,
but it is clear that the collections were big, and needed
a building or large room in which to store them. The
other cultures that had very large collections in this
period are those of the Islamic world.

Islamic libraries

Although there were books in Arabic before
Muhammad (AD 570–632), it was the birth of Islam
that was responsible for spreading the Arabic script
all over the world. Muhammad was proud of his
illiteracy, which proved that the Qur'an had been
dictated by God, but the copying out of the Qur'an and
its circulation was a key part of Islamic teaching and
very soon Islamic scholars were gathering together
and translating the learned writings of the peoples
they conquered. Twenty years after the death of the
Prophet, Syria, Iraq and Persia had been conquered. By
670 the Islamic world extended over north Africa and
Egypt and in the first half of the 8th century it included
Spain and ranged from China in the east to the Atlantic
in the west.[22]

The Qur'an has always been learned by heart. Oral
transmission was more important than the written,
so that if every physical copy of the Qur'an should be
destroyed the book would still be preserved. Reading
in the Arab world was always reading aloud and
even today mosques and madrassas hum with the
murmurings of reading and recitation.[23]

Although early Islamic manuscripts are in the
form of papyrus scrolls, in Islamic tradition the book
generally meant the codex rather than the scroll.[24]

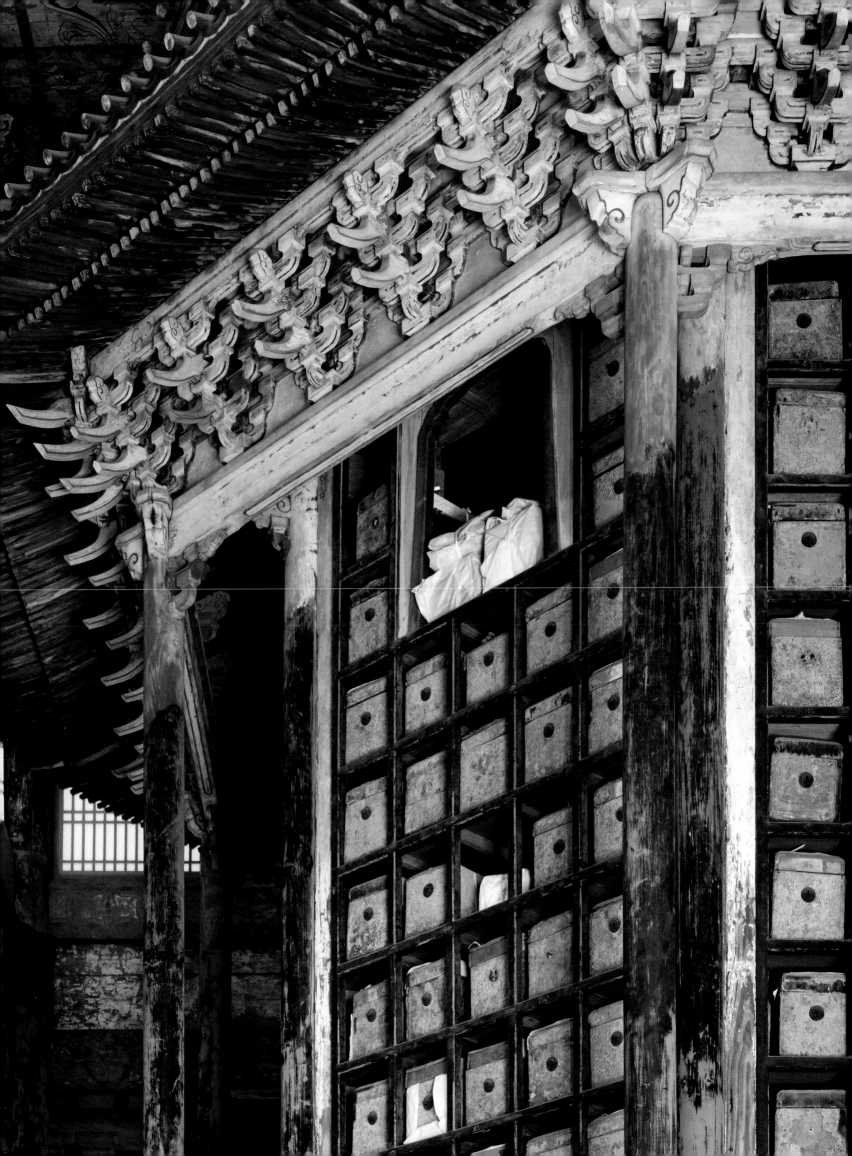

It was written on parchment at first. At the beginning of the 8th century (706–40) the Arabs conquered Transoxania (an area incorporating modern-day Uzbekistan) and other areas bordering China. It was here that they first encountered paper and indeed for the first 150 years all paper was imported from here and termed 'Samarkand paper'.[25] By 985 it was being produced in Damascus. Books were written by hand in ink on paper and then bound between wooden boards covered in leather.[26]

The three greatest libraries of the medieval Islamic world were the library of the Umayyad in Cordoba, the library of the Abbasids in Baghdad and the library of the Fatimids in Cairo. Medieval Arabic Spain boasted over seventy libraries, but the one at Cordoba founded by Caliph al-Hakam II (d. 976) is said to have contained 400,000–600,000 volumes.[27] Baghdad had thirty-six libraries, but the most famous was the House of Wisdom, founded by Caliph al-Ma'mun (813–833), which combined library, school and research centre into one institution. A forerunner of the modern university, it was said to contain 1.5 million books.[28] The library at Cairo established by the Caliph al-'Aziz (r. 975–996) in 988 is said to have had 100,000 volumes, including 2,400 Qur'ans alone.[29] These figures are unbelievable on many grounds and no doubt grossly exaggerated.

They certainly bear no relation to other collections of the time, but they do at least suggest rich libraries of some size.

We have only tantalizing glimpses of the architecture of Islamic libraries. We know for instance that in Shiraz around 990 the library was an immense hall, three sides of which opened onto a series of rooms, which were lined with wooden pigeonholes, each three spans high and closed with wooden doors.[30] Another description of a library in Cairo describes the shelves as being divided into compartments, each of which had a list of its contents on the front and could be locked with a key. Inside, the books, which had their titles on the top and bottom of each volume, were piled into small pyramids.[31] Some semblance of what an Islamic library might have looked like can be found in a manuscript illumination in the *Maqamat al-Hariri*, an Islamic manuscript in the Bibliothèque Nationale in Paris. It shows the examination of a student by an imam in the public library of Hulwan, Baghdad, with a motto in Arabic: 'During an examination, a person is either honoured or disgraced.' In the background, the shelves stacked with books can clearly be seen.[32]

The little that can be gained from these sources is that Islamic libraries were large and that they appear to have been housed in dramatic spaces. The books seem to have been placed in niches, which were decorated and sometimes locked behind doors. The books were stacked on their sides, in pyramids, the smallest at the top. That is about all we know, for every one of these remarkable libraries has vanished. Some were ransacked by the Mongol hordes, others by the Christian crusaders, but many were simply destroyed by orthodox Muslims who believed that the only book that Islam required was the Qur'an.[33] By the end of the 12th century all the great collections had been scattered. Little or nothing of their contents survives today. The subsequent centuries saw the development of madrassas, some of which had quite considerable collections of books, but each was heavily dependent on charitable donations for maintenance and all at one period or another fell on hard times and lost their collections, so that no medieval collections have remained intact until the present day.[34] Despite the Islamic world boasting the

right
**BIBLIOTECA
MALATESTIANA, 1452**
Cesena, Italy

*This view shows the stone
entrance portal to the library.
The room is normally sealed
behind timber doors, secured
by stout iron locks, which
are opened only when readers
require access. The elephant
is a symbol of the Malatesta
dynasty, whose motto is 'The
Indian elephant does not fear
mosquitoes', meaning that
the family was not afraid
of its enemies.*

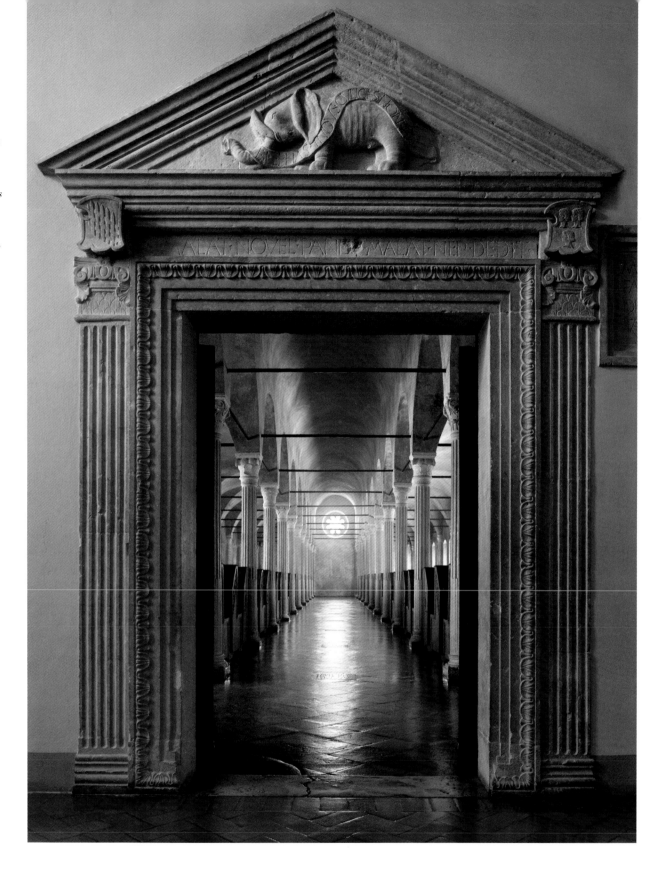

greatest book collections of the Middle Ages, no great
Islamic library buildings from this period survive.

The medieval library in the West

The oldest library space in the Western world to
retain its original fittings and collection is in the small
university town of Cesena, near Rimini, Italy. Today
the library is approached up a modern staircase
down a long corridor, turning into a small vestibule.
To the left is the entrance to the Biblioteca Piana, the
library of Pope Pius VII (Chiaramonti) (1742–1823),
a fine collection housed in a room of no particular
architectural interest. To the right is a grand, if
somewhat squat, stone portal, which marks the
entrance to the Malatestiana or Malatesta Library.
It takes its name from the local tyrant, Malatesta
Novello, who paid for it and oversaw its completion.
It was built between 1447 and 1452 and was designed
by the otherwise relatively unknown architect Matteo
Nuti. Although it is located in a Franciscan monastery,

only nine years after its completion Malatesta gave the commune of Cesena an interest in its running and it is this strange arrangement that accounts for the library's survival today.[35]

The walls of the library are green, bathing the room in green light, and the floor is red. Green and red were the colours of the coat of arms of the Malatesta family. The long, uninterrupted central aisle is covered in a barrel vault that directs the viewer to the far blank wall, while the two aisles on either side are divided into bays by cross-vaults. The eye largely ignores these features because it is immediately drawn to the furniture in the room: two rows of *banchi*, as they are referred to in Italian manuscripts.[36] These look like – and are arranged like – pews in a church. The seat of the one in front forms the support for the sloping

reading desk of the one behind. Just visible below each sloping desk there is a single shelf on which the books sit. The position of each book is fixed, as they are chained to the desk. If a reader wants to read a book he is directed to the desk where it is located and must sit there. The reader is brought to the book rather than the book being brought to the reader. The library has fifty-eight desks, twenty-nine on each side. Built between 1447 and 1452, it has remained almost entirely unaltered for over 560 years.[37] That date is important: the oldest surviving 'medieval' library was built not in the Middle Ages at all, but in what we would normally call the Renaissance. What, then, did medieval libraries look like?

The myth of the medieval library

The history of the medieval library as a room really only begins at the end of the 13th century. This is surprisingly late, towards the end of the period we call the Middle Ages. The truth is, we have a romantic vision of the medieval library that is almost entirely at odds with reality. Our view has largely been created by imaginative literature and by misinterpreting later libraries inserted into medieval complexes.

One of the finest fictional portrayals of a medieval library can be found in Umberto Eco's *The Name of the Rose* (1980). Eco is an expert on the Middle Ages and sets his story deliberately in a particular period: the year 1327.[38] The book is carefully crafted to provide an image of our current understanding of how people lived and thought in the period, without being inaccessible to a modern audience. The library and its associated scriptorium are central to the plot, which revolves around a series of grisly murders. The library is on the top floors of a tower (called the *aedificium*, which is simply the word for 'building' in Latin). It is entered by a stair from the scriptorium, which is on the first floor above the kitchen and to which our heroes gain access out of hours by a secret passage in the ossarium in the crypt of the church, itself accessed by a secret door in the church.

Nobody except the librarian and his assistant is allowed to enter the library in *The Name of the Rose*. Only the librarians know its contents and layout, until the leading character, in search of clues to the murder, finally gains access to it. They discover that

left and opposite
**BIBLIOTECA
MALATESTIANA, 1452**
Cesena, Italy

*The library is furnished with
banchi (opposite), a type of
desk that appears to have been
common in medieval libraries
in Italy. All face in the same
direction and are set back from
the walls, allowing access from
either end of the desk, no doubt
to avoid disturbing other
readers. The front desks (left)
are identical to all the others.
They are set away from the
front wall, which is adorned
only by a high window.
The desks themselves have a
sloping top above a single shelf
on which the books are stored.
The books are chained to an
iron rod, which runs along the
front edge of the sloping desk.
The chains are attached to
clasps fixed to the bottom edge
of the book. The Biblioteca
Malatestiana is unusual in
retaining its original collection
in situ, providing the clearest
idea of what a late-medieval
Italian library looked like.*

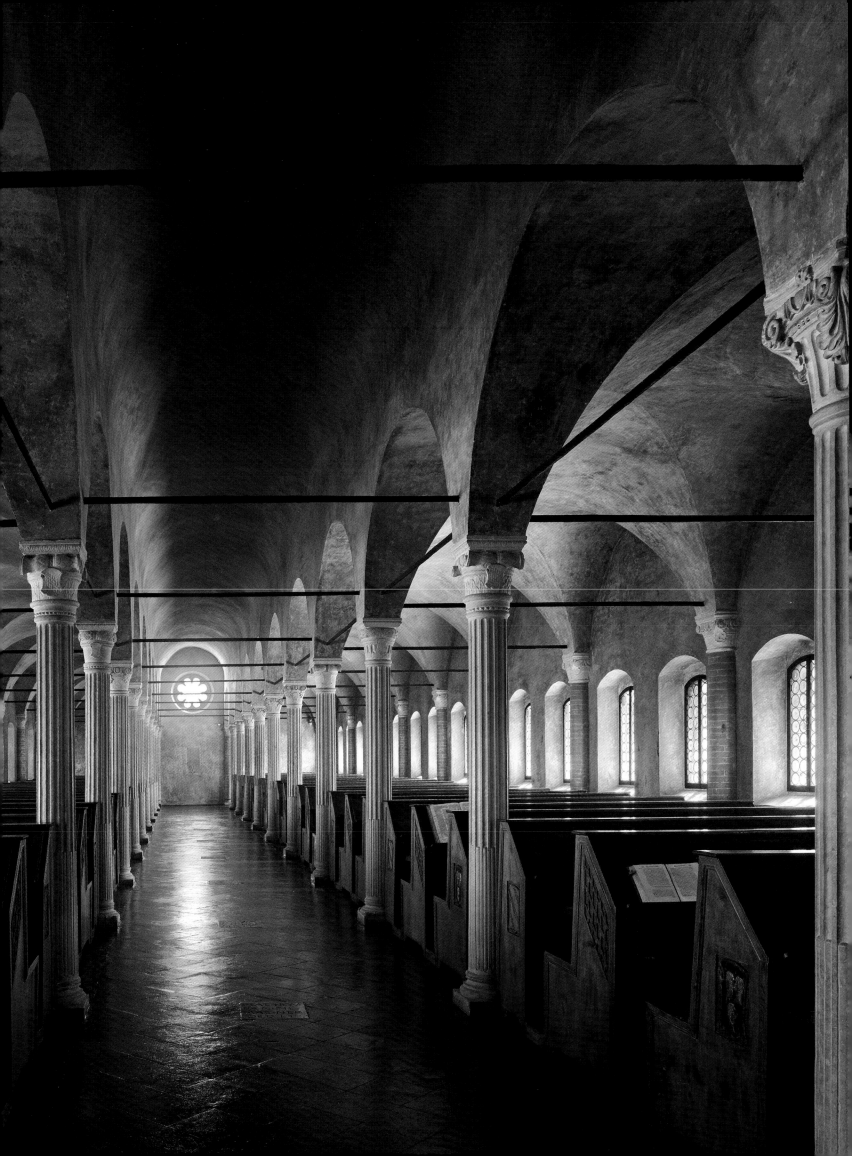

This is the oldest surviving plan of a medieval monastery. Scholars argue over whether it depicts a real or imaginary monastic complex, but it is undoubtedly a statement of what an ideal monastery should contain. A library (outlined in red on this illustration) is shown next to the choir. An inscription states that it sits over a scriptorium. Both the existence of separate rooms for these functions and their position are unusual, and there is no known surviving example of this arrangement.

the library is in the form of a labyrinth of rooms, each lined from floor to ceiling with books. They wander around getting lost until they eventually work out that the library consists of fifty-six rooms of varying shapes and configurations arranged around a central light well. Eco does not reveal the number of books the library contains but one researcher has calculated that it would hold 85,000 volumes.[39] It is a literary treasure house, in which the hero discovers all sorts of books that were thought lost, and the key to the mystery resides in one of these texts, a copy of one of Aristotle's works that we no longer have. Eco's wonderful description strikes a chord with any lover of books. His layout is very loosely based on the library in the famous St Gall plan, but it has little else to do with any medieval library ever built.

The St Gall plan

The St Gall plan, drawn in AD 820–30, is the oldest plan of a monastery in existence. It is preserved in the library of the Abbey of St Gall, in St Gallen, Switzerland. Historians have discussed at length whether it represents a real monastery, but the general consensus is that it is actually a plan of the ideal monastery. The monasteries of the Carolingian era were substantial, but as far as is known none was quite as elaborate or as huge as this. The library is shown on the plan as a square building at the north-east corner of the church. The annotations say clearly that it is a two-storey building, with the scriptorium on the ground floor and the library above. One writer has suggested that the rectangle on the right represents a staircase to the crypt and the square in the middle a light-well.[40] It is this reconstruction that probably inspired the strange location and form of Eco's library in *The Name of the Rose*. But the library shown is much smaller than Eco's fictional one. In fact, there is no evidence of either of the two elements in the St Gall plan, the scriptorium or the library, existing in early medieval monasteries. The reason was simple: medieval monasteries did not have very many books.

The size of medieval collections

In *The Name of the Rose*, Eco's imaginary library may have contained 85,000 books. The largest Chinese collections in the same period were 100,000 scrolls

and the largest Islamic collections were said to have numbered over 700,000 volumes.[41] By contrast, in the 12th century the largest known monastic collections contained fewer than 1,000 books, only a very few had as many as 500 and most probably had fewer than 100.[42] One hundred and fifty years later, in 1338, the Sorbonne boasted the richest collection in Europe, with 338 books for consultation and 1,728 books in its register, of which 300 were marked as lost.[43] The size of these collections reveals why there were no great library rooms before 1500: before that date the collections were simply too small.

There are many reasons why medieval Christian collections were so small but one of the most important was that books were so expensive to produce. Too much has been written on how Western monasticism was responsible for saving classical scholarship from loss. Sadly, Western monasticism and the form of the medieval book made it very difficult to preserve all

but a small fragment of ancient literature. The chief problem was the writing material: parchment.

Parchment

According to tradition, parchment was said to have been invented in Pergamon. The Latin word for parchment is *pergamena*. It is said that Egypt deprived Pergamon of papyrus to prevent it rivalling the library of Alexandria, forcing it to look for alternatives. Pergamon may have been the first library in antiquity to have a sizeable parchment collection, but it certainly did not invent the material.[44] Parchment is animal skin. To be precise, it is sheepskin or goatskin, whereas vellum is calfskin. Both had been used for centuries before the establishment of the great library at Pergamon. Perhaps Pergamon was responsible for a particular refinement in its production. Whatever the case, parchment was more suited to making codices and this was one of the reasons that it replaced papyrus as the writing material of choice in Europe in the early Middle Ages.

Parchment is made by stretching the skin on a frame and scraping it to remove all flesh and hair. It is then treated with alum and chalk, which whitens and sterilises it, before it is rubbed down to produce a thin, even, flat surface suitable for writing. Each animal skin becomes the equivalent of one sheet of paper. Thicker than Chinese paper, it is completely opaque and will take writing on both sides. Folded in half, one sheet of parchment made four pages of a book. This is the key to the expense. A bible consisting of 1,000 pages required 250 skins: that is, 250 sheep. The cost of the skins alone was considerable. Add to this the cost of turning the skins into parchment, and the time and effort required to bind up the sheets into quires, draw lines painstakingly on every sheet, copy every word of the text by hand, and finally bind them together into a complete volume, and one can see why each medieval codex took months if not years to complete.[45] Books were as a result extremely expensive and bindings were often appropriately lavish.[46]

Book chests, book niches and *armaria*

As the typical medieval monastic book collection consisted of somewhere between 50 and 500 codices it did not take up a great deal of space. Most collections

LATE-MEDIEVAL
BOOK CHEST
Merton College, Oxford,
United Kingdom

*This chest shows the
characteristics of a medieval
book chest. Stout locks protect
the contents from casual
thieves. The chest is raised from
the ground on wooden feet,
protecting the contents from
damp. Such chests were often
fitted with iron hoops to enable
poles to be inserted, allowing
the chest to be lifted by four
people, one at each corner.*

were locked in book chests similar to linen chests
we still use today. A fine example survives at Merton
College, Oxford. It shows all the characteristics that
one would expect: it is stoutly constructed; it has legs
to keep it clear of the damp floor and it is equipped
with a pair of stout locks. Inside, the precious books
were wrapped in blankets to protect them when they
were moved. The chest even came with iron hoops
for poles, allowing it to be carried by four men, one
at each corner. Many inventories refer to such chests,
which were a common way of storing books well into
the 16th century.[47] The chest did not require a special
room, although in the houses of the wealthy it might
be in a treasury or muniments room, with a table
nearby for consulting the books. Such muniments
rooms still survive in some of the older Oxford and
Cambridge colleges – Merton has a particularly
fine example.

Books in monastic collections were spread across
the monastery. Books for worship were stored in the
abbey church, in the choir or adjacent to it. Other
books were stored for reading in the refectory.
These were the essential works. Any other books
the monastery might own were generally held in or
near the cloister.[48] The rule drawn up by St Benedict
in the 6th century was the template on which all
subsequent Christian monastic rules were based.
It required the monks to read for several hours each
day and for books to be provided for them from a
library. There was no particular requirement for a
monk to write, only to read. With such an emphasis
on the importance of study, it might be supposed
that the library would occupy a prominent place
in medieval monasteries.

Scriptoria developed in monasteries to produce
the books for the monks to read. Their existence is
mentioned in many medieval texts. However, the term
'scriptorium' is ambiguous: it could refer to a group
of monks carrying out the activity rather than to a
physical space. Despite a separate scriptorium being
shown on the St Gall plan, buildings constructed
solely to act as scriptoria appear to have been rare in
monasteries.[49] The scriptorium, like the library, was
usually a space temporarily adapted for the purpose,
rather than one built specifically for it. The activities
of both reading and writing in the early Middle Ages

often seem to have been carried out in the cloister.
We have a number of references in contemporary
sources to the problems this posed for the monks
who had to work in the damp and the cold.[50] Some
idea of the physical arrangements that might have
existed can be found in the records of Durham
Cathedral and the surviving cloisters in Gloucester
Cathedral (in the Middle Ages both cathedrals were
Benedictine monastic foundations). The cloisters
at Durham were used as a library until as late as
the 1530s. A contemporary description survives:

> the north side of the Cloister…was all finely
> glased…and in every window 3 pews or
> Carrells, where every one of the old Monks
> had his carrel…that when they had dyned,
> they dyd resorte to that place of Cloister, and
> there studied upon there books, everyone in
> his carrel, all the after none [afternoon]…All
> there pews or carrels was all finely wainscoted
> and verie close, all but the forepart, which
> had carved wourke that gave light in at ther
> carrel doures of wainscot. And in every carrel
> was a deske to lye there bookes on. And
> the carrels was not greater then from one
> stanchell of the wyndowe to another. And over
> against the carrels against the church wall did
> stand certain great almeries [cupboards] of
> waynscott all full of bookes…[51]

A similar arrangement was used at Gloucester, but
there the monks created a more permanent solution
by building stone niches into the side of the cloister
with glazed windows. It is likely that these were
originally further enclosed by wooden walls and
a door or hangings so that each niche would have
become a single-person study carrel. These spaces
acted as both library and scriptorium. The monks
working in these carrels got books from *armaria* at
the back of the cloister. Sometimes these wooden book
cupboards were physically built into niches in the
stone walls. The wooden elements have long since
disappeared, but the niches remain.

Armaria in the cloister must have been a highly
unsatisfactory arrangement. They would have
cluttered up the space. At Gloucester and Durham

one whole side of the cloister was rendered unusable
for any other purpose. At Gloucester it was closed
off with wooden partitions at each end to become a
separate library room.[52] The side running along the
church was usually chosen for the library, both so that
processions could continue around the other three
sides and because this was the only side likely to be
uninterrupted by doors to other rooms. As collections
expanded, a better solution was clearly required.

The first was to create a book room off the cloister
at ground level so that, although reading might
continue in the cloister, the book cupboards were no
longer required. The earliest book rooms of this type
date from the 9th century.[53] From contemporary
descriptions and surviving remains we know what
these were like. They were not large rooms, usually
about 3 m square (10 x 10 ft) and about 3 to 4.5 m high
(10–15 ft). They were lined on all sides with shelving or
with cupboards.[54] Like Eco's fictional library, the book
room was accessible only to the librarian, and only he
knew where to find a particular book on a shelf.
Luckily for us, some librarians made inventories or
catalogues of their collections to help them remember
where the books were. They give us some idea of the
arrangement. The books in the book rooms were
organized by subject, with bibles usually forming the
core of the collection, and were stacked on their sides
on the shelves, bottom edge outwards This was not
particularly through choice, but simply because the
books had heavy clasps and ornate bindings, which
made it impractical to place them vertically. They were
located either by memory or by tabs of parchment
inserted into them, or by a word written
on the edge of the pages.[55]

The monastic book room was not a library in
the modern sense: it had no windows and was small
and cramped, with no facilities for looking at the
books – indeed, its lack of light must have made it very
difficult to locate anything. Architecturally it had all the
character and spatial qualities of a stationery cupboard.
It was, however, perfectly adequate for the purpose.
Monks could read the books in the adjacent cloister,
or in later monasteries take them back to their cells.
With only a few hundred books there was no reading
room as such. In rural monasteries, books were of
secondary importance: as the St Gall plan shows,

most of the buildings had agricultural uses. The major
developments in library architecture are generally
associated with monasteries in urban centres.

New orders and universities

Monastic collections in rural monasteries were
small and they were unlikely to be consulted by
anyone outside the monastery itself. The foundation
of universities in Europe created the need for a new
type of collection, one that was accessible to a wider
reading public: those studying in the universities.
The early universities were deliberately loose
confederations of teachers and had few, if any,
buildings. They generally relied on being able to
borrow spaces from urban religious organizations.
This strategy was useful because it meant that in
quarrels with the host city the institution could always
threaten to move, and indeed there are a number
of instances when this happened. The founding of
Cambridge by teachers fleeing from Oxford is an
obvious example. For religious foundations, the
provision of facilities for universities enabled them
to further their own aims. Studies of the relationship
between universities and the Dominican and
Franciscan orders in Italy make these relationships
particularly clear.[56]

The rules of St Dominic (d. 1221), St Francis (d. 1226)
and the lesser mendicant orders were specifically
dedicated to teaching and preaching. Their aims
differed. For Franciscans, libraries were a tool to train
friars to be able to preach outside the monastery,

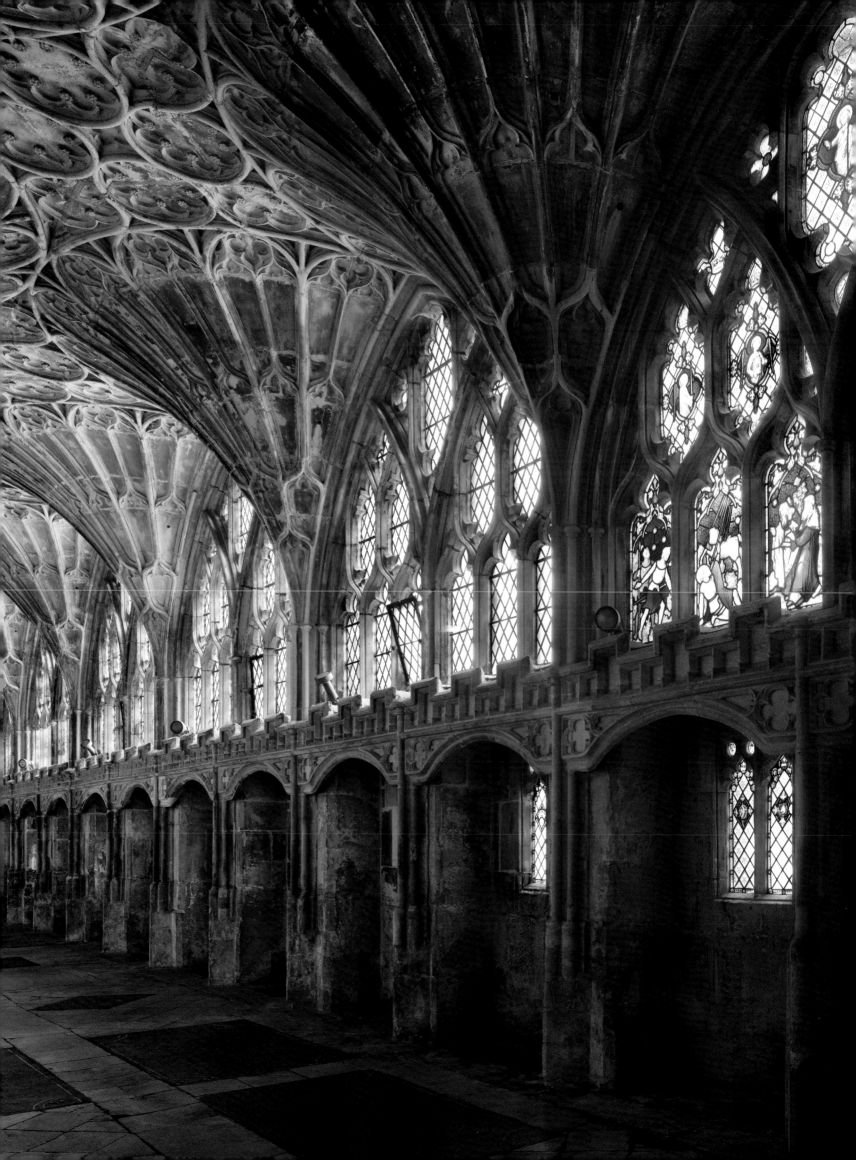

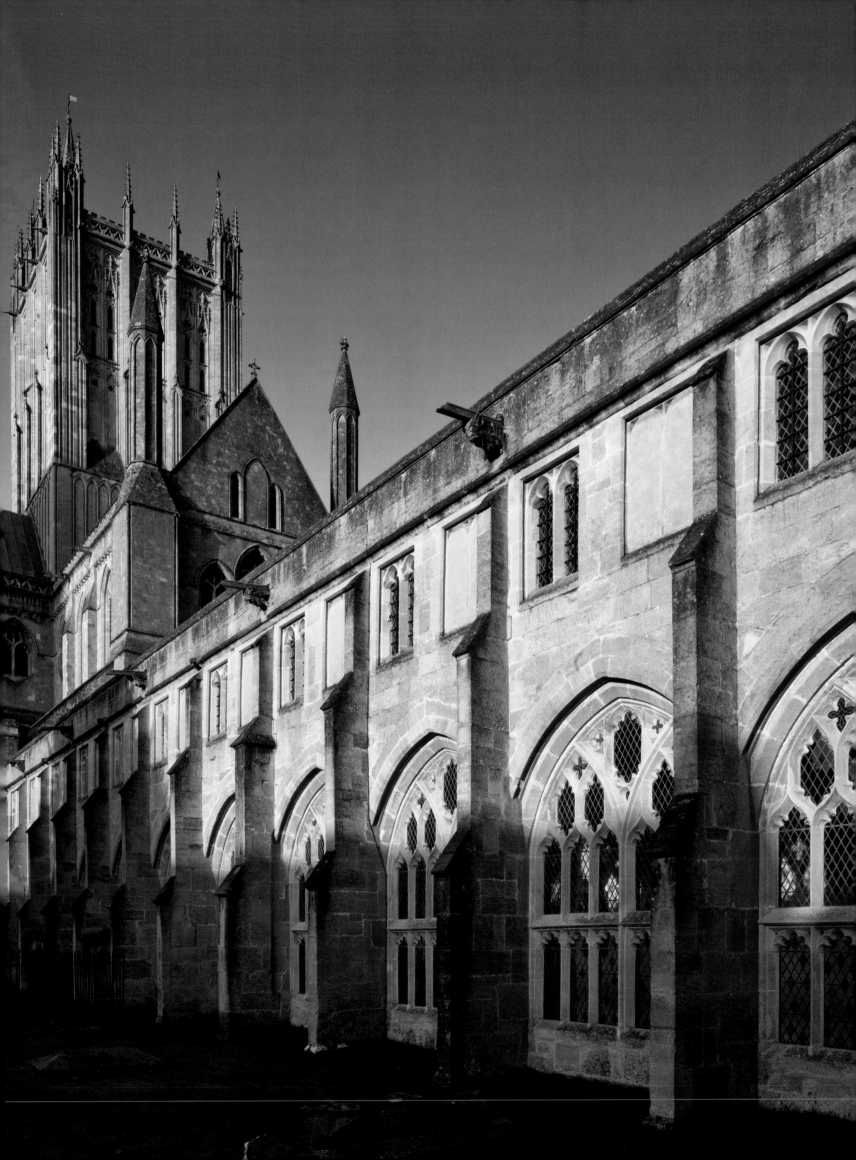

while for the Dominicans the library was a key part
of their arsenal in their battle against heresy. These
monasteries became schools. The universities trained
the teachers. It was no accident that the headquarters
of the Dominican order was in Bologna, Italy, the
home of the oldest university in Europe.

Around 1270 the Dominican Humbertus de
Romanis wrote on the necessity of providing a quiet,
well-lit space within monasteries where the monks
could consult the best books, chained to desks to
prevent theft. Presumably Humbertus was promoting
an existing building type or at least one that he had
seen. The library of the Sorbonne was established
in 1289. Other early library rooms are S. Francesco
in Pisa (1355), S. Domenico in Bologna (1381),
S. Francesco in Assisi (1381), S. Maria del Carmine
in Florence (1391), S. Antonio in Padua (1396) and
S. Marcello in Rome (1406).[57] Another is the library
at Wells Cathedral in England (1428), although its
furnishings were altered in the 17th century and will
be discussed later in the book. Like all library rooms in
the 1300 and 1400s, it is on the first floor.[58] In the Middle
Ages ground floors were normally paved with stone
or tiles placed directly onto the earth. As a result, they
were always damp. Many early books were given metal
studs specifically so that they could be placed on the
stone floor without getting wet. Rising damp also made
the walls moist. Damp and mould growth must have
been problems in all cloister spaces and book rooms.
Only the first floor could be made reliably dry. The
first-floor position was also more secure, as windows
were out of reach and books could not easily be passed
through bars to accomplices waiting outside.

For convenience, the new library rooms were
often placed over the cloister. The association
with the cloister and study was thus retained. The
reason was probably that in most cases this was the
only possible place left to build in the centre of the
monastery. Where money allowed, these buildings
were invariably stone, giving some protection against
fire. Early roofs were open, leaving the wooden
trusses exposed. Stone or brick vaulting (as at the
Malatestiana) was preferred, again to lessen the risk of
fire. Of course, not all institutions could initially afford
stone buildings, and timber ones sometimes had to
suffice. Most of these would have been replaced later,
but we have a rare (admittedly late) survival at Noyon
Cathedral in France, which gives us some idea of what
they might have looked like. Internally, the Noyon
library has been altered several times, although the
original plan can be reconstructed.[59]

Many medieval library rooms survive in northern
Europe. The earliest to retain its original fittings intact
is the delightful parish library of the church of St Peter
and St Walburga in Zutphen, the Netherlands. The
church had a small library in the 14th century on the
first floor next to the treasury, but in 1555 two church
wardens, Conrad Slindewater and Herman Berner,
decided to form a much larger collection, which would
be made available to the parish at large to help guard
against the increasing threat of Protestantism. The
current building was started in 1561 and took four
years to complete.[60] Its arrangement thus cannot be
taken as typical for libraries a century earlier or
more. Nevertheless, it represents an interesting
survival. The room is about 18.2 m long and 8 m wide

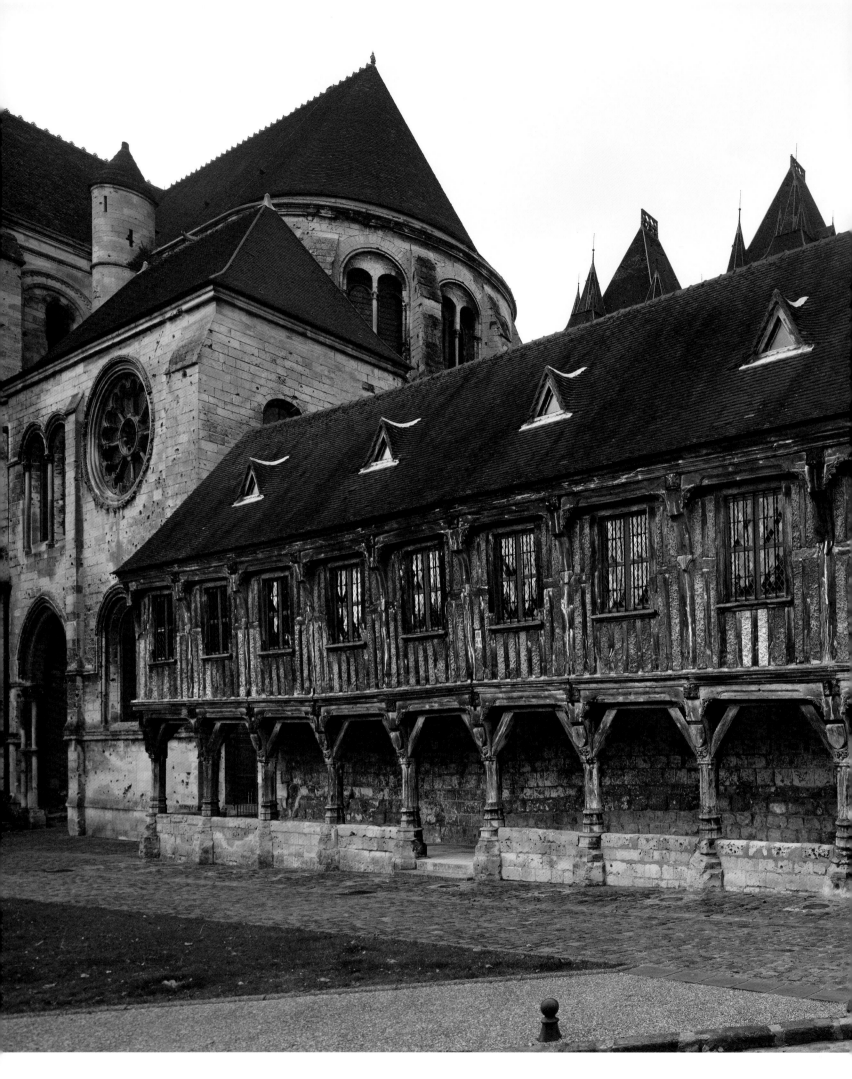

The library's east elevation gives a clear idea of what a medieval timber-framed library might have looked like. The original windows were replaced by taller, narrower ones in the late 17th century and the stone façade on the end is a later addition, but otherwise the building is largely unchanged.

(60 x 26 ft), but it is not rectangular. It was built on the ground floor alongside the church and its east end is cranked to follow the line of the east end of the church building. This irregular plan made arranging the furniture particularly difficult. The ground-floor arrangement avoids blocking the windows of the church, but is far from ideal. The building had seven windows and is vaulted in stone. However, the furniture is the most important element of the library. It consists of eighteen desks. These are not the *banco* type seen at the Biblioteca Malatestiana. Instead, they consist of double-sided lecterns, each 2.7 m (9 ft) long and about 1.7 m (5 ft 5½ in.) high from the floor to the top of the finial. The lecterns sit on sill beams to which narrow benches are also fitted, so that a reader can sit facing in either direction, but two readers cannot sit back to back. The lecterns are covered in books, for here, unlike at the Biblioteca Malatestiana, there is no shelf except the sloping surface of the lectern itself. Every book is chained to a rod running along the top of each the lecterns.[61]

This chapter has shown how few libraries remain from the period before 1500 and how little we know of them. Even the library in Zutphen is later, although it is, as far as we know, a good reflection of libraries from the period 1300–1550. Much of what we take for granted in library design appears to have been missing in this period. Rooms for reading were simple and furnished with lecterns. Where shelves existed at all, books lay flat upon them, not upright. For the most part, open shelves were entirely missing. There were no shelf-lined rooms. Books were stored in cupboards or chests and brought out for use. When they were left out at all, as in Zutphen, they were firmly fixed to the desk with chains. This was to remain the common form for the next hundred years. However, as books proliferated, the 16th century was also to see radical changes in library design and these are the subject of the next chapter.

**LIBRARY OF ST PETER
AND ST WALBURGA, 1555**
Zutphen, Netherlands

*This parish library is one of
the oldest lectern libraries in
the world and has remained
largely unchanged since its
construction, providing a
clear idea of what a medieval
lectern library in northern
Europe looked like. The books
are chained to the lectern by
means of a rod running along
the top, which is secured by
hasps and locks at one end.
Each book has its own place
on the lectern. Unlike Italian
examples, the lecterns have
two slopes and the readers face
each other, seated on narrow
benches.*

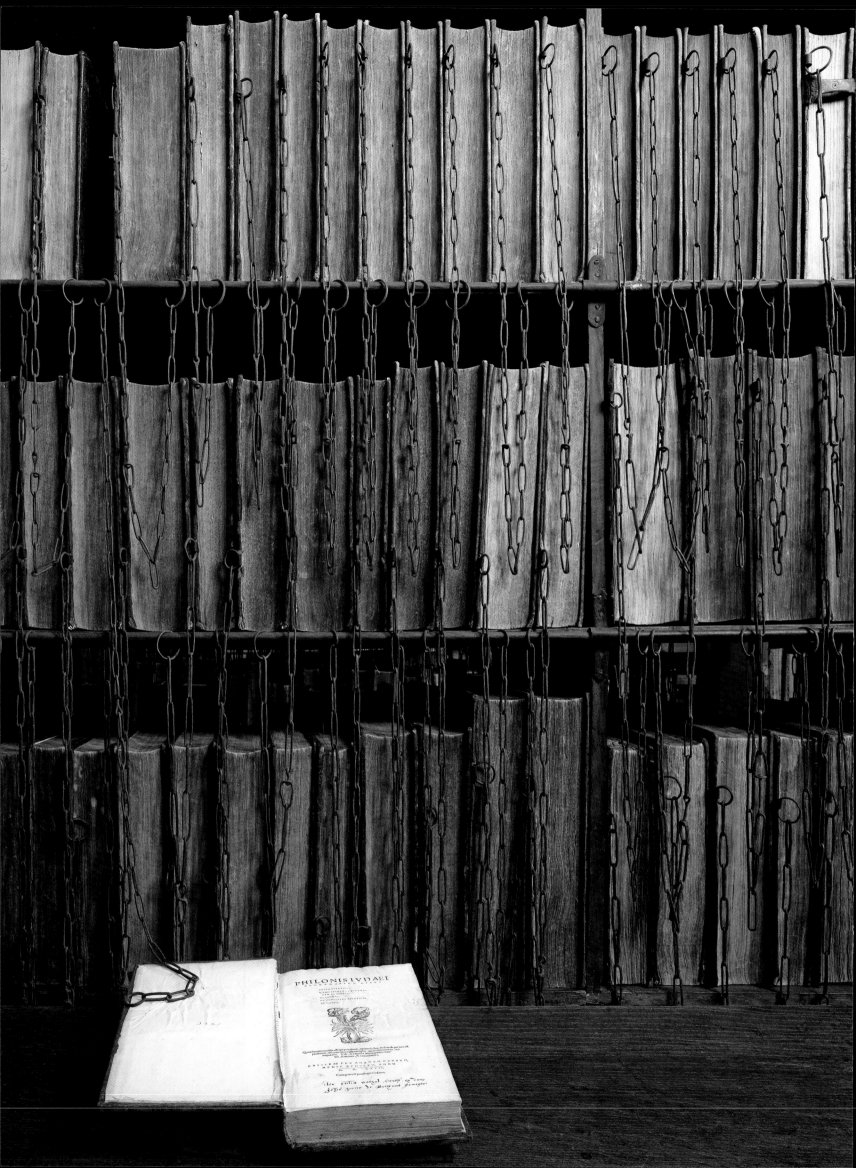

Cupboards, Chains and Stalls
Libraries in the 16th Century

This chapter covers the period of the Reformation in Europe, from 1500 to 1600. Libraries at the end of the 16th century were very different from those at the beginning. Until comparatively recently, these changes were not well understood and a number of misconceptions continue to be repeated. The effect on library design in Europe of the birth of printing and the adoption of paper was not nearly as immediate as some sources suggest. In 1500, fifty years after the setting up of the first printing presses in Europe, virtually nothing had changed, and libraries appeared very much as they had two hundred years before. Books were increasing in number, but these increases had yet to affect the physical spaces designed to house them. The 16th century saw significant developments in library form. There were changes in the rooms that housed libraries and changes in fittings and decoration.

This chapter begins not in Europe, however, but in China. Very little has been written on Chinese libraries outside China and most of the accounts of them that have appeared in Western languages have concentrated on their collections and the role of books in Chinese society. The earliest surviving Chinese library was constructed in the 16th century, but libraries in China have a very much longer history.

The development of libraries in China

China's oldest intact library building is the Tianyi Chamber in Ningbo, about 150 km (95 mi.) south of Shanghai. It was built by Fan Qin, a retired government official, around 1561 (the exact date is uncertain) and it remained in the hands of his direct descendants for nearly 400 years.[1] Fan Qin was twenty-six years old in 1532, when he passed the highest level of the imperial examinations. He went on to have a successful career in the civil service, reaching the rank of imperial governor and ruling a succession of provinces before becoming deputy minister of war in 1560. This last post was short-lived and, following an enquiry, he took early retirement and returned to the town of his birth. There he devoted himself to creating his famous library.[2]

Many Chinese libraries had been destroyed by fire. Fan Qin sought to build a library that would protect his collection through *Feng Shui*, the ancient Chinese art of geomancy. That meant paying particular attention not only to the building's location, orientation and layout but also its name. This is taken from *I Ching*, originally a divination manual, which is one of the most celebrated and important classics of early Chinese philosophy. *Tianyi* means the 'Heavenly Number One'. Commentators on the book in the Han dynasty (206 BC–AD 220) stated that when this idea of 'Heavenly Number One' was placed in the north it alluded to water. The name 'Tianyi' was

thus intended to deter fire, the traditional enemy of books and buildings. To emphasize the link, Fan Qin placed a pond in front of the building, and covered the roof timbers with pictures of ripples and waves. The number six in *I Ching* also alludes to water and this is a recurrent theme throughout the building: it is divided into six structural bays and the bookcases are proportioned accordingly.[3]

The Tianyi Chamber was a private library. A long inscription on the first floor at the top of the stairs admonishes the family never to allow any non-family member to enter and to let no one, not even a relative, take a book from the library complex, which consists of a pavilion in a walled garden. The garden is entered through a locked gate from an alleyway and is completely isolated from the world outside. The high brick walls and alleyways that surround the library were intended to protect it if fires broke out in the adjacent buildings. A large lower chamber (suitable for reading and writing) is entered from the garden. The upper chamber, where the books are stored, is accessed through a nondescript door just inside the entrance from the alley. Today, the public is allowed into the garden but not the library. Originally both were inaccessible to all except senior family members.

The building is timber with brick end walls. The books are stored on the first floor. The first of the six structural bays is occupied by the staircase and

the last is left empty to provide protection from fire.
The library proper consists of a single four-bay-long
chamber, open to the roof, with windows down both
sides. These are fitted with louvered sliding shutters.
The space is quite dark. The books are hidden inside
cupboards, which divide the room into alcoves
formed from two cupboards on each side and one
at the back. The third bay of the library contains a
larger, more ornate cupboard, which was a gift from
the emperor.

The development of books in China

The books in the Tianyi Chamber can be seen in the
photographs. Unlike modern books, they are stacked
like bundles in the traditional Chinese way. They are
on paper. The Chinese used many writing materials
before the invention of paper, including gold and silver,
but, strangely, they never adopted the Western habit
of writing on animal skin; they had no equivalent of
parchment. In Neolithic times, they wrote on clay, like
the Mesopotamians; bone, shell, bronze, bamboo and

wood were used in the Shang dynasty (1600–1046 BC) and bamboo, stone, jade and silk in the Zhou period (1030–722 BC).[4] Most of these early materials were used to write inscriptions for divination. More interesting are the surviving stone tablets.

In AD 175 and 180 an edition of seven Confucian classics was carved on forty-six stele bearing 200,000 characters. This was merely the first of seven such attempts to preserve the classics in stone between AD 175 and 1900.[5] The most impressive survivals of this trend are the collections of Buddhist sutras at Fangshan. Here, starting in AD 605 and ending in 1091, the monks carved 105 Buddhist sutras of over 4 million words on more than 7,000 stone tablets, which were then walled up in sealed caves so that the scriptures might be preserved for ever. Unfortunately, the caves were not watertight. When they were opened it was discovered that many of the tablets had been badly damaged and they have since been removed for preservation.[6]

The vertical system of writing in Chinese is derived from the early use of bamboo or wooden strips as a writing material. Bamboo strips were stitched together to form scrolls on which to write longer works, while single pieces of wood were used for letters or small essays.[7] The alternative to bamboo or wood was silk. We know from archaeological sources that silk was first used as a writing material at least as early as the 6th or 7th century BC and it continued to be used into the Southern and Northern dynasties (AD 420–589). The silk used was called *bo* and was undyed.[8] Writing was done with brushes and lamp-black ink (ink made from soot).[9] Although silk was light and relatively durable it was expensive and so was eventually completely supplanted by paper, which provided a comparable surface for a fraction of the cost.

The invention of paper

Paper was the perfect writing material: it was cheap, easily produced, smooth and durable, and its raw materials were readily available everywhere. According to Chinese contemporary accounts, paper was invented by Cai Lun (d. AD 121). He was a eunuch who worked in the imperial court and was promoted to be in charge of weapons and instruments in 97. The story goes as follows:

In ancient times writings were generally made on tablets of bamboo or pieces of silk called … [qianbo]…But silk being costly and bamboo heavy, they were not convenient to use. …[Cai Lun]… then initiated the idea of making paper from the bark of trees, remnants of hemp, rags of cloth, and fishing nets. He submitted the process to the emperor in the first year of … [Yuan-Hsing, AD 105] and received praise for his ability. From this time, paper has been in use everywhere and is universally called 'the paper of Marquis …[Cai]'.[10]

below
TIANYI CHAMBER, *c.* 1561
Ningbo, China

The corridor behind the bookcases serves no purpose other than to provide ventilation behind the cabinets.

Many earlier examples of different types of paper have now been found, so today it is assumed that Cai Lun was adapting an existing technology for new uses rather than inventing it. Nevertheless, he can be credited with developing cheaper and better processes for its manufacture and popularizing its use.

Paper is a sheet of macerated fibres, formed on a screen (or mould) from a water suspension. The water is drained from the screen and the paper removed to be dried. Sheets of paper have been made in this way since before the birth of Christ. The process is largely the same today, the main differences being the choice of fibres and the way the screen is made. Cai Lun used hemp, rags and bark, but one of the great advantages of paper is that many materials can be used. The key ingredient is vegetable fibre. Virtually all plants contain this, but those most suitable for paper combine high levels of long cellulose with lower concentrations of binding substances. The plants must be easily available, simple to convert and cheap. The most commonly used are hemp, jute, ramie, rattan, mulberry bark, reed, bamboo, cotton and the stalks of rice and wheat. Hemp and cotton produce the better paper but they were normally reserved for making garments so the Chinese paper industry tended to use paper mulberry and bamboo instead.[11]

The invention of paper put the East centuries ahead of the West, enabling elaborate systems of administration and bureaucracy to be created. In the East, paper was not invented for writing, and indeed writing was only one of the many uses to which it was put. There were paper walls, paper furniture, paper clothes, paper umbrellas, paper fans and even paper armour. By 1393 the imperial court in China was getting through 720,000 sheets of toilet paper a year alone; paper was being produced in extraordinary quantities.[12] Eventually, paper made its way via the Silk Road to the West. It was being used in Central Asia by the 7th or 8th century, but was not widely available or used for books in Europe until the 14th century.[13]

above
TIANYI CHAMBER,
c. 1564. Ningbo, China

*The garden behind the library.
The entrance to the staircase
is on the far left, next to the
entrance door to the garden,
which is surrounded on all
sides by a high wall. Only
close family members were
allowed to enter the garden.*

Early Chinese libraries

Before the 18th century, Chinese libraries were divided into two types: those for government officials (including the libraries of the emperor) and those of private scholars, such as the Tianyi Chamber. There were no equivalents of the public libraries or the semi-public medieval university libraries in the West, but private individuals were often willing to open their libraries to the wider community.[14] Since no Chinese library buildings earlier than the Tianyi Chamber survive with their fittings intact, their form can be deduced only from written sources.[15] The sole early structure comparable to the Tianyi Chamber is the Huang Shi Cheng in Beijing, completed in 1536, a vaulted, brick-built archive in which the imperial records were kept.

From as early as the Han dynasty, collections were stored in bamboo chests (called *Qie* in classical Chinese). Later libraries employed book cupboards like the ones in the Tianyi Chamber. A particularly elaborate arrangement is described in one source:

Emperor Yang ([r.] 604–607) of the Sui Dynasty (581–618) had a private library, in which there were fourteen studies, each having windows, doors, couches, cushions, and book-cases, all arranged and ornamented with exceeding great elegance. At every third study there was an open square door (in front of which) silk curtains were suspended, having above two (figures of) flying ... [immortals]. Outside these doors a kind of trigger-mechanism was (contrived) in the ground. When the emperor moved towards the Library he was preceded by certain serving maids holding perfume-burners, and when they stepped upon the trigger-mechanism, then the flying ... [immortals] ... came down and gathered in the curtains and flew up again, while at the same time the door-halves swung backwards and all the doors of the book-cases opened automatically. And when the emperor went

out, everything again closed and returned to
its original state.[16]

From very early times the imperial palace needed
archives and libraries. These were placed in the
palace's northern quadrant because in Chinese
cosmology this quadrant was traditionally associated
with water, and so was thought to protect a library
from fire. As in the Tianyi Chamber, depictions of
water were painted on the roof timbers and the
libraries were very often surrounded by moats, both
fictive and real.[17] The first emperor is infamous for
the burning of the books in 213 BC, in a vain attempt
to rewrite history, legitimize his rule and suppress
resistance. He left only the collection in the imperial
palace intact, which was subsequently destroyed in a
rebellion against his rule in 206 BC, when the palace
was set on fire.[18] The Han dynasty saw a growth of
collections and attempts to improve the imperial
holdings. The most famous of these libraries were
the Shiqu Chamber, the Tianlu Chamber and the
Qilin Chamber, all in the northern part of the gigantic
Weiyang Palace, situated close to the centre of modern
day Xi'an in central China.[19] The palace, like so much
of ancient Chinese architecture, was later completely
destroyed. We have only the briefest descriptions of
the physical form of these and later Chinese libraries.
They seem to have consisted for the most part of timber
pavilions, laid out according to the same rules that
were used for all Chinese timber-framed buildings.
The complexes typically employed staff for copying
and collating books. In Chinese libraries there seems
to have been a close association between reading and
storage from the outset.[20]

The *Siku Quanshu*

The imperial libraries through the ages repeatedly
attempted to create comprehensive collections. The
largest such compilation, the *Yongle Dadian*, was
completed in 1408 during the Ming dynasty, but
only parts of a later copy of the original survive.
A number of copies still exist of the *Siku Quanshu*
('The Complete Library of the Four Treasures'),
created for the Qing emperors in the late 18th century,
and these have been printed in facsimile. The *Siku
Quanshu* sought to bring together the leading works

in classics, history, philosophy and literature. Some
11,000 works from all over the empire were collated by
361 editors, who in the process purged and destroyed
over 3,000 texts that were viewed as unsuitable. Seven
copies of all the authorized texts were written out by
3,800 scribes and bound into 36,381 volumes (over
800 million Chinese characters). The project took
nine years, and was completed in 1782. One complete
set was then deposited in each of the seven libraries
specifically built for the purpose.[21]

Each library building is said to have been based
on the Tianyi Chamber, which was, even then,
the most respected library building in China – the
imperial cupboard in the Tianyi Chamber was given
to the family in recognition of their help in compiling
the *Siku Quanshu*.[22] Of the seven libraries originally
constructed only three remain: the Wenyuan Chamber
in the Forbidden City in Beijing, the Wenshuo
Chamber in Shenyang and the Wenjin Chamber in
Chengde.[23] All differ from the Tianyi Chamber in
having mezzanine floors between their ground and
first floors for extra book storage, but they retained
its overall structure of six bays. The centre three bays

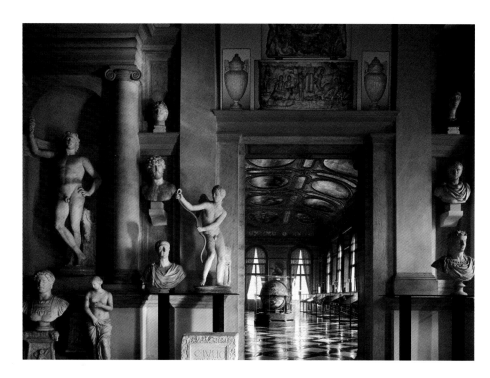

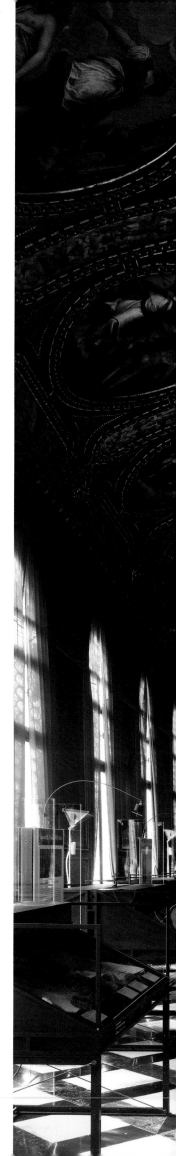

on the ground floor are double height (without a mezzanine), creating a reading room for the emperor. The first floor was entirely dedicated to book storage.

The *Siku Quanshu* is a comparatively late example of the way that the Chinese emperors throughout the ages sought to control knowledge. They collected books and censored them in equal measure, and although it was a badge of honour for a writer to have a work accepted by the imperial library, the risks, if a work was disapproved of, were severe. Written examinations, rather than connections, led to promotion at court and this also encouraged private collectors, who often opened their collections for the use of local people studying for those examinations. The ownership of books conferred status on an individual, an idea that would have been recognized not just in China, but also in Europe at the same time.

Libraries of the Italian Renaissance

Italian buildings of the 15th and 16th centuries – the period commonly referred to as the 'Italian Renaissance' – have played an unparalleled role in the history of European architecture. Their importance stems from the fact that they were drawn, discussed, published and scrutinized by architects across Europe in the following centuries. The types and forms established in Italian buildings in this period became the accepted standards of classical architectural design throughout the 18th and 19th centuries. By the 1500s, libraries in Italy already had a reasonably long history. As discussed in the last chapter, the first libraries were constructed in the late 1200s. These were first-floor rooms with open timber roofs. A new type was established in the mid-1400s by the architect Michelozzo for the Medici family with

the building of the Biblioteca S. Marco in Florence.[24] This room survives, but its furniture has long since disappeared. As usual, the library is on the first floor, but it is vaulted in stone. The central aisle has a continuous barrel vault, and the side bays are cross-vaulted. This was closely copied by Matteo Nuti for the Biblioteca Malatestiana in Cesena, discussed at length in the previous chapter. This form of room, with rows of pew-like seats (*banchi*) ranged down both sides, and a central aisle flanked by supporting columns, was typical of Italian libraries in the late 1400s. The columns rarely lined up with the walls in the floors below and as a result the vaults were difficult to construct. Not all libraries conformed to this plan: the libraries of S. Croce (1427) and SS. Annunziata (1455), both in Florence, seem to have had single spans, with no columns. Nonetheless, it is fair to say that at the end of the *quattrocento* (the 1400s) the three-aisle form was still the most popular.[25] This was to change in the 1500s, when there were a number of significant developments that had the most profound effects on all later library designs. The first of these was the project for the Biblioteca Marciana.

Biblioteca Marciana

Today the Biblioteca Marciana, the library of St Mark, Venice, is one of the most important research libraries in Italy. It currently occupies a number of buildings that have been joined together for the purpose, including the building that was constructed in the late 17th century to house the mint. The original library is still part of the complex, but it is now used only as a museum and for receptions. It sits on the corner of St Mark's Square and the Piazzetta, the smaller square that links St Mark's Square with the Grand Canal,

collection, too, might never be housed properly. From 1472 until 1485 the 1,024 works were left in their crates. A librarian was appointed in 1488 but the books remained in temporary locations for decades, noticeably inaccessible to the public and scholars alike. Change came only in the 1530s, when Cardinal Pietro Bembo (1470–1547) was appointed librarian in charge of the collection. Bembo used his considerable influence to persuade the procurators who were in charge of the buildings around St Mark's Square to provide a suitable home for the collection and to appoint the great architect Jacopo Sansovino (1486–1570) to design it. The result was a triumph of classical composition, albeit a project fraught with problems and difficulties.[29]

Sansovino conceived his library as part of a much larger scheme to rebuild one whole of side of St Mark's Square and the adjoining side of the Piazzetta facing the Doge's Palace. The scheme we see today is much as Sansovino conceived it, although he did not live to see it completed. The library, which formed the first half of the Piazzetta part of the scheme, was virtually finished when the books were moved into it in 1564, but the remainder of the building could not be completed until the rest of the site had been cleared, which took another twenty-seven years. In the meantime, the library stood half-finished. It and the rest of Sansovino's scheme for St Mark's Square were eventually completed by Vincenzo Scamozzi in the 17th century.[30]

What makes Sansovino's building so important is its façade. As usual, the library was placed on the first floor. In most instances this was simply to prevent damp, but in Venice it was also because of the constant threat of flooding. The form of the Biblioteca Marciana follows a familiar Venetian typology: it has an arcade on the ground floor and a dramatic principal floor (*piano nobile*) above. The way that Sansovino so cleverly incorporates the columns of major and minor orders and the arches was greatly admired by later architects. Internally, the library was also innovative in the care taken in the design of the way that it is entered. A grand portal gives access from the lower arcade on the square. The reader then ascends the first flight of a lavishly decorated staircase to a landing, turns and ascends a second flight to reach a vestibule. This vestibule, which has a ceiling painting by

enclosed on one side by the Doge's Palace and on the other by the loggia of the library.

The story of the Biblioteca Marciana begins with the death of Cardinal Basilios Bessarion (1403–1472) in Ravenna. Bessarion was a humanist scholar who had run an academy in Rome specialising in ancient Greek texts.[26] Humanism in the Renaissance was not, as is sometimes stated, a placing of humanity at the centre of intellectual life, but a scholarly movement that sought to resurrect the *studia humanitatis*, the study of the humanities. Medieval scholarship had focused on questions that related to the divine. The humanist sought out classical literature in all its forms, and attempted to produce accurate scholarly editions of classical works from the poorly copied and corrupted scraps that survived.[27] Humanism encouraged individuals to study a broad range of subjects.

Bessarion had used the great wealth and influence that his posts had given him to search out and acquire one of the finest collections of manuscripts in ancient Greek anywhere in the world. After lengthy negotiations, he had agreed to leave his collection to the Venetian state on the strict proviso that it was made available to anyone who wished to view it.[28] The Venetians had a bad record when it came to literary acquisitions. Petrarch (1304–1374), often called the father of Renaissance humanism, had talked of leaving his books to the Venetian state, only for negotiations to fall apart and for them to go to Padua on his death. Initially, it looked likely that Bessarion's

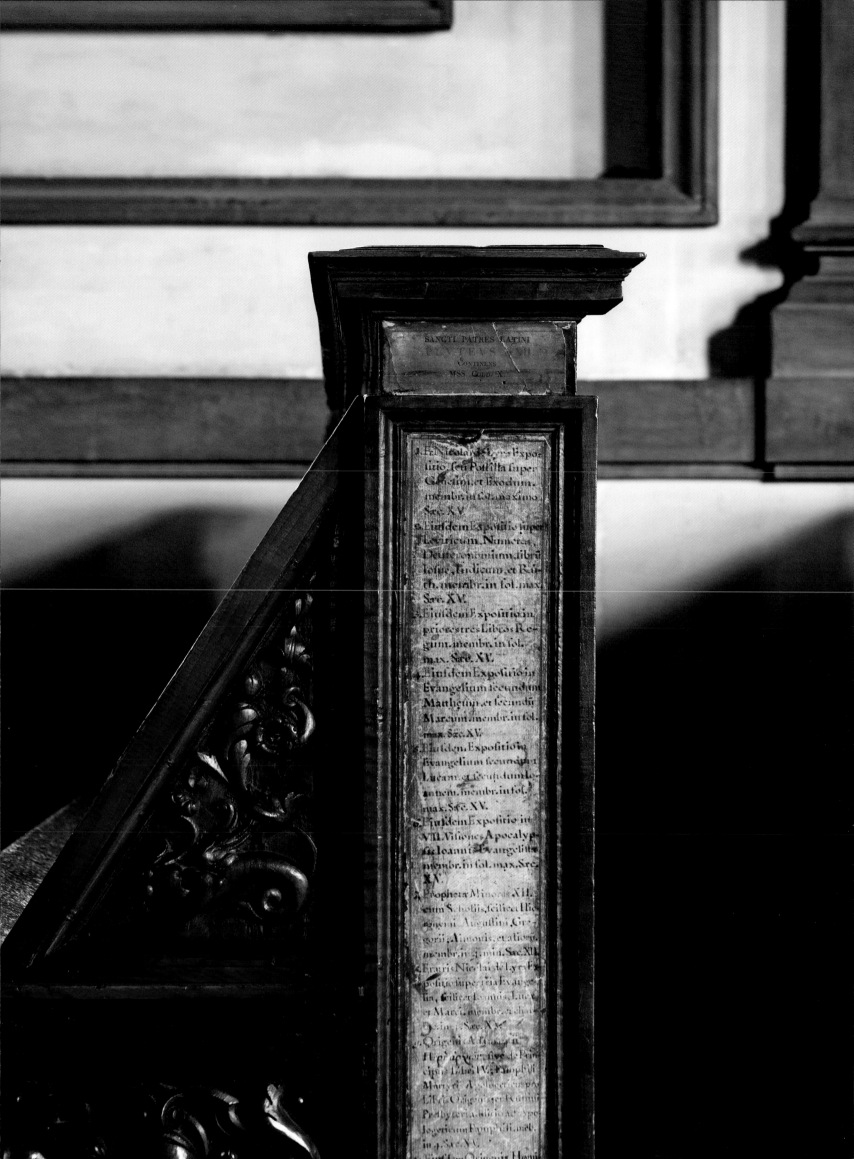

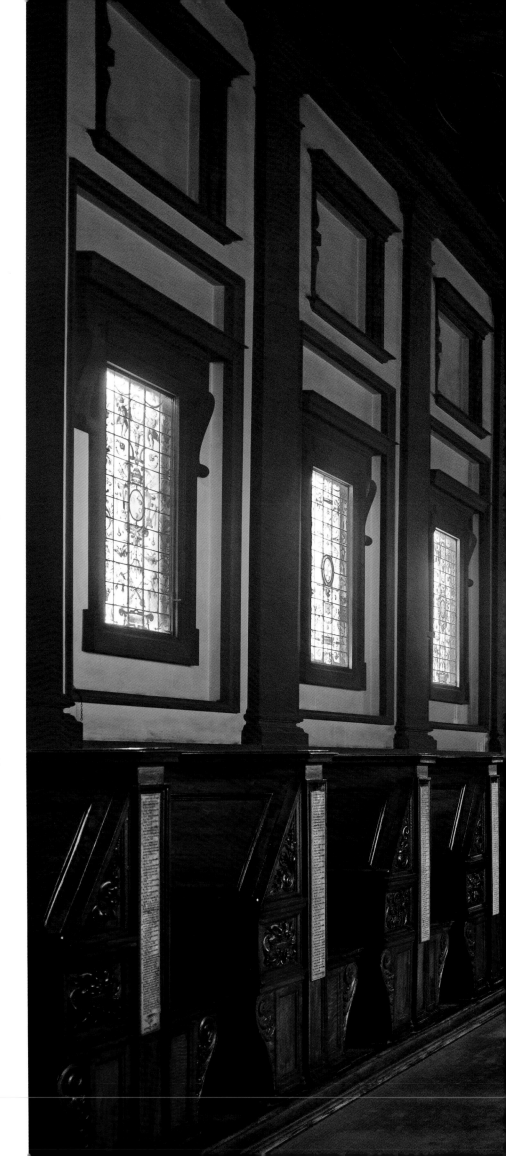

Titian, was designed to act as a classroom for a public
school, but this use was short-lived, as in 1591–6 it
was converted into a magnificent museum for the
Grimani collection of classical sculpture, which it still
houses today. The Titian ceiling, which depicts an
allegory of wisdom, prepared the visitor for the
reading room proper.[31]

After such a grand approach, the reading room
itself is today slightly disappointing. This is largely
because it lacks all its original furniture. When
first constructed it had thirty-eight desks in two
rows (presumably at least as lavish as those at the
Malatestiana), one row down each side of the room.[32]
The central aisle led to a balcony, which overlooks
the campanile and St Mark's Square. Huge windows
light the room from the east (as Vitruvius had advised),
and look out over the Doge's Palace. The windows
opposite were always blank arches, since on that
side the library is hemmed in by other buildings. The
ceiling is a triumph made out of a disaster. Sansovino's
first ceiling for the library, an ambitious low stone
vault spanning the whole space, collapsed and the
architect was thrown into prison. He was released,
but ordered to reinstate the vault at his own cost.[33]
It is no doubt partly to make up for his earlier failure
that the new vault is the showpiece that it is. Its
painted roundels, the subject of a competition, were
executed by the leading Venetian artists of the day,
including Paolo Veronese (1528–88). They depict the
subjects found in the library and the virtues. The result
is breathtaking, and one can easily imagine what it
must have been like to sit at the desks and study in
this extraordinary room when it was first completed.
This sumptuous Venetian interior was, however, to be
outshone by another library, in Florence.

The Laurentian Library

Just as Sansovino's Biblioteca Marciana had a troubled
history, so too did the Biblioteca Laurenziana, or
Laurentian Library, designed by Michelangelo for
S. Lorenzo in Florence. It was commissioned by
Cardinal Giulio de' Medici (1478–1534) shortly after
he was elected pope as Clement VII in 1523. When
Michelangelo (1475–1564) left Florence in 1534, never
to return, the walls of the reading room were complete,
including the roof, but the ornate ceiling and wonderful

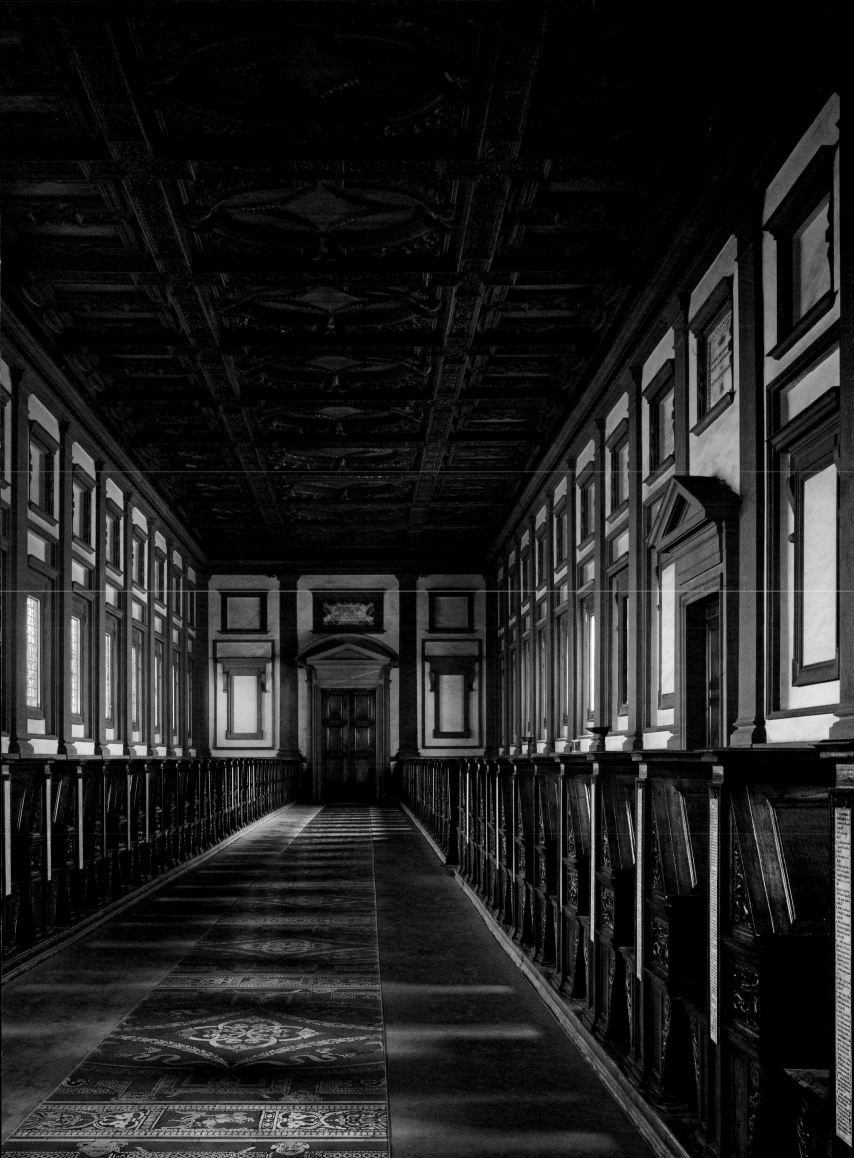

tiled floor were yet to be executed and the carving for the desks had not even been begun. The vestibule was also incomplete and indeed was not finished until the 19th century. Michelangelo sent a clay model for its remarkable staircase from Rome in 1559. The library was not finally completed and opened until 1571, forty-two years after it had been commissioned and seven years after Michelangelo's death.[54]

Although the library appears to be unchanged, it was radically altered in the 19th century. The original space consisted of a single, long, rectangular hall. The conception of a library as a hall space was not new, but Michelangelo's design was radically different from anything that had come before. Previous library spaces were typically low and vaulted or had open timber roofs. In section the Laurentian Library is not quite square (it is 10.54 m wide and 8.45 m high, 34 ft 6 in. x 27 ft 9 in.), but the ceiling is flat and timber. The overall space is thus a long, high, rectangular box. It was originally lit by windows along both sides. The side walls were entirely symmetrical, composed of fifteen bays framed by pilasters, with one tier of windows and a tier of blank windows above. In the 19th century, in what can only be described as an extraordinary act of architectural vandalism, a reading room was attached to the east side of the library. This involved blocking up most of the windows on this side and removing some of the desks. The door to the new room is sympathetic in style, but its intrusion entirely ruins Michelangelo's original conception of a perfectly symmetrical rectangular space, lit on both sides, punctuated only by a door at each end.[35] Today it requires some imagination to reconstruct what it must originally have looked like.

The Biblioteca Marciana is notable for its exterior. By contrast, the exterior of Michelangelo's library is virtually impossible to see. It is the interior that is a triumph of invention. It is built on top of an existing set of monastic buildings around a two-storey cloister. The visitor ascends a large barrel-vaulted staircase to the first floor of the cloister and then passes through a small door into a vestibule, the *ricetto*. This Mannerist staircase hall is one of the most discussed spaces in architectural history, despite the fact that it was not finished until long after Michelangelo's death, and then in a way that he never intended.[36]

The main room of the Laurentian Library, even in its current form, is breathtaking. The long walls are treated as inverted façades. Full or half columns could not be used because the walls had to be as light and thin as possible, so Michelangelo used rows of stone pilasters instead. These begin not at floor level, but on a plinth created by a band of stone at the height of the top of the desks, forming a dado. Drawings show that Michelangelo toyed with two tiers of roughly equal-sized windows, possibly to obtain a room that was as tall as it was wide, but the structural restrictions again made this difficult to achieve.[37] The flat ceiling was chosen partly for the same reason, as there was nothing that could have supported the outward thrusts of a vault, even if Michelangelo had wanted one. It seems unlikely that one was ever seriously considered.

The significance of the Laurentian Library in the history of library design has been much debated. The architectural historian James F. O'Gorman was keen to counter the idea that the move from vaulted spaces to rectangular rooms marked a significant

LAURENTIAN LIBRARY, 1571. Florence, Italy

Michelangelo produced detailed drawings for the lecterns. His design reduces the ends to a series of rectangles and triangles. The sloping end of the lectern becomes a triangle, above the square end of the shelf beneath the desk. This design is elegant but the upright back of the seat is much less comfortable than are the sloping backs of the desks in the Biblioteca Malatestiana and the decorative moulding at the top prevents the reader from leaning back.

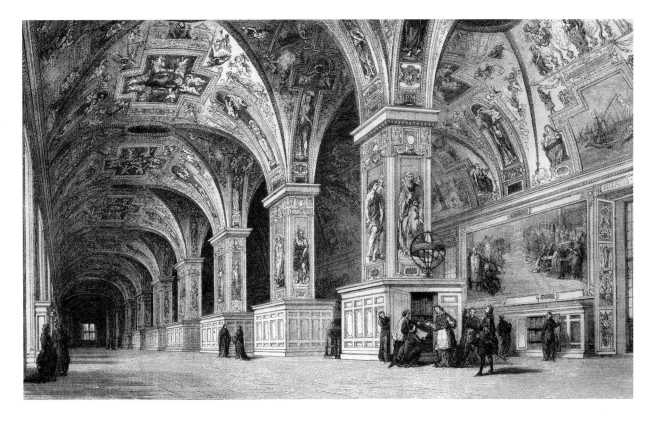

shift; he showed that libraries in the form of hall spaces uninterrupted by columns already existed.[38] Some modern commentators have suggested that Michelozzo's Biblioteca S. Marco and its ilk were deliberately mimicking religious architecture to emphasize the religious basis of the collections and that Michelangelo's library represents a secularization of library design.[39] This theory, relying on the idea that vaulted spaces are religious and unvaulted ones are not, is anachronistic: it makes no sense in the context of the day. In any case, Michelangelo was noted for his opposition to architectural theorizing.[40] To understand the true significance of the library we need to look at what it was designed for.

When Giulio de' Medici became pope he decided to use a small part of his now considerable fortune to provide symbols of the continuing power of the Medici family in Florence. He chose two projects, both attached to the church of S. Lorenzo, the new library and a new sacristy, which was to house the Medici tombs. Michelangelo was the inspired choice for both projects and in both cases he was instructed to spare no expense in their execution. The tombs are self-explanatory but the choice of a library as a symbolic benefaction deserves more explanation. Humanism in scholarship might well have arisen independently, but its flowering into a cultural movement that extended well beyond the confines of dusty manuscripts to embrace a whole culture in what we call the Renaissance was undoubtedly due to the strong financial backing it received. Giovanni di Bicci de' Medici (1360–1429) owned just three books. His

son Cosimo (1389–1464) actively sought out scholars and paid for the Biblioteca S. Marco. As scholars have shown, the Medici did not quietly support lone scholars; they flaunted their support of scholarship and the arts to justify and bolster their political position. Knowledge, and the support of the acquisition of knowledge, became yet another symbol of power.[41]

Viewed in this light, both the Biblioteca S. Marco and the Laurentian Library were not simply gifts to the city; they were showcases of Medici influence. They were intended as lavish display cases, designed to show off their contents to the best advantage. Most importantly, both libraries were designed with a specific number of books in mind: the collections they housed existed before the libraries were built. After the Medici completed the Biblioteca S. Marco they continued to collect books, but they did not donate them to the library that they had already built, as they considered it complete. Instead, they stored their acquisitions in their houses, awaiting the construction of suitable new buildings to display them to their best advantage. How they were stored in the meantime remains a mystery.[42] Many of these purchases may never have left their crates.

It is in this light, as a display case for a very particular collection, that we must understand the design of the Laurentian Library. It may have been built in the age of printing, but it was designed to show off manuscripts in rare bindings in an age that still viewed printed books as inferior, cheap alternatives to proper books, copied out by hand onto parchment. Having been given to the people, the Medici collection

was complete. It was not meant to be watered down by inferior additions. As such, it was essential that the books were shown off to the best effect. Pope Clement entered into detailed correspondence with Michelangelo over every aspect of the library and particularly its most important features: the lecterns.[43]

From cupboards to lecterns

Today we associate libraries with wall shelving. Lecterns are so rare in library buildings that we have completely forgotten their existence. In contrast, in the early 16th century there were only two ways of storing books in libraries: in book cupboards or on lecterns. The greatest collections of surviving Renaissance book cupboards line the walls of what is now the Vatican Museum and are passed by thousands of tourists every day. The library in the Vatican was a creation of the Renaissance popes. It was founded by Nicholas V (1447–55) and given a series of rooms altered for the purpose by Sixtus IV in 1471. These consisted of four chambers, furnished with lecterns (*banchi*) in the normal way. From the beginning, these were not enough to accommodate the collection, which was also stored in cupboards and chests, and as more books were acquired so more cupboards were constructed to accommodate them, the original four chambers continuing to act as reading rooms.[44] The most remarkable cupboards are in the Sala Sistina, built for Pope Sixtus V in 1587. It spans the Cortile del Belvedere from east to west and is 56 m long by 17.4 m wide (184 x 57 ft), lit from one side and roofed with stone vaults. The cupboards, walls and ceiling are all richly decorated. Indeed, so rich is the decoration that the existence of the cupboards is almost entirely concealed. In the centre of the room they look like pedestals for the row of piers supporting the roof. Just over 2 m (7 ft) high, the cupboards completely hide the books within and uninitiated viewers could be forgiven for not knowing that this is a library, so well disguised are its contents.[45]

As the Tianyi Chamber shows, cupboards with painted decoration provide an ideal way of storing books. The contents are protected from insects and dust and can be kept safely locked away from thieves. In the Middle Ages and in the 16th century, books were stacked horizontally with plenty of space around

them for ventilation. It did not matter how they were stacked, as they could not be seen. Nor did it matter if the cupboards were full, partially full or entirely empty. Visitors could be shown a full cupboard and be unaware that all the others were bare. Private collectors used cupboards in various forms for book storage in all periods.

On the subject of cupboards it is worth mentioning briefly at this point the Renaissance *studiolo*. Various writers have suggested that these tiny rooms, created for Italian princes, are richly decorated library rooms, the ornate decorated panelling concealing cupboard doors for book storage.[46] In fact, the two best-known examples, the *studiolo* from the ducal palace in Gubbio, Italy, that is now in the Metropolitan Museum of Art in New York, and the one in the ducal palace in Urbino, have no cupboards at all.[47] The decorative panelling is set flush against the walls. These studies are not, and never were, libraries. They were miniscule private spaces, the walls of which were richly adorned to represent the virtues and skills that the owner was seeking to master. No one is quite sure how they were furnished, but the likelihood is that they contained only a simple chair and table

for writing. Like Japanese study niches, the owners
brought in from elsewhere the one or two books they
wanted to consult, returning them to their place of
storage in another room or building after use.

There were more lavishly furnished studies, and
contemporary pictures of scholars at work in them
have been analysed in detail.[48] They show books stored
in cupboards, in chests and in shelves on the walls. In
the last case, the books are almost invariably shown
placed on their sides. The shelves themselves are
mounted on the wall above the desk, not on the floor-
to-ceiling shelves to which we are now accustomed.
In all cases, the writers worked at sloping lecterns,
using them for both writing and reading. The lectern
or sloping desk was the principal piece of furniture
in any medieval or Renaissance library and the care
taken over the form of the lecterns for the Laurentian
Library is indicative of the key part they played in
library design. It is a pity that so few examples survive.
It is worth pausing here to examine the Cesena and
Laurentian lecterns to understand the thinking behind
16th-century library furniture.

Lecterns and chains

The lecterns in late-medieval libraries, such as
those in Cesena, look to modern eyes very much like
pews in a church. Such parallels should, however,
be avoided, as they are anachronistic. The 19th-
century pews with integral lecterns that we are so
used to in churches are not a type that was used in
the 15th century for congregational seating. Indeed,
throughout most of the Middle Ages the congregation
in a church stood or knelt on the floor. In the 15th and
16th centuries benches were being placed in naves but
there was clearly no need to have lecterns attached to
them to hold bibles in the vernacular or hymn books
when the congregation did not read and in any case
such books were not available.[49] Longitudinally placed
seating was provided in the chancels of monastic
churches and collegiate chapels. Since books of
music were often enormous, if a church had one it
would be placed on a huge lectern in the centre of
the choir. The library lectern was thus not a piece of
religious furniture adapted to library use and should
not be misinterpreted as such. It was a form that had
developed to suit its own particular circumstances.

Types of library lecterns

Very few Renaissance and medieval library lecterns
survive. Those that do fall into a number of categories.
The outstanding lecterns designed by Michelangelo
for the Laurentian Library are beautiful examples of
banchi. The lectern and the bench are single pieces of
furniture, the back of the bench forming the support
for the lectern behind. No examples of this type of
arrangement survive outside Italy and they may
have been restricted to that region. At the Biblioteca
Malatestiana in Cesena, the *banchi* stand away from
the walls to allow space for readers to walk down the
sides of the rooms. This made it easy to join a bench
already occupied by other readers without disturbing
them. That was originally the intended arrangement at
the Laurentian Library, but Michelangelo changed his
mind and reduced the space between the wall and the
end of the desk. Although the desk does not touch the
wall, and it is possible to squeeze around the end, there
is no obvious aisle.

In Cesena, the strange shape of the ends of the
banchi is simply the form of the sloping backs of

left
LEIDEN UNIVERSITY LIBRARY, *c.* 1575
Leiden, Netherlands

This engraving from 1607 shows the library furnished with standing lecterns, with a shelf above the reading desk. The rod for the chains is clearly visible. The books are shelved with their spines inwards, and the clasps that were used to hold them shut can be seen. At the back and in the foreground are cupboards, which were presumably for the storage of more valuable material. The room, which has a high ceiling and large windows, was converted from a church. A floor was inserted to create an anatomy department and chapel below and the new library above.

the benches and the lecterns, which is brought into a semblance of order by the relief carved into it. Michelangelo was obviously not content with this solution. A sketch survives showing him struggling with the problem of the sloping back of the bench.[50] His final solution did away with it altogether. The back of the bench becomes a rectangle, mimicking a pilaster and forming a frame for the catalogue that lists the contents of that desk. Every fourth desk lines up exactly with the middle of a pilaster on the wall. In this way the desks appear to be part of the architecture of the library. The lectern terminates with a triangle filled with sculptural relief, and the end of the shelf beneath is a rectangular panel, while the underside of the bench and the bottom of the lectern mirror each other with scrolls and rectangular panels. Although this composition is aesthetically pleasing, it comes at the price of functionality. The architrave on the top of the back of the bench stops the reader leaning back, as it is almost precisely at the height of the junction between neck and head, and the vertical back of the bench is incredibly uncomfortable. The benches in Cesena are by contrast ergonomically perfect.

The lecterns at the Biblioteca Malatestiana and the Laurentian Library are exceptionally made pieces of carpentry and this may account for their survival.

The few pieces of early furniture surviving elsewhere are noticeably cruder both in design and execution. The simplest arrangement was for a lectern running between uprights attached by timber rails at floor level to a bench without a back. These are rarely found in isolation. In most cases outside Italy the lecterns are placed back-to-back. Where single lecterns with benches occur in such libraries they do so at each end of the room against the walls. An early example of a double lectern with a separate bench for each reading surface is still preserved, out of context, from the medieval cathedral library in Lincoln, England.

Standing lecterns

The examples mentioned so far are all lecterns designed for seated readers. There was another type: the standing lectern. It is unclear how or when the standing lectern was first introduced. Examples of what seem to be one-sided standing lecterns appear in an engraving of the library of the University of Leiden in 1607. Those at Trinity Hall, Cambridge, date from around 1600 and there are examples at St John's College, Cambridge, from around 1624.[51] It is possible that the earliest were those of Queens' College, Cambridge, which may have been installed as early as the mid-1400s (see p. 118), but the dating of these

opposite
TRINITY HALL LIBRARY, *c.* 1600. **Cambridge, United Kingdom**

These particularly fine standing lecterns are interesting because they also feature lower desks, which pull out from beneath the shelf below the reading desk. Originally there would have been just one shelf in this position and the lower area would have provided space for the readers' legs. The benches and lecterns are both fixed to sills that run the whole length of the library. The books are chained to iron rods that run underneath the desks near the apex. The locks that enable them to be removed are visible below the decorative finials.

is ambiguous and they too might belong to the late 1500s or early 1600s. At Trinity Hall and at Queens', the standing lecterns were combined with sitting ones in a single piece of furniture. The reader could sit and work at a lower desk or stand to read at the upper one. This may have been a common arrangement in the period. As virtually all the original fittings in early libraries have been replaced, it is unlikely that we will ever know for sure. What is certain is that lectern libraries date back to the late 1200s and they were still being built 350 years later, in the early 17th century. One of the factors that ensured their longevity was the way that they readily incorporated chaining.

The chained library

The Biblioteca Malatestiana, the Laurentian Library, the libraries at Trinity Hall and Queens' College, Cambridge, and the library of St Peter and St Walburga in Zutphen (described in the previous chapter) all have one thing in common: they were chained libraries. This meant that all the books they contained were chained to the desks. Manuscript books produced on parchment were, as was noted in the previous chapter, incredibly valuable. The sheer expense of books made them all too tempting even to relatively honest members of well-organized collegiate institutions, and book theft was a continual problem. Many book bequests came with the firm requirement from the donors that the books must be kept firmly chained to their desks.[52] Chaining began very early. Inventories dating from the middle of the 14th century mention the provision of chains, and there is nothing to suggest that the practice does not date back to the first appearance of library rooms, in the late 1200s.[53]

There are two aspects of chaining that need to be considered in examining any library. The first is the attachment of the chain to the book. This gives some indication of how the book was stored on the shelf when not in use. The second is how the chain was attached to the shelf or desk. In the earliest surviving chained books the chain was attached to the lower edge. In Zutphen the books are chained with the clasps in the centre of the bottom edge of the board, sometimes the cover board and sometimes the backboard.[54] The clasp is firmly fixed to the timber

board of the book. Usually there are other pieces of iron on the bookbinding (strengthening for the corners, clasps to hold the book closed and feet to make it stand proud of the reading desk surface in order to keep it dry.) The other end of the chain ends in a loop that is threaded onto a metal rod, firmly fixed to the desk.

The rod fixing is common to all chained libraries. Chains are never just stapled to the desk. The reason for this is simple: the purpose of the chain is to prevent unauthorized removal, but not to prevent all removal. The rod is thus fixed in such a way that at one end there is a lock, which the librarian can open with a key. The rod can then be slid back and the books removed. Removing a book even with this contrivance is not simple; the whole row of books will need to be rethreaded onto the rod in the right order without tangling the chains, before it can be locked back in place. The position of the rod, and the method of locking it, varied and exercised the ingenuity of the various designers involved. In Zutphen, for instance, the rod is at the top of the lectern and the lock is on one end, a hasp covering the hole through which the rod has to slide. In the Laurentian Library and the Biblioteca Malatestiana the rod is at the bottom of the lectern, along its leading edge, an arrangement that meant that the chain hung down out of the way when the book was being read, rather than over the pages as it has to at Zutphen. The locking mechanism in the Laurentian Library is particularly ingenious.[55] Chaining was a way of preventing unauthorized removal, but as books proliferated the real issue was finding more space.

From lecterns to stalls

It took well over a century after the invention of the printing press for any changes to be felt in European library design and when they did come they were slow and gradual, not sudden and revolutionary. The slow pace of change is evident in the developments that took place in England in the late 16th and early 17th centuries that led to a new form of library, the stall library. Most people think that stall libraries are medieval, a confusion that has arisen because many are adaptations of earlier library rooms and the few books on the history of library architecture have

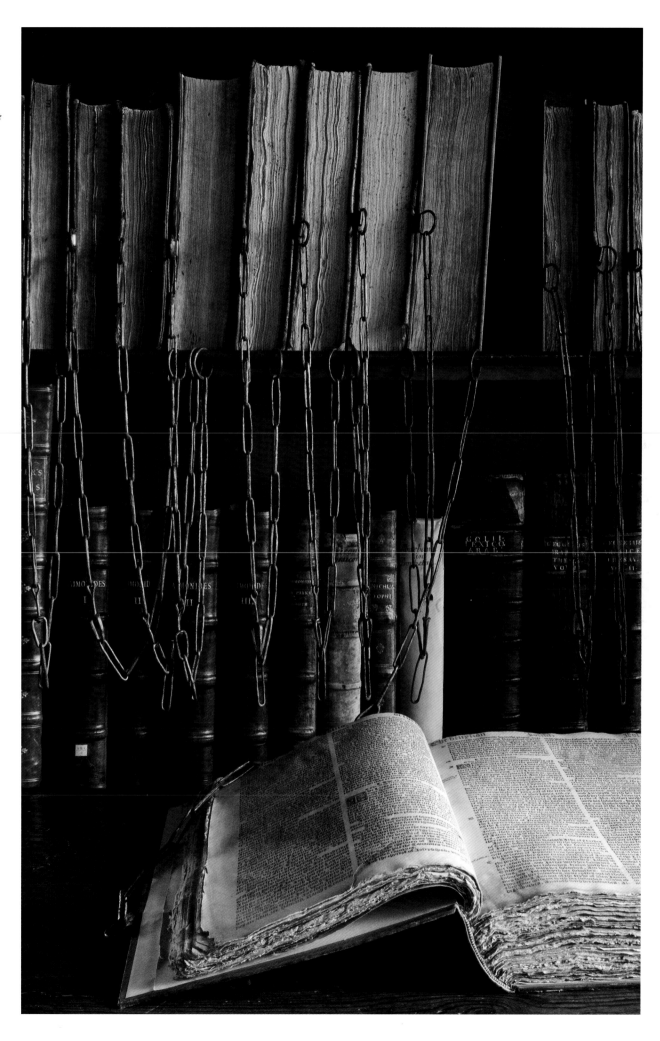

WELLS CATHEDRAL LIBRARY, 1680s
Wells, United Kingdom

Chaining books was expensive and the clasps and chains could damage the books. Most chains were removed in the late 17th and early 18th centuries. Here, a few books on the middle shelf retain their chains. As this photograph reveals, when books are chained they have to be shelved spine inwards, in contrast to the unchained books on the shelf below. Often the title would be written in ink on the edges of the pages to help the librarians find the books. In lectern libraries the chains were often attached to the bottom edge of the book. For stall-system libraries, the fixings had to be moved to the front edge. Replacement fixings on a book are evidence that it was originally in a lectern library.

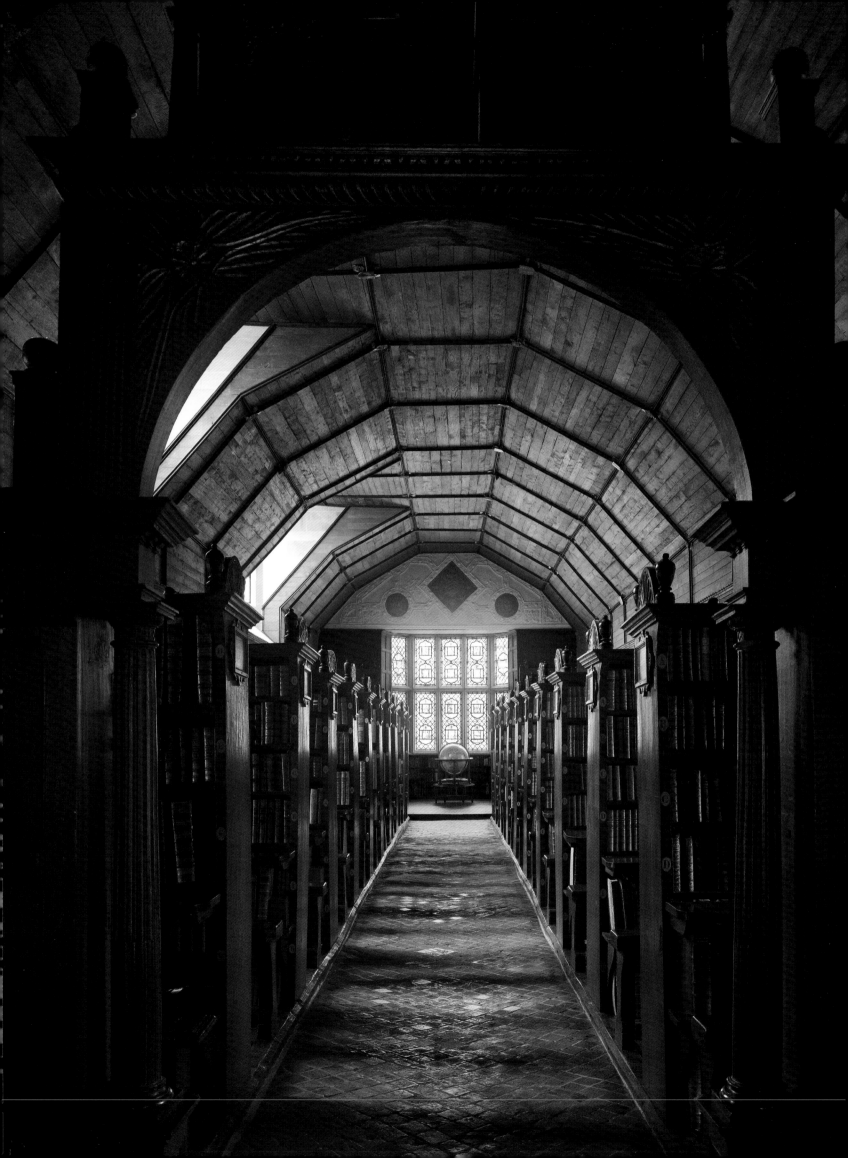

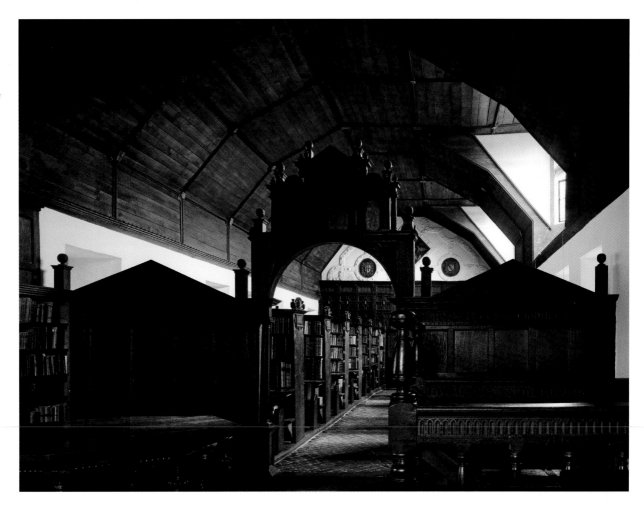

tended to repeat earlier mistakes.[56] The stall library
is not, however, medieval. The first was not built until
the end of the 16th century; at the beginning, in other
words, of the early modern era.

Merton College, Oxford

The story of the development of the stall library is
still uncertain, but it probably starts with Henry
Savile (1549–1622) at Merton College, Oxford, in the
1580s. Savile was an immensely well-connected
individual who would eventually be made Warden
of Merton by direct intervention of the Queen herself.
He was also a close friend of the founder of the
Bodleian Library, Thomas Bodley (1545–1613), and
had travelled widely in Europe. Between 1575 and
1589 Savile introduced changes to the college library
at Merton, where he was a Fellow. He secured an
endowment, established the post of librarian and
converted the east end of the existing library from
a lectern library to a stall library.[57] The bookcases
are still in position today, so Savile's innovations are
clearly visible. The benches of the old arrangement
were retained, but the desks were replaced by
freestanding bookshelves, extending above head
height and dividing the space into a series of bays or
stalls, from which the arrangement derives its name.
The books were originally chained and shelved with

the spines inwards, attached to rods that ran along the
front edge of each shelf. They were read on a desk that
stuck out at the correct height on each side and had a
slot at the back through which the chains fell, so that
they were not in the way when reading. The weight of
the four shelves above was too great to be supported
from each end, so an intermediate vertical member
was required, partitioning the shelving.

It is not clear whether Savile invented this
new arrangement or if he had seen it elsewhere.
Similarities to the arrangements in Leiden are
obvious. It is also possible that the influence was
closer to home. The accounts of New College, Oxford,
suggest that extensive alterations had been made
to the timberwork of its lectern library a few years
earlier, but no details are known. Whatever its source,
Savile's system was quick to catch on. Savile and
Bodley were both involved in alterations to the library
that was later to be called the Bodleian. Some of these
belong to the next chapter, but among them was the
reworking of Duke Humfrey's Library.[58]

Duke Humfrey's Library, Oxford

Humfrey (or Humphrey; both spellings are used) of
Lancaster, first Duke of Gloucester, was a younger
brother of Henry V. He was born in 1390 and died
in 1447. Although he seems not to have read either

Greek or Latin, he was a keen supporter of humanism.
He employed humanist secretaries, supported
humanist writers and collected manuscripts. But it
is the donation of books – 129 in 1439 and 134 in 1444 –
to the University of Oxford on which his reputation is
based. A new library room was built over the Divinity
School to house them. Completed in 1480, this was,
of course, a lectern library. Its contents, like those
of so many libraries, were confiscated by the king's
commissioners in 1550; its furniture was removed by
the university in 1556 and so it was in a very sad and
neglected state before it was refitted by Bodley
in 1598.[59]

Bodley's refitting of Duke Humfrey's Library and
Savile's work at Merton reveal a drawback of the stall

library. The English lectern library was typically built
with pairs of Gothic windows between each lectern.
These were placed low down, close to the desks they
were designed to light. As the lecterns were low, light
spilled over the top of them to illuminate the whole
room evenly. When Bodley replaced the lecterns with
tall shelves, the lighting conditions were changed
for the worse. The low windows still lit the desks, but
the tall shelves of each stall prevented any light from
them reaching the next bay or the centre of the room.
The problem was so acute at Merton that the radical
step was taken of building huge dormer windows to
throw light into the middle of the room.[60] The low-
pitched roof of Duke Humfrey's Library prevented
any such changes being made there. The result is that

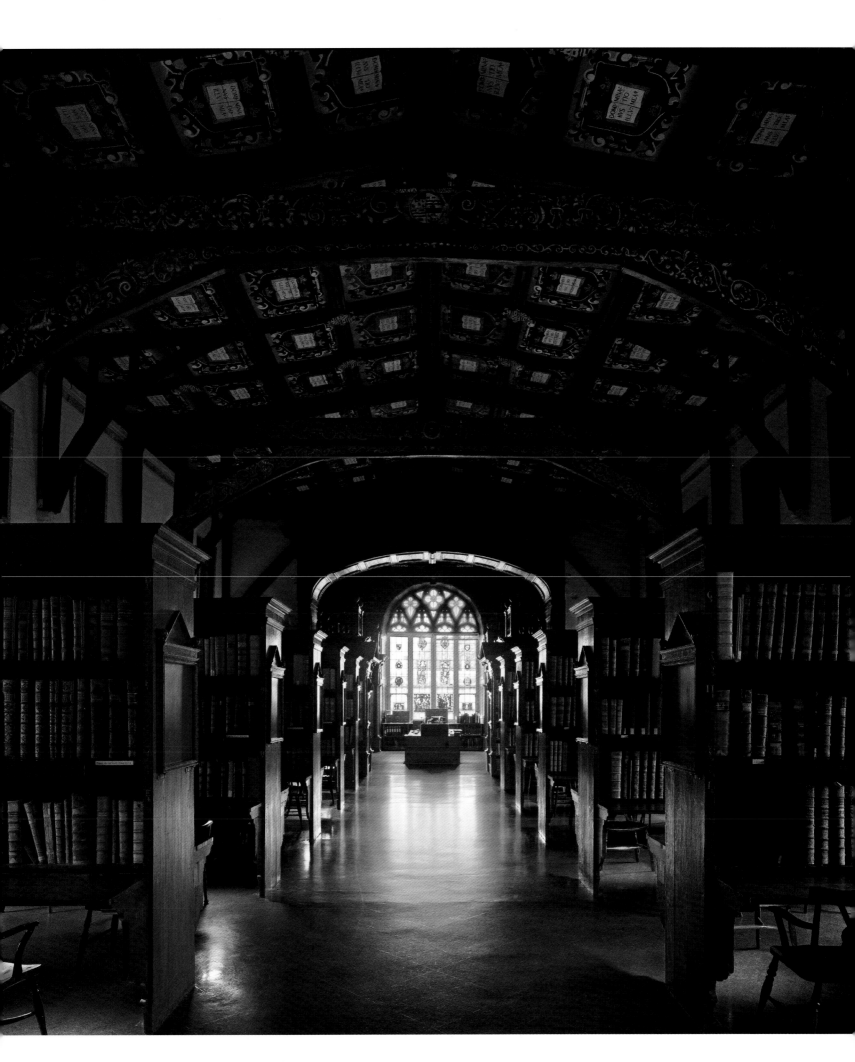

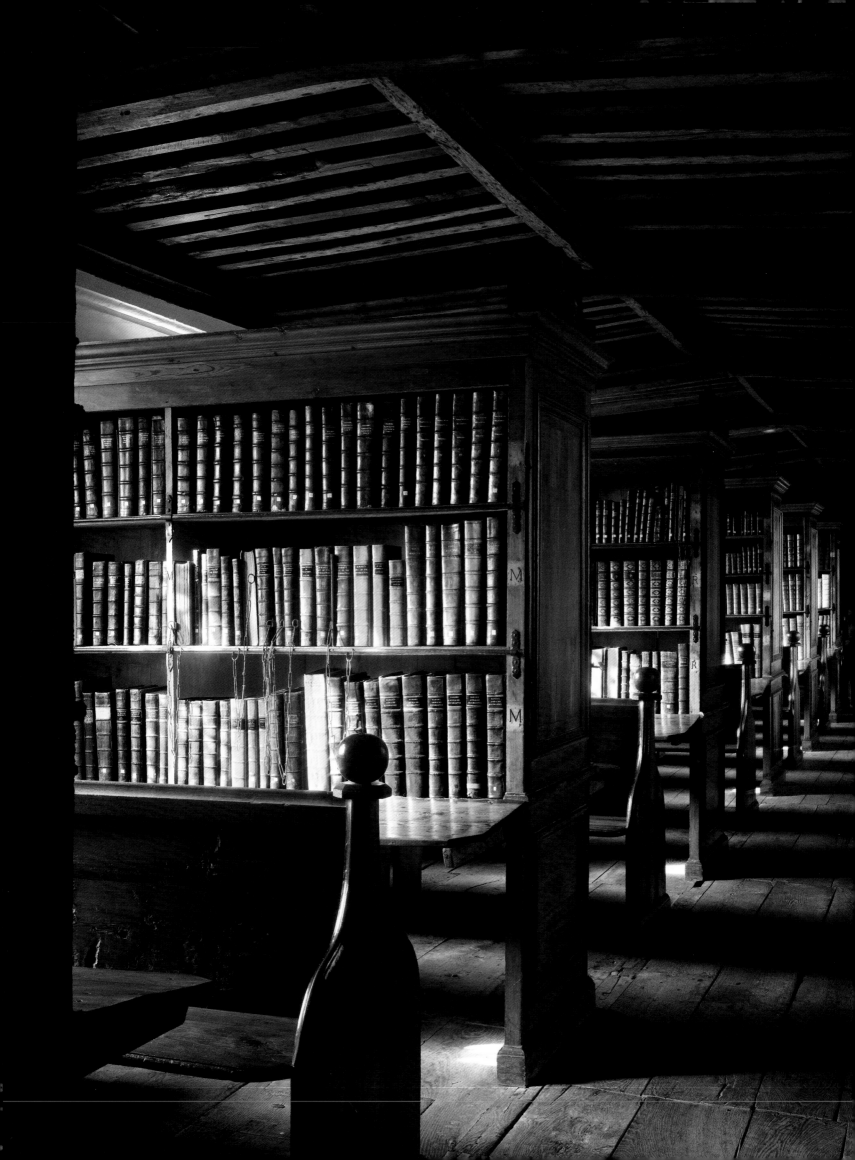

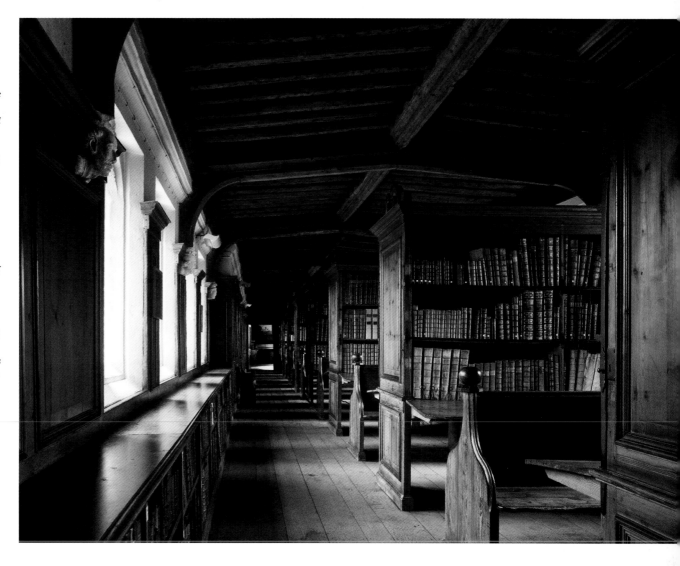

although the lighting from the windows is just
about adequate on the desks, the library as a whole
is incredibly dark, a problem of all stall libraries that,
as we shall see, would not be solved until later in the
17th century.

The stalls at Merton have lower shelves beneath
the desks but these are a later addition. Because
the books were chained to the shelves and lowered
onto the desk they had to be shelved above the work
surface. The area under the desks was originally
open, which provided room for readers to get their
feet underneath. This arrangement can be seen where
it has been restored at Duke Humfrey's Library and
Wells Cathedral library.

Wells Cathedral library

The library at Wells Cathedral in England is
particularly deceptive. The library room was built in
the mid-15th century over the cloister, and the exterior
was illustrated in the previous chapter (see p. 85) as
a surviving example of this common arrangement. It
was not refitted until as late as the 1680s.[61] Chains were
included, but by this date chaining books was already
on the way out and most libraries in the late 17th

century were built with no provision for chaining at
all. Having probably originated in Oxford in the 1580s,
the stall library spread through the colleges there,
with first St John's, All Souls and Queen's as well as
Duke Humfrey's in the 1590s, and then New College
(1602–3), Corpus Christi (1604), Magdalen (1610–11)
and Christ Church (1611). Cambridge colleges followed
suit with Trinity (1618–40), St John's (1624), Peterhouse
(1628) and Queens'.[62] These libraries were a mixture of
new buildings and the refitting of existing ones. Where
an existing room was being refitted, the usual method
of conversion was complete replacement. At Wells,
this involved filling in every other window to fit the
new cases in. At Queens', for reasons of economy, the
bookcases were chopped about and altered. The result
is particularly unusual.

Queens' College, Cambridge

Queens' College, Cambridge, was founded in 1446
and work began almost immediately on constructing
its buildings. The front court was built in two phases:
the first, in 1448–9, saw the building of the gatehouse,
chapel and library; the second, in 1449–50, continued
with the dining hall and south range, completing

below and opposite
QUEENS' COLLEGE LIBRARY,
mid-17th century. Cambridge, United Kingdom

This is a very unusual stall-system library, built by gradually changing the lecterns into bookcases. The swelling sides of the lower half of the bookshelves were once the ends of standing lecterns with desks sliding out from underneath a single shelf, as at Trinity Hall (see p. 109). The sloping top was cut off and replaced by a single bookshelf with decorative ends. These were then lifted to form the top of the present cases, with extra shelves inserted in between. More shelves were inserted at the bottom, which was originally open.

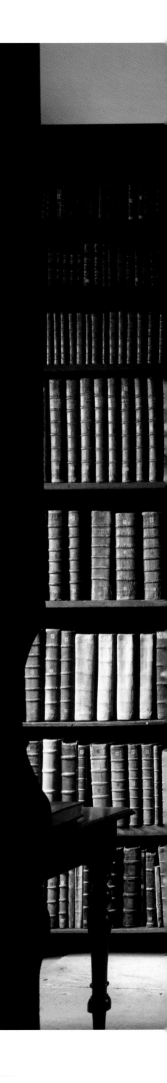

the court. The college is built of local chalk (clunch) covered in brick, a material that was just becoming fashionable. The original library was fitted with lecterns. These are thought to have been the ones that form the basis of the current presses; that is, they were two level lecterns like those at Trinity Hall, with a lower desk at sitting height and a standing lectern above it. There were ten double-sided lecterns (five on each side) and four single-sided lecterns (two at each end), with double Gothic windows in between.[63]

The lecterns at Queens' were perfectly adequate to house the collection in its early years, and the Reformation and subsequent purges of books saw the library stripped of most of its contents. The early collection was chained to the desks in the usual way and, as at Trinity Hall, the rods were at the apexes of the lecterns. In 1612–13 (or possibly in the 1590s) the upper lectern was removed and replaced by two shelves with ornate Jacobean (or Elizabethan) carved ends. Sometime in the second half of the 17th century, the bookcases at Queens' were enlarged again, by raising these ends and inserting more shelves between them, to create the tall presses that are there today.[64]

The end of the 16th century
The stall system in the 16th and early 17th centuries is a peculiarly English form. It started in the colleges of the universities and was copied all over the country for public and private libraries. The way that it divided the room into smaller bays meant that readers could enjoy some privacy from other readers, creating something akin to the carrels in medieval monasteries. Each bay became a library within a library. This system would eventually be used outside England, but for the time being it was confined to a relatively small geographical area. As a type, it produced spaces strikingly similar to those created by the cupboards in the Tianyi Chamber in China, described at the beginning of this chapter. Outside England, lectern libraries were also being replaced by the end of the 16th century, but not by stalls. In Spain, France, Italy, Germany and the rest of continental Europe a new type of layout was appearing that would come to dominate the design of libraries in the centuries to come. The age of the 'wall-system' had begun.

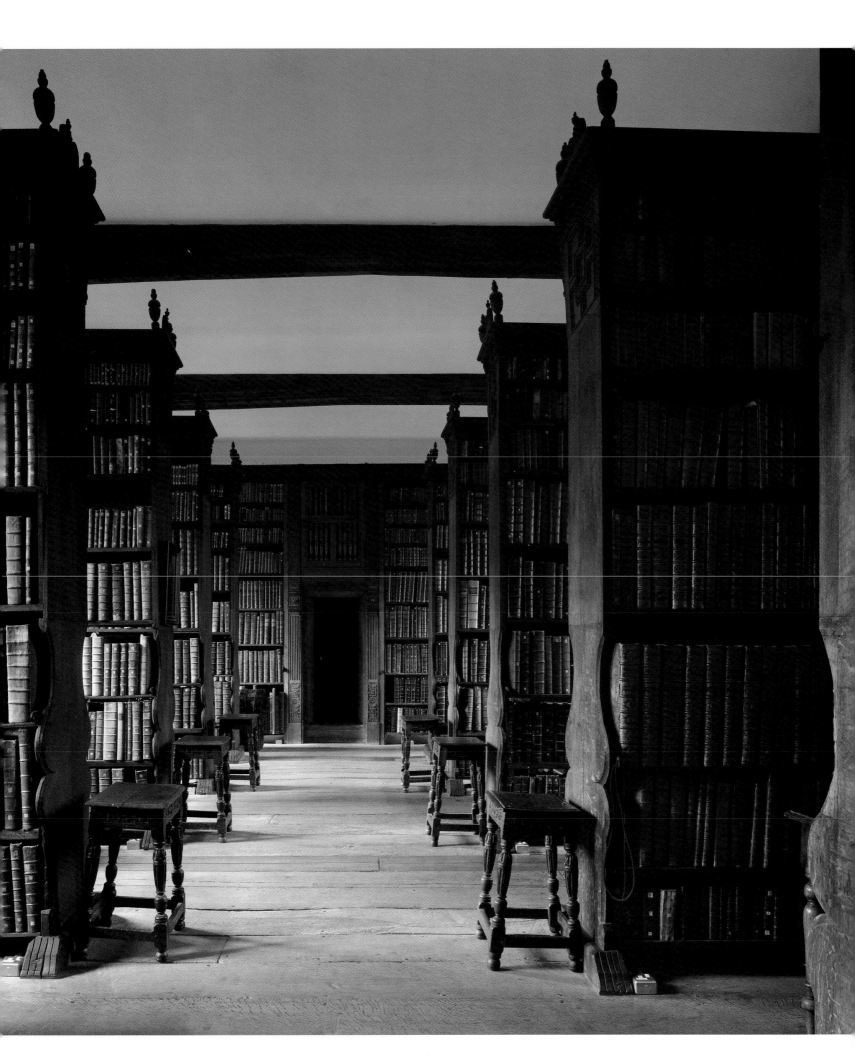

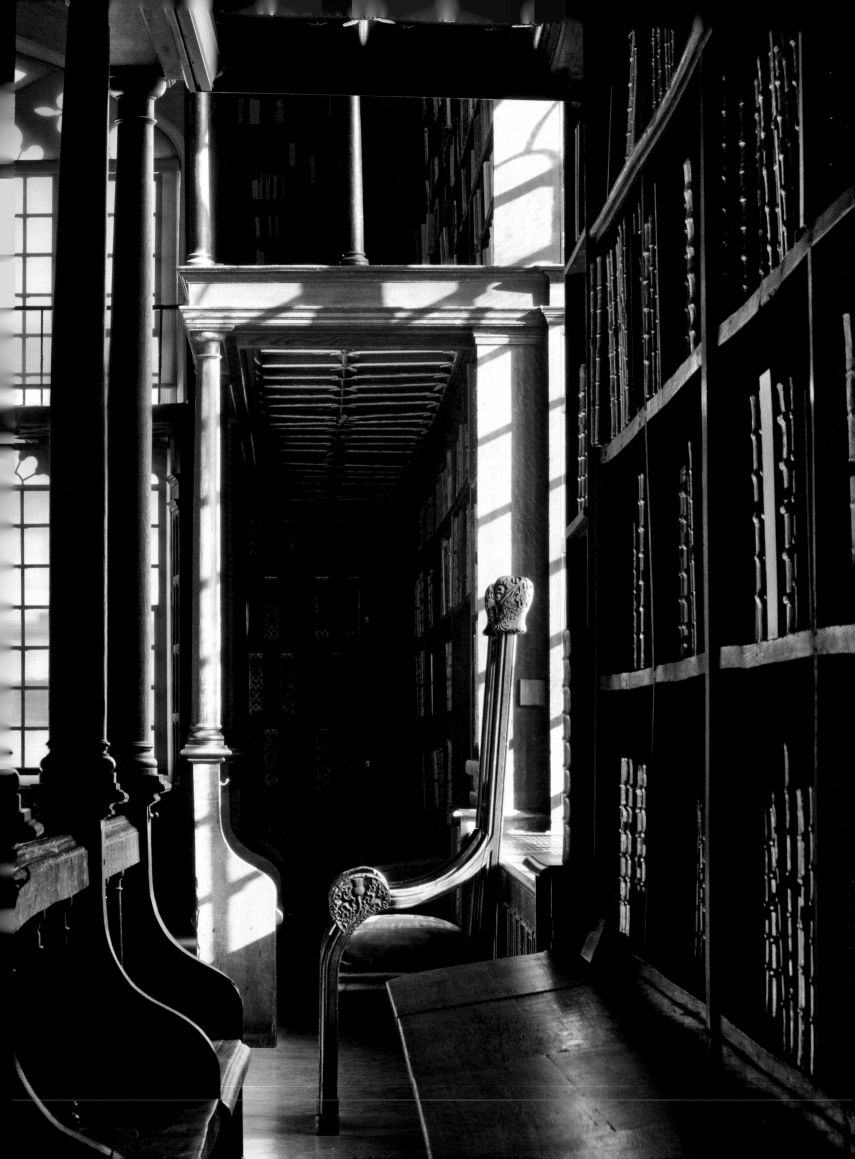

Walls, Domes and Alcoves
Libraries in the 17th Century

The 17th century marks the beginning of modern library architecture. The declining cost of books at last began noticeably to affect the way that libraries were designed. The purchase price of a typical book had been falling dramatically throughout the 16th century, but it was only in the following century that this had a recognizable effect on library fittings. To bring costs down further, new formats were introduced. Books became smaller and cheaper and the way they were shelved had to change accordingly.

The two most obvious innovations, the stall system (discussed in the previous chapter) and the wall system, were both invented in the 16th century, but it was only in the 17th century that they were fully developed. The stall system led to the invention of the alcove in this period. The wall system, which has so far hardly been mentioned, was the most common system in Europe in the 17th and 18th centuries. It led to a new type of library building: the round library.

opposite
THE BODLEIAN LIBRARY, 1612
Oxford, United Kingdom

Early morning light shines through the east window of Arts End in the Bodleian Library. The unusual arrangement of benches facing the wall was not widely copied, but it allowed the books to be chained to rods (now removed) that ran along the front edges of the shelves.

overleaf
THE ESCORIAL LIBRARY, 1585
San Lorenzo de El Escorial, Spain

This magnificent room was the first major library to use the wall system. The bookcases, which stand proud of the walls, are beautiful pieces of furniture, enriched with marquetry and architectural decoration designed to harmonize with the room.

Origins of the wall system

The origins of the wall system remain obscure and will perhaps never be completely resolved. This is partly a problem of definition. Open shelving had lined the walls of medieval book rooms. Engravings of private studies in the 15th and 16th centuries show individual shelves fixed to the walls and open book cupboards standing on the floor.[1] But these were small rooms for storage or the personal use of individual scholars and as such they barely warrant the term library: they were studies or storerooms that contained books. Larger wall-system libraries took longer to appear. Of these by far the most important – and the earliest to survive – is the library of the Escorial in Spain.

The Escorial

'Nothing can give you any idea of the Escorial, not Windsor in England, nor Peterhof in Russia, nor Versailles in France', wrote Alexandre Dumas *père* in 1846. 'It is like nothing but itself, created by a man who bent his own epoch to his will, a reverie fashioned in stone, conceived during the sleepless hours of a king on whose realms the sun never set.'[2] The library of the Escorial is an extraordinary building and became the model for monasteries and palaces for centuries to come. Combining monasteries and palaces was not a new idea, but such buildings had never taken this particular form. Architecturally, the Escorial is without doubt one of the most influential and important buildings in the history of European architecture. In terms of library design it is completely pivotal.

The palace of the Escorial has a long and complicated design history. The library, which is part of one of the late phases of its construction, was designed and built by Juan de Herrera (1530–1597) between 1575 and 1583.[3] The ceiling was then frescoed by Pellegrino Tibaldi and the whole was probably completed by about 1585. It consists of a single barrel-vaulted space, 68 m (223 ft) in length, with full-height windows at intervals in the walls down both sides. Long stretches of wall between the windows provide space for the fitting of large bookcases that sit flush against the walls. Although these are huge and built up against the walls, they are in effect large pieces of furniture, each forming a self-contained unit. However, they are radically different from previous library cupboards in their design: the books are now on display. They have become a part of the decoration of the walls of the library. The open shelving of the Escorial was both prescient and influential. It was the first time that a huge room had been lined with books, visible in serried ranks in cases along the walls. This vision of a great library hall both decorated and animated by the books that it contained was one that has dominated library architecture ever since. When we think of libraries, this is what we think of.

Defining the wall system

The parchment volumes of the Middle Ages were designed to minimize the cutting of skins, the sizes of which were determined by the dimensions of the animals they came from. The books that came off the new printing presses were predominantly produced on paper, which could be made in larger or smaller

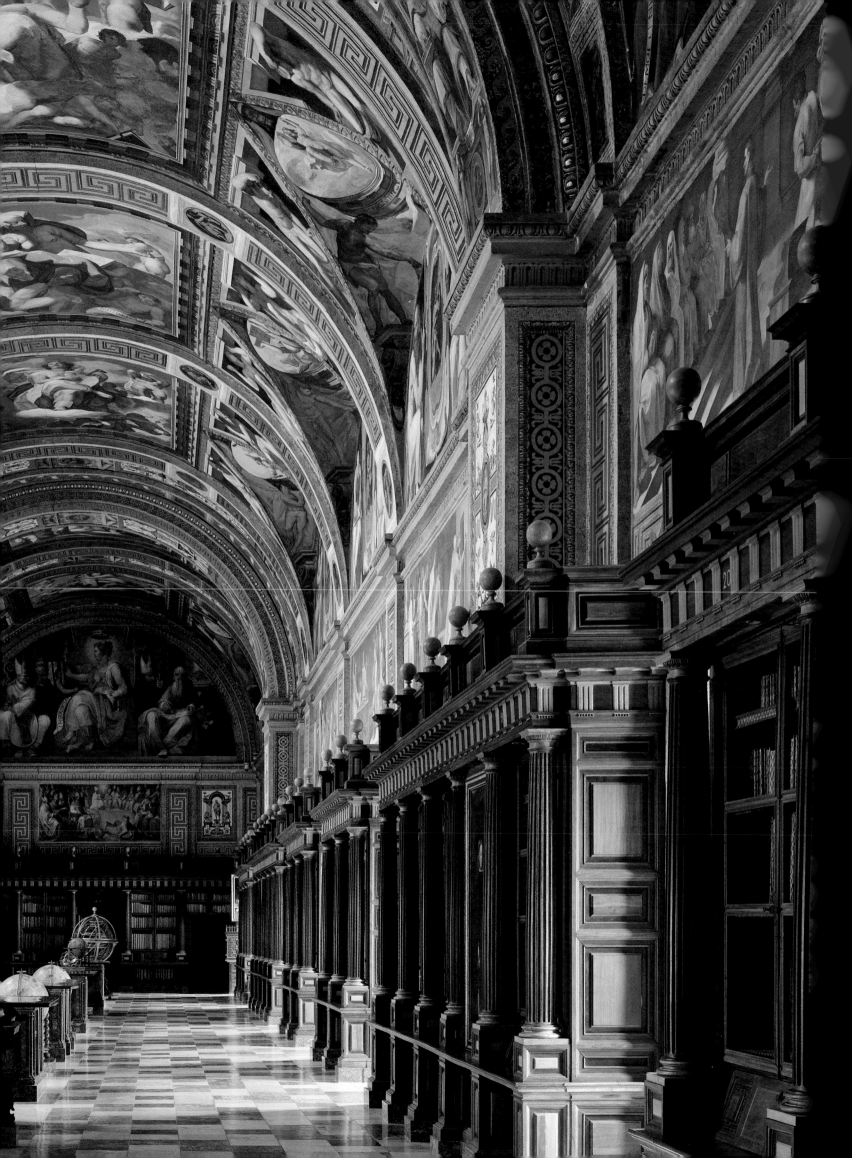

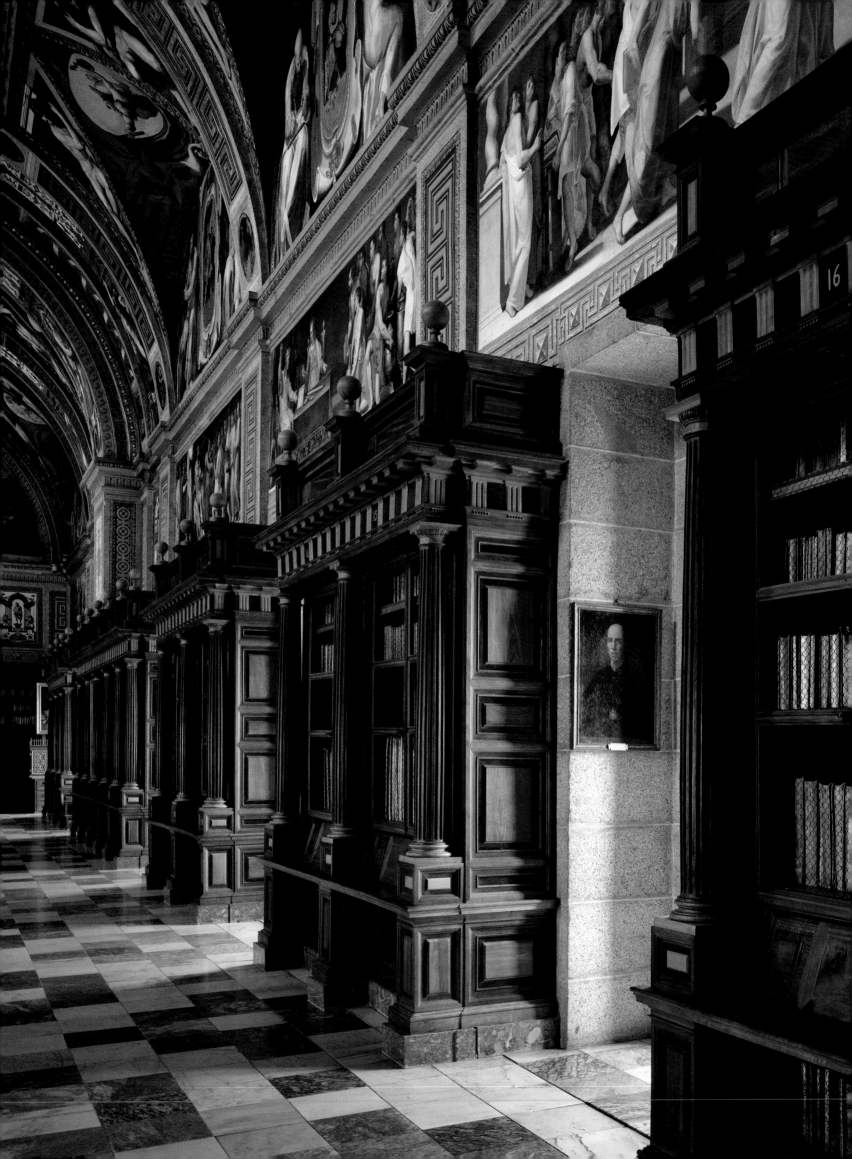

THE ESCORIAL LIBRARY, 1585
San Lorenzo de El Escorial, Spain

*Although superficially symmetrical, the two sides of the room are
subtly different. The side shown here (opposite), which faces the
square in front of the palace, has a single row of windows at low
level, while the wall facing the courtyard, visible on the left of the
preceding photograph, has two levels of windows, the upper of
which is set into the masonry vault. The portraits in the bookcases
(right) are placed where projecting piers make shelves impossible.*

sizes to suit the size of the book and the requirements
of the reader. Thus, while parchment books had
been large folio volumes, now most books were
much smaller: quarto or octavo volumes, their size
determined by folding a sheet of paper twice or four
times, to create four or eight leaves respectively. There
were even tiny sexagesimoquarto books, made by
folding a sheet six times to create sixty-four leaves
that could measure as little as 7.6 x 5 cm (3 x 2 in.).
Books could be purchased bound or unbound and as
paper was thinner and more pliable than parchment,
the need for clasps to keep books shut disappeared.
Wooden backboards were replaced by cheaper
parchment covers or pasteboard backs.[4]

All this had an immediate effect on the type of
shelving required in libraries. Lecterns had been
designed for the old-fashioned folio volumes that
were typically about 38 x 30 cm (15 x 12 in.). Because
of the way they were bound, these needed to be
shelved flat, and because they were expensive they
had to be chained to the desk. Using this layout one
book took up about 30 cm or 1 ft of a lectern – about
three books to a yard or metre. Even quite large
lectern libraries could store only 300–600 books.[5]
By the 17th century new books were cheap by
comparison and thus no longer needed chaining.
Since they were only 2.5–5 cm (1–2 in.) in thickness
when stored upright, a library shelf a yard or a metre
long could accommodate between twenty and forty
books. But, of course, there could be many tiers of
shelves, so a single metre or yard of library wall space
with between six and ten shelves could accommodate
200–400 books. Using the new layout, the number of
books that had taken up a whole room in a lectern
library could now be stored in just 1–2 metres or yards
of wall shelving.

The lower cost of books and the massive
increase in book production led to dramatic increases
in the sizes of book collections. By the beginning of
the 17th century the old lectern libraries were no
longer able to cope and a new solution was called
for. In England an interim solution – the stall system,
discussed in the previous chapter – had been adopted.
On the continent of Europe, possibly because books
were more widely available, the wall system was
used instead.

The formal characteristics of the wall system

The first and most noticeable feature of the wall
system is the walls of books from which it takes its
name. The Escorial bookcases stand proud of the
walls. They read as exquisite pieces of freestanding
furniture placed against the sides of the room, but
not entirely integral with them. The next stage
was to build the cases in such a way that they
appeared to be part of the wall and cover its whole
surface. The oldest surviving library of this type, and
probably the first library to do this in the world, was
the Biblioteca Ambrosiana in Milan. In such libraries,
the arrangement of the wall system was not simply a

This is one of the very first wall-system libraries with a gallery.
Its form, a barrel vault with semi-circular end windows, is derived
from Roman architecture and was widely copied in later libraries.
Internally, the lack of lateral windows makes the room rather dark.
The building is a faithful restoration of the original, which was
very badly damaged by bombing in the Second World War.

matter of shelving all the available wall space. The first decision the designer of such a library had to make was how tall the cases were to be. The usual maximum reach of a man is about 2.06 m (81 in.) and a woman about 1.83 m (72 in.).[6] For a wall system, this is rather low, so most libraries, as at the Biblioteca Ambrosiana, make the cases 3–4 m high (about 10–13 ft). Ladders are needed to reach the books on the upper shelves.

In all wall-system libraries, the lowest shelves never come quite to the floor. There is always some kind of skirting or plinth around the bottom of the shelves. Wall shelves have to be subdivided by uprights into presses because shelves loaded with books can only span so far without intermediate support. The sloping surfaces in lectern libraries had not needed such supports because they carried so few volumes at a time, but they were required every metre or yard or so in the densely packed conditions of the new system. These uprights could be modest and underplayed or they could be expressed and celebrated with decoration. Finally, if the walls

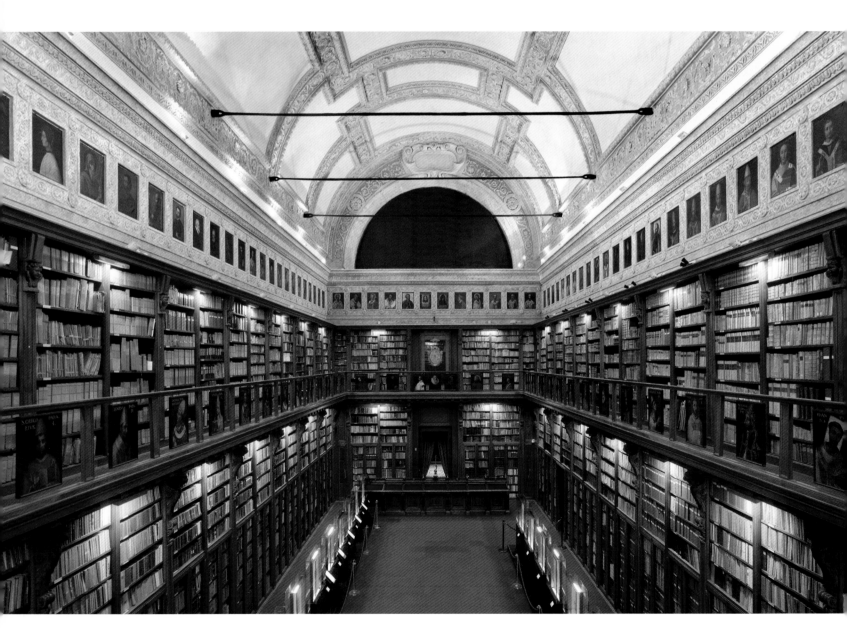

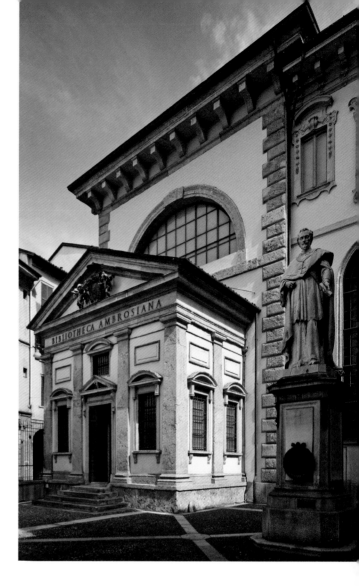

The library, which is unusual in being on the ground floor, has a particularly fine exterior. The simple, rectangular pitched-roof building is entered through this grand pedimented porch. From the beginning, the Ambrosiana was a public library, open to all visitors.

were going to have shelves above the reach of a stepladder then galleries were required. The first library to have galleries and use the wall system was again the Biblioteca Ambrosiana in Milan, but it beat the Bodleian Library in Oxford by only a couple of years, and the two were constructed so close in time as to be effectively contemporary. Because of this it is very unlikely that one influenced the other.

The Biblioteca Ambrosiana

The Biblioteca Ambrosiana is named after St Ambrose, the patron saint of Milan. It was founded by Cardinal Federico Borromeo (1564–1631), second son of the Count of Arona, and cousin of St Charles Borromeo. Federico studied law and theology in Pavia before going to Rome to complete his education. He was made a cardinal when he was just twenty-three years old and became archbishop of Milan in 1595. There he used the considerable wealth of his offices and family influence to acquire manuscripts from all over Europe and as far afield as Greece and Syria. These included the collection of manuscripts of Gian Vincenzo Pinelli (1535–1601), an Italian humanist and mentor to Galileo. The collection is said to have been so extensive that it filled seventy boxes. Borromeo decided to create a library to house his 15,000 manuscripts and 30,000 printed books. Construction of the Biblioteca Ambrosiana began in 1603.[7]

Drawings for the library were prepared by Lelio Buzzi. He had started work as a foreman on Milan Cathedral – he is mentioned in a dispute in 1569 as being inexperienced and unskilled in stonecutting. However, he went on to become head of the works at the cathedral and a local designer of some note. It was presumably through his work at the cathedral that he came into contact with Cardinal Borromeo. However, Francesco Maria Ricchino, Aurelio Trezzi and Alessandro Tesauro are also mentioned in the records as having been consulted on the project at various stages and it is not clear to whom the design of the library should actually be credited. Like so many such projects, it was probably the result of multiple hands.

Despite its unclear attribution, the building is remarkably simple and coherent in design. The library was originally housed in a single rectangular room,

now known as the Sala Fredericiana. Unlike most libraries of this period, it is only a few steps above ground level. It is entered through a doorway set in a dramatic pedimented porch in the centre of the end wall. Originally this was the only door. The bookshelves cover all the walls around the room. The lower presses are 4 m (15 ft) high and those on the gallery 2.6 m (8 ft 6 in.). This gallery is now reached by climbing a staircase in an adjacent wing of the building and passing though a door at gallery level, but it was originally accessed by spiral stairs in the corners. A band of paintings forms a cornice above the bookcases and further paintings are hung from the gallery balustrade. The room has a dramatic decorated barrel-vaulted ceiling, and lighting is provided by large semi-circular windows at each end.

The Biblioteca Ambrosiana has been substantially altered during its history. Expansions of the building to house an art gallery and an academy began soon after its completion. There were many subsequent alterations to its layout and furnishings, and after being very badly damaged in the Second World War it had to be rebuilt almost entirely. What is seen today is a faithful reproduction of the original. Nevertheless,

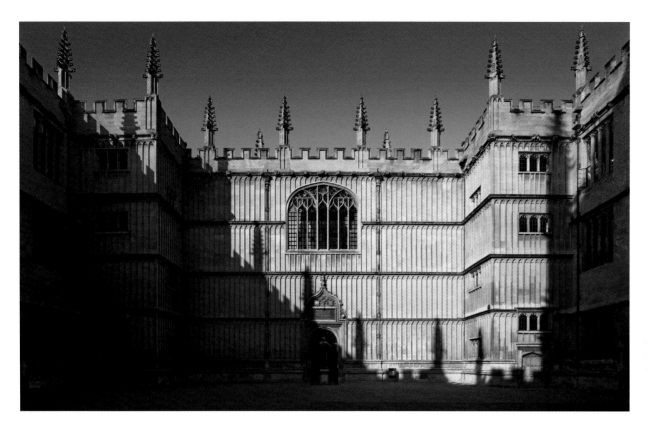

it remains one of the most important library buildings
in history. When the Biblioteca Ambrosiana opened in
1609, it appears to have been genuinely accessible to
all visitors. In 1670, an English tourist, Richard Lassels,
noted that 'The Biblioteca Ambrosiana is one of the
best Libraries in Italy, because it is not so coy as the
others which scarce let themselves be seen: whereas
this opens its dores publicly to all comers and goers,
and suffers Them to read what book they please'[8]
The Ambrosiana's openness to visitors has led some
commentators rashly to describe it as vying with the
Bodleian for the accolade of the first public library
in Europe. Clearly, as we have seen in the previous
chapters, this is not true, as many earlier libraries
had offered public access, although in all cases it
was limited to some extent. However, the Bodleian
is comparable with the Ambrosiana in another way:
it boasts a contemporary wall-system reading room
with galleries, called Arts End.

Arts End and the Bodleian Library

As mentioned in the previous chapter, Sir Thomas
Bodley was a Fellow of Merton College, Oxford,
and a good friend of Henry Savile, who fitted up the
college library there and helped Bodley to refit Duke
Humfrey's Library in 1598.[9] Bodley was determined
to re-establish the university library in Oxford, which
had been stripped of its books and furnishings in the
Reformation and political troubles of the 16th century.
He had a very modern attitude to fundraising: he
stressed the importance of thanking donors and gave

considerable sums of his own money to encourage
others to do the same.[10] The funds were raised by 1608,
but building did not begin until July 1610, and was not
finished until the end of 1612. Too ill to visit the site,
Bodley delegated much of the responsibility for the
execution of his new library to Savile.[11]

Bodley's extension to Duke Humfrey's Library
was called Arts End because it held the books on
the arts. Externally, it was designed to blend as
seamlessly as possible with the Divinity School and
Duke Humfrey's Library. It was thus constructed in
an old-fashioned Perpendicular Gothic style. The new
range was built at right angles to the old, forming
a T-shape on plan. The visitor entered the ground
floor of the new building, which formed a vestibule
called the Proscholium. This provided a new grand
entrance to the Divinity School. The library was
reached by stairs at either end of the hall. Arts End,
which is directly over the vestibule, is thus not entered
centrally, as had been typical of previous libraries, but
from either end. The windows were placed one at each
end and one in the middle. Even before the work
was finished, schemes were already underway to
complete the quadrangle in front of the library,
providing even more space.

Duke Humfrey's range had been refitted as a
stall library, but Arts End was constructed from the
beginning as a wall-system library. The inspiration
for this new arrangement is not clear, but it seems
likely to have come from Savile's travels abroad.[12]
Whatever the source, Arts End is one of the earliest

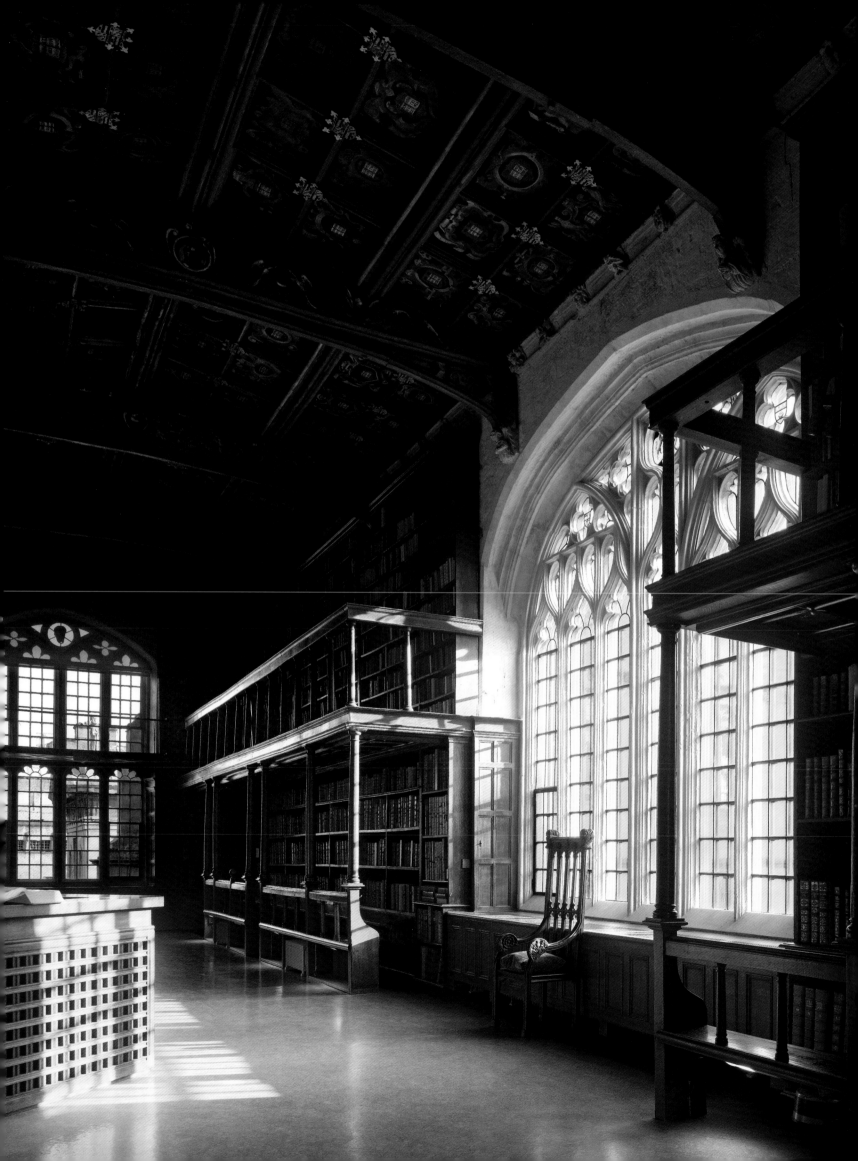

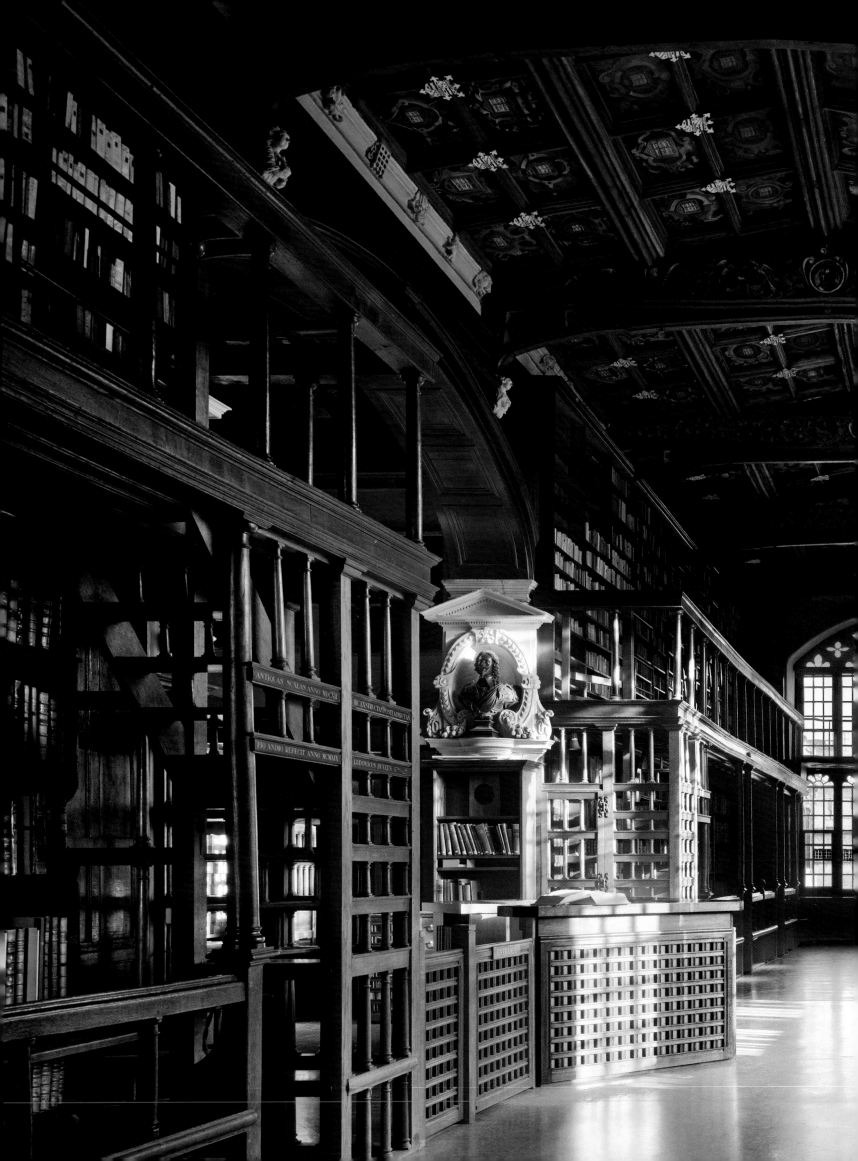

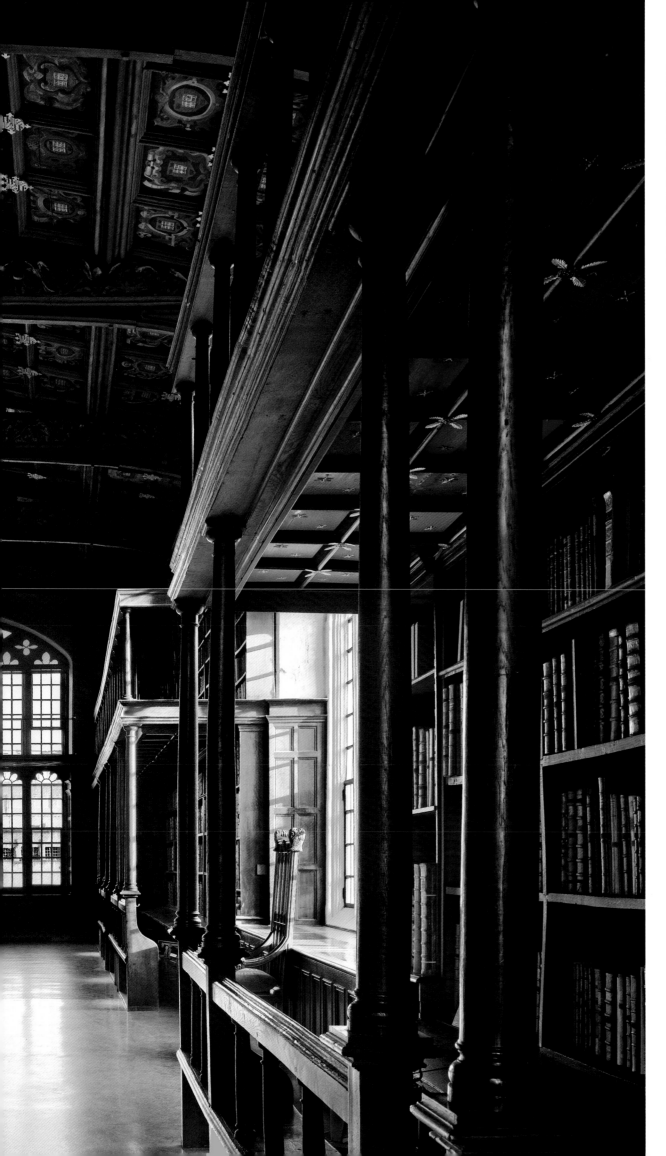

THE BODLEIAN LIBRARY, 1612
Oxford, United Kingdom

The galleries in Arts End are of a unique design never copied elsewhere. They are raised on columns that also support benches. Readers sit at desks facing the wall, and the books are chained to the shelves above. The books on the gallery were never chained, but the staircases were enclosed in timber cages to prevent unauthorized access.

131

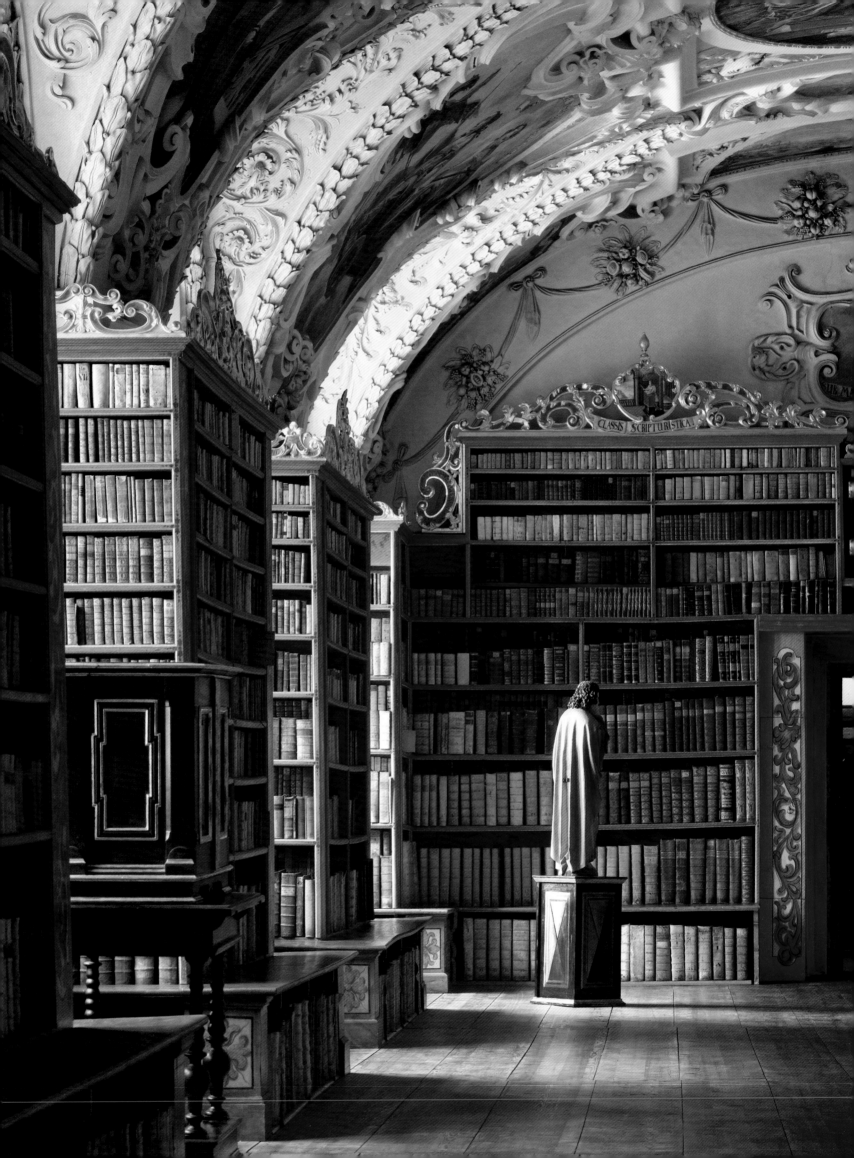

surviving wall-system libraries in Europe. However, its form is particularly unusual. The shelving appears to be integral with the wall, as at the Biblioteca Ambrosiana, but whereas there the books were presumably read at tables in the centre of the main space, at Arts End the middle of the room is kept clear for circulation. Desks are provided at the bottom of the shelves. The benches are fixed and integral with the supports of the balconies so that the reader sits facing the wall, reading at a desk projecting from the cases. This slightly odd arrangement was made odder still by the fact that the most of books in the lower cases were chained, except for the very small ones, which were kept behind caged doors at the top of the cases. Galleries gave access to more books on open shelves above. Supported by columns that form the backs of the benches, they are reached by spiral staircases enclosed in cages, which were kept locked to prevent unauthorized access. The whole arrangement forms an extraordinarily elaborate piece of joinery, never copied elsewhere. A slightly simpler layout was used when the other end of Duke Humfrey's Library was extended in 1640 by adding Selden End, named after the lawyer John Selden (1584–1654), who donated the 8,000 books that were housed there.[15]

Single-tier wall-system libraries

The wall system at its simplest involved a single storey of shelving with no gallery. This configuration was suited to rooms of the heights one might expect in private residences, up to 4–5 m (13–16 ft). Private libraries did not need chaining. It is thus almost certain that the wall system first appeared in the palaces and houses of rich collectors in the 16th century, preceding those in the larger, more public buildings discussed earlier. Many single-tier libraries were refitted in later centuries as fashions changed, or were replaced by larger buildings. The Theological Hall at Strahov Abbey in Prague provides a particularly good example of a single-tier wall-system library. The room was fitted out as a library by Abbot Jeroným Hirnhaim in 1671–9. It was created within the existing abbey complex, and the simple exterior is designed to blend with the rest of buildings. The project was chiefly concerned with the interior.[14]

The ceiling of the Theological Hall is a masonry vault, now covered in rich plasterwork added in 1721–6 by the artist Siard Nosecky, commissioned when the library was expanded in 1721 to accommodate its growing collection.[15] Masonry vaults were the preferred option for library ceilings as they offered a degree of fire protection. The concern here was not a fire within the library but isolating the library from a fire if it broke out elsewhere. Fire was a huge problem in medieval and Renaissance buildings, since coal or wood fires were used for heating. Candles presented a particular risk, usually avoided by closing the library at dusk. Library fires have been common throughout history.[16] The Escorial in Spain suffered a terrible fire in 1667 that destroyed the archives and most of the palace but mercifully left the stone-vaulted library intact.[17]

The alternative to a vaulted ceiling was a flat one, as at the Laurentian Library. Both forms were thought to reflect classical design, but flat ceilings were cheaper because they were always constructed out of timber. They also made it easier to provide large windows. The edges of a barrel vault had to come down to meet the walls. If windows were to be placed in the side walls, they had to end beneath the springing point of the vault or be cut into the vault. The latter option was not only more expensive, but also had the drawback that such windows have deep

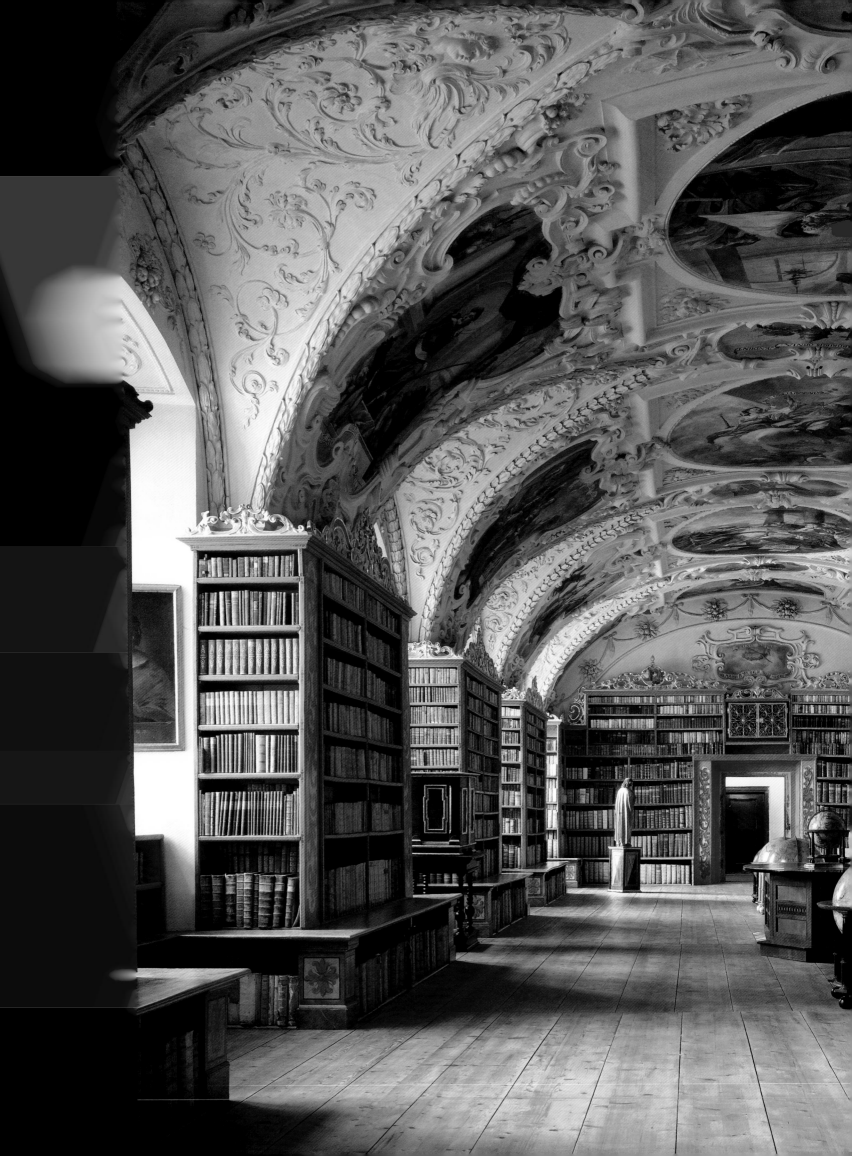

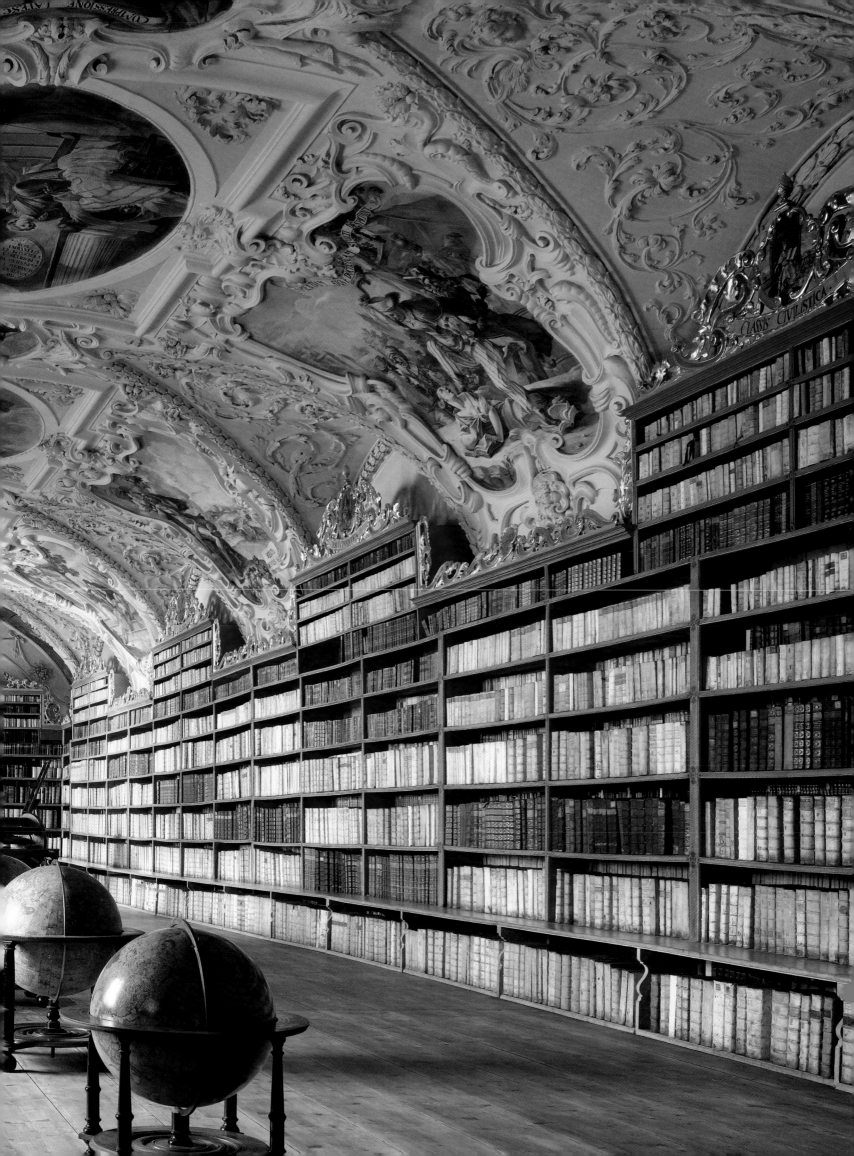

**THE THEOLOGICAL
HALL, STRAHOV ABBEY,**
1679. Prague, Czech Republic
*The shelves of the bookcases
are fixed, which provides a
pleasing uniformity. Their
timber cresting conceals the
junction between the masonry
vault and the walls.*

reveals, reducing the amount of light entering the
room. This is evident in the Theological Hall, where
the windows struggle to light the space.

Coved ceilings presented a visual compromise
between vaults and flat ceilings. These were popular
in France in the 17th century, most notably in the
ceiling designed by the architect Pierre Le Muet in
1642 for the Bibliothèque Mazarine in Paris in its
original building on the rue de Richelieu, before it
was moved to its new position in the Collège des
Quatre-Nations in 1668, where it opened to the public
in 1689. A similar solution was employed in the first
Bibliothèque Sainte-Geneviève in Paris, which was
completed in phases, starting in 1675. Built in the attics
of the abbey of Sainte-Geneviève, this consisted of a
series of long galleries lined with bookshelves on both
sides. Extensions of the library in 1699–1700, 1719 and
1732 resulted in a cross-shaped plan that in 1730 was
given a cupola at the crossing, which had the effect
more of a roof lantern than a domed library space. The
coving in the Bibliothèque Mazarine sprang from the
walls immediately above and behind the bookshelves,
leaving a flat ledge on top of the shelves. In the
Bibliothèque Sainte-Geneviève the coving – which as
at the Bibliothèque Mazarine was little more than
lathe and plaster – sprang from the front of the
shelves, which thus appeared to be set into the walls.[18]

In the Theological Hall of Strahov Abbey, the
shallow vault passes behind the bookcases and its
springing point is hidden by them. The awkward
transition is softened by decoration added to the top
of each case. The bottom of the case extends forward
to form a bench. Readers would have sat on these and
used freestanding desks (an arrangement similar to
that of the Codrington Library in Oxford, described
below). The bench at the bottom of the shelves not only
provided a place to sit but also acted as a permanent
step to help the librarians reach the higher shelves.

Libraries as museums

Today the centre of the Theological Hall is crowded
with globes and other ephemera. It is tempting to
presume that these are later additions that are ruining
our perception of the space, but this is probably not
the case: the display of globes and astronomical
instruments was encouraged by 17th-century writers

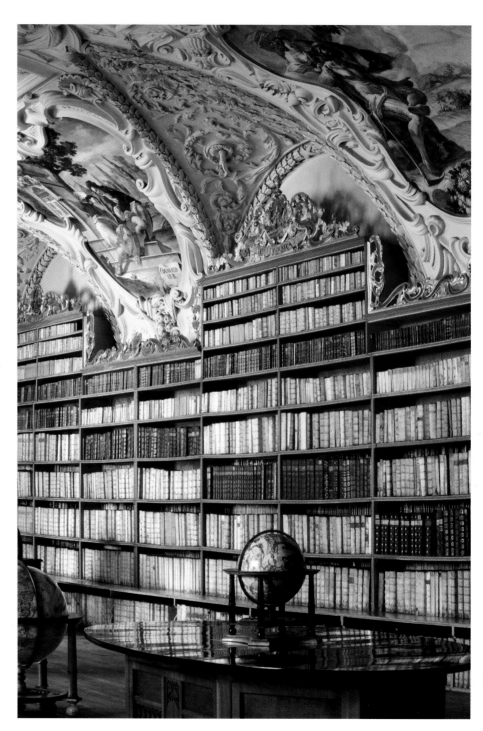

on libraries. There had been very little written on library design before the 17th century. Among the first books on the subject were Gabriel Naudé's *Advis Pour Dresser une Bibliothèque* (1627) and Claude Clément's *Musei sive bibliothecae tam privatae quàm publicae extructio, instructio, cura, vsus* (1635) Of these, Naude's *Advis Pour Dresser une Bibliothèque* said comparatively little about design and was chiefly focused on the problems surrounding creating and organizing a book collection. Clément's treatise was more important architecturally in emphasising the significance of decoration and display and in promoting the idea of the library as a 'museum', or place dedicated to the muses. These ideas were taken up in the 17th century and became the inspiration behind the great libraries of the Rococo, which form the subject of the next chapter. Central to these works was the idea of a guiding mind behind the library, a role too easily associated with the architect.

Architects and patrons

In the 17th century the meanings of the terms 'architect' or 'designer' were subtly different from our modern conception of them. There was no organized architectural profession as such. When the term was used at all, it was principally understood in reference to Vitruvius, who had written the most significant treatise on architecture in ancient Rome. This text was widely discussed in 15th-century Italy. In the first volume of his *Ten Books on Architecture*, Vitruvius described the subjects that the architect had to master, a list that encompassed virtually every field of endeavour.[19] Vitruvius's idea of the architect was thus very much that of a 'Renaissance man'. The 15th-century Italian architect and writer Leon Battista Alberti further elaborated these ideas by asserting that architecture was a profession fit for gentlemen and not just rough artisans.[20] The modern concept of the architect thus began in Italy with the Renaissance, when sculptors, painters, stonemasons and carpenters all tried their hands at architecture, and by the 16th century it was possible to get some sort of training as an architect by working for an established one. The notion spread north with the other ideas of the Renaissance. In France and Spain there were architects in the 16th century. In other countries, such as England, which lagged behind,

most buildings in the 17th century were still being designed by master masons and master carpenters.

Some caution must be exercised in ascribing the design of any library entirely to an individual, and architectural history has been all too quick to attribute the entire design of many buildings to particular architects. Even when there was an idea of what an architect was, rich gentlemen might themselves design the internal furnishings of their houses, in consultation with cabinet-makers, painters and decorators. They did not necessarily see any need to involve the expensive and perhaps temperamental services of an architect. Each historical situation needs to be examined individually. For example, drawings reveal that Le Muet designed the fittings as well as the room of the Bibliothèque Mazarine.[21] In other cases the situation is not so clear. The design of the Bodleian Library's Arts End, for instance, seems to have been prepared without any architect, whereas the Biblioteca Ambrosiana appears to have involved a number of them. A series of libraries associated with the 17th-century English architect Sir Christopher Wren (1632–1723) provides a useful set of examples. Of these, the earliest that survives is the library of Lincoln Cathedral in England.

Lincoln Cathedral library

Wren was probably involved in more library projects in the late 17th century than any other architect in Europe and he made decisive advances in library design. He travelled to Paris in 1665 and it was likely there that he first saw wall-system libraries and decided to bring the idea back to England, although he would also have been familiar with the libraries in Oxford.[22] His library at Lincoln Cathedral is a particularly fine surviving single-tier wall-system library. The room, like so many earlier libraries, is built over a cloister, placing a series of constraints on its design. It was the brainchild of Dean Michael Honeywood (1597–1681).[23] The library was begun in 1674 and a surviving building contract stipulates that the buildings should be built 'according to Sir Christopher Wren's directions and Mr Tompson's model'.[24] 'Tompson' was probably John Thompson (*c.* 1650–1700), a stonemason employed by Wren at St Paul's Cathedral, Hampton Court Palace, Kensington Palace and a number of churches in the City of

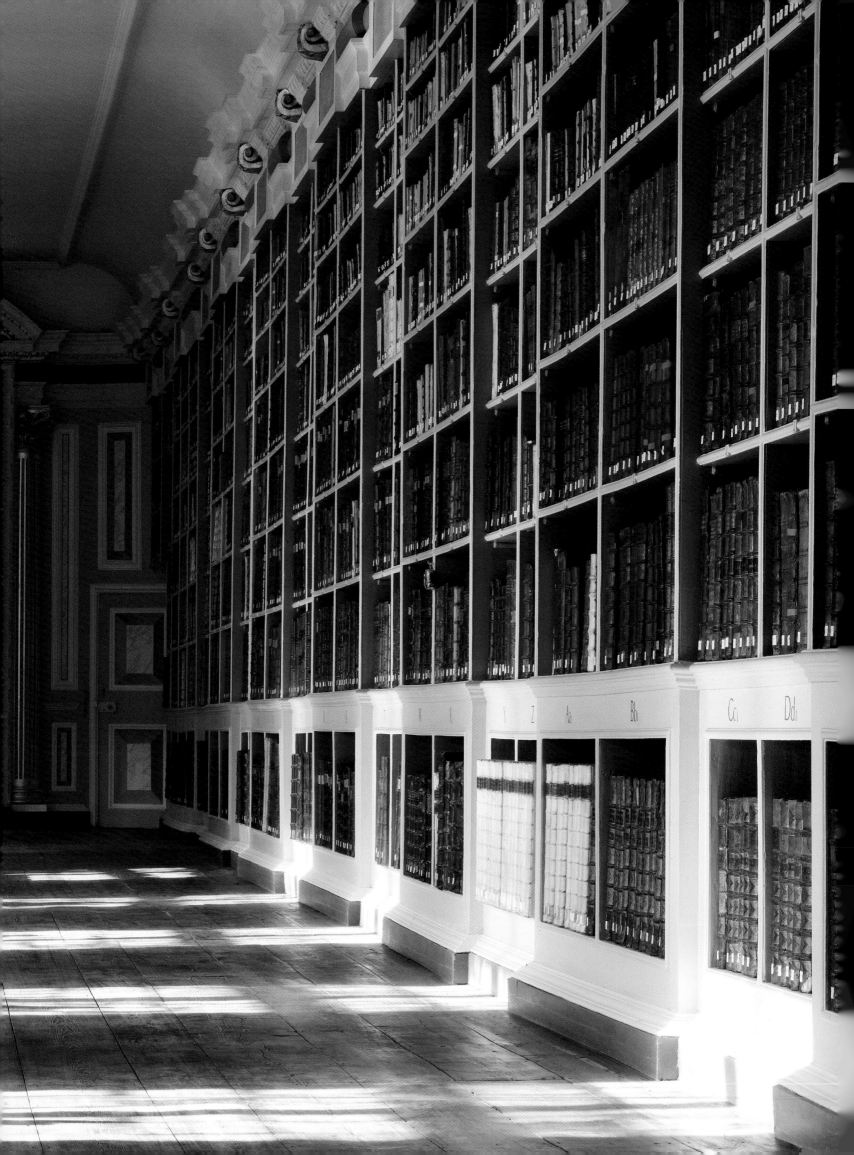

opposite
LINCOLN CATHEDRAL LIBRARY, 1674
Lincoln, United Kingdom

This long, thin library, designed by Christopher Wren, replaces one side of the existing cloister. It originally linked the Deanery with the old, timber-framed library (now partially demolished). The library is an elegant room on the first floor, lit by windows along one side, facing the bookcases on the opposite wall.

right
THE SENATE HOUSE, 1675
University of Cambridge, United Kingdom

Wren had designed the Sheldonian Theatre in Oxford as a space that could be used for the awarding of degrees. In 1675 he prepared a design for a Senate House at the University of Cambridge for much the same purpose, but it was not built. It would have incorporated a fine room for the University Library, lit by windows in the side and end walls and a long central rooflight, a feature that would have been unique.

London in the 1680s.[25] The word 'model' in England at this time could mean 'design', but here it probably meant a physical model. The exact role Wren played in the preparation and design of this model, and the degree to which he left it to Thompson and Honeywood, is uncertain. The library itself survives intact. It takes the form of a long gallery. The shelves run along one wall, facing a wall of windows. The ceiling is coved and the shelves are open and fixed. The fittings are relatively simple. The shelves do not incorporate a desk, but the lowest ones are larger and have thicker borders, suggesting that there were originally cupboards beneath the dado. The top includes an exaggerated cornice that steps forwards and backwards to break up the long face of the wall.

Wren's work at Lincoln was followed by a scheme for a building that would be both a new library and Senate House for the Universty of Cambridge. This was to include a two-tier wall-system library lit partly by side windows and partly by a long roof light down the middle. Such roof lights were uncommon in the 17th century as they were very difficult to construct. Had it been built it would have been well ahead of its time, but the scheme was thought too costly and was rejected.[26] However, Wren went on to build a two-tier wall-system library at St Paul's Cathedral.

The Dean's Library, St Paul's Cathedral
The library is on the south side of the cathedral at triforium level and is reached by a dramatic staircase in the south-west tower. Designed in the 1690s, it was built in the early 18th century as part of the last phase of the cathedral's construction. Originally there were to be two libraries, one for the dean on the south front and one in the corresponding position on the north side, to which there would be public access. However, the idea of a north library was dropped and that room became instead a permanent space for the exhibition of Wren's model of the cathedral, a function it has regained today. The Dean's Library was completed as Wren designed it.[27]

The library is a spacious room lit by large windows high up on its south wall. It is a two-tier library with a wide gallery cantilevered on timber brackets. Recent investigations have shown that the construction was somewhat makeshift and as a result the gallery leans at an alarming angle in places. It is reached by spiral staircases in a separate space beyond the library itself, concealed in the walls of the south-west tower. The most charming feature is the large fireplace, one of very few in the cathedral. Fireplaces were rare in libraries, since there was always concern about the risk of having inflammable books in easy reach of naked flames.

The choice of whether to have a gallery or not in wall-system libraries was not just a matter of convenience and height: it was also important in providing a secure area. The books on the lower

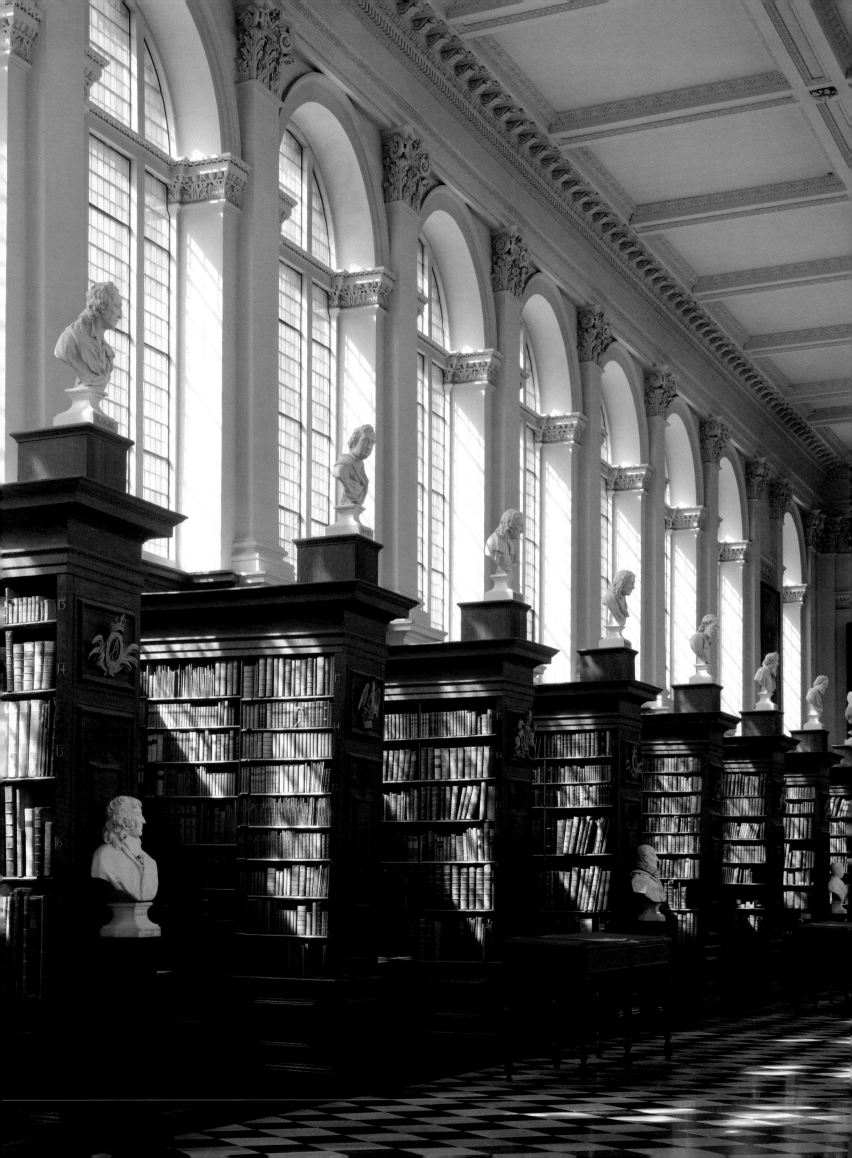

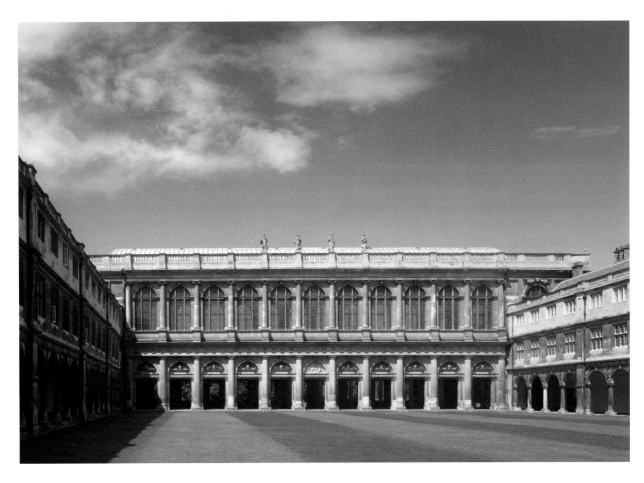

shelves of the Biblioteca Ambrosiana are protected by mesh doors to prevent their unauthorized removal. These may not be original, but similar doors were certainly provided at the Bodleian's Arts End from the beginning to protect the smaller books at the top of the lower presses, which were easily pocketed but not easily chained. Steps or ladders could be used by anyone to access the upper parts of lower tiers of shelves. However, in virtually all libraries the gallery was accessible only to librarians, and this division into books accessible from the ground and those visible on a gallery but retrievable only with assistance, became an important feature of subsequent libraries. The hiding of the stairs to the gallery was not just an aesthetic move, as it also prevented unauthorized access: if you could not see the stairs you could not sneak up them when the librarian was not looking.

The library at St Paul's is comparatively unknown, although its form is strikingly similar to later Rococo libraries in Switzerland, Austria and Germany. Some of Wren's other library designs were not built or have been destroyed. However, his most important library – that of Trinity College, Cambridge – remains intact and very much as Wren conceived it.

Trinity College, Cambridge

The colleges of Oxford and Cambridge contain some of the finest 17th- and 18th-century libraries in the world. Bequests of books in these years and the generally inadequate facilities provided by the universities meant that it was left to the individual colleges to provide spaces in which their students could study. The earliest response was the refitting of existing libraries using the stall system in place of the original lecterns. The wall system seen at Arts End in Oxford was slow to be adopted in college libraries, the first being University College, Jesus College and St Edmund Hall in Oxford, all fitted out between 1668 and 1682.[28] This was not so much because the books were still being chained – although some colleges retained chains on their book collections into the 18th century, chains were becoming less common – but rather because stalls were now the established norm.[29] When St John's College, Cambridge, built a new library in 1624 it was a stall library, but it was not fitted out for chaining.[30] Of all the libraries built for colleges in the 17th century that of Trinity College, Cambridge, was the grandest and most admired.[31] It was also one of the first to rethink the stall system.

The project is said to have been started by Isaac Barrow, Master of Trinity and at the time also vice-chancellor of the university. It was Barrow who had asked Wren to produce a scheme for the rebuilding of the Senate House that would also provide new space for a university library. When that scheme was rejected, Barrow is said to

have been so upset that, according to Roger North (1651–1734), he declared 'he would go straight to his college, and lay out the foundations of a building to enlarge his back court, and close it with a stately library, which would be more magnificent and costly than what he had proposed to them'. This account has come down to us at second hand and is probably exaggerated, but it is certain that Barrow wasted no time building a new library. In 1676, barely a year after the Senate House scheme had been rejected, foundations were begun.[32]

Trinity College is today renowned for being the richest college in Cambridge, but much of its income in the 17th century came from rents and these were depressed at the time, leaving the college's finances in a dire state. The library project thus had to be financed by donations. A campaign was launched and promises of funding were received, but problems of finance plagued the works and the building was not completed until 1695.[33] Wren's final scheme for Trinity's massive library was both original and daring. It was built on an island in the river Cam, one branch being filled in during construction. The possibility of flooding was obvious, so Wren followed the accepted practice of building the library on the first floor. The existing courtyard was short and opened onto a garden. Wren extended the two wings of the existing buildings to create a much larger courtyard, the whole end of which was completed by the new library. The cloisters that already existed under the old wings were extended and continued under the library. The resulting library is rectangular in plan, with a long front facing the river and forming the edge of the college, and a slightly shorter front facing into the court. Wren distributed windows regularly down both sides. Where the two ends of the court meet the new buildings, he cleverly positioned light wells to allow the windows to remain the same height in the end bays.

The river today runs through a series of beautiful gardens but in the 17th century it was used for barge traffic and was much less engaging. The river façade is thus treated as a rear elevation with the minimum of decoration. All the money was spent on the courtyard side – which was designed to be seen by the visitor – and on the interior. A path across the middle of the courtyard led directly to the centre archway, above

which is a relief showing Ptolemy receiving the Septuagint in the library of Alexandria, while on the roof there are four statues representing Divinity, Law, Medicine and Mathematics.[34]

Wren's façade for the courtyard side is of his own devising and drawings show that he tried a number of versions before settling on the final design. He had never been to Italy but Barrow had seen Sansovino's Biblioteca Marciana, and may have described it to Wren.[35] Its influence has been noted by historians.[36] Likewise, there is obviously a similarity between Wren's design and illustrations of public buildings in Palladio's *Quattro libri dell' architettura*.[37] The final composition, however, is Wren's own. The problem he faced was providing a substantial and elegantly proportioned façade with an internal floor level at the required height. The college wanted the rooms on either side of the library to be able to connect with it directly at the same level. Wren's solution is ingenious. He placed the floor not at the level of the lower entablature, as the eye expects, but at the level of the imposts of the lower arches, which are filled in. The result is that the room inside is far taller than the exterior suggests.[38] The library is entered via a grand staircase in a pavilion on the north end of the building. In the original drawings there are two pavilions, one at each end, but to save costs only one was built.

The invention of the library alcove

Wren's internal layout is the most original part of the design. His most important decision was to place the windows high up above a single tier of bookcases and then run bookcases along the walls as in a wall-system library, while at the same time placing them at right angles to the walls as in a stall library, to form what might be called 'alcoves', in which the books surround the readers on three sides. Alcoves are rooms within rooms. They combine the advantages of both the wall system and the stall system. The cases of books at right angles to the walls greatly increase the capacity and divide the room into useful study areas, while the disadvantages of lack of light are overcome by raising the windows above the stalls, freeing up the wall space to be used for yet more books. The result is a triumph of classical library design, the first 'alcove' library in the world.

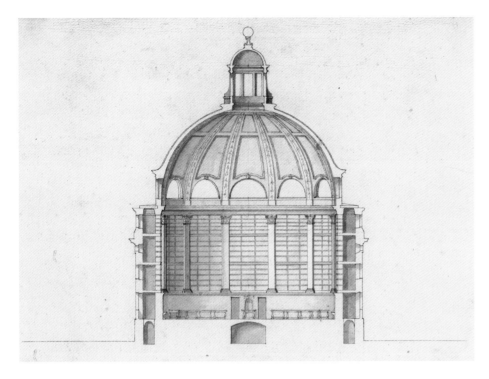

Furnishing the library

To finish off the interior, Wren intended that the
tops of the bookcases would be decorated with
full-size statues in keeping with the ideas about library
decoration voiced by the Dutch writer Justus Lipsius
in his *De bibliothecis syntagma* (1602), which were
echoed by Naudé.[39] In the event, the finances could
not stretch to full-size statues, and instead magnificent
busts of famous writers, many by Louis-François
Roubiliac, were installed, mostly long after Wren's
death. The only other decoration is the coats of arms
and festoons commemorating the library's benefactors
on the ends of the cases and over the door, carved by
Grinling Gibbons.

The Trinity College library scheme is one in
which we know for sure that the architect controlled
the design of the fittings. Drawings survive for the
shelves, desks and stools. Wren's bookcases are
beautifully worked out. All the shelves sit on a timber
dais raised above the marble library floor. This
provided both acoustic and thermal insulation and,
of course, reduced the amount of marble required.
The lowest level of the stalls is formed by a plinth
of cupboards. Above this, the shelves are ranged at
reducing heights. They were originally fixed, although
some have been moved over the years. Following the
usual custom, the smallest books were placed at the
top, well out of arm's reach. The stools were given
splayed legs, allowing them to serve as both seats and
steps, and a revolving lectern was provided in the
middle of the tables to aid study. The shelf list is neatly
fitted in a panel behind a little concealed door on the
end of each case. Because of the adjoining buildings,
the bay width is not quite even, with one shorter and
one wider bay at each end. These positions provide
space for cupboards and stalls with locked gates for
the storage of manuscripts. The size and magnificence
of this library was out of all proportion to its purpose
and made it a source of national pride that attracted
considerable comment from foreign travellers.[40]

The first round libraries

Wren had made an earlier, rejected scheme for Trinity
College library that is even more interesting than the
one that was built. Drawings show that he originally
toyed with the idea of completing the courtyard with
a free-standing centralized pavilion.[41] Architects
throughout the Renaissance had been fascinated with
the idea of such buildings. Leonardo's sketchbooks
are full of designs for centralized churches, fortresses
and palaces. Wren's design, however, was the first for a
centralized library and, despite the fact that it was never
built, it was influential.

Wren's proposal was for a round library raised
above a deep square base about 1.8 m (6 ft) high. The
reader ascended via steps to an entrance portico of
engaged columns and passed through a small elliptical
porchway into a round reading room. The librarian
sat opposite the entrance on an enormous throne. The
readers sat with their backs to a stone wall on benches
reading at desks. Above them, but out of reach, they
could see shelf upon shelf of books rising to the dome
above. Lighting came from clerestory lights and the
lantern in the centre of the dome.

This design is interesting because it was intended
for a particular way of shelving books. In the 16th
century, when books were first placed upright on
shelves, they were shelved with the paper outwards
and the spines hidden. This is the way they are still
shelved in the Escorial today. The name of the book
was written in pen or pencil on the exposed paper
edges of the pages. Books that were chained had to
be shelved this way because the chain was attached
to the leading edge of the board and dangled down
over the edge of the shelf. As books became cheaper,
chaining them became unnecessary and, indeed,
expensive in comparison to their value. The books
could then be turned around to expose the spines,
and when this was done the title for the first time
came to be written on the spine, which was often

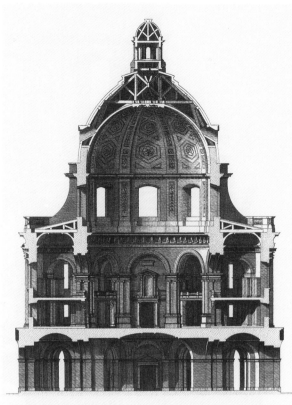

further embellished with gilding and embossed
decoration. Only when this was done did it become
desirable to have all the books in a single collection
bound in the same design so that the walls of a room
might appear uniform. The first books with writing
on the spines appear in the 16th century but the
practice became common only in the late
17th century.

Wren's design for a round library at Trinity
College marks the turning point between these two
traditions. The shelves are shown as being double-
sided. The paper side of the books would have been
visible from the galleries, from which the books
would have been retrieved by the librarians. The
leather spines would have produced a decorative
wall of books on the inside of the reading room.
This was only possible because it was assumed that
books still had the title written on the paper side,
otherwise the librarians would not have been able
to find the books they were looking for. Had Wren's
design been built it would have been the first round
library in the world, but Trinity rejected it. However,
the idea persisted in the mind of Wren's pupil
Nicholas Hawksmoor (*c.* 1661–1736).

The Radcliffe Camera, Oxford

Hawksmoor was responsible for drawing many of
Wren's designs and supervising their construction.
He worked on the library at Trinity and must have
known the unbuilt round scheme. Hawksmoor's

opportunity to design a round library came in
Oxford in 1712–14, when the eminent physician
Dr John Radcliffe (1652–1714) engaged Hawksmoor to
draw designs for an extension to the Bodleian Library,
which he wished to fund.[42] Hawksmoor produced a
scheme for a round library, attached to Selden End
and on axis with Duke Humfrey's Library. This would
have involved building in the grounds of Exeter
College. This proved impractical, so Radcliffe decided
that the library should be built in the middle of an
open square nearby, to be created by demolishing the
houses that stood there. Radcliffe died in 1714 leaving
a considerable amount of money for his library to be
constructed. However, removal of the houses proved
extremely difficult and the site had only just been
cleared at the time of Hawksmoor's death in 1736.
The project was thus passed to another architect,
James Gibbs (1682–1754), who was instructed to
follow the outline of Hawksmoor's scheme. Gibbs's
library, finally opened in 1749, is always known as
the Radcliffe Camera.[43] Even if it had been built to
Hawksmoor's designs in 1714 it would not have been
the first round library reading room in the world.
In the time that elapsed between Wren's drawings
for a round library for Trinity in 1675 and Radcliffe's
decision to bequeath a library to the University of
Oxford that title had already been taken. The project
in question was the first building that housed the
Herzog August Bibliothek in Wolfenbüttel
in Germany.

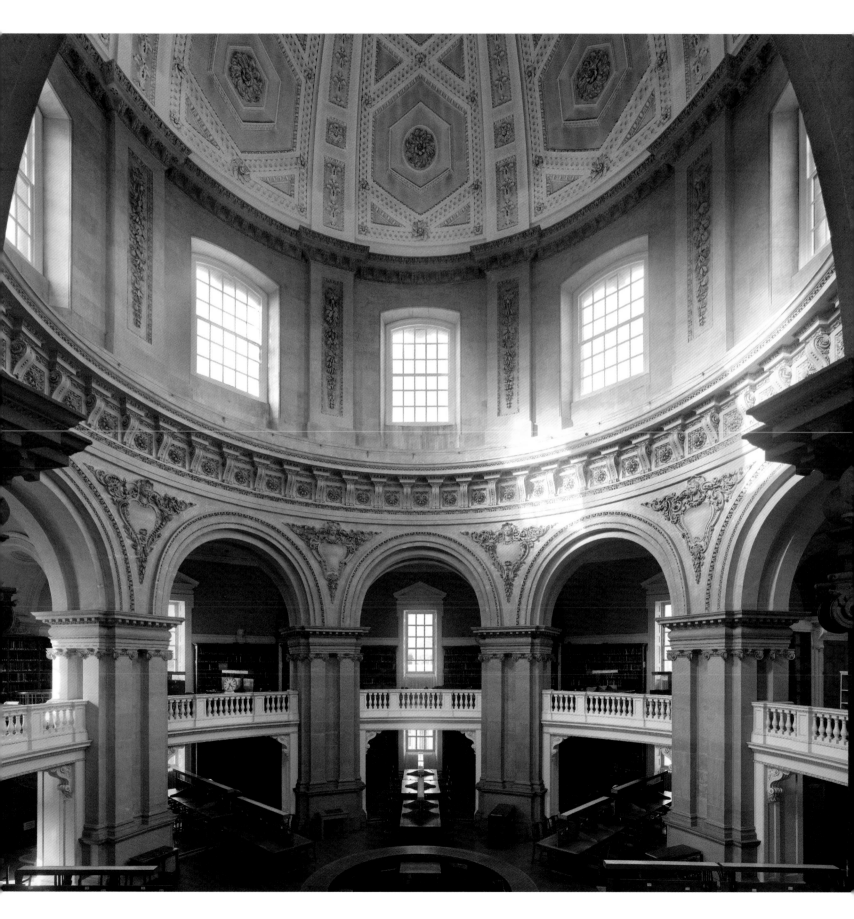

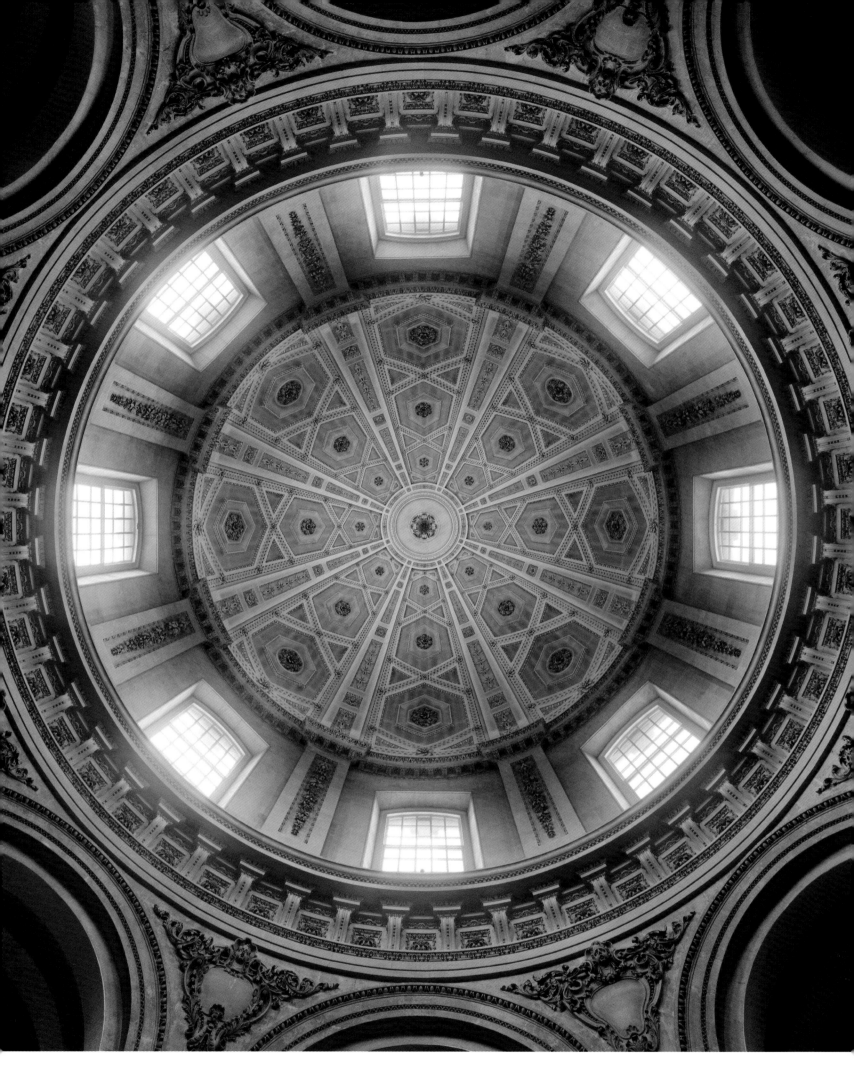

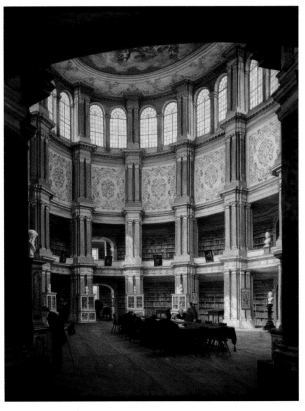

opposite
THE RADCLIFFE
CAMERA, 1749
Oxford, United Kingdom

*The view up into the dome.
The Radcliffe Camera was a
very early domed library but
it was not the first.*

below and right
HERZOG AUGUST BIBLIOTHEK, 1710
Wolfenbüttel, Germany

*The first domed library in the world, the Herzog August
Bibliothek was completed to the designs of the architect
Hermann Korb between 1705 and 1710. Although a dramatic
design, it was poorly constructed and was demolished in 1886.*

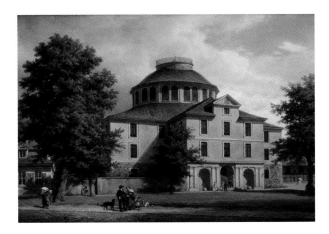

The Herzog August Bibliothek

The Herzog August Bibliothek was funded by
successive dukes of Brunswick. The most important
of them was Duke August the Younger (1579–1666),
who at his death left over 35,000 volumes to found
the library. The mathematician and philosopher
Gottfried Wilhelm Leibniz (1646–1716) held the
post of librarian, among his many other offices for
the duchy.[44] The building to house the library was
designed by Hermann Korb (1656–1735). He was a
carpenter by training and seems to have been largely
self-taught as an architect, but was evidently talented,
and rose through the ranks of the office of works of
the duchy of Brunswick to become its head in 1704.
Most of Korb's works were built in timber to imitate
stone and have disappeared. The library was probably
timber too. Its layout was particularly innovative.
Plans show that the reader entered the building
through an entrance tower, which also housed the
staircase giving access to the upper floor. Inside,
the central reading room was not circular in plan,
but oval. Tall, arched clerestory windows high
above provided much of the light. The books were
arranged around all the walls in bookshelves with
fixed shelves painted white. Large blank walls
below the windows concealed the sloping roofs
behind and were decorated with painted patterns.
The new library was built between 1705 and 1710.
Architecturally it was not entirely satisfactory and
was demolished in 1886 to be replaced with a much
larger, if less interesting, stone structure.[45]

The Codrington Library

Hawksmoor may not have designed the Radcliffe
Camera, but he was responsible for another library
in Oxford, the Codrington Library for All Souls
College. The library was begun in 1716, shortly after
his designs for Radcliffe's library, and was finished
in 1720, although the fitting out was not completed
until 1751.[46] The Codrington Library is unusual for
being on the ground floor. To attempt to alleviate
damp – the traditional problem with ground-floor
libraries – it was built over a basement.

The Codrington Library, like the Radcliffe
Camera, takes it name from its benefactor.
Christopher Codrington was a Fellow of the college
who bequeathed to it 12,000 books, together with
money for the construction of a new building to house
them.[47] The Fellows insisted that Hawksmoor's library
had to blend seamlessly with the existing college
buildings by being Gothic on the exterior. Inside,
it reflected the very latest taste in classical design.
Hawksmoor dealt with this challenge with great
cleverness, especially in the windows at each end,
which are classical serlianas (Venetian windows)
on the inside and Gothic on the outside.

The library's internal layout is entirely original.
The constraints of the site meant that it was possible
to have windows only on one side and at both ends.
At the lower level, the room is entirely lined with
books around all four sides on the wall system. The
cases are lifted above the floor by solid timber benches
running around all the walls. Readers sit with their

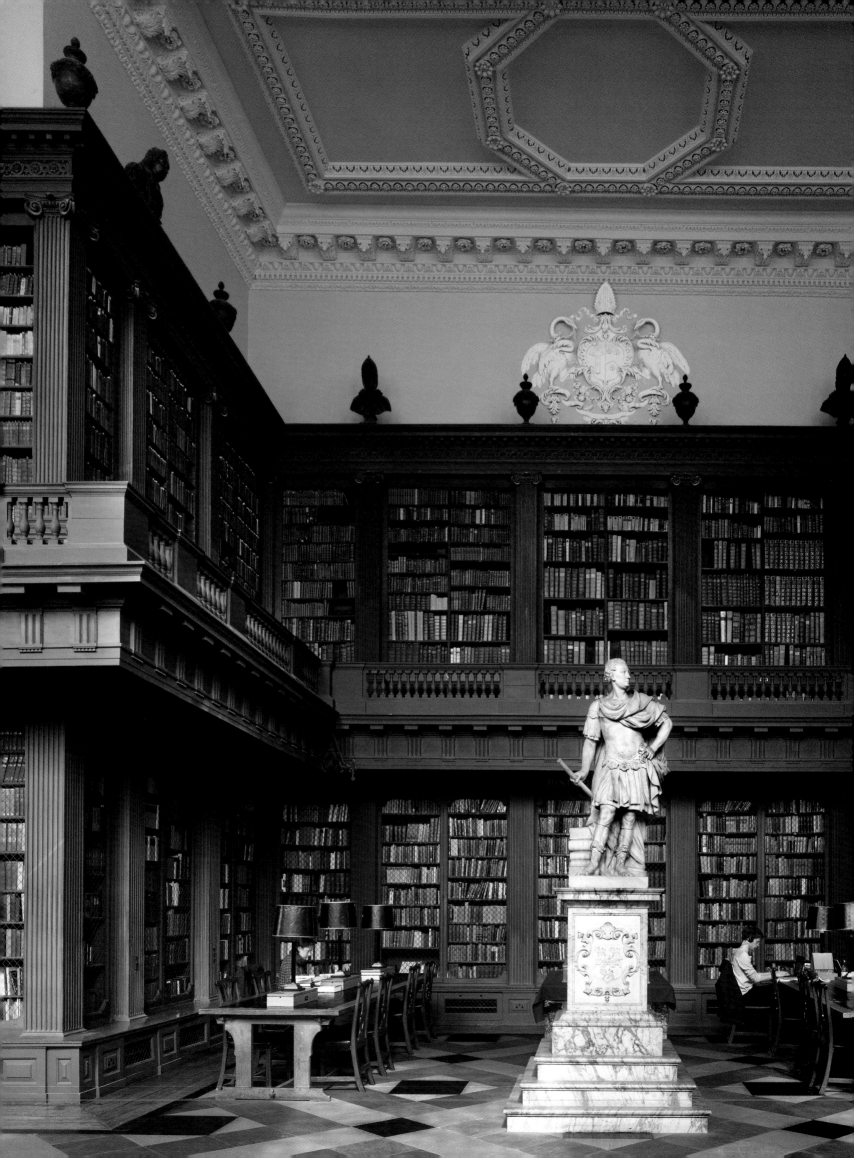

right and opposite
THE CODRINGTON LIBRARY, 1751
All Souls College, Oxford
United Kingdom

Christopher Codrington bequeathed money for the construction of a library at All Souls College, of which he had been a Fellow. A statue of him (opposite) in Roman costume by Henry Cheere stands in a recessed centre bay on the north wall. The library, which is unusual in being placed on the ground floor, was begun in 1716. The college wanted it to match the medieval hall on the other side of the quadrangle and so the initial designs by Nicholas Hawksmoor were entirely Gothic, but, following an intervention by Dr George Clarke, a Fellow and amateur architect of some note, the brief was changed. The final design was for a library that is Gothic on the outside, yet classical within. The columns of the serliana windows at each end (right), become Gothic tracery on the exterior (below right).

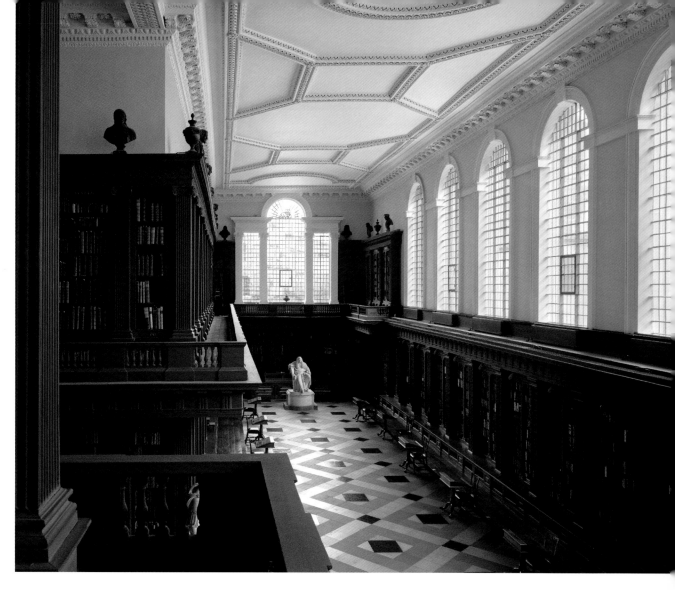

backs to the shelves reading at small desks that can be positioned to suit. The cases have moveable shelves and are protected by doors of grillework.[48] Grillework doors were used in the Escorial, are mentioned in books on libraries in the 17th century and appear to have been used throughout the period as a way of stopping unauthorized access to the books within reach while allowing free movement of air and the reading of titles on spines. Grilles must have been expensive but they were evidently cheaper than glass, which appears to have been used only occasionally. Some glass-fronted cases from Samuel Pepys's library, dating from 1666, are preserved in Magdalene College, Cambridge, and what appear to be glass-fronted cases can be seen in illustrations of the Bibliothèque Saint-Victor in Paris in 1684.[49] However, grillework predominated, and was to become increasingly common in the 18th century. Adjustable shelves seem to be an 18th-century innovation and were increasingly found in libraries in this period.

Hawksmoor proposed two levels of galleries for the Codrington Library but he died before it was completed. Gibbs was brought in to finish the project, and made a number of changes, including simplifying

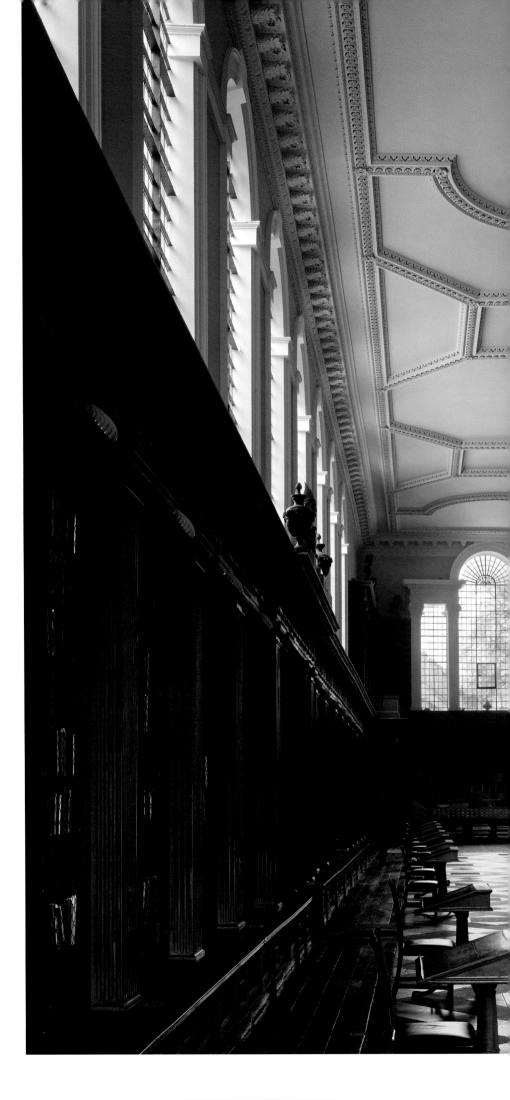

THE CODRINGTON LIBRARY, 1751
All Souls College, Oxford
United Kingdom

Hawksmoor did not live to see the completion of the library,
which was carried out by James Gibbs. The ceiling has much
deeper coffers than is indicated in Hawksmoor's drawings,
which also show that he intended two galleries on the north side,
so that the bookcases would have risen right up to the cornice.
Readers originally sat at moveable desks (visible at lower left)
on the benches that run along the bottom of the bookcases.

the ceiling and reducing the number of galleries
to one, leaving space above the shelves for busts.
Despite the fact it had two architects, the result
forms a perfectly coherent classical design.

The 18th century

The Codrington Library is a masterpiece of library
design, at once austere and classically correct, yet
whimsical in its accommodation of a Gothic exterior.
It demonstrates again that even with more than one
designer and a complex design history it is possible
to produce a unified building of great power. It also
prefigures the Neoclassicism of the late 18th and
early 19th centuries, which was to dominate library
design until the advent of Modernism in the first half
of the 20th century. The 17th century had seen the
triumph of the wall system in library design and the
introduction of both the stall and the library alcove.
Library furniture had changed out of all recognition
over the century. Starting with the Escorial in the
1580s, and then the Bibliotheca Ambrosiana and
Bodleian's Arts End in the early 17th century, the
wall system had spread throughout Europe. The
18th century developed these themes, and produced
new forms, such as the alcove and round library.
However, libraries such as the Codrington, that
of Trinity College, Dublin (see p. 19), the Radcliffe
Camera or the Herzog August Bibliothek were not
the most dramatic built in the 18th century. That
mantle belongs to quite another strand of library
design, which brought together patrons, architects,
painters, plasterers and cabinet-makers to produce
some of the greatest libraries of all time: the Rococo.

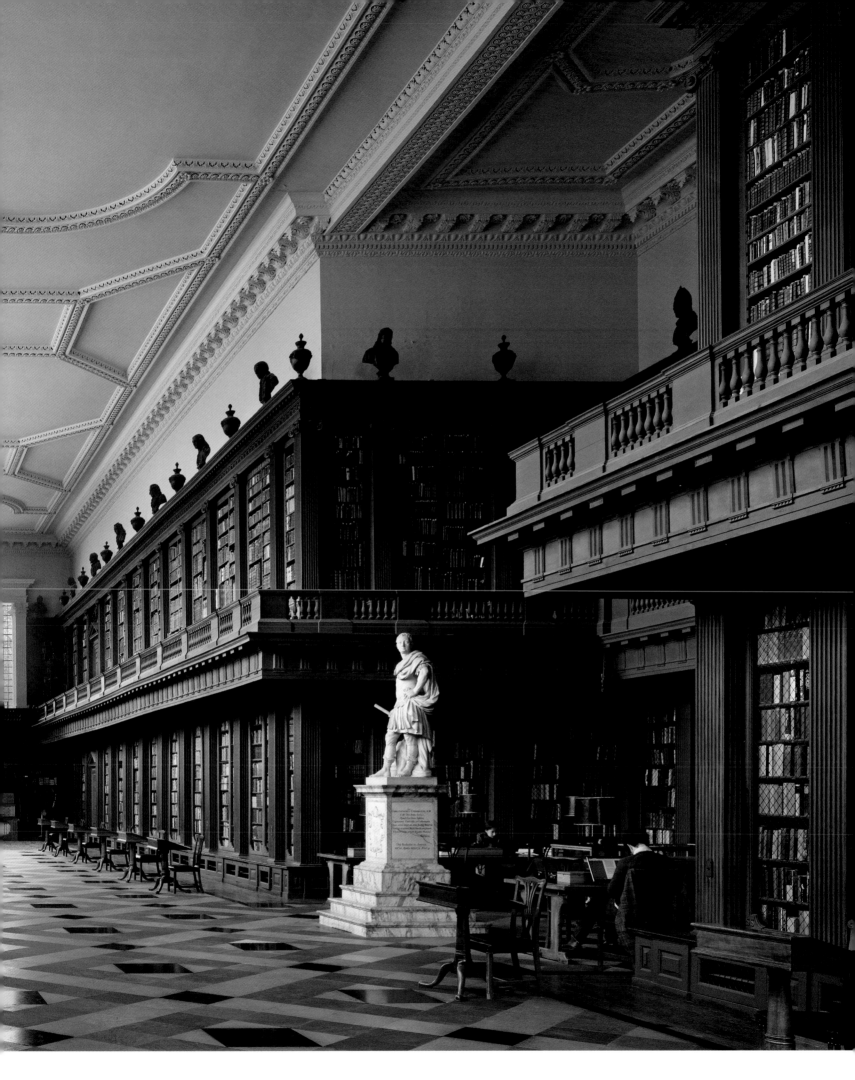

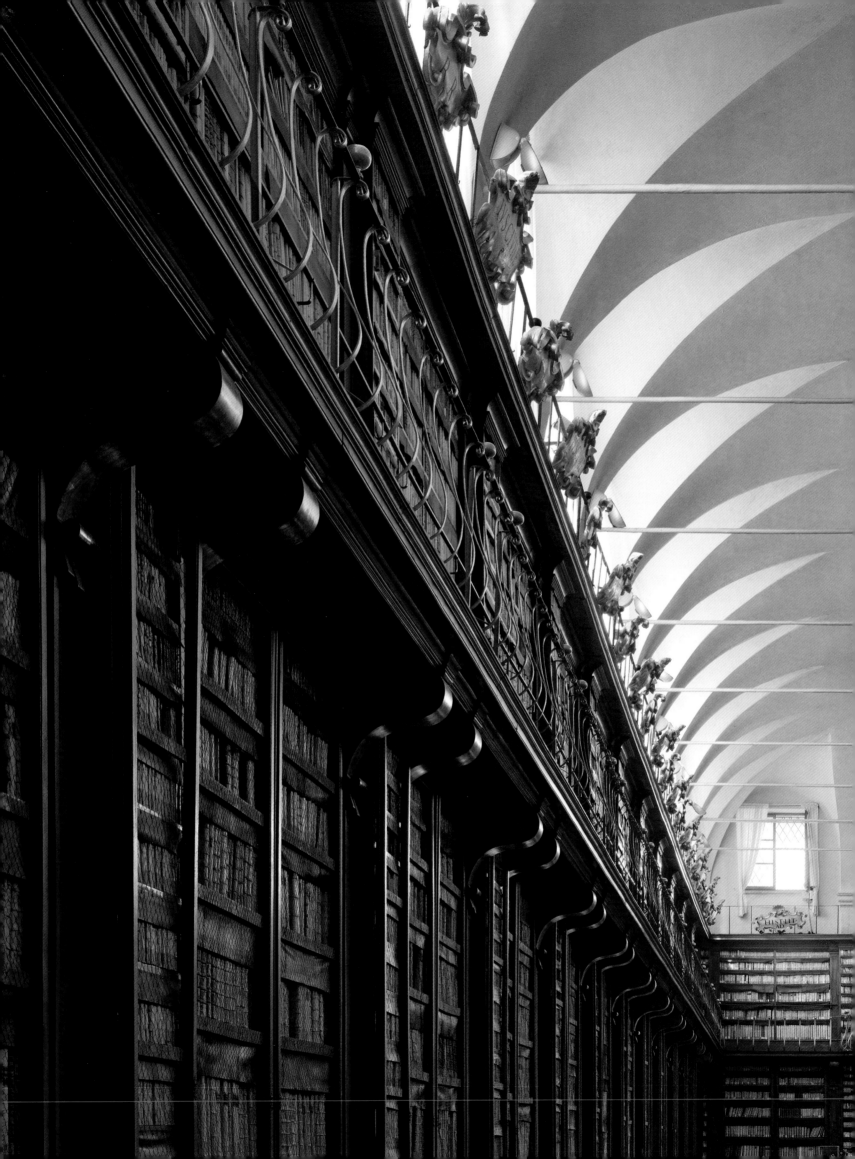

Angels, Frescoes and Secret Doors
Libraries in the 18th Century

Baroque and Rococo libraries deserve a chapter to themselves because they represent a singular moment in history: the point when collections had grown to such a size that they merited rooms of great architectural splendour, but fitting a large collection into a single space had not yet become impossible. All the buildings collected together in this chapter mark a period when library architecture was seen as especially important and a great deal of time and money was lavished on it. They also represent a particular attitude to library decoration. This was not simply a wish to produce lavish interiors for the sake of it, but a desire to use paintings, sculptures and plasterwork to carry very specific messages that would be understood by those able to read them. These libraries also reflected the intellectual arguments of the time by becoming an architectural battleground between the Church and the Enlightenment. They expressed the tensions of the age. This chapter aims to introduce some of the complex factors that shaped these extraordinary libraries, created in Catholic countries where church and state were inextricably mixed, and which were attempting to come to terms with the needs of the Counter-Reformation on the one hand and the excitement of the new science on the other.

BIBLIOTECA CASANATENSE, 1710
Rome, Italy

Designed by Carlo Fontana and Antonio Maria Borioni, this is one of the finest late-Baroque libraries in Italy. The lower half of the room is entirely covered in bookcases, bathed in light from windows set in the masonry vault above.

Defining Baroque and Rococo

The terms Baroque and Rococo are relatively recent inventions. Used at first as terms of abuse, they were more clearly defined by 19th-century art historians who were searching for ways of analysing and classifying art. The term Baroque is generally used to describe a style of art and architecture that started around 1600 in Italy and spread across Europe. In architecture, the Baroque is characterized by a new approach to the application of the classical orders and an increased use of ornament. The idea that there is a correct usage of the orders is rejected in favour of a freedom to distort them to create theatrical effect. Façades become curvilinear, ovals are used in preference to circles, and there is general increase in decorative detail. There is frequently a visual continuity between architecture, sculpture and painting, so that it becomes difficult to tell where one ends and the next begins.

Rococo is less well defined, and there is considerable argument over whether it can be applied to all 18th-century Baroque architecture or should be reserved for that which uses a specific type of shell-like ornament called 'rocaille', from which the style takes its name. Rococo in this sense is said to have started in the court of Louis XIV at Versailles at the beginning of the 18th century as a lighter and more playful form of Baroque decoration.[1] The style is characterized by rich, thin swirling ornamental patterns, typically formed in white or gold plaster on coloured backgrounds. Decoration can become extremely flamboyant and imaginative and usually includes *trompe-l'oeil* allegorical ceiling and wall paintings. Rococo architecture is typically found in France, southern Germany and Austria in the 18th century, and went out of fashion in the 1780s or 1790s.

To the artists involved in these buildings such classifications would have been meaningless; these were simply libraries decorated in the fashions of the day. In England, Rococo was referred to at the time as the 'Style Moderne'. Formal stylistic research is useful in very general terms. But, as numerous studies have shown, the classifications so beloved of 19th-century architectural historians, with their meticulous studies of the changing morphologies of spaces and decoration, were never entirely satisfactory. They merely revealed what one might expect: some areas followed the latest fashions, while others in certain periods remained defiantly behind recent trends, and the involvement of individual artists and local circumstances was far more important. Art consistently failed to fall into neat evolutionary categories.

Rococo was designed to appeal to the masses, but equally on another level it was intended to impress the most educated viewer. Thus it achieved a rare feat in art, appealing to both the tutored and the untutored alike. This is precisely the reason for its success: the Rococo can be (and was always designed to be) appreciated on many levels. The most sophisticated viewer understood that the paintings and sculpture

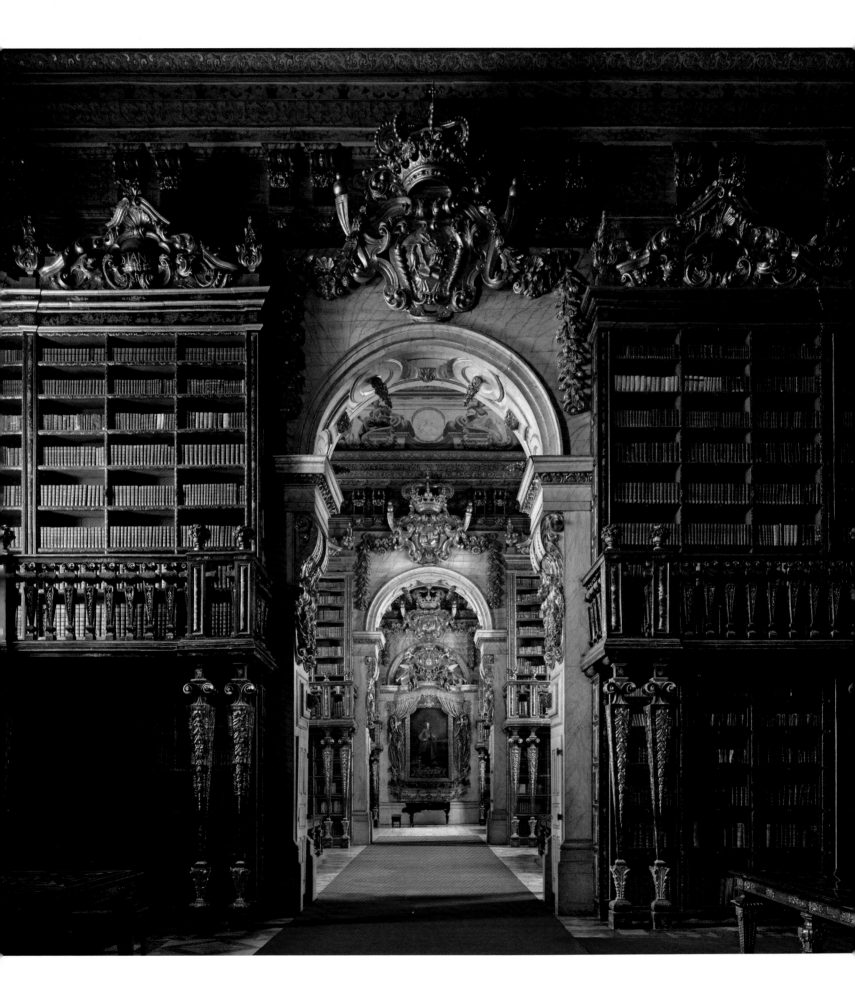

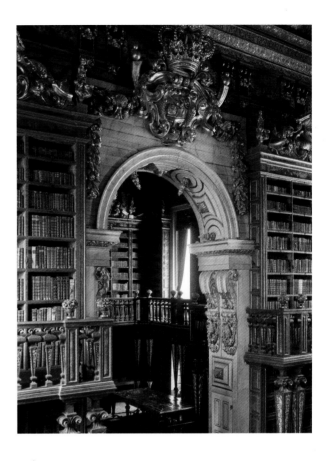

formed a detailed iconographic programme designed
to communicate a series of ideas or views about
society and, in the case of libraries, about attitudes
to knowledge. This interpretation was never easy.
Records show that even educated viewers at the
time usually required some help from a written
guide to help them interpret the precise message
being conveyed in a particular ceiling.[2] The untutored
simply admired the skill and effort that had gone
into producing such luxurious interiors. Nonetheless,
the frescoes and other decoration were never random.
They always sought to convey a particular idea or
message. At the heart of such ideas was the role of
the monarch and the Church in the modern state.
It is thus not surprising that some of the earliest of
these libraries, such as the Biblioteca Joanina at
the University of Coimbra in Portugal, were created
through royal patronage.

Royal libraries

The Biblioteca Joanina perches dramatically on the
edge of a man-made cliff. On the right-hand side as
the visitor faces the main doorway, the library is
joined to a two-storey wing that makes up one side
of the main courtyard of the University of Coimbra,
but on the left the ground drops dramatically away,
and the southern façade of the library looks down
over the river valley beyond.

The university occupies what was originally the
royal Alcáçova Palace. It is the oldest university in
Portugal and one of the oldest in Europe to have
had a continuous existence. The university itself
had been founded as a *studium generale* (a place that
received students) in Lisbon in 1290.[3] Coimbra is a
good example of the fact that early universities had
few buildings and thus could move relatively easily.[4]
Troubles with the city of Lisbon prompted it to move
to Coimbra in 1308. It returned to Lisbon in 1338,
only to go back to Coimbra in 1354. It then moved to
Lisbon once more in 1377. This peripatetic existence
finally came to an end in 1537, when João III gave
the university the Alcáçova Palace, tying it at last
to the site that it still occupies.[5] The magnificent
library building was a gift of João V (r. 1706–1750),
and in that sense it was a royal library, albeit one
founded in a university.

There had, of course, been royal libraries in
Europe before the 18th century and many held hugely
important manuscripts. In England, the wealth of
books in the royal collection in the 17th century
had been much admired by visitors. But equally they
had commented on the dreadful manner in which
the books were stored. They were piled up on tables
and on the floor, covering every surface, in small
cramped rooms, temporarily commandeered for
the purpose, without any thought of display or the
proper conditions for their preservation.[6] Much the
same could be said of the imperial collection in
Austria in the 16th century. When the Dutch Calvinist
Hugo Blotius (the Latin name of Hugues Bloot or
Blote) (1533–1608) was appointed librarian of the
Hofbibliothek in Vienna he was appalled to find, 'How
neglected and desolate everything looked! There was
mouldiness and rot everywhere, the debris of moths
and bookworms, and a thick covering of cobwebs. …
The windows had not been opened for months and
not a ray of sunshine had penetrated through them
to brighten the unfortunate books, which were slowly
pining away; and when they were opened, what a
cloud of noxious air streamed out!'[7] In France in the
16th century, the royal collections were shuffled from
building to building and lacked permanent quarters
of any great grandeur.[8]

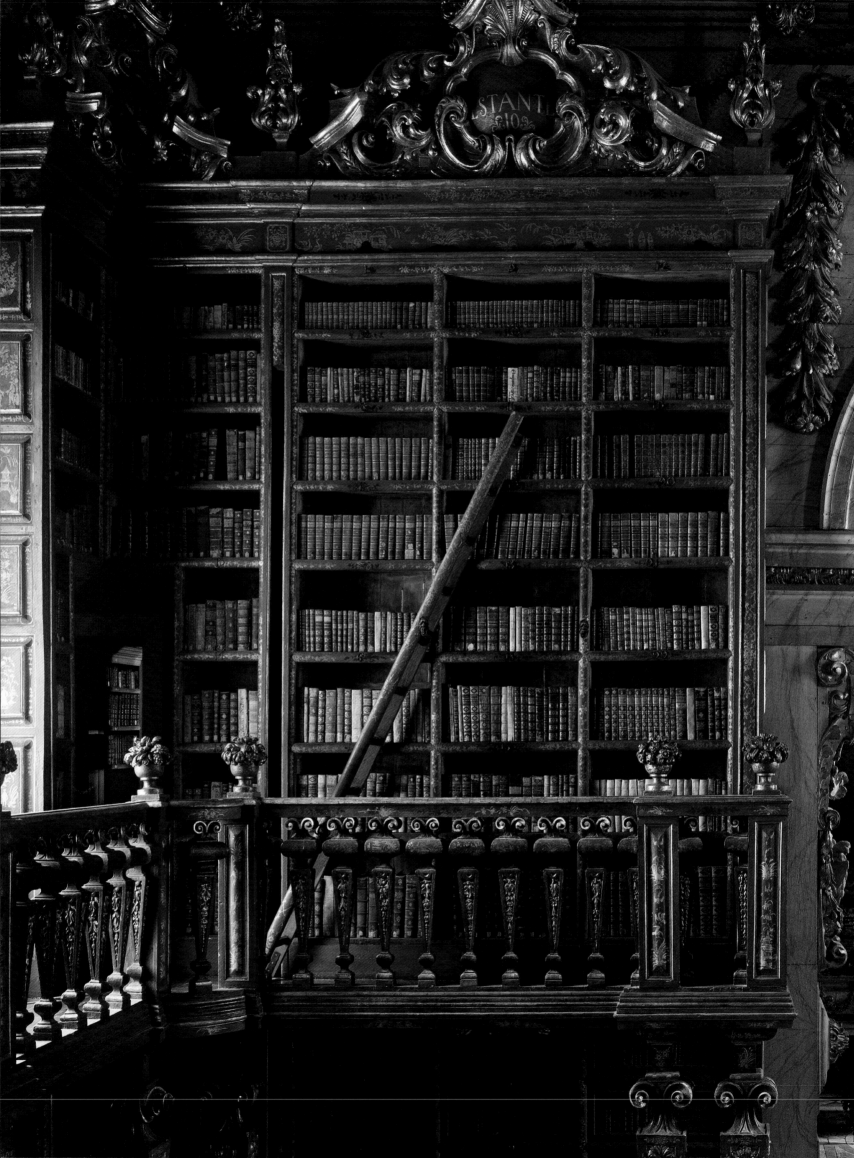

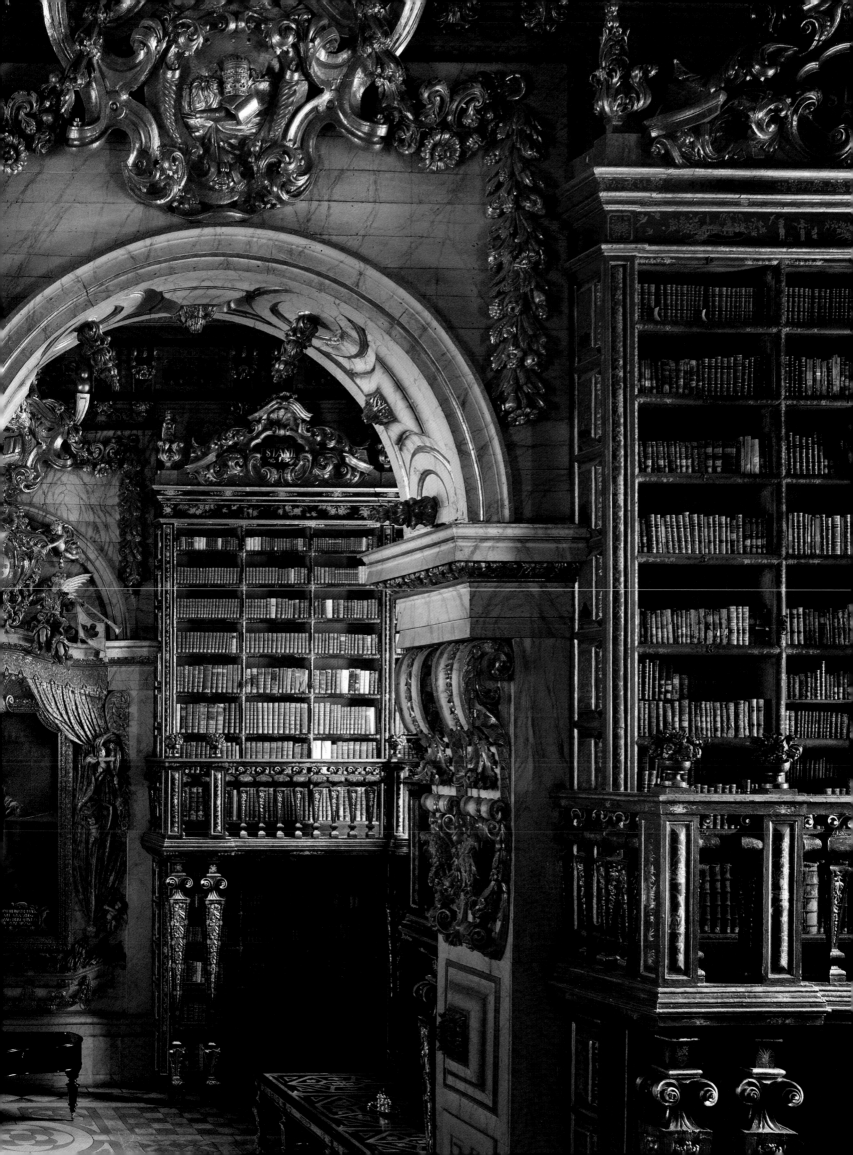

*This is one of a series of
studies behind the bookcases
on the lower level that look
out over the valley below. The
corresponding spaces on the
other side of the room are
stores. These studies provided
perfect spaces for scholars
working on longer-term
projects within the library.*

The intellectual movements of the 16th and
17th centuries had changed the face of Europe. The
Reformation, Counter-Reformation and the birth
of modern science had radically altered attitudes
to knowledge.[9] Monarchs were keen to be seen as
forward-thinking promoters of the new learning,
science and the arts. It is of course no accident that
these monarchs often carried out similar projects at
the same time. They were eager to keep up with their
rivals, to whom they were often related by a network
of strategic marriages. João V, the creator of the
libraries in Coimbra and Mafra, was married to the
sister of the Habsburg Emperor Charles VI. And it
was the same Charles VI who was responsible for
one of the grandest of all royal libraries constructed
in the 18th century, the Hofbibliothek (imperial
library) in Vienna. Of all these royal libraries,
the Biblioteca Joanina is one of the finest.

Biblioteca Joanina

João V of Portugal could afford to build lavishly
thanks to enormous gold reserves that had been
discovered in Brazil. When the rector of the University
of Coimbra wrote to him requesting a donation to
expand the poor existing library facilities, he was
surprised to receive the reply that the king would
prefer a far more ambitious plan: he wished to provide
the university with a whole new building, complete
with a suitably fine collection of books to go in it.[10]
The proposed scheme involved expanding the palace
courtyard by a third so that the library, constructed on
top of an existing building, could be entered directly
from it. No expense was to be spared on the project.
The result was a Baroque library of extraordinary
opulence, covered internally in gold leaf and
decorated with expensive paintings, plasterwork
and sculpture.

The library is divided into three rooms. There
is no obvious structural reason for this unusual
division; it is done entirely for effect. Each room in
the sequence carries a different meaning. This could
have been achieved, as elsewhere, in a single room
with a ceiling divided into three different fields, but
three rooms are certainly more dramatic and the
timber dividing-walls create more shelving space
for books. They also usefully conceal straight

flights of stairs to access the galleries on either side
of the room.

The first room in the sequence is lit from only
one side, because of the connecting wing, while the
remaining spaces are lit from both sides, so that the
library becomes progressively lighter. The first room
housed books on history and literature, the second
those on law and natural sciences, and the last those
on theology and canon law. In the first, the ceiling
shows cherubs gathering books from the four parts
of the known world (Africa, Asia, Europe and the
Americas). The image carries the motto, 'Take joy
in the fact that these books decorate the shelves'.
The ceiling of the second room is dominated by
a figure with a caption that identifies him as 'the
University', and is surrounded by the attributes that
he encompasses: 'Honour', 'Virtue', 'Fortune' and
'Fame'. Around these are figures representing the
Latin authors Virgil, Ovid, Seneca and Cicero,
indicating the classical roots of all university
education.[11] The final room is dominated by a huge
portrait of the king, surrounded by gilded trumpets
and crowns, making it perfectly clear who was
responsible for the enterprise. The ceiling of this room
represents the encyclopaedic endeavour to synthesize
all knowledge. The faculties of theology, law, nature
(medicine), mathematics and philosophy, the arts
and music are all represented. The timberwork of
the shelving in each room is painted a different
colour – green in the first, red in the second and
black in the third – and is entirely covered in rich
decoration imitating Chinese lacquerwork.

Construction of this magnificent library began in
1717. The stone contract was complete by 1722, when
work had already begun on the interior. Two artists
from Lisbon, António Simões Ribeiro and Vicente
Nunes, were hired to paint the ceiling, and a specialist
decorator, Manuel da Silva, was found to provide the
imitation lacquerwork. Once all this was complete,
six fabulously ornate tables were made by an Italian
cabinet-maker, Francesco Realdino. Everything was
finished by 1728.[12] However, Coimbra was not the
only great library that João V wanted to bequeath to
the nation. At the time of his death he was already
working on another, still larger library, in his palace
in Mafra, 28 km (17 mi.) north-west of Lisbon.

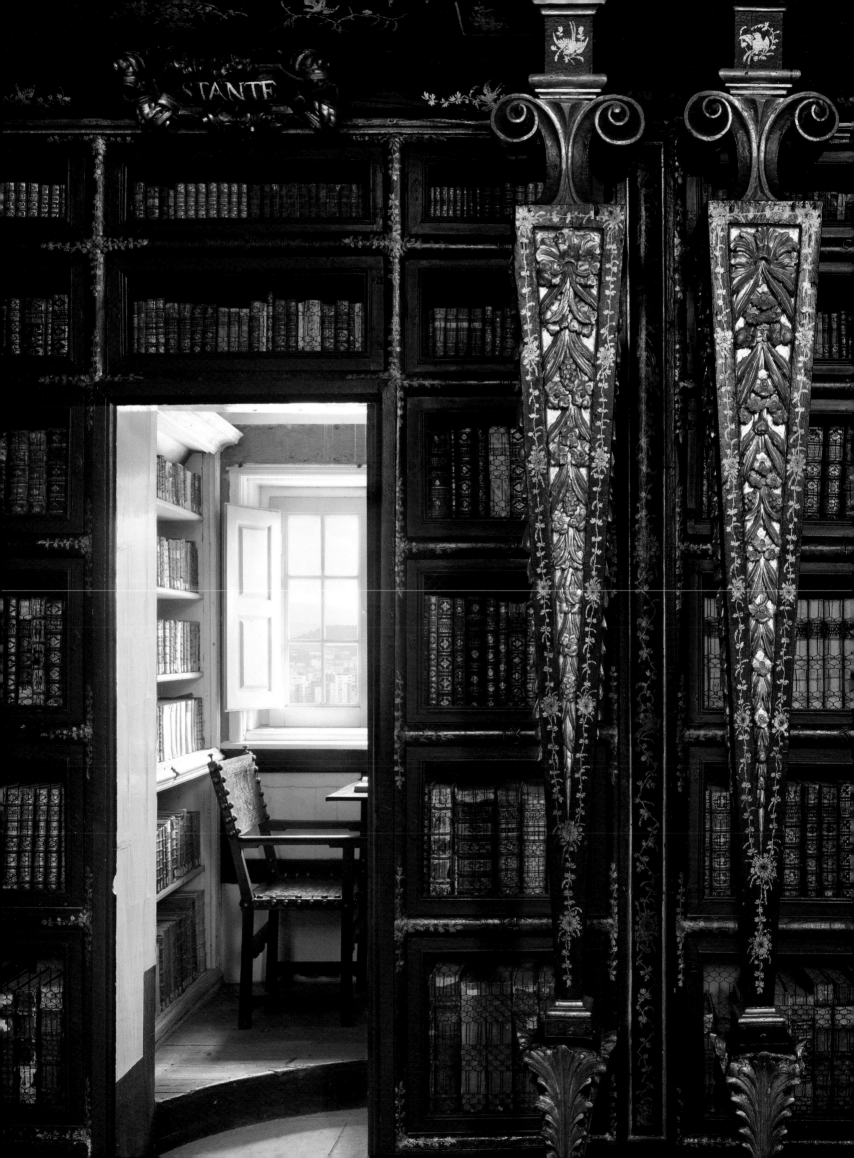

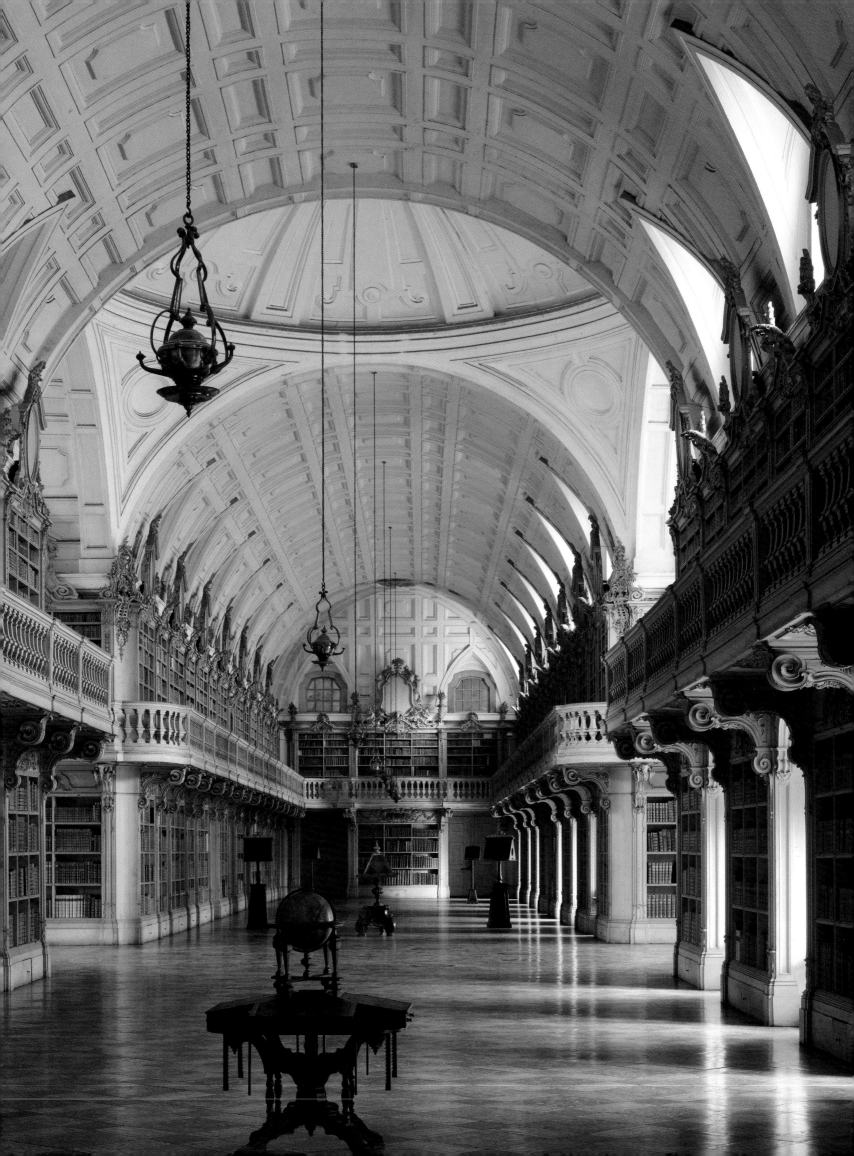

Mafra Palace library

In 1711 João V made a vow that if his wife, Maria
Anna of Austria, produced children, he would build
a monastery. His daughter, Barbara, later to become
queen of Spain, was born the same year, and a site
was chosen for the new monastery in 1713.[13] It was
designed to be not just a monastery but also a palace.
The site chosen was conveniently placed for the royal
hunting grounds. Obvious comparisons could be made
with the Escorial, that other combination of palace
and monastery constructed in the 16th century. But
while the Escorial is austere, the Mafra Palace library
is flamboyant and extravagant, and – even compared
with the Escorial – it is on a truly massive scale. The
first stone was laid with due ceremony on 11 November
1717. Construction took thirteen years. At a time when
most large building projects employed no more than a
few hundred craftsmen, 20,000–50,000 workers were
employed at Mafra. Six thousand soldiers were paid
just to keep order.[14] The palace they were constructing
is huge: it covers 37,720 sq. m (406,015 sq. ft) and was
said to contain over 154 staircases, 880 rooms and
4,500 doors and windows.[15] Its main façade alone is
220 m long (722 ft).

The building was designed by Johann Friedrich
Ludwig (João Frederico Ludovice in Portuguese),
a German silversmith-turned-architect who had
studied architecture in Rome. Many of the features
of the palace were directly copied from the works of
the Roman architect Francesco Borromini.[16] In the
Escorial, the palace and monastery are integrated
and the abbey is at the rear, with the library at the
front, over the entrance. At Mafra, the arrangement is
reversed: the monastery is separate and takes up the
rear of the complex, with the library in the centre of
the rear façade. The abbey church is the central feature
on the main façade, the rest of which forms the front of
the palace. Although the palace was officially opened
in 1730 with huge festivities involving 65,000 guests, it
was still far from complete when the king died in 1750.
By that time, João V's grand projects had exhausted the
enormous gold reserves and the country was verging
on bankruptcy. The devastating earthquake in Lisbon
in 1755 stopped the interior decoration, but it resumed
in the 1760s, when the architect Manuel Caetano de
Sousa (1738–1802) was commissioned to finish the
building.[17] The Rococo cases and marble floor of the
library were completed in 1771. The plan was to gild
the woodwork and paint the ceilings, but in the end
the whole library was simply whitewashed. Although
Mafra operated as a monastery until its dissolution in
1834, the palace was largely unoccupied. It was never
popular with the royal family and was used chiefly as
a hunting lodge. João VI lived in it for a year in 1807,
prompting a partial renovation. But it was abandoned
when he fled Napoleon's advancing armies, taking the
finest of its furniture with him to Brazil. In 1849 the
monastery was given to the military and it now partly
serves as a barracks.[18]

Coimbra and Mafra are royal libraries but the
Portuguese kings who built them did not have
collections to fill such spaces and Mafra was to remain
partially empty well into the 19th century.[19] Elsewhere
in Europe, however, monarchs were forming
collections of books, some of which they kept to
themselves and some of which were intended for public
benefit. Of the latter, the Hofbibliothek was the grandest.

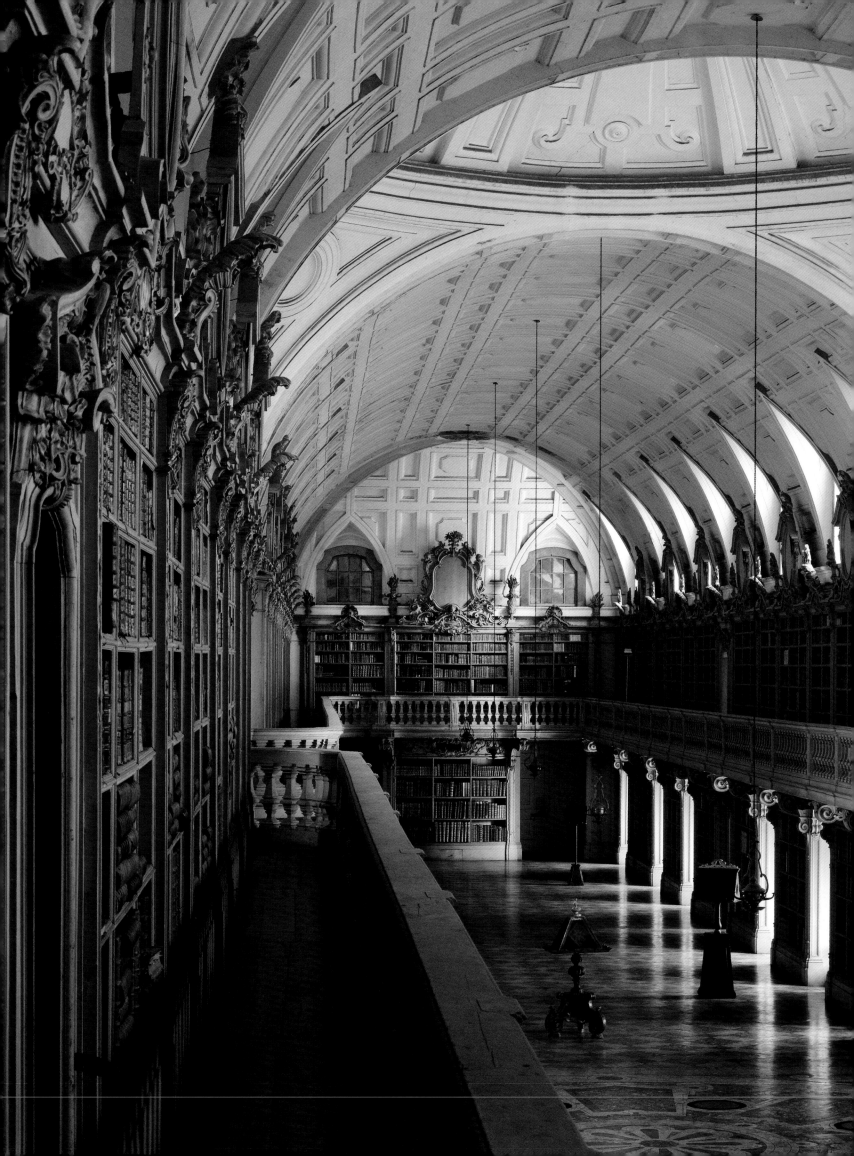

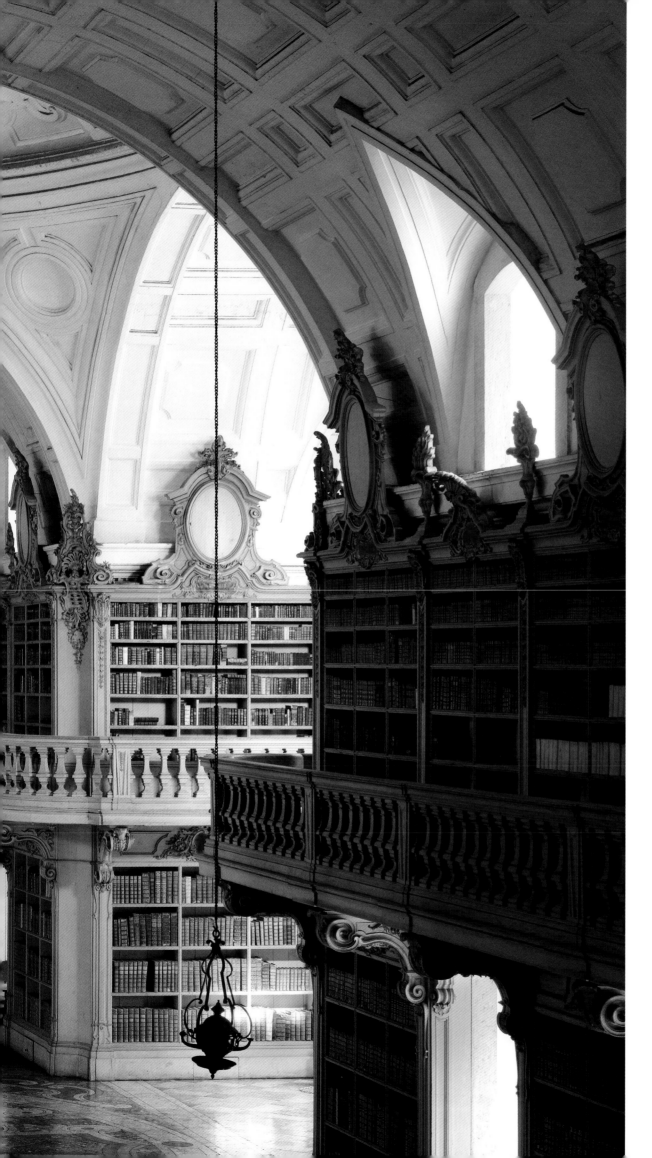

**MAFRA PALACE
LIBRARY, 1771**
Mafra, Portugal

*This view shows the doors
to the galleries (visible in the
foreground at left), which are
not hidden as they are in many
libraries of the time, but are
decorated with Rococo
surrounds. The cartouches
above the cases were
presumably intended to
contain allegorical paintings.
The original oil lamps still
hang from the ceiling. Since
its opening the library has been
home to a colony of tiny bats.
Recent studies have revealed
that they roost behind the cases
in winter, and in the orchards
outside in summer, coming
into the library at night to feed
on insects that might otherwise
damage the books.*

163

The Hofbibliothek, Vienna

The Hofbibliothek's position is often misinterpreted.
Today it sits in the centre of Vienna, but when it was
first constructed, it was on the edge of the city. Its front
faced onto a new square, the Josefplatz, but the back
looked directly over the city wall onto the glacis, an
area of open ground kept clear for defensive purposes.
The façade is a mixture of defensive and palace
architecture in keeping with this position.[20] The base
of the building is battered and rusticated like a fortress
wall, while the palace-like façade above has twinned
columns, like the new front of the Louvre designed
by Claude Perrault in 1680. Although connected with
the palace, the Hofbibliothek was always conceived
of as a public library and national collection, and
from the beginning it was intended to be open to
all except 'the ignorant, servants, layabouts, gossip-
mongers and idlers'.[21]

Whereas the outside of the Hofbibliothek is
relatively austere, the inside is like a lavish stage set.
This theatricality is not accidental. The age that saw
Shakespeare pen the words 'all the world's a stage'
had a particular interest in theatre and pageantry.
Large sums of money were spent on elaborate stage
sets for processions, masques, balls and ceremonies
of all kinds. All these spectacles were transitory in
nature, and our understanding of them is limited to
prints and contemporary descriptions. They were
designed to create a feeling of belonging to a greater
nation by a collective celebration of monarchs and
their people as one. They acted as a rare instance
when the public could directly engage with, and gain
excitement from, their rulers. Pageants had to amaze
and entertain in equal measure. There were parades
of animals, jesters, musicians and elaborate floats.
Temporary gateways were erected. Architects and
craftsmen were engaged to design and build them.[22]
The only modern equivalents (carnivals, opening
ceremonies and state occasions) pale in comparison
to these extravagant displays. Permanent theatres also
changed in this period, with proscenium arches taking
over from the older theatres designed in the round.
The proscenium controlled the angle of view and stage
sets became a series of planes receding from the
audience. It is against this backdrop of state pageantry
and stage-set design that the Hofbibliothek needs to be

understood, not least because its architect was one of
the leading pageant and stage-set designers of his day.[23]

Johann Bernhard Fischer von Erlach (1656–1723)
was born in Graz in southern Austria. Little is known
about his early life. He was the son of a sculptor who
provided decorative pieces for the local aristocracy.
He probably trained as a statuary mason under his
father, before he went to Rome in his mid-teens to
work as a sculptor for Johann Paul Schor, an Austrian
immigrant. Schor went under the local name of
Giovanni Paolo Tedesco and worked with his sons,
Philipp and Christoph. The firm specialized in the
ephemeral architecture of pageants, and also provided
paintings and sculpture for interiors. It was through
Tedesco, and his work for the ex-Queen Christina
of Sweden that Fischer von Erlach would have first
come into contact with the sculptor and architect Gian
Lorenzo Bernini (1598–1680), at the time the leading
proponent of Baroque art in Rome. After about ten
years, Fischer left Rome and spent three years in the
service of the Marchese del Carpio, viceroy of the
Spanish crown in Naples, before finally returning to
Austria in 1686.[24]

Fischer's Italian experience led him to be
appointed architectural tutor to the emperor's son,
the future Joseph I. In later life this would lead to his
appointment as His Imperial Majesty's Superintendent
of Court and Pleasure Buildings, but by that stage
Fischer had already established himself as Austria's
leading architect. He was admired in academic
circles: Leibniz sponsored him for membership of the

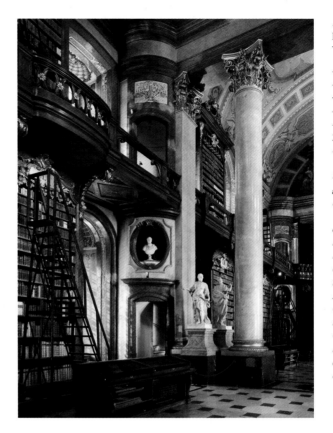

left and opposite
HOFBIBLIOTHEK, 1750
Vienna, Austria

*Designed by Fischer von
Erlach and completed by his
son Joseph Emmanuel, the
Hofbibliothek is the largest
Rococo library ever built,
being 77.7 m long, 14.2 m wide
and 19.6 m high (255 x 47 x 64 ft).
The four spiral staircases
that give access to the
galleries are contained within
large projecting drums (left).
The size of the stepladders
demonstrates the extraordinary
height of the cases on each
level. The central space
(opposite) is decorated with
trompe-l'oeil paintings by
Daniel Gran, the court artist.
Completed in 1730, they depict
the apotheosis of Emperor
Charles VI, for whom the
library was built, and include
an allegorical depiction of its
construction.*

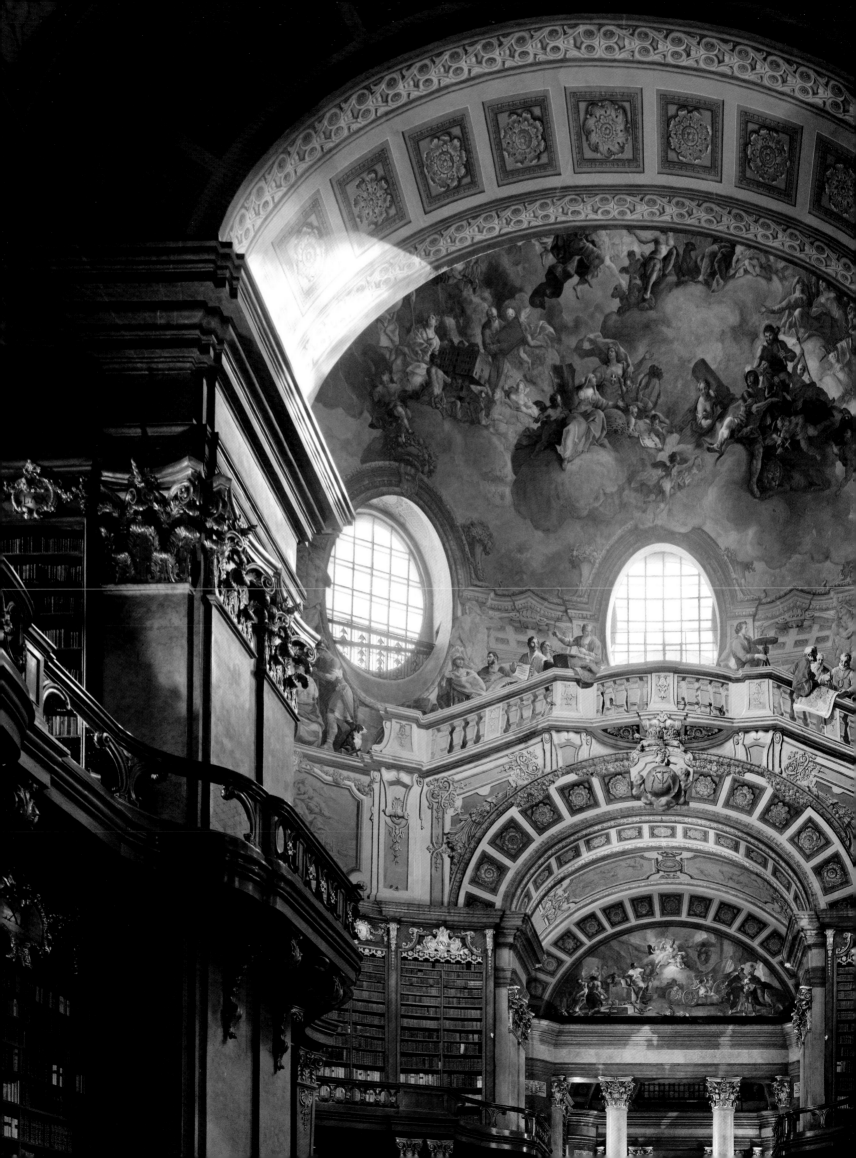

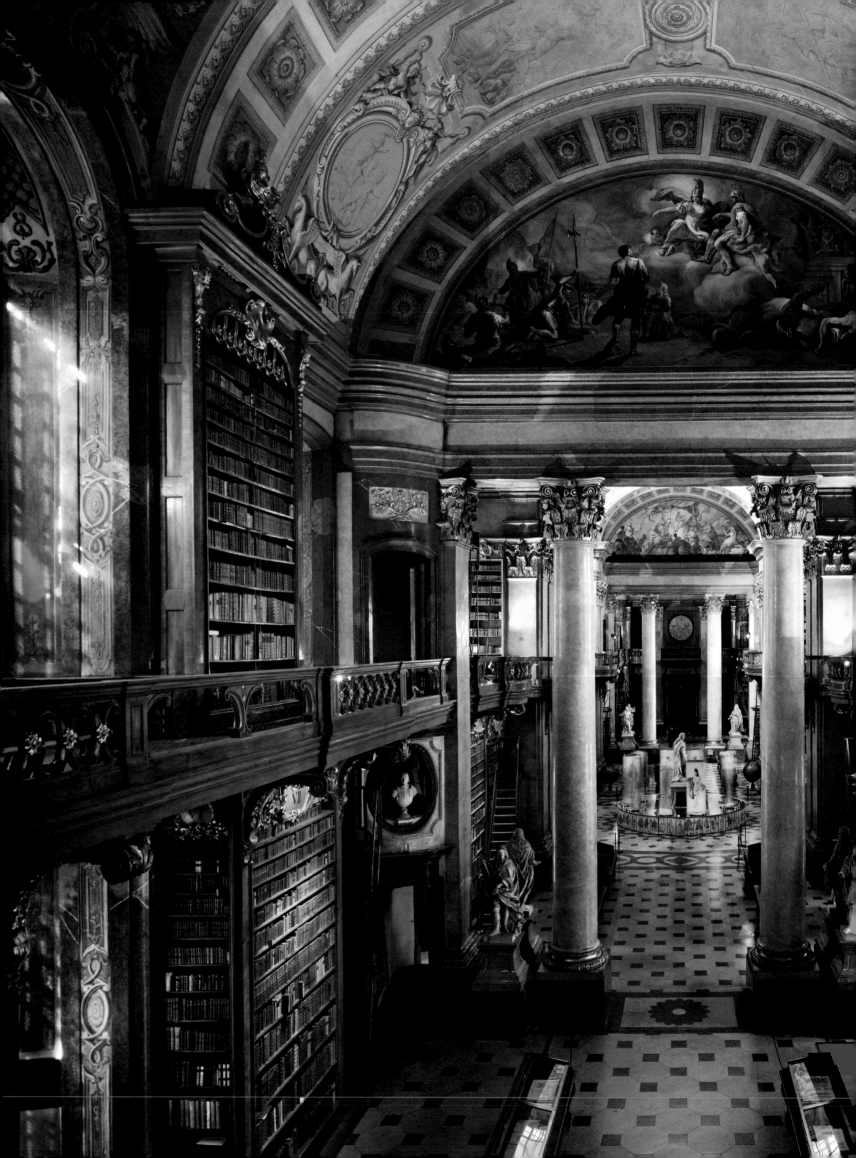

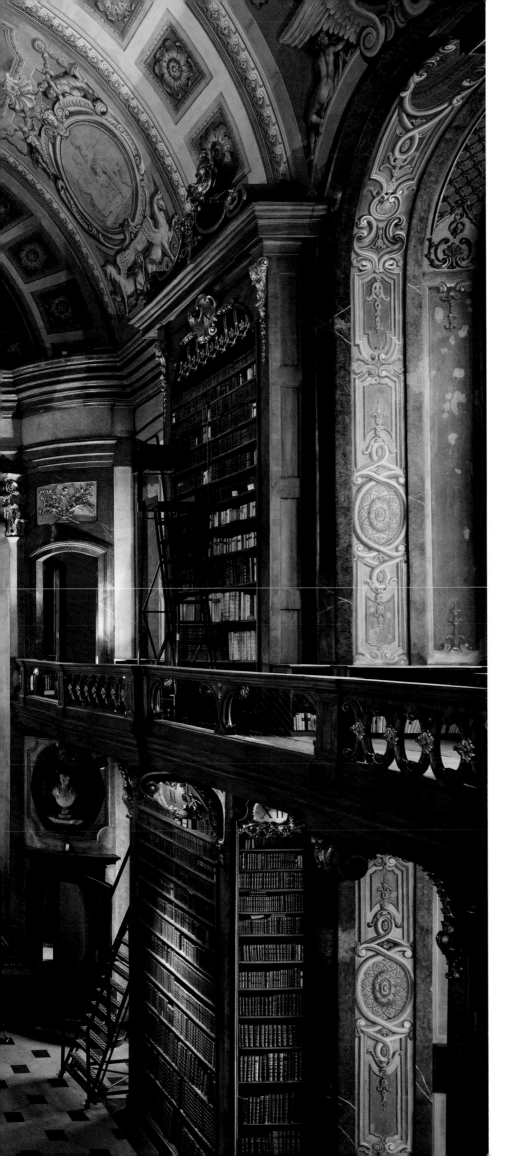

HOFBIBLIOTHEK, 1750
Vienna, Austria

*The two ends of the library are decorated differently. The end
which the reader enters, seen here, is called the 'War Wing', and
the far end is the 'Peace Wing'. The main lunette in the War Wing
depicts the story of Cadmus, who in legend gave the Greeks the
alphabet.*

Imperial Academy of Learning and Fischer presented
a manuscript of his treatise *Entwurff einer historischen
Architektur* ('An Outline of Historical Architecture') to
Emperor Charles VI, who succeeded Joseph I in 1711.
It was thus hardly surprising that the emperor should
entrust the design of the library to Fischer. Although
by 1711 his architecture was beginning to look a little
dated in Italian terms, he was still the acknowledged
leading Austrian architect of the day.[25]

Architecture in the 17th and 18th centuries is all
about the effect created. The arches that divide the
rooms in the Biblioteca Joanina appear to be masonry
but are in fact just timber and plaster. This does not
matter. It is what the eye sees that is important, not the
method by which it is achieved. This is the sensibility
of scagliola and other *faux* materials. Scagliola or
marbling is the technique of creating marble finishes
in plaster, using paint and powdered marble or
alabaster. It is related to graining, which produces
the effect of fine timberwork using oil paints. Both
were very popular in the 17th and 18th centuries and
enabled the effect of lavish materials to be produced
at a reasonable cost. The interior of the Hofbibliothek
took nearly thirty years to complete. As is typical in
Rococo libraries, it mixes real and fake materials
in such a way that the divisions are deliberately
impossible to determine. The interior is conceived as
a series of arches, as if the viewer is entering into a
stage set and passing through a series of flats, each
concealing part of the next, so the whole can never
be seen from any angle and the viewer cannot grasp
the scale of the space.

The centre of the library is an oval domed
space created to focus attention on the giant statue
of Charles VI in the centre. Surrounding him are
smaller, life-size statues of his ancestors. This space
is often cited as the inspiration for all 18th-century
library domes. This is probably not entirely the case,
because the construction of the Hofbibliothek was
slow. Discussions began in 1716 and the foundations
were laid in 1722, but the library was not completed
until 1730. Wolfenbüttel (see pp. 144–7) had been
completed in 1710 and must have been well known.
A less dramatic version of the same plan can be seen
at the Bibliothèque Sainte-Geneviève in Paris, also
built around 1730 (see p. 136).[26] The Hofbibliothek did,

however, influence later Austrian libraries, for which flattering the emperor by emulation had obvious benefits and positive connotations.

The scale of the Hofbibliothek is particularly striking. All too often, people say that classical architecture is proportioned like the human body. This comes from a misunderstanding of Vitruvius, who compares the relative slenderness of the various orders in architecture (Doric, Ionic, Corinthian) with men, women and young girls. This does not, however, imply that any of these orders had to be a certain multiple of the height of a person. The classical orders were never scaled to the human body. The various parts of a classical building are in fixed proportion to one another. A classical temple may be very large or very small but the elements keep the same relationship to each other. Doors and windows are scaled up or down in proportion, so a museum with an enormous portico will have correspondingly huge doors. These are not scaled to the human body; they are scaled to the architecture. It is precisely because of this proportioning without scale that it is possible to produce tiny garden buildings that are simply smaller copies of the Pantheon, or to use the same design to produce a massive building. It is very difficult to read the size of a classical building from a distance and this is one of the features of classical architecture that reduces its capacity to be overbearing.

The interior of the Hofbibliothek plays with these ideas of scale. Despite the fact that the books provide some indication to the eye of how large the room is, the treatment of the bookcases as wall-coverings makes it difficult to read the scale. The first clue to the reader about the size of the cases is the height of the ladders required to fetch the books. The highest shelf below the gallery is over 5 m (16 ft) above the library floor. The bookcases in the lower tier project into the space to help support the balcony above, which spans the columns and is further supported by dramatic brackets projecting from the cases. This gallery is much wider than most library galleries. It needs to be, because the shelving on the gallery is as tall as that beneath and thus 5 m ladders need to be balanced on the gallery to reach the topmost shelves, the librarians balancing precariously over 10 m (32 ft) above the floor. The bookcases are in proportion with

the architecture, which is scaled for giants, not mere mortals.

The staircases to the galleries are spiral and are placed within hollow drums. The most intriguing spaces, however, are at the lower level next to the dome and on the upper level around its periphery. In these locations there are windows on the outside of the building, but none is visible on the interior, where there simply appear to be more bookcases. In fact, these shelves conceal little rooms. Lit by the huge external windows, these provide extra storage space for books. They are accessed by portions of the shelving, which are hinged so that they can open like doors. The weight of the books is considerable, so the cases have to be mounted on rollers. When the doors of these 'secret rooms' are opened, they provide a glimpse behind the stage set.

In terms of library design, the Hofbibliothek was highly influential. Its position as a court library open to the general public meant that it could be viewed by virtually anyone who wanted to see it. Even today, it retains the power to inspire the same awe in the visitor that it did two centuries ago. It is also interesting stylistically as it was derived from Italian Baroque architecture of the late 17th century. By the time that it was finished, the style in Italy had moved on. Thus to Italian eyes, used to libraries like the Biblioteca Casanatense, it might have looked rather old-fashioned.

Biblioteca Casanatense

The Biblioteca Casanatense is in the Dominican monastery of S. Maria sopra Minerva in Rome. It is named after Cardinal Girolamo Casanata (1620–1700), who asked in his will that the library should be opened to the public. It still operates as a research library, now run by the Italian Ministry of Culture. The main reading room was constructed in 1690–2 and extended in 1719. The design history is unclear. It is associated with the architect Carlo Fontana (1638–1714), who had worked extensively for Bernini and is known by architectural historians for designing in a style that sought a return to classical rules. This is clearly visible in the library.[27] A lesser-known architect, Antonio Maria Borioni, has been connected with its execution.[28] The design takes its cue from the long, barrel-vaulted, book-lined space of the Biblioteca

BIBLIOTECA CASANATENSE, 1719
Rome, Italy

A statue of Cardinal Girolamo Casanata presides proudly over the public library that he founded. The door in the background is now the main entrance.

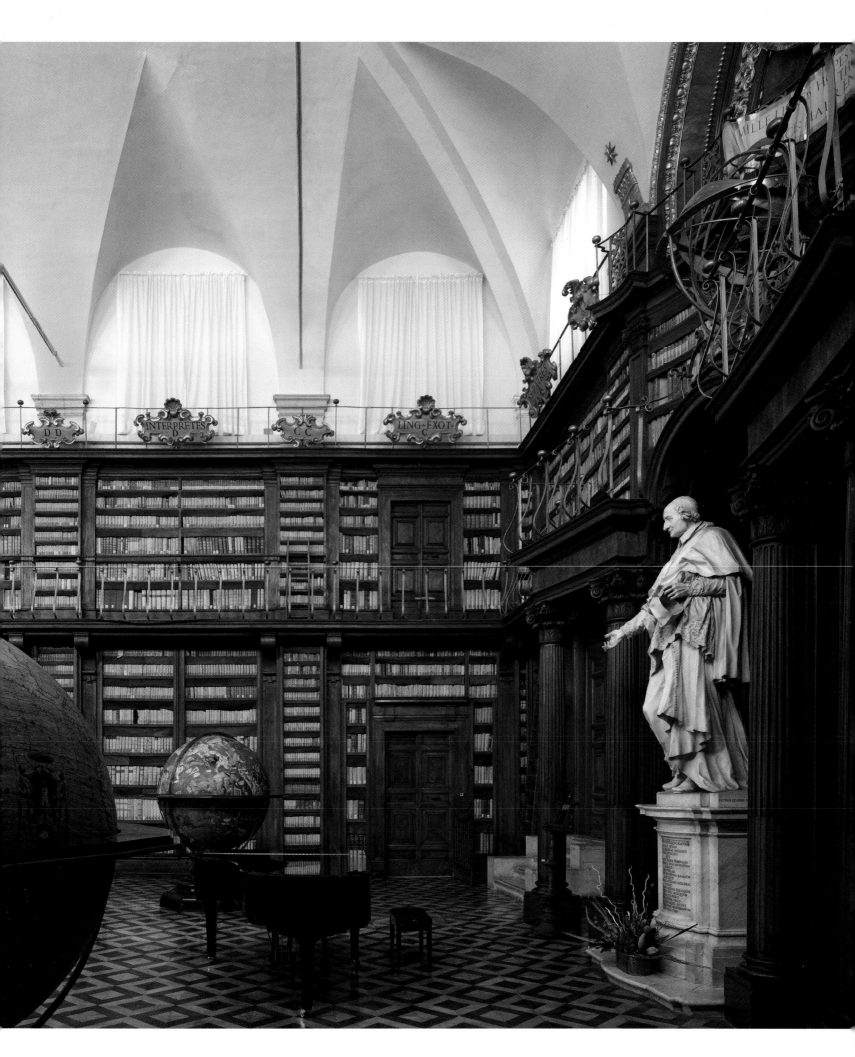

The library was originally intended to be seen from here, the obvious point of entry. It is remarkably simple, consisting of a long, rectangular, vaulted hall, with bookcases lining all four walls. The only light is from lunettes in the masonry vault above.

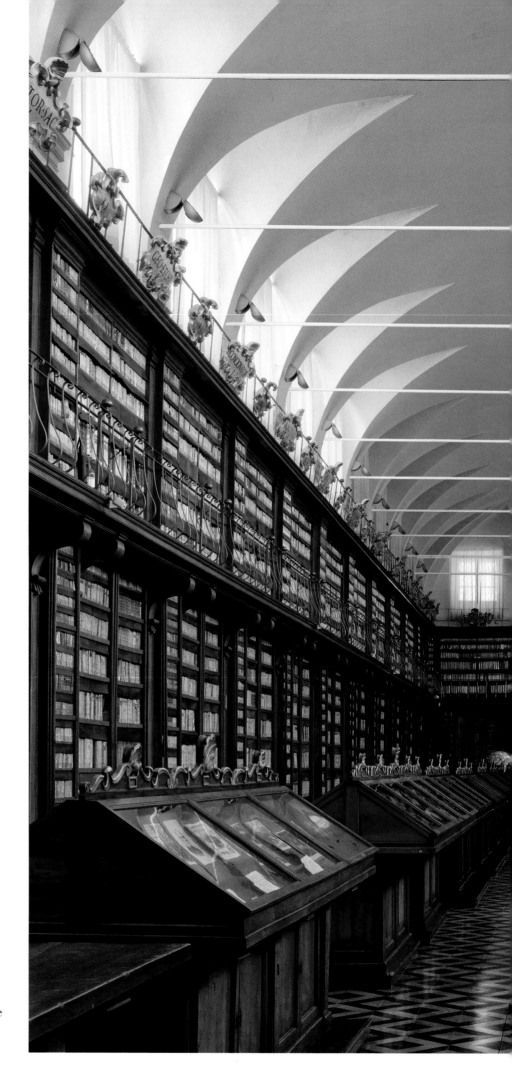

Ambrosiana (see pp. 125–8). Like that library, the hall uses a two-tier wall system, but the lighting problem of the former is solved in the Biblioteca Casanatense by a series of dormer windows cut into the barrel vault down each side. The bookcases themselves are beautifully designed, with dark wood veneers. The gallery, supported on decorative brackets projecting from the wall, has a simple, curved brass handrail. The cases are also simple. Framed by classical columns, they are surmounted by elaborate gilded shields that display the subjects of the shelves below. Only the end walls are decorated. One end, originally the entry, has a door flanked by two spiral staircases leading to the gallery. The other frames a statue of the founder. It is difficult to know whether this library is Baroque or Neoclassical, and the cartouches are even suggestive of Rococo.

Biblioteca Angelica

The Biblioteca Angelica in Rome has a complex history and did not reach its current arrangement until 1765.[29] Founded at the Convento Sant'Agostino in Rome, the headquarters of the Augustinian order, it was the brainchild of Angelo Rocca (1545–1620), an Augustinian friar who was entrusted with producing a printed edition of the Vulgate (the Latin Bible) for the Vatican. Angelo rose to prominence in the Church as a result and amassed a huge collection of books (said to number over 20,000 volumes), which he left to the Convento Sant'Agostino on the strict proviso that it should be made available to anyone without restriction, censorship or government interference. The Biblioteca Angelica thus proudly boasts today that it was the first public library not only in Europe but also the world, although – as discussed in the previous chapter – such claims are meaningless.

The building began as a Baroque wall-system library designed by Borromini. Its present form is the result of a major reconstruction by the architect Luigi Vanvitelli (1700–1773), who was commissioned to rebuild both the convent and library in 1753–65.[30] The Biblioteca Angelica is a rare example of a three-tier wall-system library, with not one but two levels of galleries. These are as slight as was technically possible at the time, with thin metal balustrades designed to be as inconspicuous as the material would allow.

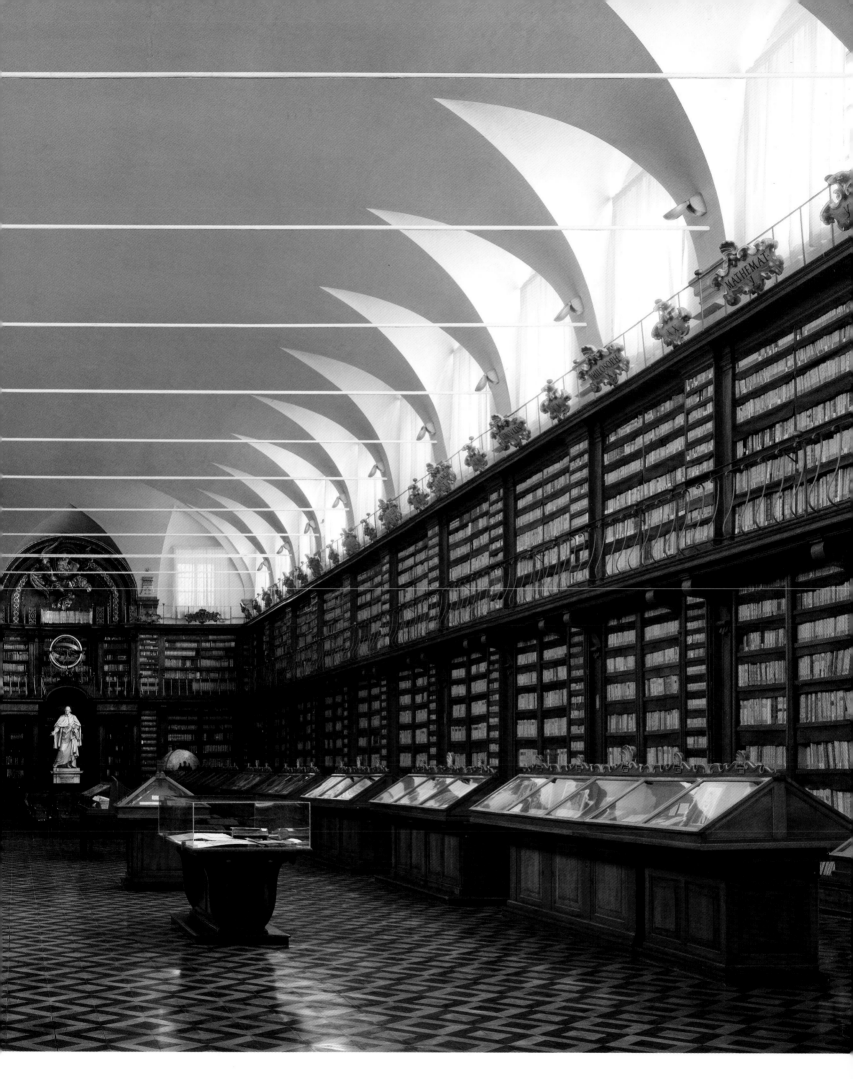

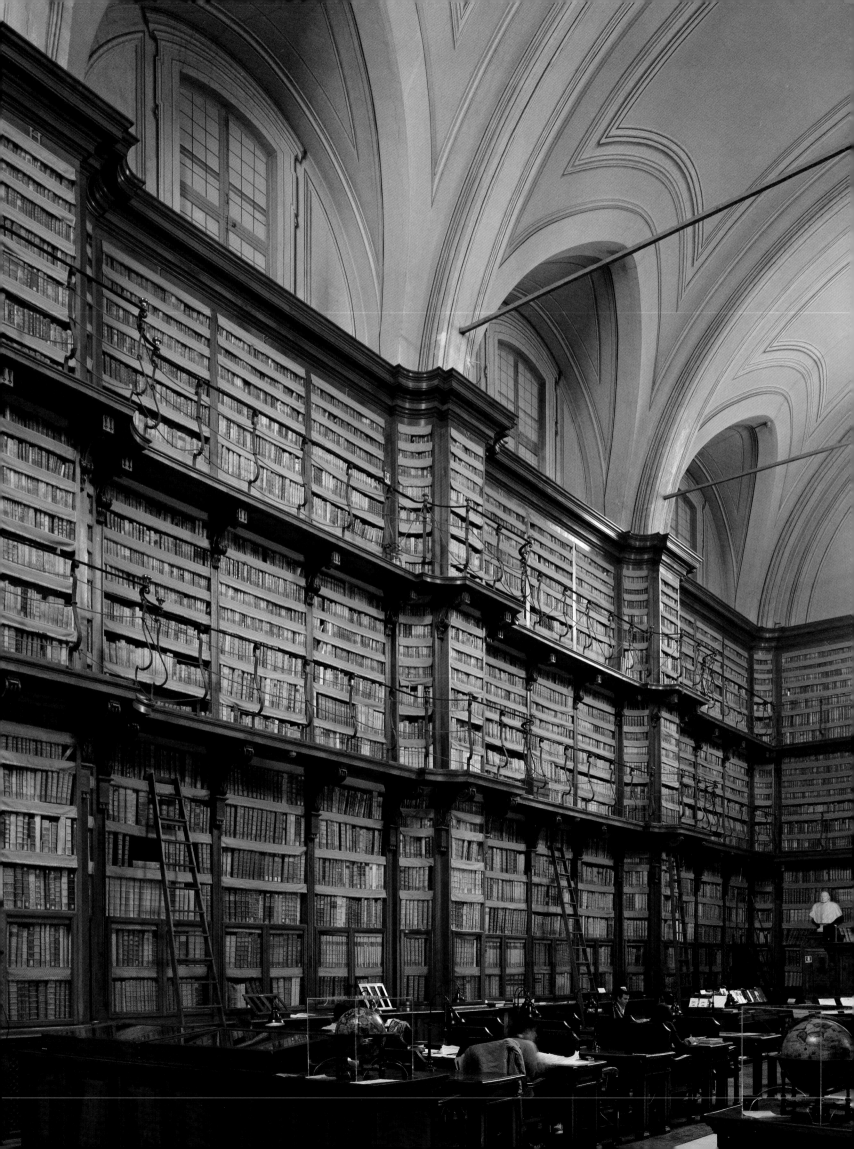

Accessing these galleries provided the architect with a particular challenge. There are secret doors hidden in plinths that support busts. These give access to spiral staircases in the depth of the walls, and secret doors in hinged bookcases at each level open onto the galleries above. The library is lit from only two sides, but it successfully creates the illusion of a symmetrical space in which the reader is entirely enveloped in books.

Although in its final form the Biblioteca Angelica is certainly elaborate, it is not Rococo. That style flourished in the monasteries of southern Germany and Austria in the early to mid-18th century. The motivations for the creation of these lavish interiors in religious institutions were complicated. Melk Abbey in Austria provides an excellent example.

Melk Abbey

Melk Abbey's location could hardly be more dramatic. A huge, palace-like building, it sits on a promontory,

above a curve in the Danube. The abbey church is in the most prominent position, overlooking the river, flanked by the *Festsaal* (festival hall) and library. The *Festsaal* was a grand function room used for the reception of dignitaries and as such one of the most important rooms in the monastery after the church. Placing the library in a position that matched the *Festsaal* indicated its status. The size and scale of abbeys of this period, which seem extraordinary to modern eyes, can only be understood in the context in which they were built, for they were never conceived of as isolated buildings, but as the centres of huge estates, and as palaces for minor royalty. The monasteries were governed by the chapter and a provost (*Propst*) or abbot. Abbots in the Holy Roman Empire could have extremely high status, some ranking as princes and ruling over substantial territories.[31] Since the middle of the 17th century, large building projects had become an established

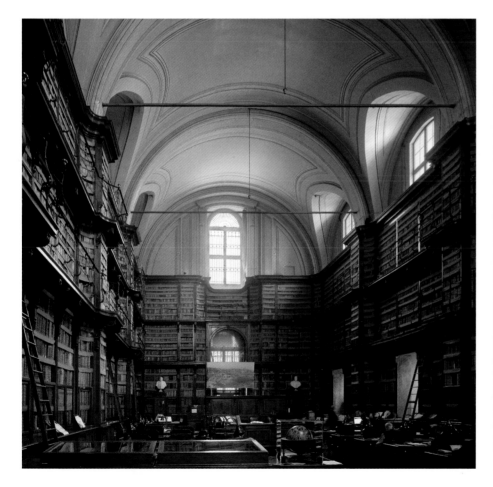

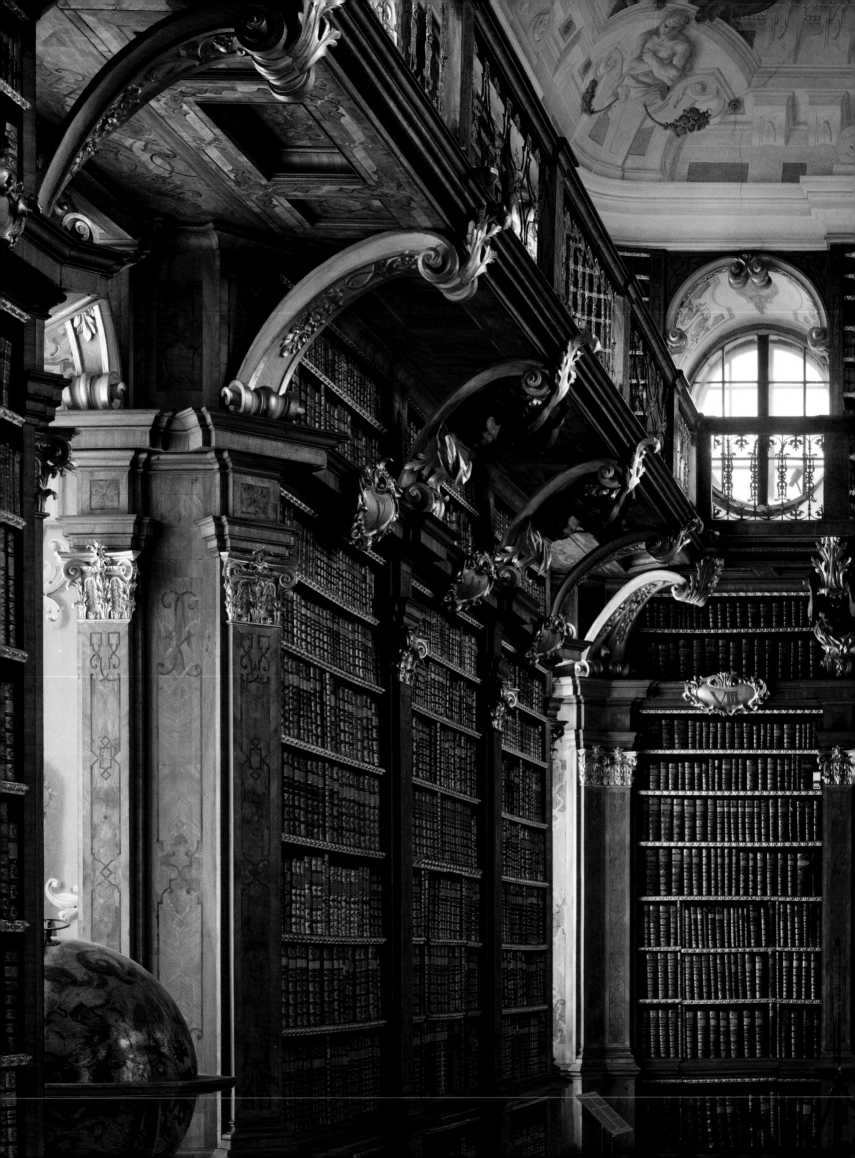

way of expressing political power and prestige. Newly appointed abbots were expected to build and they were regarded with suspicion if they failed to do so. Building projects were an accepted way of using income from agriculture to boost the local economy, and monasteries were subject to regular visitations from the court to inspect the works carried out and the facilities provided and make sure that adequate money was being spent. It is only in this context that these vast complexes, with their grand lodgings for the court, the abbot and the visiting emperor can be understood. The size of the complex and the accommodation it provided usually bore little relation to the number of monks that were housed there, which in many cases was only a few dozen.

With this emphasis on building, all prelates were expected to have an understanding of architecture. The subject was considered a necessary part of their training in seminaries and universities and they were expected to play an active role in planning the buildings under their control. Their portraits often showed them holding plans of the projects they had carried out. By the 18th century, there was an established formula for designing abbeys. The most prominent feature in all cases was the abbey church, and whatever the layout of the other buildings, this had to be seen to be the most important and central element of the whole design. To achieve this aim, the other ranges were usually designed to be as uniform as possible. This uniformity in no way precluded grandeur. The usual method was to produce long ranges with regularly spaced windows. Accent pavilions were positioned at the corners and in the centre where appropriate. There was, of course, nothing new in any of this. The Escorial had exhibited exactly the same characteristics in the 16th century and royal palaces had been built in a similar way throughout the 17th century. The monasteries were rarely built from scratch. Usually there was an existing medieval abbey that was replaced piece by piece until its original fabric was buried deep within the walls of the new construction or had been swept away for new courtyards. Old buildings were demolished without any sentimentality when their new, more worthy replacements were completed. Such was the case at Melk. The monastery had

been founded in 1089, when Leopold II, Margrave of Austria, gave one of his castles to the Benedictine order. By the 12th century it was already renowned for its outstanding collection of manuscripts. In the 15th century it became a centre of monastic reform. Its Baroque transformation, carried out under Abbot Berthold Dietmayr, involved the demolition of the medieval buildings.[32]

Dietmayr (1670–1739) was only thirty years old when he was appointed abbot of Melk. The position quickly led to other political appointments, including rector of the University of Vienna in 1706, advisor to three successive emperors (Leopold I, Joseph I and Charles VI) and imperial envoy to Rome and Poland. His frequent absences, the costs of the building works and the upheavals they involved caused understandable friction with the chapter in Melk.[33] Dietmayr initially appointed the Italian architect Carlo Antonio Carlone (1635–1708) to design and oversee the works, and construction began in 1702. The initial plans seem to have been modest, but in 1705 Dietmayr changed his mind and decided that only a complete

rebuilding would achieve his aims. On Carlone's death, Jakob Prandtauer (1660–1726) took control of the works.[54] Little is known about his early life. He seems to have been apprenticed to the painter Hans Georg Asam, but on the death of his mother he was described as a sculptor. He appears to have worked with Carlone at the abbey of Kremsmünster, a building that includes a fine richly painted single-storey Baroque library, 65 m (213 ft) in length, built in about 1680. On Prandtauer's death, his nephew Josef Muggenast (1680–1741) took over the work at Melk.[55]

The designer

It is not clear who designed the library at Melk. The abbot certainly took a keen interest and may well have drawn up the plans himself. It was the usual practice for the architect to be responsible for the room, but cabinet-makers often designed the shelving and the plasterers the plaster decoration of the walls and ceiling. The content of the ceiling frescoes was then decided by the abbot, rather than the architect. He typically sent a letter to one or more artists describing the composition he desired. They then submitted designs for approval.[56]

At Melk, the library is in an unusual position. It was designed to mirror the *Festsaal* on the other side of the abbey. This was more for external effect than practicality. In this period it was expected that libraries would be shown to visitors as part of a tour, which always included the *Festsaal* and the church, but until the external veranda overlooking the Danube was built in 1731–2 the route between the library and

below and opposite
**MELK ABBEY LIBRARY,
1752. Melk, Austria**

The main hall (below) is 20 m long, 9 m wide and 9 m high (66 x 29 x 29 ft). The door at the end leads onto the external walkway overlooking the Danube that links the library to the Festsaal *on the far side of the church. The building has five windows along each side, but internally only three are visible. The lower part of the middle sets of bookcases in each bay is mounted on rollers and hinges to give access to secret study carrels, which have their own windows behind. The ceiling, which depicts Divine Wisdom, is by Paul Troger. The bookshelves (opposite) are fixed, each shelf getting successively shallower so that the top shelves on the galleries are in fact too low to hold any but the very smallest books and so are provided with fake ones to fill the space. Smaller books were traditionally placed on galleries because they were easier to steal.*

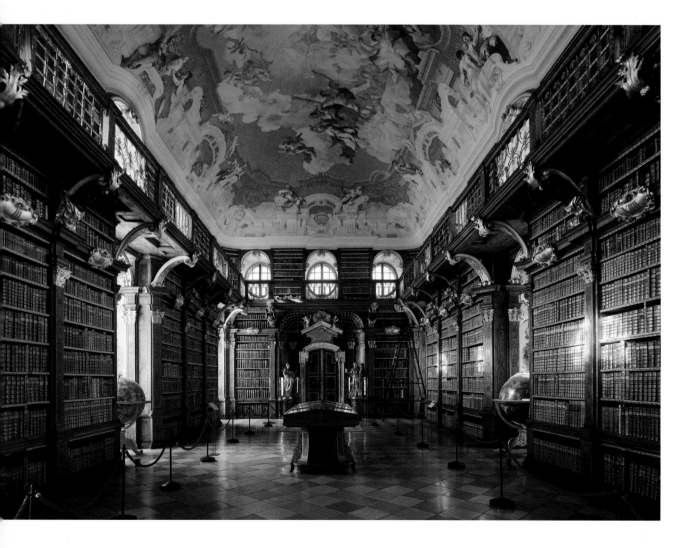

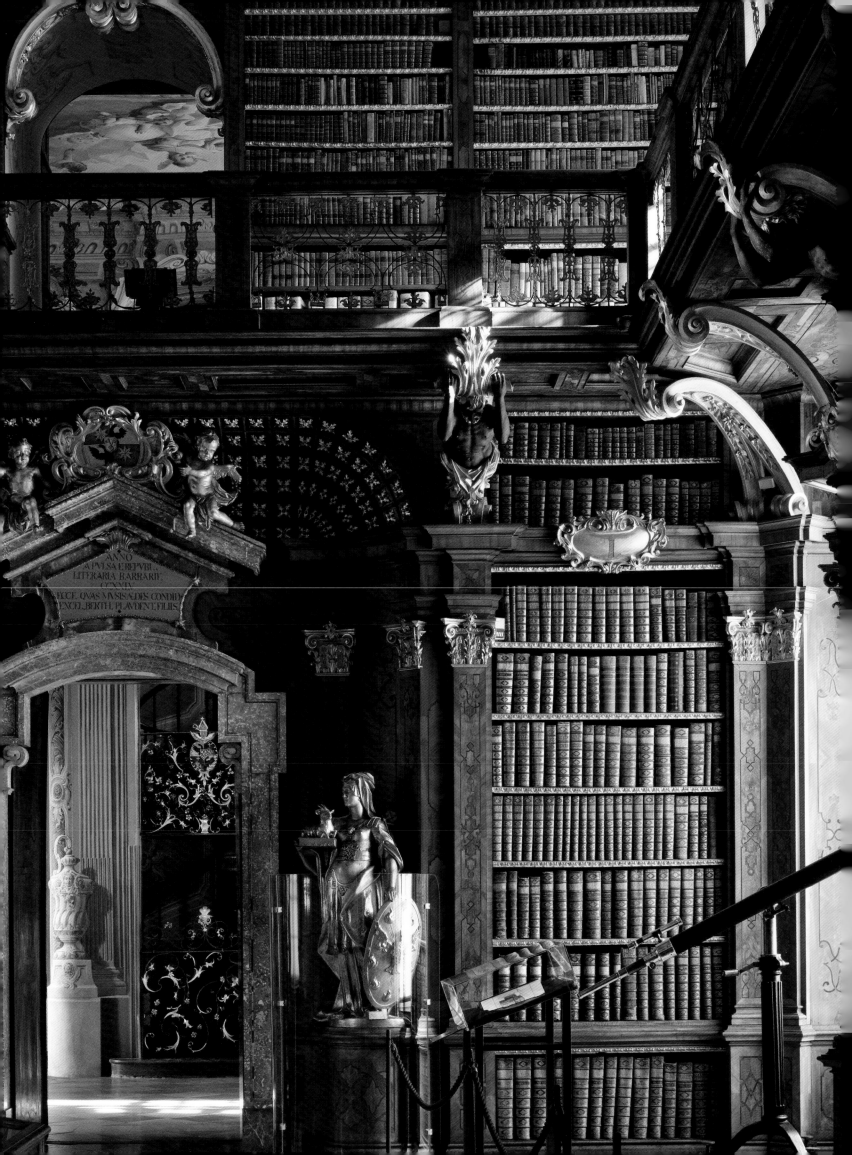

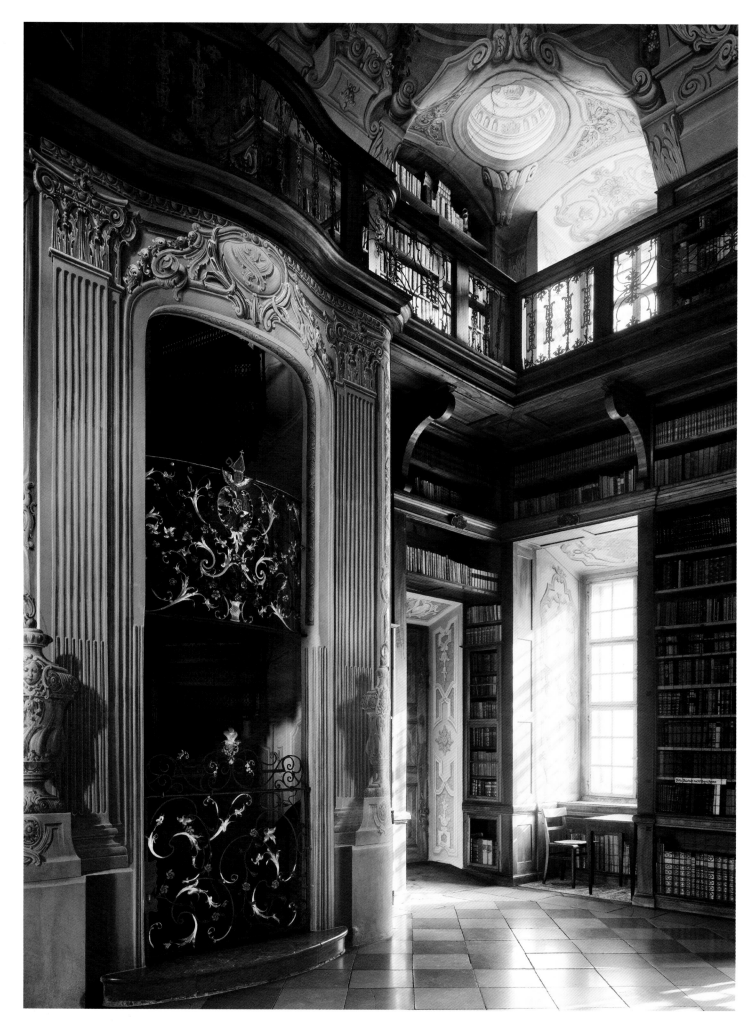

Festsaal at Melk was convoluted.[37] Even with this external walkway it was far from ideal in winter. The *Festsaal* was designed to be as open as possible, with huge windows enjoying views over the valley below. Externally, the library is designed to match the *Festsaal*, but such huge windows would have left little wall space for books. The solution was to push the cases into the room and build some of them in front of the windows. The spaces behind these bookcases are little studies, accessed by secret doors in the bookcases in much the same way as at the Hofbibliothek, which may well have provided the inspiration for this feature.

Fixed shelving

The library shelves at Melk Abbey are all fixed. This has the advantage that the shelves run continuously round the room, forming regular horizontal stripes. The obvious disadvantage is that each shelf can carry only books up to a certain size. At Melk, large books were shelved closest to the ground with the shelves above becoming progressively smaller. This continues above the gallery right to the ceiling, and has the effect of exaggerating the perspective, so the room seems taller than it is. In fact, the topmost shelves are so low that they cannot be used to take even the smallest books, so the shelves are filled with wooden blocks painted to look like books with jocular titles, such as *Anonymous de Xylo* ('Wood, by Anonymous') and *Lignarus de Vacuo* ('Empty, by Woody') painted on the spines.[38]

The bookcases are inlaid with veneer and adorned with carved and gilded decoration. Their width is governed by the maximum span of the lower shelves, which have to carry the heaviest books. The cases are divided by Corinthian pilasters, which sit on plinths rising to dado height. The largest folios are shelved below this rail, but there is no desk. Indeed, there is no furniture for reading of any kind (for reasons that will be explained below), apart from the desks in the niches already mentioned. The Corinthian capitals support an entablature. Decorative gilded brackets spring from this level to the underside of the cantilevered galleries. The staircase to the gallery is in an anteroom, also lined with books, which gives access to other smaller single-storey rooms for special collections, which are decorated in the Rococo style. These are never open to the public. A centre of

Benedictine scholarship since the 11th century, Melk had one of the finest collections of manuscripts in the world. Not all abbeys were in such a good position.

Creating the illusion of a collection: Altenburg

Altenburg Abbey in Lower Austria, not far from Vienna, was closely associated with Melk Abbey. It is thus no surprise that the same team of Josef Muggenast (the architect who had taken over from Prandtauer) and the artist Paul Troger (who executed the ceiling paintings at Melk) were employed to carry out major reconstructions at Altenburg. The rebuilding encompassed not only the church, but also palatial accommodation for the provost and abbot, rooms for the emperor (should he visit), grand guest quarters for other dignitaries (with stables for their horses) and a huge suite of banqueting rooms. When all these were complete, attention turned to the library.

Altenburg had a particular problem when it came to providing a library of suitable proportions to match the scale of the rest of the complex. Whereas

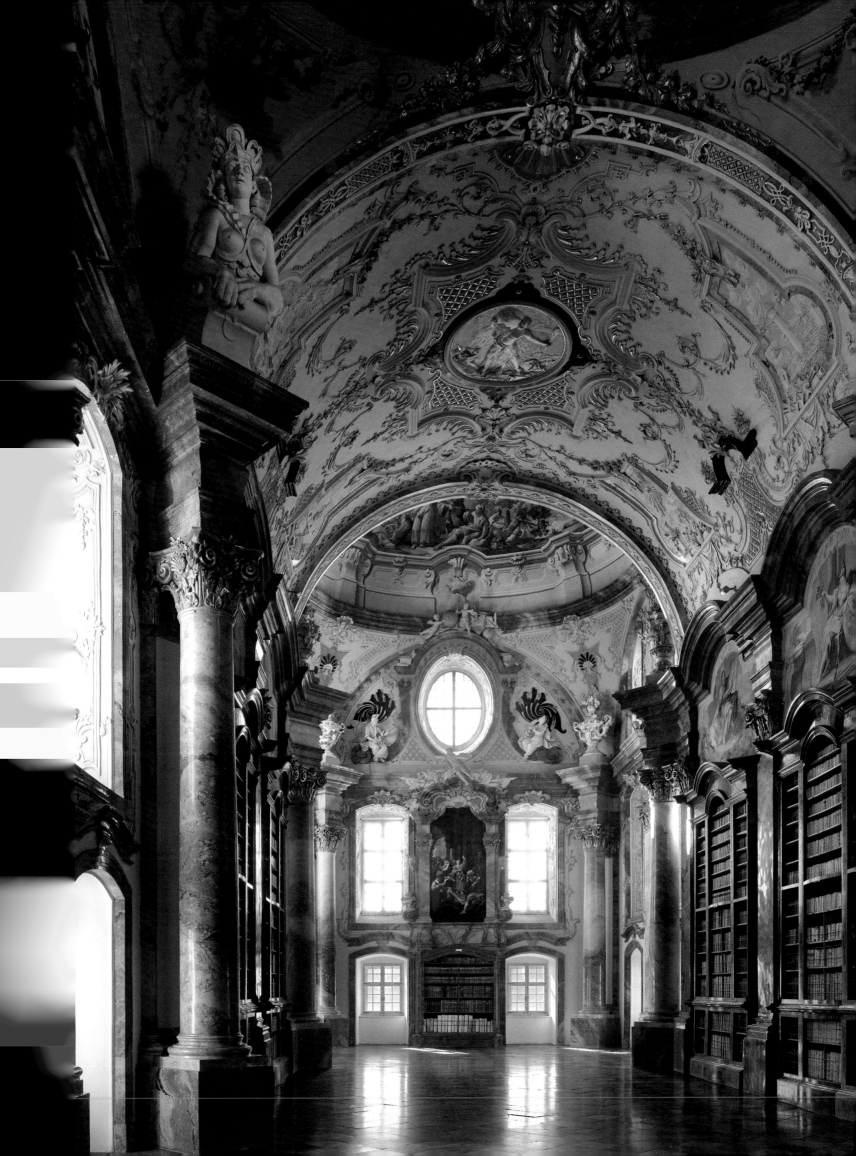

This view down the second half of the library from the central dome (opposite) gives a clear idea of the room's size: 9.5 m wide, 47.5 m long and 15 m high (31 x 156 x 49 ft). The contract for the ceiling frescoes by Paul Troger and Johann Jakob Zeiller is dated 1742. The frescoes explore the nature of Divine Wisdom. The south dome (right), shows Philosophy with Dionysius the Areopagite at the bottom explaining the eclipse at the Crucifixion, at the top, and Medicine with the Good Samaritan, in the centre, on the right.

Melk had enjoyed a long history of bookmaking and book collecting and boasted a huge collection of manuscripts and printed volumes, Altenburg had disappointingly few books of any kind.[39] It was considered necessary to provide a library room in a monastic complex as proof that the monastery was fulfilling its expected duties. Many monasteries had few books of any note, however, and this left abbots and architects with not inconsiderable problems. One solution was to build a small library and decorate it as lavishly as possible to distract attention from the contents. This tactic was used at Metten Abbey, in Bavaria, where the single-storey library is incredibly ornate and the vaults of the roof are supported by contorted allegorical figures.[40]

Another, less convincing, solution, used at the abbey of St Pölten in Lower Austria, was to hide the books in cabinets.[41] But this was against the advice of manuals on library design of the time, which suggested that it should be possible to see all the books from anywhere in the room. To try to overcome this, the books at Schussenried Abbey in Upper Swabia were stored in cabinets with a difference. The lower part of the cases had wooden doors with books painted on them and a fold-out desk for consulting works in situ, while the upper parts had opening doors with canvas panels also painted with *trompe-l'oeil* books.[42] Writers had noted the advantages of cabinets for keeping books in good order. They had even commented on the possibility of painting books on them to reflect the contents, but they had rejected the idea because the cabinets would have had to be repainted every time the books were rearranged.

The designers of the library at Altenburg opted for a third way: architectural sleight of hand. Here, rather than making the library small and single-storey, revealing the shortcomings of the collection, the abbot and architect decided to build an enormous new wing on the side of the monastery, on a steep hillside. A dramatic Baroque staircase links the new building with the main part of the abbey. The library is formed of a great hall 9.5 m wide, 47.5 m long and 15 m high (31 x 156 x 49 ft).[43] The room consists of three domed spaces (one at the entrance, one in the middle and one at the far end), separated by barrel vaults. From the door the viewer sees the long central part of the hall, but the

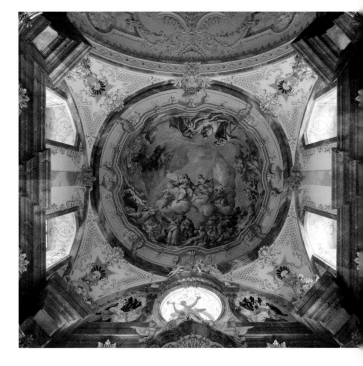

sides of the domed spaces are out of view. As there are huge cases in the barrel-vaulted spaces between the domes, the viewer assumes that all the walls are lined with books. In fact, apart from one on the end wall, these are the only cases in the room. The walls of the domed spaces are filled with windows, but once under the domes visitors are naturally drawn to look upwards to admire Troger's magnificent paintings. The result is a huge library that actually has shelf space for very few books, which is exactly what the monks intended.

More surprising still is the space below the library. By this point, the abbey had more than enough accommodation, but the steeply sloping site chosen for the library meant that a space was left to be filled underneath it. The solution chosen was to make it into a vast crypt, so that future provosts would be interred beneath the library in a room designed only for funerary services. The words of the dead were thus kept above and the bodies of the dead below.

Positioning the library

At 15 m (49 ft) high, the library room at Altenburg is extraordinarily tall for a single-tier library. The sloping site and the fact that it was built on the side of the complex meant that the architect had more freedom

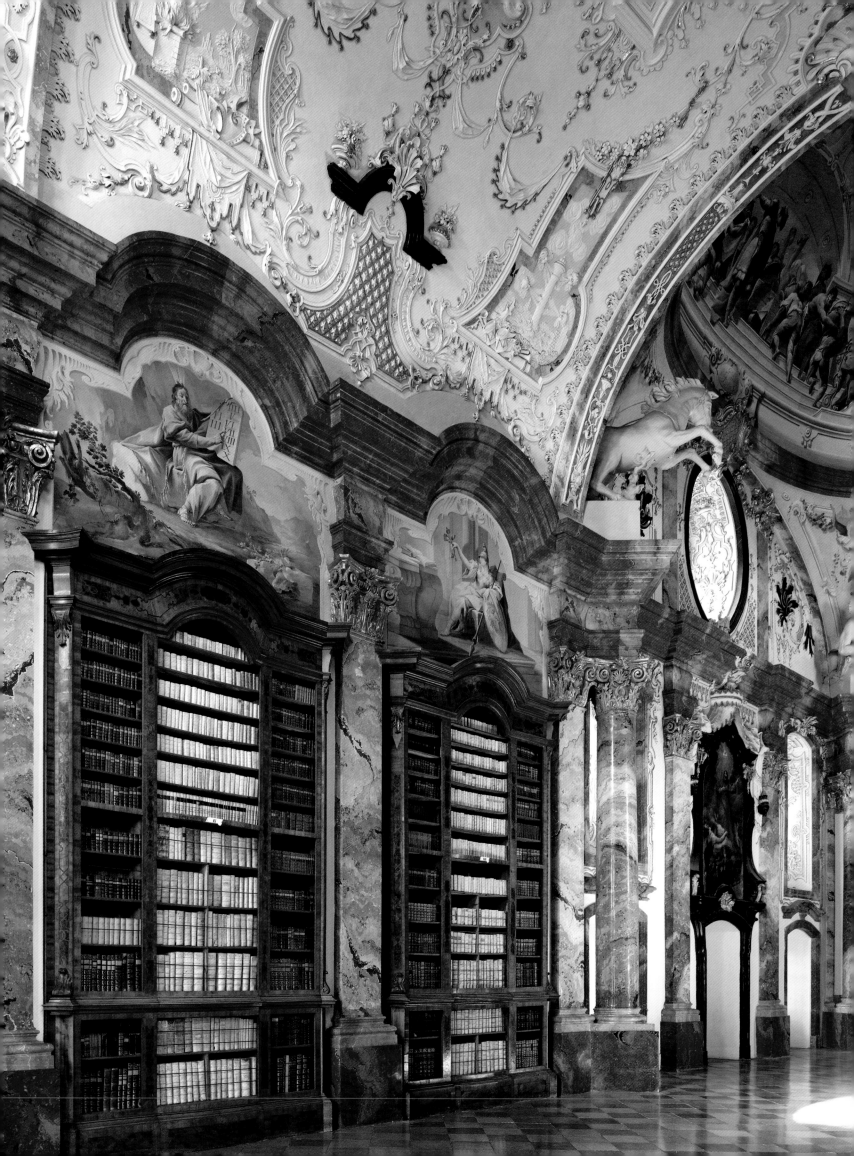

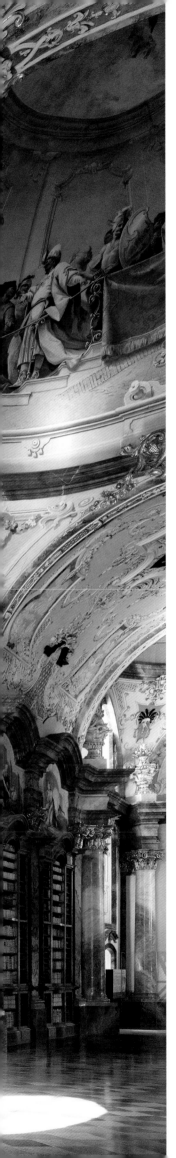

ALTENBURG ABBEY LIBRARY, 1742
Altenburg, Austria

*The library (left) was designed to exaggerate the importance of
the collection. Despite its vast size, it contains only nine bookcases,
two on each of the walls between the domes and one at the end.
There are no bookcases under the domes, as the walls there
have windows. The crypt underneath the library (below) was
designed as a mortuary chapel for the abbots. The dead are thus
remembered below the library, which is itself a repository of the
thoughts of the departed.*

in its layout than usual. Even here, the roofline of
the library and the spacing of its windows on the
elevations match those on the main blocks. Thus the
library has windows on two levels and from the outside
the wing looks as though it contains two storeys of
accommodation. Far from expressing the purpose of
the space within, the exterior of the library deliberately
attempts to blend seamlessly with the other buildings
in the complex. Hiding the library within the complex,
rather than expressing it, was part of the general
strategy of keeping the other buildings subsidiary to
the abbey church, the only element that was instantly
recognizable from the outside. It also meant that
building of the external walls of these monasteries
could begin before the interiors had been fully worked

out; indeed, the shell could be left empty until the
money could be raised to complete the work. The
disadvantage was that the exterior design had to work
equally well for the demands of monastic cells and the
larger spaces within. There was no standard solution.
One strategy can be seen at Wiblingen Abbey.

Wiblingen Abbey

Wiblingen Abbey is in Germany, near Ulm in Upper
Swabia. It was founded in 1093 and like many of the
great monasteries, it attracted money from pilgrims
coming to see its holy relics. Here the relics in
question were pieces of the cross on which Christ
was crucified. In the 15th century the monastery was
one of those that participated in the Melk Reform, a

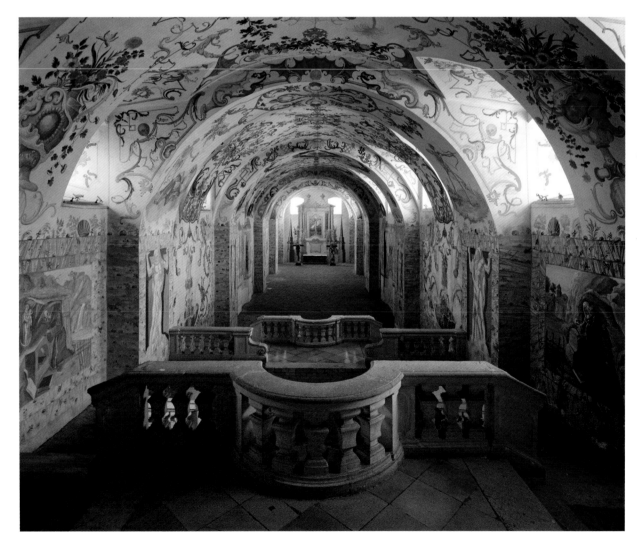

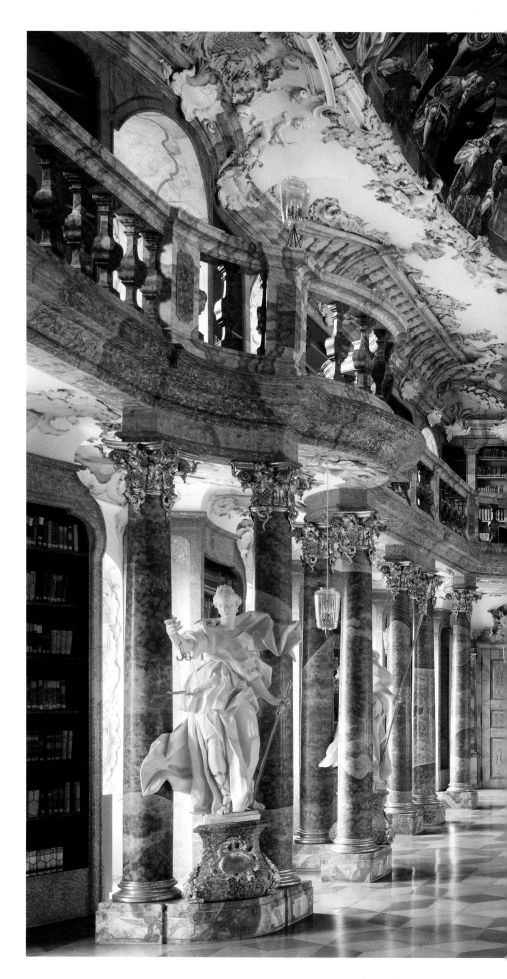

right and overleaf
WIBLINGEN ABBEY LIBRARY, 1744
Wiblingen, Germany

Constructed between 1737 and 1740 and decorated in 1744,
this magnificent library is 23 m long and 11 m wide (75 x 36 ft),
spanning the complete width of one wing of the monastery. The
statues (overleaf), which represent the virtues and the disciplines,
are timber, painted to look like marble, and the columns are
timber finished in scagliola.

movement originating at Melk Abbey that sought to
revive monasticism in the region by a strict adherence
to the original rules and aims of the Benedictine
order. By encouraging learning, the movement was
instrumental in spreading the ideas of humanism in
Austria and southern Germany. Scholarship in the Melk
Reform monasteries benefitted greatly. Wiblingen had
an active scriptorium and by the middle of the 18th
century it owned a library of over 15,000 books.[44] Over
the course of the centuries the monastery was rebuilt
several times. The present buildings date from 1714–83,
but one wing was not completed until the 20th century.
The complex was set out by Christian Wiedemann
(1680–1739), although the wing containing the library,
which was not started until 1737, was carried out by
his nephew Johannes. Construction of the library was
complete by 1740, and most of the decoration, which
included paintings by Franz Martin Kühn, by 1744, save
the undersides of the galleries, which were not finished
until 1750.[45] The first thing that strikes the visitor is the
rich pastel palette chosen for the scagliola columns and
the undulating edge of the balcony. The pinks and blues
of the scagliola bear no relation to actual marbles. The
allegorical statues of the virtues (Obedience, Solitude,
Piety and Devotion) and the disciplines (Philosophy,
History, Law and Theology) are wood, painted to
resemble highly polished marble. The doorways on the
gallery are concealed by niches that contain statues of
Civil and Royal Authority.[46] Each entire niche is hinged
and set on rollers, allowing it to move like a door.

Full-width versus corridor plans
The library at Wiblingen Abbey occupies a pavilion
in the centre of a long range. Its existence is not
signalled on the outside. The two-storey library has
two levels of windows, and the slightly raised roof of
the pavilion provides the extra space necessary for
a domed ceiling. The library occupies the complete
width of the range. Such an arrangement was ideal
because it meant that the library could be lit from both
sides, but the obvious disadvantage was that it blocked
circulation through the range, unless people were
allowed to walk through the library in order to access
the rooms beyond it. This was not generally possible
for security reasons. Libraries were usually kept
locked and indeed a frequent complaint of visitors to

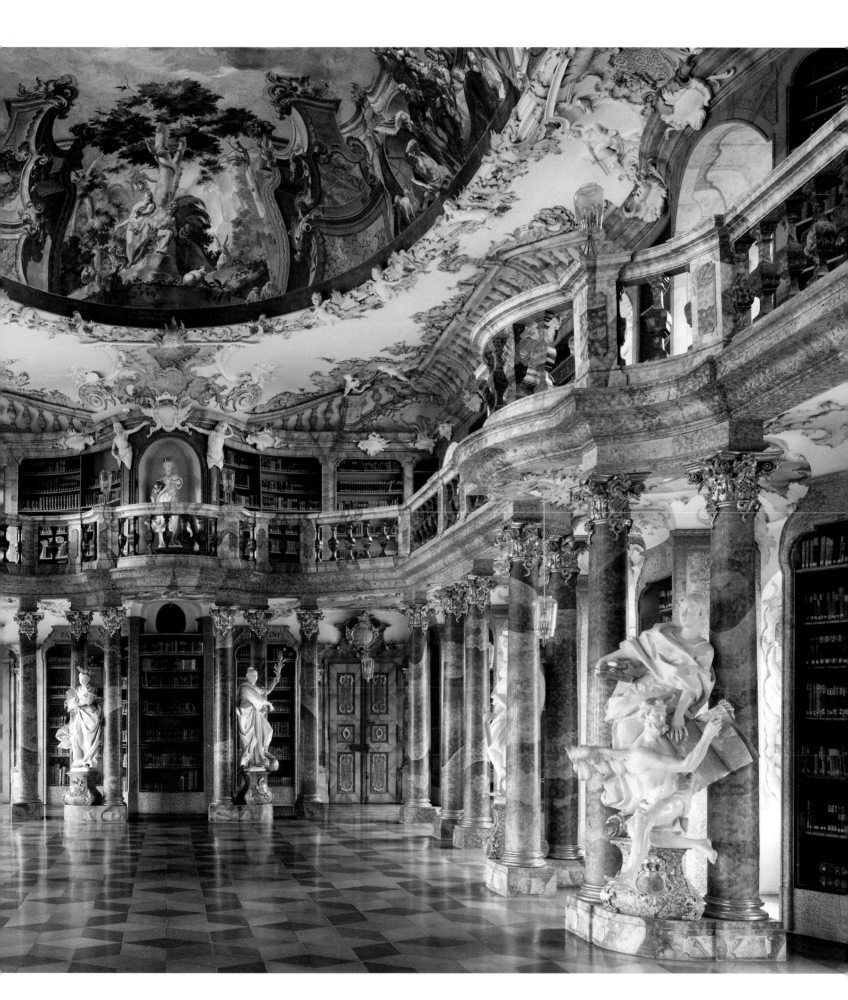

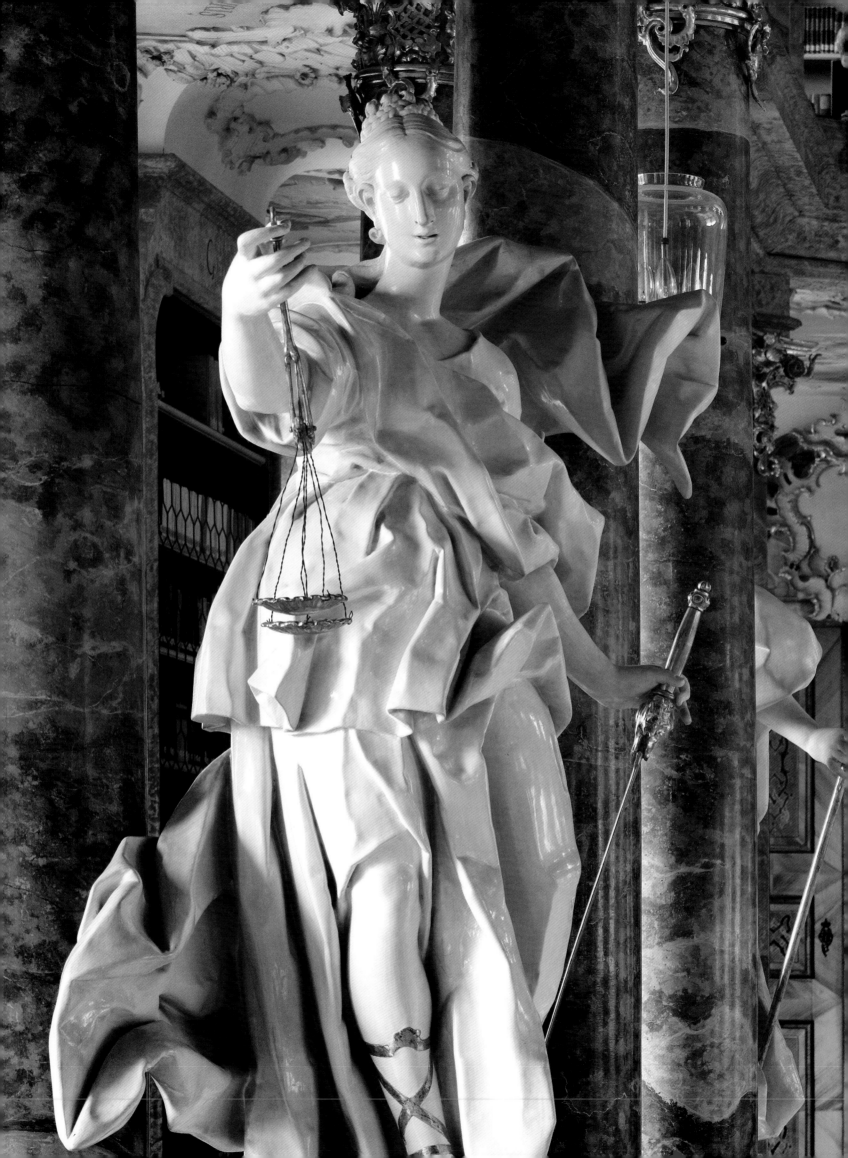

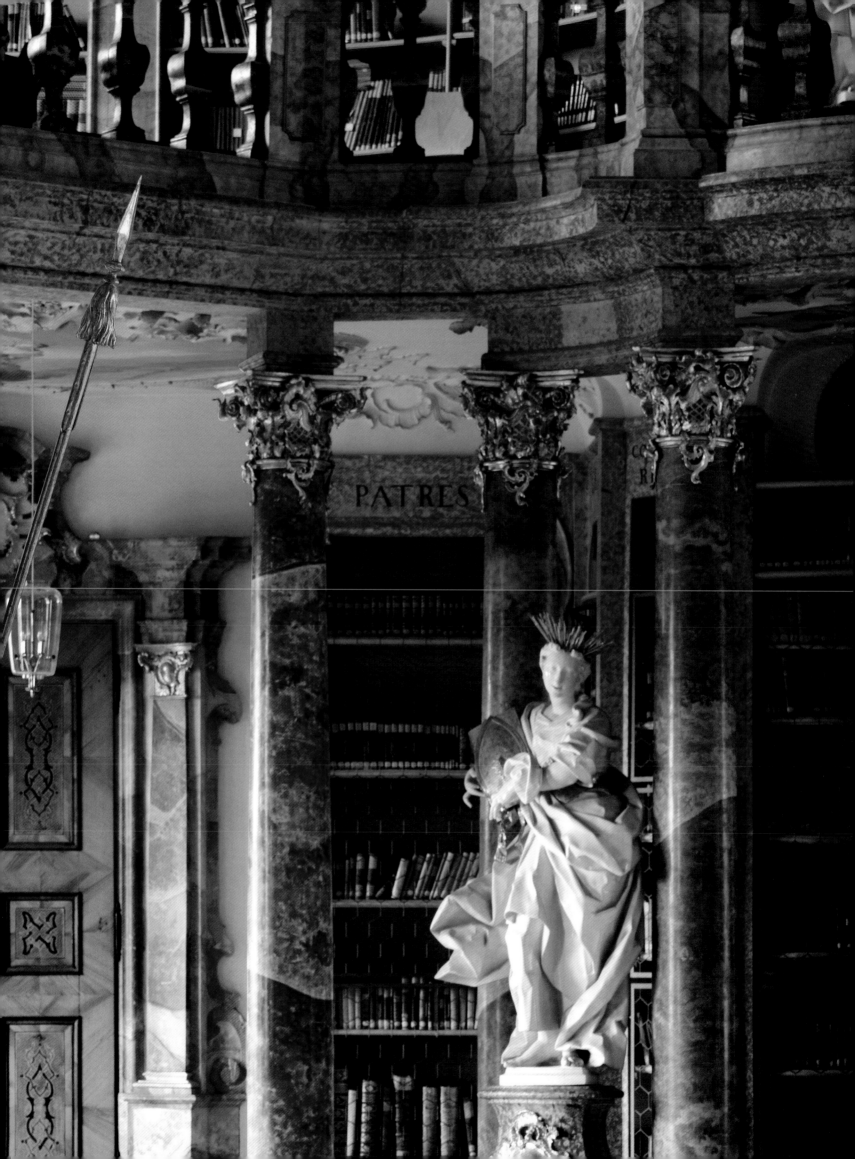

left and opposite
**ABBEY OF ST FLORIAN
LIBRARY, 1750**
St Florian, Austria

*The library, constructed
between 1744 and 1750, occupies
one side of the long east range
of the south court. It is entered
by way of a magnificent
staircase, in the centre of the
long side (left). The library is
lit from one side (opposite).
Its decoration, which depicts
the marriage of Virtue and
Learning by means of religion
and the Augustinian tradition,
was devised by the abbey
provost and executed by
Bartolomeo Altomonte.*

libraries in the 18th centuries was that they could not
be admitted because the librarian was away and had
taken the key with him. Libraries might have doors
at both ends, but if these were useful for circulation
at all, it was only on special occasions (such as royal
visits). More often than not, the doors simply led to
manuscript rooms or offices for the librarian. The
alternative was to have the library on one side of the
range and a corridor on the other.

When the library occupied the complete width of
the range, it was often quite wide in proportion to its
height. This could have the unfortunate effect of making
even quite a large space look too low. The library at
Wiblingen shows one solution to this problem, which
was to construct very wide galleries that are necessarily
supported on columns. In general columns are used
to support galleries in German Rococo libraries and
cantilevered galleries on brackets in Austrian ones,
but this is a simplification and there are a number
of exceptions to the rule. There are German two-tier
libraries with cantilevered galleries (Amorbach and
Füssen abbeys) and Austrian ones with columns
(the first library at Admont Abbey, which has been
demolished, and the Abbey of St Lambrecht).[47] All
that can be said with certainty is that in Germany
full-width libraries with column-supported galleries

were more common. The alternative to the Wiblingen
arrangement, in which the library spanned the whole
width of the wing, was that of abbeys such as St Florian,
in Upper Austria, where the library was lit from one
side and corridors or other rooms ran alongside.

Abbey of St Florian

The original Abbey of St Florian was laid out by Jakob
Prandtauer (the architect for Melk) in 1710–16, but
work on the library did not begin until 1744–50, under
Johann Gotthard Hayberger (1695–1764).[48] The library
is constructed on the east side of the main entrance
courtyard. Its windows face eastwards, perhaps
following Vitruvius's advice but more probably through
simple expediency.[49] It is on the upper floors of a central
pavilion, which also contains a grand Baroque staircase
on axis with the main gatehouse. Most Rococo
libraries are entered at one end, so that the viewer
appreciates the length of the library. By long tradition,
the bibles are placed at one end, usually the far end,
with the rest of the subjects arranged in relation to
them, theology and the Church Fathers closest and
the works of mankind and literature furthest away.
Although this arrangement is maintained at St Florian,
the central entrance means that the visitor arrives at
no particular point in the sequence.

The complexity of a library such as St Florian's
and the way the paintings are so well integrated
with the architecture makes it tempting to see it and
other Rococo libraries as *Gesamtkunstwerks*, total
works of art. Research has shown, however, that they
were never the products of a single mind but always
the result of complex collaborations.[50] Hayberger
may notionally have been the architect in charge
of the works at St Florian, but the records clearly
show that the library was the brainchild of, and
carefully planned by the abbey provost, Johann Georg
Wiesmayr (*fl.* 1732–55), working in close collaboration
with his artists and craftsmen.[51] There was, however,
no single controlling genius determining every detail.
The uniformity emerged from an understanding of
what was expected from each contributor.

Reading in the library

The library at St Florian follows a two-tier wall system,
with veneered bookcases covering all the walls. There

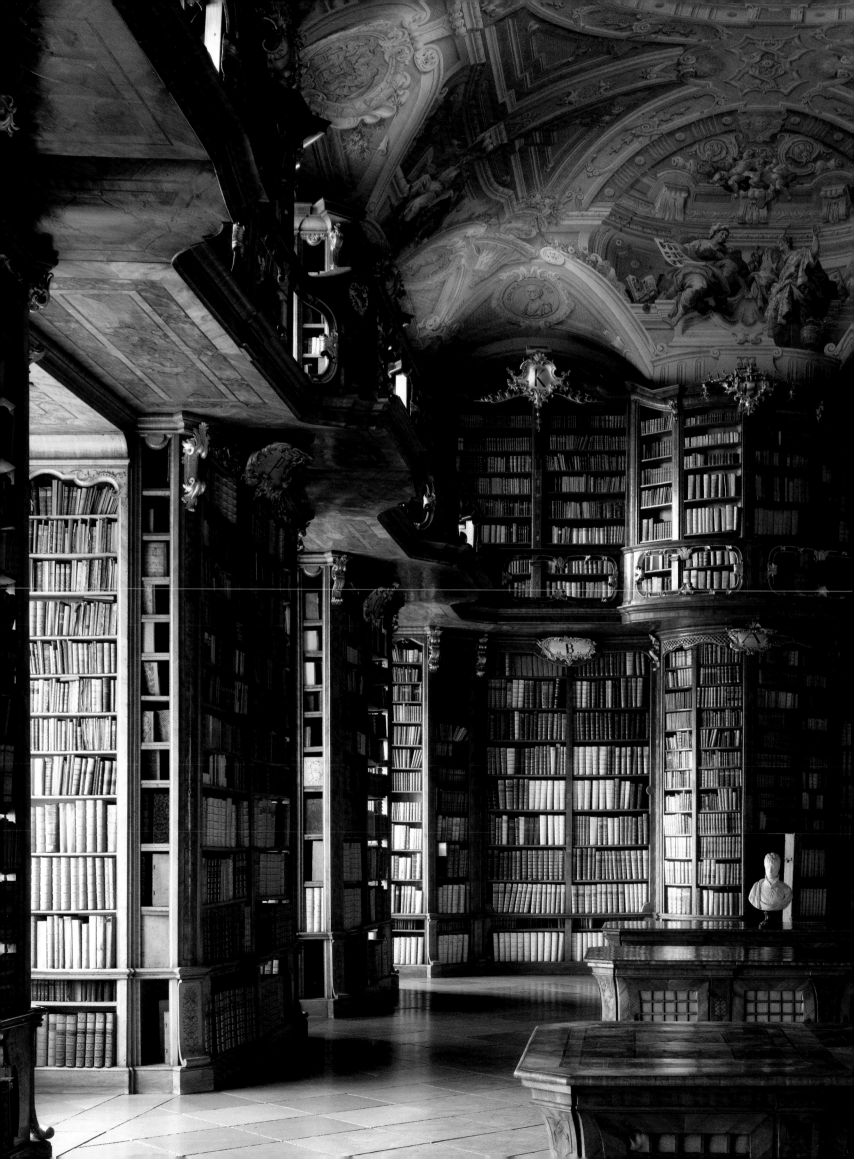

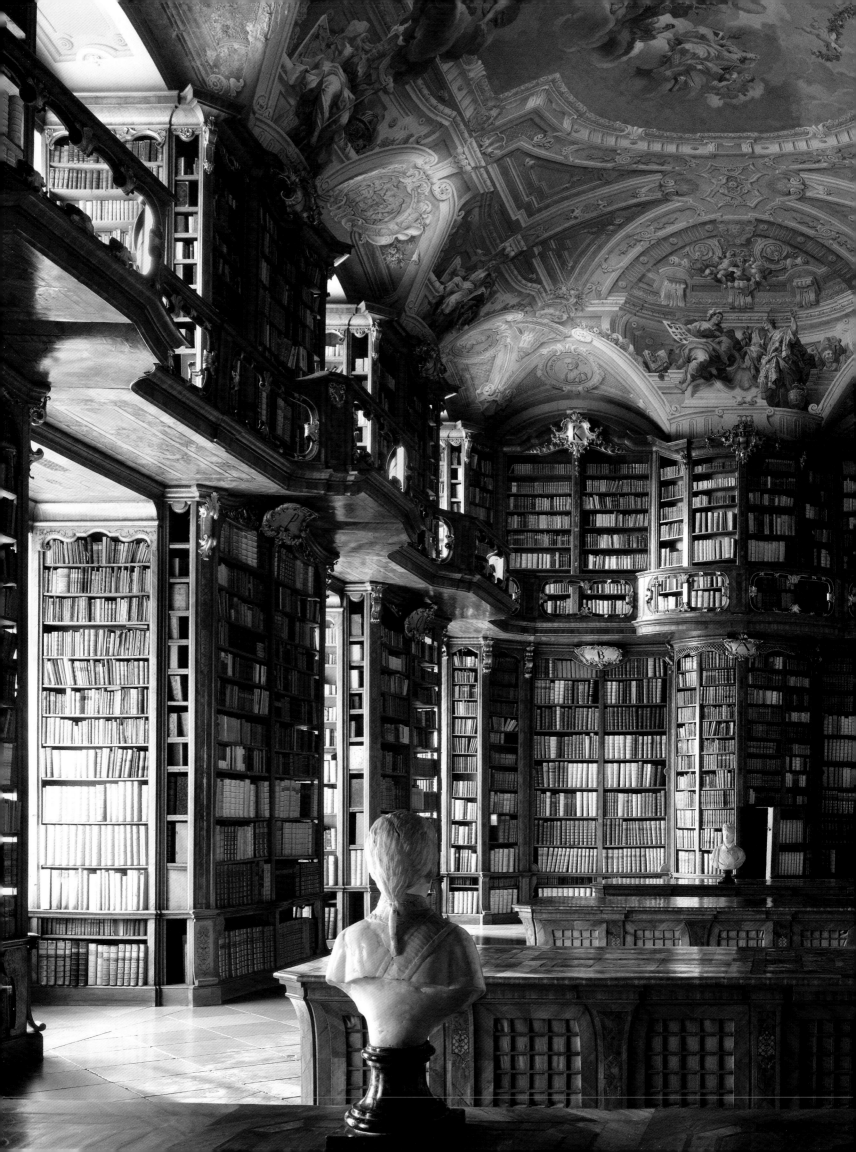

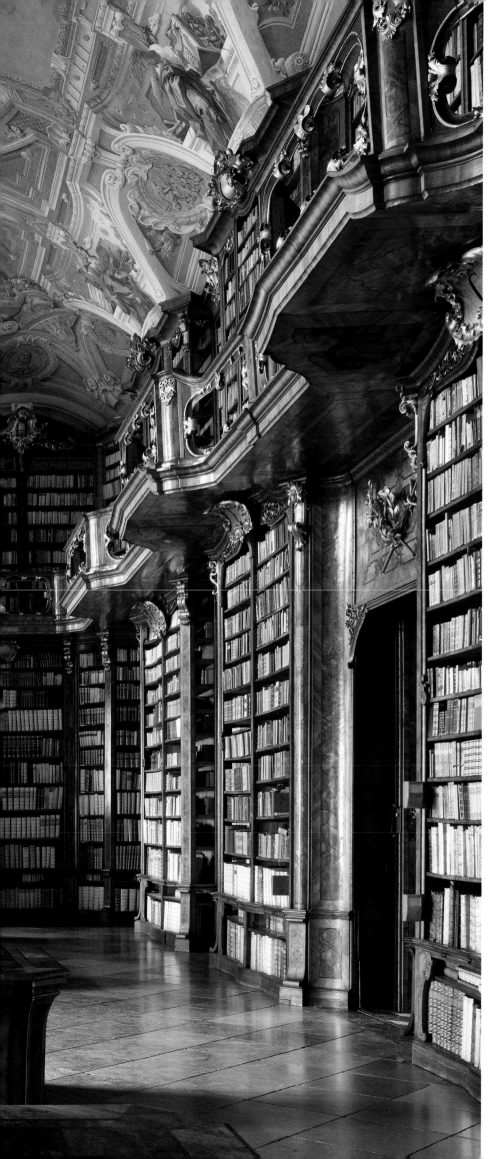

The main space is 13 m wide, 24 m long and 10 m high (43 x 79 x 33 ft). The bookcases on one side of the projecting drum at each end are mounted on rollers and hinges to give access to a series of ancillary rooms for manuscripts and other objects, including a coin collection. Spiral staircases inside these drums lead up to the galleries, via similarly concealed doors on the upper level.

are no classical columns. The presses are separated by thin dividing elements, which curve into arches at the top. The handrail of the gallery is light and richly decorated. Standing on the gallery, it feels insubstantial and unlikely to help in the event of a stumble but this was not considered important because the gallery was never intended to be accessed by anyone except the librarian. The handrail is more decorative than functional and for the same reason it is enriched only on the side visible from below, a reminder that the architecture is being treated like a stage set. On the rear side, which is visible only to the librarians and thus behind the scenes, the balustrade is roughly sawn and the nails and fixings can be seen clearly. The gallery is accessed by spiral staircases behind the bookcases, which have hinging cases acting as doors at the upper and lower levels. These doors also give access to ancillary rooms, which were designed to house manuscripts, globes, scientific instruments, and maps. There was also a room for forbidden books that had been placed on the Index and were thus not available to monks without a specific reason to consult them and permission from the abbot to do so.

In the centre of the room four fixed tables contain cupboards and drawers for manuscripts and other items. Several of the cupboard doors become chairs when pulled open. These, however, are designed for monks wanting to check references quickly rather than to read at for any length of time. Rococo monastic libraries were never heated. The monks had stoves in their cells and were expected to borrow the books and read them there. In some libraries a separate heated reading hall (termed a *Musaeum*) with study carrels was provided.[52] It is important to remember that all these great Rococo libraries were for storing and displaying books, not reading them. They were never intended as places for study.

Arrangement of books

The position of the books in the St Florian's library is marked by lettered cartouches above the cases. Bibles were normally in cases marked 'A', but the rest of the letters provided only a way of finding the books from the written catalogue; they did not indicate the subjects shelved there. By the 18th century, book

collections were growing at such a pace that it was not sensible to allocate shelves to particular subjects. Books were being continuously moved around. For this reason, too, the painted and sculptural decoration did not, as some writers have suggested, strictly act as a visual catalogue. Instead, the sculptures and paintings set out an ideal arrangement of knowledge. It could hardly be otherwise. Although all these libraries professed to encompass the whole of human knowledge, they were usually very strong in some subjects (typically theology) and much weaker in others (such as natural science or mathematics). Even libraries with very rich collections, however, did not match decoration to book placement.[55]

Abbey of St Gall

The Abbey of St Gall in St Gallen, Switzerland, has perhaps the most famous of all medieval libraries (see pp. 78–82). The collection was begun in the middle of the 8th century under Abbot Waldo (740–814), who went on to found another great library at Reichenau Abbey in southern Germany. Over the next two centuries, St Gall established itself as a major centre of book production. An extraordinary four hundred manuscripts survive from this period alone.[54] In the 13th century, the abbey and town became an independent principality in which the abbot ruled as a prince of the Holy Roman Empire, a status it retained until 1805, when it was secularized. The monks were then thrown out and the monastery became the seat of a bishop, and the abbey its cathedral. Although the abbey suffered many setbacks in the 15th century and lost books through invasions and theft in various periods, it still retains 2,100 manuscripts and over 1,650 incunabula (books printed before 1500), making it one of the most important book collections in the Western world.[55] The current monastic buildings date from the very last period of its existence as a monastery. They were designed between 1749 and 1768 by the architect Peter Thumb (1681–1766).[56]

Decoration as catalogue

The subjects in the library are represented by putti, which sit in niches above the cases and carry items relating to their disciplines. However, these figures are placed around the library to represent only the

left, opposite and overleaf
ABBEY OF ST GALL LIBRARY, 1763
St Gallen, Switzerland

The library has many forms of decoration, including putti in niches above the cases, representing the mechanical disciplines and the fine arts. This putto (left) represents architecture and is holding a plan, with drawing instruments tucked into his belt. The library wing (opposite) was added by the architect Peter Thumb in 1758–60. The decoration was completed in 1762–3. The library is on the second floor and is 9.95 m wide, 28.4 m long and 7.3 m high (33 x 93 x 24 ft). The projecting end bay (overleaf) contains the staircase to the gallery. The door on the upper level leads to the manuscript room. The ceiling frescoes by Josef Wannenmacher represent church teachings, providing a guide for the scholarly, pastoral and pedagogical aspects of monastic life.

range of subjects, not the position of subjects within it. Here, as in other monastic libraries, the books were arranged on the shelves roughly in subject order. The number of shelves varied according to the holdings, while the sculptures and the ceiling paintings depict the range of knowledge suitable for an ideal monastic library and its idealized disposition. At St Gall, panels between the shelves hinge out to reveal ingenious shelf lists. Shelf lists on the ends of presses had been used in libraries for centuries, as in the Laurentian Library (see pp. 101–7) and Christopher Wren's library at Trinity College, Cambridge (see pp. 140–2), but they were usually just lists on paper and entries had to be crossed out if books were moved. The innovation at St Gall was to use a vertical row of slots in a wooden board. Small cards, each marked with a book title, were placed in the slots in the order they appeared on the adjacent shelves. These could easily be reordered if the books on the shelves were rearranged, and marked if the book was borrowed.

The ceiling of this extraordinary library was painted by Josef Wannenmacher (1722–1780).[57] Completed in 1762–3, it sets out to show that the teachings established by the Fathers and early councils of the Church should be considered the guiding light for the duties of the monastery. Here, as in other Rococo libraries, the plasterwork divides the ceiling into separate fields. The main fields show representations of the early Church councils at Nicaea, Constantinople, Ephesus and Chalcedon, and the Virgin Mary, representing Divine Wisdom. Paintings in the western lunettes show the Latin Fathers (Gregory the

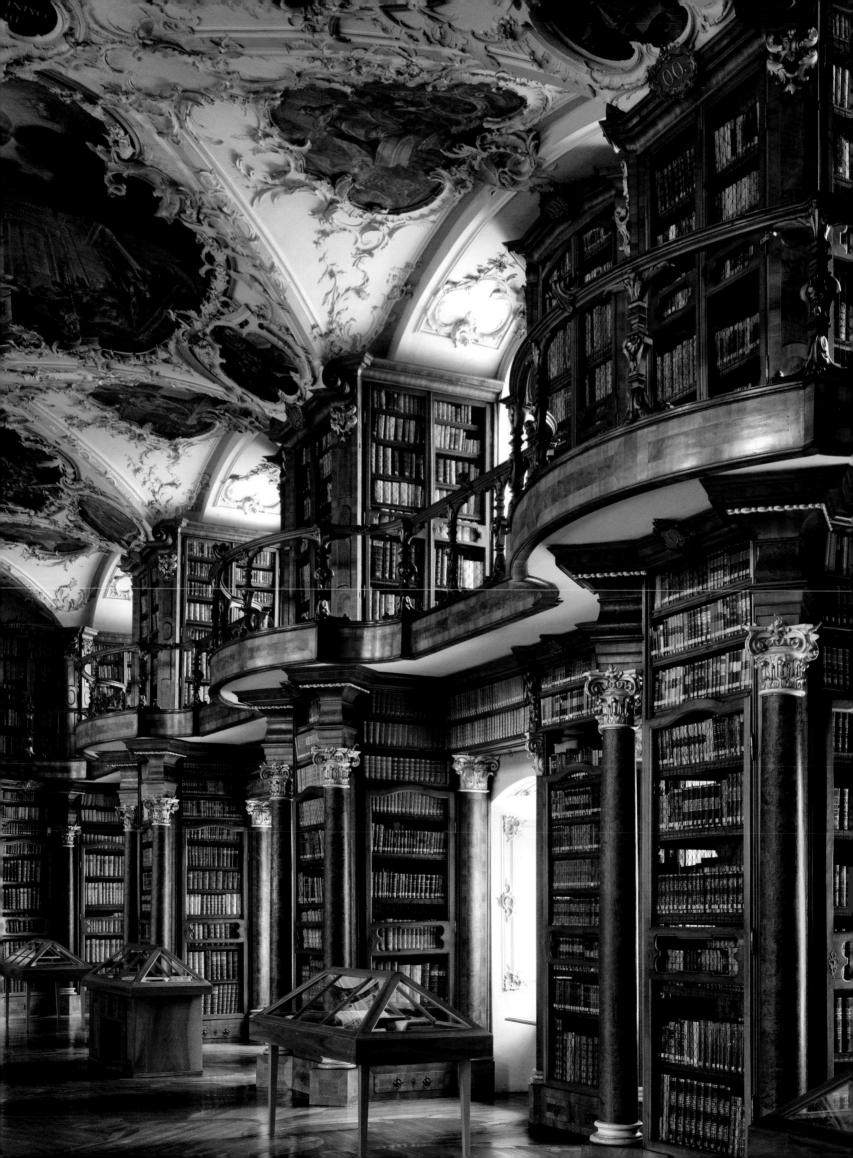

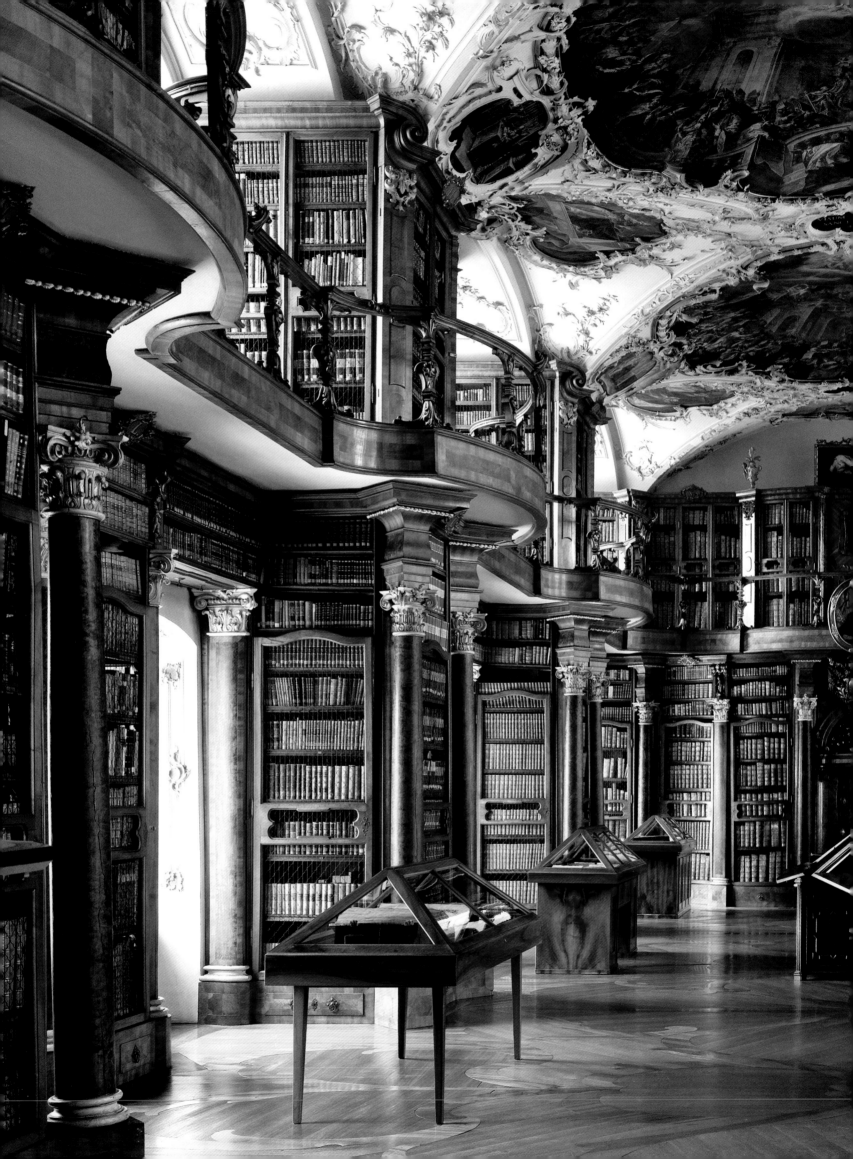

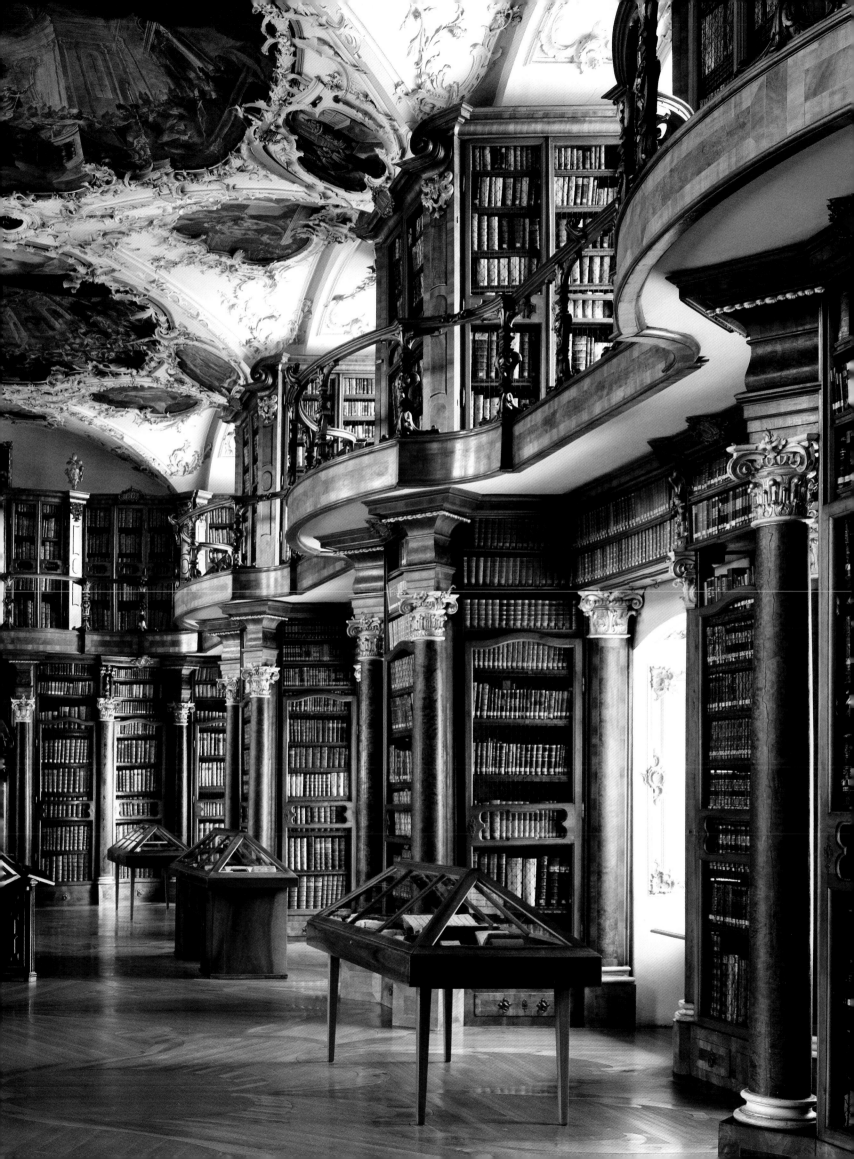

left
ABBEY OF ST GALL LIBRARY, 1763
St Gallen, Switzerland

The columns under the balconies are purely decorative and hinge open to reveal finding lists. The plinth at the bottom of the cases incorporates hidden drawers for loose papers. Although the doors that protect the lower part of the cases from theft are sympathetic in style, they are probably not original.

monastic library ever constructed: that at Admont Abbey in Austria, built between 1764 and 1779.[60]

Admont Abbey

Admont Abbey was founded in 1074 by Gebhard, Archbishop of Salzburg, with monks from the Benedictine house of St Peter's in Salzburg. It is recorded that he also provided the new abbey with gold and silver artefacts, books, silk vestments, chalices and everything necessary for divine offices. Copies of works from St Peter's are still in the library. In the 1100s Admont Abbey ran a successful scriptorium and produced numerous manuscripts, but copying then appears to have ceased and the rest of the collection was acquired in later centuries by purchase and donation.[61] In the 15th century a bookroom lined with cupboards was built over the Lady Chapel. In the 17th century this was replaced by a library 34 m (111 ft) long, again furnished with cupboards. Subsequent libraries to house the monastery's 95,000 volumes included one by Hayberger, the architect of the St Florian library, but this was abandoned because of sinking foundations. The present building was designed by Josef Hueber (*c.* 1716–1787) between 1764 and 1776. The painter Bartolomeo Altomonte (1694–1783) had been asked to create a ceiling before work on the library began, but did not sign the contract until 1774, when he was seventy-four. He completed it two years later. The architectural surrounds were painted by Johann Georg Dallicher, and Josef Thaddäus Stammel produced statues of wood painted to look like bronze.[62]

The dominant colours throughout the library were white and gold. The abbot ordered that the books be rebound in white pigskin to match the shelves. This relatively muted colour scheme draws attention to the floor, which has an interesting three-dimensional pattern, and the painted ceiling, made up of six saucer domes and one larger central dome, below which the bibles and books on the Church Fathers are housed. The overall layout, with a central dome and its archways framed by columns, is obviously influenced by the Hofbibliothek in Vienna.

The design of the decorative scheme
Documents show that although abbots were willing to leave some decisions about library design to their

opposite and overleaf
ADMONT ABBEY LIBRARY, 1776
Admont, Austria

Designed by the architect Josef Hueber and constructed between 1764 and 1774, the library has painted decoration by Bartolomeo Altomonte and Johann Georg Dallicher, completed in 1776. The 'bronze' statues under the central dome (opposite) are in fact made of wood. They represent the Four Last Things. The library (overleaf) is 13 m wide and a staggering 72 m long (43 x 236 ft), making it one of the longest monastic libraries in the world. The top shelves are reached using specially designed stepladders that sit on top of the projecting lower cases.

Great, Ambrose, Augustine, Jerome and an unidentified figure, possibly Anselm of Canterbury). Those on the east show the Greek Fathers (Gregory of Nazianzus, Athanasius, Basil, John Chrysostom and possibly Cyril of Jerusalem). Pictures between the windows show monks undertaking their scholarly, pedagogical and pastoral roles.[58] These scenes are painted in a type of *trompe l'oeil* termed *quadratura*. They are designed to be seen from one end of the room, from which the perspective creates an illusion of the space of the room extending into the painting and carrying on up to the heavens. This kind of illusionist ceiling painting had been popularized in late-17th-century Rome by Andrea Pozzo (1642–1709) and others. A Jesuit monk, painter and architect who achieved fame through his ceiling for the church of S. Ignazio in Rome, Pozzo set out his artistic theories in a book, *Perspectiva pictorum et architectorum Andrea Putei a societate Jesu*, published in Rome in 1693–1700. He spent the last years of his life in Vienna, where he executed ceilings for the Jesuit church and the Hercules Hall of the Liechtenstein Garden Palace. He died in Vienna in 1709.[59] Although St Gall had the largest book collection of any of these 18th-century monastic libraries, architecturally its impact cannot compare with the most impressive

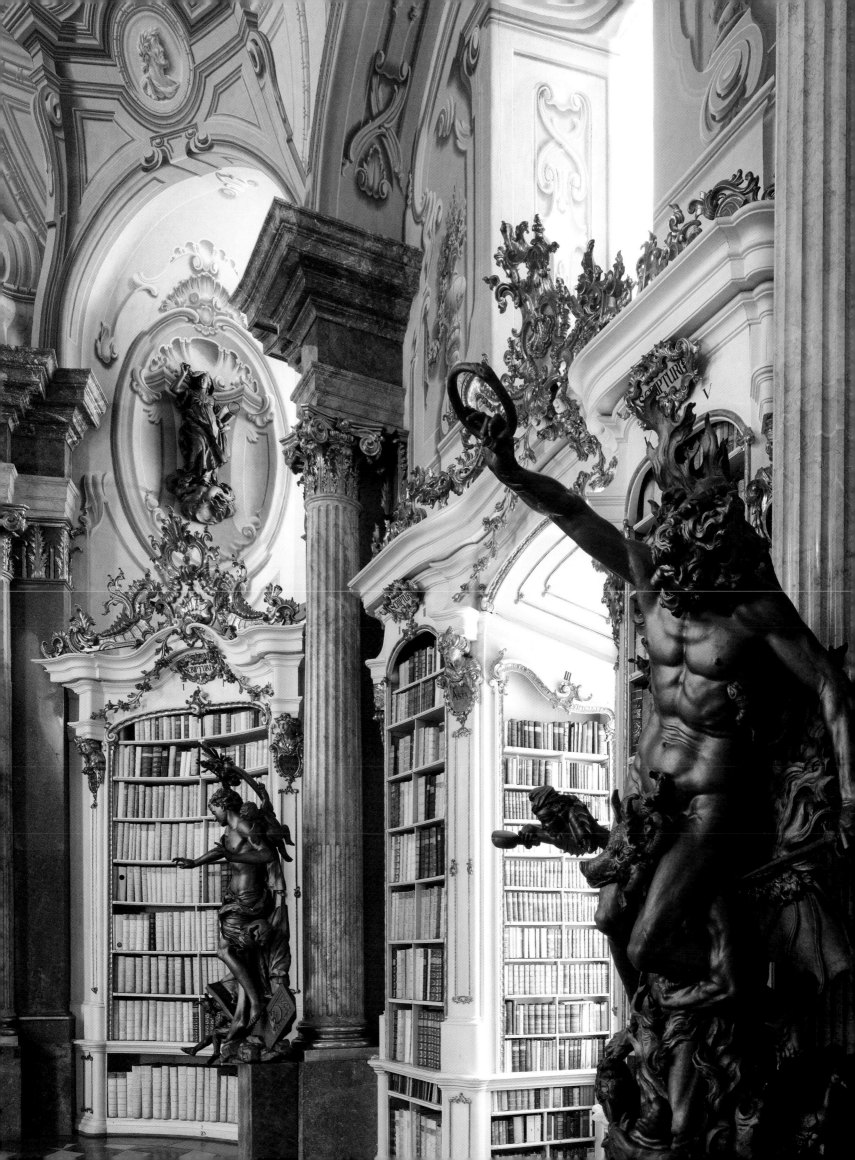

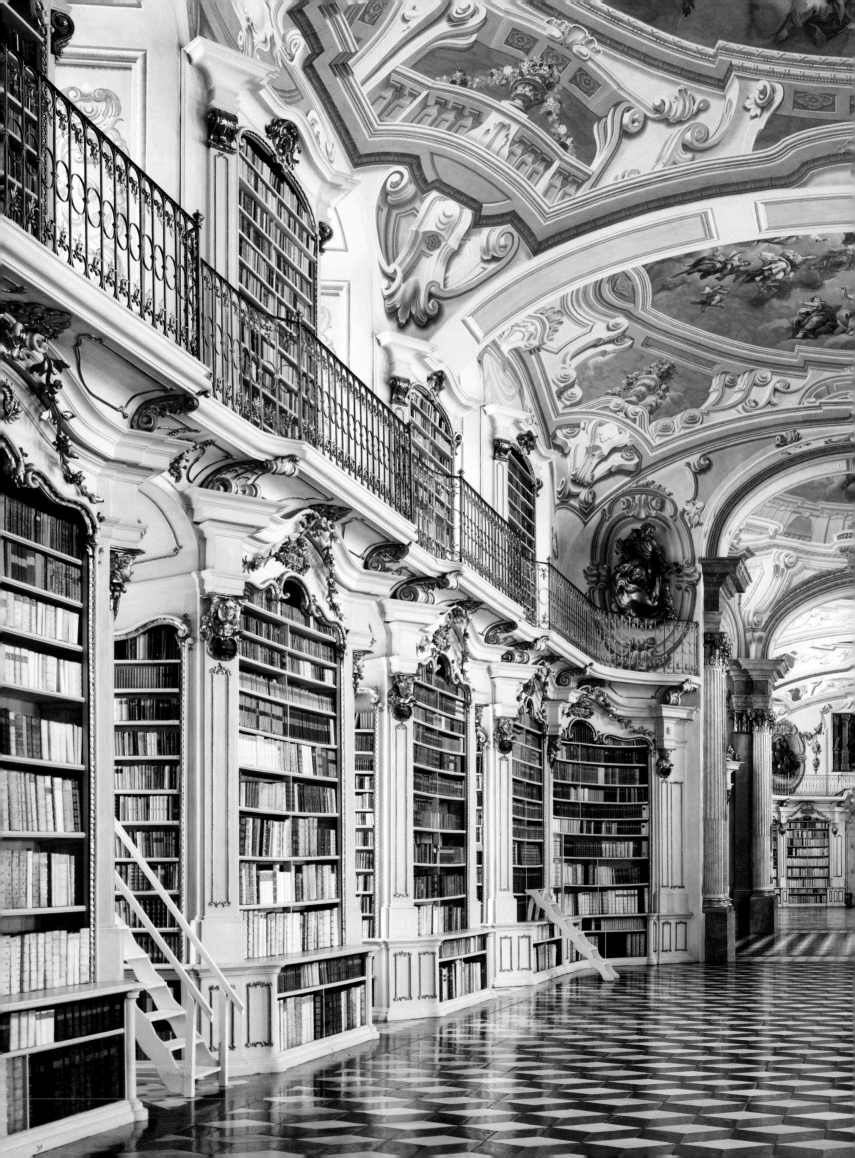

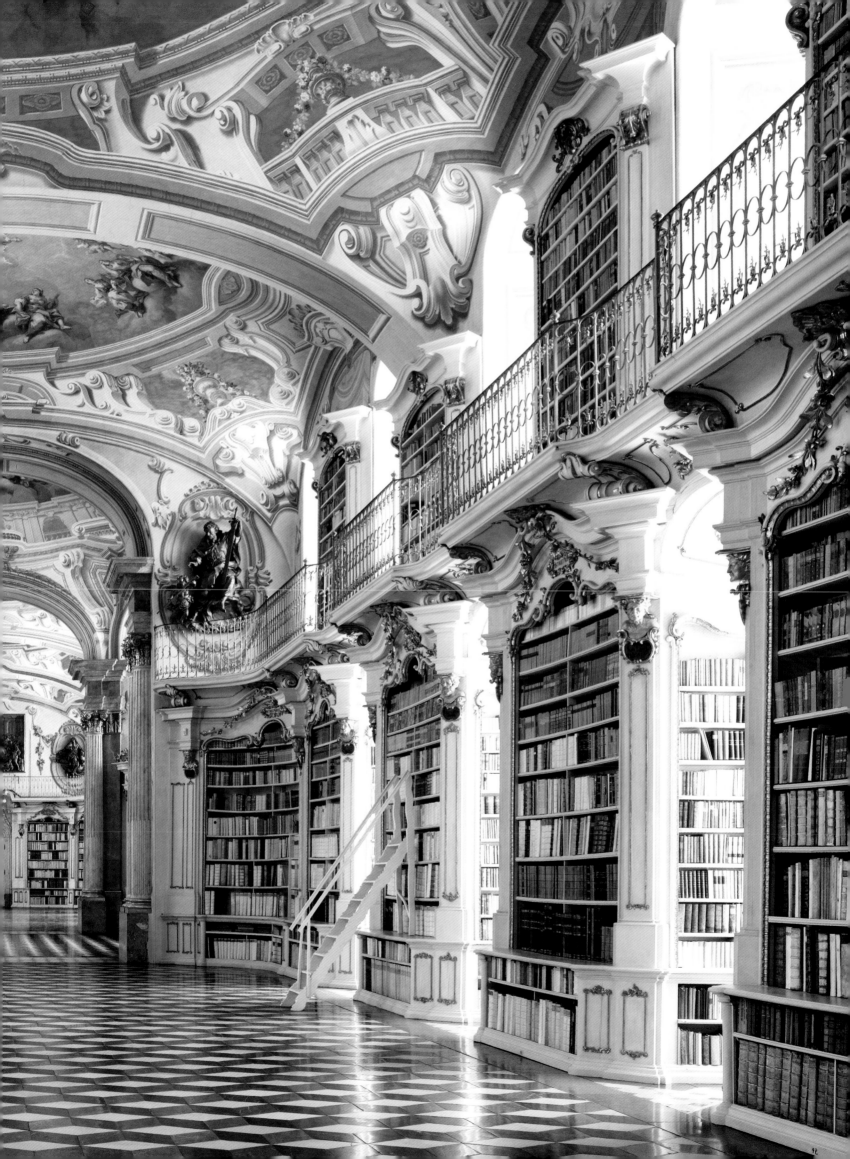

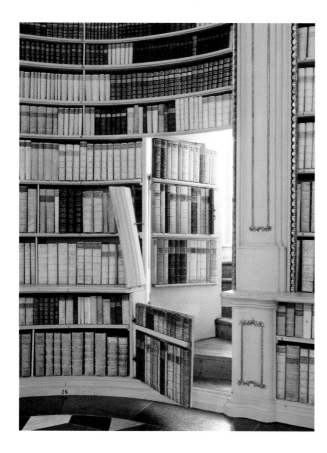

left and right
ADMONT ABBEY LIBRARY, 1776
Admont, Austria

The books in the original collection were rebound in white at enormous expense to match the rest of the decorative scheme. The galleries (right) are not continuous (there are none in the central dome). The staircases to them are concealed behind ingenious secret doors (left) in the four corners of the wings nearest the dome.

craftsmen and architects, they generally took a much keener interest in the decoration. Typically, it was the abbot or provost who set out on paper the general themes of the ceiling paintings, which artists then designed. The attributes of the various figures were determined by established emblem books, the most successful of which was Cesare Ripa's *Iconologia* (1593).[63] The theme at Admont was typical of monastic libraries in the 18th century.[64] It centred on the figure of Divine Wisdom. Here, she is shown flanked by Moses and Ecclesia (the Church), representing the Old and New Testaments, the two ways by which she is revealed to the world. The object of monastic study was to obtain wisdom. There was considerable debate within the Church as to whether monks should study. A key argument in this was that although knowledge could be gained by reading, wisdom could only be found, or revealed, through faith and divine revelation. In the 15th and 16th centuries a new interpretation of wisdom appeared, which suggested that it was obtainable through intellectual pursuit. Such questioning of existing knowledge was one of the things that led the 17th-century abbot Armand Jean le Bouthillier de Rancé to deny the appropriateness of study to a religious mind, which he argued should be focused entirely on faith. Against this, the Benedictine monk and scholar Jean Mabillon argued that knowledge was an essential part of monastic life and necessary to counter the intellectual attacks being launched by the enemies of the Church. The debate that ensued led the Church to look for a way to accommodate intellectual

activity without compromising belief in the opposition between 'human knowledge' and 'divine wisdom'.[65]

At Admont, below Ecclesia sit the four Latin Church Fathers, who watch as a genius with a three-cross patriarchal staff that represents the Fathers' writings drives out figures representing the Lutheran and infidel heresies. The tradition of Church teachings is represented around the rim of the dome by figures of the four prophets, the four evangelists, and the doctors of the church. The six subsidiary domes group the faculties and disciplines according to recent reorganizations of knowledge, with disciplines of particular interest to monastic life given the most prominent places. Thus the northernmost dome shows Aurora, representing the Enlightenment. Below her, the light she gives off has provoked Vice, Ignorance and Sloth. Meanwhile, the figure of a young spirit is awakened by Grammar, Rhetoric and the Study of Languages. The first two were part of the traditional medieval *trivium* (the three subjects that students were taught first) whereas the latter was a new requirement of increasing importance in the 18th century, when literature was increasingly written in vernacular tongues rather than solely in Latin.[66]

The next dome represents History, here shown as a female figure wearing Mercury's winged helmet. Above her, putti pour forth books, while Fame flies by with her trumpet and laurel wreath. Below her, a winged genius is writing in a large book supported by Time while being shown a portrait by a putto. Figures round the rim of the dome represent history's auxiliary disciplines: logic, geography, diplomacy, heraldry, genealogy and the study of antiquities. The remaining four domes represent in similar ways canon and civil law; theology; medicine and the natural sciences; and, lastly, the fine and mechanical arts.[67] The fact that all this is too much to take in within a single lifetime, and that all earthly knowledge is transient, is symbolized by the statues of the 'Four Last Things', which occupy the floor under the central dome: namely, Death, Judgment, Heaven and Hell.[68]

The end of the Rococo
The Enlightenment offered more than an intellectual challenge to monastic libraries; it offered a political and social one. In countries across Europe,

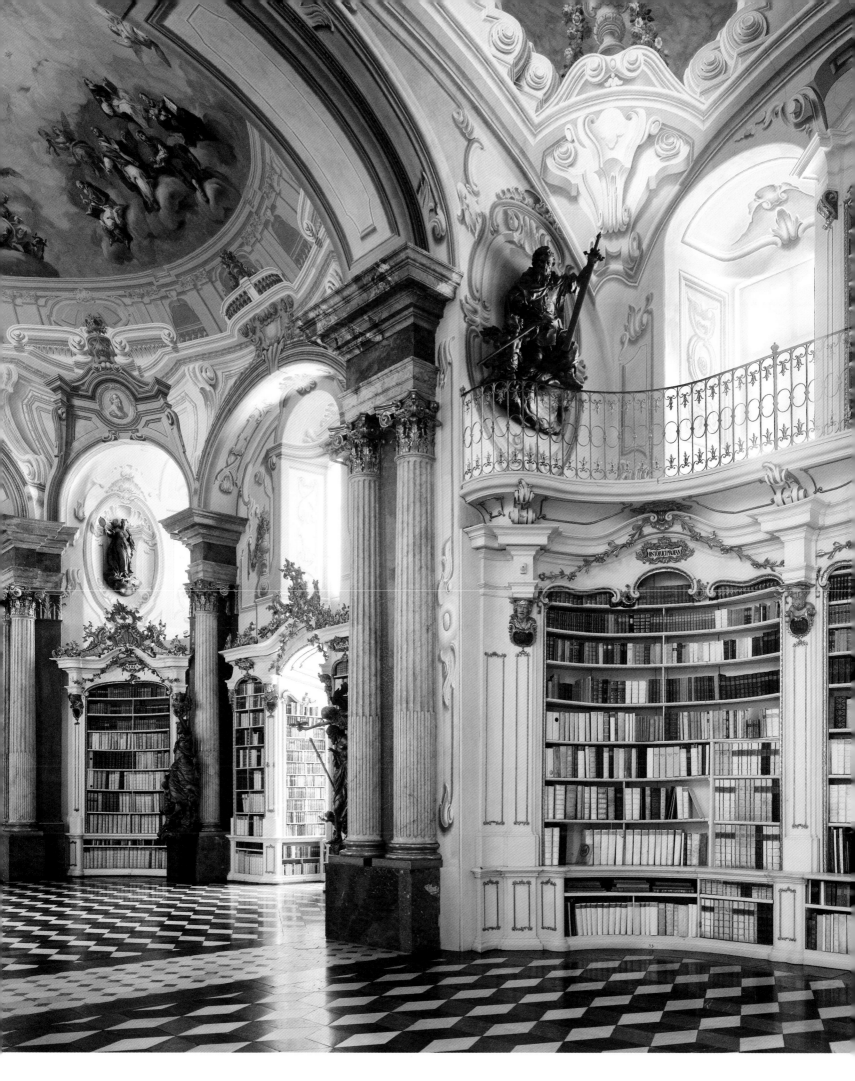

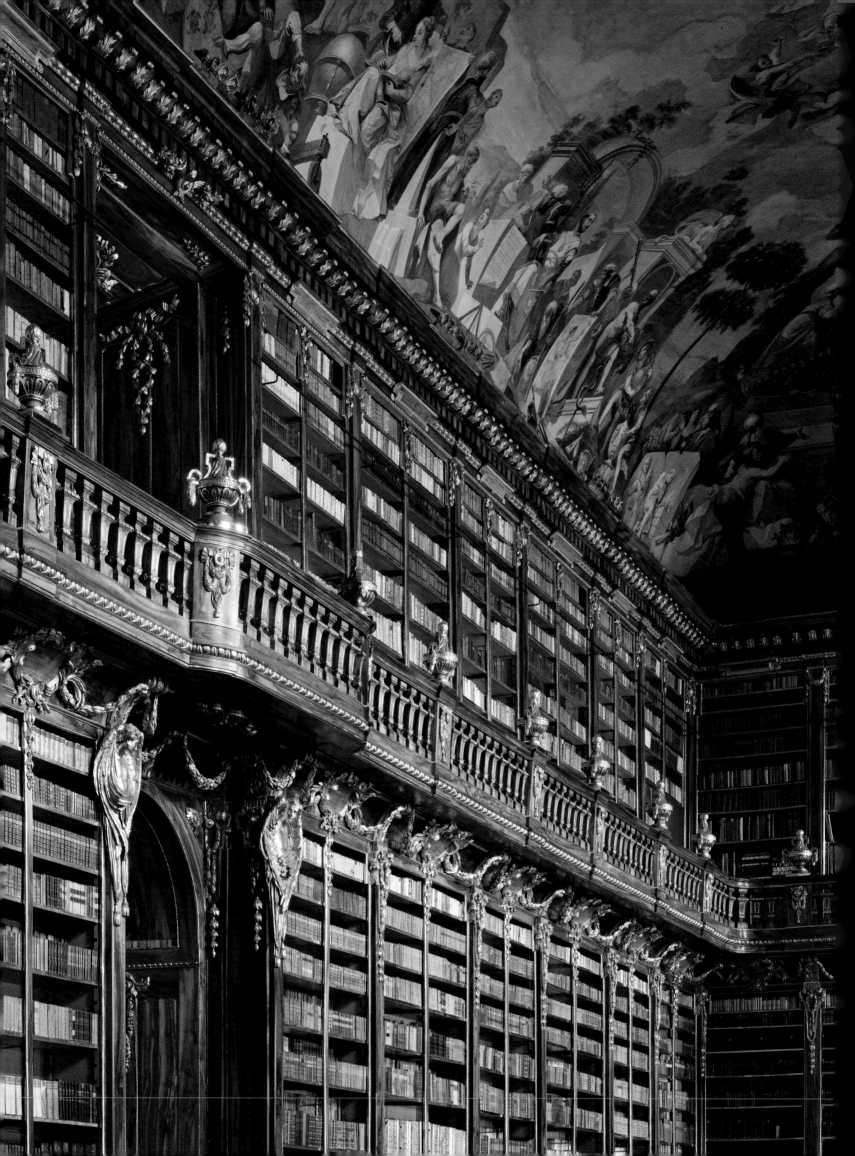

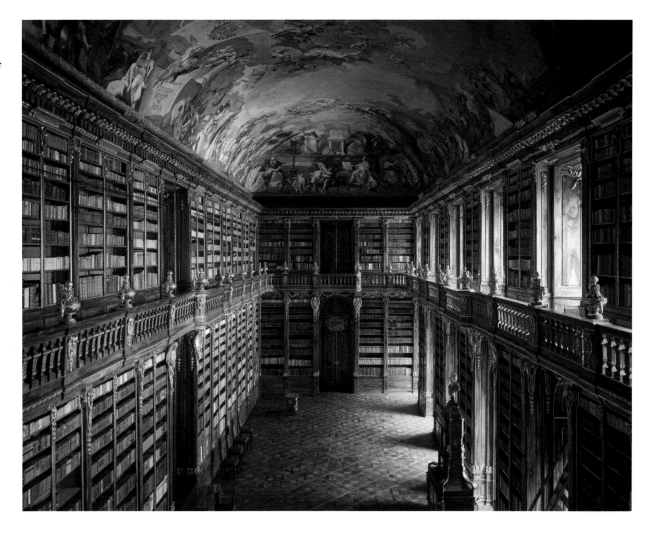

monasteries and their wealth were looked upon with envious eyes by rulers, who increasingly saw ideas of reform as a useful excuse for seizing monastic assets to bolster their coffers. Architectural ideas were also moving on. Archaeology was producing new ideas about the architecture of the ancient world, which in turn were suggesting new ways of approaching architectural design. The Philosophical Hall of Strahov Abbey in Prague is one of the last Rococo monastic libraries to be built. By the 1780s Strahov's existing library (see pp. 132–6) was in desperate need of expansion. The opportunity came in the form of bookcases salvaged from an abolished Premonstratensian monastery in Louka, near Znojmo in south-western Moravia. In 1782–4 a wing linked to Strahov's library was substantially reconstructed and the cases were adapted and installed in 1794–7.[69] The imported timberwork of the shelving of the Philosophical Hall is recognizably Rococo in its florid gilded ornament. The stairs, as in other Rococo libraries, are hidden behind moving *trompe-l'oeil*

bookcases. Gone, however, is the plaster decoration with its shell-like rocaille work framing the painted ceiling. The allegorical ceiling rises straight from the cornice. In this sense, the room in which these cases have been placed is Neoclassical, not Rococo.

The Rococo libraries of the 18th century mark a very particular era. They attempted to encompass the whole of knowledge in a single room and in a single decorative scheme. In the 17th century, Gabriel Naudé (see p. 137) had dreamt that a viewer standing in the middle of a library could see everything that was known laid out on the shelves. By the end of the 18th century, this was already an impossible fantasy. Books continued to be printed at ever-increasing rates and no room, however big, could hope any longer to contain all of them. The ages of the library room were over; the era of the library building had begun. Nevertheless, the image of these all-encompassing, richly decorated halls had a lasting effect on library design, the results of which are still visible today.

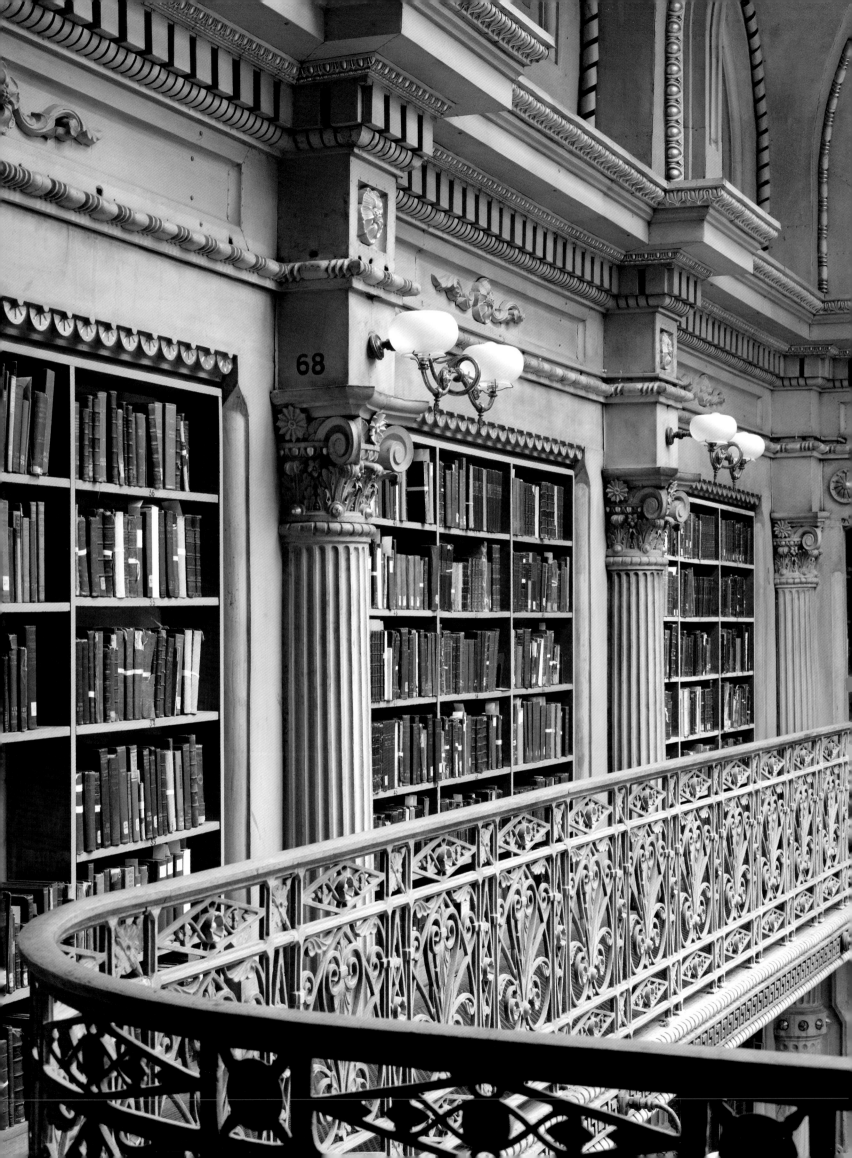

Iron Stacks, Gaslights and Card Catalogues
Libraries in the 19th Century

In the 19th century advances in mechanization produced books at ever-increasing rates, forcing libraries to respond, but size and capacity were not the only changes: this period saw new methods of commissioning, financing, staffing, furnishing, heating, lighting, organizing and constructing libraries. Perhaps more important than these was the huge increase in both the number of libraries and the number of readers who had access to them. None of these changes happened immediately. At the beginning of the century, libraries remained superficially similar to their predecessors in the 17th and 18th centuries: the grand library hall, the defining image of the 18th-century library, continued to be the most popular form, even though the spaces around it became larger and increasingly complex.

Myths abound about the 19th-century library. Some have claimed that this was the first period to have freestanding libraries, or the first to introduce public libraries, form national libraries or have round libraries. The use of stacks, the importance of technology and the place of cataloguing in the design of libraries are generally not well understood. In all these areas, the 19th century saw radical developments. Throughout the period, however, libraries remained heavily reliant on private patronage and perhaps the most sensible place to begin is not with public libraries but with the private libraries of the richest individuals.

THE GEORGE PEABODY LIBRARY, 1866 Baltimore, MD, United States of America

The iron stacks and gaslight fittings of Edmund Lind's masterpiece, one of the finest libraries constructed in the 19th century.

The country-house library in the 18th and 19th centuries

The ostentatious display of private book collections, begun in the Renaissance by families such as the Medici, continued in the palaces and country houses of the rich and powerful in the 18th and 19th centuries. In Britain during this period, aristocratic families amassed vast fortunes, controlled huge tracts of land and built enormous country houses. These self-styled 'dilettantes' prided themselves on their collections of paintings and sculpture brought back from Grand Tours in Italy. Alongside galleries for displaying these, no substantial house in Britain could be constructed without its library, designed to show off the patron's collection of books.[1] A group of English aristocrats, including George John, 2nd Earl Spencer (1758–1834), purchased large numbers of books from French libraries after the Revolution, styling themselves 'The Bibliomaniacs'. At his death, Spencer's library was among the finest in Europe. He was a founder of the Roxburghe Club, an influential and exclusive society of book collectors, which survives to this day. Spencer's books eventually went to the John Rylands Library in Manchester. Bequests by other private collectors laid the foundations of the British Museum Library (later the British Library) and other public institutions.[2]

Hatfield House, 30 km (appx. 20 mi.) north of London, is a good example of a 19th-century country-house library. Such rooms were usually fitted with wall shelving, the amount of shelving being very much dependent on the number of books. Some 'library' rooms had very little, but most tried to line the walls from the floor to the ceiling. The upper shelves were usually reached by stepladders. There was a whole range of other furnishings thought suitable: globes, leather armchairs and leather-covered desks. By the late 18th and early 19th centuries galleries were becoming increasingly common in the grander examples. These features were copied in the libraries of the gentlemen's clubs that grew up in London in Pall Mall and St James's and self-consciously provided a 'home from home': clubs such as the Athenaeum, Brooks's, the Carlton and the Reform.[3]

The style of a library's fittings was usually in keeping with the style of the building. For example, at Strawberry Hill, the Gothic-revival mansion in south-west London designed in 1749–76 for Horace Walpole (1717–1797), the library shelves were Gothic.[4] Hatfield, an Elizabethan house, had one of the oldest English country-house book collections, boasting a library as early as 1607–11.[5] The style of the current shelving is in keeping with the original fireplace and ceiling, but was installed after a fire in 1835, and the gallery was added in the 1870s.

Not all private libraries' rooms were so grand. At Frederick the Great's Rococo Sanssouci Palace in

below and opposite
HATFIELD HOUSE, c. 1875
Hatfield, Hertfordshire, United Kingdom

This room (below and opposite) was converted into a library in 1833 but did not reach its present configuration until the addition of the galleries in the 1870s. By the 19th century a well-outfitted library was considered essential in any large private house. Libraries were treated as living rooms for use in the morning and frequently doubled up as studies.

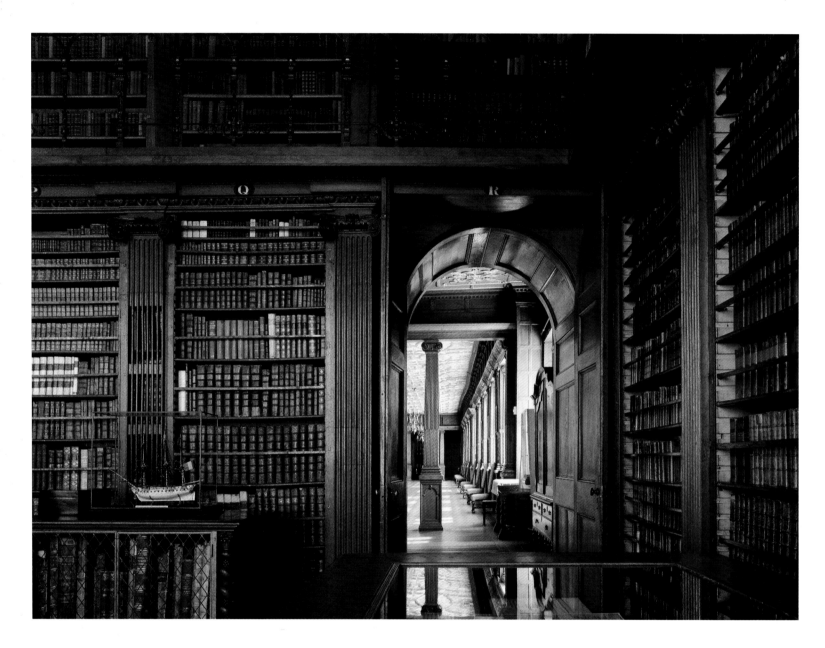

Potsdam, Prussia, the library is a tiny oval room with Rococo cabinets, which held only a modest collection.[6] In the United States, Thomas Jefferson's (1743–1826) library room at Monticello in Virginia is similarly small, compared to those in the larger European country houses of the period. However, large rooms did not necessarily mean important collections. In the 19th century many new English country-house owners simply purchased books 'by the yard' to decorate their grand library rooms, taking more interest in the bindings than the contents.[7]

Talk of continuity in private collecting risks giving the impression of political stability, but the end of the 18th century and the beginning of the 19th century saw radical political changes across the world. In every country, the Church and the monarchy, the traditional holders of political power and patrons of library building, were under threat. Monasteries were being disbanded all over Europe, and monarchs were ceding increasing powers to parliaments and democratic institutions. New political structures invited new architectural representations.

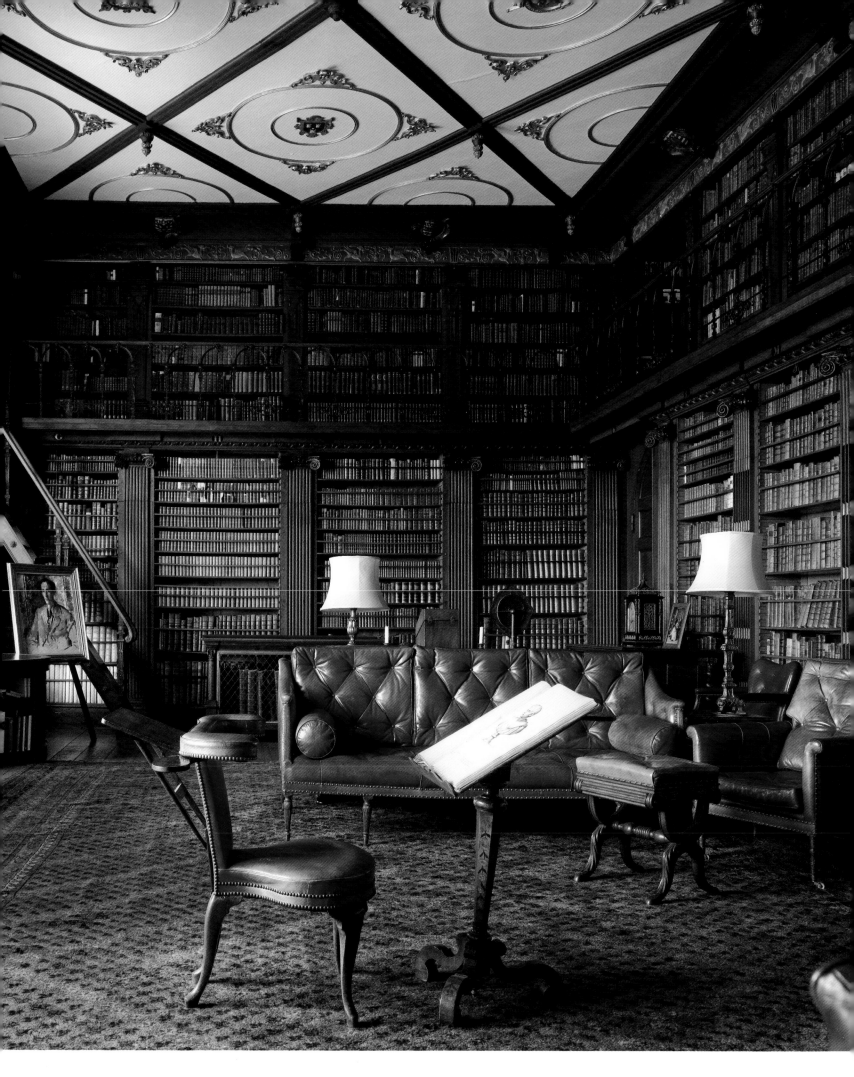

left, below and opposite
**THE ROTUNDA,
THE UNIVERSITY
OF VIRGINIA**, 1826/1973
Charlottesville, VA,
United States of America

*Designed by Thomas Jefferson
to be the focal point of his
new university, the rotunda
(left) was modelled externally
on the Pantheon in Rome.
The door in the portico leads
into a vestibule (below). Three
oval rooms off this served as
classrooms. The stairs flanking
the door ascend to the library
(opposite). This dramatic space
was covered by a great timber
and plaster dome. The present
building is a 20th-century
reconstruction, housing only a
small collection. In the original
building there were books in
cases around the walls of the
gallery and radiating from
the centre of the room.*

The University of Virginia library

Only four years after the Declaration of Independence,
Jefferson began formulating plans for a new
university in Charlottesville, Virginia. In doing so, he
was consciously creating a new type of institution:
a secular university. All previous universities had
featured religious buildings at the very heart of the
institution. Jefferson's plan was to put the library at
the centre.[8] The students were to be accommodated
in low buildings, between houses for professors,
who would teach in their front rooms. The idea of
students and professors living side-by-side was not in
itself revolutionary. It was borrowed from European

collegiate universities. What was unusual was the
placement of these residential buildings in two lines,
facing each other across the Lawn, the central open
space around which the buildings are arranged.
Further rows of buildings behind these provided
dining halls and additional accommodation.

Jefferson placed the university library on the top
floor of the building at the end of Lawn: the Rotunda.
The Rotunda, which takes its external form from
the Pantheon in Rome, is entered through a grand
portico. The library fills the whole of the upper
floor. It originally had bookcases radiating from the
centre, both on the lower floor and on a gallery level
above, but the centre of the space was kept clear of
fixed furniture to allow the room to be used for other
purposes. The first thing that strikes the viewer is how
few books the library could have contained. It housed
the initial collection with ease, but failed to allow for
expansion. The original building was completed in
October 1826. In 1851–3 a large rectangular annexe
was added to the rear. When a fire broke out in 1895
the professors tried to save the Rotunda by blowing up
this extension, but they only succeeded in destroying
the whole building. A rebuilding by Stanford White of
McKim Mead and White in 1896–8 produced a dramatic
and far more practical domed library, which operated
until 1939, when a new library was built nearby. After a
long argument, White's library was controversially torn
down in 1973 and replaced by the copy of Jefferson's
original that occupies the site today.[9]

Neoclassicism

Based on a Roman precedent, Jefferson's library for
the University of Virginia was Neoclassical. In fact,
with the exception of the Rococo libraries described

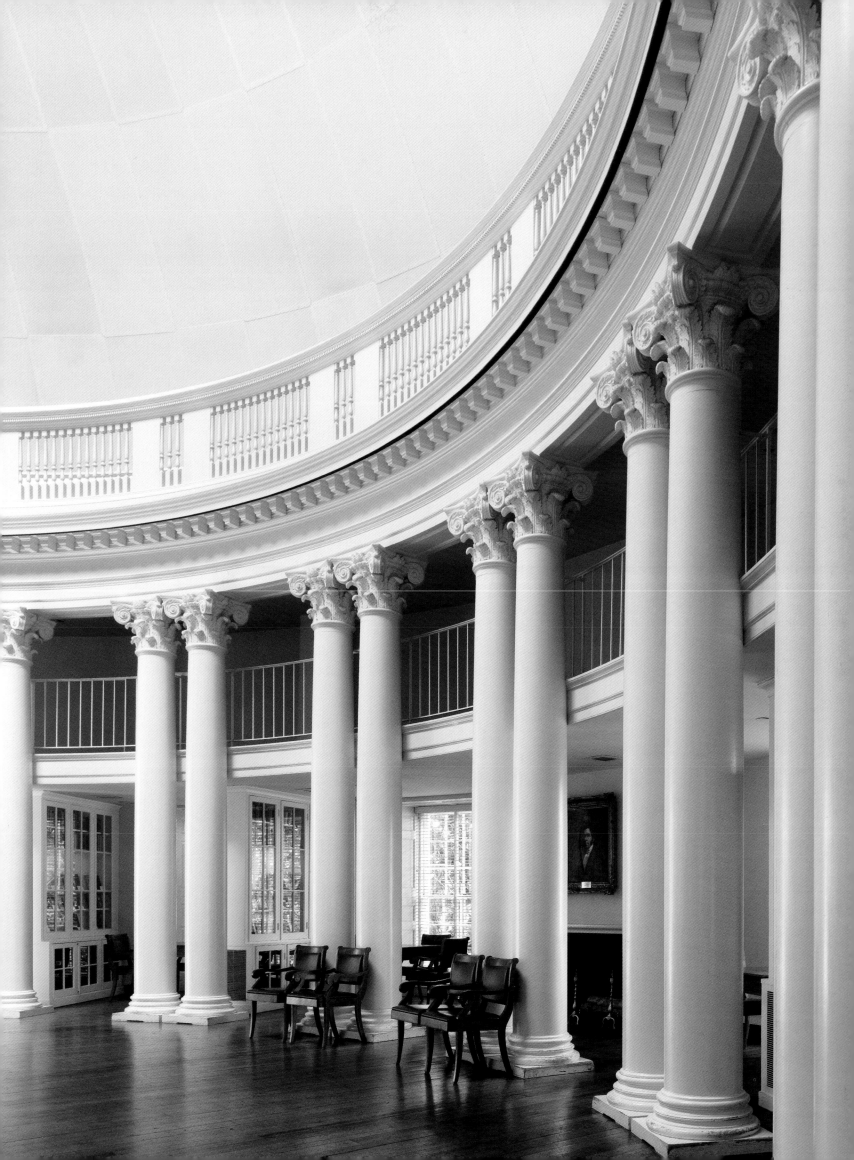

below and bottom
DESIGN FOR THE BIBLIOTHÈQUE NATIONALE,
Paris, France, 1785

*This grandiose scheme was produced by Étienne-Louis Boullée
for the royal librarian, Jean-Charles-Pierre Lenoir. The then
Bibliothèque du Roi (renamed the Bibliothèque Nationale after
the Revolution) was housed in the Hôtel de Nevers, in the rue de
Richelieu, but had no proper reading room. Boullée's unrealistic
but highly influential solution was to roof over the courtyard to
produce a single enormous space lined with books in stepped tiers.*

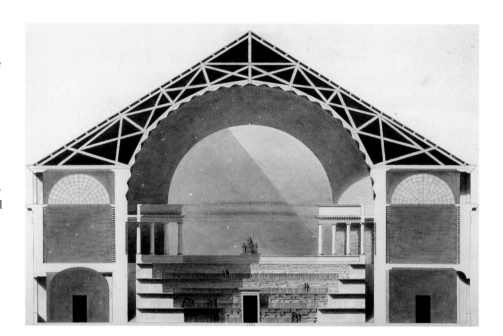

in the last chapter, Neoclassicism was the favoured
style for libraries in most countries in the late 18th
and early 19th centuries. Gothic-revival libraries were
built in the second half of the 19th century, but they
were comparatively rare before 1850.

Neoclassicism established itself as a reaction
against Rococo and Baroque. Its roots can be traced
back to the late 17th century, which had seen the
beginning of a more scientific and scholarly attitude to
archaeology, and a growing interest in antiquarianism.
The opening up of Greece and increasing foreign travel
brought the rich into contact with the antiquities of
Rome and Athens for the first time. In the 18th century
writers such as Johann Joachim Winckelmann were
influential in drawing attention to the fundamental
differences between Greek and Roman art.[10] The
Baroque and Rococo were thought to have strayed
from the true path of architecture. In his *Essai sur
l'architecture* (1753) Marc-Antoine Laugier called
for a return to an architecture based on structural
rationalism.[11] Architects and archaeologists measured,
drew and published the ruins of Athens, Palmyra,
Baalbek, Rome, Paestum and, most importantly,
Pompeii.

Neoclassicism's beginnings were in France and
Britain, but the style soon spread across Europe.
Protestant Britain had flirted with, but never really
embraced, Baroque, and by 1720 had already returned
to Palladian architecture. The switch from this to
Neoclassicism was relatively simple and was marked
by an increasing wish to use archaeologically accurate
ornament. In France, the birthplace of Rococo, the
switch was more marked, but here, too, in works
such as Claude Perrault's (1613–1688) east front of
the Louvre, there had always been a Neoclassical
tendency existing alongside the Baroque. Although the
existence of libraries in Rome and ancient Greece was
well documented, the Neoclassical architect had no
physical prototypes to follow, since no archaeological
remains of any ancient libraries had yet been
identified. The Neoclassical library was thus based
not on a return to classical ideals, but on existing
library forms clothed in the latest understanding of
the correct language of classical architecture.

However, many of the grandest 18th-century
Neoclassical library schemes remained on the

drawing board, including Jacques-Germain Soufflot's
plans for a library in the Louvre, Robert Adam's plans
for Edinburgh University and the Register House, and,
perhaps most notably, Étienne-Louis Boullée's (1728–
1799) grandiose and impossibly over-scaled scheme
for a Bibliothèque Nationale.[12] Of these, Boullée's
scheme would in time become the most influential,

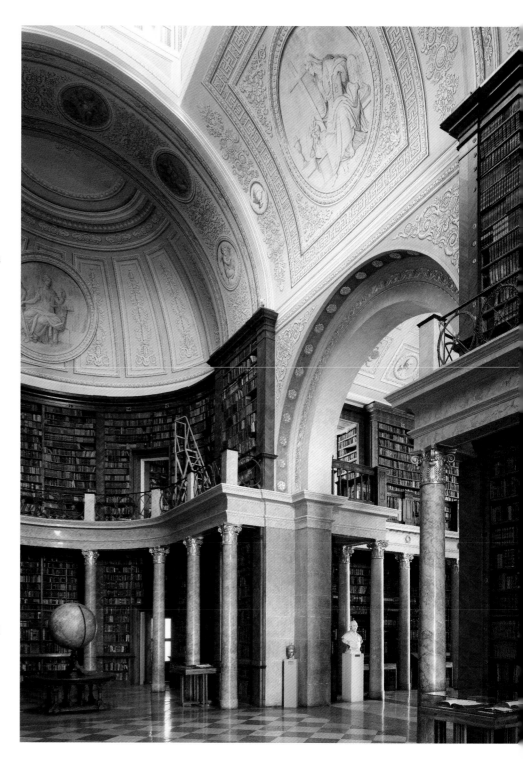

below

LIBRARY OF PANNONHALMA ABBEY,
1852. Pannonhalma, Hungary

The library was constructed in two phases. The reader enters the room through an oval hall lit from above and by a window at one end. Designed by János Packh, this was the second part of the library to be constructed. From here the reader continues on axis through the archway on the right into the rectangular hall beyond.

although it was completely impossible to build using the technology of the time.

Boullée's Bibliothèque Nationale

Boullée's scheme for the Bibliothèque Nationale (or Bibliothèque du Roi as it still then was) was drawn in 1785. The most dramatic perspectives show a single room, which would have been by far the largest indoor space in the world, 100 m long and 30 m wide (328 x 98 ft), covered by a vast, barrel-vaulted ceiling. Light was provided by huge semi-circular windows at each end (based on the arch depicted in Raphael's fresco *The School of Athens*) and a gaping hole in the vault.[15] Boullée shows readers consulting books in the central space. Separated from them by an iron fence, librarians are shown fetching the books from shelves arranged in stepped tiers behind them. This idea of a stepped library was entirely novel. This arrangement had not been used before for a number of very good reasons, not least because it was extremely wasteful of space. However, as we shall see, Boullée's library was to become an iconic project for architects, who would copy the idea again and again. The practicality of the scheme was not important to Boullée. His library was meant to house ten million books, but it was never a serious design for a real building. It was a graphic illustration of the problem facing all library designers at the end of the 18th century: how to house the growing masses of books being produced at ever-increasing rates. In some countries, such as Germany, new library types were already developing in which readers and books were divided between many small reading rooms built around courtyards.[14] In the long term, however, these were less influential architecturally than the hall libraries that continued to be produced. The libraries of Pannonhalma Abbey in Hungary, the Assemblée Nationale in Paris, the new Cambridge University Library and the Finnish National Library in Helsinki will serve to explain some of their characteristics.

Pannonhalma Abbey library

The Benedictine abbey in Pannonhalma, in north-west Hungary, was founded in 996. The abbey church dates from the 13th century, but the rest of the monastery was substantially rebuilt in the 18th century. The

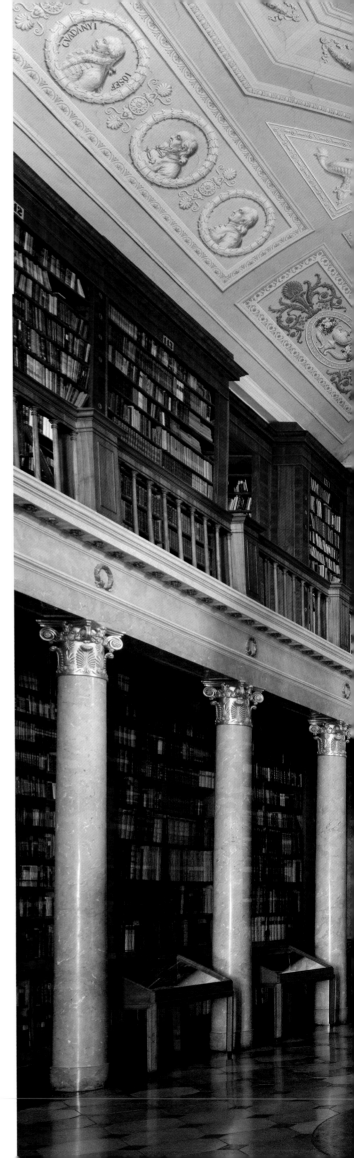

LIBRARY OF PANNONHALMA ABBEY,
1852. Pannonhalma, Hungary

Designed by Jószef Ferenc Engel in the 1820s, the rectangular hall of the library was the first section to be built. The main entrance door is in the background. The library is two storeys high. At the lower level there are doors on each side leading to rooms for reading or study. There are more rooms on the upper levels, entered from galleries lined with shelves for book storage.

library is part of a further extension designed by Jószef Ferenc Engel (*fl.* 1819–1833) in the 1820s and completed by János Packh (1796–1839). The painted decoration was carried out by Josef Klieber (1773-1850), a Viennese artist.[15] The building forms a new end to an existing wing and was intended to be matched by a similar building on the other side of the church.

The Pannonhalma library consists of two parts, a domed entrance vestibule and a rectangular hall. The hall, which was built first, is a simple, barrel-vaulted space. The unbroken barrel vault was the preferred solution for the ceilings of most Neoclassical libraries, although here the vault is elliptical rather than semi-circular. The dominating features are the galleries. Marble Corinthian columns with gold capitals support an entablature of pink and blue scagliola. The railings of the gallery are treated as separate timber elements supported on the entablature and the gallery is conceived as an external colonnade with a walkway above. The shelving is richly veneered and although it lines the walls behind, it reads as furniture rather than architecture. The whole ensemble is conceived as a grand architectural composition, devised in the mind of a single person, the architect.

Architects and architectural training

Architects are the key to understanding libraries in this period, since the role they played in their design was fundamental. The architectural profession developed at different speeds in different countries. In France, the foundation of the Académie royale d'architecture in 1671 was a deliberate attempt by Louis XIV's minster of finance Jean-Baptiste Colbert to decrease the power of the guilds by establishing an architectural profession. The academy, which was transformed into the École des Beaux-Arts after the French Revolution, influenced perceptions well beyond France.[16] Most architects elsewhere in Europe still learned their trade on the job, by being apprenticed or articled to established practitioners. Some were from craft backgrounds, but by the 19th century this was increasingly rare and most came from the new middle class. If they could, they travelled to Rome to learn about architecture 'from the source'. When Napoleon's armies disrupted travel to Italy, they went to Greece instead, but Rome was always

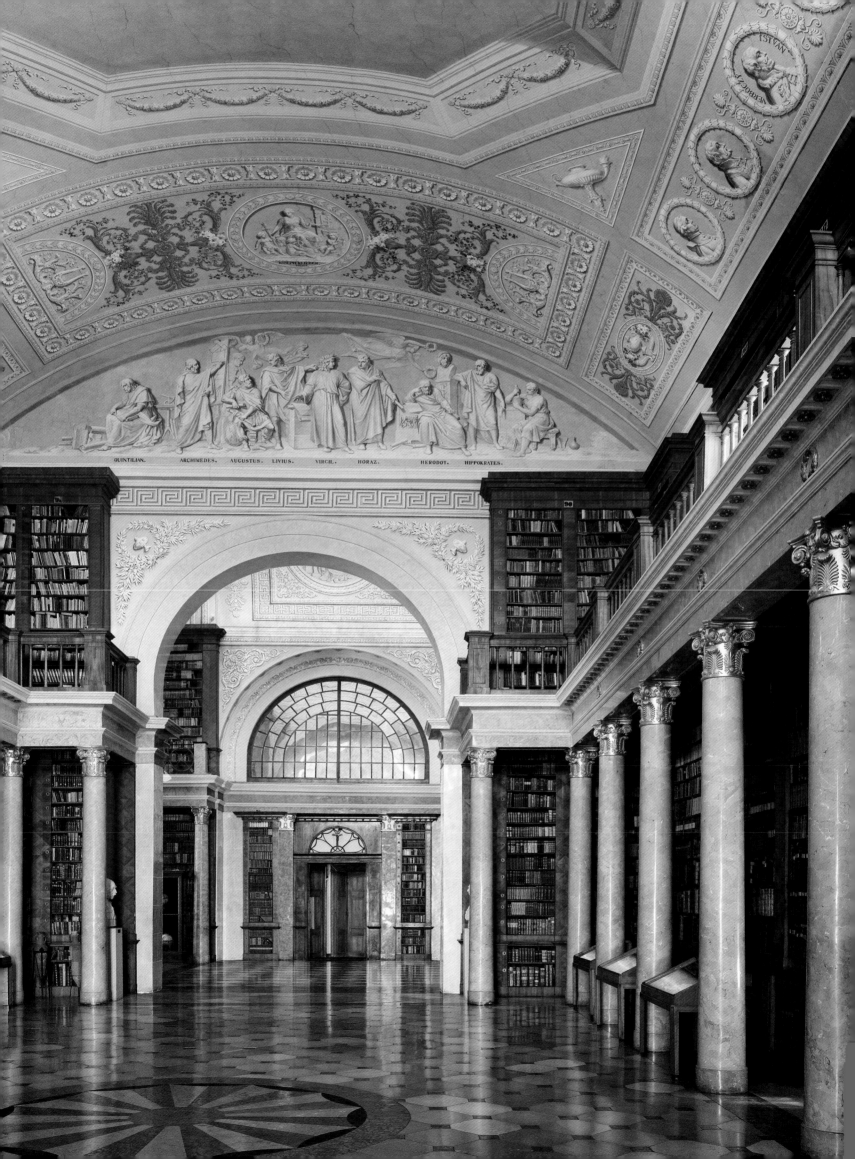

QUINTILIAN. ARCHIMEDES. AUGUSTUS. LIVIUS. VIRGIL. HORAZ. HERODOT. HIPPOKRATES.

the chief attraction and its Renaissance buildings were as influential as its ancient ones. Both were copied for their plans and use of classical detail. During the 19th century the power of the architectural profession increased and architects increasingly expected to exercise complete control over both the external and internal appearance of the buildings they were working on. However, at the beginning of the century the situation still remained ambiguous, as the Assemblée Nationale in Paris demonstrates.

The Assemblée Nationale
The building that houses the Assemblée Nationale began life as the Palais Bourbon, built by Louis XIV as a home for his daughter by Madame de Montespan, who was legitimized as Louise-Françoise, Duchess of Bourbon. Designed by the Italian architect Lorenzo Giardini (d. *c.* 1724), it was enlarged in 1765 by Jacques-Germain Soufflot (1713–1780) for the Duchess's grandson. It was confiscated during the Revolution and from 1798 it became the seat of the Council of the Five Hundred. Napoleon commissioned the architect Bernard Poyet (1742–1824) to add a grand portico towards the Seine. After the Bourbon restoration it became the seat of the Chamber of Deputies and major works were carried out to make it suitable for its new role, directed by the architect Jules de Joly (1788–1865), which included the creation of a library.[17] Following the February Revolution in 1848, the building became the seat of the Assemblée Nationale.

In designing the library, Joly faced a particular problem of lighting. The room was entirely enclosed and the only way to introduce light was by means of lunettes high up near the ceiling. Half of these have since been blocked, making the library even darker than it would originally have been. The ceiling is formed of five saucer domes and a hemispherical dome at each end, originally lit by concealed roof lights. These domes are supported by six internal buttresses on each side. At the upper level the gallery passes through these buttresses, but on the lower level they are encased in books, so that the library looks like a strange hybrid between a stall library and a wall library. Two features are particularly worth noting. The first is the unusual fireplaces, which are in the middle of the room. This arrangement was especially

difficult to achieve as the smoke had to be removed via concealed chimneys under the floor and carried to the roof. The second feature was the inclusion of gas lighting. In the 1850s, when construction of the library was completed, this was still a comparative novelty. Gas street lights were first used in Paris in 1820 but it was not until the 1850s that gaslight became relatively common. It was 75% cheaper than its equivalents and relatively safe.[18] Its arrival marked an important turning point in library design, enabling libraries to stay open later and operate after dark. Hitherto, library designers had always regarded huge windows as a prerequisite, but the introduction of gas lighting was the first step in the path towards libraries becoming increasingly reliant on artificial light.

However, the importance of the library of the Assemblée Nationale as an architectural space, or as an example of technical innovation, is however completely overshadowed by an element of its design in which the architect played not the slightest part: the decoration of its ceiling. This was carried out over a protracted period between 1838 and 1847 by the French Romantic artist Eugène Delacroix (1798–1863). Subsequent changes to the room have obscured the proportions of the bookcases, and tables now clutter up the once open floor space, but Delacroix's ceiling has been beautifully restored. He was given an entirely free hand in the choice of subject. The five domes depict poetry, theology, law, philosophy and the sciences. The images in the pendentives are celebrated figures from antiquity, and the domes at the ends carry depictions of the chaos of war (Attila the Hun and his barbarian hordes) and the paradise of peace (Orpheus teaching the Greeks the arts of peace).[19]

Cockerell's Cambridge University Library and the rise of the architectural competition
Before the 19th century, architects, craftsmen and others involved in library design had typically been selected by individuals, such as bishops, abbots, monarchs or noblemen. The 19th century saw the rise of libraries funded by councils, parliaments or other corporate bodies – in other words, the rise of the committee as client. Each member of a committee might have a favourite architect or be open to bribery, so competition was increasingly used as a method of

LIBRARY OF THE ASSEMBLÉE NATIONALE, 1850–47. Paris, France

Designed by Jules de Joly, the library is a hall 42 m long and 10 m wide (138 x 33 ft) divided into five bays covered by domes, with two smaller bays covered by semi-domes at each end. Since it was created in the middle of an existing building, it is lit entirely from above, through semi-circular windows on each side and rooflights in the semi-domes. The room was ready for decoration by 1838.

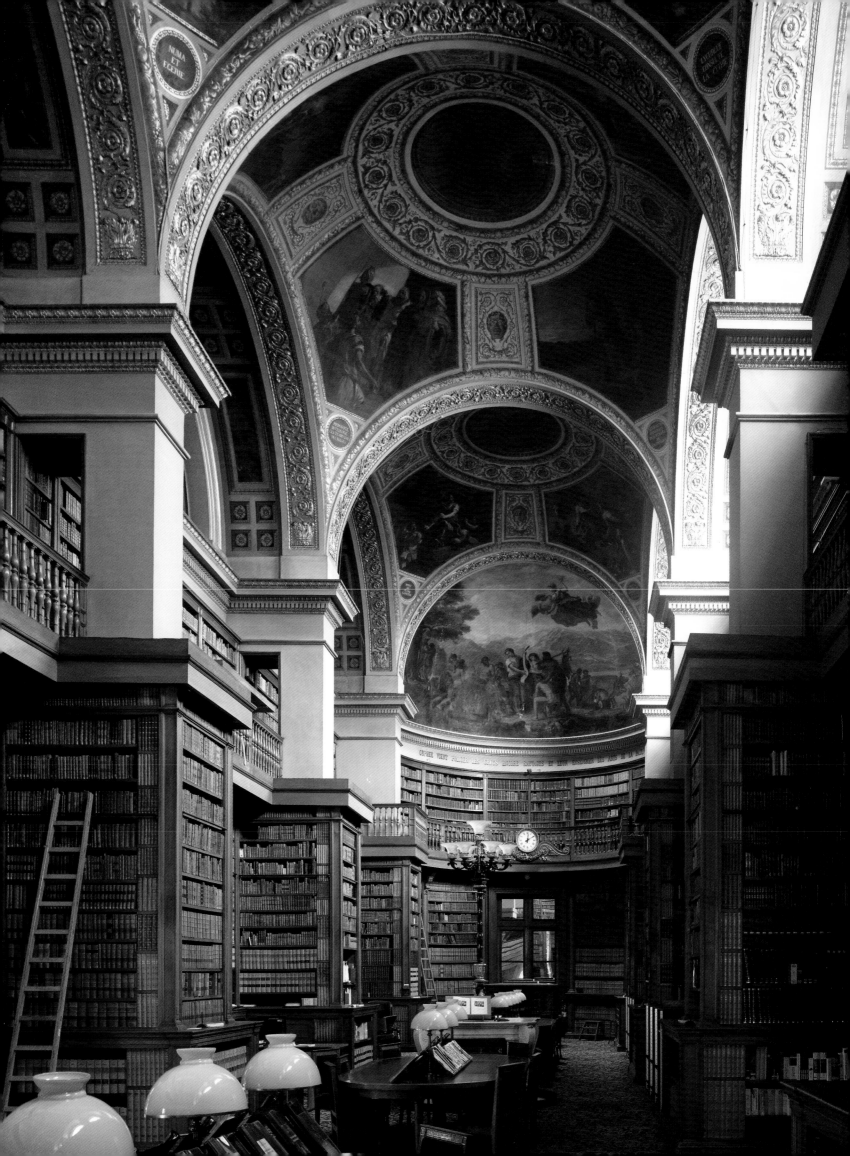

NUMA
ET
EGERIE.

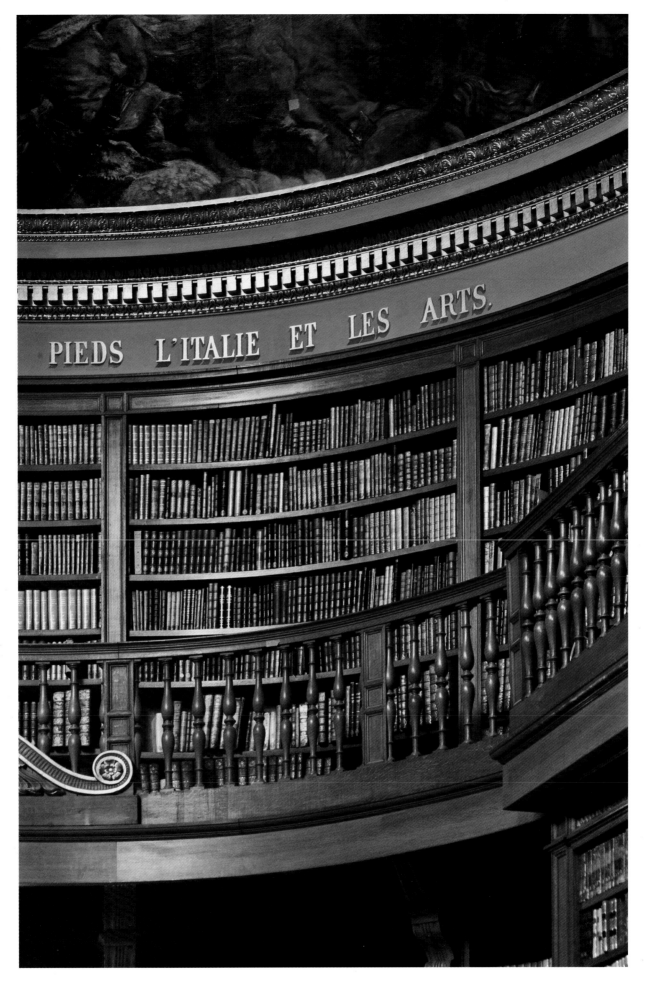

right and opposite

LIBRARY OF THE ASSEMBLÉE NATIONALE, 1830–47. Paris, France

In 1838 Eugène Delacroix was commissioned to paint the ceiling, one of the finest in any library. It took him nine years. He was given a completely free hand in the design. The figures shown here (opposite) represent Numa, the second king of Rome, and the nymph Egeria, his consort and divine counsellor, who dictated to him the laws of Rome. The galleries continue around the ends of the room (right) beneath the half domes, which are also richly painted by Delacroix.

PIEDS L'ITALIE ET LES ARTS.

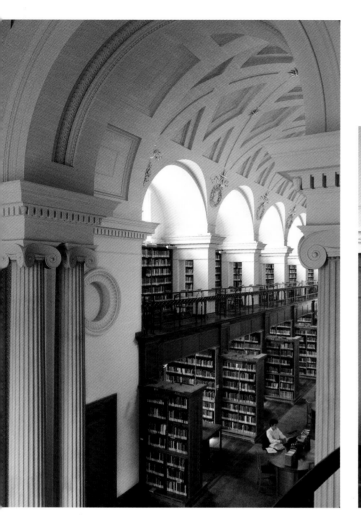

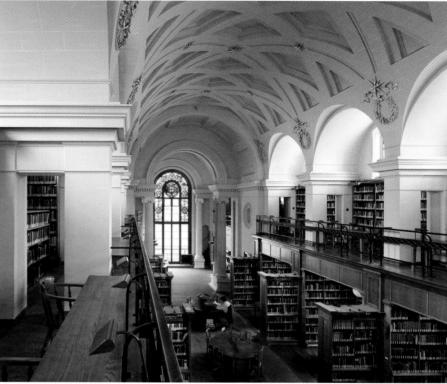

selection, with the competitors often being required to submit their entries marked with a code or sign so that they could not be identified by the judges. Competitions might seem like a very good way of selecting future architects but they were not without their drawbacks.

In 1829 the University of Cambridge decided to hold a competition to design a new building for its central site next to King's College Chapel, the Senate House and Great St Mary's Church. The move had been prompted by King's College, which had agreed to sell to the university its uncompleted Old Court, adjoining the University Library and offices.[20] The brief for the competition demanded a building that would house on the ground floor museums for geology, mineralogy, botany and zoology; teaching rooms for divinity, law, medicine and arts; a model room for the Jacksonian Professor of Natural Philosophy; an apparatus room; and offices for university officials and the librarian. The entire first floor was to be devoted to the University Library. A limited competition was held, with four leading architectural practices (C. R. Cockerell; Decimus Burton; William Wilkins; and Rickman and Hutchinson) being invited to enter. Designs were submitted on 25 November and Cockerell (1788–1863) won. It then became clear that there would be a

considerable problem raising the necessary funds and after a delay a second competition had to be held for a much simpler building on the rear of the site. This time Rickman and Hutchinson won, Cockerell having been disqualified on a technicality, but in the arguments that resulted neither scheme was put up for final ratification. Finally, to resolve the matter, a third competition was held in 1836 for an even smaller building, this time occupying just the north part of the original site. Cockerell's scheme was selected and approval was given. Construction began in September 1837 and the building opened in 1842.[21]

The system of design by competitions without fixed budgets and clear briefs had created a series of fascinating and wonderful projects but had wasted a great deal of time and money. At least by making the competition a limited one at each stage, the university avoided the problem all too frequent in anonymous architectural competitions of selecting a winner only to find out that the architect in question had no experience and was incapable of carrying out the work. It is one thing to produce a set of beguiling presentation designs and quite another to oversee the construction of a major building project on site, on time and within budget. Competitions did, however, leave behind them enticing illustrations of what might

above, above left and opposite
CAMBRIDGE UNIVERSITY LIBRARY, 1842. Cambridge, United Kingdom
By the 19th century the rooms housing the University Library at Cambridge were wholly inadequate. After a series of competitions, C. R. Cockerell's design was chosen. The main library is a long, barrel-vaulted room on the first floor (opposite), with an arched window overlooking the Senate House. The galleries pass though the piers (above), an idea that Cockerell copied from Joly's Assemblée Nationale. The Ionic capitals (above left) are derived from the Temple of Apollo Epicurius at Bassae, which Cockerell had surveyed on his Grand Tour. The building is now the library of Gonville and Caius College.

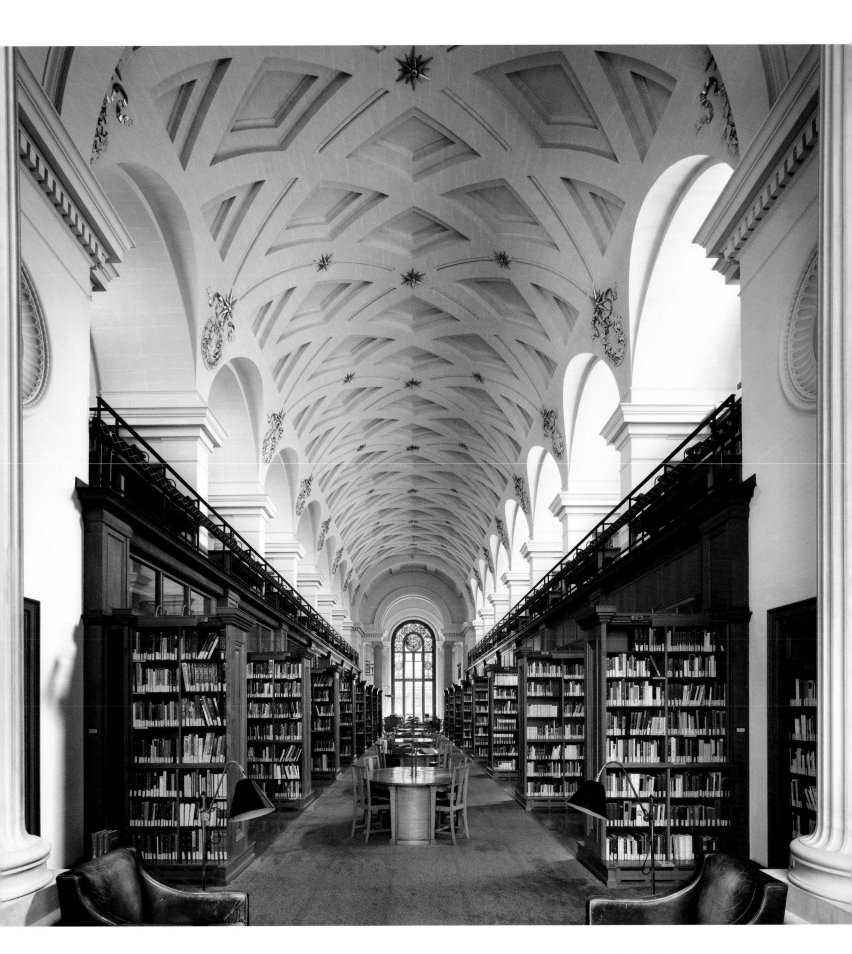

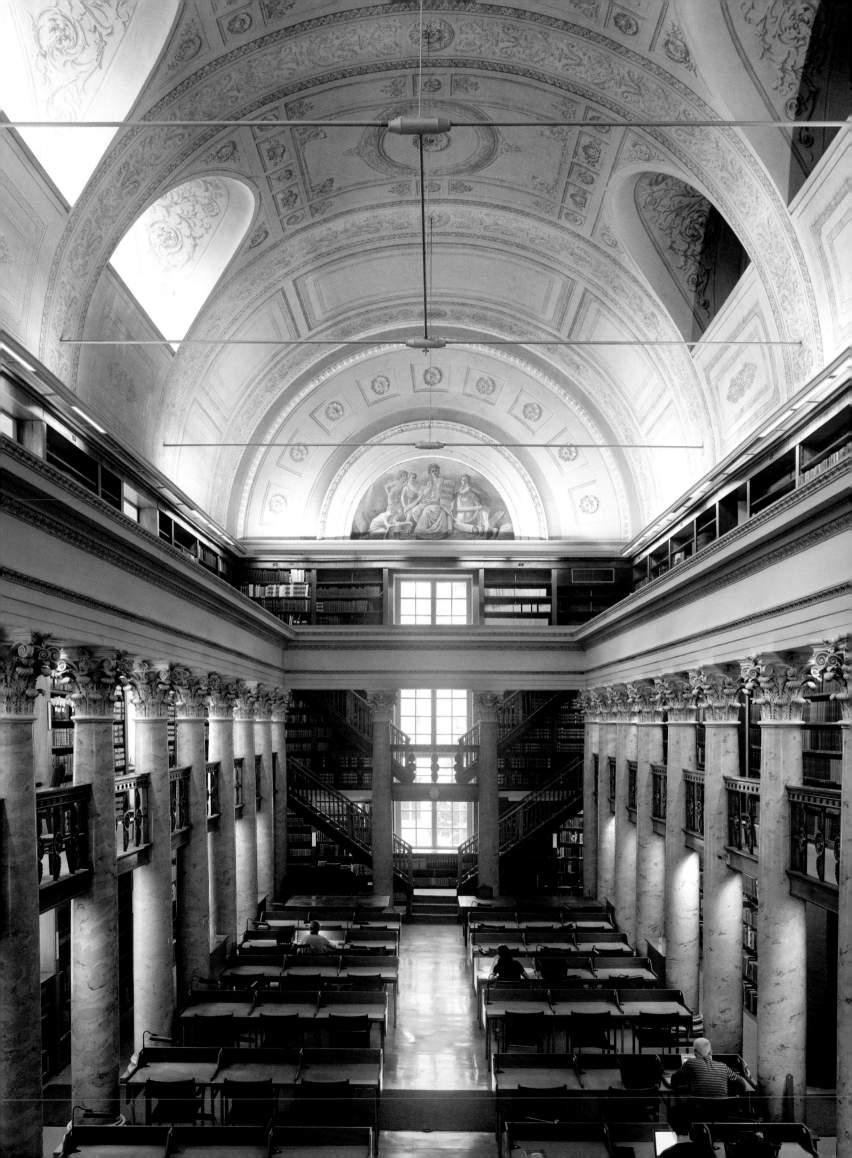

*Designed as the library of
Helsinki University by Carl
Ludvig Engel, and renamed
the National Library of
Finland in 2006, the building
is symmetrical. The south
(shown here) and north halls
flank a central Cupola Hall
(see overleaf). A semi-circular
extension, the rotunda, was
added in 1902–7 (see page
229). The two side halls have
a particularly interesting
arrangement of galleries. The
lower gallery is supported on
the columns, the readers' heads
being level with the Corinthian
capitals. The upper gallery is
behind the entablature, the
back of which acts as parapet
concealing low bookcases. Both
halls were originally furnished
only with plaster casts of Greek
and Roman statues.*

have been. These show that if Cockerell's winning
scheme for the first competition had been built it
would have been spectacular: long top-lit barrel-
vaulted halls extended around all four sides of the
courtyard with domed rooms at the corners. The
upper floor of his final, executed scheme gives some
clue as to what just one of the halls might have looked
like, but without the oculi in the ceiling.[22]

Cockerell's library is a long, barrel-vaulted space
with a vestibule at each end. Its structure is strikingly
similar to Joly's at the Assemblée Nationale (in one
drawing Cockerell compares the two, showing that
he was aware of the similarities): large rectangular
piers support the roof and divide the sides into bays
like a stall library.[23] On the upper level, the galleries
pass through doors in these piers. The galleries are
sufficiently wide to permit desks overlooking the
main space. The bays provide space for private study.
The strength of Cockerell's original design is clear in
the view from the gallery, along the well-lit space of
this magnificent, book-lined hall.

This type of library, consisting of a long, central,
barrel-vaulted hall with galleries giving access to
two storeys of alcoves running down each side,
was new. As well as the Assemblée Nationale and
Cambridge University Library, it appears at Edinburgh
University Library, designed by William Playfair in
1827, in Gothic dress in Gore Hall (1837–41) in Harvard
University, and slightly later in Deane and Woodward's
remodelling of the library at Trinity College, Dublin
(1857–61).[24] The layout was advocated in two German
books of the period on library design: L.-A.-C.
Hesse's *Bibliothéconomie* (1839) and J. A. F. Schmidt's
*Handbuch der Bibliothekwissenschaft, der Literatur-
und Bücherkunde* (1840).[25] The origin of the form is
unclear. It may simply have occurred to many architects
working at the same time from similar classical
and library precedents to solve the same problem.[26]
Whatever the source, it remained a distinct type of
library throughout the 19th and early 20th centuries.

The National Library of Finland
and Beaux-Arts planning.

One of the features of Neoclassical architecture was
rigidly symmetrical planning. In Paris, the École des
Beaux-Arts and the teachings of Jean-Louis Durand,

professor of architecture at the École Polytechnique,
were highly influential in promoting an axial setting-
out of buildings. In the hands of the best architects,
this was a powerful tool of composition. But in less
accomplished hands it led to poorly worked-out
buildings, with more circulation than usable space.
The method of symmetrical composition extended
well beyond architectural interiors to designs for
squares and whole city quarters.[27]

The library of the University of Finland, designed
by the German architect Carl Ludvig Engel (1778–1840),
now the National Library of Finland, was the product
of just this kind of Neoclassical planning. It was
designed as part of the Senate Square in Helsinki. This
formal urban square is dominated on the northern side
by Engel's Church of St Nicholas (now a cathedral).
On the eastern side, it is bounded by his University of
Helsinki building, completed in 1832, and on the west
by the matching façade of his Palace of the Council
of State, completed in 1822. The whole quarter was
commissioned by Tsar Alexander I (1777–1825) to
create a new St Petersburg in the Finnish capital.
Finland was then under Russian control, ruled as
an autonomous duchy, with the Russian emperor
as crown prince.[28]

The library was built next to the university
building. Engel submitted three alternatives to Tsar
Nicholas I (1796–1855), who selected the design that
was built. Its façade, which faces the west side of the
cathedral, consists of a massive central portico with an
attic, mimicking a triumphal arch. The visitor enters
a vestibule with cloakrooms on either side (essential
in the Finnish winter), and great doors then lead into
the central, domed space that forms the heart of the
library. This is flanked by two reading rooms. Here, as
in the Hofbibliothek in Vienna, the use of the classical
orders helps to disguise the huge scale of the spaces.
Corinthian columns support the galleries, which come
at two levels, one half-way up the columns and the
other above them, so that the top of the entablature
forms a balustrade, with shelves beneath. The ceilings
are coffered and richly decorated in gold leaf, but
there is little by way of figural decoration. Instead, the
library was used to display classical statues. When it
opened, its halls were sparsely furnished with none
of the tables and display cabinets that now clutter

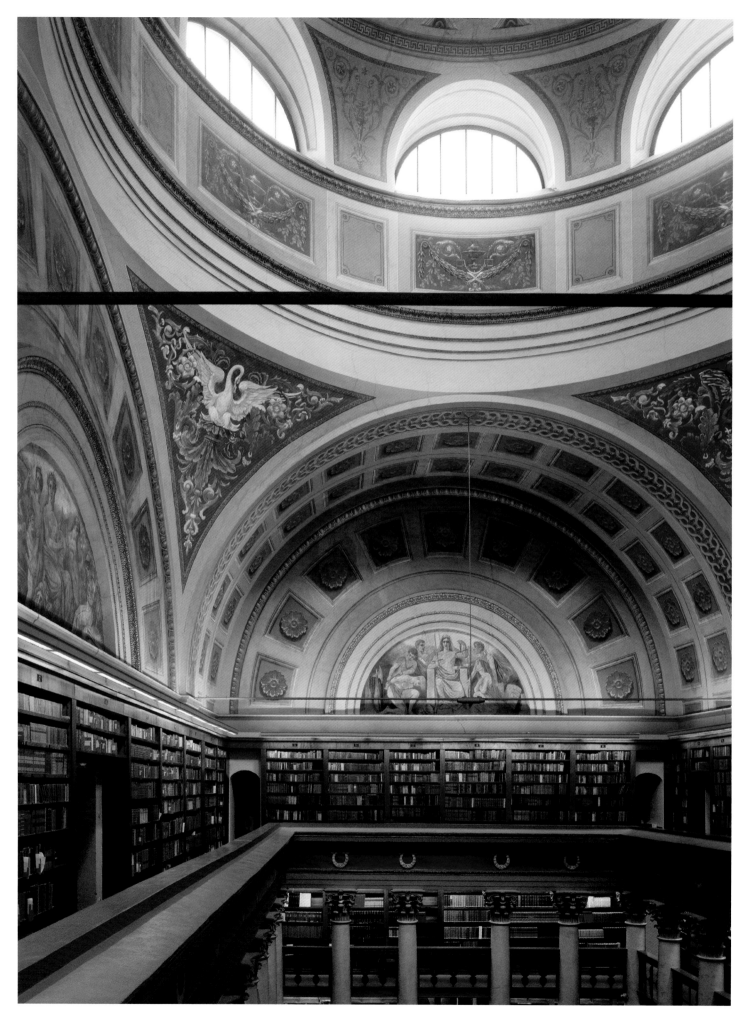

opposite
THE NATIONAL LIBRARY OF FINLAND, 1840–5
Helsinki, Finland

The central hall. Readers pass from here into the reading rooms on either side (see previous page) or into the rotunda (see page 229). The gallery of the rotunda connects directly with the galleries of these spaces and has no staircase of its own.

below
BIBLIOTHÈQUE SAINTE-GENEVIÈVE, 1850
Paris, France

The entrance hall of the library, which was designed by Henri Labrouste. The walls are painted with trees to give the impression of passing though a garden. The room retains its original gas lights, now converted to electricity. The iron arches in the ceiling give a hint of the form of the reading room above, reached by the stairs that ascend to the left and right of the archway ahead.

the space, but with statues positioned at key points throughout the building.

Engel had not been trained in France, but he had attended the Prussian Academy of Arts, and classical ideas of symmetry as the root of beauty were common across Europe. The problem is not symmetry *per se* but the way it was used in Beaux-Arts planning.[29] There was a tendency for plans to be treated as works of art in their own right, as abstract patterns on paper, not depictions of real buildings. In reality, it does not matter if a room on the other side of the building does not match the exact proportions of the one I am standing in. As Wren showed in his architecture, you cannot see the two opposite sides of a building at the same time. However, on a plan it will look incorrect. Buildings rarely have pairs of functions: a house does not need two kitchens, and a library rarely needs more than one identical reading room. The results of Beaux-Arts planning were all too often libraries in which librarians worked in increasingly impractical layouts, designed to look good on plan rather than function well in reality. This was the tyranny of the

symmetrical plan. A good designer knew when and how to break the symmetry, a bad designer did not.

Iron and the Bibliothèque Sainte-Geneviève

Although the École des Beaux-Arts and the competition system may have been responsible for a certain method of composing plans, it would be wrong to suppose that this method represented a consistent attitude to architectural style. Throughout the 19th century, architects argued continuously about the problems of developing an appropriate style suitable for expressing the principles of the age. In England, the publication of A. W. N. Pugin's (1812–1852) *Contrasts* in 1836 led to a revival of the interest in Gothic design that had never entirely disappeared from English architecture. In Berlin, Karl Friedrich Schinkel (1781–1841) turned away from the classicism of his early works towards a brick Romanesque. In the École itself, the rebellion took the form of the *Néo-Grec*, led by the architect Henri Labrouste (1801–1875). Despite its name, *Néo-Grec* did not advocate a return to Greek architecture, but rather the formation of a new, expressive *architecture parlante*

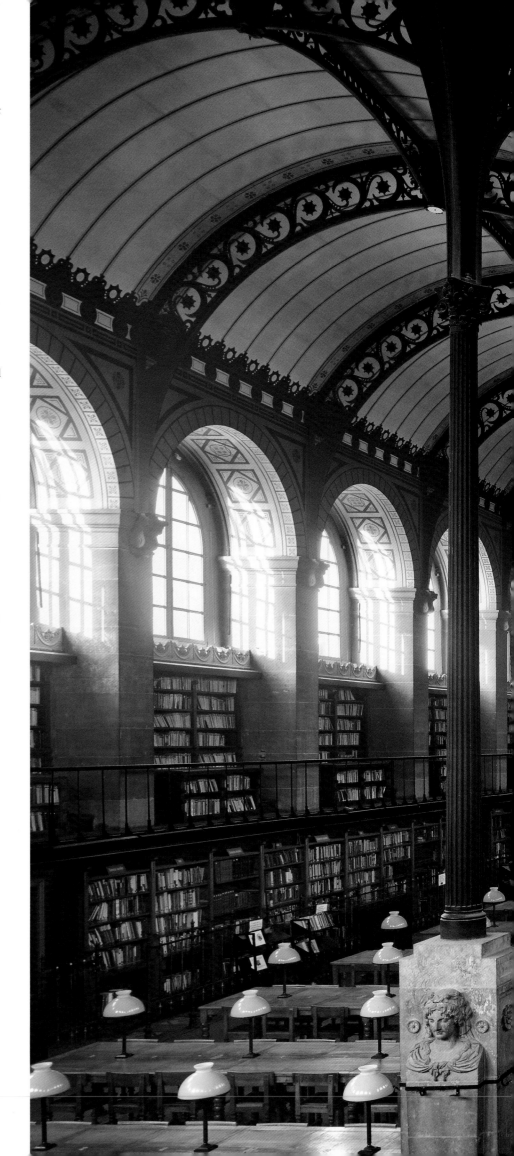

BIBLIOTHÈQUE SAINTE-GENEVIÈVE, 1850
Paris, France

The library is 83.5 m (274 ft) long and 21 m (69 ft) wide and its famous iron roof is supported on sixteen iron columns. The layout of the tables is new. Originally there were shelves between the columns and two tables ran the length of the hall, one on each side. The galleries are stepped. This creates spaces underneath them, which form passages lit by small windows in the front façade and lined internally with shelves to provide additional book storage.

– that is, architecture that 'speaks' or proclaims its function or purpose. It is in the light of *Néo-Grec* that the architecture of one of the most talked about of all 19th-century libraries, Labrouste's Bibliothèque Sainte-Geneviève, needs to be discussed.[30]

By 1800 the old Bibliothèque Sainte-Geneviève (see p. 136) had outgrown its original premises and moved to the upper floor of the Lycée Henri IV, behind the Panthéon. The site given to Labrouste was to the Panthéon's north. It was 86 m (282 ft) long but only 29 m (95 ft) wide. Labrouste later said that the site had made the idea of a garden forecourt, to separate the library from the square, impossible. Instead, he was constrained to produce a single volume, filling the whole site. The garden idea was not lost, however: it became the theme for the entrance hall, which was decorated with murals of trees and bushes seemingly poking up above garden walls.[31]

Labrouste's use of iron in the library was not a rationalist reaction against traditional masonry structures. Iron was much more frequently used in architecture in the 1840s than is commonly believed.[32] This was the age of the railways, and iron-roofed railway stations were being constructed all over Europe. It was also the age of gaslight. The library was not made of iron because that is what Labrouste wanted, but because it was to be lit by gas and thus the brief required from the outset that it should be built of iron to protect it against fire. Labrouste's use of iron was neither his idea nor the first use of the material in a library building. Nor was this the first library building to be lit by gas, nor was it the first to have bookstacks (which had been used since at least the middle of the 18th century), although all these claims have been made about it.[33] The library's originality lies in the way that Labrouste combined these existing elements and expressed them, rather than concealing them in traditional forms.

The whole of the library's ground floor was devoted to storage, in the form of row upon row of tall shelving units, accessed by ladders. These have long since been replaced by steel stacks. Stairways from these stacks led up to the reading room above. The use of gaslight meant that Labrouste felt able to reduce the size of the ground-floor windows. The entrance hall is particularly dim, which heightens

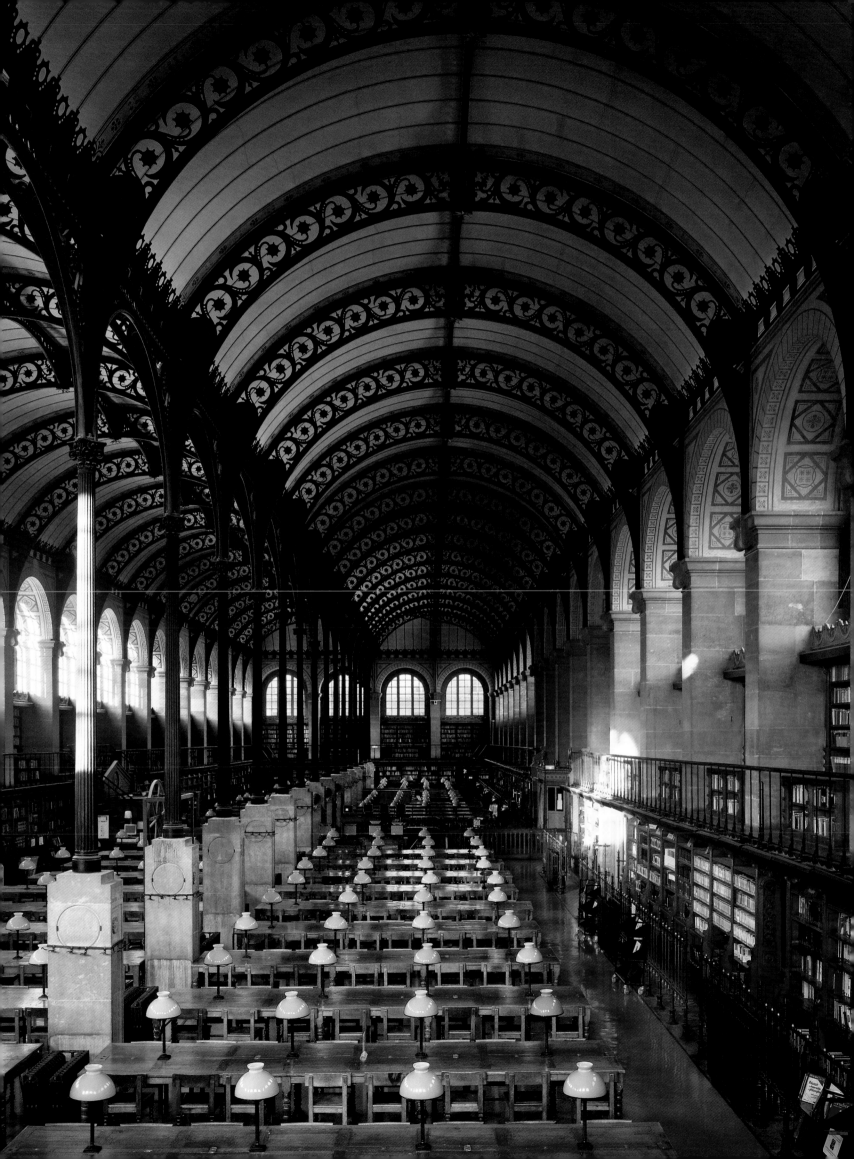

BIBLIOTHÈQUE SAINTE-GENEVIÈVE, 1850
Paris, France

One of the beautiful sculpted plinths that support the iron columns in the reading room, cast into shadow by the early morning light from the large windows above.

the effect of walking through a garden at twilight, illuminated by streetlights. The square pillars are reminiscent of pergolas, supporting iron beams above. The hall leads to a staircase, more brightly lit from windows above, signalling the way the visitor must go. The top of the staircase is decorated with a mural of Raphael's *School of Athens*. From here, the reader enters the reading room, a single rectangular space that takes up the entire first floor.[34] In contrast to the ground floor, it is brightly lit by huge windows on all sides.

The main reading room is also more traditional in form. Its galleries are clearly directly inspired by Boullée's scheme for the Bibliothèque Nationale. Readers are separated from the shelves by an iron fence. The lowest tier of shelving extends barely above head height, so that the books can be easily reached. In section, the library steps back, as in Boullée's scheme, so that that the gallery sits over a passageway and the lower tier of bookcases. The passageway is Labrouste's innovation. Dimly lit by tiny windows, it provides storage for more books. The reading room's roof consists of two rows of cast-iron arches, springing from a central line of slim, cast-iron columns. The space could easily have been spanned without the central columns, which were introduced entirely for aesthetic reasons. Construction began on the main body of the library in 1843, but the drawings suggest that Labrouste put off producing the detailed drawings for the ironwork until 1845, when work on the masonry was well advanced. He created a new language of decoration appropriate to the material.[35]

Of all the features of the Bibliothèque Sainte-Geneviève, the façade has attracted the most comment. Again, Labrouste seems to have turned his attention to its decoration only late in the design process, when work was comparatively well advanced. The stone panels below the windows carry 810 names of famous authors, arranged chronologically. The first name, on the panel in the north-west corner, is Moses and the last, in the north-east corner, is the Swedish chemist J. J. Berzelius, representing the history of knowledge from theology to modern science.[36]

The Bibliothèque Sainte-Geneviève was hugely influential. Its façade was widely copied, perhaps most famously by McKim, Mead and White for the Boston Public Library, built in 1887–95, although the buildings' internal layouts are entirely different.[37] In France, it established Labrouste as a serious architect and contributed to his appointment as architect for the Bibliothèque Nationale in 1854. After organizing various renovations in the Bibliothèque Nationale, he turned his attention to designing new buildings. His first project was for new iron stacks (the *magasin*), completed in 1867, which was followed by a new reading room, the *salle des imprimés*, in 1869 (see illustration on p. 228).[38] Both are iron. The stacks are self-supporting iron shelving four storeys high. Each storey is only 2 m (6 ft 6 in.) high, so that the librarians can retrieve the books without using ladders. The floors are iron grilles, so that light can percolate down from the glass rooflights above. The stacks are visible from the main reading room through a huge glass window behind the librarians' desks, where the readers order their books.[39]

The librarian and the bookstack

The 19th century saw the emergence of a new figure in library design: the professional librarian. Up until this point, librarians do not seem to have played a major part in library design. The post of head librarian in national collections was often an honorary title given to a senior academic or other public figure, who might have little or no time to spare to attend to the library in his care. Assistants were appointed to look after the books and keep them in order on a day-to-day basis. More important libraries had full-time librarians who devoted their lives to cataloguing and preserving their

collections, but in the case of new libraries they seem usually to have been appointed after construction was finished, and were thus rarely involved in their design. However, the growth of libraries in size and number led to the emergence of a new breed of professional librarian who, as head of an institution funded by the state, was expected to lead decisions on how libraries should expand and what they should look like. Antonio Panizzi, the head of the library of the British Museum, was an excellent example.

Panizzi (1797–1879) began his career as a lawyer in Modena in Italy, where his fondness for secret societies that mixed politics with esoteric mysticism led to a conviction for treason. He arrived in London, a fugitive from justice, penniless and unable to speak English. He scraped a living, initially teaching Italian, taught himself English, and was soon lecturing on the Renaissance at the newly established University of London. To supplement his meagre income he took a job as 'assistant librarian' at the British Museum, where he made a name for himself by producing an entirely new catalogue of the complete collection. He was promoted to Keeper of Printed Books (1837–56) and finally Principal Librarian (1856–66).[40] The British Museum had been founded as both a library and a museum. From the outset it had contained both a collection of objects and a sizeable collection of books, including the royal library donated by King George II. George III was also a keen book collector and had constructed a new library in Buckingham Palace, including a dramatic octagonal library room, to house his acquisitions. This collection was also transferred to the British Museum in 1823 and with it went the right to legal deposit – by law, one copy of every book in the United Kingdom had to be given to the library by its

publisher. A new library room, the King's Library, a wall-system library with a gallery around it, was built especially to house the collection, and it remains on show in the museum today. By 1833 the library had over 250,000 books. Steam power was increasing the production of presses, and publications of all types were increasing in number year-on-year. Up to this point, the system of legal deposit had been poorly enforced, but Panizzi was instrumental in correcting this and soon books began to pour in, creating ever-increasing storage problems. It was Panizzi rather than an architect who came up with the solution. He produced the first sketch for a round library, occupying the unused and dark central courtyard of the museum, and he came up with the idea of filling the rest of the space with bookstacks to solve the problem of storage. The architect Sydney Smirke (c. 1798–1877) was then responsible for turning Panizzi's sketches into a building. Construction began in 1854 and the reading room was completed and open to the public on 2 May 1857.[41]

Whereas Labrouste's Bibliothèque Sainte-Genevieve had masonry walls – only the roof and the floors had been framed in iron – the new round reading room at the British Museum was a completely iron-framed building. The dome permitted a very large pillarless space, 42.6 m (140 ft) in diameter. The project's emphasis was on speed of construction and the problems of building within an existing building, so the ceiling of the dome was made from papier mâché.[42] The stacks were load-bearing cast-iron shelving with wide aisles of open, iron grillework to allow the light from the glass roof to penetrate to the lower levels. They were built in stages – the last segment was not completed until 1887 – and accommodated one and a half million volumes. Essentially utilitarian in design, they were never meant to be seen by the public and were accessible only to librarians. The use of iron also allowed Smirke to introduce large windows around the whole perimeter of the dome, ensuring that the library was adequately lit throughout the day. No gas was allowed for fear of fire; the reading room and stacks both relied entirely on daylight. The desks for the readers were carefully designed to incorporate swinging lecterns for consulting multiple works at a time, as well as

below
BIBLIOTHÈQUE NATIONALE, 1867
Paris, France

The iron book stacks (Salle de Magasin) in the Bibliothèque Nationale, designed by Henri Labrouste, were heavily influenced by the iron stacks that surrounded the round reading room of the British Museum. Whereas those were hidden, Labrouste's could be seen through a window in the reading-room wall, behind the desks for the librarians. The walkways were made of open ironwork, and lit from above.

opposite
THE NATIONAL LIBRARY OF FINLAND, 1902–7
Helsinki, Finland

Designed by Gustaf Nyström to hold 200,000 books on six floors, this rotunda, begun in 1902 and completed in 1906–7, was an extension to what was then Helsinki's university library. The structure is iron, but the bookcases are timber. They radiate for reasons not of surveillance but of light, which is provided by windows in the outside wall and from the hemispherical glass dome above.

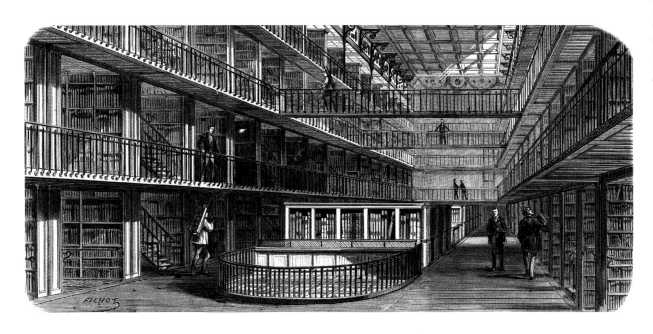

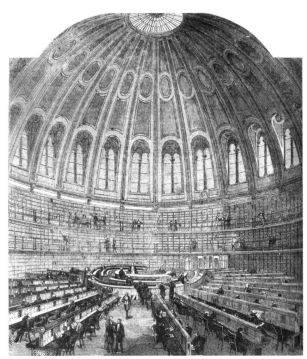

above
ROUND READING ROOM, BRITISH MUSEUM, 1857
London, United Kingdom

The brainchild of the librarian Antonio Panizzi, the iron-framed round reading room, 42.6 m (140 ft) in diameter, was designed by Sydney Smirke. Before the opening of the new British Library next to St Pancras Station in 1997, this was the main reading room for the national collection.

places to put pens and other items. They were ranged radiating out from the centre so that the librarians had a clear view down the aisles. This was an early example of a library laid out to aid the surveillance of the readers, an idea possibly taken from the 'Panopticon', a conceptual design by the philosopher Jeremy Bentham for a type of institutional building with a watchman at the centre and radiating wards, or cells, ranged around, which had been published in 1791. As we have seen in previous chapters, the idea of a round reading room was far from new. What was revolutionary was the scale, Panizzi's idea of having the librarians at the centre and the readers ranged around them, and placing huge stacks adjacent to the reading room on the same level. The Bibliothèque Nationale took up the latter idea and went one stage further: since its stacks were visible from the reading room, it made the act of fetching the books into a spectacle. The round reading room became a theme that occurred again and again in the following century in libraries such as the Picton Library in Liverpool, (1879), the Library of Parliament, Ottawa (1880), the Königliche Bibliothek in Berlin (1914), Stockholm City Library (1924) and Manchester Central Library (1934). The most famous library inspired by Panizzi's round reading room is the Library of Congress in Washington DC.

THE LIBRARY OF CONGRESS, 1897
Washington DC, United States of America

The main reading room (left) is an octagon, 38 m high and 30.5 m in diameter (125 x 100 ft). The librarians sit at a raised desk in the centre. The dome was undoubtedly inspired by the round reading room at the British Museum, but the Library of Congress building is more richly decorated throughout, and has a particularly grand staircase (below) leading up to the reading room.

The Library of Congress

The Library of Congress was founded by President John Adams in 1800. It was destroyed by the British in 1814 and in the following year Jefferson sold it 6,487 books for $23,950 to form the core of the new collection. Most of these works and many more were lost in a fire in 1851. The library became a copyright library in 1870, but it took some time to raise funds for a new building and a competition was not held until 1873. After considerable disagreement, the plans of architects John L. Smithmeyer (1832–1908) and Paul J. Pelz (1841–1918) were chosen, although construction was eventually overseen by an army engineer, General Thomas Lincoln Casey, and many of the details were drawn by his son, the architect Edward Pearce Casey (1864–1940). The building was not finished until 1897, by which time the collection it had to house had grown to 840,000 volumes.[45] In design, the Library of Congress is conservative: broadly Neoclassical, it is richly painted and decorated in the Beaux-Arts style. Although the central desk in the reading room is superficially similar to Panizzi's arrangement,

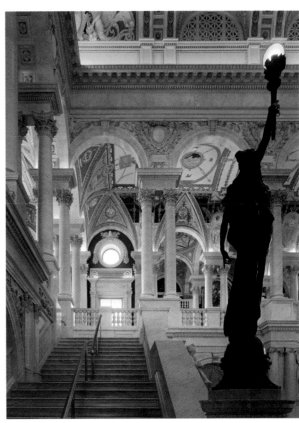

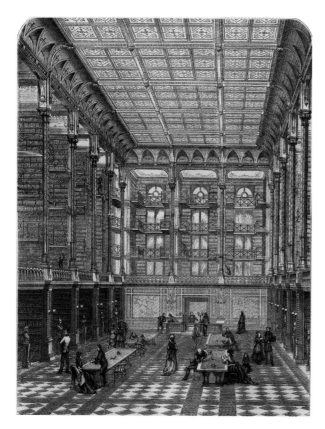

which opened on Boylston Street in 1858, and Cincinnati Public Library, which opened in 1874, designed by James W. McLaughlin (1834–1923).[45] The most dramatic surviving example of this type is the George Peabody Library, founded as the library of the Peabody Institute of the City of Baltimore.

The library of the Peabody Institute

The library was the brainchild of George Peabody (1795–1869), best known today as the founder of the charity that financed, and continues to finance, housing for low-income families in London. He was a self-made man from Massachusetts, who had left school at the age of eleven to help support his ten brothers and sisters. Peabody started his working life in Baltimore, Maryland, and made his money in wool trading. In 1837 he moved to London, where he expanded his business and founded a merchant bank. Before his death he donated his considerable fortune to charitable works, including a large sum to found the Peabody Institute in Baltimore. The building was to include an art gallery, concert hall and library.[46]

The Peabody Institute was designed by Edmund Lind (1829–1909), who won the competition to design the building in the late 1850s. The first phase, containing the Peabody Hall, conservatory rooms and picture gallery, was completed in 1866, and the rest of building, including the library, was finished in 1878.[47] The library is entered from the main entrance vestibule through a large hall that acted as a reading room. Nothing prepares the visitor for the scale of the main library room beyond, which is seven storeys 18.5 m (61 ft) high, six of which are devoted to book storage, the top storey forming the roof. The room is well lit through rooflights. The ceiling arches are made of artificial stone but all the other visible elements are made from iron to protect the library in the event of a fire. This included the cast-iron decorative columns, the floors of the stacks and the decorative mouldings, which were originally painted grey-green, with highlights in gold leaf. Steam-driven dumb-waiters were installed to help the librarians fetch the books from the upper floors.[48]

The interest in designing iron-stack reading rooms did not last long. The top floors tended to get excessively hot and humid, a problem made worse by

the desks run in rings around it. The stacks are in a separate block behind, which is accessed from underneath. Beautiful as it is, the building was not revolutionary and at the time it was rivalled in size by the United States's largest public library, in Boston.

The rise and fall of the iron-stack reading room

The period around 1850 saw a rapid growth in public libraries. This was aided by changes in legislation in many countries, which allowed local municipalities to raise money on taxes for their support. Funding was crucial both to the libraries' initial form and to the changes that followed. Typically, the libraries were built with money from rich benefactors and then run by the local city councils. More rarely, the benefactors also left endowments for the running and stocking of the libraries. The design of these libraries had to meet a number of conflicting criteria. There was the need to accommodate expanding collections (this was always underestimated), the need to allow plenty of space to read the collection (which was initially to be read on site rather than taken away) and a wish to have the whole library in a single impressive space. It was this last requirement that led to a new type of library: the iron-stack reading room. This consisted of a huge top-lit central hall with the tall iron bookcases arranged in alcoves down each side of the room. The Astor Library in New York, which opened in 1854 and was designed by the German architect Alexander Saeltzer (1814–1883), seems to have been the first.[44] The form was copied soon after at the first Boston Public Library,

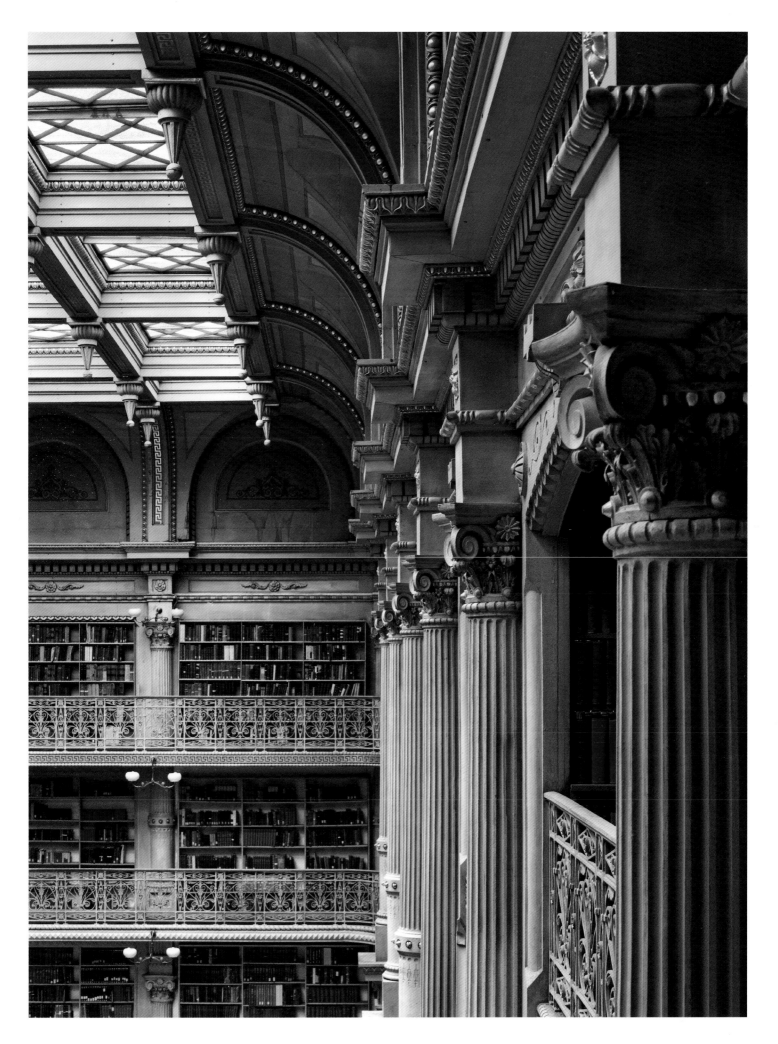

THE GEORGE PEABODY LIBRARY, 1878
Baltimore, MD, United States of America

*The library employed iron for both its strength and fire-resistant
properties. The columns and all the interior decoration (below)
appear to be stone but in fact they are entirely cast and wrought
iron. The library (right) was originally lit by gas, and the round
fittings are visible under the galleries. This allowed the library to
remain open in the evenings, but it carried a risk of fire, which
iron was thought to reduce. The use of iron also enabled the
hall to be supported above a recital hall beneath it.*

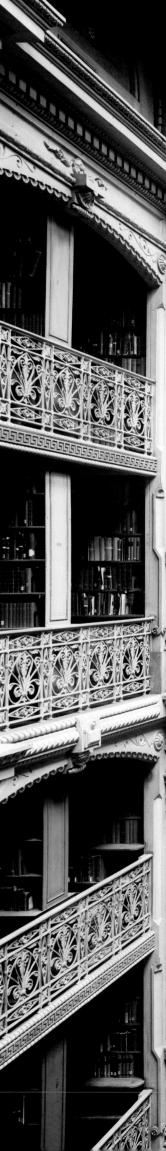

the use of gas lighting. This was bad for the books, and
in addition the reading areas on the ground floor were
draughty and cold. Such libraries were also difficult
to expand. The Peabody is one of the few remaining
examples of this type of library. Boston Public Library
moved to larger premises in Copley Square in 1895. The
Astor Library ceased to be a library in 1911, when its
collection passed to the New York Public Library, and
was a set of offices until it was converted into a theatre
in 1965. Cincinnati Library lasted until 1955, when it
was replaced by a modern building. However, the form
influenced a number of 20th-century architects.

The expansion of public libraries
in the late 19th century

George Peabody represents a new type of philanthropist
that emerged in the second half of the 19th century.
Industrialization had affected and changed every
aspect of society. Unprecedented growth in urban
populations had led to poverty and overcrowding

but industrialization had also made a small number
of individuals – often from comparatively humble
backgrounds – unimaginably rich. The best known
of these, and the one who had the most influence over
library design, was Andrew Carnegie. Carnegie (1835–
1919) was born into a poor family in Dunfermline
in Scotland. He emigrated to the United States with
his parents as a teenager. His first job was in a
factory and he educated himself in the evenings. His
break came with a job at the Pennsylvania Railroad
Company, where he worked his way up through the
ranks. It was through investing in stocks and shares
using inside information that he gradually amassed
his first fortune. He went on to found the Carnegie
Steel Company, which gave him control of American
iron and steel production and made him one of the
richest men in the world. He believed passionately
in philanthropy and in libraries. He gave away a
staggering $550,695,653 providing grants for 2,811
free public libraries, of which 1,946 were in the

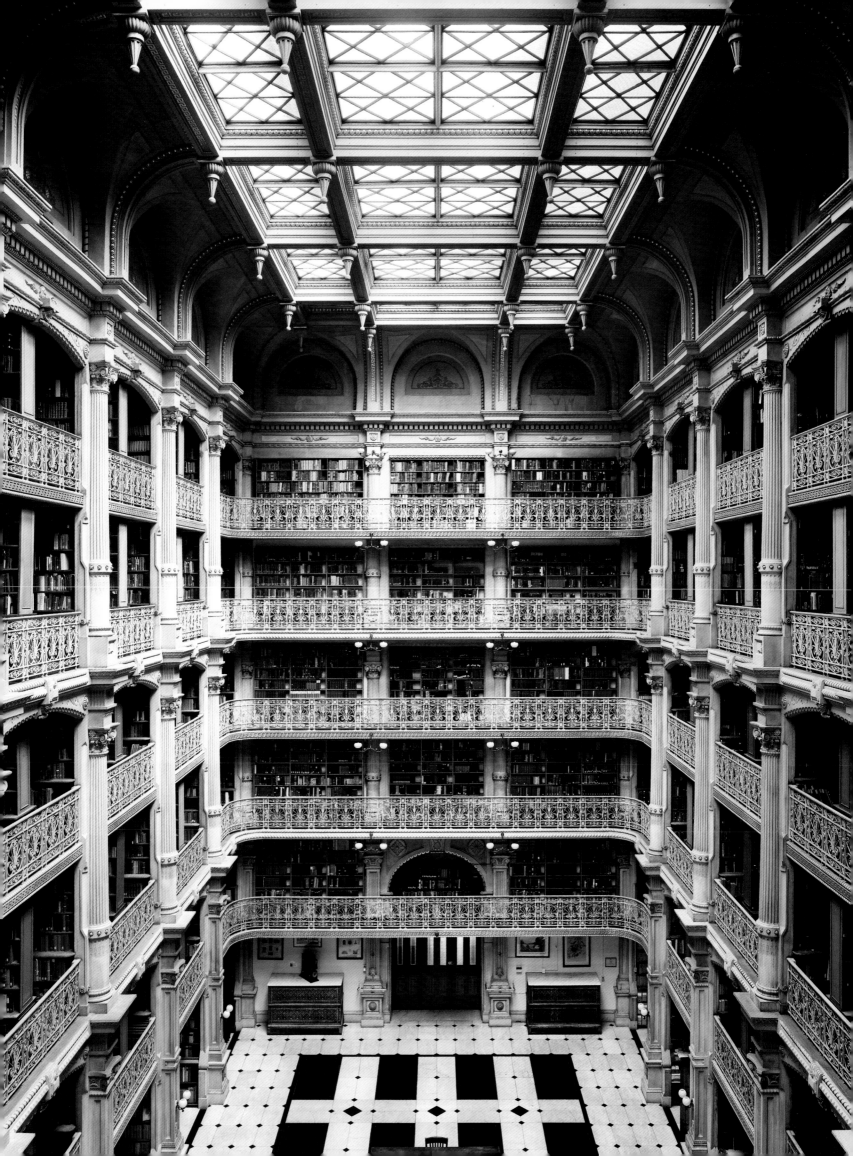

United States, 660 in the United Kingdom and the rest spread across the English-speaking world.[49]

Carnegie's contribution to library design was huge. The money he provided was only for new library buildings. The benefactors had to find the money for the land, the books and the running costs and often these were not inconsiderable obstacles. However, his largesse allowed an enormous expansion in library provision. Most large towns already had central libraries, so Carnegie's libraries were usually in suburbs or smaller towns. It was only in 1911 that the Carnegie Foundation issued its *Notes on the Erection of Library Buildings*, but even before that all plans had to be approved by Carnegie or the foundation. Certain architects began to specialize in library design to meet the growing demand. The sheer size and number of libraries built in this period have led to major academic studies, and readers wishing to understand the development of public library design should look to these.[50] However, some of the general issues involved can be discussed by looking at the Thomas Crane Memorial Library in Quincy, Massachusetts, designed by Henry Hobson Richardson (1838–1886).

The Thomas Crane Memorial Library
Richardson produced a series of designs for small public libraries in the United States, of which

the Thomas Crane Memorial Library is the most successful.[51] The building was completed in 1882 and sympathetically extended in 1908 by William Martin Aiken.[52] The first thing that strikes a visitor today is the size of the original building. Most of the libraries built in this period were small, but this is about as small as they get. The library consists of a single hall. Readers entered through an archway, which has a seat on which to shelter in bad weather when waiting for the library to open. Inside, the reader would have come immediately to the librarian's desk. To the left, the books were prominently displayed, ranged in alcoves mimicking a 17th-century Oxford or Cambridge college library. To the right, there was a huge fireplace, around which the readers could sit and read the newspapers. Newspapers were available to browse, books were not.

The Thomas Crane Memorial Library was a public lending library and the books were fetched by a librarian, to be borrowed and read at home. Public libraries initially barred the readers from direct access to the bookshelves. The librarian was seen as the essential filter between reader and the books, ensuring that the books were kept in order and inappropriate works were not issued to the wrong reader. Naturally, this lack of access affected the form of the lending library. Bigger libraries had newspaper reading rooms, with newspapers chained to standing lecterns, as

well as lending desks and specific reference rooms, where dictionaries and other innocuous works might be picked off the shelf, but most of the material was fetched by staff. Being able to guide an enquirer to the correct text to find a particular piece of information was very much seen as an important measure of the good reference librarian.[53] In this, such libraries differed from other types, such as subscription libraries or libraries of clubs, or any library where there was a membership fee, where the readers tended to be allowed access to the shelves.[54] Presumably it was believed that the fee excluded undesirables and those likely to steal the books. It was not until the 1890s that libraries in Britain and the United States started to allow the public to browse the books.[55] This meant that all the library fittings designed to separate the public from the collection had to be removed and the collections arranged in a way that the public could find the material they wanted.

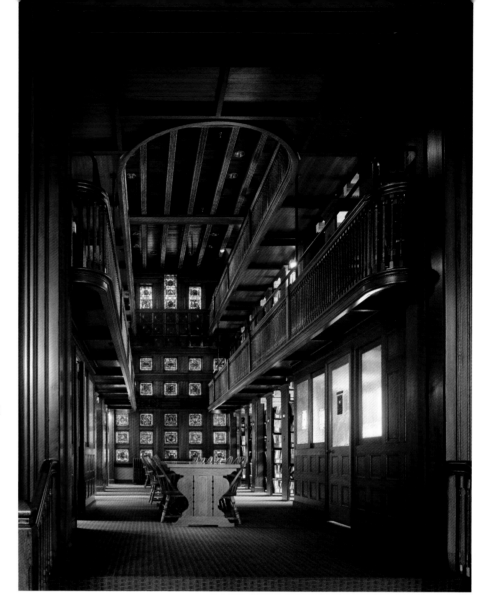

Catalogues and library fittings

Traditionally, libraries had been arranged by subject and each book was assigned a number according to its position on the shelves. This meant that every book, whatever its contents, had to be placed in just one subject category, but it facilitated browsing, since books on similar subjects were placed together. The use of closed stacks meant that books would not be browsed and could thus be placed on the shelves in any order. With a closed-stack library, an accurate catalogue was crucial to enable readers to order books. If a book was not catalogued it could never be ordered and would remain on the shelves unseen. Panizzi's author catalogue for the British Museum had been printed, and like all printed catalogues, which had been popular throughout the 18th century, it was out of date the day it was published. Earlier libraries had coped with this by annotating the printed copy, but the rate of accession in the bigger 19th-century libraries made this impractical. There were two ways of dealing with this problem. One was the slip catalogue, first introduced in the library at Harvard College by William Coswell in the early 19th century.[56] This involved cutting up one copy of the printed catalogue into slips, which were pasted into blank volumes called guard-books, with spaces left between

for new entries. The huge number of volumes involved took up considerable space. The system was adopted by Panizzi at the British Museum library, where the guard-books ran around the central desk in the Round Reading Room. When the new Cambridge University Library was built in the 1930s a special room was designed just to house the slip catalogue.[57] Another alternative was the card catalogue which seems to have first appeared at the end of the 18th century, when playing cards were used by Edward Gibbon to catalogue his library.[58] Playing cards were also used after the French Revolution to keep track of the books sequestrated from aristocratic libraries for the new Bibliothèque Nationale.[59] It was only in the 1870s that the use of blank cards became common, partly through the work of Melvil Dewey, who played an important role in transforming librarianship from an occupation into a profession.[60]

Dewey (1851–1931) was born in upstate New York and went to Amherst College. While working as a library assistant at Amherst to help fund his studies he became obsessed with improving libraries. It was there that he formulated his classification system – the Dewey Decimal System – which sought to produce

a system of knowledge that would easily enable a
reader to find a book on any subject on the shelves.
Dewey went on to found the American Library
Association in 1876 and he opened the first 'School
of Library Economy' in Columbia College (now
Columbia University) in New York in 1884. Although
he is best known for his classification system,
Dewey's professionalization of librarianship and
his supply of library fittings had a greater effect on
library design. He started selling products to make
libraries more efficient in 1876 while he was still at
Amherst and his Library Bureau grew to become
the largest library-supply business in the world.
It provided standardized catalogue cards and the
drawers they went in, shelving, shelf dividers,
stamps for library books, library tables and library
chairs. The Library Bureau promoted the use of card
cataloguing and the fittings that it supplied featured
prominently in library interiors from the end of the
19th century onwards.[61]

Librarians versus architects
The American Library Association provided a place
for librarians to share experiences and views and one
view they quickly formulated was that the existing
designs for public libraries were not fit for purpose.
Richardson had been by far the most influential
of the architects working on these small-town
libraries. The form – a small room with alcoves, a
reading room with a fireplace – was copied widely
in England. Yet librarians were quick to point out
how impractical they were. There was little room
for storage or expansion, the windows were tiny and
arranged to provide an architectural impression but
were completely impractical for reading, and the
galleries were accessed by dangerous tight, winding
staircases.[62] It was not just these smaller provincial
libraries that came in for attack but also the larger
urban public libraries. The iron-stack halls, in
particular, were too cold at the bottom for readers and
too hot at the top for books. The position was elegantly
summarized by W. H. Overall of the City of London
Corporation Library, who, addressing a conference
on library design, is said to have declared that 'the two
great enemies to libraries were architects and gas'.
He went on to say:

[the] librarian's troubles begin with the
commencement of the building, the architect
desiring to erect a grand hall, often without
the slightest regard to its use as a library.
The question of galleries, again, becomes
a nuisance – the architect for the sake of
appearance, wishing to keep them at a great
height; whilst the librarian, for the better
working of the library, desires to keep …[the
shelves]… at a height, which may be reached
by the attendants without ladders.[63]

Similar criticisms could have been levelled at many
of the greatest libraries of the previous two hundred
years. What had changed was that the number of
librarians had increased and that they had become
more organized and more vocal. The people who had
paid for the libraries in the past were not librarians
and rarely had to sit in them day after day. Now the
librarians had a voice, and they were exercising
it. Arguments between architects and librarians
would rage throughout the 20th century, and indeed
librarians have a tendency to be scathing about
architects to this day. The better architects and the
better librarians sought to gain expertise in each
others' worlds; the lesser ones continued to bicker.

In terms of the design of public libraries, the
sheer number being built was part of the problem.
The rate of change in the way they were operated
was also a key factor. Small-town public libraries
were always created with the idea of providing a
place where the common man and woman could
educate themselves.[64] Libraries did indeed play a
very significant role in providing opportunities for
self-education, but from the beginning librarians
complained that the people who used public libraries
were primarily interested in popular fiction.[65] Those
commissioning libraries were reluctant to accept this
reality, so buildings were created for one purpose but
had gradually to be adapted piecemeal to suit another.
All of these 19th-century public libraries have suffered
from the stripping-out of their original fittings and
the imposition of new and usually unsympathetic
furnishings. Neither architects nor librarians can
be blamed for this and neither particularly enjoyed
the consequences. The result of constant changes

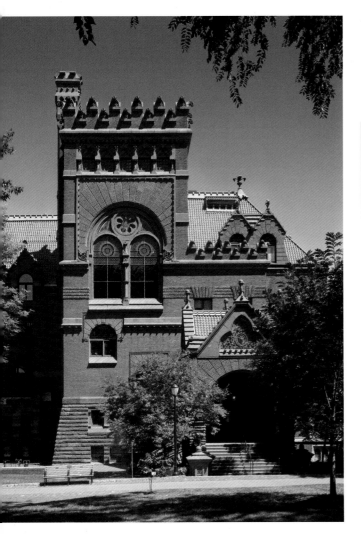

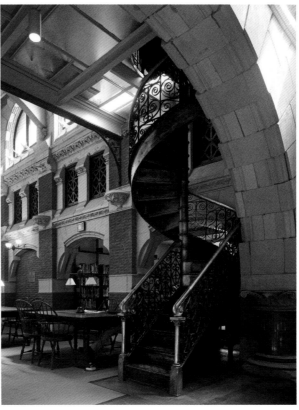

meant that libraries were always being altered and the buildings became less and less suitable for the purposes that they were being asked to serve. Small public libraries were, however, just one type of library, albeit a very numerous and visible one. Other types of libraries, such as academic research libraries, did not face the same problems because their purpose was largely unchanging. Nevertheless, they still had to adapt to changes in technology, increases in book production and changes in architectural taste.

The Fisher Fine Arts Library and the functional academic library

The Fisher Fine Arts Library, Philadelphia (originally the library of the University of Pennsylvania), provides an interesting example of design collaboration between an architect and librarian. It also demonstrates how, even with the best of intentions, changes in taste can cause a building to go in and out of fashion, creating problems of their own. In 1884 the University of Pennsylvania employed an energetic new librarian, James G. Barnwell, to take over its collection of books, which at the time was stored in a single room. Barnwell's appeal to raise money for acquisitions was so successful that books were soon stacked all over

the floor. He called repeatedly for a new building, finally resigning in frustration in 1887. This forced the provost, William Pepper, to look seriously into library provision. He persuaded the university to hire an architectural firm to draw up plans and called upon leading librarians for advice. They consulted Justin Winsor, the librarian who had overseen the construction of the purpose-designed steel stacks of Gore Hall for Harvard University, and Melvil Dewey. The extent of their respective contributions is unclear, but a letter survives showing that Dewey approved the final designs by the architect, Frank Furness.[66]

Furness (1839–1912) was a local boy, born and raised in Philadelphia. He trained under Richard Morris Hunt, the first native-born American to study at the École des Beaux-Arts in Paris.[67] Furness's architecture was a robust and eccentric mixture of the Gothic revival with railway-inspired ironwork, built in a mixture of materials, but predominantly red brick and terracotta. Stylistically, the result is unique. The library that Furness and his librarian consultants devised was designed to cope with a very specific problem: expansion. Although it could be assumed that the number of readers might remain

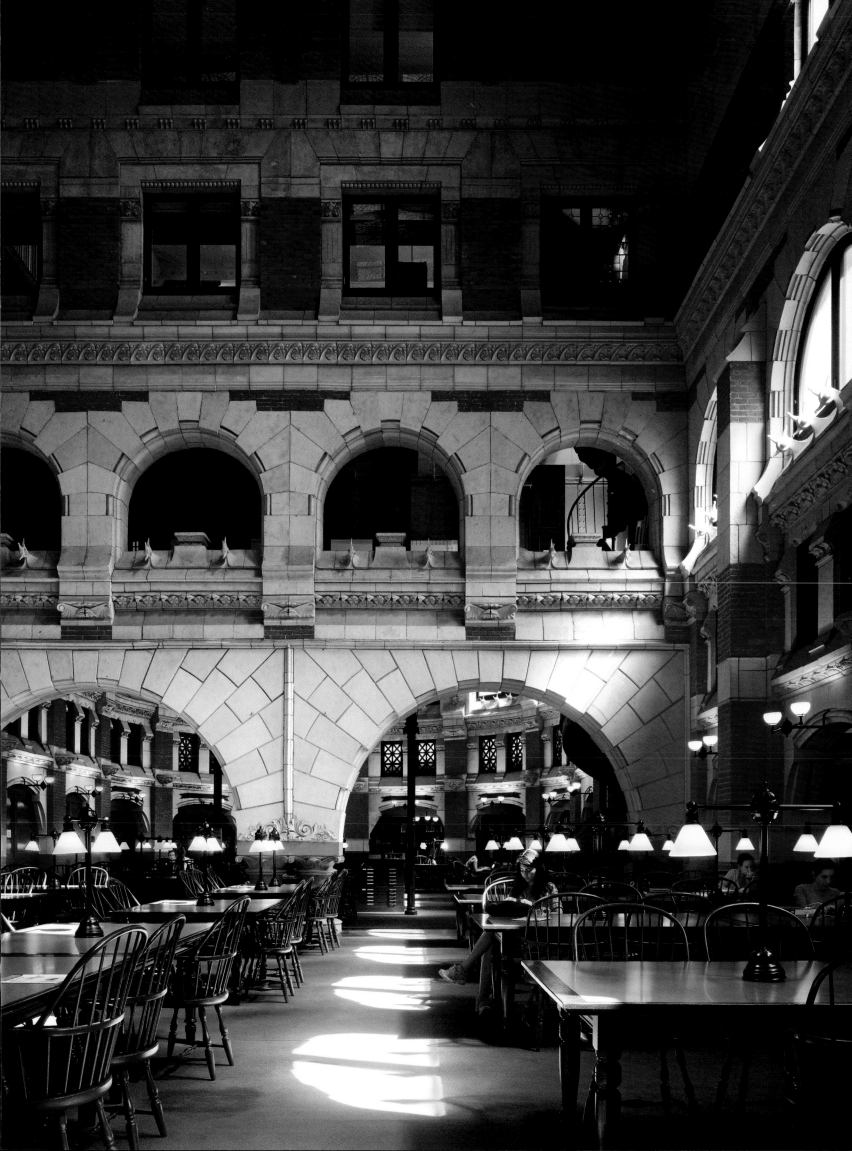

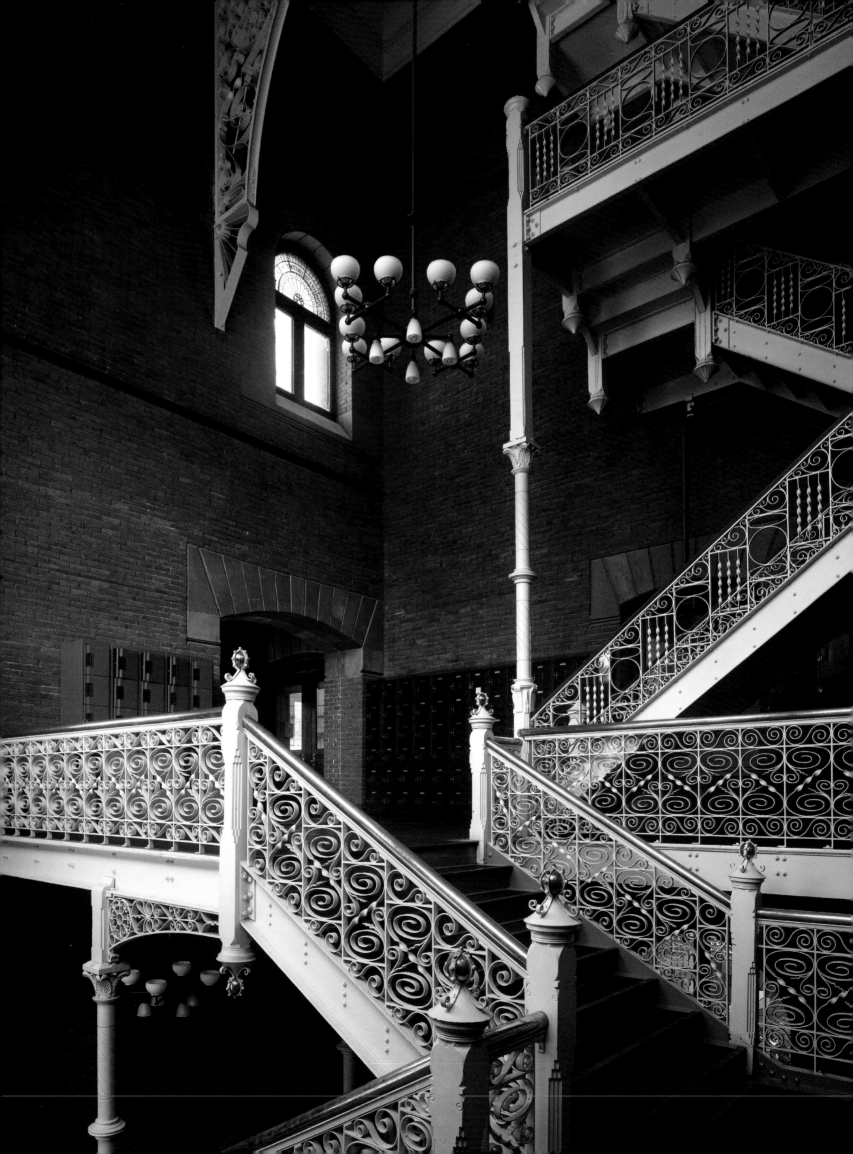

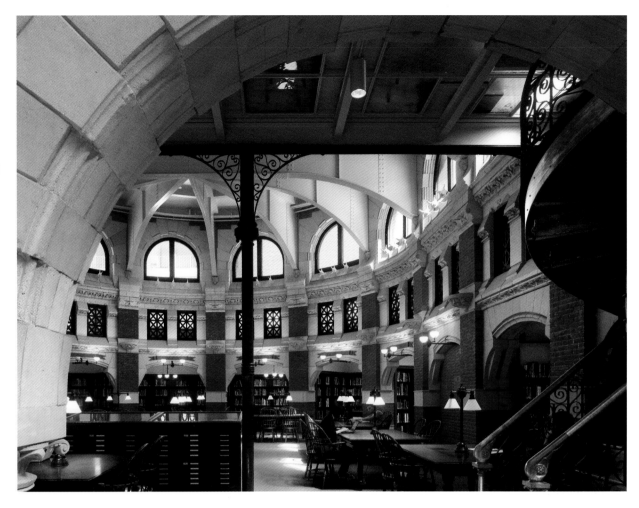

roughly the same, it was clear that the number of
books was going to increase indefinitely. To solve
this, the stacks were placed to one side, in a four-
storey shed with sloping copper roofs and red-brick
arches, strongly reminiscent of a railway station or a
cathedral nave. Only three bays were built initially, but
the building was designed to be extensible, allowing
the library to add extra bays until it reached the edge
of the site 150 m (nearly 500 ft) away, providing a
possible capacity of millions of volumes, which would
have served the university for over a century at least.
It was no doubt this incredible expandability that
prompted much of the praise from the librarians.

Legacy and taste

Despite its initial positive reception, Furness's building
was not extended as intended. The reason was not
practical but aesthetic: his architecture went out of
fashion in the 20th century. His strident and eccentric
style was at odds not with Modernism, as one might
expect, but with the collegiate Gothic in which the
rest of the university was subsequently constructed.
In 1948 serious discussions were held about
demolishing Furness's library and building a new
one on the same site. In the end, a new library was
built, but elsewhere, and Furness's building was
relegated to being the Library of Fine Arts and home

of the architecture school. It was only in 1957, when
Frank Lloyd Wright visited the library and declared
it 'the work of an artist' that it began again to be
appreciated, although no action was taken. Various
unsympathetic additions and alterations had already
been carried out. Tastes change and Furness's *oeuvre*
underwent a major reappraisal in the 1980s, by which
time most of his works had already been demolished.
He was hailed as a forgotten genius and the library
was restored to much of its former appearance.[68]

What is interesting about the story of the Fisher
Fine Arts Library is that the abandoning of its
intended development was the result of criticism not
from librarians but from architects and the public,
for whom its architectural forms were out of step
with later tastes. Functionally, the building seems to
have worked admirably and its extensibility should
have ensured that it continued to do so well into the
20th century. Taste masquerading as functionalism
might be said to be a theme underlying much of
the most influential architecture of the 19th century.
Ironically, much the same could be said of the 20th
century, a period that liked to think of itself as coolly
rational, but in architecture in general, and library
design in particular, turned out, initially at least, to
be as wedded to the whims of fashion and historical
precedent as the centuries that came before it.

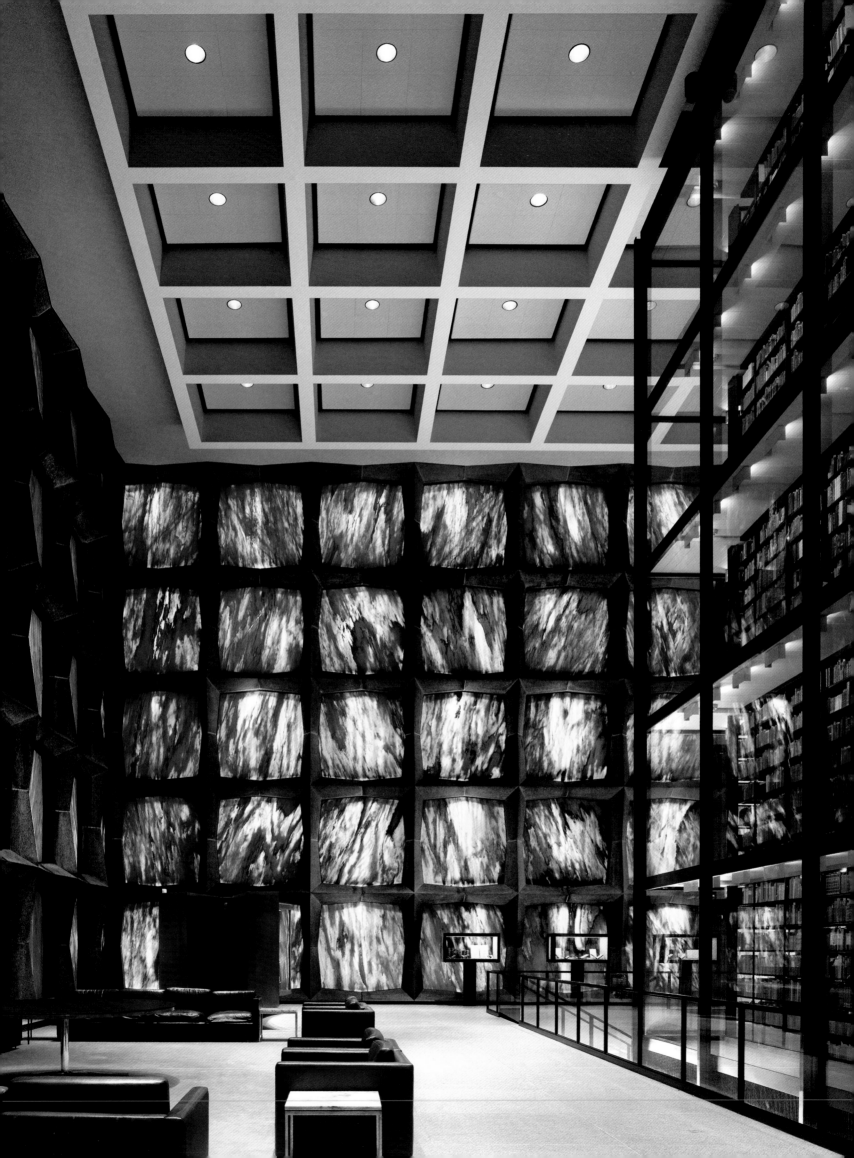

Electricity, Concrete and Steel
Libraries in the 20th Century

When the architectural historian Nikolaus Pevsner wrote his seminal essay on the history of library design, published in 1976, he could find little to say about 20th-century libraries.[1] He illustrated just five buildings, only one of which would still be considered a great library today. He completely failed to mention any buildings by Gunnar Asplund, Jože Plečnik, Hans Scharoun or Louis Kahn. Writing in the 21st century, however, the problem is more what to leave out than what to put in. The 1970s saw an explosion in library design, especially in the United States. Part of Pevsner's problem may have been that libraries did not seem to obey the rules of 20th-century architectural history written from a Modernist point of view, as promoted by him. It is easy to assume that the 20th century was dominated by Modernism of the sort exemplified by the Bauhaus and Le Corbusier. In fact, the first half of the century was dominated by other developments, no less interesting, but all too often ignored in the haste to explain later events. The tendency to see early-20th-century architects as 'proto-Modernists' should be resisted. The designers in architectural styles such as the Arts and Crafts and Art Deco had their own preoccupations.

Arts and Crafts

The period leading up to the First World War was one of great architectural debate, but this does not seem to have been reflected in library design. Two themes predominated, both of which were rather conservative. The first was the Arts and Crafts. As discussed in the previous chapter, in Britain and the United States, small-town libraries increased, thanks to finance from Carnegie grants that were not available to other European countries.[2] In the United States (and to a lesser extent in Britain) these libraries were often homely in feel. Richardson had established an architectural style for libraries, based on Romanesque churches and Oxford and Cambridge college libraries, which was widely copied.[3] In Britain, Arts and Crafts libraries could be found, but monumental classicism predominated, with Dutch-inspired brick Modernism appearing between the wars.[4] Charles Rennie Mackintosh's library for the Glasgow School of Art is a particularly notable and original interpretation of Arts and Crafts, mixed with ideas from Art Nouveau.

The Glasgow School of Art

Charles Rennie Mackintosh (1868–1928) began his association with the Glasgow School of Art in 1883, when he took evening classes in architecture in the rooms occupied by the school in the city art gallery.[5] These premises were entirely inadequate, and in 1895 funds were finally raised to construct a new building. A limited competition was held, with eight local firms asked to submit designs. The winning

firm was Honeyman and Keppie, where Mackintosh had been working since 1888.[6] Mackintosh had been a prize-winning student in the architecture school and throughout his working life he sketched, drawing inspiration from plants, Gothic buildings and Scottish tower houses. He was more interested in nature and vernacular building than classical architecture and his idiosyncratic drawing style is instantly recognizable. The drawings for the competition designs are undoubtedly in his hand and the building was constructed under his direction.[7]

Because of limitations in the funding that was initially available, the new Glasgow School of Art had to be designed in two phases. Work began in 1897 but the second phase, containing the library, was not completed until 1909. The library is two storeys high and square on plan, with a gallery running around all four sides. The whole interior is panelled and fitted out in dark-stained wood. The columns that appear to support the gallery are pulled forward into the room. In fact, they conceal steel hangers, which descend from beams in the roof through three floors to support the library floor. This is not appreciable from within, where the lamps, balustrades, bookcases, chairs and tables provide a remarkably unified interior, bathed in light from large windows down one side. At the opening, Sir John Stirling Maxwell praised Mackintosh for demonstrating that 'it was possible to have a good building without plastering it all over with the traditional, expensive and, often, ugly ornament'.[8] Claims that the building inspired early

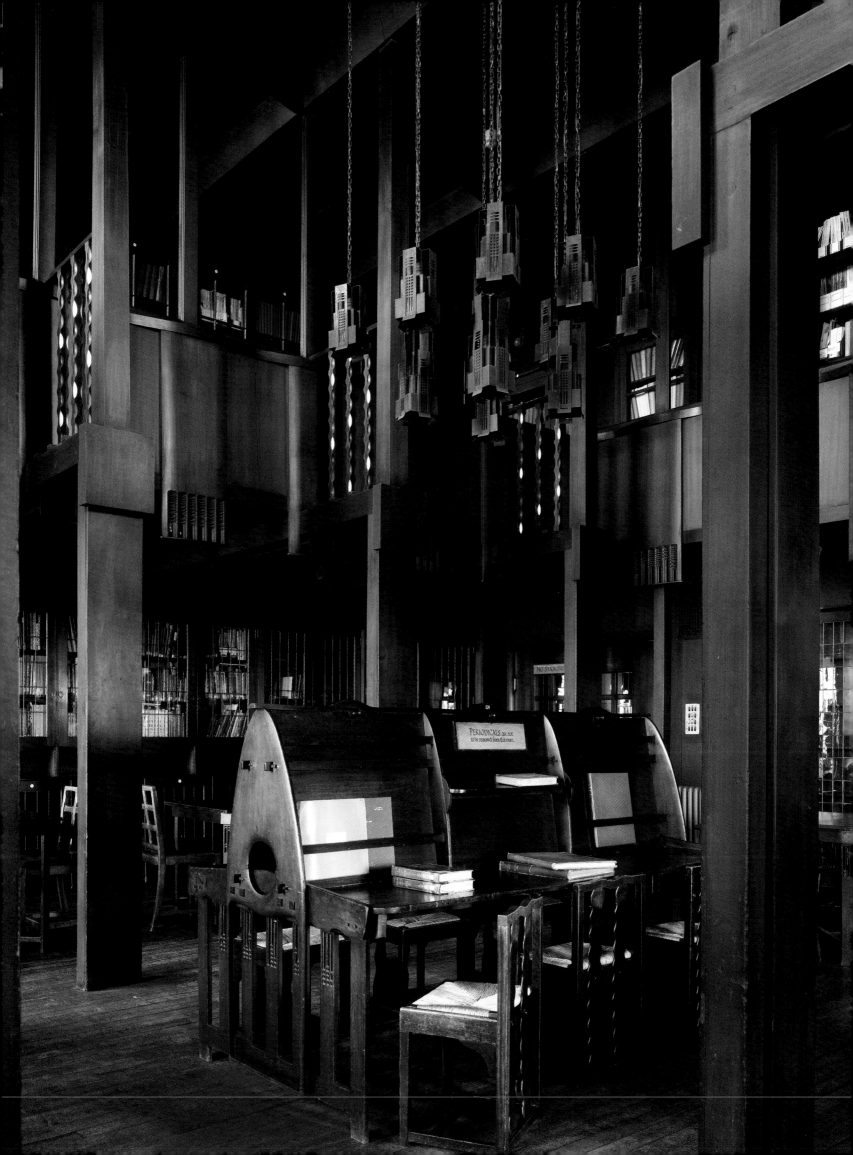

Modernist architects in the Netherlands, Germany and Scandinavia are possibly exaggerated. The School of Art is well-known today but it was hardly mentioned in the architectural press at the time. No photographs of it were published until 1924 and the first plans were not published until 1950.[9]

Arts and Crafts and Art Nouveau were not universal. Classicism still dominated for larger structures, where it was felt to carry the appropriate weight and dignity. There is no doubt that benefactors both major and minor liked the monumental aspects of classical design. Boston Public Library had been completed in 1895 and the Library of Congress in 1897. The grandest classical library constructed at the beginning of the new century, however, was the New York Public Library.

The New York Public Library

In the 19th century, New York City boasted two sizeable libraries: the Astor Library (discussed in the previous chapter) and the Lenox Library. By 1892 both were in financial difficulties, caused by dwindling endowments and increases in book numbers. The opportunity for change came with a large bequest by Samuel J. Tilden to establish and maintain a free library and reading room in the city of New York. A plan was devised to use the funds to combine the two existing collections and house them in a brand new building, which would be capable of future expansion.[10] Once this course of action was agreed, the trustees set out to appoint a librarian. They chose Dr John Shaw Billings (1838–1913), a military surgeon who had reorganized the library of the Surgeon General's Office and created the *Index Medicus*, a comprehensive index of medical journals that enabled practitioners and researchers to keep up with the latest research. It was Billings who devised the layout of the library.[11]

His scheme combines old and new thinking. The innovation was placing the reading room on top of the stacks. From a librarian's point of view, this was ideal. The books were moved using electric lifts and conveyors directly from the stacks to the desks in the reading room. Books came in and were unpacked and catalogued at the lowest level and then shelved above.[12] The thinking behind this layout was similar

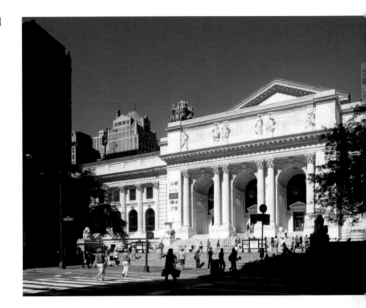

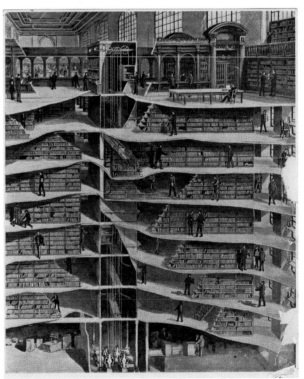

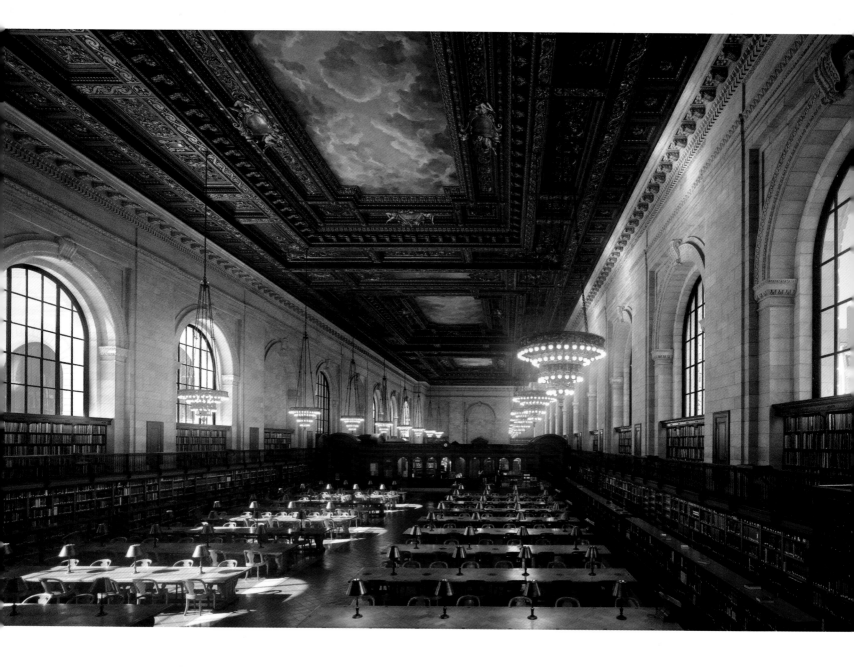

to the time and motion studies that were to become
very popular in the first decades of the 20th century.
The library was perceived as a machine for the
efficient storage, retrieval and reshelving of books.
The reading room was placed on the top of the
building because its ceiling could be high and it
could have large windows to let in as much light
as possible.

Only once the layout had been agreed was the
architect appointed. This was done by competition,
with entries from all the largest firms in New York,
although the winning design was by a then little-known
practice, Carrère and Hastings. The cornerstone was
laid in May 1902, the roof was complete by 1906 and
the building finally opened on 23 May 1911. It already
had one million books and boasted 120 km (75 mi.)
of shelving.[15] It was claimed at the time that the main
reading room was the largest of its kind in the world at
23.8 m wide by 90.5 m long (78 x 297 ft), with ceilings
15.5 m (51 ft 2 in.) high. Numerous subsidiary reading

rooms were provided for specialist collections.[14] The
reason why libraries typically placed reading rooms
next to, and not on top of, the stacks was that to do so
lifted the reading room unnecessarily high in the air.
When the doors of the New York Public Library open,
the readers have to climb huge sets of staircases and
pass through a series of grand marble-lined halls to
reach the reading rooms above.

The style of the building is conservative and
classical. Its exterior is marble, and the walls load-
bearing, but internally the book stacks and floors
are steel-framed and self-supporting. Mild steel was
gradually replacing iron as a construction material.
In the early part of the 19th century, buildings such
as Henri Labrouste's Bibliothèque Sainte-Geneviève in
Paris had used iron rather than timber and masonry
because it was considered fireproof. Although it is true
that iron is not flammable, its loss of strength in fires
leads to failure, and a series of disastrous fires in
the mid-19th century led to the growing realization

that iron or steel frames needed to be clad in cement,
stone or brick to insulate them from fire.[15] Steel was
not the only new technology employed at the New York
Public Library. It was reliant on another: electricity.

Electricity in libraries

In 1911 horses were still a common sight on city
streets but gaslight had been used in libraries for
almost a hundred years. Gas was far from perfect.
It created fumes and heat, which collected at the
tops of buildings and damaged the books. It also
posed the constant risk of fire. Thomas Edison's

patent for his incandescent light in 1880 and, on
the other side of the Atlantic, Joseph Swan's patent
in the same year, are well-known.[16] The library of
the Literary and Philosophical Society in Westgate,
Newcastle upon Tyne, was the first public room to be
lit by incandescent electric light when Swan gave a
demonstration there on 20 October 1880.[17] However,
there is a tendency to forget the existence of electric
arc lighting, which had been invented over seventy
years earlier.[18] The British Museum Library and the
Liverpool Public Library installed electric arc lights in
1879.[19] The principal obstacle was the lack of electrical

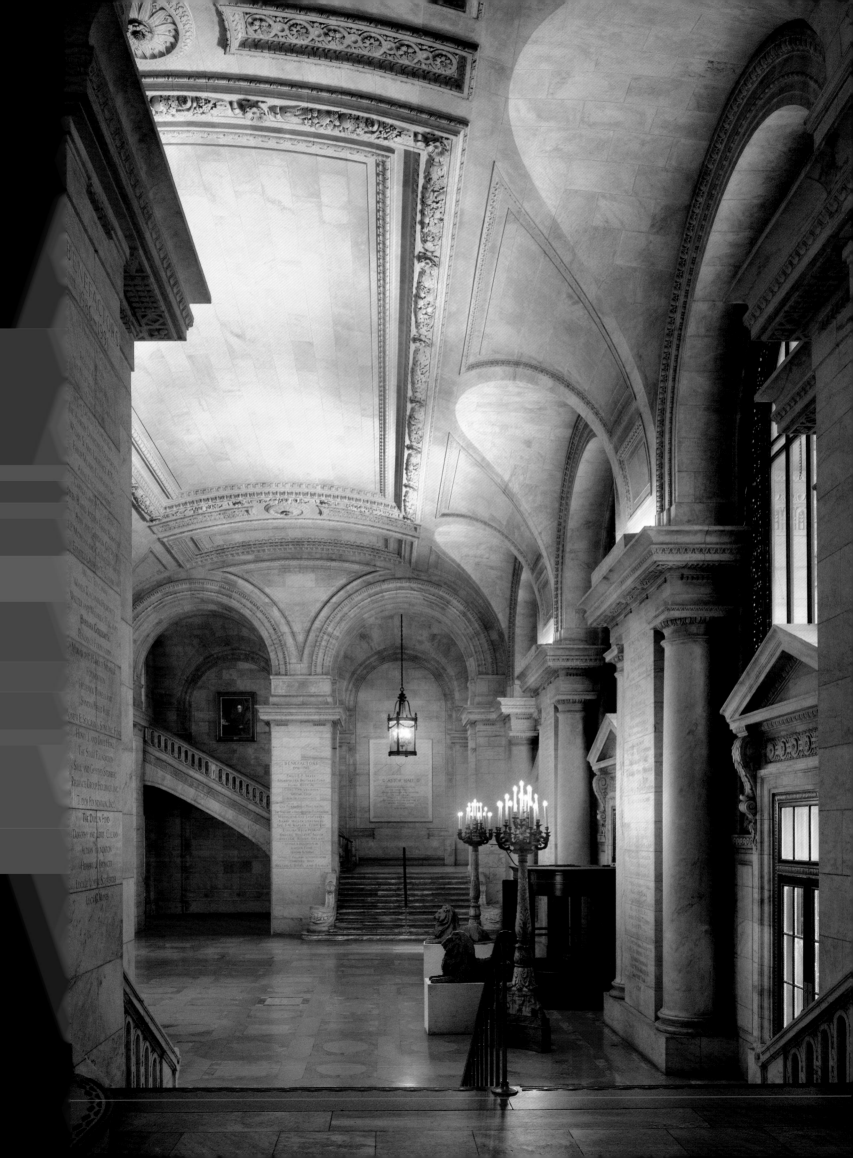

supplies in most cities. The British Museum Library initially generated its own power. However, the 1880s saw an extraordinary spread of electrical generation and supply. Power stations were built across the United States and Europe, leading to the wider adoption of electric light.[20]

Lighting design remained unscientific. It was not until 1908 the first technical papers were published detailing methods of predicting and calculating lighting levels on a surface. Even then, architects were very slow to respond. Through the early part of the century lighting was generally a matter of trial and error. Physical models helped to predict daylighting, but artificial lighting had to be mocked up when the rooms were completed.[21] The lack of cheap and safe artificial lighting had an effect on many buildings, not just libraries. For instance, in the 19th-century, schools in northern Europe had high ceilings and huge windows to ensure adequate lighting on dull days.[22] As a result, they were cold and draughty. When better artificial lighting became available, ceilings were lowered and window sizes decreased. Libraries underwent a similar development, but lighting was first introduced not to make it easier to read but to extend opening hours. Some small public libraries opened in the evenings because their patrons were at work during the day, so artificial lighting had always been an important consideration.[23] Many library interiors and most bookstacks would be completely impossible to use without artificial light. The Osaka Library in Japan is a good example.

The Osaka Library
Outwardly, the Osaka Library, later named the Osaka Prefectural Nakanoshima Library, looks like a Western library. The Western colonial powers would build such libraries all over the world. Japan is particularly interesting because it was never colonized: its Westernization was self-imposed. From the 17th century until the middle of the 19th century the country had limited political contact with the rest of the world. This began to change with the growing awareness in Japan that it was hopelessly behind the West in technology and military power. From the late 1860s onwards, it set about industrializing, and sent fact-finding missions across the world.

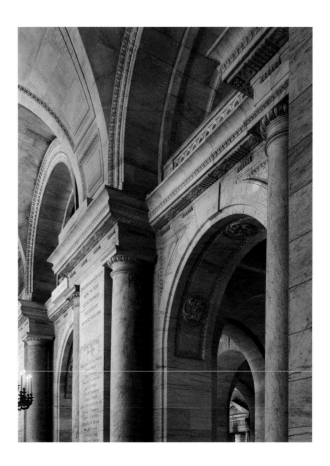

In 1872 there were 29 km (18 mi.) of railway in Japan. By 1914 there were more than 11,200 km (7,000 mi.). Every part of Western society was studied and ruthlessly copied. This extended to education, modes of dress, the public library system and even Western architectural styles.

The Osaka Library is an interesting survival from a period of architecture that has since gone out of fashion and is largely ignored in Japan. The library, which opened in 1904, functioned exactly like a Western public library but its collection was Japanese. The visitor entered through the classical portico into a grand circular entrance hall, which so lacked adequate windows that it was always artificially lit, even in the middle of the day. The library reading rooms were ranged on two floors on ether side, with a basement providing service access and circulation for the staff. The books were stored in a series of steel stacks at the back. The plan is strongly reminiscent of 19th-century German public libraries, such as the

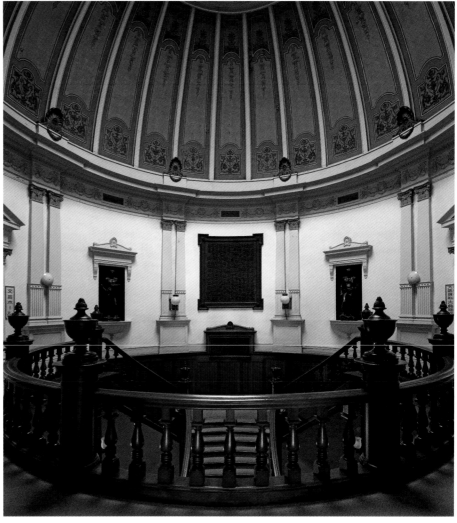

left and above
OSAKA LIBRARY, 1904
Osaka, Japan

Nothing on the library's exterior (left) betrays its Japanese location. Its architecture is typical of buildings constructed during the Meiji period, when Japan looked to Europe for inspiration. The library was paid for by the Sumitomo family, of which the designers, the architect–engineers Noguchi Magoichi and Hidaka Yutaka, were members. The main building was completed in 1904. It then consisted of the central dome and portico with a rectangular wing containing a single reading room on each floor on either side. The end wings at right angles to these were added in 1922. A round, domed vestibule (above) contains the staircase to the first floor. The library was artificially lit from the outset: the vestibule's sole, and rather inadequate, natural light comes from the oculus in the top of the dome.

THE RUSSIAN STATE LIBRARY, 1945
Moscow, Russia

Although the architects Vladimir Shchuko and Vladimir Gelfreikh were commissioned to prepare designs in 1927, the library did not move into its present building until the middle of the 20th century. Building began in 1930 and continued sporadically for the next fifteen years. The design is a modernized version of classicism. A long stairway ascends to the catalogue room (below), filled with an enormous card catalogue. In the main reading room (opposite) readers sit under the watchful gaze of a huge statue of Comrade Lenin, a reminder of the power of the state.

Frankfurt Stadtbibliothek, which probably provided the inspiration.[24]

Classicism was not unchanging. New materials and new technology provided new possibilities and architects were continually searching for new ways of using and developing its forms. In Paris and the United States the 1920s and 1930s saw the development of Art Deco. In Britain, Charles Holden (1875–1960) designed monumental classical buildings, including the University of London's Senate House and library.[25] In Moscow, the Russian State Library was designed by Vladimir Shchuko and Vladimir Gelfreikh in 1927–9 and constructed between 1930 and

1941 in a modernized Neoclassicism.[26] Perhaps the most interesting developments were taking place in Scandinavia, in the works of such architects as Sigurd Lewerentz, Gunnar Asplund and Alvar Aalto.

Stockholm City Library
In 1918, following a series of generous bequests, the City of Stockholm library committee engaged Asplund (1885–1940) to travel to Germany, England and the United States to look at libraries and draw up a brief for an architectural competition. His report so impressed the committee that they decided to dispense with the competition and simply appoint him to design

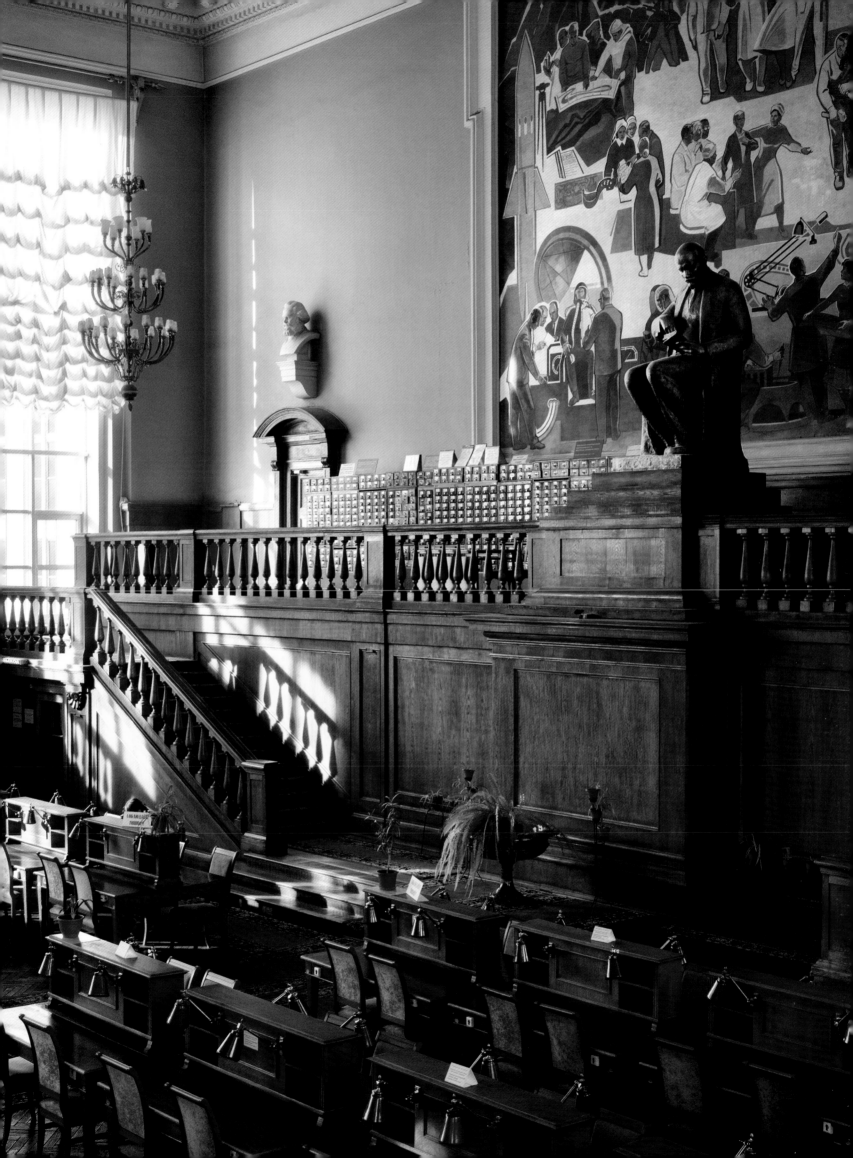

the library.[27] Some parts of the final scheme were established early on in the design process. The plan was always square, with a central rotunda. On his travels Asplund had seen many libraries with central halls and side reading rooms, a common arrangement in 19th-century Germany that had been copied in Albert Kahn's Minnesota and Michigan university libraries.[28] Asplund would presumably also have seen the Library of Congress and the British Museum's round reading room. Initially, his plans included a domed central room, but the most significant part of his rotunda design was influenced not by other round libraries but by Boullée's Bibliothèque Nationale scheme and its stepped galleries. Asplund wrapped such galleries around the walls of his central room, although their stepped section goes largely unnoticed.

The design went through a number of iterations. The first scheme included a dome with a thick shell. This would have been dramatic but not very practical, and once lighting began to be taken into account

Asplund changed the dome to a drum with clerestory windows, giving an even light.[29] The great height of the drum gives the library prominence in the city. It also leads to the most striking part of the internal design: the large expanse of blank wall between the top of the bookcases and the windows. This drum externally bears a striking resemblance to a number of projects by the French Neoclassical architect Claude Nicolas Ledoux (1736–1806), most notably his Barrière de la Villette, one of a series of customs houses designed for the city of Paris in the 1780s, in which a circular drum rises out of a square base.[30] But whereas Ledoux's architecture is ornamented externally, Asplund's almost shockingly austere drum is covered in plain render and has a simple stone cornice.

The reader enters through huge doors, which originally had handles in the form of Adam and of Eve, each offering the apple of wisdom. The black stone walls of the entrance hall have scenes from Homer's *Iliad* carved in relief.[31] A straight flight of stairs then

above and opposite
**STOCKHOLM CITY LIBRARY, 1928
Stockholm, Sweden**

Gunnar Asplund was initially asked in 1918 simply to provide the brief for the competition to design a new library, but he so impressed the committee that they gave him the commission. A lengthy design process followed. The library's defining feature is its tall drum with large clerestory windows, which solved the problem of lighting the central space. This dominates the park that provides one of the approaches to the library (above) and was also designed by Asplund. The main entrance is from the road, up a flight of stairs on the outside to a tall entrance hall (opposite), from which stairs rise straight into the middle of the drum.

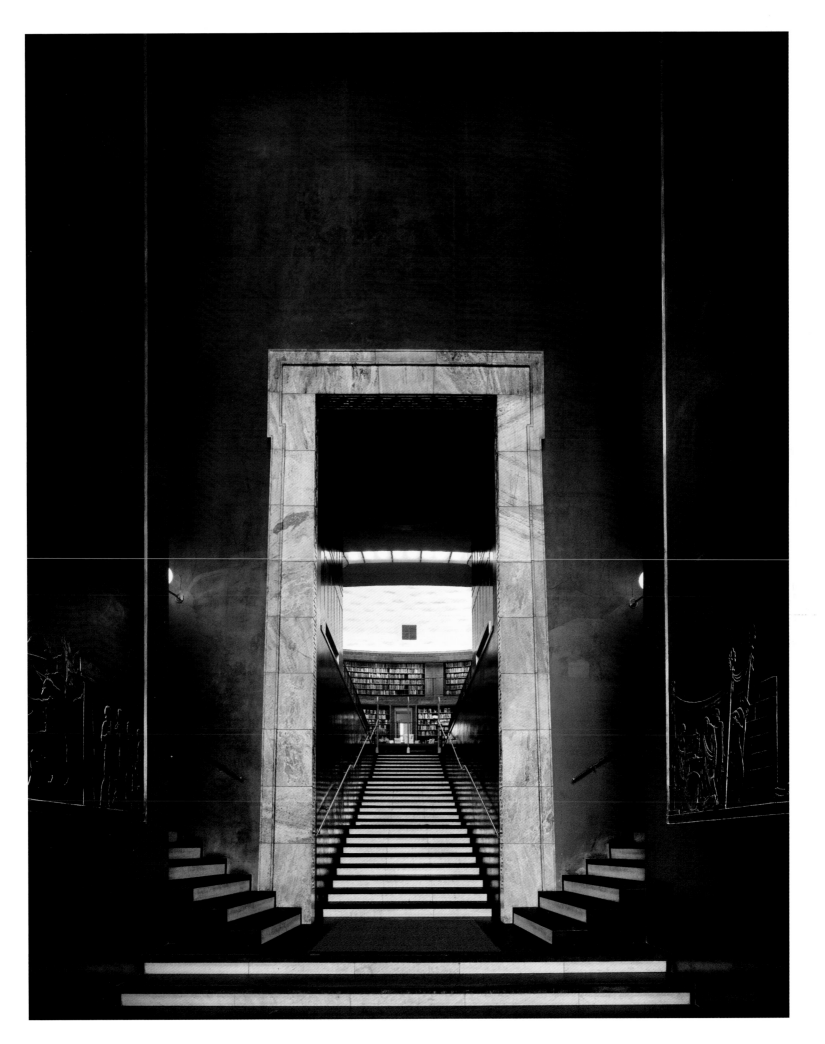

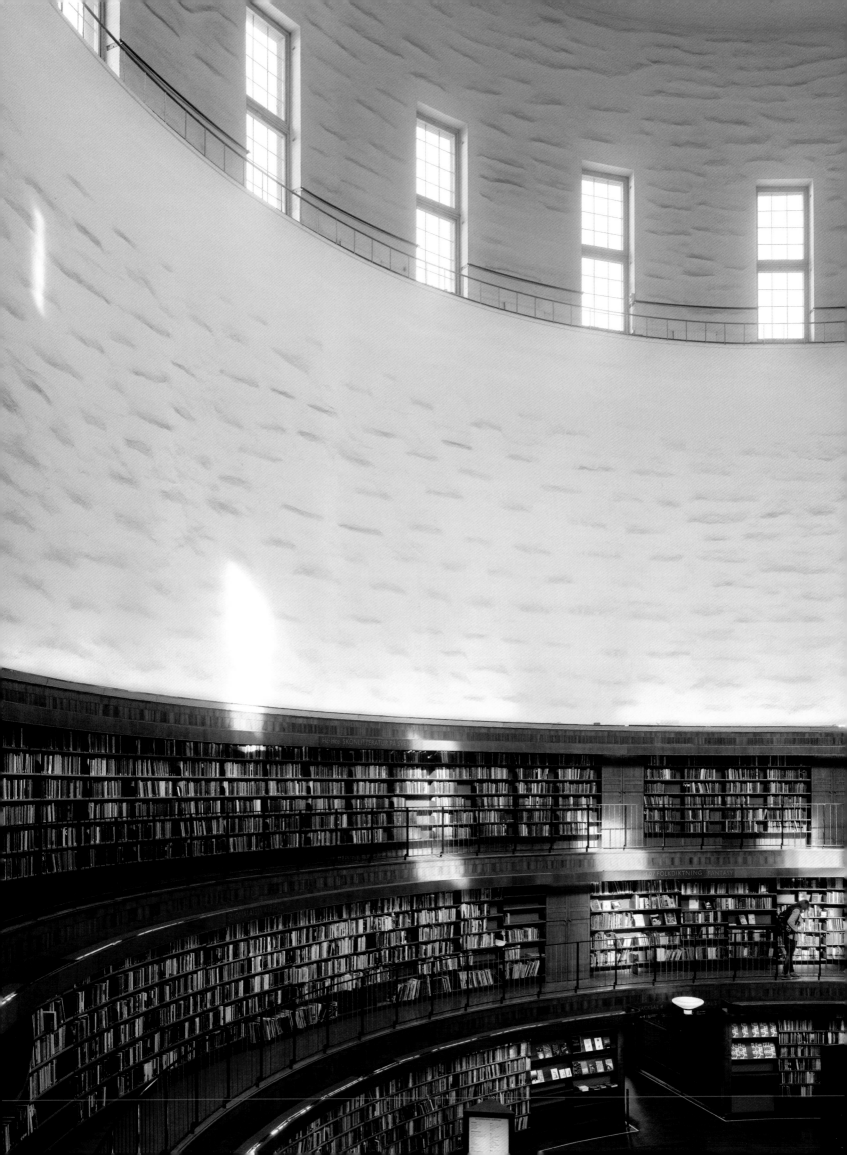

right and opposite
STOCKHOLM CITY LIBRARY, 1928
Stockholm, Sweden

The most surprising feature of the central drum is the large expanse of empty wall on the inside between the top of the bookcases and the clerestory windows (opposite). These white walls help to reflect light down into the space, but they also reveal how the drum was deliberately extended vertically to increase its prominence externally. The library's decoration is discreet. The walls of the entrance hall (right and previous page), for instance, have low reliefs of scenes from the Iliad, *which are easily missed by those walking past them on the way to the reading rooms above.*

takes the reader up into the centre of the rotunda, which acts more as a reception area than a reading room. Great care is taken over seemingly insignificant details such as lamps, water fountains, door handles and handrails. Each is classically inspired, but none is truly classical.

The Stockholm library still looks modern and must have been provocative when it was completed in 1928. By then, however, Asplund had begun to experiment with Modernist architecture, and the library is the last of his Nordic classicist buildings.[32] His Modernist buildings retained some of the features of his early work but are rather dull by comparison. The City Library is his masterpiece and it had a lasting influence on library design.

The National Library of Slovenia

The second outstanding library of the interwar period remained relatively unknown outside Slovenia until the fall of the Iron Curtain. Like the Stockholm City Library, the National Library of Slovenia by Jože Plečnik (1872–1957) is classical in character but with a modern twist. Plečnik regarded the commission for the library as just one of a number of connected projects in the centre of Ljubljana.[33] The exterior is a peculiar mix of stone (some of it from buildings that formerly occupied the site) and red brick. The library is entered off Turjaška Street through a dramatic bronze door, which leads into a small vestibule. A cloakroom on one side allows for the removal of coats in winter, before the visitor returns to the hallway and ascends the grand marble staircase. This straight stair rising through the centre of the building is reminiscent of the great stair in the centre of the Bayerische Staatsbibliothek in Munich (completed 1843, destroyed in 1943–5 and later partially reconstructed), designed by Friedrich von Gärtner. Its similarities to the dark staircase in Asplund's Stockholm City Library are also obvious. Plečnik believed strongly in the symbolic power of architecture and meant the reader to perceive the ascent as a rise from the darkness of ignorance towards the light of learning, represented by the reading room beyond. This spans the complete width of the building from east to west, with full-height windows at both ends. Further windows set high in the south wall ensure an even light throughout the space. Most of the books are kept in stacks and are ordered at the desk. The readers sit surrounded by cupboards, with reference works available on open shelves in the gallery above. The panelling, galleries

below and opposite
THE NATIONAL LIBRARY OF SLOVENIA, 1941
Ljubljana, Slovenia

Designed by Jože Plečnik, the library offers a deliberate challenge to the Modernist rejection of ornament. The main façade (below left) was inspired by the Palazzo Zuccari in Florence, designed by the Mannerist architect Federico Zuccari in 1579, which combines fine ashlar with large fragments of rough stone and archaeological remains. Plečnik's façade incorporates fragments of stone from the medieval ruins on the site. The huge window on the right is one of the end windows of the reading room. Internally, the decoration is classically inspired, as seen in the entrance to the exhibition room above the main entrance (below right). The main reading room (opposite) extends the entire width of the site. It is lit from both ends and by high clerestory windows in the middle. Its furniture was entirely designed by Plečnik. The tables are supported on tapering marble columns and the electric lamps are on swivelling arms. The railings on the steel galleries are made from gas pipes. The left gallery is reached by steel stairs from behind the librarian's desk in the centre of the room. The bridges crossing the space provide access to the galleries on the right.

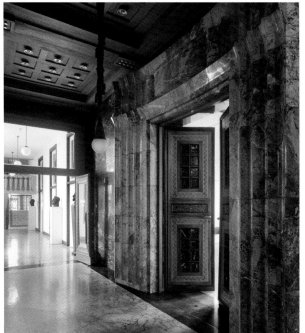

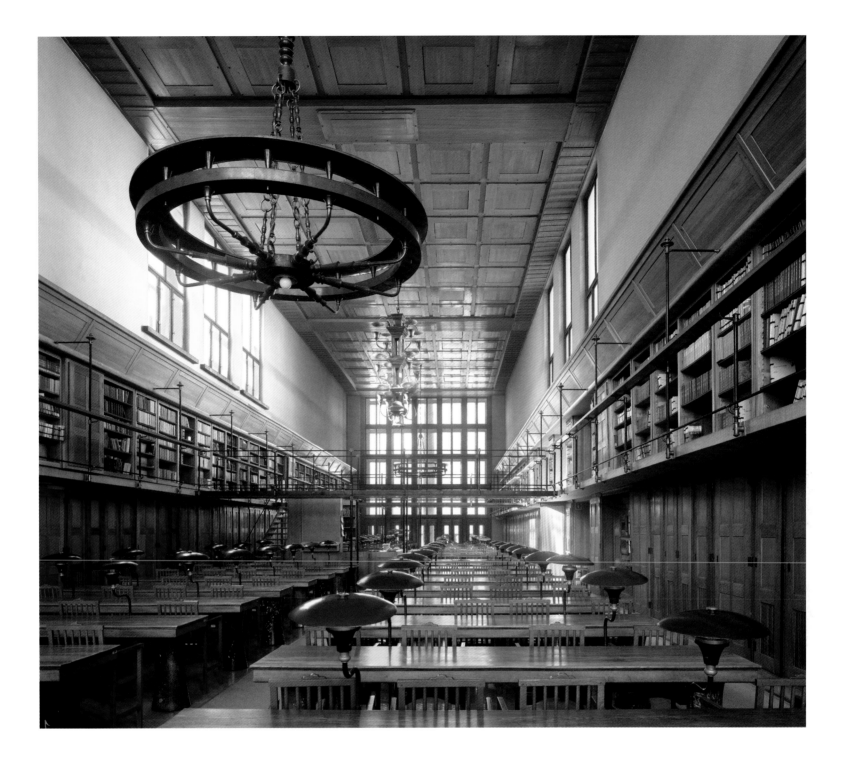

and finishes are Arts and Crafts in inspiration. Work
on the library began in 1934 and it was opened in 1941,
but a German aircraft crashed into the reading room
in 1944, closing it again until 1947.

Modernism takes over

The Modern Movement had been growing steadily
since the end of the First World War, but it took a
generation for it to become mainstream and attract
major commissions. It was not until 1945 that
Modernism became firmly established, and the post-
war period offered plenty of opportunities for architects
to demonstrate its advantages. It is not possible to do
justice here to the full range of libraries built after the

Second World War. It is true that not all were successful
in the long term. Thin, uninsulated concrete walls,
large expanses of glass and flat roofs led to problems
with heating and maintenance. Librarians had long
complained that library interiors were inflexible and
one solution was to provide them with huge areas
of undifferentiated floor space, which they could
furnish as they wished and adapt to changing needs.
The results often turned out not to be as flexible as
promised. But it would be wrong to assume that all
post-war libraries were like this. Many were highly
successful. Some, such as the Beinecke Rare Book and
Manuscript Library at Yale University, managed to be
functional and aesthetically powerful at the same time.

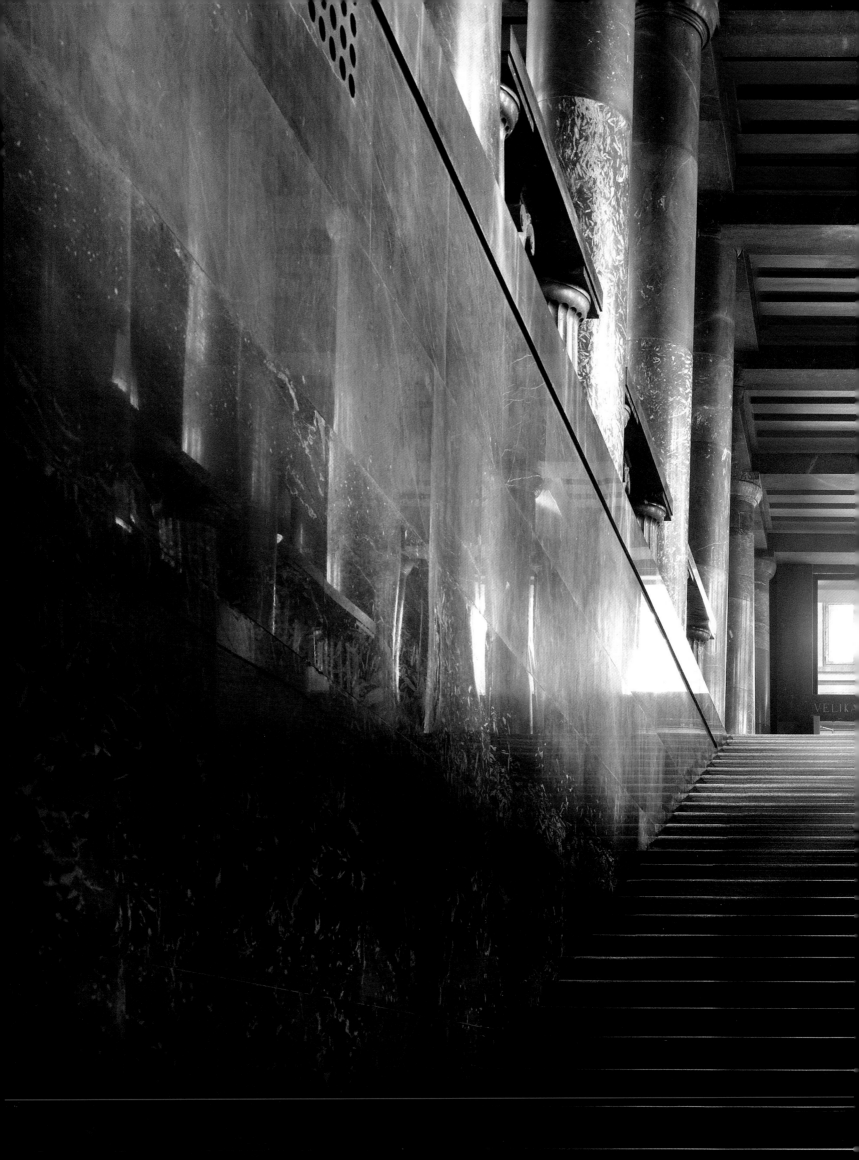

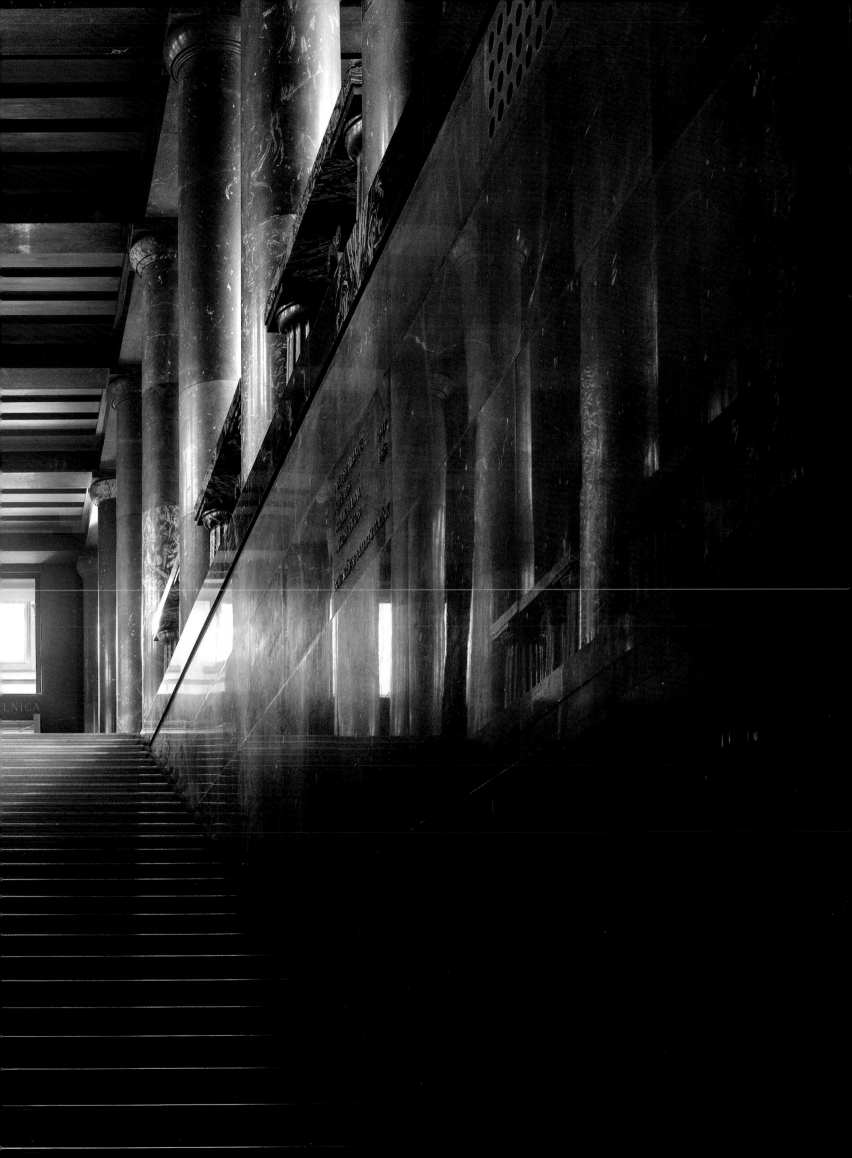

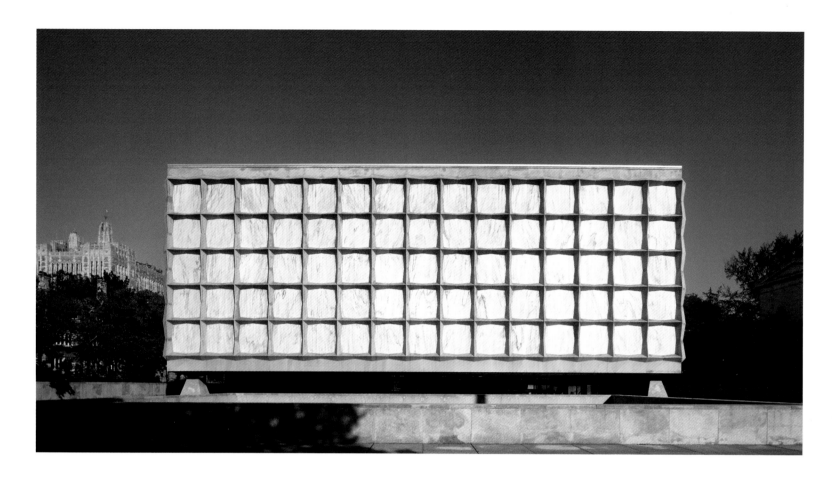

The Beinecke Rare Book and Manuscript Library
The story of how Gordon Bunshaft (1909–1990) got the job of designing the Beinecke Library (built 1960–3) provides a useful insight into the shortcomings of competitions. When Paul Rudolph, the dean of the Yale School of Architecture in New Haven, Connecticut, was attempting to persuade the university provost to hold a competition to design a new library, he rang Bunshaft to ask if he would enter. To his surprise, Bunshaft declined, explaining that he disliked competitions because the entrants had to work to a fixed brief and were never allowed to talk to the clients or end-users. If they won the competition they usually found that the brief they had been asked to work to was flawed, but they were then forced to continue with it to avoid complaints from the losing competitors. In Bunshaft's view, competitions were costly for the architect to enter and produced substandard buildings. With Rudolph's permission, Bunshaft asked to be allowed to contact the Provost direct. He persuaded him to abandon the idea of a competition altogether and appoint an architect by interview. Various architects were asked to submit particulars and Bunshaft was selected.[34]

The brief that Bunshaft then worked out with the library staff was simple. There needed to be sealed stacks, which in the New Haven climate had to be air conditioned to maintain constant temperature and humidity. He also had to provide exhibition spaces, reading spaces and offices. None of these

was particularly challenging. Bunshaft's final design was based on two key insights. The first was that the library stacks could themselves contribute to the display and become the focus of the exhibition space. Thus he saw that the space could be centred around a huge air-conditioned glass box, which provided a totally secure and sealed environment for the books. Second, he realized that, although the space needed to be lit, direct sunlight would damage the books. His solution was to place the glass box, and the exhibition space that surrounds it, inside a bigger box with translucent marble walls. On the outside, the marble appears entirely opaque but when the sun shines, the panels transmit a honey-coloured light to the interior that compliments the leather bindings of the books within. The result, executed with great skill, is a space of almost unimaginable power and simplicity.

Bunshaft later gave a remarkably revealing interview on his experiences in architecture in which he explained the choice of material for the Beinecke Library walls. He had seen what he took to be an onyx dome in a Renaissance-style palace in Istanbul. In fact, it was alabaster. He investigated and found that both onyx and alabaster had been used for windows. Told that alabaster would dissolve in the rain, he went looking for onyx. The subsequent search involved attempts to secure onyx from places as far afield as Algeria and Peru, but no one could produce it in large enough sizes. In the end, he used marble from

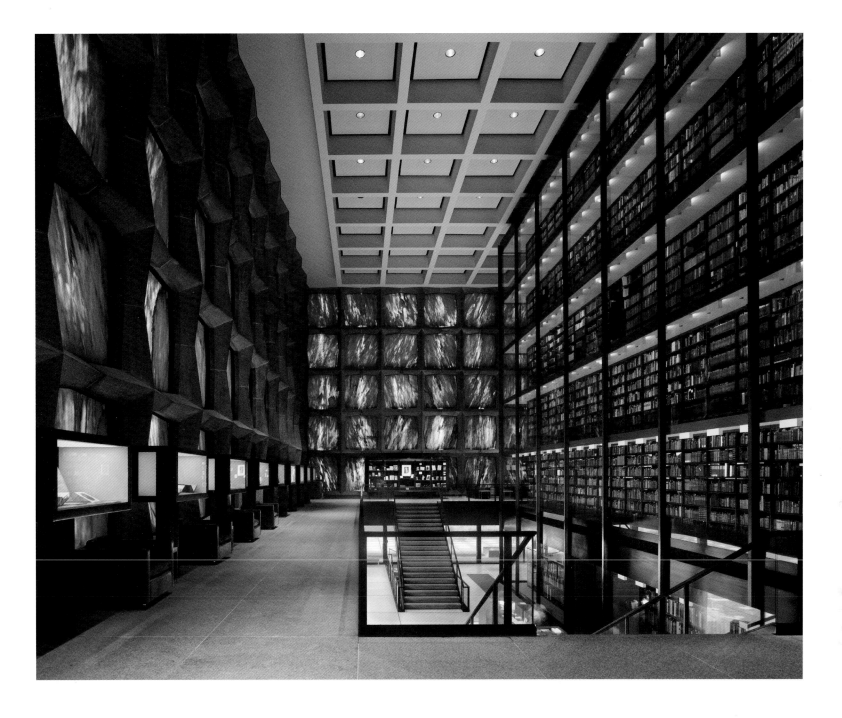

Vermont, which blended on the outside with the white
concrete supporting frame. The effect is extremely
successful but, surprisingly, Bunshaft still maintained
that he would have preferred to cover the entire
building in alabaster.[55] This story shows how architects
often begin with a vision in their heads without any
real understanding of how it is to be achieved. It is
also a demonstration that not all compromises are
necessarily detrimental to the end result.

It would be wrong to assume that the Beinecke
was a typical Modernist response to library design.
In fact, the Modernist emphasis on producing 'logical
solutions' to 'design problems' produced a wide
variety of layouts. Bunshaft's other work was rarely as
symmetrical as the Beinecke. In many of his buildings
he actively sought asymmetrical solutions. Functions
are rarely twinned and thus rarely symmetrical, so

asymmetry was partly a signalling of the architect's
desire to produce the most functional solution. Some
architects, such as Alvar Aalto, Hugo Häring and Hans
Scharoun, practised asymmetrical planning with an
almost religious zeal.

Aalto, Scharoun and free planning

The Finnish architect Alvar Aalto (1898–1976) designed
a series of libraries. His architecture is always highly
sensitive to brief and context and no two of his
projects are similar. However, a common feature
of many of his libraries is a sunken enclosure.[36] The
arrangement first appears in his 1927 design for the
library in Viipuri, then in Finland, but now in Russia
and known as Vyborg. The Viipuri municipal library
was completed in 1935. Here, readers ascend a short
flight to arrive at a lower library space surrounded by

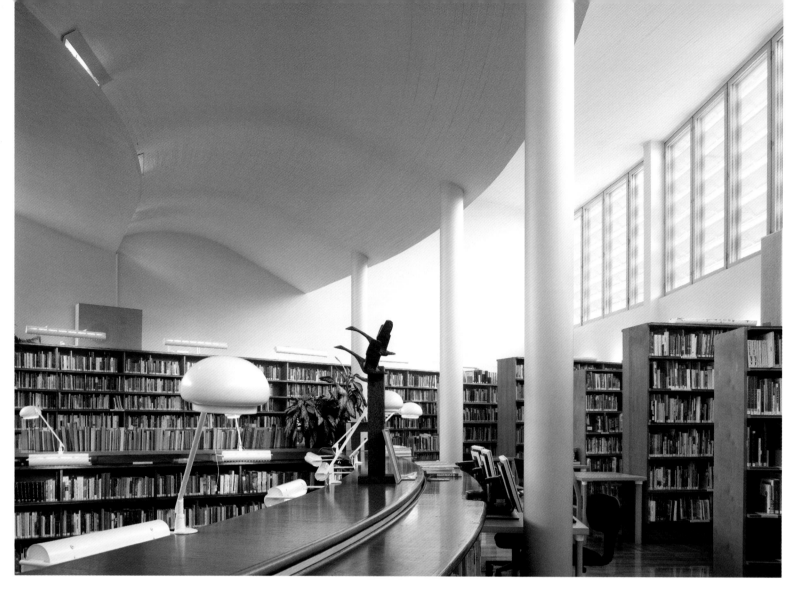

books. They then turn 180 degrees and go up a second
short flight to reach the main reading desk.[37] In his
library for the National Pensions Institute in Helsinki
the visitor enters a rectangular space in which the
centre is sunken to provide a reading desk surrounded
by full-height shelves, overlooked by a gallery at the
entrance level running around the space.[38] The same
device is used again in 1962 in the libraries for Aalto's
Wolfsburg Cultural Centre in Germany and civic
centre in Rovaniemi, Finland.[39] The characteristics of
these spaces are amply demonstrated in his public
lending library, completed in 1965, for the small town
of Seinäjoki in Finland.

The Seinäjoki public library
The library forms one side of the town square, which
is faced on all sides by other buildings designed by
Aalto.[40] It is a single-storey structure, with a basement
for storage and services. Readers enter up a short
flight of stairs that leads to a relatively narrow set
of doors, to be greeted by cloakroom racks and the
librarians' desk. The main area of the library is
comparatively small but Aalto made it look larger and
more spacious by sinking the centre of the space. The
floor of the sunken area is about 1 m (3 ft 3 in.) lower

right and opposite
**SEINÄJOKI PUBLIC
LIBRARY, 1965**
Seinäjoki, Finland

The library is part of a larger complex built around a square, consisting of a church, city hall, city offices, library and theatre, all designed by Alvar Aalto. The library is entered up a short ramp leading through a comparatively modest doorway (opposite below), enlivened by Aalto's door handles. The reader enters a space with a comparatively low ceiling before emerging into the main reading room (opposite). This is curved on plan with shelves at right angles to the walls forming a series of alcoves, lit by large windows above. The central area of the reading room is half a floor below the level of the main reading room, and is reached via a short flight of stairs beside the librarian's desk. A further short flight descends from here to the book storage in the basement. This lowered space is a feature of most of Aalto's library designs. Sitting here, the reader is surrounded by books, and enjoys a higher ceiling, giving the illusion of a larger space. Aalto also designed the desks (right), formed in triangular sections, each providing a separate, delineated workspace for a single reader. The desk's curving form follows that of the reading space. The library deliberately has no view out. Once inside, the reader is meant to be immersed in the books, free from the distractions of the outside world.

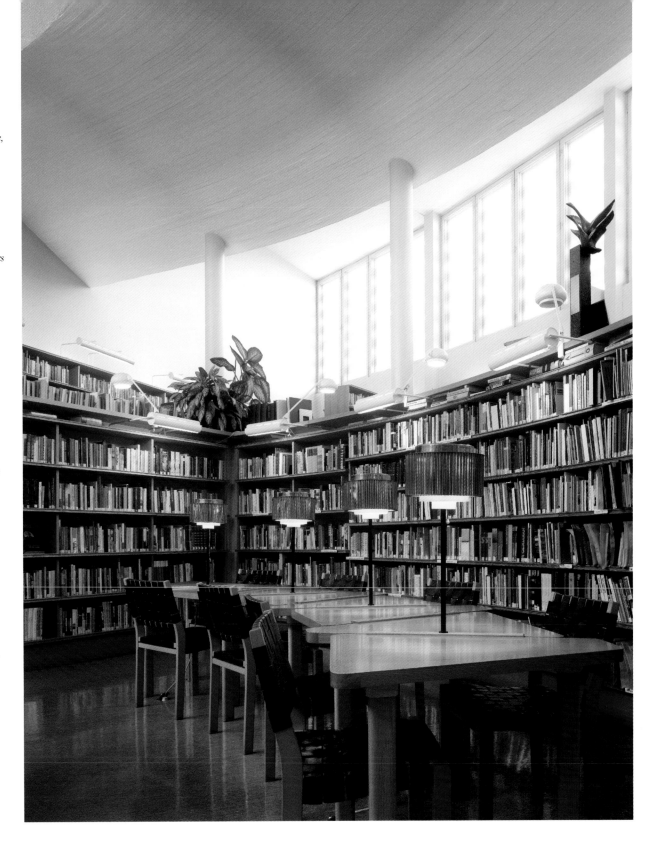

than the floor of the main area, which is enough for the full-height bookcases that form its edge to act as a parapet to stop people on the upper level from falling in. A reader on the lower level has the sense of being completely surrounded by books with a gallery above. In section, the library is again reminiscent of Boullée's Bibliothèque Nationale scheme, although there is no evidence that this was Aalto's inspiration. As a spatial device, the sunken library area was copied in many late-20th-century buildings, particularly bookshops, where it increased the bookshelf area and allowed

the shopper to see more levels of the shop below, inviting further exploration.

Aalto's planning for Seinäjoki is asymmetric, but the building is basically rectilinear with the exception of the central space, which has an undulating wall forming the rear of the main reading room and two side walls that splay to encompass its ends. The same could not be said of Scharoun's works, in which the plans tend to be extremely complex and involve a large number of conflicting and, at first sight, rather random geometries.

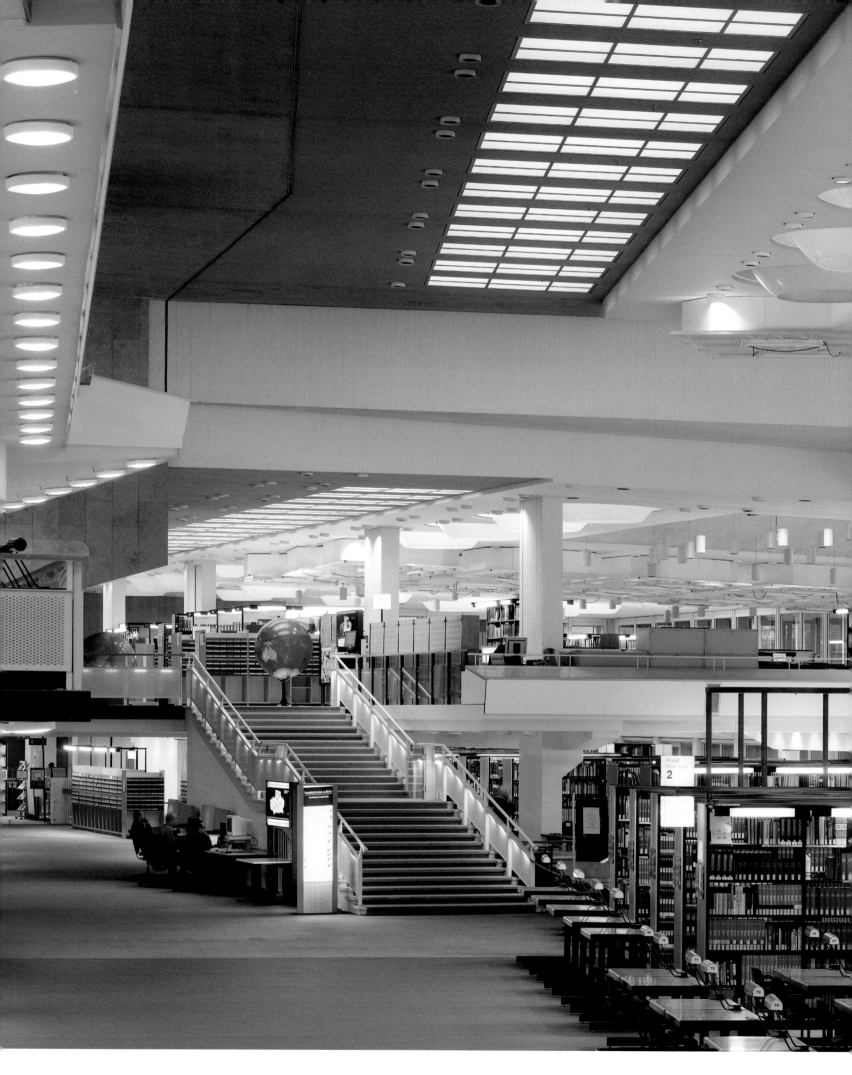

BERLIN STAATSBIBLIOTHEK,
1978. Berlin, Germany

The Berlin Staatsbibliothek, founded as a state library in 1661, is now the country's national library and the largest academic research library in the German-speaking world. Its contents were divided after the Second World War. Since the original building was in East Germany, Hans Scharoun's building provided a new home for the library in West Germany. Its single, huge reading room provides a wide variety of working spaces.

The Berlin Staatsbibliothek

Hans Scharoun (1893–1972) was a German architect who practised and taught architecture throughout his life but had to wait until he was in his sixties before he started to get major commissions and died before most of them were completed.[41] His free planning had a profound effect, particularly in the 1990s, when it seemed remarkably prescient to architects interested in such concepts as deconstruction and chaos theory. Sharoun composed these plans as a series of elements, each complete in themselves, arranged according to movement patterns and views. His first major project was the Berliner Philharmonie. The main hall was started in 1956 and completed in 1963; the minor hall followed in 1979–84. Like Aalto's later Finlandia Hall in Helsinki (1967–71), the foyer spaces appear on plan to be highly complex and free-form. The Beaux-Arts ideas of axial planning are entirely rejected. Instead, on entering the building, visitors first see the cloakrooms in front of them. They are then guided up through a series of staircases to their seats in the concert hall. The foyer is one huge space arranged on many levels, the upper ones overlooking the lower ones.[42]

In 1967 Scharoun was commissioned to design the Staatsbibliothek in Berlin. He died in 1972 and the building was finished by his pupil Edgar Wisniewski in 1978.[43] During the Second World War the Staatsbibliothek's collection had been stored for safety in various locations and when Berlin was divided in 1945 half of the books were on one side of the boundary and half on the other. The old Staatsbibliothek building was in East Berlin, and so the collection in West Berlin lacked a home. Scharoun's building was designed to provide space for 4 million books with a possible extension to hold another 4 million. It is entered on the ground floor, where the cloakrooms, lending department and delivery sections are located. The reader then passes through security to a staircase leading to the first floor. The reading room itself is a single, huge space, composed of many levels linked by staircases and terraces. This arrangement allows readers to find a space to suit them. There are small private carrels, niches hidden away in corners, areas under high roofs, desks near windows, and places with long

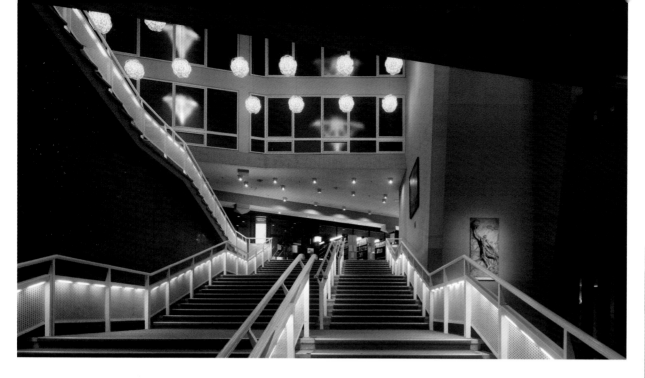

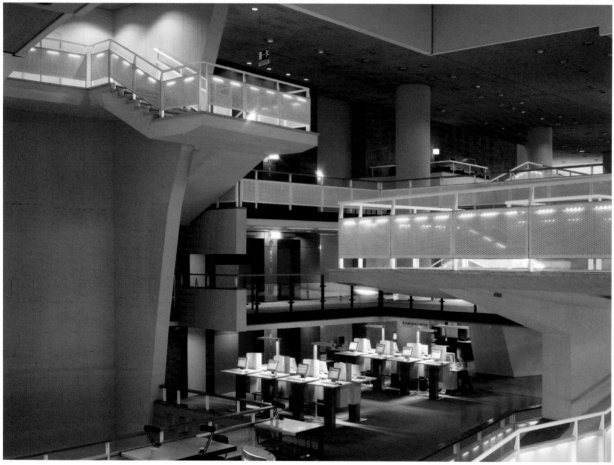

views down the length of the building. The bookstacks and librarians' offices form a wall along the back of the building, which originally was to face a new main road.

The search for order
Scharoun's reading-room arrangement is strikingly similar to a theatre foyer – an analogy that extends to his bookstacks, which project from the roof like a fly-tower. The 'library as foyer' arrangement was entirely new. As visitors move around the building they experience high and low spaces, some lit from the side and others from above. As none of the walls are parallel, distances are difficult to judge. To its fans, this is an architecture of heterogeneity, which takes joy in variety and constantly changing experience. To its detractors, this is an unnecessarily complex, even wilful architecture, which confuses and disorientates. These differences in viewpoint are as marked as those between Rococo and Neoclassicism.

The library is entered at the lower ground-floor level, which contains space for cloakrooms and the lending desks. Dramatic staircases (opposite above) ascend to the enormous main reading room. Reading spaces are provided on a series of galleries (opposite below) on many levels. The whole reading room feels like a theatre foyer, which may well have been Scharoun's inspiration. Some spaces (below) were initially left free of furniture so that they could be used for events and exhibitions.

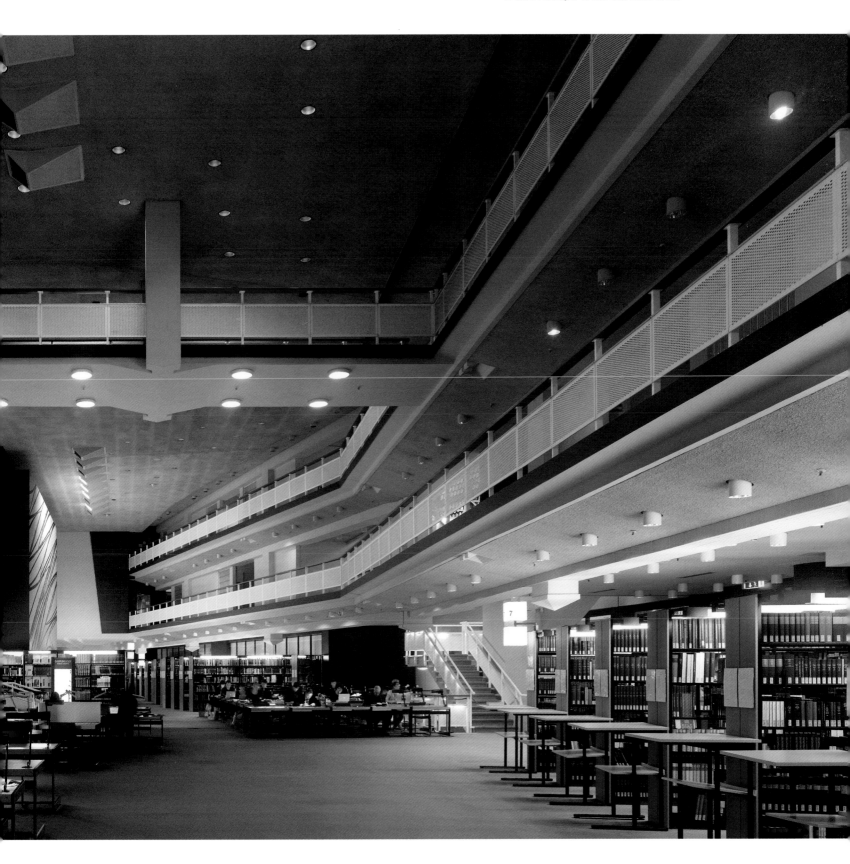

Designed by Louis Kahn, the library is built in red brick to blend with the rest of the school, which is Neo-Georgian in style. The library stands alone in the middle of a wide expanse of lawn. The openings on the ground floor form an covered walkway. This was originally intended to be much taller, but attempts to reduce costs led to its height being cut down. The entrance is within this walkway.

Although Scharoun's architecture is made of materials, it is not about materials: it is about visual experience.

The period 1945–80 saw an increasing number of books published on library design that exemplify Modernism's fascination with space planning, modularity and so-called 'functional' design. Some, such as Michael Brawne's *Libraries: Architecture and Equipment* (1970), were written by architects but most, such as Keyes DeWitt Metcalf's *Planning Academic and Research Library Buildings* (1965) and Godfrey Thompson's *Planning and Design of Library Buildings* (1975), were by librarians.[44] With their advice on the correct positioning of card catalogues and the latest designs for message tubes, they now look dated. They provided rules for optimizing the spacing of shelves and desks to pack in the maximum numbers of books and readers. Stacks were almost invariably shown placed in the heart of very deep plans, with reading spaces around the periphery, close to the windows. There was an emphasis on optimal column spacing and flexibility. The accompanying black-and-white photographs show dull, rectangular libraries with regularly spaced desks continuing into the distance full of bored-looking people. However, not all architects were willing to follow these directions. Some defiantly insisted on thinking things out for themselves – what the architect Louis Kahn called 'returning to first principles'.

The Phillips Exeter Academy library
In 1965 Phillips Exeter Academy, an American private school in Exeter, New Hampshire, interviewed leading architects of the day about a proposed new library. From a list that included I. M. Pei, Paul Rudolph, Philip Johnson and Edward Barnes, the selection panel chose Louis Kahn (1901–1974).[45] Despite his statement that 'You plan a library as though no library ever existed', a strategy that would have risked reinventing the wheel, there is plenty of evidence that Kahn spent a great deal of time looking at precedents. He knew the description of the monastic carrels in the cloisters in Durham, England, in John Willis Clark's *The Care of Books* (1901). He also thought about daylight, saying, 'A man with a book goes to the light. A library begins that way. He will not go fifty feet away to an electric light.'[46] Commenting on Boullée's design for the Bibliothèque

Nationale, he noted that it showed 'the feeling of what a library should be – you come into a chamber and there are all the books'.[47]

His design for Phillips Exeter Academy was contextual in its choice of materials. The rest of the buildings were red-brick Neo-Georgian in style, so Kahn chose to make his library of brick. Both plan and elevation are roughly square. The result is a building that commands the site like a castle keep. Externally, the brick appears to be load-bearing. Like Georgian buildings, it has flat jack-arches over the windows and the openings are of roughly the same proportions as Georgian windows, but there are no stone dressings and no external ornament.

The reader enters the library through a ground-floor cloister, which runs around the bottom of the building. This is, in fact, a cloister in reverse because it faces outwards towards the garden, rather than surrounding it. One side of the cloister is glazed, and forms an entrance lobby. Marble stairs lead from there

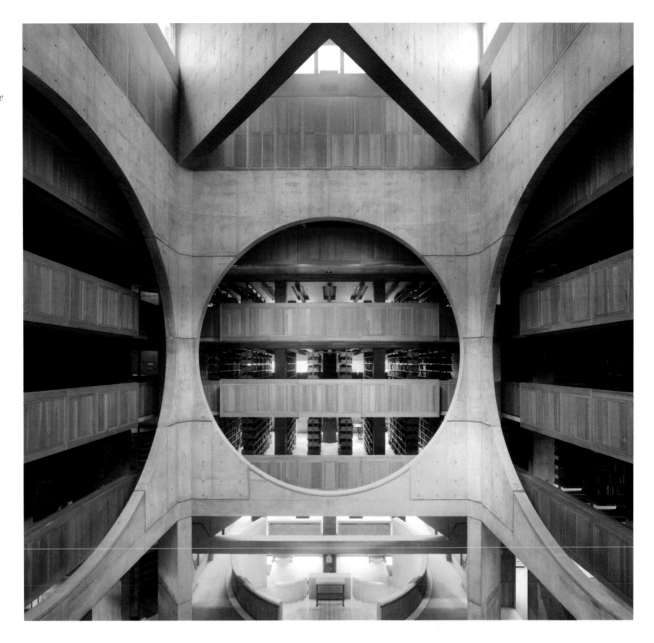

to the main hall on the first floor, which provides the focus of the whole building. From here, the reader catches glimpses of the shelves above and sees the whole extent of the library. The proportions of this central space are reminiscent of the Peabody Library in Baltimore (see pp. 252–5). Here, however, it is not intended as the primary reading space. It instead forms a central core, an internal courtyard. The books are arranged in stacks around it. The reading spaces are individual carrels placed next to the windows in double-height halls on alternate floors. In other words, Kahn has taken the design advocated in the literature of the time and expanded it. The stacks are no longer in the centre but are ranged around it, and the reading spaces surround them. Services and stairs occupy the corners of the building. This kind of planning is far from efficient. When drawn in plan, the centre of each floor is a useless space. In his *Planning Academic and Research Library Buildings*, Metcalf called this type of area 'non-assignable architectural space'.[48] He

recognized that it was essential but said that it should be kept to a minimum. He and the other writers of books on library design were obsessed with plans. But the idea that the plan is in some way the 'generator' of architecture – a phrase coined by the Swiss architect Le Corbusier – is, and always has been, misleading. Plans and other crude diagrams do play an important part at various stages of the design process, but prioritizing them risks inhibiting creative and more efficient solutions and underplays the importance of other key factors in the design, such as materials, heating, lighting and visual experience. The ultimate success of a building is not measured in floor areas but in how the building works in three dimensions and how much people enjoy using it. These aspects are more easily tested in model than on plan. Kahn understood this and worked extensively with physical models when designing. Every aspect of the shelving and desk space was considered and designed. The result is an extraordinarily powerful building that has

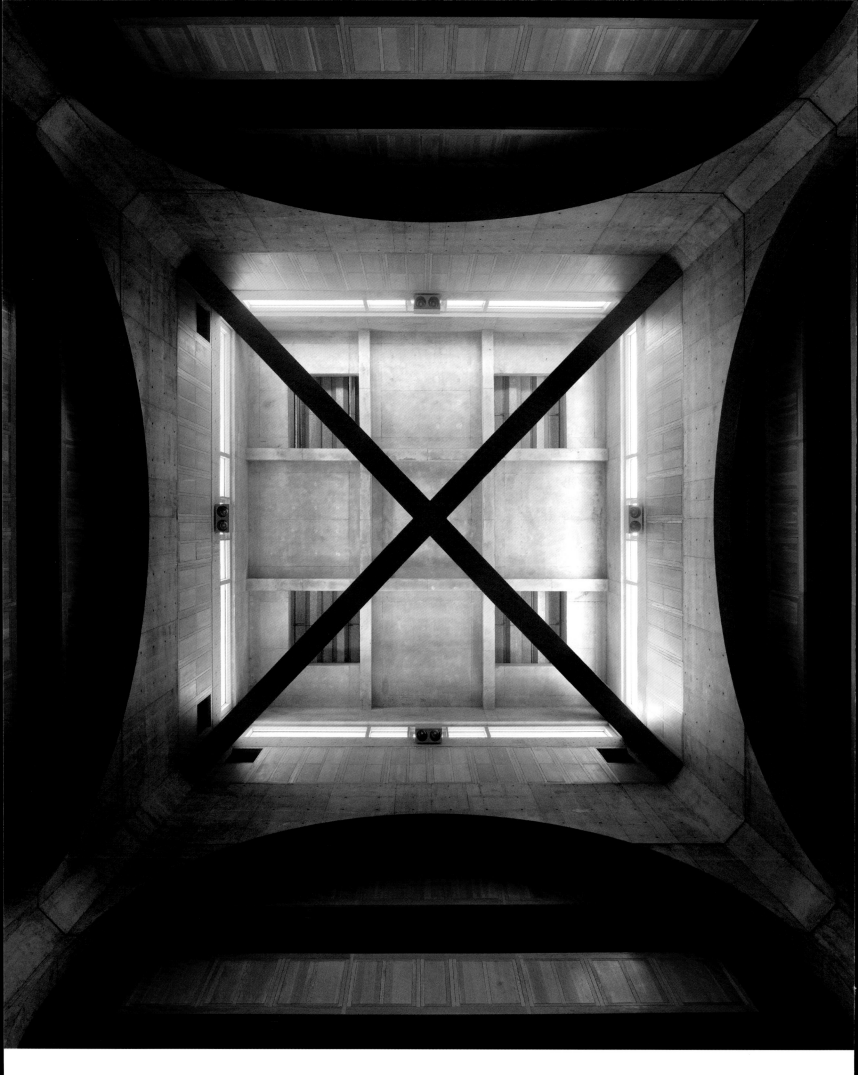

below and opposite
PHILLIPS EXETER ACADEMY LIBRARY, 1971
Exeter, NH, United States of America

*This photograph shows the view looking straight up in the main
hall to the cruciform beams that support the roof slab (opposite).
The hall provides readers with a focus and orientation point
wherever they are in the library but otherwise serves no practical
purpose. It is a purely architectural gesture, but one of such
immense power that it is impossible for the viewer not to be moved.
Whereas the bookstacks have a comparatively low headroom,
the carrels (below) are in generous spaces around the edge of the
building, where light floods down from above.*

been much loved by the generations of students who
have sat in it, and is visited by admirers from all over
the world.

Yet more problems of space

The library at Phillips Exeter Academy failed to obey
most of the rules set down in the books on library
design at the time. Most importantly, its free-standing
form made long-term expansion almost impossible.
In its defence, however, it is unlikely to need
expansion. It was built with significant capacity beyond
its requirements and is without doubt one of the largest
school libraries in the world. Most libraries, including
local lending, school and university libraries, can
deal with excessive numbers of books by getting rid
of outdated volumes, although not usually until after
considerable discussion.[49] Legal-deposit libraries are
in a more difficult position. The public expects them
to keep a copy of everything published. Although
even legal-deposit libraries have to be selective and
do dispose of materials, they are still expected to store
most of what they are sent. Digital technology, which
was expected to reduce the amount of publication,
actually increased it and all legal-deposit libraries were
facing problems in the later years of the 20th century in
keeping up with the rate of acquisition. The two most
notable attempts to deal with this challenge were the
new buildings to house the Bibliothèque Nationale in
Paris and the British Library in London. Whereas the
British Library took over thirty-six years to complete,
the Bibliothèque Nationale was finished in seven.
As a result, it suffered from none of the continuous
changes of brief that plagued its English counterpart.[50]
Nevertheless, it was still highly controversial.

The Bibliothèque Nationale

By the 1980s the Bibliothèque Nationale had long
outgrown its Labrouste-designed reading rooms and
had annexes all over Paris. The decision to provide
new premises was entirely political. When in 1989
President François Mitterrand signed the decree that
authorized the new building it was only one of many
grands projets that characterized French presidencies.
The architect, chosen by international competition,
was Dominique Perrault (b. 1953), who was only
thirty-six at the time. A French architect was a

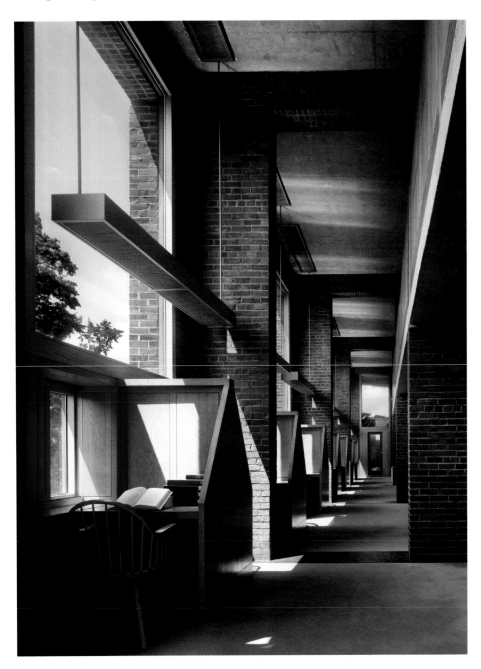

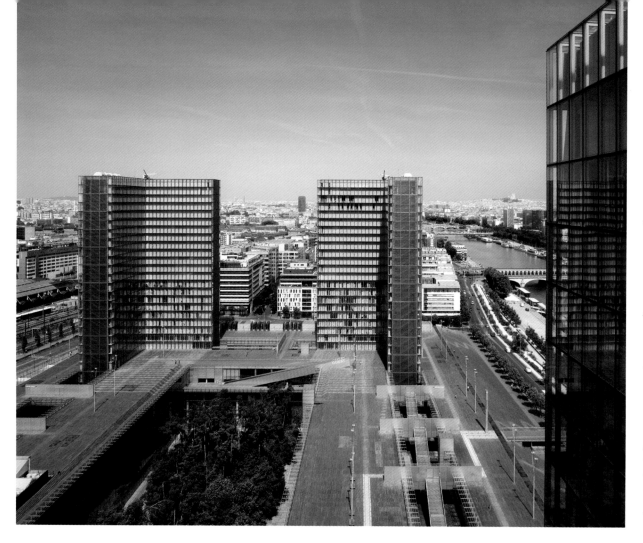

popular choice, but Perrault's design was daring and it aroused hostility.[51]

In the late 1980s there was a general acceptance among librarians that bookstacks should be at the bottom of the building, preferably, as at the British Library, in a basement protected from heat and sunlight. Perrault had realized that the site of the new Bibliothèque Nationale, next to the Seine, made basement book storage difficult. However, bookstacks at ground level would take up much of the public space and result in a bulky and inelegant structure. He thus proposed to place the books in tall towers at the four corners of the site. With the books removed from the main body of the building, there was more clear space for reading rooms. Perrault's scheme exploits the slope of the site. The library's roof was made into a huge, open public square, the centre of which is opened up to form a sunken garden filled with pine trees, the tops of which are just visible from the square.

The reaction to Perrault's scheme in the French press was vitriolic. Writers objected to the fact that anyone would be allowed to use the upper part of the building, which would have facilities to encourage public participation. This, they said, would disturb serious researchers. Most of all, they condemned the bookstack towers, which they claimed would overheat and were an inefficient use of space. All these claims

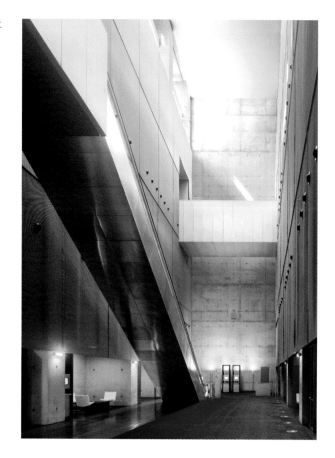

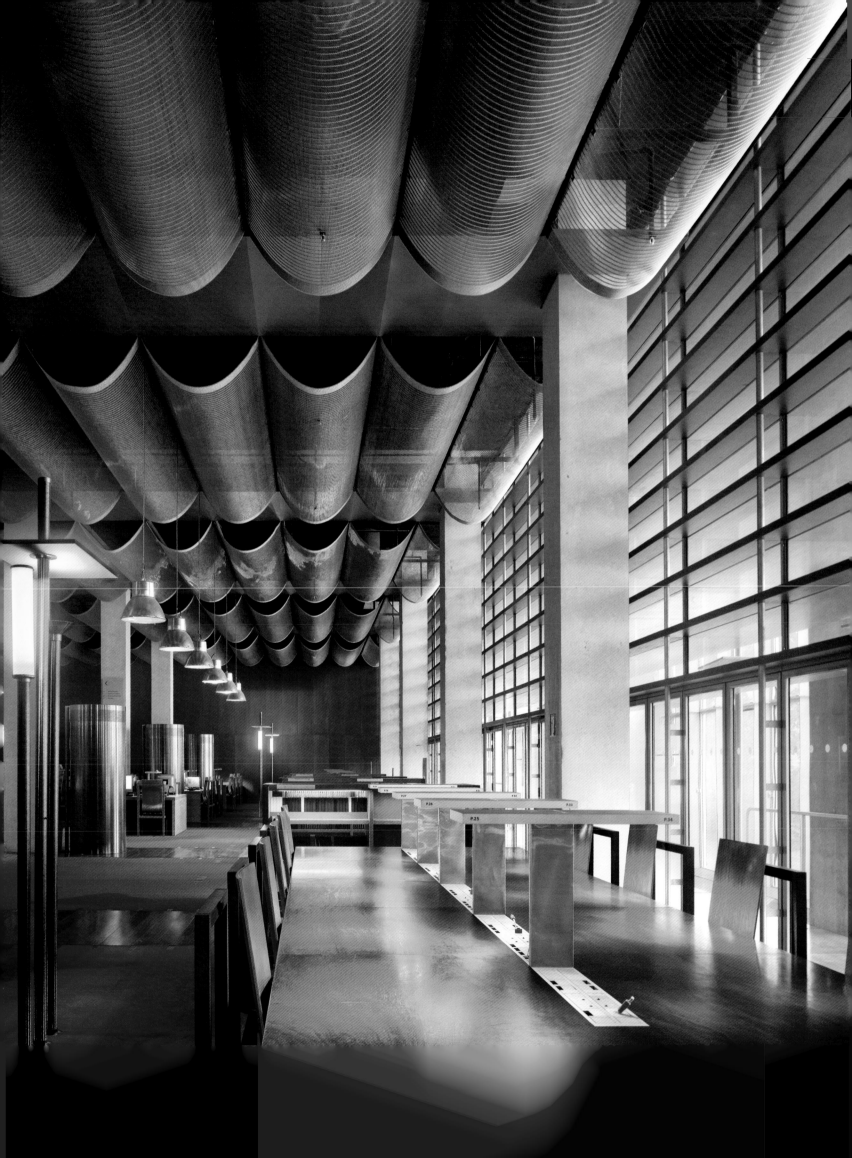

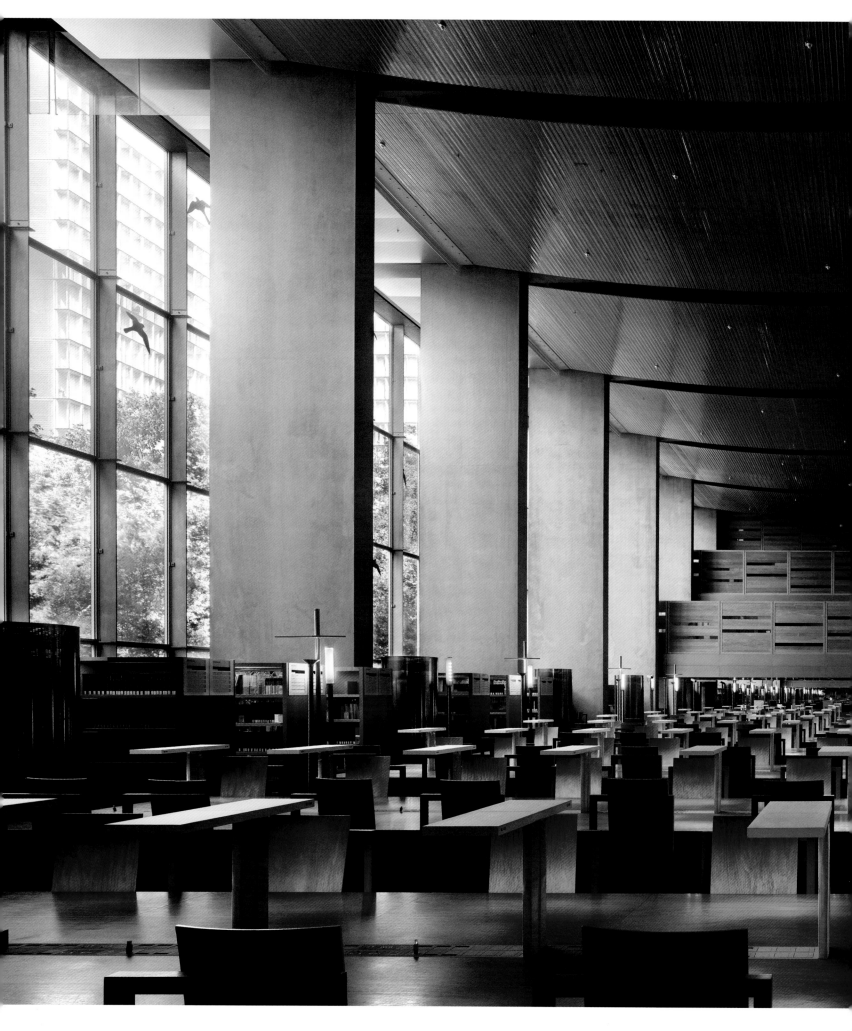

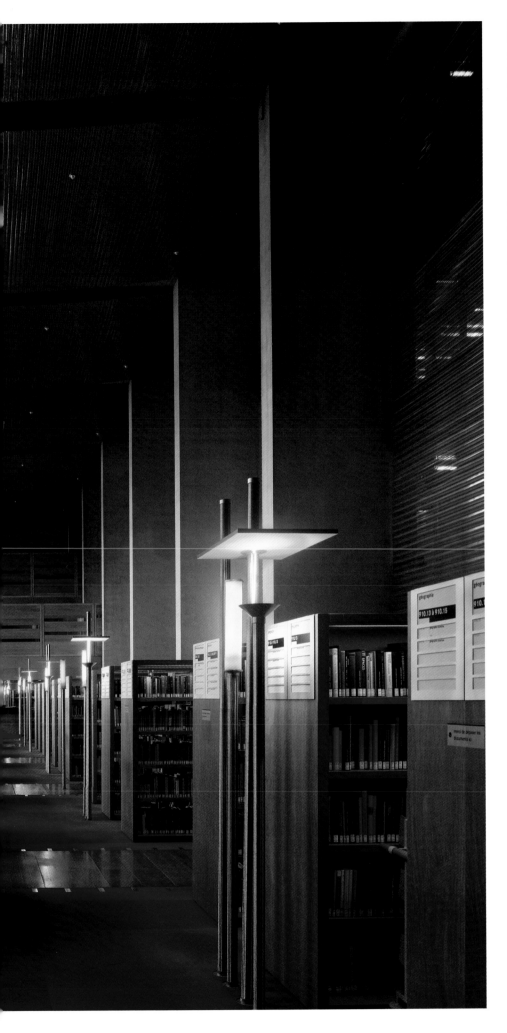

The main reading spaces are arranged around the central garden and are unusual in having a direct view of the outside world. Although the reading rooms form a continuous space, they are broken up visually by bridges that cross at regular intervals.

have turned out to be unfounded. Work began on site late in 1990. The structure was completed in 1993; the trees were planted in 1994 and the project was opened at the end of 1996.[52]

Perrault's scheme is characterized by generosity on every level. Firstly, there is a genuinely useful public space in a part of Paris that had few open spaces. Its wooden decks provide a place for people to lie outside in the sun or sit and enjoy the Seine. Internally, its hallways are generously proportioned, with high ceilings. The upper floor provides a set of public spaces for exhibitions and casual visitors. The real achievement, however, is in the main reading rooms. These provide seating for 1,556 readers. Perrault has designed the shelving and interior fittings to completely co-ordinate. In too many modern libraries shelving is ordered later, after the project is completed, ruining an interior with ill-thought-out and ugly fittings. Here, everything has been carefully selected and positioned. Shelves and galleries divide the vast expanse of the reading rooms into smaller halls. All overlook the garden. Wherever you are, you see the trees out of the corner of your eyes, so when sitting in the Bibliothèque Nationale in the middle of Paris you feel as if you are in the countryside, away from the noise and bustle of the city. Whereas Labrouste brought his gardens to the reading rooms on the rue de Richelieu by painting them on the walls, Perrault brings the actual countryside into the centre of the building. This unmatched architectural experience makes the Bibliothèque Nationale one of the greatest libraries in history.

Library as landscape
Classical and Gothic buildings generally sat on the ground from practical necessity. Moving earth was expensive and it was difficult to waterproof subterranean structures. There were of course exceptions to this rule, such as the embankments in Paris and London, but for most purposes before the 20th century earthworks were avoided where possible. The invention of reinforced concrete in the 1890s and the development of mechanical excavators in the late 19th and early 20th centuries opened new architectural possibilities. Post-war architects played with ground levels, creating streets in the air, raised plazas, hanging

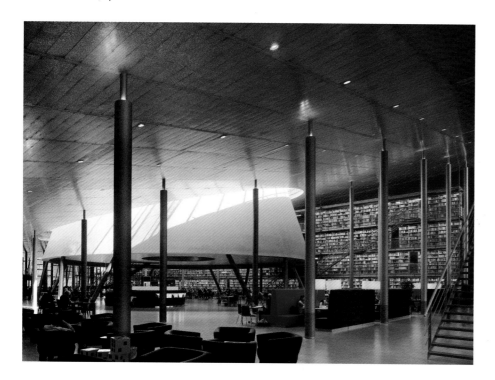

gardens and basement carparks, so that the pedestrian was uncertain where the real ground level in a development was. Nowhere was this more explicitly done than in the library for the Delft University of Technology (TU Delft), in the Netherlands.

The TU Delft Library

In 1992 TU Delft held a limited competition to design a new library. Of the schemes submitted by the three invited practices, Jo Coenen, Benthem Crouwel and Mecanoo, a firm based in Delft, the judges felt that Coenen's was too complex, Crouwel's 'was not interesting enough', but Mecanoo's was 'seductive', 'affordable' and 'realizable'.[55] The site chosen was a difficult one, beside a strident concrete auditorium by Van den Broek and Bakema, at the back of the university site. Mecanoo's winning design placed the library partially underground. The final scheme slightly altered the arrangement. The side nearest the auditorium is buried in the earth, with the roof of the building grassed over to become an artificial hill. In the flat landscape of Delft this artificial hill appears particularly poignant. The students use it in summer as a place to meet and sit and talk. From the roadside, the edge of the building that contains offices

for the staff looks conventional. The most striking feature of the exterior is the cone projecting from the hillside, which the architects said was inspired by Asplund's Stockholm library.[54]

The library is entered on the first floor by walking up steps or a ramp, although the hillside rising above makes it impossible to tell where ground level should be. The whole basement (at true ground level) is occupied by bookstacks. The main reading room sits beneath the sloping ceiling of the hill above. The entrance side is comparatively low but the height of the far side allows for a dramatically lit wall of books, which forms the focus of the library. Although it is the most striking part of the exterior, the cone is the least successful element of the interior and met with mixed reviews in the architectural press.[55] Its solid sides permit no view out and the claustrophobic space is used in an unsatisfactory way for reading desks.

Mecanoo's library demonstrates the dilemmas and problems of library design in the late 20th century. The building is placed within a campus that consists of freestanding buildings surrounded by car parking and access roads. The library is like a green island poking out of a concrete sea. Externally, the solution is highly successful, creating a welcome green space

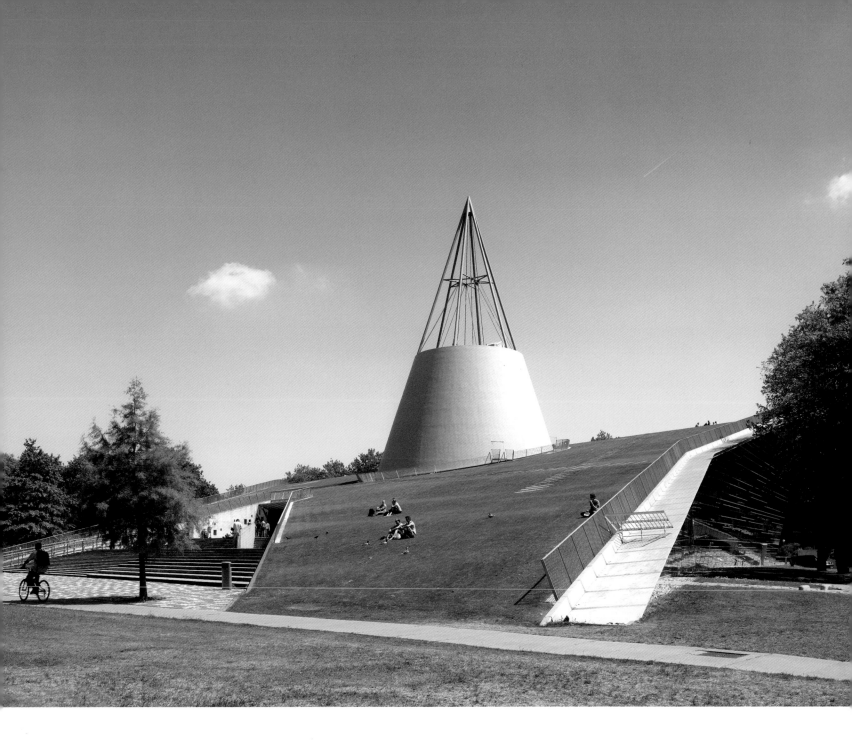

within this rather barren landscape. Internally, like the Bibilothèque Nationale, it deliberately challenges the diagrams in books on library design that set out the correct spacing of chairs, tables, shelves and lights. Mecanoo and Perrault demonstrated that libraries did not have to be rectangular boxes with books in the middle and desks round the edge. The danger was that when such innovative strategies fail they provide ammunition for the opponents of architects being involved in library design. These new approaches were also indicative of architects' growing rejection of the idea that Modernism was based on functionalism and standardization.

The first few generations of Modernists had genuinely wanted an architecture stripped of all superfluous ornament and based entirely on

research into the most efficient use of space. They firmly believed that such research would reveal perfect solutions, leading to standardization and modularization. There were a number of obvious problems with this. Firstly, the most successful buildings of the period, such as the Beinecke Library or Scharoun's Berlin Philharmonie were not based on ideas of functionalism but on other principles, even when they pretended to be functional. Secondly, and perhaps more importantly, libraries throughout the 20th century were changing so fast that a library that was drawn in plan to be perfectly functional one year would typically be out of date by the time it was completed and the books had been moved in. Lastly, the relationships between librarians and architects continued to be fraught. Librarians were frustrated by what they saw as architects' continual failure to

TU DELFT LIBRARY, 1997
Delft, Netherlands

The most successful element of the interior is the large blue wall of books that dominates the main reading space, which is noisy and buzzing with energy. Quiet reading rooms are provided on either side, behind glass screens. Most of the books are stored in moving closed-storage stacks on the floor below.

produce practical buildings, on budget, on time. The architects were frustrated by the fact that librarians seemed to think that the design of a library could be reduced to an exercise in space-planning.

The end of the century

The history of the library in the 20th century is not quite what one would expect. For the first half of it, libraries continued to be designed in a traditional way. The detailing was stripped classicism (Art Deco, Nordic classicism, Arts and Crafts), but it was still recognizably based on traditional architectural styles and proportions. Modernist libraries in the first half of the 20th century were extremely rare – buildings such as Aalto's Viipuri library are the exceptions rather than the rule. In all other ways, however, these pre-1945 libraries were technically advanced: they incorporated electric lights, electric lifts, conveyor systems, steel and concrete frames, mass-produced metal shelving and tubular-steel and plywood furniture.

Modernism, and with it an obsession with functionalism and standardization, took over after the Second World War. The 1980s saw a crisis of confidence in the Modernist project and architects began to take divergent paths. A few architects and designers returned to traditional typologies and styles but most used the new climate to explore new territories and architectural possibilities. The plurality of these approaches makes them exhilarating and difficult to summarize in equal measure. In addition, a new theme began to appear in writings on libraries: books predicting the death of the library and the end of the book.

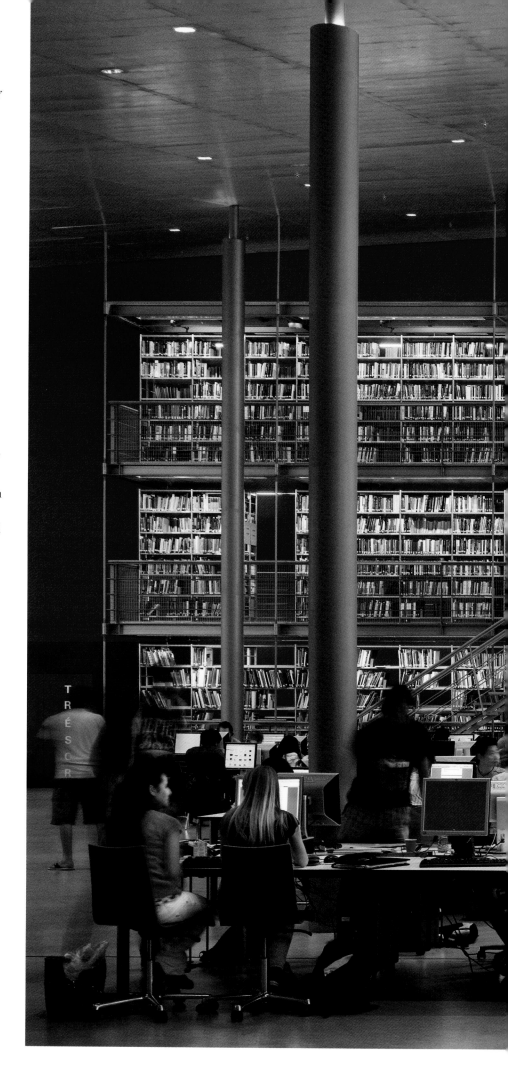

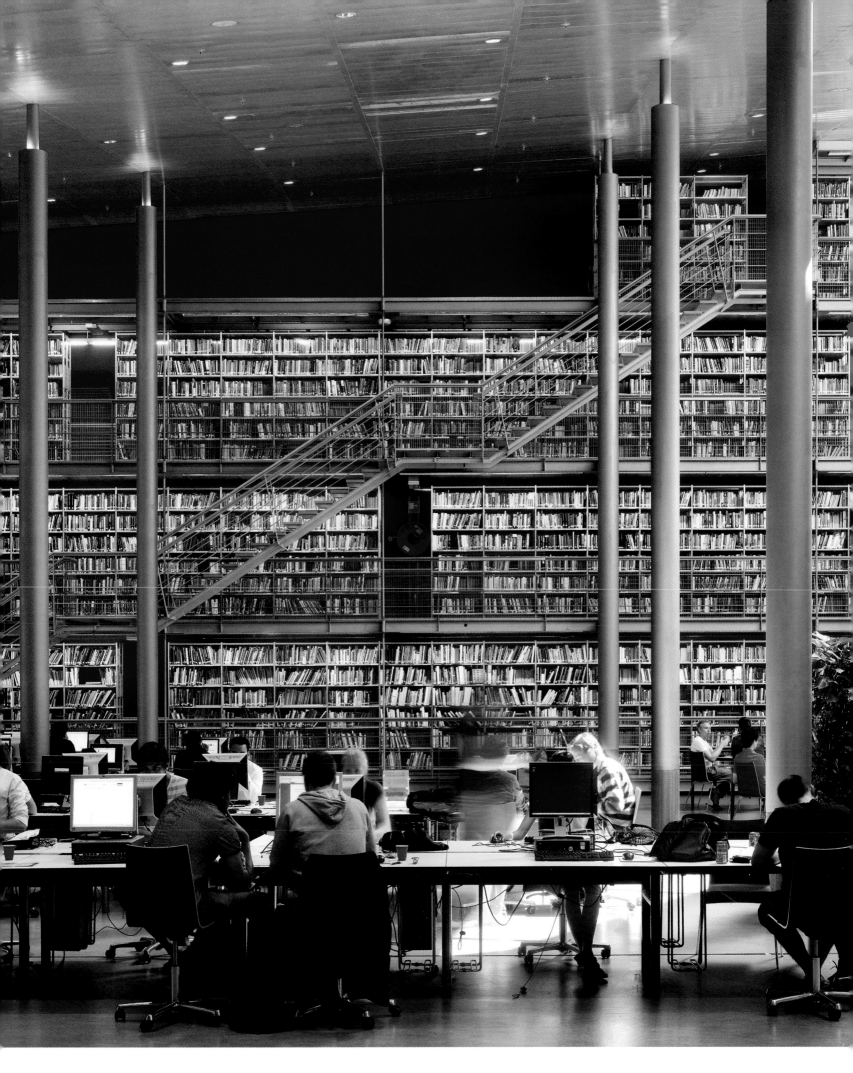

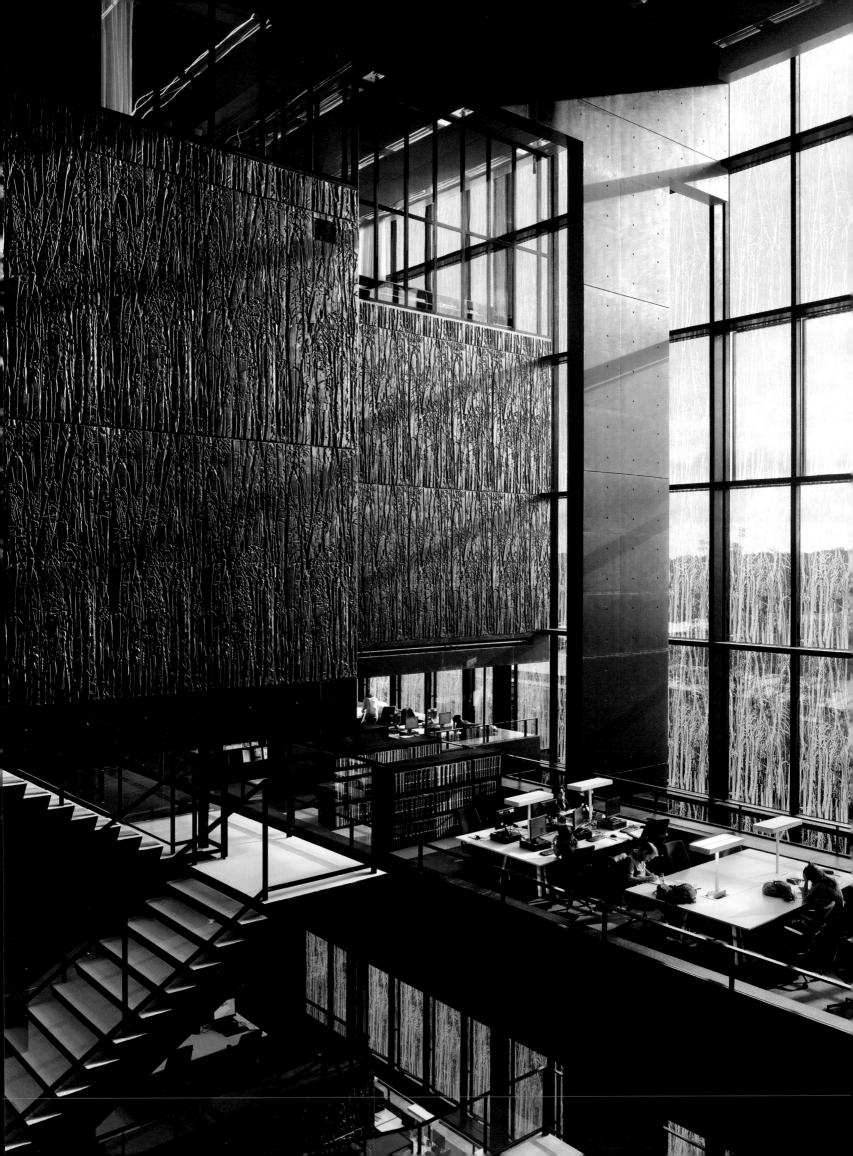

The Future of Libraries in the Electronic Age

It is clearly too early to get any sort of historical perspective on the architecture of the 21st century. All this chapter can hope to do is to provide some observations on recent trends. To some commentators, the current era marks the end of the library. There is widespread talk of a crisis in library design. The birth of the computer and the internet have led to a popular new branch of literature predicting the imminent death of the printed book. Economic crises, public spending cuts and closures of public libraries have also led to talk of the end of the library as a social institution. It is difficult to reconcile any of these positions with the continued explosion in library construction in the first decade of this century and the large number of library buildings currently being built. For a construction sector in crisis it seems to be remarkably healthy one. This chapter will examine some key libraries built in the first decade of the 21st century and ask whether there really is a future for the library and, if so, what form it might take.

Japanese libraries

Japan's recovery after the Second World War and its transformation into an economic superpower led to a boom in construction. Its architects were inspired by Western Modernism but they were not entirely beholden to it and developed their own styles. As a result, Japanese architecture in the late 20th century was widely admired in Europe and the United States. A series of striking library designs was built throughout the period. Brutalist architecture – which celebrated raw concrete and exposed steel – may have been invented in Britain but the Brutalism of Arata Isozaki's Ōita Prefectural Library (1962–6) predated Western libraries in the style, such as the Robert Hutchings Goddard Library (1965–9) at Clark University in Worcester, Massachusetts, by John M. Johansen, and James Stirling's history faculty library at the University of Cambridge (1964–7).[1] The 1990s were particularly prolific, highpoints being Isozaki's Post-Modern Toyonokuni Libraries, Ōita, (1991–5), Hiroshi Hara's High-Tech Miyagi Prefectural Library (1993–8), which placed the library in a steel and concrete tube, and Toyo Ito's Sendai Mediatheque (1994–2000), where a relatively conventional square floorplate was enlivened by bundles of thin, inclined steel columns.[2] The Shiba Ryōtarō Memorial Museum in Osaka (2001) is perhaps the most beautiful of all the libraries to emerge from this tradition of Modernist Japanese library design, and also one of the most unusual.

The Shiba Ryōtarō Memorial Museum

The museum is devoted to the life and works of the famous Japanese writer Shiba Ryōtarō (1923–1996).

Shiba had been deeply scarred by his experiences in the Second World War, and in particular by the brutality of his commanding officers and the military class they represented. After the war he became a reporter and then a writer, devoting his life to researching and writing historical novels. His works, such as *Drunk as a Lord*, *The Last Shogun* and *Burn, O Sword*, captured the post-war mood perfectly and won wide acclaim both in Japan and in translation across the world. Shiba was born in Osaka and he returned there after the war to live in a relatively modest and undistinguished house in the suburbs. On his death, his widow created a foundation in his name, which gives prizes and literary awards and funds the museum based in the house in which he lived.[3]

The Shiba Ryōtarō Museum is entered off an unassuming suburban street. Visitors pass through a gateway into the garden of the original house, which is preserved intact. Shiba's works were based on meticulous research and throughout his life he collected books. All the spaces of the original house gradually filled up with bookcases, and photographs show books stacked in piles on the floor. Simply opening the house to the numbers of visitors who wanted to see it was impractical, so the construction of a separate museum building was an obvious solution. This could provide space for showing off – and properly storing – the books the writer had amassed, as well as a permanent exhibition explaining his life and an auditorium for readings and lectures. All these facilities had to be fitted into the corner of the garden of a normal suburban house. The architect Tadao Ando was appointed to deal with this challenging

below, below left and opposite
**SHIBA RYŌTARŌ
MUSEUM, 2001**
Osaka, Japan

*Designed by Tadao Ando,
the museum provides a home
for the 20,000 books collected
by the author Shiba Ryōtarō
during his lifetime. The
books, which he used when
researching the historical
novels that made him famous,
originally filled his home.
The museum, constructed
in the garden, allows the
scale of the collection to be
appreciated. The visitor enters
at ground level and sees a
view of the library (opposite)
before descending through
an exhibition about Shiba's
life and work that finishes in
the lower level of the library
(below and below left).*

brief. His ingenious solution was to bring the visitor
in through a long, curving path, providing a covered
place for queuing on busy days. This path descends
to the entrance level, which contains a shop and café,
overlooking the library. The visitor is then led through
the exhibition down to the lower level, where the full
extent and size of Shiba's book collection becomes
apparent, towering over the visitor on shelves of
Japanese oak set against the inside of the curving
entrance wall.

This is a particularly unusual library. Although
it contains a great many books and all are accessible
should they be required, it is not designed to facilitate
reading. The books are stored here as an exhibit

demonstrating a lifetime's book collecting. They
include all the various editions and translations of
Shiba's work, but the vast majority of these works are
readily available elsewhere. This is a library looked
after as a museum, and the attendants are museum
curators rather than librarians. It is an apt reminder
that the museum and the library have a common
origin in the Museion of the library of Alexandria
(see Chapter One). In many periods libraries have
served as repositories for artefacts as well as books.
Looked at in this way, librarianship could be seen
as a specialist branch of museum curatorship.

Modern museums are very different from
their cluttered forebears. Today they all pay great

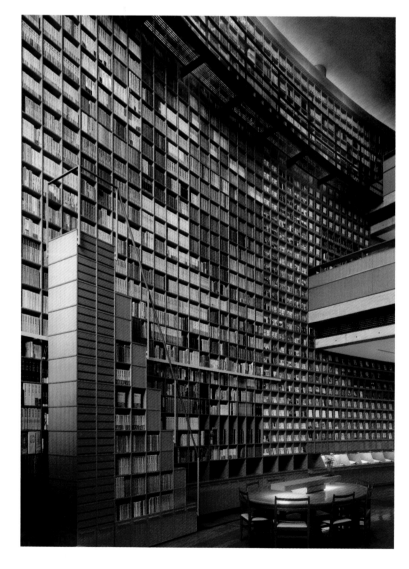

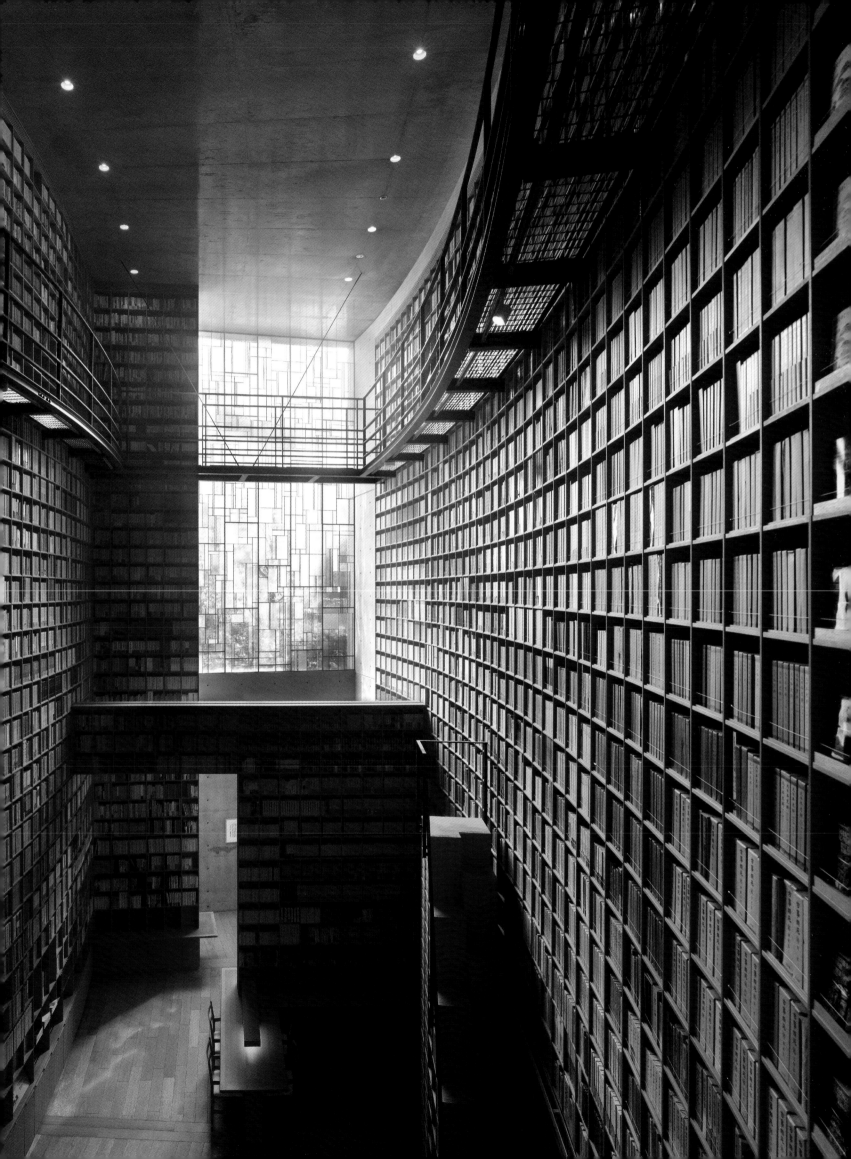

The building's designers, Herzog & de Meuron, specified a different garish paint colour for each floor. The galvanized steel bookcases lend an industrial quality to the interiors. Floor-to-ceiling heights are set deliberately low to correspond with the maximum height of shelving that can be accessed without ladders. The staircases and lifts are contained in circular cores, one of which can be seen at the right of the picture.

attention to the presentation of their collections, carefully designing the cases in which the artefacts are stored, and ensuring that they are properly and discreetly lit. The rooms in which they are displayed are immaculate. There are no trailing wires, peeling paintwork or fittings that are out of place to distract the visitor's attention. For a museum curator, a particular museum building may not be ideal at the outset, but, if not, it must be made perfect and pristine. The visitor experience is of primary importance. The museum curator's job is to look after the collection; the building in which it is housed is not secondary to this function. The building is understood as part of the image of the museum: to use a modern marketing concept, it is part of its brand. All these matters apply equally to the librarian. The books in a library must be looked after but the way that they are housed, and thus the way that they are presented, cannot be treated as secondary. The library in the 21st century is not just a repository for books: it is a museum for their preservation, display and presentation. Its appearance is part of the image that it presents to its reading

public: it defines its brand. In some cases, the library's form has become instrumental in creating a more positive image for a whole institution. The very title of the new Information, Communications and Media Centre of the Brandenburg University of Technology in Cottbus, Germany (BTU Cottbus) spells out both its intentions in this regard.

BTU Cottbus

Brandenburg University of Technology was founded in 1991, after German reunification, on the site of a former university of civil engineering and other associated institutions. As a new foundation, the buildings were laid out in a clear pattern and conformed to a strict height limit. Cottbus is a small town in what was formerly East Germany. It has a medieval core with a number of interesting buildings and a particularly fine Art Nouveau theatre. Like many towns in this part of Germany, its industry had collapsed after the Second World War, leaving widespread unemployment and many of its fine 19th- and early 20th-century buildings are in a sad

*The library commands the entrance to the university, standing
on a slight hill above the road. The exterior is enveloped in a
continuous glass screen. During the day, the building reads as
a single volume and the disposition of the windows and interior
walls is concealed, but at night the lights reveal the different
spaces within, clearly showing the mixture of single-storey
stacks and two-storey reading spaces.*

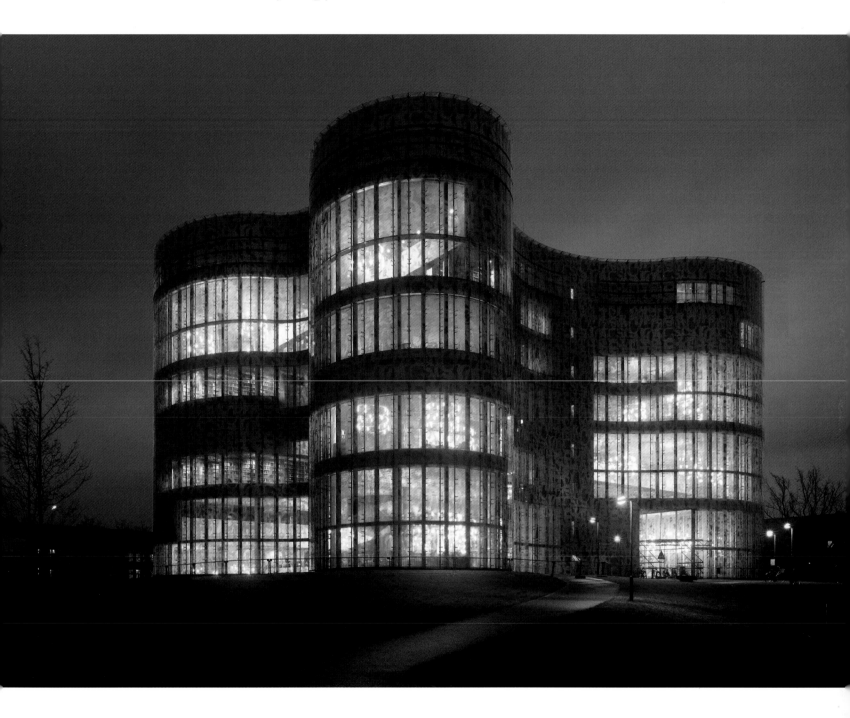

state of disrepair. BTU Cottbus is part of a broader
plan to revitalize the district and a significant
investment has been made in its buildings. The
campus is entered through a gateway building that
opens into a courtyard surrounded by the other major
communal buildings, including the student cafeterias,
the lecture rooms and a conference centre. This

gateway building is entered off Karl Marx Strasse, a
broad road edged on both sides by wide expanses of
grass. The Information, Communications and Media
Centre (Das Informations-, Kommunikations- und
Medienzentrum) sits on the opposite side of the road,
raised up on a grass-covered knoll, so that it looks
down on the campus and can be seen clearly from

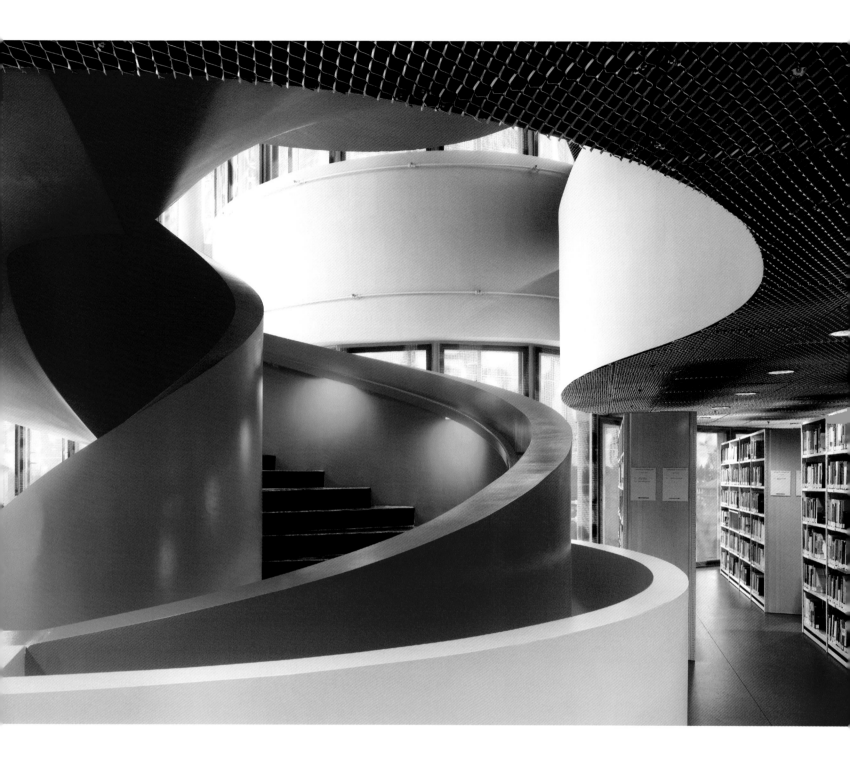

all directions. It acts as a sign, announcing arrival, a beacon marking the entrance to the whole university.[4]

The building was designed by the Swiss architectural firm Herzog & de Meuron. As a library, its external form is entirely original. Its façade is a single, undulating skin of glass printed with intertwined letters in white. These merge into a pattern that is particularly visible at night, when the building lights up like a lantern. This continuous glass skin wraps around the whole building, concealing the openings and solid walls behind it and making it impossible to gauge the building's scale. As a result, it appears much larger than it actually is, resembling a castle tower commanding and protecting the entrance to the campus.

The architects themselves describe the building's plan as being amoeba-like. Lifts, fire stairs and bathrooms are squeezed into two circular service cores and an open spiral staircase connects the public floors. At various points throughout the building, the floor plates are cut back to produce double-height spaces, so that no two floors are identical. This effect is amplified by the use of bright colours throughout, with different colours on different floors. The furnishings are varied to provide both warm, lounge-like spaces and more formal, office-like areas. Students are offered spaces to gather for group working and others where they can work in relative privacy without being disturbed. The distribution of the books on different floors naturally groups the working areas

into subjects. All this appears highly original and almost chaotic, but there is a well-defined order within the apparent chaos. On closer inspection this is in many ways a conventional modern library: the books are concentrated in the central area of the floor plates, away from the light, and the reading spaces are distributed around the periphery. What is particularly clever is the way that the architects have used an undulating external façade to create variations in the size and scale of the reading spaces to cater for the tastes of the broadest range of readers.

The library's position on a knoll was the result of a change in brief early on in the project. The original design envisaged a building entered at pavement level with two storeys of basement underneath for services. When it became clear that this could not be achieved within the available budget, money was saved by placing the basement above ground and heaping up soil around it to conceal it, an interesting example of a successful aspect of a design being prompted by expediency.[5]

From library to media centre to study centre
The fact that BTU Cottbus felt that it had to give its new library the ungainly title of 'The Information,

Communications and Media Centre' is a sad reflection of the current lack of confidence in the word 'library'.[6] In the 1970s, not long after computers began to become more common, a new strand of literature appeared predicting the imminent death of the book, and thus that libraries would become redundant by the end of the 20th century.[7] Forty years on books are being produced in greater numbers than ever before.[8] The arrival of computers also led people to talk about the 'paperless office', although so far the ease of printing from desktop computers has hugely increased world paper consumption.[9] It is true that the digital revolution is changing the way we work, but not in the ways that were predicted. Certain types of book are disappearing. Law reports, for instance, once constituted a huge part of academic library holdings in England, in whose legal system each case changed the interpretation of the law, which meant that every legal library had to keep rooms full of case reports to enable students and practising lawyers to keep up to date with the latest developments. These are now available (and easier to search and access) online and most libraries are disposing of their paper copies of law reports to make space for other material. Similarly, journals are increasingly being digitized and made available to researchers wherever they are in the world without the necessity of going to the library to search through bound volumes of back issues. However, digitization is not confined to journals and law reports. Vast digitization projects have been carried out on rare books, allowing researchers to download images page-by-page from a sizeable percentage of books published between the 15th and 18th centuries. The quality of these digitizations varies enormously, but the sheer number of books now available online in one form or another is staggering. The question can thus legitimately be asked: why would anyone want to go to a library anymore? The Utrecht University library, completed in 2004, offers one answer.

The Utrecht University Library
Utrecht has the largest university in the Netherlands. Its 1960s campus, De Uithof, has been radically upgraded and expanded as part of a fifteen-year master plan. The library, designed by the Dutch

architect Wiel Arets, is just part of a larger scheme that also includes buildings designed by OMA (the Educatorium, 1997), Neutelings Riedijk (the earth sciences building, 1997) and NL Architects (the BasketBar, 2003).[10] The new library is entered from a street level animated by shops and cafés, across a bridge from neighbouring campus buildings or through a multi-storey car park, which forms part of the library itself. In a campus where most of the buildings are linked at first-floor level by bridges, and in which students can pass seamlessly from one building to the next in cold weather, it can be difficult to know which building you are in. The library is immediately recognizable, however, thanks to both its etched, glazed walls (which provide oblique views of the outside world) and the fact that the whole interior is painted a single colour: black.

In the 19th century, and for most of the 20th, libraries were obsessed with the idea of surveillance. They were often designed so that as much of the library as possible was visible from the librarian's desk. In Stirling's history faculty library at the University of Cambridge, this idea was taken to an absurd conclusion by radiating all the stacks from a central point, despite the fact that, as students pointed out at the time, it remained laughably easy to pocket books by simply walking around the end of the cases. All this was swept away at the end of the 20th century, when electronic tagging technology significantly reduced the risk of book theft, and surveillance cameras became increasingly common. The position of the librarian's desk could now be divorced from the need to police the collection, except for rare books, where the risk of damage and theft remained

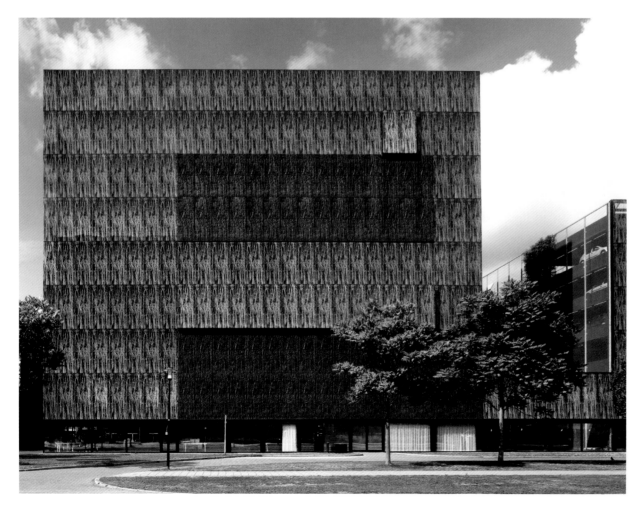

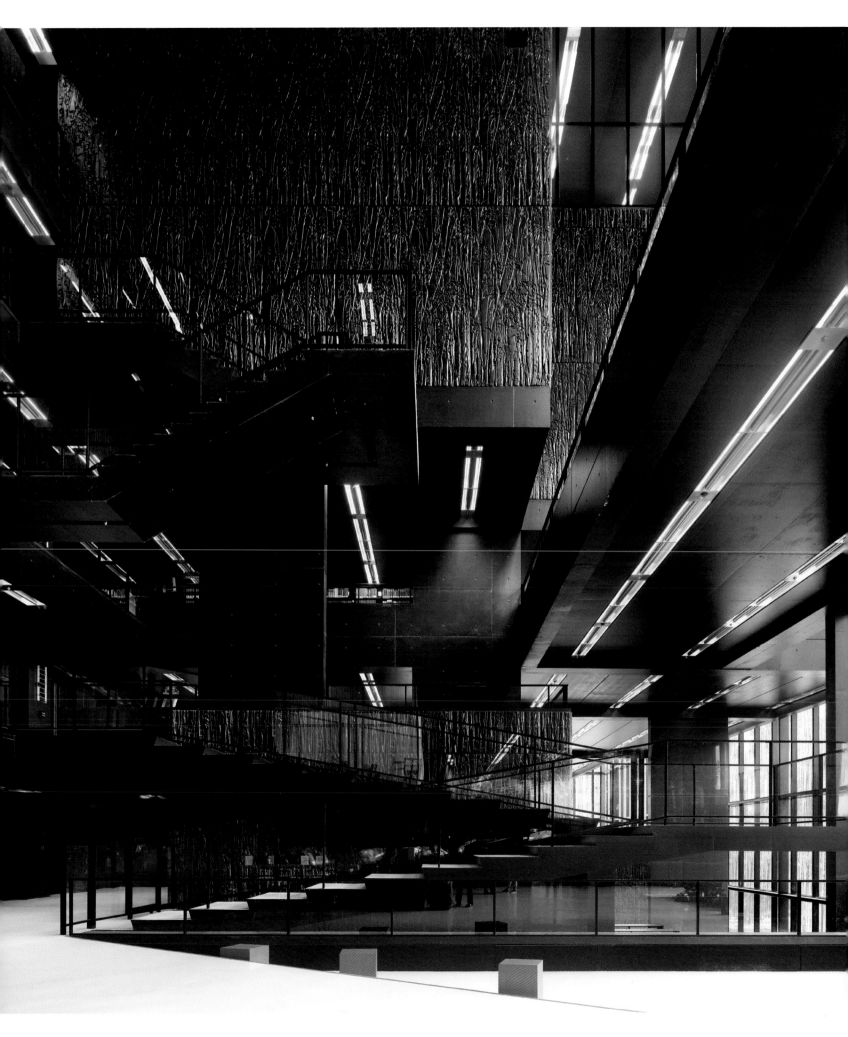

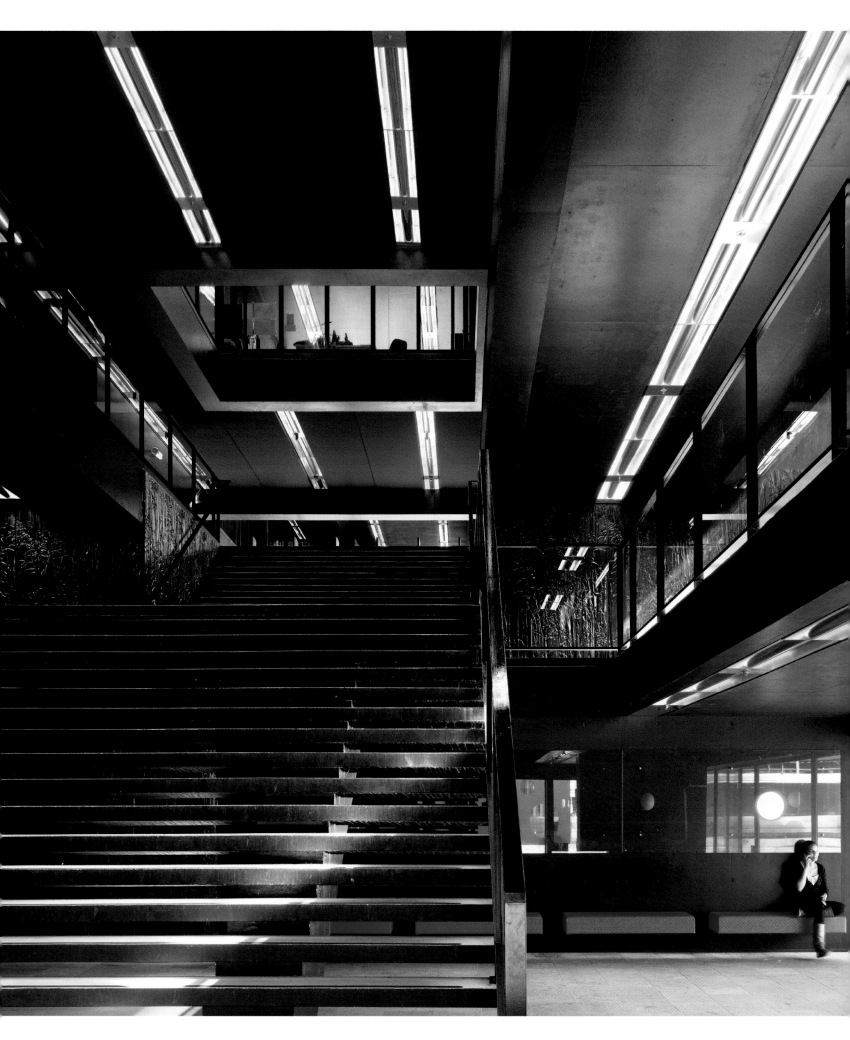

UTRECHT UNIVERSITY LIBRARY, 2004
Utrecht, Netherlands

The main stair (opposite), which leads from the ground floor to the reception (below right), and a view towards the windows at an upper level (right). The colour scheme in the library is strong. The floor is white. Everything else is black, except for the benches, a set of cubic stools and the reception desk, which are bright red.

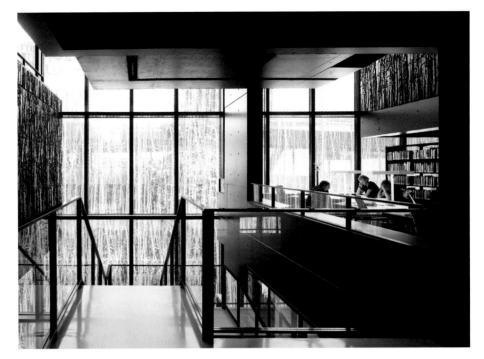

exceptionally high and where more strict surveillance is thus still essential. Librarians often now sit in reception areas outside the library itself where they can more easily answer questions and carry out other duties without disturbing the readers.

Libraries such as those at Cottbus and Utrecht are only possible in a world in which the idea of direct surveillance has become an irrelevance. The Utrecht University library is designed to provide the widest possible variety in reading spaces, but there is no shortage of storage for books. It has a capacity for 4.2 million volumes and much of the material is available on open shelving.[11] But these books provide the backdrop for the workspaces, since the shelving is used to create rooms within what is, for the most part, a single huge space, above which sealed storage and specialist reading rooms hover. The books provide colour against the black background. On a typical day students fill the reading rooms. Probably most are here not to look at the books, but to use the space. Although modern student residences offer facilities such as ensuite bathrooms, which were rare in the past, they are often cramped and difficult to work in. They are also often remote from the campus. Study spaces on campus give students somewhere to work between lectures and provide opportunities for group work or just meeting friends. Spaces are not allocated but students will nevertheless typically find a favourite place to sit. Some like to work in large, open spaces, surrounded by people. Others like to find small spaces tucked away in the stacks. The library is not merely a place to store books; it is a place to work. In a world in which space is expensive, free workspace is a popular attraction.

Sooner or later, Utrecht, like all university libraries, will have a problem with space for book storage. Here the adjacent car park offers an ingenious possibility. At first sight, car parks and book stacks appear to share several things in common: neither needs high ceilings and they both appear to require very high floor loading. In fact, car parks require a much lower structural loading than might be expected – bookstacks require floor loading as much as three times as high. Nevertheless, the structure of the car park here has been designed so that it can be extended vertically to provide extra book storage on top.[12]

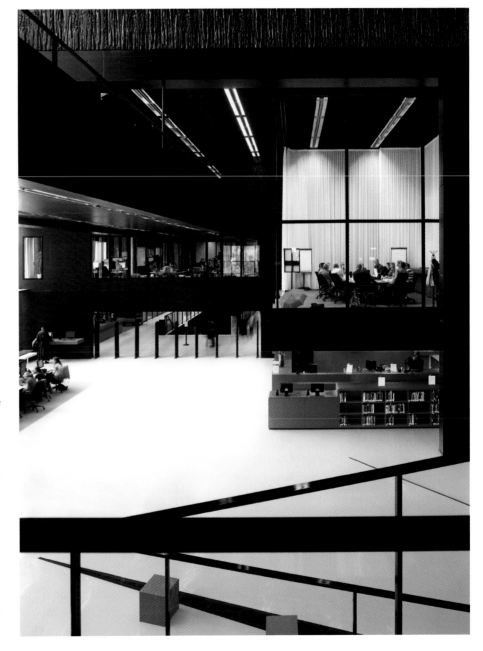

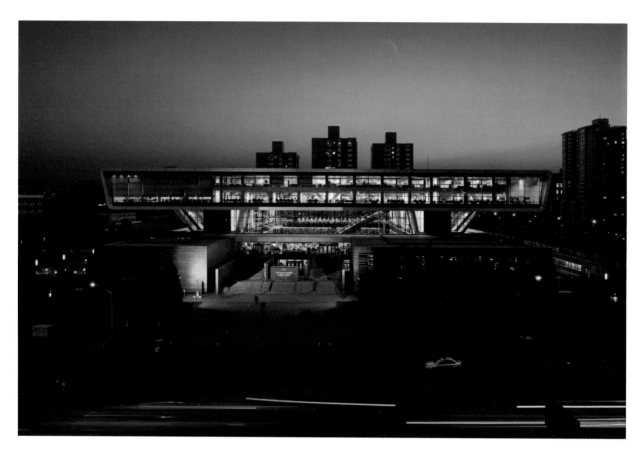

The National Library of China

With all the talk of the decline of libraries in Europe
and the United States, where literacy rates are
close to 100%, it is tempting to forget the rest of the
world. In rapidly developing countries, libraries are
increasing in number. The creation of a national
library to rival those in rich countries is seen as a
symbol of national pride and an indication that a
nation has reached economic maturity. Perhaps the
most striking national library so far constructed
in the 21st century is the National Library of China
in Beijing, completed in 2008.[15] The new library
sits next door to its predecessor, constructed in
1987, but architecturally they could hardly be more
different.[14] The former main building looks like an
undistinguished 1970s hotel. Its façade is a mass of
windows and its appearance dated. The new library
looks more like a sleek piece of industrial design than
a building. Streamlined metal panels are curved to
form a tube, in form vaguely reminiscent of the bent

plywood furniture so popular in the early 20th century.
Here the tube has two glass ends and is supported
high in the air on a glass box. This is architecture that
is intended to stand out on an urban scale. Beijing is a
sprawling modern city and the new library faces onto
a busy urban highway clogged with traffic. Only an
architectural gesture on this scale could compete in
this gritty environment.

The library is designed to be an extension, not a
replacement of the building alongside. Whereas the
latter had forty reading rooms, the new building has
one huge, open reading space seating 2,900 readers.
Together, they are designed to cope with 12,000
readers a day.[15] Internally, the main reading room
is in the form of a stepped court, each tier becoming
successively smaller, with open stacks provided on
each side. The lowest tier is special. Its walls are
lined with a complete facsimile of the *Siku Quanshu*
and from this level a glass screen looks into an air-
conditioned storage space, which contains one of

In addition to the main reading room, specialist reading rooms are located around the edges of the building. The upper ones open directly into the main space. From here, the great steel and glass roof that covers the reading room, and provides perfect light for reading, can be fully appreciated.

the surviving sets of this extraordinary compilation of all Chinese literature, assembled between 1773 and 1782. This precious work is thus at the symbolic heart of the building and reflects the purpose of the new library, which seeks to be a repository for all Chinese books.

The National Library in Beijing is not the only national library in China: the other is in Shanghai. China's book collections have had a turbulent past. During the Cultural Revolution, the Communist Party instigated a brutal repression of what it saw as intellectual and academic resistance to its doctrines. Libraries closed their doors, and even where they remained open, people were too frightened to visit them for fear of being accused of plotting against the state. The destruction of books in this period was disastrous and many ancient texts were saved only by being hidden or smuggled abroad. Even after restrictions were lifted, freedom of speech remained seriously curtailed.[16] However, the very state apparatus that was once turned against libraries now ensures their support. The Chinese government actively promotes academic research and the provision of library facilities as an important part of the drive for modernization and economic growth. The National Library in Beijing aims not only to collect all the works produced in China but also to provide public access to the largest collection of Western titles in country, currently amounting to 25% of all its holdings, some 1.9 million items.[17] As with all legal-deposit libraries, this creates massive problems of storage.

Stack storage

In the essay on library design in his *History of Building Types* (1976), Nikolaus Pevsner described the library built in Karlsruhe, Germany, in 1761 as anticipating 'the great innovation of the early nineteenth century in the separation of stacks from the reading room'.[18] He reprinted the plan of it published in Edward Edwards's *Memoirs of Libraries* (1859), which shows a rectangular building with corridors linking long, narrow storage rooms. Pevsner traced the use of stacks further back, to August Hermann Francke's library in his *Waisenhaus* (orphanage) of 1727 in Halle, Germany, but claimed that the separation of stacks and reading rooms was made popular by

its depiction in Leopoldo della Santa's *Della costruzione e del regolamento di una pubblica universale biblioteca* (1816), citing Friedrich von Gärtner's Bayerische Staatsbibliothek in Munich (1832–4) and K. F. Schinkel's unbuilt scheme for the Berlin Staatsbibliothek (1835) as early examples.[19] In fact, as this book has shown, the idea of separating storage rooms from libraries is as old as the library itself. The first libraries in ancient Mesopotamia adopted this strategy and it is found in medieval bookrooms and in traditional Japanese houses. Indeed, it is the combination of display and storage in a single room that is historically unusual, not the other

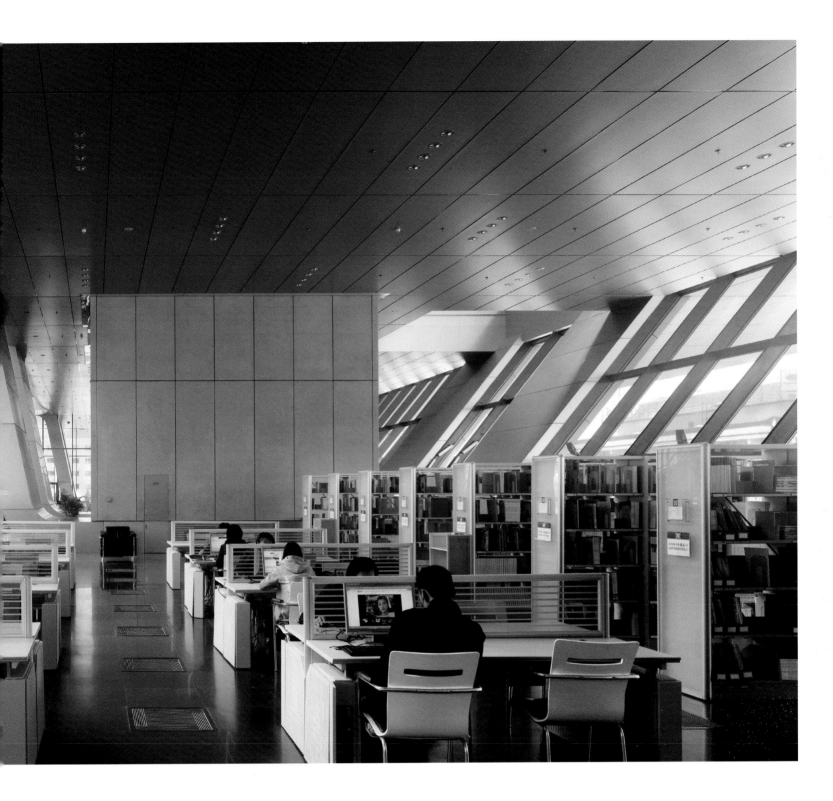

way round. There is no doubt, however, that Pevsner is correct that the early 19th century saw progressively more libraries using this arrangement. Books were increasingly stored on the ground floor in purpose-made stacks with the reading rooms on the floor above. The next step was to make the stacks out of iron, which was stronger and more resistant to fire. Iron shelving and walkways could then be made part of the same structural unit. This was the system developed in the 19th century in the British Museum under Antonio Panizzi and copied in the Bibliothèque Nationale in Paris (see Chapter Six). In the United States, the civil engineer Bernard Richardson Green developed a

special self-supporting iron stack system for Harvard University in 1895.[20] The iron was manufactured by Snead & Company of Louisville, Kentucky, which went on to develop a proprietary shelving system that was used for many subsequent library projects, including the Library of Congress.[21] Metal shelving became standard for library storage, with mild steel replacing cast and wrought iron in the 20th century.

Compact roller-shelving storage was also a 19th-century invention. The earliest examples were installed in the aisles of the stacks of the British Library in the 1880s. These were suspended on tracks from above. The floor-mounted compact

roller-shelving commonly seen in libraries today was a mid-20th-century innovation.[22] Steel stacks and roller-shelving greatly increased the capacity of many libraries, but even these were not going to solve the problems faced by larger legal-deposit libraries. The British Library increasingly relied on offsite storage. Modern libraries have taken this one step further by designing purpose-built storage facilities, such as the new facilities in Swindon for the University of Oxford's Bodleian Library.

Storage for the Bodleian Library

By the end of the 20th century the Bodleian Library was facing a problem of storage. It had long outgrown the accommodation that Thomas Bodley had provided for it in the centre of Oxford (see Chapter Four). It had expanded from its home in the Schools Quadrangle, with a huge underground storage facility linking it to the Radcliffe Camera in 1909–12, and the construction of the New Library, on the other side of Broad Street, designed by Giles Gilbert Scott in the 1940s.[23] All these were now full and there was no further space for expansion. Since the Bodleian is a legal-deposit library, its storage problems were only going to get worse. High land prices in central Oxford and planning restrictions around its periphery made building new local storage expensive. The decision was thus taken to build a new storage facility in South Marston, near Swindon, some 45 km (28 mi.) away.

Remote storage of this sort is unusual but not entirely without precedent. The idea of using offsite storage for rarely accessed books had been suggested in the 1880s by Charles William Eliot, President of Harvard University. A number of American libraries opened offsite facilities in the 1940s.[24] The British Museum had struggled to find storage on its main site throughout the second half of the 20th century and had used various warehouses around London. In 1973, when it was merged with other government libraries to form the British Library, it acquired what is now called the Document Supply Centre (DSC) in Boston Spa, Yorkshire, in the north of England.[25] This became the base for the inter-library loan service. From the outset, the DSC was designed as a storage facility with minimal space for reading on site. In 2012 it completed a new £26 million warehouse boasting 262 km (162 miles) of shelving to cope with the three million accessions a year.[26] The Bodleian Storage Facility, designed by the architectural firm Scott Brownrigg, is similar in concept. The building, which opened in 2009, is enormous and is designed to expand. Its current floor area is equivalent to 1.6 soccer pitches, providing 230 km (153 mi.) of shelving, capable of holding 8 million volumes.[27]

In both the Bodleian Storage Facility and the DSC, books are stored in bar-coded crates. These are slotted into specially designed racks. The DSC uses a robotic retrieval system, which allows more compact storage.[28] The Bodleian Storage Facility uses specially modified fork-lift trucks and human operators. Although these take up more space, the system is easier to maintain. In both cases, the warehouses are

*The building, designed by the Swiss architect Max Dudler for
Humboldt University, is the largest open-stack library in Germany.
The stacks are placed around the outside of the building, with a
large top-lit reading room occupying the centre. The spacing of
the openings in the side walls and the windows in the front façade
matches the optimal spacing of the fixed-stack shelving within.*

filled with shelving and kept at a constant temperature
and humidity to preserve the books. Such facilities do
not replace libraries; they merely separate the act of
reading from the storage. Readers order books online.
The requested volumes are retrieved from the boxes in
the stacks, packaged and sent to the libraries, where
they are read and returned. Such mass book-storage
facilities rely on the reader knowing which book to
request. They offer a solution to a particular problem
but, at the moment at least, there is still a place for
a library such as the Grimm Centre (the Jacob-und-
Wilhelm-Grimm-Zentrum) in Berlin, which facilitates
browsing as well as online retrieval.

The Grimm Centre, Berlin

The Grimm Centre is named after the brothers Jacob
(1785–1863) and Wilhelm Grimm (1786–1859), chiefly
known for their collection of folk tales, published in
various editions between 1812 and 1857. In Germany
they are also known as famous academics who began
the *Deutsches Wörterbuch*, the most comprehensive
dictionary of the German language. The Grimm
Centre is not just the home of the book collection
of the Grimm brothers; it is also the library of the
Humboldt University of Berlin. The new building,
a long-overdue replacement for one destroyed in
the Second World War, was designed by the Swiss
architect Max Dudler and completed in 2009.[29]
Its most important feature is its open-stack shelving:
the Grimm Centre is the largest open-shelving library
in Germany.[30] The stacks are ranged over six floors
on either side of a central, stepped reading room.

The ability to browse library shelves is generally
welcomed by readers. All the books on a subject are
collected in a particular area and the reader can
quickly and easily find similar books on the same
subject without needing to know the name of the
author or wait for them to be retrieved from storage.
Of course, some books can belong in several places,
so the system is not perfect, but given the choice
most readers would prefer open stacks to ordering
up books from elsewhere. Open stacks also allow
readers to wander, to spend idle moments picking
interesting-looking books off the shelves and delving
into subjects that they would otherwise never be
inclined to consider. In other words, open stacks

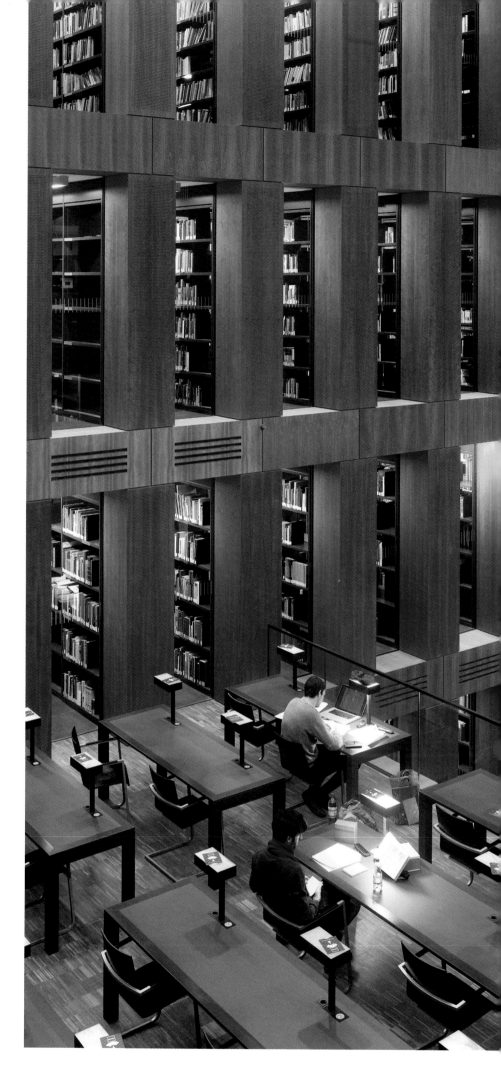

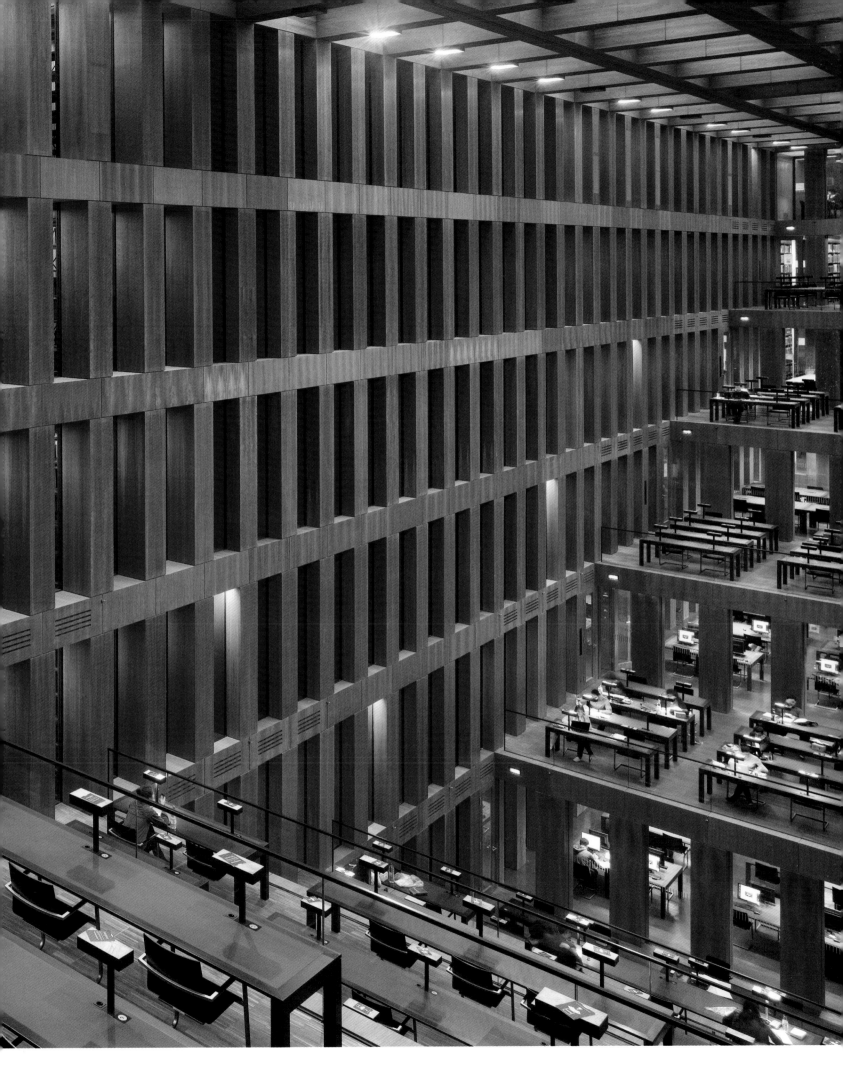

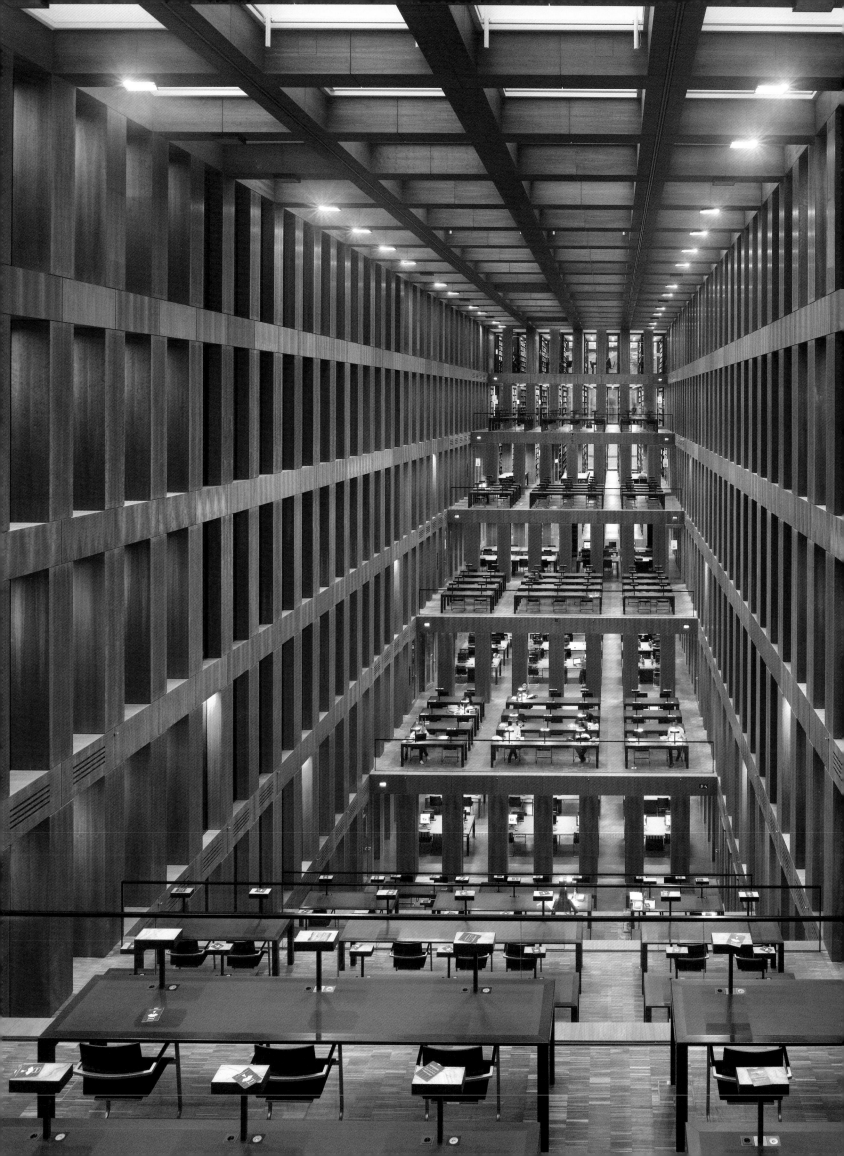

right and opposite
THE GRIMM CENTRE,
2009. Berlin, Germany

right and opposite
THE GRIMM CENTRE,
2009. Berlin, Germany

The stepped section of the main reading room (opposite) is reminiscent of Boullée's project for the Bibliothèque du Roi (see p. 210), but here it serves a different purpose. As the library has open stacks, different subjects are housed on different levels. Stepping the reading room allows readers to collect their books and take them to a desk without having to go up or down stairs. The different levels are linked by a series of staircases (right) on the side of the reading room closest to the entrance. These follow the room's stepped profile.

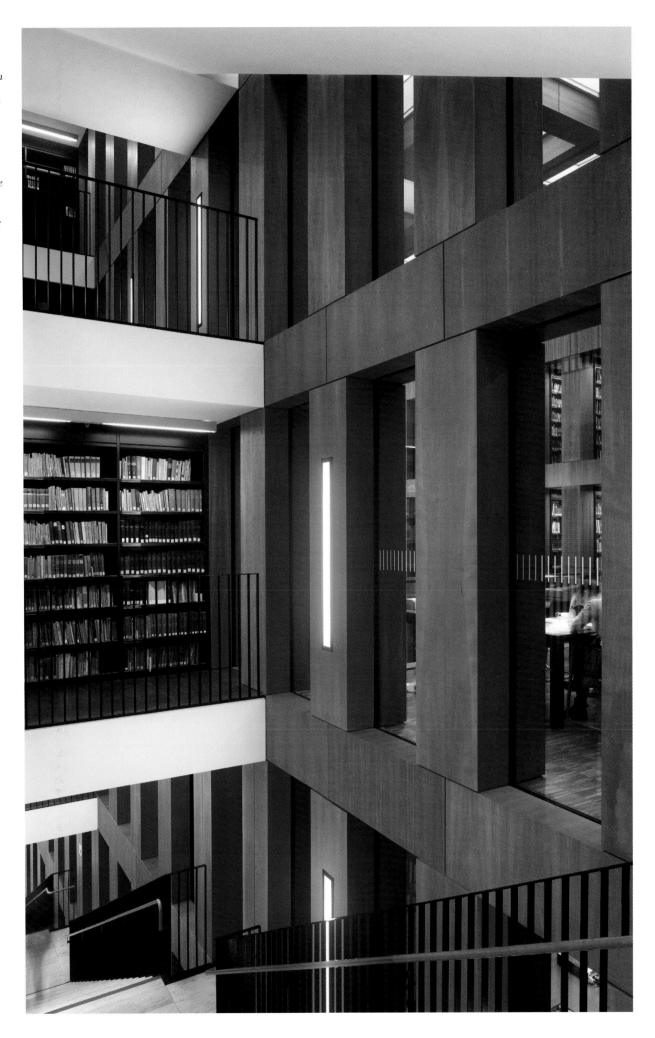

take us back to the time when we first discovered reading and all books were new and exciting.

The Liyuan Library

Literacy is the key to success in the modern world and everywhere networks of schools and libraries are being used to increase it. Nowhere, perhaps, is this transformation more striking than in China. Chinese state statistics reported that there were 2,925 public libraries in China in 2011.[31] Undoubtedly not all of these boast their own buildings. Indeed, in the 19th century, before the massive benefactions of wealthy individuals such as Andrew Carnegie, most British and American public libraries were housed in the corners of rooms in town halls and public buildings.[32]

The Liyuan Library, designed by the Chinese architect and academic Li Xiaodong, sits in the hills in the village of Jiaojiehe, a two-hour drive north of Beijing. 'Liyuan', which literally means 'fenced garden', refers to the wood in which the building is clad. The library is nestled behind a ridge, out of sight of the village, next to a mountain stream. This is a tiny building, a single reading room that treats the library as a playground and a living room. Visitors enter at the lowest level, removing their shoes by the door, and then climb up the shelves, which act simultaneously as steps, places to store books and seats. At the top, perched in the corner, overlooking the stream and hills beyond, a small sunken seating area allows the readers to sit around a fire, sip tea, listen to stories and quietly read books.

A gift to Jiaojiehe from the Luke Him Sau Charitable Trust, the Liyuan Library is a modern equivalent of Henry Hobson Richardson's Thomas Crane Memorial Library (see pp. 256–9).[33] Although it contains many ideas drawn from the history of library architecture, it could not have been designed by someone working from the advice found in any library planning manual. People too often criticize architects for their impractical designs. Practicality implies fulfilling a particular function. This book has shown that throughout history the functional requirements of a library have continually evolved. Changing technologies (books, paper, printing, gas lighting, stacks, electricity and computing) and shifting ideas about the purpose of libraries and the ways that they should be operated are not new problems. Libraries have been in a state of continual change for centuries. This book has looked at the successes rather than dwelling on the failures of library design.

The Liyuan Library provides a fitting example of what design can achieve. The form of this beautiful little building was not dictated by functional diagrams. It fits perfectly in its landscape. Through our study of the history of libraries we can understand how its location and its twig-clad elevations pick up a theme of gardens in libraries that links, intentionally or not, the Tianyi Chamber, Labrouste's Bibliothèque Sainte-Geneviève, Perrault's Bibliothèque Nationale and Arets's library in Utrecht. Internally, the Liyuan Library reinvents Boullée's stepped Bibliothèque du Roi (see pp. 210–11), turning it into a playground for introducing adults and children to the joys of reading.

Most of all, the originality of the Liyuan Library reminds us of the unique talents of designers and artists in the making of buildings; it reminds us of the power of imagination. In the end, libraries are places of imagination, and imagination is a form of play – play of the mind. Libraries can take us back to our childhood, or transport us to imaginary worlds. As this book has shown, humankind has created an extraordinary variety of spaces in which to read, to think, to dream and to celebrate knowledge. As long as humankind continues to value these activities, it will continue to build places to house them. Whether they will involve books or will still be called libraries, only time will tell.

THE LIYUAN LIBRARY,
2012. Jiaojiehe, China

Nestled beside a pond in the mountains, a two-hour drive north of Beijing, the Liyuan Library,
designed by the Chinese architect Li Xiaodong, blends perfectly into its surroundings, its enigmatic
exterior (below) giving no hint to passing hill-walkers of the books hidden within. The library is
entered from a bridge that crosses the pond, or from a path on the other side, which lead into a
passage that passes through its centre. The rough finish of the exterior, consisting simply of flexed
twigs wedged between rusty steel rails, contrasts with the finely finished joinery of the interior
(overleaf), which is entirely composed of bookshelves, serving also as floor, stairs, seats and tables.
In the corner, a fireplace provides a place to rest, read and drink tea.

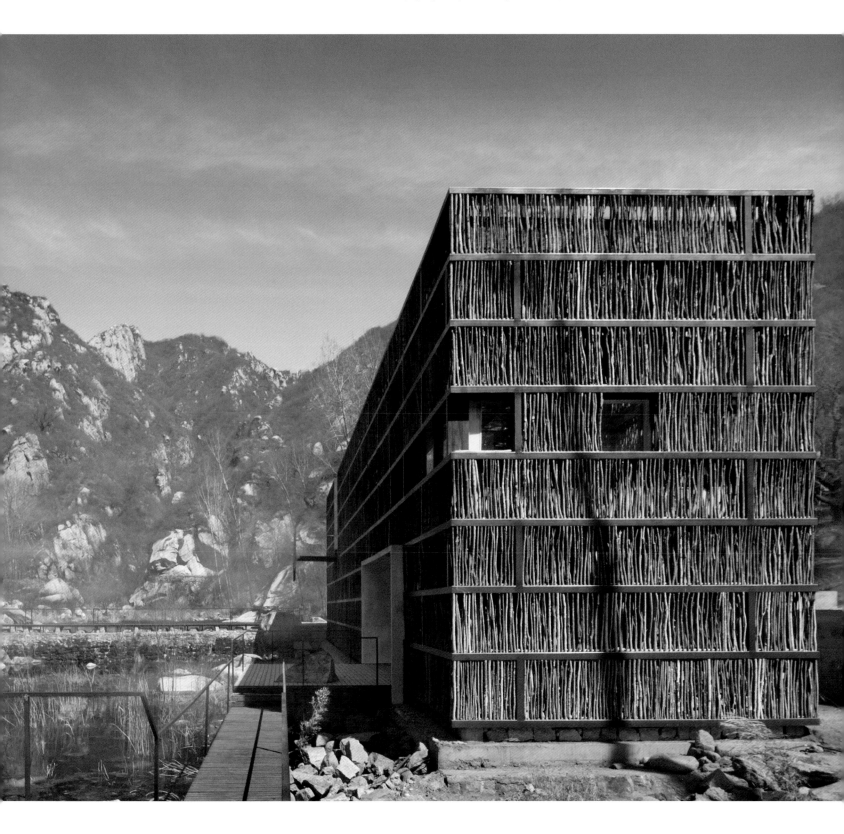

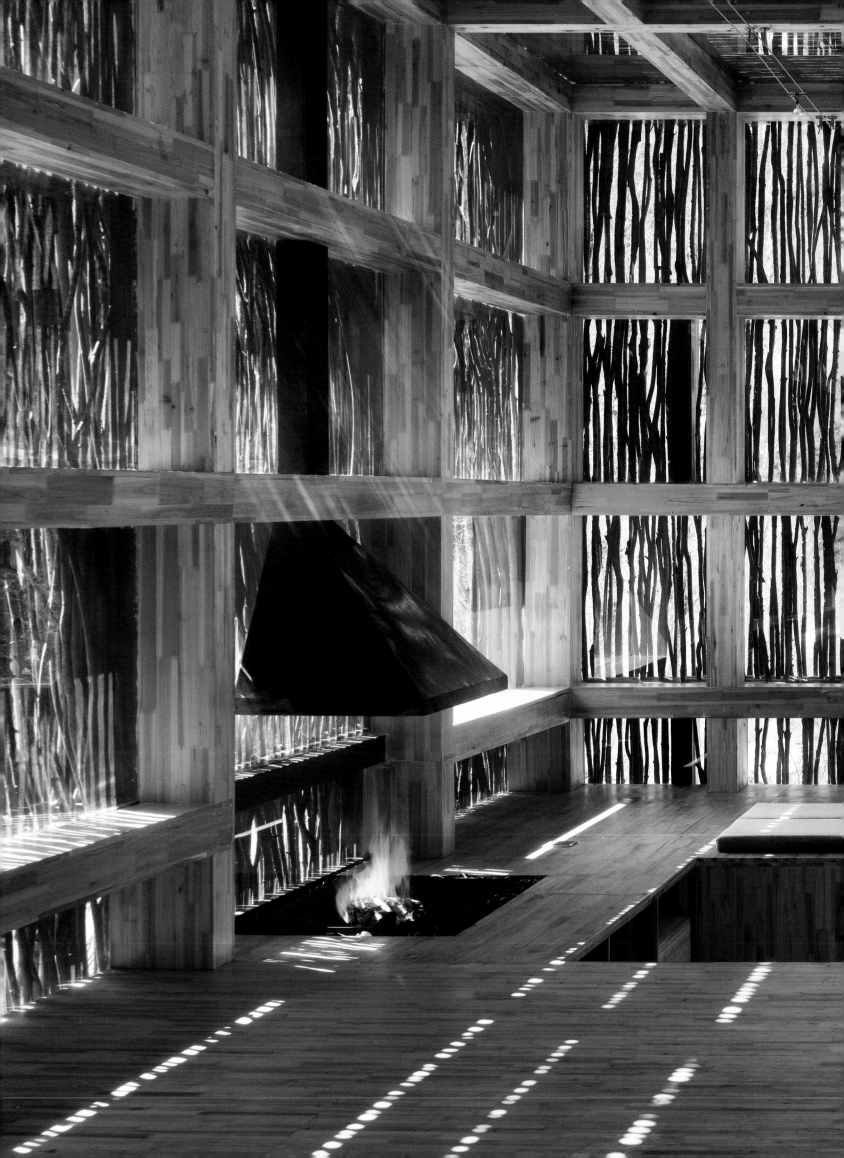

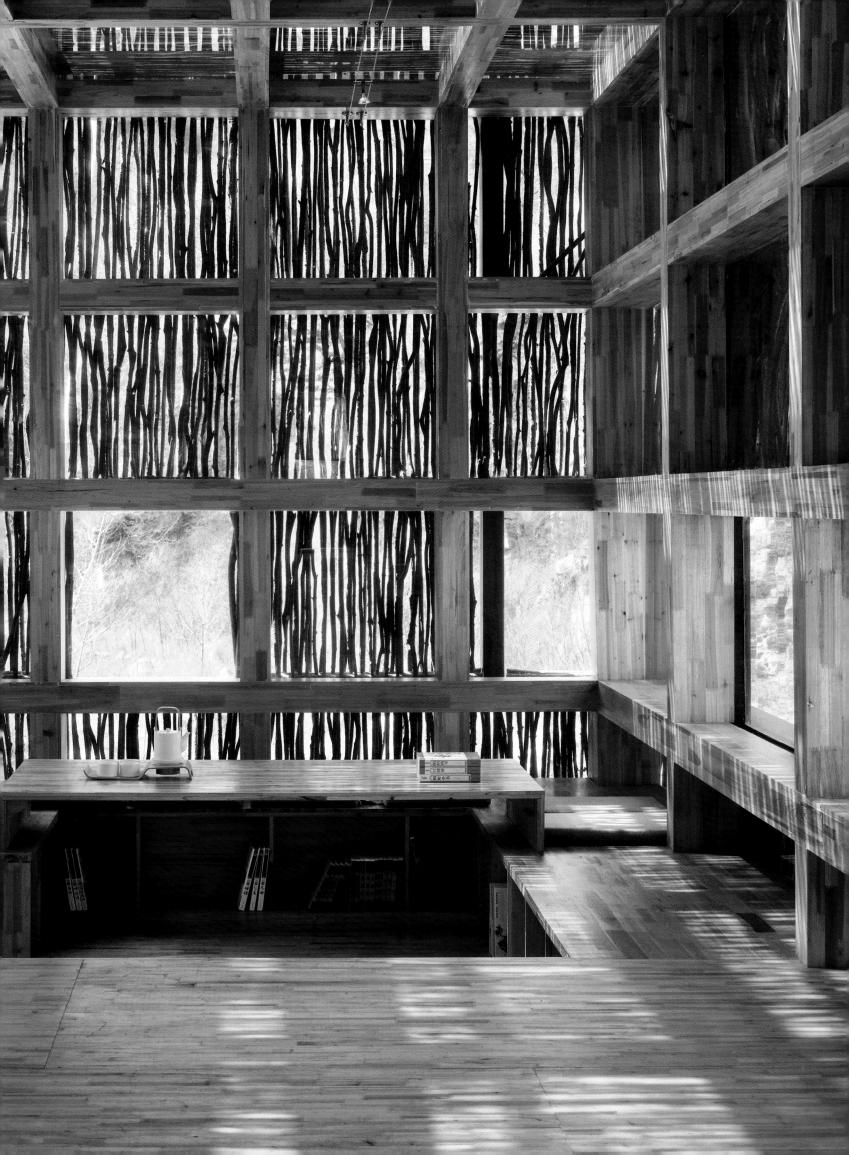

NOTES

Works included in the bibliographical essay on pages 313–15 are referred to in these notes only by the author and date of publication, together with a number in square brackets that links to the relevant entry in the essay, where full bibliographical details are provided. Website addresses have been omitted, as these tend to change.

ABBREVIATIONS
Cam.Hist.Bk. = D. McKitterick and L. Hellinga (eds), *The Cambridge History of the Book in Britain* (six vols, Cambridge, 1999–2011)

Cam.Hist.Lib. = P. Hoare (general ed.), *The Cambridge History of Libraries in Britain and Ireland* (three vols, Cambridge, 2006)

Cun.Arch.Lib. = K. Veenhof (ed.), *Cuneiform Archives and Libraries* (Leiden, 1986)

Hist.Bib.Fr. = C. Jolly, A. Vernet, D. Varry and M. Poulian (eds), *Histoire des bibliothèques Françaises* (four vols, Paris, 1988–92)

Sc.Civ.Ch. = J. Needham et al. (eds), *Science and Civilisation in China* (Cambridge, 1954–)

SCP = *Statistical Communiqué of the People's Republic of China on the 2011 National Economic and Social Development* (National Bureau of Statistics of China, 22 February 2012, accessed online)

Introduction (pages 19–35)
1 *SCP*.
2 [182] Breisch (1997), p. 15.
3 [207] Benson (2006), p. 117.
4 [207] Benson (2006), p. 117.
5 [60] Tsien (1985), p. 227.
6 [60] Tsien (1985), pp. 227–33.
7 [29] Clark (1901), p. 147.
8 [29] Clark (1901), p. 167.
9 [29] Clark (1901), p. 267.
10 [35] Masson (1981).
11 It has survived only in fragments: see [36] Casson (2001), p. 59; [37] Macleod (2005), pp. 69, 98.
12 [77] Padover (1957), p. 361.
13 [5] Polastron (2007), *passim*.
14 For a list of pests and treatments, see [278] Pinniger (2012).
15 [144] Colvin (1995), p. 43 and pl. 23.

CHAPTER ONE
Lost Beginnings: Libraries in the Ancient World (pages 36–59)
1 [39] Potts (2005), pp. 19–33, p. 19; [41] Radner and Robson (2011), pp. xxvii–87.
2 K. Veenhof, 'Cuneiform Archives: An Introduction' in [40] *Cun.Arch.Lib.* (1986), pp. 8–10.
3 K. Veenhof, 'Cuneiform Archives: An Introduction' in [40] *Cun.Arch.Lib.* (1986), p. 2.
4 Room ref. L.2769: see [42] Pettinato (1991); [43] Matthiae (1991).
5 [43] Matthiae (1991), p. 68; [42] Pettinato (1991), p. 54.
6 K. Veenhof, 'Cuneiform Archives: An Introduction' in [40] *Cun.Arch.Lib.* (1986), pp. 5–7.
7 J. Taylor, 'Tablets as Artefacts, Scribes as Artisans' in [41] Radner and Robson (2011), pp. 8–9.
8 K. Veenhof, 'Cuneiform Archives: An Introduction' in [40] *Cun.Arch.Lib.* (1986), p. 1.
9 [43] Matthiae (1991), pp. 64–5.
10 [39] Potts (2005), p. 22; K. Veenhof, 'Cuneiform Archives: An Introduction' in [40] *Cun.Arch.Lib.* (1986), pp. 11–13.
11 C. Woods et al. (eds), *Visible Language: Inventions of Writing in the Ancient Middle East and Beyond* (Chicago, 2010), p. 33.
12 [41] Radner and Robson (2011), pp. 83–5.
13 [39] Potts (2005), p. 19; [45] Reade (1986), p. 213.
14 The figures are much disputed: see [39] Potts (2005), p. 23.
15 [44] Layard (1853) pp. 344–7; [45] Reade (1986), pp. 213–22.
16 K. Veenhof, 'Cuneiform Archives: An Introduction' in [40] *Cun.Arch.Lib.* (1986), p. 12.
17 For manufacture and history, see [58] Bagnall (2009).
18 [36] Casson (2001), p. 25.
19 See J. Frosén, 'Conservation of Ancient Papyrus Materials' in [58] Bagnall (2009), pp. 79–99, p. 79.
20 [5] Harris (1999), pp. 27–33.
21 [5] Harris (1999), p. 28.
22 [36] Casson (2001), pp. 17–19.
23 Pliny, *Historia Naturalis*, pp. 13, 74–82.
24 A. Bülow-Jacobsen, 'Writing Materials in the Ancient World' in [58] Bagnall (2009), pp. 4–11.
25 W. Johnson, 'The Ancient Book' in [58] Bagnall (2009), p. 257; [36] Casson (2001), p. 25.
26 [36] Casson (2001), pp. 28–9.
27 [47] Makowieka (1978), pp. 7–13.
28 [36] Casson (2001), pp. 48–9.
29 [36] Casson (2001), p. 50; [49] Bagnall (2002), pp. 348–62, n. 24.
30 [36] Casson (2001), p. 49
31 [48] Radt (1999), pp. 165–8.
32 For discussion, see [47] Makowieka (1978), p. 17.
33 [37] Macleod (2005), pp. 1–5; [36] Casson (2001), pp. 35–6.
34 [37] Macleod (2005), pp. 5–5. On problems surrounding 'Museion', see [49] Bagnall (2002), p. 351.
35 [37] Macleod (2005), pp. 4, 6, 69–70, 98, 102; [36] Casson, p. 33
36 The legend is in *Letter of Aristeas to Philocrates* (c. 180–145 BC), trans. in R. Charles, *The Apocrypha and Pseudepigrapha of the Old Testament in English* (Oxford, 1913), vol. 2, pp. 83–122. For problems, see [49] Bagnall (2002), p. 349.
37 [36] Casson (2001), p. 34; [49] Bagnall (2002), p. 358.
38 [49] Bagnall (2002), pp. 349–51; [36] Casson, p. 34; [37] Macleod (2005), pp. 61–6.
39 [49] Bagnall (2002), pp. 351–4; [37] Macleod (2005), pp. 70–5
40 For discussion, see [49] Bagnall (2002), p. 353.
41 [37] Macleod (2005), pp. 67–9.
42 [37] Macleod (2005), pp. 9–11; 73–5; [49] Bagnall (2002), pp. 356–61; [5] Polastron (2007), pp. 16–23.
43 [37] Macleod (2005), p. 10.
44 [49] Bagnall (2002), 359–60.
45 [50] Marshall (1976); [51] Dix (1994).
46 Translation: [36] Casson (2001), p. 115
47 Excavation report, [53] Wilberg (1953); [47] Makowieka (1978), pp. 62–5.
48 [36] Casson (2001), p. 116.
49 [36] Casson (2001), p. 97.
50 W. Johnson 'The Ancient Book' in [58] Bagnall (2009), p. 259.
51 [36] Casson (2001), p. 28.
52 [49] Bagnall (2002), p. 353.
53 [51] Dix (1994), p. 287.
54 [47] Makowieka (1978), pp. 55–9.
55 [36] Casson (2001), pp. 80–1; [47] Makowieka (1978), pp. 28–33.
56 [36] Casson (2001), pp. 84–88. For doubts, see [55] Richardson (1992), p. 177; [47] Makowieka (1978), p. 55.
57 For doubts, see [55] Richardson (1992), p. 397; [51] Dix (1994), p. 288, citing [56] Seve (1990), pp. 173–9 and [57] Johnson (1984), pp. 149–84.
58 For doubts, see [55] Richardson (1992), p. 389; [51] Dix (1994), p. 288.
59 [58] Sider (2005), pp. 16–23.
60 [36] Casson (2001), pp. 74–5.
61 [36] Casson (2001), pp. 145–5; [5] Polastron (2007), pp. 36–7.

CHAPTER TWO
Cloisters, Codices and Chests: Libraries in the Middle Ages (pages 60–89)
1 [62] Haeinsa (2011), p. 10; UNESCO World Heritage Site Report online.
2 [65]*Korean Cultural Insights* (2011), pp. 70–1; UNESCO World Heritage Site Report, online.
3 [61] Sohn (1959), p. 99.
4 [64] Korean Ministry of Culture (2009), pp. 52–7.
5 [65]*Korean Cultural Insights* (2011), pp. 70–1; UNESCO World Heritage Site Report, online.
6 UNESCO World Heritage Site Report, online.
7 [61] Sohn (1959); [60] Tsien (1985).
8 [60] Tsien (1985), p. 1.
9 [59] McDermott (2006), p. 11.
10 [60] Tsien (1985), p. 325; [61] Sohn (1959), p. 98.
11 [66] Young (2004), pp. 94–5.
12 [66] Young (2004), p. 94.
13 Possibly AD 757: [67] Kidder (1964), p. 156.
14 [66] Young (2004), pp. 56–7.
15 [65] Kornicki (2001), p. 367–8.
16 [69] Goodrich (1942), p. 132.
17 [70] Guo (1999), p. 96.
18 [65] Kornicki (2001), p. 569–70.
19 [59] McDermott (2006), p. 49.
20 [59] McDermott (2006), p. 49.
21 [59] McDermott (2006), p. 50.
22 [76] Pederson (1984), p. 16
23 [76] Pederson (1984), p. 17
24 [76] Pederson (1984), pp. 101–2.
25 [76] Pederson (1984), pp. 62–6.
26 [76] Pederson (1984), pp. 104–5
27 [77] Padover (1965), p. 360–1.
28 [77] Padover (1965), p. 350; [1] Battles (2004), pp. 62–3, 66.
29 [77] Padover (1965), p. 356.
30 [77] Padover (1965), p. 354.
31 [5] Polastron (2007), p. 55.
32 Bibliothèque nationale, MS. Ref. arabe 5847
33 [5] Polastron (2007), pp. 71–2; [1] Battles (2004), pp. 66–7; [77] Padover (1965), pp. 367–8.
34 [76] Pederson (1984), pp. 128–30.
35 [84] O'Gorman (1972), p. 44.
36 [84] O'Gorman (1972), p. 17.
37 [84] O'Gorman (1972), p. 44.
38 U. Eco, *The Name of the Rose* (London, 1983) p. 1.
39 J. Ward, 'Alexandria and its Medieval Legacy: The Book, the Monk and the Rose' in [37] Macleod (2005), p. 170.
40 J. Ward, 'Alexandria and its Medieval Legacy: The Book, the Monk and the Rose' in [37] Macleod (2005), p. 170. For a different interpretation, see [94] Horn and Born (1986), pp. 16–47.
41 [59] McDermott (2006), p. 50; [77] Padover (1965), pp. 347–68.
42 J. Ward, 'Alexandria and its Medieval Legacy: The Book, the Monk and the Rose' in [37] Macleod (2005), pp. 171, 178; [84] O'Gorman (1972), p. 3.
43 J. Ward, 'Alexandria and its Medieval Legacy: The Book, the Monk and the Rose' in [37] Macleod (2005), p. 171.
44 [36] Casson, (2001), p. 52; Bagnall (2009), p. 11.
45 [87] McKitterick (1989); R. Gameson, 'The Material Fabric of Early British Books' in [73] *Cam.Hist.Bk.*, vol. 1, pp. 13–93; P. Robinson, 'The Format of Books: Books, Booklets and Rolls' in [74] *Cam.Hist.Bk.*, vol. 2, pp. 41–74; R. Thomson, N. Morgan, M. Gullick and N. Hadgraft, 'Technology of Production of the Manuscript Book' in [74] *Cam.Hist.Bk.*, vol. 2, pp. 75–109; [89] Rouse and Rouse (1990), pp. 103–15.
46 R. Thomson, N. Morgan, M. Gullick and N. Hadgraft, 'Technology of Production of the Manuscript Book' in [74] *Cam.Hist.Bk.*, vol. 2, p. 75; [91] Bell (1936–7), pp. 312–32; [92] Szirmai (1999).
47 [54] Petroski, pp. 42–5; [29] Clark (1901), pp. 292–3; for various references to the use of chests, see [9] *Cam.Hist.Lib.* (2006), pp. 37, 49, 64, 164, 358, 428, 505.
48 [29] Clark (1901), pp. 51–94.

49 [94] Horn and Born (1986), p. 16; for a rare mention of a scriptorium building, see [95] Gullick (1988), p. 7.

50 [29] Clark (1901), pp. 70–1; [71] Thompson (1957), p. 597.

51 [96] Fowler (1903), p. 83; [29] Clark (1901), p. 85.

52 [29] Clark (1901), p. 89; [25] Pevsner (1976), pp. 92–3.

53 [98] Pradié, p. 170; [80] Gameson (2006), p. 21; [29] Clark (1901), pp. 84–9.

54 [80] Gameson, pp. 21–8; [29] Clark (1901), pp. 74–82.

55 [80] Gameson, (2006), pp. 21–8.

56 [84] O'Gorman (1972), pp. 6–15.

57 [84] O'Gorman (1972), p. 16.

58 [84] O'Gorman (1972), p. 18.

59 [102] Le Goff et al. (2006).

60 [29] Clark (1901), pp. 147–54.

61 [29] Clark (1901), pp. 147–54; [81] Streeter (1931), pp. 9–13, 27, 158.

CHAPTER THREE
Cupboards, Chains and Stalls: Libraries in the 16th Century (pages 91–119)

1 [103] Situ (2007), pp. 421–30.

2 [104] Luo (1993), p. 3.

3 [106] Ren (2001), vol. 2, p. 1012.

4 Tsien in [60] *Sc.Civ.Chin.* (1954–), vol. 5, pt 1, p. 40.

5 [105] Tsien (2004), p. 81.

6 Hu Ying, 'Yunju Si Cangjing Dong 53 Zai Zai Kaidong' [Re-opening the Sutra Library Cave in Yunju Temple after Fifty-three Years'], *Beijing Daily*, 5 June 2009.

7 [60] Tsien (1985), pp. 29–33.

8 [60] Tsien (1985), p. 126.

9 [60] Tsien (1985), p. 52.

10 [60] Tsien (1985), p. 40.

11 [60] Tsien (1985), p. 126.

12 [60] Tsien (1985), pp. 84–132.

13 [105] Tsien (2004), pp. 150–4.

14 [59] McDermott (2006), p. 126.

15 [106] Ren (2001), vol. 1, p. 206.

16 See J. Needham and L. Wang, 'Mechanical Engineering', *Sc.Civ.Chin.*, vol. 4, pt 2 (1965), p. 162.

17 E. Wilkinson, *Chinese History: A Manual* (Cambridge, Mass., 1998), p. 474.

18 Ibid.

19 Ibid.

20 [106] Ren (2001), vol. 1, p. 86.

21 D. Twitchett and P. Smith, *The Cambridge History of China*, vol. 9, pt 1, *The Ch'ing Empire to 1800* (Cambridge, 2002), p. 285.

22 [59] McDermott (2006), p. 137.

23 [106] Ren (2001), vol. 2, pp. 1337–73.

24 [84] O'Gorman (1972), pp. 4, 57–9.

25 [84] O'Gorman (1972), p. 19.

26 [109] Howard (1975), p. 163, n. 41; [110] Labowsky (1980), pp. 4–100.

27 N. Mann, 'The Origins of Humanism' in J. Kraye, *Renaissance Humanism* (Cambridge, 1996), pp. 1–19, at pp. 1–2.

28 [110] Labowsky (1980), pp. 25, 52.

29 [109] Howard (1975), pp. 18–19.

30 [109] Howard (1975), p. 20.

31 [109] Howard (1975), p. 25.

32 [110] Labowsky (1980), pp. 95–7.

33 [109] Howard (1975), p. 21.

34 [112] Wittchower (1934), pp. 125–218; [113] Corti and Parronchi (1965), pp. 9–31.

35 [114] Argan and Contardi (1993), pp. 117–45.

36 [112] Wittkower (1934); [115] Hemsoll (2003), pp. 29–62.

37 [111] Ackerman (1986), p. 102.

38 [84] O'Gorman (1972), pp. 29–30.

39 [114] Argan and Contardi (1993), p. 117.

40 [111] Ackerman (1986), pp. 37–8.

41 [117] Jardine (1996).

42 [8] Hobson (1970), pp. 85–91; [6] Staikos, pp. 339–56.

43 [112] Wittkower (1934), pp. 145–6.

44 [29] Clark (1901), pp. 202–26.

45 [8] Hobson (1970), pp. 79–80.

46 E.g., [117] Jardine (1996), pp. 183–9.

47 See [118] Raggio and Wilmering (1999).

48 [29] Clark (1901), pp. 291–520; [34] Petroski (1999), pp. 100–28.

49 For the case in England, see F. Howard and F. Crossley, *English Church Woodwork* (London, 1917), p. 297;

J. Cox and A. Harvey, *English Church Furniture* (London, 1907), p. 265.

50 [29] Clark (1901), Fig. 103.

51 [81] Streeter, pp. 35–41, 69–72; [88] Gameson (2012), p. 61.

52 [80] Gameson (2006), p. 35.

53 [84] O'Gorman (1972), p. 4.

54 [29] Clark (1901), pp. 147–53.

55 [29] Clark (1901), pp. 233–4.

56 The mistake is first made in [81] Streeter (1931). For analysis, see [122] Ker (1985), pp. 429–31. Streeter's mistake is still repeated, in e.g. [2] Lerner (2009), p. 73; [28] Cosme (2004), p. 70.

57 [124] Newman (1978), pp. 248–57; [125] Newman (1997), pp. 146–55.

58 [124] Newman (1978); [125] Newman (1997), pp. 147–8.

59 [124] Newman (1978), pp. 248–57; [125] Newman (1997), pp. 147–8.

60 [125] Newman (1997), pp. 146–8.

61 [81] Streeter (1931), pp. 273–9; [101] Wells (2006), pp. 19–21.

62 [122] Ker (1985), pp. 429–31.

63 [125] Sargent (2006), pp. 51–65, 57–9; replacing [81] Streeter, pp. 27–35.

64 [81] Streeter (1931), pp. 28–9.

CHAPTER FOUR
Walls, Domes and Alcoves: Libraries in the 17th Century
(pages 120–51)

1 [34] Petroski (1999), pp. 101–28; [29] Clark (1901), pp. 291–520.

2 [131] Kamen (2010), p. 142.

3 [132] Kubler (1982), pp. 95–7.

4 [95] Middleton (1963).

5 On lectern capacities, see [119] Gaskell (1980), pp. 6–7.

6 [241] Thompson (1973), p. 80.

7 [29] Clark (1901), pp. 269–70; [8] Hobson (1970), pp. 186–201.

8 Quoted in [8] Hobson (1970), p. 194.

9 [126] Tyacke (1997), pp. 147–9, 659–66.

10 [125] Newman (1997), p. 158.

11 [125] Newman (1997), p. 151

12 [123] Sargent (2006), p. 55.

13 [125] Newman (1997), p. 162.

14 [6] Staikos (2000), pp. 478–9; [26] Masson (1972), pp. 173–4.

15 [6] Staikos (2000), pp. 478–9; [26] Masson (1972), pp. 173–4.

16 [5] Polastron (2007), *passim*.

17 [132] Kubler (1982), pp. 119–122.

18 C. Mignot, 'Première "Bibliothèque Mazarine," rue de Richelieu' in [129] Bacha and Hottin (2002), pp. 68–70, and J. Barreau, 'Sainte-Geneviève du Mont' in [129] Bacha and Hottin (2002), pp. 73–6.

19 I. Rowland and T. Howe (eds), *Vitruvius: 'Ten Books on Architecture'* (Cambridge, 1999), pp. 21–4.

20 J. Rykwert, N. Leach, R. Tavenor, *Leon Battista Alberti: On the Art of Building in Ten Books* (Cambridge, Mass., 1988), p. x.

21 Claude Mignot, 'Première "bibliothèque Mazarine," rue de Richelieu' in [129] Bacha and Hottin (2002), pp. 68–71.

22 [139] Wren Society, vol. 13, pp. 40–3; M. Whinney, 'Sir Christopher Wren's Visit to Paris', *Gazette des Beaux-Arts*, 51 (1958), pp. 229–42.

23 [141] Linnell (1983), pp. 126–40.

24 [139] Wren Society, vol. 17, pp. 76–7; [144] Colvin (1995), pp. 33–4.

25 [142] Knoop and Jones (1935), p. 43.

26 [143] Newman (2006), p. 197; [139] *Wren Society*, vol. 5, p. 31; vol. 19, p. xi; [144] Colvin (1995), p. 30.

27 [145] Ramsay (2004), pp. 421–2; [143] Newman (2006), p. 200.

28 [124] Newman (1978), p. 253.

29 [125] Newman (1997), p. 191; [127] Barber (1995), p. 102.

30 [125] Newman (1997), p. 191.

31 [135] McKitterick (1995), pp. 16–20.

32 [135] McKitterick (1995), p. 5.

33 [135] McKitterick (1995), pp. 6–8.

34 [135] McKitterick (1995), pp. 52–5.

35 [144] Colvin (1995), p. 33.

36 [144] Colvin (1995), pp. 33–4; [143] Newman (2006), pp. 195–6.

37 [144] Colvin (1995), pp. 33.

38 [144] Colvin (1995), pp. 56.

39 [135] McKitterick (1995), p. 113.

40 [135] McKitterick (1995), pp. 16–20.

41 [144] Colvin (1995), pp. 32–5.

42 [150] Gillam (1958), pp. vii–viii.

43 [150] Gillam (1958), p. xxi.

44 [8] Hobson (1970), pp. 202–11.

45 [8] Hobson (1970), p. 211.

46 [153] Colvin and Simmons (1989), pp. 19–46; [154] Maclean (2008), p. 20.

47 [153] Colvin and Simmons (1989), pp. 19–46; [154] Maclean (2008), p. 20.

48 [127] Barber (1995), p. 102.

49 [29] Clark (1901), pp. 518–19; [34] Petroski (1999), pp. 126–8; J.-P. Willesme, 'Saint-Victor…' in [129] Bacha and Hottin (2002), pp. 77–9.

CHAPTER FIVE
Angels, Frescoes and Secret Doors: Libraries in the 18th Century
(pages 152–203)

1 [155] Hitchcock (1968), pp. 1–17. On problems with French origins, see [156] Harries (1983), pp. 1–47.

2 [160] Garberson (1998), pp. 103–4.

3 [161] Coimbra (1998), p. 7.

4 [84] O'Gorman (1972), p. 6.

5 [161] Coimbra (1998), pp. 8–11.

6 [1] Battles (2004), p. 92.

7 Quoted in [8] Hobson (1970), p. 143.

8 B. de Andia, 'Les Temples du savoir' in [129] Bacha and Hottin (2002), p. 8.

9 See J. Levine, *The Battle of the Books: History and Literature in the Augustan Age* (Ithaca, NY, 1991); R. James, *Ancients and Moderns* (New York, 1982).

10 Library website.

11 Library website.

12 [8] Hobson (1970), p. 235.

13 [162] Smith (1973), p. 562.

14 [162] Smith (1973), p. 563.

15 [18] Bosser and de Laubier (2003), p. 200.

16 [18] Bosser and de Laubier (2003), p. 200; [163] Pereira (1996–).

17 [18] Bosser and de Laubier (2003), p. 201.

18 [18] Bosser and de Laubier (2003), p. 201.

19 [18] Bosser and de Laubier (2003), p. 201.

20 [165] Dotson (2012), p. 7.

21 [167] Kubadinow (2004), p. 20.

22 On the importance of festivals and pageants, see [165] Dotson (2012), pp. 5–17; [166] Strong (1984).

23 [165] Dotson (2012), pp. 19–23.

24 [165] Dotson (2012), pp. 5–17.

25 [165] Dotson (2012), pp. 133–56.

26 J. Barreau, 'Sainte-Geneviève du Mont' in [129] Bacha and Hottin (2002), pp. 74–75.

27 [170] Braham and Hager (1977), p. 16; [171] Hager.

28 [169] Pietrangeli (1993), pp. 13–14.

29 Library website.

30 [172] Pane et al. (1973), pp. 61–2.

31 [160] Garberson (1998), pp. 15–18.

32 [173] Ellegast et al. (2008), pp. 1–21.

33 [173] Ellegast et al. (2008), p. 18.

34 [173] Ellegast et al. (2008), p. 18.

35 [160] Garberson, pp. 86–88, 167–8; [157] Lehmann, pp. 99–100.

36 [160] Garberson (1998), pp. 100–4.

37 [160] Garberson (1998), p. 104.

38 [160] Garberson (1998), p. 86.

39 [160] Garberson (1998), pp. 82–3.

40 [157] Lehmann (1996), pp. 198–9.

41 [160] Garberson (1998), pp. 12–15, 86–7.

42 [160] Garberson (1998), vol. 1, p. 87.

43 [157] Lehmann (1996), p. 252, figs. 206, 298; [160] Garberson (1998), p. 156.

44 [157] Lehmann (1996), p. 112.

45 [160] Garberson (1998), p. 189.

46 [160] Garberson (1998), p. 189.

47 Typologies in [158] Adriani and [157] Lehmann, disproved in [160] Garberson (1998), pp. 84–5.

48 [157] Lehmann (1996), vol. 1, p. 103; [160] Garberson (1998), p. 178.

49 I. Rowland and T. Howe (eds), *Vitruvius: 'Ten Books on Architecture'* (Cambridge, 1999), p. 25.

50 [160] Garberson (1998), pp. 65–71.
51 [160] Garberson (1998), pp. 89–90, 178.
52 [160] Garberson (1998), p. 95.
53 [160] Garberson (1998), pp. 46–50.
54 [176] Tremp et al. (2007), pp. 9–12.
55 [176] Tremp et al. (2007), p. 25.
56 [176] Tremp et al. (2007), p. 33.
57 [176] Tremp et al. (2007), pp. 58–9.
58 [176] Tremp et al. (2007), pp. 58–9; [160] Garberson (1998), p. 179.
59 For a life of Pozzo, see R. Bösel. 'Andrea Pozzo,' *Grove Dictionary of Art* (1998); B. Kerber, *Andrea Pozzo* (Berlin, 1971).
60 [160] Garberson (1998), p. 154.
61 A. Gerhardt, 'Admont Abbey', Grove Art Online.
62 [160] Garberson (1998), pp. 70, 80–1, 154–5.
63 [160] Garberson (1998), pp. 110–11.
64 [160] Garberson (1998), pp. 100–4.
65 [160] Garberson (1998), pp. 18–27.
66 [160] Garberson (1998), pp. 134–6.
67 [160] Garberson (1998), pp. 134–6.
68 [18] Bosser and de Laubier (2003), p. 25.
69 Library website

CHAPTER SIX
Iron Stacks, Gas Lights and Card Catalogues
(pages 204–43)

1 [185] Girouard (1978), pp. 234–7.
2 See P. Harris, 'The First Century of the British Museum Library' in [10] *Cam.Hist.Lib.*, vol. 2, pp. 405–21, and M. Spevack, 'The Impact of the British Museum Library' in [10] *Cam.Hist.Lib.*, vol. 2, pp. 458–58.
3 [179] Port (2006), pp. 459–78.
4 [186] Snodin (2009), pp. 37–42.
5 [179] Port (2006), p. 208.
6 [187] Wesch (2005), pp. 31–3.
7 [188] Reid (2001), pp. 345–66.
8 [190] Wills (2002), pp. 5–86.
9 [190] Wills (2002), pp. 89–115.
10 [193] Winckelmann (1756).
11 [194] Laugier (1753).
12 On these libraries, see G. Fonkenell, 'Projets au Louvre' in [129] Bacha and Hottin (2002), pp. 55–5; [179] Port (2006), pp. 465–8; and [196] Pérouse de Montclos in [129] Bacha and Hottin (2002), p. 56.
13 [196] Pérouse de Montclos in [129] Bacha and Hottin (2002), p. 56.
14 [184] Crass (1976).
15 [25] Pevsner (1976), p. 104.
16 [199] Chafee (1977), pp. 61–109; [201] Drexler (1977), pp. 417–93.
17 [202] Sérullaz (1977), pp. 187–91.
18 [203] Papworth and Papworth (1853); [178] Black et al. (2009), pp. 75–6.
19 [202] Sérullaz (1977).
20 [204] Watkin (1974), pp. 183.
21 [204] Watkin (1974), pp. 184–7.
22 [204] Watkin (1974), pp. 186–96, pls. 85–99.
23 [205] Watkin, (1983), p. 90.
24 On Edinburgh, see [179] Port (2006), pp. 462–8. On Gore Hall and Trinity College, Dublin, see [182] Breisch (1997), pp. 60–4.
25 [182] Breisch (1997), pp. 63–64, ns 17–18.
26 [182] Breisch (1997), pp. 462–9.
27 [209] Pöykkö, Grove Art Online.
28 [209] Pöykkö, Grove Art Online.
29 D. Zanten, 'Architectural Composition at the Ecole des Beaux-Arts from Charles Percier to Charles Garnier', in [200] Drexler, pp. 111–323.
30 [210] Levine (1977), pp. 325–416.
31 [211] Vendredi-Auzanneau (2002), pp. 158–42; [210] Levine (1977), p. 340.
32 [213] Saint (2007), pp. 65–106.
33 For the use of gas leading to an iron frame, see [210] Levine (1977), pp. 325–411. Labrouste himself claimed that iron was used to increase light. See ibid. and [54] Petroski (1999), p. 169; [178] Black et al. (2009), pp. 76–7.
34 [210] Levine (1977), p. 340.
35 [210] Levine (1977), pp. 358–49.
36 [210] Levine (1977), pp. 350–2.
37 [201] Drexler (1977), pp. 468–9.

58 [201] Drexler (1977), pp. 430–1.
59 [214] Foucaud (2002), pp. 110–14.
40 [1] Battles (2004), pp. 128–34.
41 [215] Esdaile (1946), pp. 86–9, 117–24; [178] Black et al. (2009), pp. 78–80.
42 [178] Black et al. (2009), p. 78.
43 [18] Bosser and de Laubier (2003), pp. 218–20.
44 [182] Breisch (1997), pp. 68–71.
45 On Boston, see [182] Breisch (1997), pp. 73–9; [178] Black et al. (2009), pp. 85–6; on Cincinnati, see [182] Breisch (1997), pp. 77, 222–3; [217] Belfoure (2009), pp. 129–31.
46 [217] Belfoure (2009), pp. 65–5.
47 [217] Belfoure (2009), *passim*.
48 [217] Belfoure (2009), pp. 124–56.
49 G. Tweedale, 'Andrew Carnegie (1855–1919), Steelmaker and Philanthropist', *Oxford Dictionary of National Biography*; [178] Black et al. (2009), p. 158.
50 For a good bibliography, see [178] Black et al. (2009), p. 21, ns 36–7, pp. 435–55.
51 [182] Breisch (1997), pp. 5, 7, 152–91.
52 [182] Breisch (1997), p. 268.
55 [1] Battles (2004), pp. 148–55.
54 [182] Breisch (1997), pp. 73–83; [178] Black et al. (2009), pp. 211–40.
55 Ibid.
56 [1] Battles (2004), p. 142.
57 P. Moorish, 'Library Management in the Pre-Professional Age' in [10] *Cam.Hist.Lib.* (2006), vol. 2, p. 490.
58 [1] Battles (2004), p. 104.
59 [5] Polastron (2007), p. 154.
60 [1] Battles (2004), p. 142.
61 [1] Battles (2004), pp. 137–45.
62 [178] Black et al. (2009), pp. 100–6.
63 [218] Nicolson and Tedder (1878), pp. 147–8, quoted in [178] Black et al. (2009), p. 104.
64 [178] Black et al. (2009), pp. 27–63.
65 [178] Black et al. (2009), p. 48.
66 [219] Bosley (1996), pp. 12–15.
67 [219] Bosley (1996), p. 8.
68 [219] Bosley (1996), pp. 22–3, 60.

CHAPTER SEVEN
Electricity, Concrete and Steel: Libraries in the 20th Century (pages 244–85)

1 [25] Pevsner (1976), pp. 108–10.
2 [5] Harris (1999), p. 218.
3 [182] Breisch (1997), pp. 6, 256–69.
4 [178] Black et al. (2009), pp. 187–201.
5 [223] Macaulay (1993), pp. 2–3
6 [223] Macaulay (1993), p. 5
7 [223] Macaulay (1993), pp. 3–4.
8 [223] Macaulay (1993), p. 21.
9 [223] Macaulay (1993), p. 21.
10 [224] Dain (2000), pp. 11–14; [225] Reed and Morrone (2011), pp. 19–21.
11 [225] Reed and Morrone (2011), p. 22.
12 [224] Dain (2000), pp. 19–23.
13 [18] Bosser (2003), pp. 228–9.
14 [225] Reed and Morrone (2011), *passim*.
15 [227] Burgoyne (1905), pp. 19–25.
16 [228] Brox (2010).
17 [228] Brox (2010), pp. 110–27 (who underplays the role of Joseph Swan, see [229] Poulter (1986), pp. 23–6).
18 [228] Brox (2010), pp. 102–9.
19 [54] Petroski (2000), p. 174; [178] Black et al. (2009), pp. 285–6, 289; [230] Prizeman (2012), pp. 74–5; [228] Poulter (1986), pp. 22–3.
20 [229] Poulter (1986), pp. 30–9.
21 [230] Prizeman (2012), p. 61.
22 [230] Prizeman (2012), pp. 65–9.
23 [178] Black et al. (2009), p. 22.
24 [184] Crass (1976), pls. 6–12.
25 [232] *University of London* (1958), *passim*.
26 A. Ikonnikov, 'Vladimir Shchuko', Grove Art Online.
27 [233] Blundell Jones (2006), p. 111.
28 [233] Blundell Jones (2006), p. 112; [184] Crass (1976), *passim*; [226] Burgoyne (1905), pp. 279–82.
29 [233] Blundell Jones (2006), pp. 117–25.
30 C. Ledoux, *Architecture (1847)* (repr., Princeton, 1983), pls 25, 35; influence refuted in [233] Blundell Jones

(2006), p. 117.
51 [233] Blundell Jones (2006), p. 117.
52 [233] Blundell Jones (2006), pp. 127–68.
53 [254] Gooding (1997), *passim*.
54 [235] Krinsky, (1988), pp. 141–2; [256] 'Oral History of Gordon Bunshaft', accessed online.
55 [235] Krinsky, (1988), pp. 144–5.
56 [33] Brawne (1970), pp. 22–9.
57 [33] Brawne (1970), p. 22; [237] Weston (2002), pp. 63–9.
58 [33] Brawne (1970), p. 23.
59 [33] Brawne (1970), pp. 24, 26.
40 [237] Weston (2002), pp. 172–84.
41 [239] Blundell Jones (1995), p. 196 and *passim*.
42 [258] Blundell Jones (1995), pp. 174–95.
43 [258] Blundell Jones (1995), p. 198.
44 [33] Brawne (1970); [240] Metcalf (1965); [241] Thompson (1975).
45 [242] Brownlee and De Long (1991), p. 390.
46 [243] McCarter (2005), p. 505.
47 [243] McCarter (2005), p. 505.
48 [240] Metcalf (1965), pp. 516–17.
49 [5] Polastron (2007), pp. 267–81.
50 [244] Spens (1997); [246] Stonehouse and Stromberg (2004).
51 [248] Perrault and Jacques (ed.) (1995), pp. 18–23.
52 [244] Spens (1997), p. 21.
53 [249] Wortmann, (1998), p. 67.
54 [249] Wortmann, (1998), p. 71.
55 [249] Wortmann, (1998), p. 71; [250] Lootsma (1999), p. 29; [251] Van Cleef (1999), pp. 45–9.

CHAPTER EIGHT
The Future of Libraries in the Electronic Age
(pages 284–309)

1 On these libraries, see [252] 'Oita New Prefectural Library' (1993); [255] Moholy-Nagy, (1969); [33] Brawne (1970), pp. 100–3.
2 On these libraries, see [254] Futagawa (2006), pp. 206–13, 240–7; [255] Spinelli (2012), pp. 154–6; [261] Arets (2005), p. 162.
3 [256] Webb (2003); [256] Martin (2008).
4 [258] 'Herzog and de Meuron' (2005); [259] Webb (2006); [260] Gänshirt (2005).
5 [260] Gänshirt (2005).
6 [260] Gänshirt (2005).
7 [279] Lyons (2011), pp. 204–13.
8 [278] Shepherd; [261] Arets (2005), p. 112.
9 [261] Arets (2005), p. 112.
10 [261] Arets (2005), p. 330, and *passim*; [262] Betsky (2005); [265] 'Wiel Arets: Library Utrecht' (2005).
11 [264] 'Wiel Arets: Library Utrecht' (2012), p. 34.
12 [264] 'Wiel Arets: Library Utrecht' (2012), p. 137.
13 [265] Cilento (2009).
14 [265] Cilento (2009).
15 [266] BeijingReview.com (2008–9).
16 [267] Ting (1981), pp. 417–34.
17 Statistics from the Beijing National Library website; [268] Gu (1999), pp. 33–40.
18 [25] Pevsner (1976), p. 100.
19 [25] Pevsner (1976), p. 106.
20 [34] Petroski (1999), pp. 176–84.
21 [34] Petroski (1999), pp. 176–84.
22 [34] Petroski (1999), pp. 206–9.
23 [269] Hoare (2006), p. 345.
24 [34] Petroski (1999), pp. 209–12.
25 [270] Hopson (2006).
26 [271] Davis (2004), pp. 28–52.
27 Bodleian Library website
28 [271] Davis (2004), pp. 28–52.
29 [272] 'Max Dudler: Jacob and Wilhelm Grimm Center, Berlin, Germany 2005–2009' (2010).
30 [273] Kaltenbach (2009), p. 1315.
31 SCP.
52 [182] Breisch (1997), p. 13.
33 [274] Chiorino and Zappa (2012), pp. 32–9; [275] Xiadong (2012), pp. 60–5; [276] Li (2012).

BIBLIOGRAPHICAL ESSAY

GENERAL SURVEYS

The history of libraries has attracted an immense literature but, as many writers have noted, most of it concentrates on the book collections and says comparatively little about the buildings that contain them. The best general introductions in English to the history of libraries are [1] M. Battles, *Library: An Unquiet History* (London, 2003), [2] F. Lerner, *The Story of Libraries* (London, 2009) and [3] M. Harris, *A History of Libraries in the Western World* (4th ed., London, 1999). [4] L. Polastron, *Livres en feu* (Paris, 2004), translated by J. Graham as [5] *Books on Fire* (London, 2007), provides a guide to the tragic history of their loss and destruction. [6] K. Staikos, *Great Libraries* (London, 2000) covers the period 3000 BC to AD 1600 and [7] K. Staikos, *The History of the Library in Western Civilization* (London, 2000–12), vols 1–4, covers the earlier periods. [8] A. Hobson, *Great Libraries* (London, 1970) provides a good short introduction to both architecture and collections, with an excellent bibliography.

In the UK, the study of libraries has been transformed by the recent publication of the three volumes of *The Cambridge History of Libraries in Britain and Ireland* (Cambridge, 2006), hereafter *Cam.Hist.Lib.*: [9] vol. 1, edited by E. Leedham-Green and T. Webber, covers the period up to 1640; [10] vol. 2, by G. Mandelbrote and K. Manley, covers 1640–1850, and [11] vol. 3, edited by A. Black and P. Hoare, covers 1850–2000. This has replaced previous studies such as [12] F. Wormald and C. Wright, *The English Library before 1700* (London, 1958). For France, see [13] C. Jolly, A. Vernet, D. Varry and M. Poulian (eds), *Histoire des bibliothèques Françaises* (4 vols, Paris, 1988–92), hereafter *Hist.Bib.Fr.*, and in German, the first three volumes of the series [14] L. Buzás, *Elemente Des Buch- und Bibliothekswesens* (Wiesbaden, 1975–8), translated into English in a single volume by W. Boyd as [15] *German Library History, 800–1945* (London, 1986), which contains short chapters on library building. More recently, [16] W. Nerdinger (ed.), *Die Weisheit baut sich ein Haus* (Munich, 2011) contains some interesting introductory essays.

There are a number of picture books on libraries, such as [17] W. Löschburg, *Historic Libraries of Europe* (Leipzig, 1974) and [18] J. Bosser and G. de Laubier, *Bibliothèques du monde* (Paris, 2003), translated by L. Hirsch as [19] *The Most Beautiful Libraries in the World* (London, 2003). The latter has good essays on individual libraries. [20] C. Hofer, *Libraries* (London, 2005) and [21] A. Ertug, *Temples of Knowledge* (Istanbul, 2010) are purely photographic studies. [22] D. Stam (ed.), *International Dictionary of Library Histories* (London, 2001) and [23] W. Wiegand and D. Davis, *Encyclopedia of Library History* (New York, 1994) contain surprisingly little on buildings. [24] The journal *Library Literature and Information Science* (New York, 1980–) provides an annual review of articles relating to libraries in over 400 titles.

HISTORIES OF LIBRARY BUILDINGS

The best overview of library buildings is still [25] N. Pevsner, *A History of Building Types* (London, 1976), pp. 91–110, although it is beginning to look dated. See also [26] A. Masson, *Le Décor des bibliothèques de Moyen Age à la Révolution* (Geneva, 1972) and [27] M. Baur-Heinhold, *Schöne alte Bibliotheken* (Munich, 1972), which both cover the Middle Ages to c. 1800, and [28] A. Cosme, *Los Espacios del Saber: Historia de la Arquitectura de las Bibliotecas* (Gijón, 2004), which provides a compact overview of the whole history of libraries in Europe, with plans and a good bibliography. In English, the most substantial study before Pevsner was [29] J. Clark, *The Care of Books* (Cambridge, 1901), which had begun as an expansion of his chapter on libraries in [30] R. Willis and J. Clark, *Architectural History of the University of Cambridge* (four vols, Cambridge, 1886). Clark's research was extremely thorough and has held up remarkably well, but inevitably a number of his conclusions have had to be revised in light of subsequent scholarship: see [31] P. S. Morrish,

'John Willis Clark Revisited: Aspects of Early Modern Library Design', *Library History*, 3, no. 3 (spring 1974), pp. 87–107. [32] A. Thompson, *Library Buildings of Britain and Europe* (London, 1963) and [33] M. Brawne, *Libraries: Architecture and Equipment* (London, 1970) contain short historical chapters, but are chiefly useful for their illustrations of 20th-century buildings. [34] H. Petroski, *The Book on the Bookshelf* (New York, 1999) provides an entertaining history of the bookshelf and its role in library design. For an introduction to library decoration, see [35] A. Masson, *The Pictorial Catalogue* (Oxford, 1981).

LIBRARIES IN THE ANCIENT WORLD

The best single-volume introduction is [36] L. Casson, *Libraries in the Ancient World* (London, 2001). The essays in [37] R. MacLeod, *The Library of Alexandria* (London, 2005) are also immensely useful. They cover the period from the first libraries to the Middle Ages. A good introduction to writing materials in this period can be found in [38] R. Bagnall (ed.), *The Oxford Handbook of Papyrology* (Oxford, 2009). There is an introduction to Mesopotamian libraries in [39] D. Potts, 'Before Alexandria: Libraries in the Near East', in [37] MacLeod, pp. 19–34. [40] K. Veenhof (ed.), *Cuneiform Archives and Libraries* (Leiden, 1986), hereafter *Cun.Arch. Lib.*, contains many very useful papers. For clay tablets, see [41] K. Radner and E. Robson, *The Oxford Handbook of Cuneiform Culture* (Oxford, 2011). For the palace at Ebla, see [42] G. Pettinato, *Ebla* (Baltimore, 1991) and [43] P. Matthiae, 'The Archives of the Royal Palace G of Ebla' in [40] *Cun.Arch.Lib.*, pp. 53–71. Sir Henry Layard published several accounts of his exploits and excavations, including [44] A. Layard, *Nineveh and its Remains* (two vols, London, 1848–9). For a modern account of the library at Nineveh, see [45] J. Reade, 'Archaeology and the Kuyunjik Archive', in [40] *Cun.Arch.Lib.*, pp. 213–22. A short overview of Egyptian libraries in English is provided in [3] Harris, pp. 27–35. The best summary is [46] G. Burkard, 'Bibliotheken im alten Ägypten', *Bibliothek Forschung und Praxis*, 4, no. 2 (1980), pp. 79–115.

For a discussion of the form of Greek libraries, see [36] Casson and [47] E. Makowiecka, 'The Origin and Evolution of Architectural Form of [the] Roman Library', *Studia Antiqua*, 1 (1978). On Pergamon, see [36] Casson and [48] W. Radt, *Pergamon: Geschichte und Bauten einer antiken Metropole* (Darmstadt, 1999), pp. 165–8. [49] R. Bagnall, 'Alexandria: Library of Dreams', *Proceedings of the American Philosophical Society*, 146, no. 4 (Dec. 2002), pp. 348–62, provides a sceptical view on the size of collections during this period. [50] A. Marshall, 'Library Resources and Creative Writing at Rome', *Phoenix*, 30, no. 3 (1976), pp. 252–64, and [51] T. Dix, 'Public Libraries in Ancient Rome: Ideology and Reality', *Libraries and Culture*, 29, no. 3 (1994), pp. 282–96, provide good introductions to Roman libraries. For the library of Celsus, I have used [52] V. Strocker, 'The Celsus Library in Ephesus', *Ancient Libraries in Anatolia* (Ankara, 2003), pp. 33–43. The archaeological reports were published in [53] W. Wilberg (ed.), *Forschungen in Ephesos* (Vienna, 1953). For Timgad, see [54] H. Pfeiffer, 'The Roman Library at Timgad', *Memoirs of the American Academy in Rome*, 9 (1931), pp. 157–65. [56] Casson and [47] Makowiecka both provide good introductions to the libraries of Rome itself. For doubts, see [55] L. Richardson, *A New Topographical Dictionary of Ancient Rome* (Baltimore, 1992), p. 397; [51] Dix, p. 288, citing [56] M. Sève, 'Sur le taille des rayonnages dans les bibliothèques antiques', *Revue de Philologie*, 117 (1990), pp. 173–9; and [57] L. Johnson, 'The Hellenistic and Roman Library: Studies Pertaining to their Architectural Form' (Ph.D. dissertation, Brown University, 1984), pp. 149–84 (which I have not seen). For a bibliography of the Villa of the Papyri, see [58] D. Sider, *The Library of the Villa Dei Papiri at Herculaneum* (Los Angeles, 2005), pp. 16–23.

EARLY JAPANESE AND KOREAN LIBRARIES

There is very little literature available in English on Chinese, Korean and Japanese library buildings. Good introductions to the subject of printing in East Asia can be found in [59] J. McDermott, *A Social History of the Chinese Book* (Hong Kong, 2006) and [60] T.-H. Tsien, *Science and Civilisation in China*, vol. 5, *Chemistry and Chemical Technology: Part I: Papermaking and Printing* (Cambridge, 1985). See also [61] Pow-key Sohn, 'Early Korean Printing', *Journal of the American Oriental Society*, 79, no. 2 (1959), pp. 96–103. On the Haeinsa Temple, see [62] *Millennial Anniversary of the Tripitaka Koreana* (Haeinsa, 2011); [63] *Korean Cultural Insights* (Seoul [2011]) and [64] *Korean Documents on UNESCO's Memory of the World Register* (Seoul, 2009), but the most reliable source in English is the UNESCO World Heritage Site Report, available online. The best introduction in English to Japanese libraries is [65] P. Kornicki, *The Book in Japan* (Hawaii, 2001). For basic introductions to Japanese architecture, see [66] D. and M. Young, *Introduction to Japanese Architecture* (Hong Kong, 2004) and [67] J. Kidder, *Japanese Temples* (Tokyo, 1964). The Tōshōdai-ji sutra house is briefly covered in [68] B. Kurata, *Tōshōdaiji* (Tōshōdai-ji, 1985). For revolving sutra cases, see [69] L. Goodrich, 'The Revolving Book-Case in China', in *Harvard Journal of Asiatic Studies*, 7, no. 2 (July 1942), pp. 130–61, and [70] Q. Guo, 'The Architecture of Joinery: The Form and Construction of Rotating Sutra-Case Cabinets', *Architectural History*, 42 (1999), pp. 96–109.

MEDIEVAL LIBRARIES

The bibliography on medieval book collections is enormous. [71] J. Thompson (ed.), *The Medieval Library* (New York, 1957) is dated but still useful; the revised 1965 edition has a critical essay by B. Boyer correcting errors in the original. The English context is discussed in detail in [9] *Cam.Hist.Lib.*, vol. 1, and in the first three volumes of [72] D. McKitterick and L. Hellinga (eds), *The Cambridge History of the Book in Britain* (Cambridge, 1999–2012): [73] R. Gameson (ed.), vol. 1 (c. 400–1100); [74] N. Morgan and R. Thomson (eds), vol. 2 (1100–1400); and [75] L. Hellinga and J. Trapp (eds), vol. 3 (1400–1557). For the loss of Islamic libraries, see [76] J. Pederson, *The Arabic Book* (Princeton, 1984); [77] S. Padover in [13] *Thompson* (pp. 347–68); Harris [3], pp. 71–87; Battles [1], pp. 60–7; Polastron [5], pp. 42–72; [78] H. BenAicha, 'Mosques as Libraries in Islamic Civilization, 700–1400 A.D.', *Journal of Library History*, 21, no. 2 (spring 1986), pp. 253–60, and [79] R. Elayyan, 'The History of the Arab-Islamic Libraries: 7th–14th centuries', *International Library Review*, 22 (1990), pp. 119–35.

[29] Clark pointed out that medieval books were generally stored in freestanding cupboards, niches fitted with doors or later in bookrooms. [80] R. Gameson, 'The Medieval Library (to c. 1450)' in [9] *Cam.Hist.Lib.*, vol. 1, pp. 13–50, notes that no study has yet attempted to collate and analyse the scattered physical remains of medieval libraries. [81] B. Streeter, *The Chained Library* (Cambridge, 1931) provides a detailed analysis of early library furniture but draws some conclusions regarding dating that are now known to be false (see below). French examples are noted in [82] A. Prache, 'Bâtiments et décor' in [13] *Hist.Bib.Fr.*, vol. 1, pp. 350–63, and [83] J. Vezin, 'Les mobilier des bibliothèques', in the same volume, pp. 364–71. The best discussion of medieval Italian libraries in English is still [84] J. O'Gorman, *The Architecture of the Monastic Library in Italy 1300–1600* (New York, 1972). For Germany and Northern Europe, see [85] E. Lehmann, *Die Bibliotheksräume der deutschen Klöster im Mittelalter* (Berlin, 1957) and [86] K. Christ, *The Handbook of Medieval Library History* (London, 1984), translated by T. Otto from the 1950–65 German original.

The availability of books, their cost, production and literacy in the early Middle Ages are discussed in [87] R. McKitterick, *The Carolingians and the Written Word* (Cambridge, 1989). For more details of parchment and

book manufacture, see **[88]** R. Gameson, 'The Material Fabric of Early British Books', in **[9]** *Cam.Hist.Bk.*, vol. 1, pp. 15–93, and the chapters in **[10]** *Cam.Hist.Bk.*, vol. 2, pp. 41–109; **[89]** R. Rouse and M. Rouse, 'The Commercial Production of Manuscripts in Late Thirteenth and Early Fourteenth Century France', in **[90]** L. Brownrigg (ed), *Medieval Book Production* (Los Altos, 1990), pp. 103–15; **[91]** H. Bell, 'The Price of the Book in Medieval England', *Library*, 4th ser., 17 (1936–7), pp. 312–32; **[92]** J.A. Szirmai, *The Archaeology of Medieval Bookbinding* (Aldershot, 1999); and **[95]** B. Middleton, *A History of English Craft Bookbinding Technique* (4th ed., London, 1996). On the physical setting for book production and the plan of St Gall, see **[94]** W. Horn and E. Born, 'The Medieval Monastery as a Setting for the Production of Manuscripts', *Journal of the Walters Art Gallery*, 44 (1986), pp. 16–47. For a rare mention of a scriptorium building, at St Albans, see **[95]** M. Gullick, 'Professional Scribes in Eleventh- and Twelfth-Century England', *English Manuscript Studies 1100–1700*, 7 (1988), pp. 1–24. The use of cloisters for reading and writing is discussed in **[80]** Gameson and in **[29]** Clark, quoting the Rites of Durham, published in **[96]** J. T. Fowler (ed.), *Rites of Durham*, Surtees Society, 107 (Durham, 1903), p. 83. The carrels at Gloucester are discussed in **[29]** Clark and **[81]** Streeter. For the dating, see **[97]** D. Verey and A. Brooks, *Gloucester: The Cathedral Church* (London, 2002), pp. 34–7. **[29]** Clark and **[80]** Gameson give good accounts of the emergence of book rooms, the latter citing **[98]** P. Pradié (ed.), *Chronique des abbés de Fontenelle (Saint-Wandrille)* (Paris, 1999), p. 170, for the first, 9th-century example. For the next stage, the move to libraries proper, rather than rooms just for storage, see **[29]** Clark, **[84]** O'Gorman and **[80]** Gameson. The evidence from Humbertus de Romanis is reprinted in his **[99]** *Opera de vita regulari*, ed. J. Berthier (Rome, 1888–9), II.265. For the role of the mendicant orders, see **[100]** K. Humphreys, *The Book Provision of the Medieval Friars, 1215–1460* (Amsterdam, 1964). On the physical fabric of surviving spaces, see **[101]** *Wells Cathedral Library* (Wells, 2006); **[84]** O'Gorman, pp. 1–4 and 44–5; **[102]** M. Le Goff, C. Batard and N. Petit, *La Bibliothèque du Chapitre* (Noyons, 2006) and **[26]** Masson. The parish library of the church of St Peter and St Walburga in Zutphen is discussed in many English books, including **[81]** Streeter and **[29]** Clark, who provide plans.

EARLY CHINESE LIBRARIES

The Tianyi Chamber is not well known outside China. The best account in English is **[103]** P. Situ, 'The Tianyige Library: A Symbol of the Continuity of Chinese Culture', *Library Trends*, 55, no. 3 (2007), pp. 421–50. For those who can read Chinese, there is **[104]** Luo Zhaoping, *Tianyi Ge Congtan* [Essays on Tianyi Pavilion] (Beijing, 1995). For an account of Chinese book production in English, see **[60]** *Sc.Civ.Ch.*, vol. 5, pt 1, by Tsien Tsuen-Hsuin, and, by the same author, **[105]** *Written on Bamboo and Silk; the Beginnings of Chinese Books and Inscriptions* (Chicago, 2004). **[2]** Lerner provides a short bibliography on Chinese libraries in English and **[59]** McDermott provides a bibliography of libraries and book production in English and Chinese. In Chinese, the best study is **[106]** Ren Jiyu, *Zhongguo Cangshulou* [Traditional Chinese Libraries] (two vols, Liaoning, 2001). On the invention of paper, see **[60]**. The transmission of paper to the West and its use in book production is discussed in **[107]** R. Clapperton, *Paper* (Oxford, 1934) and **[108]** D. Hunter, *Papermaking* (rev. ed., London, 1978).

RENAISSANCE LIBRARIES

The best general study of library buildings in the Italian Renaissance is still **[84]** O'Gorman, which provides a detailed catalogue of libraries, together with bibliographies and plans. The Biblioteca Marciana is discussed in **[109]** D. Howard, *Jacopo Sansovino* (London, 1975) and **[110]** C. Labowsky, *Bessarion's Library and the Biblioteca Marciana* (Rome, 1980). The Laurentian Library has attracted a great deal of attention: see **[84]** O'Gorman; **[111]** J. Ackerman, *Michelangelo* (2nd ed., Harmondsworth, 1986), pp. 95–119; **[112]** R. Wittkower, 'Michelangelo's Biblioteca Laurenziana', *Art Bulletin*, 16 (1934), pp. 123–218; **[113]** G. Corti and A. Parronchi, 'Michelangelo al tempo dei lavori di San Lorenzo in una "ricordanza" del

Figiovanni', *Paragone*, 175 (1965), pp. 9–31; **[114]** I. Argan and B. Contardi, trans. M. Grayson, *Michelangelo Architect* (London, 1993); **[115]** D. Hemsoll, 'The Laurentian Library and Michelangelo's Architectural Method', *Journal of the Warburg and Courtauld Institutes*, 66 (2003), pp. 29–62; and **[116]** F. Salmon, 'The Site of Michelangelo's Laurentian Library", *Journal of the Society of Architectural Historians*, 49, no.4 (Dec. 1990), pp. 407–29.

On the role of books in the display of wealth, see **[117]** L. Jardine, *Worldly Goods* (London, 1996). **[118]** O. Raggio and A. Wilmering (eds), *The Gubbio Studiolo and its Conservation* (two vols, New York, 1999) provides a detailed bibliography for the Renaissance *studiolo*. The libraries in the Vatican and at the University of Leiden are dealt with in **[29]** Clark, with corrections on the dating of the cupboards in **[51]** Morrish. On calculating lectern capacities, see **[119]** P. Gaskell, *Trinity College Library: The First 150 Years* (Cambridge, 1980), pp.6–7. The subject of chaining books to desks is dealt with in most surveys of library architecture; **[29]** Clark provides an introduction. **[81]** Streeter provides a close examination of the desks themselves.

The change from lecterns to stall libraries was first identified in **[29]** Clark. Streeter revised Clark's dates, but both were shown to be wrong by Nicholas Ker, whose detailed analysis of primary documentary sources, first published in the 1950s, finally established that stall libraries did not appear until the very end of the 16th century: see **[120]** J. Myres, 'Oxford Libraries in the Seventeenth and Eighteenth Centuries' in **[12]** Wormald and Wright, pp. 236–55, and **[121]** N. Ker, 'Oxford College Libraries in the Sixteenth Century', first published in 1978 and reprinted in **[122]** N. Ker, *Books, Collectors and Libraries* (Hambledon, 1985), pp. 379–436. For an up-to-date discussion, see **[123]** C. Sargent, 'The Early Modern Library' in **[9]** *Cam.Hist.Lib.*, vol. 1, pp. 51–65. For Oxford libraries, see **[124]** J. Newman, 'Oxford Libraries before 1800', *Archaeological Journal*, 135 (1978), pp. 248–57; **[125]** J. Newman, 'The Architectural Setting', in **[126]** N. Tyacke (ed), *The History of the University of Oxford*, vol. 4, *Seventeenth-Century Oxford* (Oxford, 1997), pp. 155–177, and for pictures, **[127]** G. Barber, *Arks for Learning* (Oxford, 1995). For Trinity Hall, Cambridge, see **[128]** L. Hinton, *Trinity Hall; The Story of the Library* (Cambridge [n.d.]); for Wells, see **[101]**. For Queens' College, Cambridge, see **[123]** Sargent and her forthcoming book on the library.

17TH-CENTURY LIBRARIES

[29] Clark, pp. 291–320, and **[54]** Petroski, pp. 101–28, discuss the origins of the wall system. For the French situation, see **[129]** M. Bacha and C. Hottin, *Les Bibliothèques parisiennes* (Paris, 2002), which supersedes **[130]** C. Jolly, 'Bâtiments, mobilier, décors' in **[15]** *Hist. Bib.Fr.*, vol. 2, pp. 359–71. The Germans use the term *Saal-system*, meaning 'hall library'. The Escorial has been widely discussed. For bibliographies, see **[28]** Cosme; **[151]** H. Kamen, *The Escorial: Art and Power in the Renaissance* (New Haven, 2010); and **[152]** G. Kubler, *Building the Escorial* (Princeton, 1982). For the Ambrosiana, see **[133]** P. Jones, *Federico Borromeo and the Ambrosiana* (Cambridge, 1993), **[29]** Clarke, pp. 269–70, and **[8]** Hobson, pp. 186–201. The building of Arts End is detailed in **[126]** N. Tyacke, pp. 147–9, 659–66, and **[123]** Sargent. The best source for the building of Strahov's Theological Hall is the historical account on the library's excellent website, **[6]** Staikos, pp. 478–9, and **[26]** Masson, pp. 173–4. The projects for the Bibliothèque Mazarine and the first Bibliothèque Sainte-Geneviève are described in **[129]** Bacha and Hottin, pp. 68–70 and 73–6.

Extracts from writings on library buildings in Spanish are provided in **[28]** Cosme, pp. 349–95. For 17th-century writers on libraries, see **[154]** C. Jolly, 'Naissances de la "Science" des bibliothèques', in **[15]** *Hist.Bib.Fr.*, vol. 2, pp. 580–5; **[155]** D. McKitterick, *The Making of the Wren Library* (Cambridge, 1995), pp. 1–27; **[156]** T. Walker, 'Justus Lipsius and the Historiography of Libraries', *Libraries and Culture*, 26, no. 1 (winter, 1991), pp. 49–65; **[157]** M. Rovelstad, 'Two Seventeenth-Century Library Handbooks, Two Different Library Theories', *Libraries and Culture*, 35, no. 4 (2000), pp. 540–56; and **[158]** M. Rovelstad, 'Claude Clement's Pictorial Catalog: A Seventeenth-

Century Proposal for Physical Access and Literature', *Library Quarterly*, 61, no. 2 (Apr. 1991), pp. 174–87. **[159]** The collected papers of Christopher Wren were edited for the Wren Society by A. Boulton and H. Hendry in twenty volumes (Oxford, 1923–43). The best summary of the literature is **[140]** A. Geraghty, *The Architectural Drawings of Sir Christopher Wren at All Souls College Oxford* (Aldershot, 2007). Lincoln Cathedral library is covered in **[159]** volume 15 of the Wren Society, pp. 40–3, and **[141]** N. Linnell, 'Michael Honywood and Lincoln Cathedral Library', *The Library*, 6th ser., 5 (1983), pp. 126–40. There is a biography of the mason Thompson in **[142]** D. Knoop and G. Jones, *The London Mason in the Seventeenth Century*, (Manchester, 1935), p. 43. Wren's designs for the Senate House in Cambridge are discussed in **[143]** J. Newman, 'Library Buildings and Fittings' in **[9]** *Cam.Hist.Lib.*, vol. 2, pp. 190–211; **[159]** Wren Society, vol. 5, p. 31, and vol. 9, p. xi; **[144]** H. Colvin, 'The Building' in **[135]** McKitterick, p. 30, and **[140]** Geraghty, pp. 27–9. For St Paul's Cathedral library, see **[145]** Nigel Ramsay 'The Library to 1897' in **[146]** D. Keene, A. Burns, A. Saint (eds), *St Paul's: The Cathedral Church of London 604–2004* (London, 2004), pp. 421–2. For Trinity College library, see **[155]** D. McKitterick. The drawings for the round scheme are discussed in **[140]** Geraghty, pp. 32–43. The Radcliffe Camera is discussed in **[147]** K. Downes, *Hawksmoor* (London, 1959), pp. 126–31; **[148]** S. Lang, 'By Hawksmoor out of Gibbs', *Architectural Review*, 105 (Apr. 1949), pp. 184–7; **[149]** T. Friedman, *James Gibbs* (London, 1984), pp. 240–55, and the original documents are reprinted in **[150]** S. Gillam, *The Building Accounts of the Radcliffe Camera* (Oxford, 1958). Little has been written on Wolfenbüttel in English; **[151]** E. Edwards, *Memoirs of Libraries* (London, 1859) reprints the plans and **[8]** Hobson gives a short account. The Codrington Library at All Soul's College, Oxford, is described in **[147]** Downes, pp. 152–43; **[152]** E. Craster, *The History of All Souls College Library* (London, 1971), pp. 66–81; **[153]** H. Colvin and J. Simmons, *All Souls* (Oxford, 1989), pp. 19–46; and **[154]** I. Maclean, *All Souls Library 1438–2008* (Oxford, 2008), p. 20.

ROCOCO LIBRARIES

For a definition of Rococo, see **[155]** H.-R. Hitchcock, *Rococo Architecture in Southern Germany* (London, 1968). On the problems of its French origins, see **[156]** K. Harries, *The Bavarian Rococo Church* (New Haven, 1983), pp. 1–47. The best study of Rococo libraries is **[157]** E. Lehmann's magisterial two-volume *Die Bibliotheksräume der Deutschen Klöster in der Zeit des Barock* (Berlin, 1996), which includes a catalogue of libraries and comprehensive bibliographies of sources for Austrian and German Rococo library design. This has replaced **[158]** G. Adriani, *Die Klosterbibliotheken des Spätbarock in Österreich und Süddeutschland* (Vienna, 1935). State and monastic library iconography is discussed in **[159]** C.-P. Warncke (ed.), *Ikonographie der Bibliotheken* (Wiesbaden, 1992). The best account in English is **[160]** E. Garberson, *Eighteenth-Century Monastic Libraries in Southern Germany and Austria: Architecture and Decorations* (Baden-Baden, 1998), which provides a catalogue, full bibliography and detailed analyses of their iconography.

The best source of information on the library in Coimbra is the library's website. See also **[161]** *A Universidade de Coimbra* (Coimbra, 1998); **[28]** Cosme, p. 142; and **[26]** Masson, p. 160. Mafra appears to have attracted surprisingly little scholarly attention: it is briefly discussed in **[28]** Cosme, p. 142; **[157]** Lehmann; **[162]** R. Smith, 'The Building of Mafra', *Apollo*, 97, no. 134 (Apr. 1973), pp. 360–7; **[18]** J. Bosser and de Laubier; and **[163]** J. Pereira in *The Grove Dictionary of Art*, vol. 19, pp. 775–8, and vol. 20, pp. 85–6.

The standard work on J. B. Fischer von Erlach is **[164]** H. Sedlmayer, *Johann Bernhard Fischer von Erlach* (Vienna, 1956). See also **[165]** E. Dotson, *J.B. Fischer von Erlach* (London, 2012). On temporary architecture, see **[166]** R. Strong, *Art and Power: Renaissance Festivals 1450–1650* (Berkeley, 1984). On the Hofbibliothek, see **[167]** I. Kubadinow, *The Austrian National Library* (London, 2004), and **[168]** W. Buchowiecki, *Der Barockbau der ehemaligen Hofbibliothek in Wien* (Vienna, 1957). On the Hofbibliothek as a model for other libraries, see **[160]** Garberson, pp. 80–2.

The architecture of the Biblioteca Casanatense is mentioned only briefly in **[169]** C. Pietrangeli, *La Biblioteca*

Casanatense (Florence, 1993), pp. 13–14; [170] A. Braham and H. Hager, *Carlo Fontana: The Drawings at Windsor Castle* (London, 1977), p. 16; [171] H. Hager, 'Carlo Fontana', *The Grove Dictionary of Art*; and [28] Cosme, p. 108. For the Biblioteca Angelica, see brief references in [172] R. De Fusco, et al., *Luigi Vanvitelli* (Naples, 1973), pp. 61–2; and [28] Cosme, p. 108. Austrian and German Baroque libraries are better served, with bibliographies, in [160] Garberson and [157] Lehmann. See also, for Melk, [173] B. Ellegast, E. Bruckmüller and M. Rotheneder (English translation by K. Stumpfer), *Melk* (Melk, 2008), pp. 1–21; for Altenburg, see [174] A. Gross and W. Telesko (eds), *Benediktinerstift Altenburg* (Vienna, 2008), particularly the chapters on the library and crypt by Andreas Gamerith, pp. 112–28; for St Florian, [175] T. Korth, *Stift St Florian* (Nuremberg, 1975), and for St Gallen, [176] E. Tremp, J. Huber and K. Schmukt, *The Abbey Library of Saint Gall* (St Gallen, 2007). The standard work on Admont is [177] M. Mannewitz, *Stift Admont* (Munich, 1989), pp. 185–257, and there is an analysis of its iconography by the same author in [159] Warncke, pp. 271–307. The Strahov library is treated in [157] Lehmann and [160] Garberson, but the best source is the library's website.

19TH-CENTURY LIBRARIES

The literature on 19th-century libraries, particularly public ones, is very extensive. For a bibliography, see [178] A. Black, S. Pepper and K. Bagshaw, *Books, Buildings and Social Engineering* (Farnham, 2009). The British situation is discussed there and in [179] M. Port, 'Library Architecture and Interiors' in [10] *Cam.Hist.Lib.*, vol. 2, and [180] S. Pepper, 'Storehouses of Knowledge' in [11] *Cam.Hist. Lib.*, vol. 3. For America, see [181] A. Van Slyck, *Free for All: Carnegie Libraries and American Culture 1890–1920* (Chicago, 1995) and [182] K. Breisch, *Henry Hobson Richardson and the Small Public Library in America* (Cambridge, Mass., 1997). For France, see [15] *Hist.Bib.Fr.*, vol. 3, and in particular [183] J. Bleton, 'Les Bâtiments', pp. 182–257. For Germany, see [184] H. Crass, *Bibliotheksbauten des 19. Jahrhunderts in Deutschland* (Munich, 1976), which has a useful English summary and excellent illustrations of many lost libraries. English country-house libraries are discussed in [185] M. Girouard, *Life in the English Country House* (London, 1978), pp. 234–7, and [179] Port. On particular houses, see [186] M. Snodin, *Strawberry Hill* (London, 2009), pp. 37–42, and [187] P. Wesch, *Sanssouci: The Summer Residence of Frederick the Great* (Prestel, 2003). For their demise, see [188] P. Reid, 'The Decline and Fall of the British Country House Library', *Libraries and Culture*, 36, no. 2 (spring 2001), pp. 345–66. For Jefferson, see [189] M. Brawne, *University of Virginia: The Lawn* (London, 1994) and [190] G. Wills, *Mr Jefferson's University* (Washington, DC, 2002), pp. 102–15.

For an introduction to Neoclassicism and the Beaux Arts, see [191] A. Braham, *The Architecture of the French Enlightenment* (London, 1980) and [192] R. Middleton and D. Watkin, *Neoclassical and 19th century architecture* (two vols, London, 1987). For the origin of the ideas, see [193] J. Winckelmann, *Gedanken über die Nachahmung der griechischen werke in Malerei und Bildhauerkunst* (Dresden, 1756) and [194] M.-A. Laugier, *Essai sur l'architecture* (Paris, 1753). On the unbuilt schemes for the Louvre, see [195] G. Fonkenell in [129] Bacha and Hottin, pp. 53–5. Schemes by Adam are discussed in [179] Port, pp. 463–8, and by Boullée in [196] J.-M. Pérouse de Montclos in [129] Bacha and Hottin, p. 56, and [197] J.-M. Pérouse de Montclos, *Étienne-Louis Boullée* (Paris, 1969), pp. 166–7, pls. 96–101. Pannonhalma is mentioned in [25] Pevsner and [157] Lehmann. For the Ecole des Beaux Arts, see [198] D. Egbert, *The Beaux-Arts Tradition in French Architecture* (Princeton, 1980); [199] R. Chafee, 'The Teaching of Architecture at the Ecole Des Beaux Arts',), pp. 61–109, in [200] E. Drexler (ed.), *The Architecture of the Ecole des Beaux Arts* (London, 1977); and [201] Drexler, 'Beaux Arts Buildings in France and America' in the same work, pp. 417–93. For the construction of the library of the Assemblée nationale, see [202] A. Sérullaz in [129] Bacha and Hottin, pp. 187–91. Gas lighting is discussed in [203] J. Papworth and W. Papworth, *Museums, Libraries and Picture Galleries* (London, 1855) and [178] Black et al., pp. 75–6.

For Cambridge University Library, see [204] D. Watkin, *The Life and Work of C.R. Cockerell* (London, 1974), pp. 185–

96; [205] D. Watkin, 'Newly Discovered Drawings by C. R. Cockerell for Cambridge University Library', *Architectural History*, 26 (1985), pp. 87–91 and pls. 44–57; and [206] D. McKitterick, *Cambridge University Library, A History: The Eighteenth and Nineteenth Centuries* (Cambridge, 1986), pp. 472–92. For Playfair in Edinburgh, see [179] Port, pp. 462–8; on Gore Hall, see [182] Breisch, pp. 60–4. The library at Trinity College, Dublin, is described in [207] C. Benson, in [10] *Cam.Hist.Lib.* vol. 2, pp. 116–17, and [208] F. O'Dwyer, *The Architecture of Deane and Woodward* (Cork, 1997).

The National Library of Finland has an excellent history on its website. See also [209] K. Pöykkö, 'Carl Ludwig Engel', in *The Grove Dictionary of Art*. For the Bibliothèque Sainte-Geneviève, see [210] N. Levine, 'The Romantic Idea of Architectural Legibility: Henri Labrouste and the Néo-Grec', in [200] Drexler, pp. 325–416, and [211] C. Vendredi-Auzanneau, 'Sainte-Geneviève' in [129] Bacha and Hottin, pp. 138–42. For Boston Public Library, see [212] R. Wilson, *McKim, Mead and White* (New York, 1983), pp. 154–45. On iron in buildings, see [213] A. Saint, *Architect and Engineer: A Study in Sibling Rivalry* (London, 2007), pp. 65–106. For the Bibliothèque Nationale stacks, see [214] J.-F. Foucaud, 'Les réalisations de Labrouste' in [129] Bacha and Hottin, pp. 110–14. The story of the British national library is told in [215] A. Esdaile, *The British Museum Library* (London, 1946). For a biography of Panizzi, see [216] E. Miller, *Prince of Librarians* (London, 1967). Iron-stack libraries and Peabody are discussed in [217] C. Belfoure, *Edmund G. Lind* (Baltimore, 2009) and [182] Breisch, the best source for Richardson's libraries. On battles between librarians and architects, see [178] Black et al., pp. 100–6, who quote [218] E. Nicolson and H. Tedder (eds), *Transactions and Proceedings of the Conference of Librarians Held in London October 1877* (London, 1878), pp. 147–8. Finally, there is an excellent monograph on Furness's masterpiece: [219] E. Bosley, *University of Pennsylvania Library: Frank Furness* (London, 1996).

20TH-CENTURY LIBRARIES

There is as yet no definitive guide to 20th-century library architecture. General surveys can be found in [52] Thompson, [53] Brawne and [28] Cosme. For France, see [220] J. Gasguel, 'Les Bâtiments' in [15] Jolly et al., vol. 4, pp. 446–71; for Germany, see [221] G. Liebers, *Bibliotheksbauten in der Bundesrepublik Deutschland* (Frankfurt, 1968); and for Britain, see [178] Black et al. See also [222] M. Brawne (ed.) *Library Builders* (London, 1997). On individual libraries mentioned in the text, see [223] J. Macaulay, *Glasgow School of Art* (London, 1993); [224] P. Dain, *New York Public Library: A Universe of Knowledge* (New York, 2000), pp. 11–14; [225] H. Reed and F. Morrone, *The New York Public Library* (New York, 2011), pp. 19–21. The only work on the Osaka library is in Japanese: [226] *Nakanoshima hyakunen: Ōsaka furitsu toshokan no ayumi* [One Hundred Years of the Nakanoshima: A Look at the History of the Osaka Prefectural Library] (Osaka, 2004).

On lighting, see [227] F. Burgoyne, *Library Construction* (London, 1905); [228] J. Brox, *Brilliant: The Evolution of Artificial Light* (New York, 2010); [229] J. Poulter, *An Early History of Electricity Supply* (Exeter, 1986); [250] O. Prizeman, *Philanthropy and Light* (Farnham, 2012); and [251] M. Steane, *The Architecture of Light* (Abingdon, 2011). On the University of London, see [252] *The Senate House and Library/University of London* (London, 1938). Stockholm City Library is discussed in [253] P. Blundell Jones, *Gunnar Asplund* (London, 2006). On Plečnik, see [254] M. Gooding, *National and University Library, Ljubljana* (London, 1997). The story behind the Beinecke Library is told in [255] C. Krinsky, *Gordon Bunshaft* (London, 1988), pp. 141–2; and [256] 'Gordon Bunshaft Interviewed by Betty J. Blum', Chicago Architects Oral History Project, The Art Institute of Chicago, available online. The library in Seinäjoki is discussed in [257] R. Weston, *Alvar Aalto* (London, 2002); [258] N. Ray, *Alvar Aalto* (London, 2005); and [251] Steane. The Berlin Staatsbibliothek is discussed at length in [259] P. Blundell Jones, *Hans Scharoun* (London, 1995).

Books on library planning are numerous. See, for instance: [53] Brawne; [240] K. Metcalf, *Planning Academic and Research Library Buildings* (New York, 1965);

and [241] G. Thompson, *Planning and Design of Library Buildings* (Norwich, 1975). Phillips Exeter Academy Library is discussed at length in [242] D. Brownlee and D. De Long, *Louis Kahn* (New York, 1991) and [243] R. McCarter, *Louis Kahn* (London, 2005). The national library building projects in Paris and London are discussed in [244] M. Spens, 'The Tale of Two Libraries' in [245] M. Brawne (ed.), *The Library Builders* (London, 1997), pp. 20–5; [246] R. Stonehouse and G. Stromberg, *The Architecture of the British Library at St Pancras* (London, 2004); [247] C. Wilson, *The Design and Construction of the British Library* (London, 1998); and [248] D. Perrault and M. Jacques (eds), *Bibliothèque nationale de France 1989–1995* (Basel, 1995). The library at TU Delft is reviewed in [249] A. Wortmann, 'Mecanoo's Purgatorial Mound: University Library in Delft', *Archis* (Mar. 1998), pp. 66–73; [250] B. Lootsma, 'University Library, Delft, the Netherlands', *Domus*, Feb. 1999, pp. 22–9, and [251] C. Van Cleef, 'Book Bunker', *Architectural Review*, 125, no. 1225 (Mar. 1999), pp. 45–9.

THE 21ST CENTURY

For the libraries discussed in the text, see: [252] 'Oita New Prefectural Library; Architects: Arata Isozaki & Associates', *GA Documents*, 36 (1993), pp. 48–51; [253] S. Moholy-Nagy, 'Robert Hutchings Goddard Library', *Architectural Forum*, Sept. 1969, pp. 41–7; and on James Stirling's history faculty library at Cambridge, see [53] Brawne. On Japan, see [254] Y. Futagawa, *Library* (Tokyo, 2006) and [255] L. Spinelli, 'Sendai Mediathèque; Architects: Toyo Ito', *Domus*, 957 (Apr. 2012), pp. 154–6. On the Shiba Ryotaro Museum, see [256] M. Webb, 'The Architecture of Books', *Domus*, 855 (Jan. 2003), pp. 62–73; [257] J.-M. Martin, 'Tadao Ando: Museo Shiba Ryotaro, Higashi-Osaka', *Casabella*, 72, no. 769 (Sept. 2008), pp. 75–85. On the library at BTU Cottbus, see [258] 'Herzog & de Meuron: IKMZ BTU Cottbus, Germany', *GA Documents*, 86 (July 2005), pp. 30–41; [259] M. Webb, 'Cottbus Kaleidoscope: Library and Media Centre, Cottbus, Germany', *Architectural Review*, 219, no. 1310 (Apr. 2006), pp. 64–7; and [260] C. Gänshirt, 'Bibliothèque universitaire (IKMZ), Cottbus', *L'Architecture d'Aujourd'hui*, 358 (May–June 2005), pp. 100–5.

On the University of Utrecht library, see [261] W. Arets, *Living Library* (Munich, 2005), p. 330 and passim; [262] A. Betsky, 'Dark Clouds of Knowledge', *Architecture*, 93, no. 4 (Apr. 2005), pp. 52–61; [263] 'Wiel Arets: Library Utrecht', *Architecture and Urbanism*, Feb. 2005, pp. 52–41, and [264] 'Wiel Arets: Library Utrecht', *Architecture and Urbanism*, Jan. 2012, p. 34 and pp. 56–9. On the National Library of China, see [265] K. Cilento, 'National Library/KSP Jürgen Engel Architekten', www.archdaily.com (posted 27 July 2009). On the National Library of China, see [266] 'National Library, World's 3rd Largest', BeijingReview.com (posted 25 Sept. 2008); [267] Lee-Hsia Hsu Ting, 'Chinese Libraries During and After the Cultural Revolution', *The Journal of Library History* (1974–1987), 16, no. 2, *Libraries and Culture II* (Spring 1981), pp. 417–34; and [268] Gu Ben, 'Western Language Books in the Beijing Library', *Learned Publishing*, 12 (1999), pp. 33–40.

On the Bodleian and British Library storage, see [269] P. Hoare, 'The Libraries of the Ancient Universities to 1960' in [11] *Cam.Hist.Lib.*, vol. 3, pp. 321–44; [270] J. Hopson, 'The British Library and its Antecedents' in [11] *Cam.Hist. Lib.*, vol. 3, pp. 299–315; and [271] N. Davis, 'A Surprise in Store', *The Times Eureka Magazine*, 34 (July 2004), pp. 28–52. On the Grimm Centre, see [272] 'Max Dudler: Jacob and Wilhelm Grimm Center, Berlin, Germany 2005–2009', *Architecture and Urbanism*, Sept. 2010, pp. 72–9; [275] F. Kaltenbach, 'A Critical View: Jacob and Wilhelm Grimm Centre in Berlin', *Detail*, 49, no. 12 (2009), pp. 1314–15; on the Liyuan Library, see [274] F. Chiorino and A. Zappa, 'Biblioteca Liyuan, Jiaojiehe Village', *Casabella*, 814 (June 2012), pp. 52–9; [275] L. Xiaodong, 'Liyuan Library', *Space*, 530 (Jan. 2012), pp. 60–5; [276] M. Li, 'Liyuan Library', *Leap: The International Art Magazine of Contemporary China* (July 2012), accessed online. For a brief introduction to library pests, see [277] D. Pinniger, *British Library Preservation Advisory Centre: Pests* (London: 2012). Finally, for the future of the book, see [278] Lloyd Shepherd, 'The Death of Books Has Been Greatly Exaggerated', Guardian. co.uk (posted 30 Aug. 2011) and [279] M. Lyons, *Books: A Living History* (London, 2011).

London: British Library 205, 228, 275, 276, 301; British
 Museum Library 205, 227–8, *228*, 238, 249, 251, 299, 301;
 Buckingham Palace 227; gentlemen's clubs 205;
 St Paul's Cathedral 137, 139–41; Senate House,
 University of London 254; Strawberry Hill 205
Louis XIV, King of France 153, 212, 214
Louka Abbey, Znojmo 203
Louvre, Paris 164, 210
Ludwig, Johann Frederick 161
Lysimachus 43

Mabillon, Jean 200
McKim, Charles 227
McKim, Mead and White (architectural practice) 208, 226,
 227
Mackintosh, Charles Rennie 245, 247
McLaughlin, James W. 252
Mafra Palace library, Portugal 25, 26, *26*, 33, *160*, 161–3, *161*,
 162–3
Magdalen College, Oxford 117
Magdalene College, Cambridge 149
Magoichi, Noguchi 253
Malatesta Novello 72
Malatestiana, Biblioteca, Cesena *1*, 6–7, 73–7, *73*, *74*, *75*, 76–7,
 85, 98, 107–8, *107*, 110
al-Ma'mun, Caliph 72
Manchester: Central Library 228;
 John Rylands Library 205
Mannerism 104, 260
manuscripts 22, 72, 105, 110, 179, 192
Maqamat al-Hariri 72, *72*
marble 33, 143, 212, 248, 264
Marciana, Biblioteca, Venice *2–3*, 54, 98–102, *98–9*, *100*, 104,
 105, 142
Maria Anna, Archduchess of Austria 161
Mark Antony 43, 46
mass storage *see* offsite storage; stacks
Masson, André 29
Maulbertsch, Franz Anton 203
Mazarine, Bibliothèque, Paris 136, 237
Mecanoo (architectural practice) 280–81
media centres 288–91
Medici family 98, 102, 105, 205
Melk Abbey, Austria 173–9, *174*, *175*, 176, *177*, *178*, 183–4
Merton College, Oxford 20, 80, *81*, 112–13, *112*, *113*, 114
Mesopotamia 37–40, 45, 59, 65, 298
Metcalf, Keyes DeWitt, *Planning Academic and Research
 Library Buildings* 272, 273
Metten Abbey, Germany 181
Michelangelo 102–6, *107*
Michelozzo 96, 105
Mii-dera Temple, Ōtsu *60*, 61, 68–9, *69*, 70, *70*, *71*
Milan: Biblioteca Ambrosiana 125–8, *126*, *127*, 133, 137, 139,
 150, 170
Mitterrand, François 275
Modernism 33, 245, 261, 265, 272, 281–2, 285
Mongolia, Virginia 206
Moscow: Russian State Library 20, 31, *31*, 254, *255*, 261
Muggenast, Josef 28, 176, 179
Muhammad (prophet) 70
Munich: Bayerische Staatsbibliothek 260, *261*
museum curatorship 286–8

Napoleon Bonaparte 161, 212, 214
Nara, Japan: Tōshōdai-ji sutra store *66*, *66*, 68
National Library of China, Beijing *16–17*, 296–8, *296*, *297*,
 298–9
Naudé, Gabriel 137, 143, 203
Neoclassicism 208–210, 221–3, 247, 254, 282
Netherlands: medieval 85, 87; 17th century 108;
 20th century 245; *see also* Delft; Utrecht; Zutphen
New College, Oxford 113, 117
New Haven, Connecticut: Beineke Library *244*, 261, 264–5,
 264, *265*, 281
New York City: Astor Library 232, 234, 247; Columbia
 University 259; Lenox Library 247; New York Public
 Library 34, 234, 247–9, *247*, *248*, 249, *250*, 251, *251*
Newcastle upon Tyne: Literary and Philosophical Society
 249
Nicholas I, Tsar 221

Nicolas V, Pope 106
Nineveh: library of Ashurbanipal 39–40, *40*
Ningbo, China: Tianyi Chamber 33, 91–2, *92*, *93*, 94–5, *95*, 96,
 96, 97, 106, 118, 306
Nippur 39
North, Roger 142
Nosecky, Siard 133
Noyon, France: chapter library *4–5*, 85, *85*, 86–7, *87*
Nunes, Vicente 158
Nuti, Matteo 73, 98
Nyström, Gustaf 228

Ōe no Masafusa 70
offsite storage 301–2
O'Gorman, James F. 104–5
Ōita, Japan: Prefectural Library 285; Toyonokuni Libraries
 285
open access 121, 258, 302
Osaka, Japan: Osaka Prefectural Nakanoshima Library
 251–4, *252–3*; Shiba Ryōtarō Memorial Museum 285–6,
 286, *287*
Ōtsu, Japan: Mii-dera Temple sutra hall *60*, 61, 68–9, *69*, 70,
 70, *71*
Ottawa: Library of Parliament 228
Ottoman Empire 59
Overall, W.H. 259
Oxford 82; All Souls College 117; Christ Church 117;
 Codrington Library 136, 147–50, *148*, *149*, *150–51*; Corpus
 Christi College 117; Duke Humfrey's Library 113–17, *114*,
 115, 117, 128, 133, 144; Jesus College 141; Magdalen College
 117; Merton College 20, 80, *81*, 112–13, *112*, *113*, 114; New
 College 113, 117; Queen's College 117; Radcliffe Camera
 15, 144–6, *144*, *145*, *146*, 150, 301; St Edmund Hall 141;
 St John's College 117; Sheldonian Theatre 139;
 University College 141; *see also* Bodleian Library
Oxford system *see* stall system

Packh, János 211, 212
Padua 100; S. Antonio 85
Paestum 210
painted decoration and frescoes 20, 29, 100, 102, 106, 121,
 153–5, 176, 192, 196, 200, 214
painters 20, 137, 150, 176
Palatine library, Rome 29, 55, *55*
Palladio, Andrea 142, 210
Palliardi, Johann Ignaz 203
Palmyra 210
Panizzi, Sir Antonio 227–8, 258, 299
Pannonhalma Abbey, Hungary 211–12, *211*, *212–13*
panopticon 227–8
paper, Chinese: invention 95–5; manufacture 22, 72, 95
paper, Western: invention 91, 95, 121, 125; manufacture 22
papyrus 40, 41, 79
parchment 79, 92, 121, 125
Paris 254, 256; Assemblée Nationale 211, 214, *215*, *216*, *217*, 221;
 Bibliothèque Mazarine 136, 237; Bibliothèque Saint-
 Victor 149; Bibliothèque Sainte-Geneviève *30*, 31, 136, 167,
 223–5, *223*, 224–5, 226, 227, 306; École des Beaux-Arts 212,
 221, 223, 240; Louvre 164, 210; Sorbonne 79, 85;
 see also Bibliothèque Nationale
Peabody, George 252
Peabody Library, Baltimore *14*, 33, *204*, 252–4, *255*, 273
Pei, I. M. 272
Pelz, Paul J. 251
Pepper, William 240
Pepys, Samuel 149
Pergamum 79; library of 41–5, *41*, *42–3*, 44–5
Perrault, Claude 164, 210
Perrault, Dominique 33, 275–9, 281, 306
Persia 45, 70
Peterhouse, Cambridge 117
Petrarch 100
Pevsner, Sir Nikolaus: *A History of Building Types* 15, 245,
 298
Philadelphia: Fischer Fine Arts Library 240–43, *240*, *241*, *242*,
 243
Philetaerus 43
Philip II of Macedon 45
Phillips Exeter Academy Library, New Hampshire 272–5,
 272, *273*, *274*, *275*
Phoenicians 41

Picton Library, Liverpool 228
pictorial catalogues 29, 192, 196
Pinelli, Gian Vincenzo 127
Pisa 85
Pius VII, Pope 75
plaster decoration 133, 150, 153, 176, 203
Playfair, William 221
Plečnik, Jože 33, 245, 260
Pollio, Asinius 55
Pompeii 57, 210
Portugal: Coimbra, Biblioteca Joanina *8*, 26, 33, *154*, *155*,
 156–7, 158, *159*, 167; Mafra Palace library 25, 26, *26*, 33, *160*,
 161–3, *161*, *162–3*
Post-Modernism 285
Potsdam: Sanssouci Palace 205–6
Poyet, Bernard 214
Pozzo, Andrea 196
Prague: Strahov Abbey *132*, 133–6, *133*, *134–5*, 136, 202, 203, *203*
Prandtauer, Jakob 176, 179, 188
pressmarks *see* cataloguing
printing: Chinese, Korean and Japanese 20, 22, 65;
 moveable type 65, 91, 121; number of books produced
 today 15, 291
Ptolemaic dynasty 45–6, 142
Pugin, Augustus, *Contrasts* 223

Queens' College, Cambridge 108, 110, 117–19, *118*, *119*
Queen's College, Oxford 117
Quincy, Massachusetts: Thomas Crane Memorial Library
 236, 237–8, *237*, *238*, 239, 506
quires 22
Qur'an 70, 72

Radcliffe, John 144
Radcliffe Camera, Oxford 15, 144–6, *144*, *145*, *146*, 150, 301
Ramesses II 40
Rancé, Armand Jean le Bouthillier de 200
Raphael, *The School of Athens* 211, 226
Rassam, Hormuzd 39
reading in libraries 33–4, 54–5, 80, 190
Realdino, Francesco 158
Reform Club, London 205
Reformation 91, 118, 128, 158
Reichenau Abbey, Germany 192
Reizei House, Kyoto 67–8, *67*, *68*
Ribeiro, António Simões 158
Ricchino, Francesco Maria 127
Richardson, Henry Hobson 237, 239, 506
Rickman and Hutchinson (architectural practice) 218
Ripa, Cesare: *Iconologia* 200
Rocca, Angelo 170
Rococo 26, 153–4, 173, 200–203, 210
Roman Empire 37, 46, 47–59
Rome 210, 212, 214; Baths of Caracalla library 51, *52–3*, 57, *57*;
 Baths of Trajan library 54, *55*, 56–7, *56*, *57*; Biblioteca
 Angelica 170–73, *172*, *173*; Biblioteca Casanatense *152*, 153,
 168–70, *169*, *170–71*; Palatine library 29, 55, *55*; S. Marcello
 85; Sala Sistina, Vatican 105, *105*, 106; Trajan's Forum
 library 55–6
Rose, Sandra Priest and Frederick Phineas 248
Roubiliac, Louis-François 143
round libraries 121, 143–7, 208, 227–8, 256
Rovaniemi, Finland: civic centre 266
Roxburghe Club 205
Rudolf, Paul 264
Rudolph, Paul 272
Russia 221; Russian State Library, Moscow 20, 31, *31*, 254, *255*,
 261; Vyborg library 265–6, 282
Ryōtarō, Shiba 285, *286*

Saeltzer, Alexander 252
St Edmund Hall, Oxford 141
St Florian, Abbey of, Austria 22, 188–92, *189*, *190–91*
St Gall plan 78, *78*, 80, 82
St Gallen, Switzerland, Abbey of St Gall *11*, 78, *78*, 192–6, *192*,
 193, *194–5*, 196
St John's College, Cambridge 117, 141
St John's College, Oxford 117
St Lambrecht, Abbey of, Austria 188
St Paul's Cathedral, London 137; Dean's Library 139–41
Saint-Victor, Bibliothèque, Paris 149

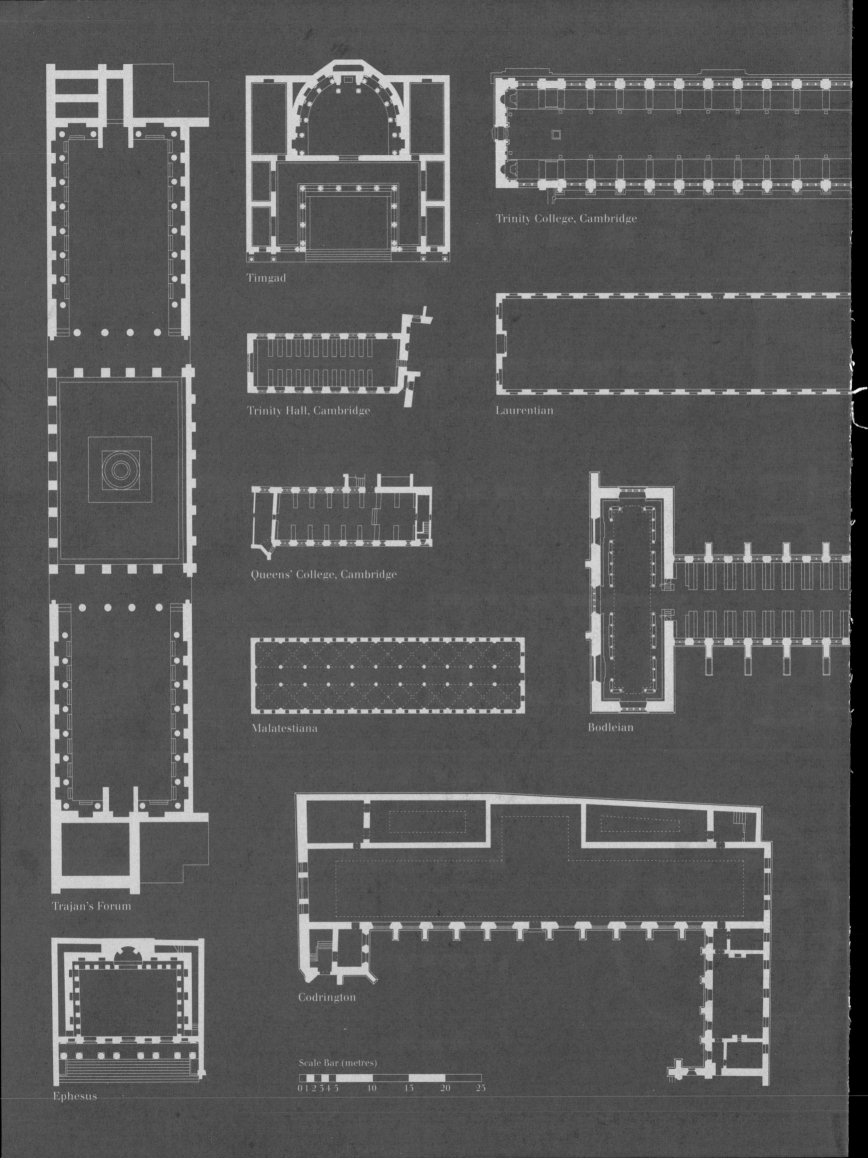

Trinity College, Cambridge

Timgad

Trinity Hall, Cambridge

Laurentian

Queens' College, Cambridge

Malatestiana

Bodleian

Trajan's Forum

Codrington

Ephesus

Scale Bar (metres)

0 1 2 3 4 5 10 15 20 25